Timete dñm oms sci ei: qm ñ e inopia timentibz eu.

Divites eguerunt & esurierunt: inquirentes autem dñm ñ minuentur omni bono.

Venite filii audite me: timore dñi docebo

Quis est homo qui vult vitam: & uos diligit dies videre bonos:

Prohibe linguam tuam a malo: et labia tua ne loquantur dolum:

Diverte a malo et fac bonum: inquire pacem et persequere eam. Seorum

Oculi dñi sup iustos: & aures ei ad preces

Vultus autem domini sup facientes mala: ut perdat de terra memoriam eorum.

Clamauerunt iusti & dñs exaudiuit eos: et ex omnibz tribulationibz eor liberauit eos.

Iuxta est dñs hiis qui tribulato ē corde: et humiles spiritu saluabit:

Multe tribulationes iustorum: et de omnibz his liberauit eos dominus:

Custodit dominus omnia ossa eorū:

André Bouwman
Irene O'Daly

WRITTEN TREASURES

*50 Manuscripts
from Medieval Europe*

Universiteit
Leiden

Lannoo

Foreword

Were you to stroll today from the imposing Pieterskerk towards the Academy Building on the Rapenburg canal in Leiden, you may not be aware that this historic heart of the city was — already 450 years ago — the birthplace of the oldest university of the Netherlands. On 8 February 1575, Leiden University was established in the Pieterskerk — a 'bulwark of freedom' which would grow into an international centre of scholarship and study.

To fulfil her humanistic ambition, a library was indispensable. And while the University Library would predominantly acquire printed editions, studies and textbooks, manuscripts were also collected from the very start. That remained the case throughout the subsequent centuries and is still the case today. To underscore the significance of our medieval manuscripts, over the past few years we have worked hard on the digitization of the collection. Thanks to this comprehensive process, these unique manuscripts are now used in teaching and research, not only in Leiden but also worldwide.

Written Treasures: 50 Manuscripts from Medieval Europe presents an exceptional collection of medieval manuscripts, forming a rich reflection of the culture of medieval Europe. Without the painstaking work of industrious medieval scribes, many old texts would no longer survive. And without the work of our predecessors in the library, these handwritten treasures would not have been so well preserved nor studied.

Written Treasures introduces you to a research collection. Leiden's treasure chamber contains not simply richly decorated and illuminated manuscripts, but rather a gamut of handwritten texts which have formed our image of the world, sometimes through the medium of a beautifully calligraphed codex, but sometimes messily scrawled on a humble scrap of parchment.

In the first place, I wish to express my great appreciation for the two principal authors: André Bouwman (Curator) and Irene O'Daly (Assistant Professor).

They wrote the introductory essays and a portion of the texts regarding the fifty manuscripts which are central in this book. Their collaboration reflects the strong relationship between our library and the Faculty of Humanities, that along with its department of Book Studies, shapes new generations of book historians and medievalists, for whom our medieval manuscripts are objects of study and sources of inspiration. Thanks are due too to the other contributing authors who provided essays about our manuscripts.

Frits van Oostrom (Professor Emeritus) — who has brought the Middle Ages to life in his books like no other — has written an introduction to this book, for which I heartily thank him. I'm also very grateful to Uitgeverij Lannoo. Following on from the book on our map holdings, we are again bringing an important collection to the attention of a broad public in a wonderful way.

This book is not only a milestone in terms of the centuries-long cataloguing and description of our collection of medieval manuscripts, but also marks the end of the career of André Bouwman as Curator of Western Manuscripts. André has served Leiden University Libraries in many ways and in different roles and functions, but his heart has always been with the medieval manuscripts. Here I wish to thank him for his contributions across many years and for the exemplary manner in which he has always protected 'his' manuscripts.

It remains for me to wish you a good journey through medieval Europe, alongside royal courts, monastic libraries, scriptoria and universities. It is a journey full of meetings with authors and scribes, collectors and scholars, librarians and curators, guided by fifty of our treasured manuscripts.

— Kurt De Belder
University Librarian
Director of University Libraries
& Leiden University Press

Contents

Foreword — Kurt De Belder — 5

The Middle Ages as an open book — Frits van Oostrom — 12

Windows to the past — Irene O'Daly — 15

Collected in Leiden — André Bouwman — 37

Preface — 67

The word of God — 69

01 The other side of an illuminated page — 70
9th century, c. 875 — Gospel Book from Saint-Amand
André Bouwman

02 Escaping the maze: Understanding the medieval Bible — 74
12th century, 2nd half — Book of Job (Old Testament)
Irene O'Daly

03 A sacred book — used, cherished and passed down — 78
12th century, c. 1190 — Saint Louis Psalter
Hanno Wijsman

04 The Bible as a growing manuscript — 82
15th century, 2nd half — Southern Netherlands History Bible
Mart van Duijn

05 Restrained elegance for pious women — 86
15th century, c. 1470 — *Leven ons heren*
Anne Korteweg

Personal devotion — 91

06 By and for the hands of a noble nun — 92
15th century, c. 1440 — Book of Hours belonging to 'ic Zaers'
Anne Margreet As-Vijvers

07 Book production as an international business — 96
15th century, c. 1420–1440 — Latin Book of Hours intended
for the English market
Saskia van Bergen

08 Up to date — 100
15th century, 1498–1499 — Book of Hours with calendar and colophon
André Bouwman

09 A manual for the higher spheres — 104
15th century, last quarter — Collection of devotional and ascetic texts
Geert Warnar

10 A printed manuscript? — 108
16th century, 1st half — Compendium of spiritual texts
Anna Dlabačová

Makers and materiality — 113

11 The triumph of word spacing — 114
9th century, last quarter & 7th century, 2nd half — Carolingian codex with flyleaves in uncial script
André Bouwman

12 Reversed, repurposed and recovered — 118
c. 800 & 12th or 13th century — Codex with Carolingian panels in a Romanesque binding structure
Karin Scheper

13 Text and images: Two means to the same end — 122
11th century, c. 1010–1034 — Schoolbooks by Ademar of Chabannes
Ad van Els

14 Perfect to a fault — 126
11th century — Dioscorides, *De materia medica*
Erik Kwakkel

15 A unique edition of the *Liber floridus* — 130
13th century, late — Lambert of Saint-Omer, *Liber floridus*
Hanna Vorholt

16 The nature of a manuscript — 134
14th century, c. 1317 — Lodewijk van Velthem, Fifth Part of the *Spiegel historiael*
Jos Biemans

17 Continuation errors when copying a printed text — 138
15th century, after 1484 — Otto van Passau, *Boeck des guldenen throens*
André Bouwman

Reading, correcting, annotating — 143

18 A thousand years of textual editing — 144
9th century, mid — Cicero, Philosophical works
Irene O'Daly

19 Studying Lucretius at Charlemagne's court — 148
9th century, 1st quarter — Lucretius, *De rerum natura*
David Ganz

20 Erasing evil: The battle of the Virtues and the Vices — 152
9th century, 2nd quarter — Prudentius, *Psychomachia* and other works
Irene O'Daly

21 A multicultural book — 156
9th century, 838 — Priscian, *Institutiones grammaticae* and other texts
Mariken Teeuwen

22 Guided reading: An annotated classical text — 160
11th century — Persius, *Satyrae*; Juvenal, *Satyrae*
Irene O'Daly

23 Canon law in Bologna — 164
14th century, 1322–1334 — Manuscript containing the *Constitutiones Clementinae*
Quintijn Mauer

Words and languages — 169

24 Searching for words — 170
8th century, late, or 9th century, early —
Latin glossary and other texts
Irene O'Daly

25 In the classroom — 174
9th century, 2nd & 3rd quarters — Glossary manuscript
with the *Hermeneumata Pseudodositheana*
Rolf H. Bremmer Jr

26 A riddle that can be solved but cannot be read — 178
9th century, 2nd quarter — Aldhelm and Symphosius, *Ænigmata*
and the Old English 'Leiden Riddle'
Thijs Porck

27 Signed, sealed, delivered: A shorthand lexicon — 182
9th century, late, or 10th century, early —
Commentarii notarum Tironianarum
Irene O'Daly

28 How the Egmond Willeram became the Leiden Willeram — 186
c. 1100 — West Low Franconian paraphrase of the Song of Solomon
André Bouwman

Counting and classifying — 191

29 Nature cures, miraculously or otherwise — 192
6th century, 2nd half — The *Herbarium* of Pseudo-Apuleius
Claudine A. Chavannes-Mazel

30 A giant book — 196
8th century, 2nd quarter — Pliny, *Naturalis historia*
Mary Garrison

31 A constellation of copies and innovations — 200
9th century, 814–840 — Aratus / Germanicus, *Aratea*
Suzette van Haaren

32 Hand signals and medieval counting — 204
12th century, 1st half — Rabanus Maurus, *De computo*
Irene O'Daly

33 An impossible object — 208
14th century — Euclid, *Elementa XI-XV*
Tazuko van Berkel

34 The Creation glitters in gold — 212
14th century, c. 1360 — Jacob van Maerlant, *Der naturen bloeme*
Bram Caers

35 Travelling scholars, travelling texts — 216
15th century, early — Adelard of Bath, *Regulae abaci*
Irene O'Daly

Fables and fiction — 221

36 For education and entertainment — 222
14th century, c. 1325 — Composite manuscript with the fables of *Esopet*
André Bouwman

37 Narrative pearls in a single volume — 226
14th century, c. 1350 — *Roman van Limborch* and *Roman van Walewein*
Bart Besamusca

38 The Holy Grail of German Arthuriana — 230
14th century, 1372 — Leiden's *Wigalois* manuscript
Jef Jacobs

Presenting the past — 235

39 A Roman history of the papacy and its readers — 236
8th century, late — *Liber pontificalis*
Rosamond McKitterick

40 Liudger's treasure-trove of charters — 240
9th century, 2nd half, or 10th century, early — *Liber cartarum*
Kaj van Vliet

41 Additions to an abbot's work by his monks — 244
11th century, 1027–1039 — Abbo of Fleury, *Excerptum de gestis Romanorum pontificum*
Marco Mostert

42 Robert of Torigni's historical compendium — 248
12th century, 2nd or 3rd quarter — Composite manuscript, including the *Gesta Normannorum ducum* by William of Jumièges
Benjamin Pohl

43 The master's hand — 252
14th century, mid or 3rd quarter — Composite manuscript from the private library of Filips van Leiden
Ed van der Vlist

44 Liturgical or not? — 256
15th century, mid — Middle Dutch martyrology
Eef Overgaauw

Old texts, new readers — 261

45 'By God, he shall not pass!' — 262
13th century, 2nd half — *Digestum vetus* with glosses and *additiones*
Egbert Koops

46 Six plays for students and scholars — 266
14th century — Greek tragedies by Aeschylus and Sophocles
Casper de Jonge

47 A literary bestseller from the Renaissance — 270
15th century, 2nd half — Cicero, *Epistulae ad familiares*
Christoph Pieper

48 Frisia in Ferrara — 274
15th century, 1478 — Pliny's letters, copied by Rudolph Agricola
Adrie van der Laan

49 Ancient philosophers in Christian company — 278
15th century & 16th century, 1st half —
Collection of Greek writings from the Near East
Gerard Boter

50 A French *Iliad* for the king — 282
16th century, c. 1540 — Translation of Homer's *Iliad* by Hugues Salel
Alisa van de Haar

Literature — 287

Manuscript descriptions — 297

Glossary — 307

Index — 311

Photo credits — 323

About the authors — 325

The Middle Ages as an open book

Frits van Oostrom

Taking people back in time to the Middle Ages is no easy task. History soon loses out to the present in all its urgency, and the Middle Ages have the added disadvantage of a poor reputation — is calling something *medieval* ever a recommendation? All too often quite the opposite. There is one tried and tested method, though, for overcoming this indifference: show someone an original medieval manuscript. I have yet to meet anyone who didn't succumb immediately.

It doesn't even have to be an exceptional work: a simple everyday text, even if dog-eared or falling apart, will still have that effect. The fascination of being face to face with a text that someone wrote by hand centuries ago is irresistible. Figuring out the mechanisms behind this magic would be worthy of a psychological study in its own right. I suspect it has something to do with the fact that we see — in the most direct way — the link to someone in the distant past doing something we are still familiar with, namely writing by hand. Even though the keyboard is now mightier than the pen, we all still have memories of being taught to write; something that was often a struggle, with results that were far from aesthetically pleasing. You see a fellow human being, living perhaps a thousand years ago, effortlessly doing the same and you feel a sense of historical awareness.

The Middle Dutch encyclopaedia *Sidrac* calls writing the hardest profession in the world. After all, it requires the complete dedication of body and soul; at least bricklayers and plasterers can sing along while they work. The result, a manuscript — a book written by hand, as the word suggests — is so much more than a mere material object. It is a tangible link to history, infused with the spirit of the past.

With any luck, there will be someone at hand who can tell you the tale of any such medieval book. The story of the goose quill, how it was cut, then dipped in ink that had been patiently prepared from oak gall apples, gum arabic and water. Of the actual writing, often by candlelight with cold hands. Of the parchment made from animal skins that were first soaked in lime for days on end, then stretched on a frame to make them flat, and scraped smooth, after which any holes were sewn up and the parchment cut to size. This was an exceptionally costly and time-consuming process that had to be repeated dozens of times just for a single book, although you did end up with a carrier for texts that could survive centuries. It was far more durable than the paper that followed, not to mention our modern web texts. They can tell you the the story of amazing miniatures and surprise additions in the margins, whether scholarly glosses or jokes. Or something in between, like the anecdote in a Leiden manuscript about a thirteenth-century student in Bologna who blundered in an exam and when told he would fail, chose the monastery instead (see no. 45).

Experts can tell us about the techniques that underpin the medieval bindings with their wood and leather and glue, and about modern restorers such as Sister Lucie Gimbrère, a Benedictine nun in Oosterhout, who spent five months in 1987 working on a Leiden volume from 800 AD (see no. 12). Or they may point out an amusing note in the back of a manuscript in a tenth-century hand: 'If anyone takes it from this place with the evil intent of not returning it, may he be cursed along with the traitor Judas' (see no. 11). And we can listen to the story of the books' lives: the scribes in the monasteries and towns, their readers and owners through the centuries, and their peregrinations before ending up purchased by or bequeathed to Leiden University Library, where they would normally expect to be safe for eternity.

And, as in any self-respecting history, that examination of a distant past also enhances our awareness of our own time. Experts might tell the story of the handwritten book as a customised product before the printing press introduced the manufacture of ready-made books. Linked to that is the freedom the medieval book as a

unique object offered the maker; according to medieval etymology, the word *liber* (book) was derived from *libertas* (freedom). From a linguistic point of view they were wrong, but this misguided etymology perfectly encapsulates the spirit of the manuscript. After all, it was the printed book that made the large-scale controls possible that are required for effective censorship.

They will tell the story of the book as the perfect form; like the spoon, according to Umberto Eco, it is something that cannot be improved once invented. And of our responsibility for all this heritage. Medieval books in Leiden and other university libraries are not only stored and made available in accordance with the highest standards and most recent expertise, but have been studied for centuries by scholars from all over the world, bringing history to life. Incidentally, what about all those scribes? Might some of them have been women? Academics nowadays are more alert to this possibility, after having long assumed far too automatically that sophisticated writing would have had to have been a male occupation. This illustrates how an acquaintance with medieval manuscripts not only reveals a distant past but also holds up a mirror to our world today.

Recently, while in the Leiden Special Collections reading room, I had a daydream. You would ideally want everyone to be able to enjoy these medieval handwritten books — including, and perhaps above all, people who come to Leiden to study a completely different subject. Well, Leiden University has roughly thirty thousand students who generally spend about five years on their degree. If we were to divide them into groups of ten at most and give each group a one hour-long session perusing medieval books in the Leiden Special Collections reading room, then two groups a day would be sufficient to accommodate them all. What would that cost? Perhaps the equivalent of one full-time post per year? Would that be such a mad investment, giving each and every Leiden student a unique university experience that will last them a lifetime? Perhaps this would be an appropriate gift to the academic community to celebrate the University's 450th anniversary.

I realise it won't happen, and perhaps my daydream is more of a pipe dream. But fortunately there is also good news for realists. Because medieval books evoke not only a sense of awe and nostalgia but also awareness of and gratitude for progress in the production of books. The book you are currently reading demonstrates that in full. Photographic technology, design and layout options, printing techniques and typography have all brought huge benefits since the Middle Ages and made books so much cheaper that they are now within reach for far greater groups of readers. And let us not forget all those experts who introduce us to Leiden's medieval manuscripts in this book, with their stirring stories about world-famous books such as the *Aratea*, one of Leiden's foremost treasures, for which a dedicated climate-controlled, impact-resistant crate was designed to transport the book safely to an exhibition in the Getty Museum in Los Angeles in 2024 (see no. 31). But they also have an eye for the smallest details, such as the barely perceptible red circle at the top right in a miniature of Christ on the Cross, serving as a quality mark showing that this gem really did come from the illumination mecca of Bruges (see no. 7). And if this leaves you hankering for more, there is a website containing all fifty manuscripts, fully digitised and available for browsing around the clock.

There is nothing quite like being able to see these medieval volumes with your own eyes, but this superb book brings us closer than ever to Leiden's treasure trove of manuscripts.

So, to quote the first line of the Leiden *Wigalois* manuscript, "What excellent person has opened me?"

Detail from the concluding miniature of the *Wigalois* manuscript, depicting a Cistercian monk writing. LTK 537, fol. 95r.

Decies centena milia manibus insertis & digitis inuicem implicatis.

Octuginta milia femori p[ro]p[r]ia

Nonaginta milia pollice ad inguinem uerso.

Windows to the past

Irene O'Daly

Written treasures

What is a treasure? The word summons images of items adorned with precious metals or valuable gemstones, or things of particular rarity. Some medieval manuscripts — books patiently written by hand in the period following the collapse of the Roman Empire in the West in 476 AD to c. 1550 — certainly live up to this image. Such manuscripts were richly decorated in a variety of pigments, highlighted with gold and written in careful script; often made for liturgical settings, they were objects of high value for the monasteries where they were produced. Other medieval manuscripts contain unique copies of texts; had they not survived, their words would have been lost forever.

The vast majority of medieval manuscripts do not fit such conventional perceptions of 'treasure'. They are instead workaday items, sometimes written on inexpensive materials, lacking substantial decoration and speedily copied to save both time and money. The collection of contributions in this volume suggests, however, that these written items, sometimes over a thousand years old, should not be dismissed on account of their, often modest, appearance. While readers will certainly encounter manuscripts adorned with gold in this book (see no. 3), along with rare copies of texts (see no. 19), every manuscript selected for this collection can be regarded as a 'treasure', whether on account of the text(s) it contains, a particularity of its production or its capacity to bring to life an aspect of the conditions in which it was produced and used. Every manuscript permits a sort of time travel — bringing us closer to an understanding of how people in the Middle Ages made, read and used their books.

The medieval period has sometimes been treated as a 'dark age' in the transmission of knowledge. It was, however, an intellectually vibrant one. Texts that originated in Antiquity were preserved during this period through the industry of medieval copyists — scribes — who wrote them out by hand, sometimes painstakingly comparing multiple versions of a text to preserve important readings. The vast majority of medieval manuscripts are not 'autographs'; they are not written in the hand of the author of the text but are instead copies of such texts, sometimes written even hundreds of years after a text had been composed. To make a manuscript, a scribe first had to be in possession of what we term an 'exemplar' — a copy of a text that they could replicate word by word. To facilitate this, manuscripts were exchanged between various individuals and religious and educational institutions; they travelled the roads of medieval Europe. Private collections and ecclesiastical libraries dotted the map of Europe during this period, highlighting centres of intellectual activity, where books were copied and stored. Therefore, as well as transmitting texts, medieval manuscripts also preserve evidence of crisscrossing networks of communication in medieval Western Europe.

The collection of contributions presented in this volume investigates a selection of Western medieval manuscripts, as seen through the eyes of various expert researchers, who approach these 'treasures' from different disciplinary angles, including literary and philological analysis, material approaches and art-historical perspectives. The selection of manuscripts is drawn from the holdings of Leiden University Libraries (UBL) in the Netherlands. Leiden's collection is impressive, in terms of both its scope and its significant quantity of older medieval manuscripts (more than a hundred manuscripts in the collection date from prior to 900 AD). Furthermore, it is the oldest surviving university or national library collection of manuscripts in the Low Countries, with its first medieval manuscript acquired in 1587. This selection of fifty 'treasures' has been curated not only to show the breadth of Leiden's holdings, but also to illustrate the diversity of Western medieval manuscripts. Whether produced by a scholar for personal use or by a professional scribe for sale; for a cloister or for a king; in Latin, Greek or a medieval vernacular, when we open these manuscripts we open a window through which we can view the past.

A reader visiting the library of Leiden University today accesses these manuscripts in the Special Collections Reading Room (or online, through its digital repository).

< Fig. 1
A monk in a twelfth-century manuscript demonstrates how to represent the number 1,000,000 using raised arms and interlocked fingers. See no. 32 for more on medieval finger-counting.
BPL 191 BD, fol. 5v.

Readers request a manuscript by referring to its 'shelfmark' (also known as a call number or signature). The shelfmark of a manuscript records important information that allows it to be distinguished from other manuscripts (even other copies of the same text), such as (in Leiden's case, at least) information about its acquisition history or size. The shelfmark, made up of a combination of letters and numbers, also guides library staff, the custodians of these treasures, to the place where the book is shelved. Finally, the shelfmark (together with the name of the library) is the unique identifier of this specific book. When writing about a particular manuscript, a scholar will cite its shelfmark to avoid confusion with other copies of a text, including those held in other libraries. Throughout this book, manuscripts will be referred to both by the title of the texts that they hold and by these shelfmarks. Across these fifty contributions, we invite you to take a virtual visit to Leiden's reading room, exploring these treasures from throughout the medieval period.

Studying the manuscript

Well into the twentieth century, manuscripts were studied by scholars primarily for their texts; philologists, in particular, analysed their textual variants and treasured manuscripts that preserved otherwise unknown readings. However, scholars have become increasingly interested in the material aspects of the manuscript, investigating what its present condition may reveal about how the book was made and used. At the heart of such an approach is an understanding that the manuscript as we hold it in our hands today is the result of a series of cumulative processes, which may have taken place over a long period of time.

These range from the making of the writing surface (such as parchment or paper) to the process of writing itself (script), to the binding of the book, to actions the reader may have carried out in using the text (such as annotation), right up to decisions made by later owners (such as rebinding). Even the present needs of contemporary readers must be considered, for example, through stabilising the condition of a damaged manuscript to allow its continued consultation. Each of these processes can reveal different information about how a manuscript was prepared and used. Researchers use a variety of techniques to evaluate these processes and, through these, build up a picture of a manuscript's past. Two key sub-disciplines of medieval manuscript research are codicology — the study of manuscripts in codex-form — and palaeography — the study of script. Both are essential for reading and studying the medieval book.

Codicology concerns itself with the study of the materiality of the book. By investigating each of its features and the processes involved in its production, codicologists establish how the book as object developed over time. Tiny details — like how the binding was sewn, or evidence that leaves were removed or added — can help us understand a constellation of craft practices fundamental to the book's making and use. The discipline of codicology traditionally involves examining a book in person ('in autopsy') and painstakingly recording its features. Exciting multidisciplinary collaborations are now pushing the boundaries of what codicologists can now determine about the manuscript. Parchment origins may be established through examining its molecular qualities; pigment types can now be evaluated through multi-spectral and other types of photographic imagery; bindings can be X-rayed or 3D modelled to explore their structure. While many of these new multidisciplinary techniques remain financially out of reach for most scholars and institutions, they illustrate that manuscript research, in tandem with conservation practices, continues to innovate and, hopefully, reveal new secrets of the book.

Meanwhile, the academic discipline of palaeography, the study of script, developed from the seventeenth century onwards, with the publication of Jean Mabillon's (1632–1707) six-volume *De re diplomatica* (1681) marking an important milestone. Mabillon's work illustrated how the characteristics of medieval handwriting varied between geographic area and period. The handwriting of an authentic document should match that of the period and the area in which it was claimed to have been produced, giving scholars a convenient means to identify and exclude forgeries.

To establish the characteristics of handwriting from various periods and areas, Mabillon and other researchers relied heavily on the internal evidence that manuscripts themselves provided, notably scribal notes (colophons) which recorded dates and places of production. As the vast majority of medieval manuscripts do not contain such information, however, much palaeographical study entails comparison of the 'certain' with the 'uncertain', comparing the characteristics of soundly dated manuscripts with those of undated ones. The discipline

of studying script was, particularly in its early days, marred by subjectivity, dependent as it was on the fallibility of the human eye and on the opinions of researchers who had access to only limited material.

The discipline of palaeography was transformed in the late nineteenth century by the proliferation of photography. For the first time, researchers were no longer constrained by the limit of whatever collection was immediately within their reach, but could compare manuscripts with photographic plates and, later, microfilms, from collections all around the world. Photography vastly expanded the base of comparative material which was available to palaeographers, resulting in more nuanced dating and the development of increasingly objective standards for describing script.

Digitisation has transformed the field of palaeography anew. Digitised material is now widely available, allowing researchers to pull up comparable manuscripts on-screen with the touch of a button and zoom in to see script features in minute detail. The International Image Interoperability Framework (IIIF), a standard for presenting digital images, has eased access by encouraging consistency in image quality and metadata standards across institutions. Digitisation also creates new possibilities for research. Using deep learning models, scholars can train computers to compare images of text on a scale unimaginable for a single researcher. Handwritten text recognition technologies have also developed in leaps and bounds within the last ten years, meaning that computer models can be trained to read medieval handwriting, often to a reasonable degree of accuracy. Most significantly, the availability of digitised materials has democratised access to the medieval manuscript: no longer reserved as an object of study for the few who are lucky enough to have access to a local collection, digitisation projects mean that manuscripts can be easily incorporated into study at various levels of education and used in public outreach.

However, an important variable remains at the root of both palaeography and codicology, in spite of these new developments — that is, the human factor behind the act of writing and making the manuscript. When we 'date' a manuscript, it is the activity of the scribe and maker that we are dating — their idiosyncrasies. This human aspect introduces a degree of imprecision into any analysis: a scribe may, for example, have used similar handwriting throughout their lifetime, meaning that we must think in terms of ranges of possible dates of production rather than specific years. They could have travelled from place to place, and their style could have been influenced by external factors — whether by visitors to a monastery or the borrowing of a book — all aspects which complicate the localisation of a manuscript. Manuscript research, therefore, remains a form of detective work.

Materiality of the manuscript

While the earliest manuscripts were copied on papyrus, a writing surface made by overlaying reeds of the papyrus plant, parchment became the favoured medium for the medieval book up to the introduction of paper in Europe in the thirteenth century. Parchment was usually made from the skins of common grazing animals like goats, sheep and cows. Unlike papyrus — which was available only in arid landscapes, like the Nile Valley — parchment was a readily available product of the medieval European agrarian economy. Parchment was made by first de-hairing the animal's skin in a lime solution, which dissolved adhering flesh and hair, followed by scraping to remove remaining residues and stubble. Then the skin was stretched on a wooden frame under tension. Once dry, the skin could be polished with a pumice stone or similar substance, smoothing out irregularities in the sheet, and whitened with chalk or equivalent, which also increased its absor-

Fig. 2
This late-twelfth-century copy of Thierry of Chartres's (c. 1100–c. 1150) commentary on Cicero's *De inventione* ('On Invention') was probably made by a student for personal use. The parchment was filled with text almost to its edges, although a reader still found space to sketch a face in the outer margin.
BPL 189, fol. 45r, detail.

bency. The result was a flexible, thin, light-coloured writing surface. In comparison to papyrus, parchment was relatively resistant to humidity. It could be easily cut but was difficult to tear.

Once a sheet of parchment was prepared, it was then cut to size and (usually) trimmed of its irregular edges. When folded once along its shorter axis, the result was one large bifolium. When folded a second time (*in quarto*), and with the first fold cut open, the sheet supplied two bifolia, or four leaves. The parchment could also be cut to the desired size without folding. Each leaf, or folio, of parchment could be written on its front (*recto*) and back (*verso*). The upper limit of the parchment sheet's dimensions depended on the size of the animal used. The scale of the medieval book is, in effect, determined by the animals who grazed the fields of medieval Europe. Larger books, like Leiden, UBL, VLF 4 (see no. 30), demanded large sheets of (calf) parchment. A smaller book could also be produced by cutting and folding parchment sheets down to the required size. Even inferior leaves could be used for small, inexpensive books (see Fig. 2).

The written heritage of the medieval period depended on a process whereby every scrap of an animal was put to good purpose. Parchment making was a valued industry alongside the production of meat, wool and leather. Occasionally, these animal traces can be spied in the skin: hardened or yellowing curved sections that betray that the parchment was cut from the edge of a sheet, a scattering of holes recalling insect bites the animal endured, the light dotting of the follicle pattern of the skin (see Fig. 3). Other traces reveal the work of the parchment maker: cuts created by the slip of a knife, light striations or thin grooves in its surface from the forceful movement of the scraper. It is a testament to the value of parchment as a writing medium that flaws in the skin were often attentively stitched or inventively worked around by the scribe (see Fig. 4). In fact, parchment was so precious that written leaves were sometimes erased and reused, a process known as palimpsesting.

Once the sheets were cut to the required size, they were assembled into quires, the gatherings of parchment leaves which were the building blocks of the medieval manuscript. Quires were usually assembled by stacking cut parchment bifolia on top of each other, folding them in half, and stitching or tacketing (provisionally stitching) them together. Most quires consist of four bifolia stacked together, resulting in a quire of eight leaves (a quaternion), although quires of five bifolia or ten leaves (a quinion) were also common in certain areas and periods (such as fifteenth-century Italy). Generally, the leaves within a quire were arranged so the darker-coloured side of the parchment, originally the hair side of the animal, would be stacked against the dark surface of the next leaf, with the lighter flesh side of that leaf then facing the lighter side of another leaf, and so on. This results in openings of even colour, with the hair side of a leaf facing hair side and the flesh side facing flesh side (for an exception, see no. 24). When turning the pages of a medieval manuscript, the effect of this process is sometimes striking, with one opening starkly pale compared with its darker counterpart.

Paper was produced in Europe from the thirteenth century onwards, with production radiating out from Italy to France, Germany and England by the fifteenth century. Made from torn and soaked cloth rags, the resulting pulp was strained in a sieve-like rectangular wire mould, then pressed and dried into sheets. These sheets were then soaked in 'size', a gelatine solution that made the paper more durable and less absorbent. Traces of the making process are frequently visible on medieval sheets of paper, which are crisscrossed by the chain lines and laid lines of the metal mould. Paper makers often added a maker's mark to their moulds, a wire decoration which left an impression, or watermark, on the paper, serving to authenticate its origin and quality. Given that paper had to be imported across Europe for much of the medieval period, it was not necessarily cheaper than parchment to obtain in bulk. Both parchment and paper had different qualities and were preferred for different purposes. For example, parchment was more tear resistant than paper, but paper was lighter to carry than parchment (for examples of manuscripts written on paper in this volume, see nos 5, 33 and 48). Some manuscripts used a blend of materials (see nos 9 and 17).

Medieval scribes generally wrote their texts into pre-made quires, meaning that when they reached the end of one side of a leaf, they could effortlessly continue onto the top of the next. As longer texts required multiple quires, scribes and binders would include markings, or signatures, to ensure that quires followed the proper order of the text. Quire signatures, usually given in the form of letters (A, B, C, …) or numbers (I, II, III, …) were generally copied in the lower margin of the back (*verso*) of the final leaf of a quire. In the later medieval

Fig. 3 (left)
Here, a scribe has turned a flaw in their parchment into an opportunity. A face hangs from the A of *Aristophanes*, its bearded lip and chin recalling the once hairy origin of the parchment. The parchment's follicle pattern can be seen on the preceding leaf, here visible in the bottom-left corner. VLF 88, fol. 61v, detail.

Fig. 4 (right)
We know that this manuscript of Cicero's *De officiis* ('On Duties') was made for a schoolteacher (as a note at its end suggests). This may explain the poor-quality parchment that was used. Here, a tear in the parchment was sewn before writing; the scribe has worked around the stitches. GRO 36, fol. 10v, detail.

period, catchwords — indications giving the first word or two from the opening leaf of the following quire — were often added to serve the same purpose (see Fig. 5). For codicologists, such markings can be useful for establishing the original arrangement of a medieval book or working out if text is missing or has been added.

Preparing for writing

After acquiring the text they wished to copy — the exemplar manuscript — along with the parchment or paper they intended to use as a writing surface, the scribe had to make a series of important decisions. Before the scribe could begin to write on parchment or paper, they had to imagine the copied text's ultimate appearance. First, the scribe had to outline the size and shape of the text block, often following the proportions of the page itself. The text block was enclosed by the margins of the page, with its lower and outer margins usually slightly larger than the upper and inner ones. This empty space visually contrasted with the text on the page, while also ensuring that the manuscript could be handled safely without unnecessary touching of the text itself. As we will see in several examples throughout this book, the margins did not always remain empty for long; they provided space for reactions to the text, personal notes and even drawings.

Once the size of the text block had been determined, the scribe then had to consider whether to present the text in 'long lines' that stretched across the text block's full width, or to divide the space into two or more columns, with shorter lines of text. Factors that could influence this decision included text type, the size of the page and aesthetics. A verse text with short lines, like the *Odes* and *Epodes* of the Roman poet Horace, might be presented in narrow columns to emphasise

Fig. 5
Catchwords marked the ends of quires and were sometimes an opportunity for scribes to add comedic or even bawdy detail. The elongated body of this twisted figure carries the word *grant* (large). SCA 40, fol. 10v, detail.

its metrical structure. A text written on a very large page could also be broken into columns to facilitate its legibility, ensuring that the eye of the reader could easily move from the end of one line of text to the beginning of the next (see nos 30 and 35). Regardless of page size, text layouts in two columns increased in fashion during the later medieval period, showing that aesthetics must have also played a role in such scribal decisions. Having determined the line length, the scribe then turned to consider their spacing, a factor that corresponded to the size of the letters to be used.

Once these decisions had been made, the scribe marked the text block and its divisions on the page, reserving space, if necessary, for elements such as miniatures or decorated initials. They then ruled the text block. Up until the middle of the twelfth century, it was conventional to rule the page using a sharp implement such as a knife, which left a near-invisible impression on the parchment ('blind ruling'). By the thirteenth century, 'plummet', a lead marking tool which left a dark trace on the writing surface, was almost universally preferred; by the later medieval period, ink was also used for this purpose. To ensure that the lines were drafted accurately and equally spaced, the scribe pricked holes at regular intervals along the page's edge using an awl or another implement with a sharp point. These pricking holes were used as guides to draw straight lines across the writing surface. With the text block marked out and the lines ruled, the scribe could then proceed to write.

Marking out and ruling the page was a time-consuming process, and scribes seem to have experimented with various ways to improve efficiency. One way to streamline the process was to emulate the layout of the exemplar from which the scribe was copying, replicating its format. Another was to prick and rule several pages at once; if folios were ruled with a sharp implement in a stack, a deep impression would be left on the uppermost folio, while the furrows would still be lightly visible on the folios beneath. It is easy to disregard the essential role played by these preparatory stages of writing — well-executed and uniform ruling across pages and pages of a manuscript fades into the visual background for a reader — but these marks, traced by hand, formed an essential scaffolding to receive the text.

Finally, the scribe prepared their writing tools and mixed their inks. Quill pens were generally made from the wing feathers of swans or geese, another important way in which manuscript production connected to the wider agricultural economy of the Middle Ages. Stripped of its plume and hardened, the tip of the quill was cut for purpose, with the angle and breadth of the nib carefully selected to facilitate the broad and narrow strokes that a particular script might require, as well as personalised to the preferences of the scribe's own grip. Scribes usually worked with both a quill and knife to hand. The knife allowed the quill to be sharpened but could be used in other ways too: its blunt side could apply light pressure to the parchment to keep the surface still as the scribe was writing; its sharp side could excise mistakes.

For writing, a dark-brown or black ink was generally preferred, as it contrasted with the creamy surface of the parchment or paper. A common medieval recipe for such ink involves the use of oak galls, growths

Fig. 6
This copy of Horace's *Epodes* is written in two columns. An illustration, coloured with a yellow wash, has been added to accompany the text.
GRO 15, fol. 18r.

rich in tannins that form on oak trees. The galls were ground and combined with a stabiliser (typically gum arabic, a type of tree sap) and iron sulphate to produce the dark-brown ink that is characteristic of many medieval manuscripts.

Writing as a craft

When we open a medieval manuscript, we encounter the craftsmanship of the medieval scribe. Our fingers touch the parchment they once held; they put gentle pressure on the same page with their hands or the flat edge of a knife, holding it still as they traced letters with a quill pen onto the parchment's yielding surface. In the early medieval period, most manuscripts were copied in monastic houses (both male and female), where the demand for books was high. The important work done by medieval scribes was sometimes referenced in the illustrations accompanying their manuscripts (see no. 22). In a twelfth-century copy of some of the New Testament Epistles (Leiden, UBL, BPL 136 C), for example, two portraits depict the saints Peter and Jude at work. Peter, sitting at a slanted desk, holds a quill pen, his hand clasping a red-bordered expanse of parchment sheet. Jude is writing on a parchment roll spread across his lap. A horn-shaped inkwell containing a stirring stick is inserted into a nearby desk.

Christianity is a religion of the book, and to live as a good Christian entailed having accurate copies of the key religious works required to pray and perform the liturgy. In the monastery, the processes of book production generally took place in house, in *scriptoria*, or writing spaces — from preparing parchment (perhaps even sourced from the herds of the monastery's fields) to setting out the layout of the page, from copying its text to the binding of the book. Copying important religious works, such as the Gospels (see no. 1), was considered a form of prayer, a way of showing honour to God. These monastic houses were also important centres of learning; non-religious works (such as the works of Cicero, Lucretius and Priscian; see nos 18, 19 and 21) were copied by monastic scribes eager to perfect their Latin and hone the argumentation skills required to defend their faith. Such manuscripts were often intensively studied, as their accompanying annotations and commentaries show.

From the twelfth century onwards, medieval Europe became increasingly urbanised and, with the development of towns and a complex market economy, the various processes of medieval manuscript production became increasingly professionalised and fragmented. While manuscript production continued in religious houses, many books were now made by professional craftspeople who were responsible for the various

Fig. 7 (left)
Saint Peter sits — pen in hand, writing — in this twelfth-century copy of the Epistles of the New Testament.
BPL 136 C, fol. 17r, detail.

Fig. 8 (right)
Jude the Apostle stares contemplatively over his writing desk. A roll is unfurled across his knees.
BPL 136 C, fol. 52r, detail.

stages: sourcing parchment (sometimes even sold already assembled into quires), copying, decorating, binding and so forth.

In some medieval towns like Oxford, Paris and Bruges, middlemen — stationers, or *libraires* — took responsibility for coordinating the various groups involved in the production of a book, feeding the demand of the universities for accurate textbooks (see no. 23) or ensuring that books were made according to the desires of purchasers. Patrons, whether students, members of religious orders, or laypeople, could have books made to their own specifications, choosing various grades of parchment or decoration, while enterprising workshops emerged where books were also copied speculatively, anticipating demand and, later, personalisation by their owners. This is the case, for example, for a Book of Hours copied in Bruges for export to the English market (no. 7), and a copy of Cicero's letters made in Italy for an unknown buyer (no. 47). In the latter case, an empty roundel was provided for the eventual owner to add their own coat of arms to its opening page.

Factors that influenced scribal performance

The speed with which a scribe could copy a text was influenced by several factors. Environmental conditions had an impact — was the weather warm enough for the scribe to hold a sharpened quill steadily? Was there sufficient light, either from a window or a lit candle? The tools the scribe had to hand were also significant — for example, was the parchment of sufficient quality to absorb ink in a consistent manner, or did the scribe have to vary their writing to avoid blots? Was their quill, cut from the shaft of a feather, sufficiently sharp? Scribes who were more experienced and skilled at writing could copy faster, whereas a scribe who laboured over replicating the letter forms and text of the exemplar in front of them — whether on account of lack of experience, age or bad eyesight — would inevitably write more slowly.

Perhaps the factor which was most significant with respect to the length of time it took a scribe to copy a text, however, was the type of script used and the grade of formality the scribe was expected to produce. Different scripts demanded different levels of competence and care; an elaborately curlicued script was more time-consuming to replicate than one with simple letter forms. Meanwhile, a manuscript that was intended primarily for personal use required less finesse in the execution of its letter forms than one intended for the readership of others, and certainly less than one prepared for a rich and exacting patron.

Throughout the Middle Ages, scribes used a variety of script types. As we will see in the brief and non-exhaustive survey that follows, certain scripts were dominant in medieval Europe at various points on account of their legibility, ease of execution or association with particular intellectual movements or circles. The choice of a type of script by a scribe depended on at least five elements. First, which scripts were in current usage in a particular period and area? Second, in which of these scripts had the scribe been trained? Third, what was the expectation of the intended reader, and which scripts could they read? Fourth, the exemplar from which the scribe was copying may also have played a role: might it have made sense to emulate its script type? Finally, were there particularities of a text itself that might lend to its copying in a specific script or call for the use of multiple scripts? For example, were there textual features, such as headings, that needed to be distinguished in some manner?

Writing in practice

To illustrate the various factors that might have motivated such choices, a close look at a single example from Leiden's collection will suffice, namely one of Leiden University's most famous manuscripts, the Leiden *Aratea* (Leiden, UBL, VLQ 79; see no. 31). This ninth-century manuscript, which is in many respects exceptional, contains a Latin translation by Germanicus (c. 16/15 BC–19 AD) of a Greek astronomical text (the *Phainomena*, by Aratus, 314–245 BC) and is illustrated throughout with images that represent the various constellations discussed in the text. Its text is copied in rustic capitals (*capitalis rustica*), a script that was used as a Latin bookhand (a script executed with a certain degree of formality or concern for legibility that is used for copying books) from the first century AD onwards. *Capitalis rustica* is distinguished by its use of solely majuscule letter forms (with no ascender or descender elements — that is, no extending strokes on letters like *b*, *d*, *p* or *q* which go above or below the main body, or x-height, of other letters); letters are thin and quite angular in form.

The first four lines of fol. 49r, which introduce the constellation Aquarius, depicted in the accompanying image pouring stars out from a pitcher, are written in rustic capitals. Notable features of the script include the almost uniform height of the letters, which in this sample diminish slightly in size from the start of each verse line. Only rare letters, such as *F* (line 3, *FLAM[M]A*) and *L* (line 2, *LIQUORUS*), stick their heads above the other letters, while the lack of a cross-stroke on the *A* means that this letter can be difficult to identify at first glance (see the end of line 4, *SIGNA*).

By the time in which this manuscript was copied, rustic capitals were already anomalous. Carolingian minuscule (discussed later) was the script that was coming into common use. Rustic capitals were usually employed in this period for decoration or to distinguish text elements, such as headings or the opening lines of a text. The scribe of this manuscript explicitly chose to use this antiquated script type in copying this text to underscore the links between this manuscript and its classical heritage, most likely inspired by the features of his (late antique) exemplar. Here, we see one of the ways in which the choice of script is about more than just the conveying of the words of a text: the choice of script can also signal to the reader that a work is to be associated with a particular context — in this case, classical Antiquity. While word separation is inconsistent and there is no punctuation (aside from the presentation of the text in verse lines, with the first letter of each line in red), the letters are aerated and legible — that is, once the array of forms of the alphabet are identified.

However, a script that may have been common in one period can appear baffling, even illegible, in another. Below the four lines of rustic capitals, we find another four lines of text, copied in a darker ink. The words replicate those already presented on the page — it is a transcription. But this scribe, writing in the thirteenth century, is using a different type of script — in this case a Gothic bookhand (*littera textualis*), a type of script common across Europe from the early thirteenth century onwards. Why did this later user of the manuscript find it necessary to add a transcription of the text (on this folio and throughout the manuscript), a choice that — to the modern eye — drastically impacts the visual balance of the original? Given the care they took (the transcription has been ruled to ensure it is neatly entered on the leaf, and the initial letter of each line has been set carefully apart from the rest to indicate that this is a verse text), it is likely that they intended to improve the legibility of the text. Word spacing is consistent, while the letter *i* (see line 1) generally receives a diacritic to distinguish it from other letters with a similar base form (such as *n*, *m* and *u*, also made up of short vertical strokes, or minims). Rustic capitals,

Fig. 9
A depiction of the constellation Aquarius in the Leiden *Aratea*, with accompanying text written in rustic capitals and Gothic *textualis* scripts. VLQ 79, fols 48v-49r.

a script that might have appeared clear (if antiquated) to its ninth-century reader, was seemingly seen as outdated and hard to read by this thirteenth-century user, although we can also entertain other possibilities, such as the scribe using this manuscript for transcription practice.

The visual differences between this Gothic script type and the rustic capitals are notable. First, this script uses majuscule and minuscule forms of letters. Minuscule scripts include elements that reach below the baseline (descenders) or extend above the headline (ascenders) of the main body of the letter (its x-height). Elements here that reach below the ruled baseline of the script include the *x* (line 1, *dextra*) and the descender stroke on the *p* (line 4, *pedibus*). Letter forms are compressed, which is common in Gothic scripts. In *dextra*, for example, the shaft of the *d*, its ascender, is angled, leading to the vertical compression of the letter, while the letters *de* are fused to each other, which enhances the horizontal compression of the word. The scribe has formed the *ra* at the end of the word by joining the head stroke of the *r* to the curved head and vertical stroke forming the back of the *a*, a trick that meant they did not have to lift their pen off the parchment between the two letters (the fewer the individual pen strokes, the faster the scribe could write). Such features of compression, along with the joining of one letter form to another, can, however, inhibit the legibility of a script to an unpractised eye.

Furthermore, the scribe of this Gothic transcription of the text makes substantial use of abbreviations throughout (expansions of abbreviations are indicated in the transcription here and throughout this volume in parentheses). For the second word of their text, *p(ro)cul* (line 1), the scribe uses a common abbreviation form, stretching to the left of the letter *p* like a stuck-out tongue, to indicate the syllable *pro-*, omitting the *r* and *o*. Later in the same line, in the penultimate word, *aq(u)ari(us)*, the second *a* of the word is presented in superscript (a part of the syllable *-qua-*, omitting the letter *u*), while the last letters, *-us*, a common word ending in Latin, are indicated by a small squiggle, resembling the number 9. These variants of abbreviation types — the contraction of commonly occurring groups of letters or the suspension of letters at the end of a word — are used throughout the Middle Ages but became increasingly common in texts written in Gothic scripts, perhaps reflecting higher levels of literacy among readers in the later medieval period. Using abbreviations facilitated the speed of copying while enhancing the visual compression of the text. For modern readers, however, such abbreviations can be complex to unravel, a daunting obstacle to the reading of medieval script.

Scripts in transition

This examination of the thirteenth-century transcription in the Leiden *Aratea* reflects the fact that standards of legibility change over time, as does the perceived purpose of a script. For the Carolingian scribe, writing in the ninth century, the choice of rustic capitals, a classical script type, was suggestive of the text's history. For the Gothic scribe, copying their transcription in the thirteenth century, accessibility was key. By using a set of familiar (to them) letter forms, they rendered the text more readable, perhaps facilitating other goals, such as its memorisation. The considerable contrasts between rustic capitals and this Gothic bookhand (*littera textualis*) show the potential repertoire of forms a script could take. These changed quite dramatically over time. For scholars of medieval manuscripts, identifying script types can be an important step towards dating and localising a manuscript (note that the names that we give to these script types were usually retrospectively invented).

In the early medieval period, many manuscripts were copied in scripts that emulated those that had been used in Antiquity. These included rustic capitals, along with another majuscule script, square capitals (*capitalis quadrata*), derived from script types used in stone-carved monumental epigraphy. Cursive scripts, which involved fewer pen lifts on account of the connecting strokes (ligatures) that were drawn within or between letters, were also in use; these had the advantage of being quicker to write and were common in administrative circles. Manuscripts in these older scripts are rare.

The oldest manuscripts treated in this volume (nos 11 and 29) are written in an uncial script (*uncialis*). This script, inspired by Roman cursive script, spread over Europe in the fifth century. It is characterised by rounded letter forms, accentuated by the contrasting visual rhythm of shaded broad and narrow strokes. Short ascender and descender strokes were gradually added to letters such as *D*, *H*, *P* and *Q*, leading to easier discernment of these letter forms, although it remains in principle a majuscule script. Uncial required a lot of precision on the part of the scribe; as other medieval scripts came into fashion, it (like rustic and square cap-

itals) was often used as a 'display script', intended to accentuate elements like headings or text titles.

Book production in the early medieval period was somewhat fragmented. Latin no longer held authoritative sway in the manner in which it had during the heyday of the Roman Empire. The disintegration of the administrative structures of Roman political life led to book production becoming centralised in ecclesiastical settings, each with its own regional practices. During the seventh and eighth centuries, these various regional centres developed their own bookhands, characterised by unusual letter forms and innovative use of ligatures. This fragmentation of practice was to change, however, in tandem with European political developments. Crowned the Holy Roman Emperor on Christmas Day 800 AD, Charlemagne created the Carolingian Empire which united vast swathes of Europe into a single political entity, unparalleled since the collapse of the Roman Empire.

Under the rule of Charlemagne and his descendants, a refined script came to dominate book production in Western Europe, namely Carolingian minuscule. This rounded script was marked by few ligatures, its uniform length of ascender and descender elements (on letters such as *p*, *q*, *d* and *h*) and standardised letter forms. Whereas regional scripts sometimes developed idiosyncratic traits, making them hard to write and read, the rounded and regular forms of Carolingian minuscule were easy to teach to scribes and resulted in highly legible text. The spread of Carolingian minuscule from the last quarter of the eighth century onwards (facilitated by the efforts of scholars and scribes at important ecclesiastical centres of the empire, such as Tours and Reims) coincided with other intellectual trends in this period, namely an emphasis on the need for accurate manuscripts required to improve the quality of religious observance across the empire. Book production boomed during this period, and Carolingian minuscule remained dominant into the twelfth century, although in some areas, like Ireland, England and southern Italy, regional scripts continued to be used (see nos 14, 19 and 21).

A glossary manuscript produced in Amiens, France, in the late eighth or early ninth century (Leiden, UBL, VLF 26) captures this exciting period of script innovation. This large manuscript, measuring 340 mm × 255 mm, is impressive in terms of both its scale and its standard of execution. Here, script is used to underscore the purpose of the text; words to be defined (to the left of each column) were written in an uncial script, while their definitions (to the right of each column) were written in Carolingian minuscule. As well as illustrating the visual differences between the two scripts, this manuscript also highlights another important facet of book production, namely that some scribes could write in multiple scripts. Moreover, some readers were clearly adept in reading a variety of scripts, as this codex and others in this collection (see no. 14) show.

In the twelfth century, Carolingian minuscule was gradually transformed into the more angular and compressed bookhands that characterise the Gothic families of script. This was achieved through various means (as illustrated in the sample of *littera textualis*, a Gothic bookhand, contained in VLQ 79, discussed above), such as the shortening of ascenders and descenders, the introduction of fusions between letter forms and increased use of abbreviations to shorten the graphic unit of the word. In the transitional period of the twelfth century, between Carolingian minuscule and fully developed Gothic scripts, scribes incorporated Gothic features to various degrees; we characterise these transitional scripts as 'proto-Gothic' or 'pre-Gothic' (for examples, see nos 32 and 42).

In its most elaborate examples, Gothic bookhands call to mind the pinnacled features of Gothic cathedrals. It is difficult to assign a single reason that motivated the shift between Carolingian and Gothic script: changing aesthetics across various art forms, an increase in the volume of books produced by professional scribes (perhaps eager to distinguish their skill) and the desire to mark newly composed works (such as the

Fig. 10
In this late-eighth- or early-ninth-century glossary, words to be defined are written in uncial script, while their definitions are provided in an early Carolingian minuscule. VLF 26, fol. 1r, detail.

commentaries on legal and theological works produced in profusion at the medieval universities) as textual innovations may all have played a role. Gothic script forms dominated from the thirteenth century onwards, in Latin as well as in vernacular writings, with variants introduced depending on the desired formality of execution (such as in the treatment of the tops and bottoms of letters, which were often squared off, or sometimes finished with a diamond-like flourish).

A copy of collected works of Cicero made in the early fifteenth century in northern France (Leiden, UBL, PER F 25) offers a good example of a refined Gothic book script. In the selected opening (fols 34v-35r), the compacted height of the various letters is evident; minim strokes (such as those forming the verticals of letters like *m*, *n* and *i*) are barely distinguishable from each other, although light diagonal strokes have been added to the letter *i*. Ascenders and descenders on letters like *p*, *q* and *l* are short, while the letter *d* (which had a vertical backstroke in Carolingian minuscule) now slants. Other features enhanced the appearance of the Gothic manuscript page: ruling was preferably done with a visible marking tool (in this case, lead), which emphasised the shape of the text block, further framed here (on fol. 34v) by a decorated initial that extends its tendrils along the page. A running title, *De officiis l(iber) iii(ius)*, was added in red to the upper margin to facilitate navigation through the volume — no small feat given that it had 324 leaves. The manuscript is not without elements of personalisation or humour. A small face peeks into the inner margin on fol. 35r, representing the Roman general Scipio Africanus, who is referred to at this point of the text by Cicero as 'never less at leisure than when he was at leisure nor less alone than when he was alone' (Cicero, De *officiis*, Book III.1).

In the fifteenth century, Gothic *littera textualis* became the model for the first experiments in printing with movable type. Johannes Gutenberg, credited with the invention of the printing press in the West in the 1440s, modelled his cast letter forms on those of Gothic bookhands, replicating their angular and compressed forms, and even casting elements for the script's typical ligatures and abbreviations. In fact, incunable books (books printed prior to 1501) often bear a striking resemblance to manuscript books, a reminder that the two forms of book production coexisted (see nos 10 and 17). In this manner, the innovations of medieval scribes continued to exercise an influence into the period of print.

Fig. 11
This manuscript opening showcases features typical of the layout of late medieval Gothic manuscripts. A running title, *De officiis* ('On Duties'), and a book location, III, are added in red in the upper margin. Red rubricated headings break up the text, while an elaborately decorated initial fills the margin.
PER F 25, fols 34v-35r.

In the fourteenth and fifteenth centuries, scribes continued to innovate with regard to the scripts they used. Cursive Gothic scripts, initially employed in administrative contexts, came into use for the copying of books: since the scribe could write such scripts more quickly (connecting letter parts meant fewer lifts of the quill), cursive scripts could be an economical choice for book commissions, although their complex ligatures, along with elaborate shading of strokes, required a practised hand. Forms from cursive scripts were borrowed into other script types, as was the case for Gothic hybrid (*hybrida*) script, popular in the Low Countries in the fifteenth century (see, for example, nos 4 and 9).

In some circles, such as at the Burgundian Court, cursive bookhands achieved a high quality of execution. A copy of the *Traison et mort* chronicle — a French text describing the treason and death of Richard II, King of England (1367–1400) — copied at the beginning of the fifteenth century (Leiden, UBL, SCA 40) is an example of such an intricate cursive. Particularly notable on this folio (42v) are the distinctive slanted tapering forms of the *f* and *s* (which, here, as in many medieval manuscripts, has a similar form to an *f*, but without a transverse stroke), as seen in the first word, *enffant*. Loops are present on the ascenders of letters like *b*, *d* and *l*. A gruesome miniature, in *grisaille* (grey-tinted) style, elucidates the accompanying narrative, which describes the death of Thomas Blount (†1400), a supporter of Richard II, who was eviscerated — here, his innards are thrown onto a fire.

In fifteenth-century Italy, meanwhile, a circle of humanist scholars experimented with the introduction of new scripts — a minuscule and a cursive. Inspired by the Carolingian exemplars they were uncovering in their quest to reconstruct the glories of Antiquity, these scholars also began to replicate some of the distinctive forms of Carolingian minuscule. Along with reducing the number of ligatures between letters and minimising the use of abbreviations, they returned to some of the letter forms typical of Carolingian minuscule, such as the straight-backed *d*. Humanist manuscripts, particularly those of classical texts, are notably spacious in their layout, with wide margins and minimalist decoration, and were often copied on smooth, uniform, cream-coloured parchment (see no. 47). The self-conscious transformation of script initiated by these humanist scribes reminds us anew that the choice to copy a manuscript in one script rather than another was an expression of the perceived status of the text, the motivations of the scribe and the expectations of the reader.

Fig. 12
Illustrating a scene from the *Traison et mort* ('Treason and Death') chronicle, this gruesome *grisaille* miniature depicts a disembowelment. Its script is an elaborate Gothic cursive.
SCA 40, fol. 42v.

Decorative elements

As well as planning the layout of the text, a scribe also had to anticipate whether or not a manuscript would include illustrations. Such illustrations ranged in complexity from simple coloured initials to full-page miniatures. Pigments were often expensive and time-consuming to obtain and make. Gold gave the most richly decorated manuscripts their shine — they were literally 'illuminated' with ground gold or feather-thin gold leaf (see no. 3). Sulphuric yellows, corrosive copper greens and precious lapis lazuli blues populated the palette of the medieval artist along with pigments obtained from local plants and soils. Again, it is worth considering manuscript production as part of a broader set of medieval craft practices: many of these pigments were also used for other purposes, such as in textile dyes and medical treatments. Such intricate decoration and complex colour use elevated some manuscripts to the status of valuable treasures; manuscripts intended for wealthy users, along with particularly significant texts (notably

Fig. 13
A historiated initial *G*, depicting the church father Augustine and his friend Marcellinus at the opening of the text of a twelfth-century copy of Augustine's *De civitate Dei* ('On the City of God'). BPL 12, fol. 2r, detail.

those used in the liturgy), were often singled out for rich decorative treatment.

Many late medieval manuscripts contain simple alternating red and blue capitals indicating the start of sentences or sections, but initials could also take on more complex forms. A twelfth-century copy of the church father Augustine's *De civitate Dei* ('On the City of God') made in the north of France (Leiden, UBL, BPL 12) opens (fol. 2r) with an example of what is termed a 'historiated initial', literally an initial that tells a story. Two figures are depicted in this initial *G*. One, holding a crozier, or bishop's staff, is Augustine himself. The other is Marcellinus, a friend who apparently encouraged Augustine to compose his work and who is addressed directly in its opening lines. This complex initial not only emphasises the opening of the text, but also draws the reader into its narrative.

Other decorated initials in the manuscript, however, have no relationship to its content, such as the one opening Book xv of this text (fol. 114v). Here, a figure with a dog's head holds a monochord, a musical instrument with a single string that could be plucked or bowed. Dressed in a long green garment, his mouth is wide open, and the word *alleluia*, accompanied by medieval musical notation (neumes), stretches down the side of the page. A close examination of this initial reveals an important preparatory stage to adding illustrations to a manuscript. Not only did the scribe leave the space free for the initial (in this case, a *D*), but the artist of the initial also carefully sketched out their work on the parchment first, using a sharp point. To the left of the monochord, ghostly tracings of the artist's first attempt can be seen. It was common for artists to trace their planned decoration onto the parchment, before inking it and then adding colour.

Initials and other illustrative elements were usually added to the manuscript after the text had been copied, often by an artist who was specifically skilled in such work. Sometimes these artists travelled from far and wide to popular centres of manuscript production, such as large monasteries. The monastery of St Albans in the south of England attracted one such artist in

Fig. 14 (left)
The artist of this decorated initial first made a drypoint sketch with a stylus, visible here to the left of the photograph, taken under raking light. BPL 12, fol. 114v, detail.

Fig. 15 (right)
With his foot on the text and his bald head peering above it, this character, depicting the initial *I*, holds open a wax tablet. A preparatory tracing of the drawing can be seen to the left of the monk's head. BPL 114 B, fol. 147v, detail.

28

the early twelfth century. Termed the 'Alexis Master' (for his work illustrating a miniature of St Alexis), this artist worked in several monastic centres in the south of England. A copy of Priscian's *Institutiones grammaticae* (Leiden, UBL, BPL 114 B) was made in St Albans in this period and contains several decorated initials in the style of the Alexis Master. One initial — showing a monk, recognisable on account of his bald, tonsured head — has an elongated body of a type characteristic of this artist's style. Here, text and image needed to be 'read' in conjunction. The monk's long body functions as the initial *I*, introducing the passage on *interiectionem* ('interjection'). This initial also underscores the text's grammatical point. This part of the text describes the grammar of spontaneous cries and remarks, such as 'wow' (*papae*). These, often involuntary, remarks were seen by medieval grammarians as particularly human utterances, making the choice of imagery particularly apt.

Many medieval manuscripts contained more elaborate decoration. Miniatures were anticipated by scribes, who left space for them (as was the case in Fig. 12), but they were also sometimes added at a later stage (see nos 6 and 9). Books of hours, prayer books popular in the late medieval period, particularly among members of the laity, were often accompanied by elaborate illustrations. The 'hours', the cycles of prayers said throughout the monastic day, were often introduced by appropriate images. The Hours of the Virgin, a set of devotions to the Virgin Mary, for example, usually included depictions of key moments in the life of the Virgin, such as the Annunciation and the Nativity. These images had multiple functions. They provided a meditative focus for the reader at prayer, while their distribution allowed for ease of navigation through the manuscript. Often the decoration was customised to suit the reader's particular devotional preferences and practices.

A fifteenth-century book of hours written in Latin (Leiden, UBL, BPL 2379) like many such books, contains a series of prayers (suffrages) to various saints. Each prayer, presented with a formulaic response asking the saint to save the sinner-reader, is accompanied by a miniature of the relevant saint, while its text block is surrounded by an elaborate illuminated border with floral and fruit motifs. The miniature on fol. 45v depicts the martyrdom of Thomas Becket, Archbishop of Canterbury (1118–1170). Becket is depicted saying mass in the cathedral at Canterbury at the moment when he is violently set upon and murdered by soldiers of the English king, Henry II (1133–1189). By the time this manuscript was made, Becket's remains had made Canterbury one of Europe's most famous pilgrimage destinations. This miniature depicts the fatal blow struck to Becket's head; the crown of his skull was one of the most treasured relics of Canterbury.

As well as providing a dramatic depiction of the scene, the miniature and text inform us of the likely destination of this book of hours. While its artistic style suggests that the manuscript was most likely made in a professional workshop in the area of Rouen in northern France, it was probably made for export to England, where the cult of Becket was most celebrated. A reader of this book could relive the moment of Becket's martyrdom (and sainthood). Hand-sized, this manuscript

Fig. 16
In spite of the richly decorated border, the reader's eye is drawn to the action of the scene depicted in the miniature, which shows the murder of Thomas Becket. BPL 2379, fol. 45v.

was intended to be a valuable personal possession for a layperson eager to emulate the lives of the saints and achieve salvation.

Scribal identities and practices

The vast majority of medieval manuscripts were written by anonymous scribes. Their anonymity is compounded by the fact that within scribal communities, whether in particular monastic, court or workshop contexts, scribes were often trained to write scripts to the same standard, using similar letter forms. On account of this imposed discipline, it can sometimes be very difficult to discern the features of one individual's hand from another. Uniformity with a particular aesthetic, following the idealised forms of a particular script type, was the apparent goal; the fact that it is often challenging to identify the hallmarks of particular individual scribes across multiple manuscripts shows just how good medieval scribes were at carrying out their task. The same observation may be made of artists, who often worked in workshop contexts or followed the lead of a particular master. Such uniformity can conceal the contributions of particular groups, including those of women and minorities, leading scholars to underestimate their presence in medieval contexts. While the identity of most medieval scribes is now lost, their work still provides us with clues to their methods.

Fig. 17
This tenth-century manuscript, a copy of Vitruvius' *De architectura* ('On Architecture'), was copied by multiple scribes. At least three are active on this page alone. VLF 88, fol. 15r.

A tenth-century copy of Vitruvius' *De architectura* ('On Architecture') was made in Germany, perhaps in Hildesheim, where it was later owned (Leiden, UBL, VLF 88). Although only 107 folia long, it was copied by at least twelve scribes, who sometimes changed over on the same page. On fol. 15r, for example, the first scribe wrote the first fifteen lines, the second wrote lines 15–24, and a third took over for the subsequent three lines, before the second scribe picked up their quill again. What drove these frequent hand changes? The demands of other aspects of monastic life? A hasty approach, perhaps due to the limited availability of the exemplar from which the text was copied? These questions remain unanswered. Still, this manuscript reveals the processes of cooperation upon which the copying of the text depended and allows us to gauge the number of trained scribes active in the centre where it was produced.

Scribal processes were also influenced by pragmatism. To copy manuscripts quickly, groups of scribes would sometimes split an exemplar manuscript into its constituent quires, delegating different scribes the job of simultaneously copying each quire into a new quire. While the overall result could sometimes be jarring, with hands visibly differing from quire to quire or with scribes sometimes overestimating or underestimating the space required to replicate their segment of text, this practice of copying by divided quires meant that several scribes could simultaneously work towards producing a single copy of a given manuscript at speed. Again, this shows that some medieval scribal centres were highly organised (see, for example, no. 1).

Stationers in medieval university towns like Paris and Bologna came up with a comparable solution in the thirteenth century, enabling multiple copies of the same initial exemplar to be made at once. Each exemplar, containing an authorised version of a text approved by the university, was broken into segments called *peciae* ('pieces'), then loaned out on payment to individual scribes (sometimes even students). Once a scribe had finished copying a *pecia*, they returned that section and borrowed the next. While it did not speed up the process of producing a new copy, as the resulting sections were copied one after another into a new manuscript, the *pecia* system meant that multiple copies of parts of a single exemplar could be reproduced by various scribes at the same time and to the same textual standard. Medieval manuscripts copied in this piecemeal manner often include small markings numbering the individual

sections; these notes were useful not only for recording where the scribe was in the text, but also for tracking the cost of making the copy (see no. 23).

Occasionally, scribes signed their work or provided an indication of the date on which the manuscript was finished, a testimony to the laborious task of such handiwork. Leiden, UBL, BPL 136 E, for example, contains a copy of Curtius Rufus' *Historiae Alexandri Magni* ('History of Alexander the Great'). At the conclusion of this paper manuscript, copied in Italy, the scribe helpfully noted in a colophon that it was finished on the 7th of April, 1470, at the 21st hour. A 24-hour clock was in use in Italy during this period, with the first hour starting at sunset, so this manuscript was probably finished in the late afternoon or early evening. While this manuscript was copied by a professional scribe in a humanist cursive script, a relatively fast script to write, the scribe still wished to mark its moment of completion (see also nos 8 and 48).

Another fifteenth-century manuscript, a copy of Seneca's *Tragedies* from the Cistercian abbey of Ter Doest in the north of present-day Belgium (Leiden, UBL, BPL 45 A) contains even more detail about its context of production. Its colophon (fol. 218v) records not only the year (1477) and the place of production, but also how the first part of the manuscript (up to the middle of the seventh Tragedy) was copied by Thomas Feye, the prior of the abbey. However, Feye died and was unable to finish the text. From fol. 132v, another scribe and monk of the abbey, Cornelius Heyns, took over and completed the manuscript. Yet another monk, Jacob Egidius, was responsible for adding a commentary to the text throughout, copied in a precise minuscule. Through the colophon, the manuscript becomes a place of commemoration of the work of the deceased prior and his two fellow monks; Feye's life is memorialised at the end of the book in which he wrote his final words.

Navigating the text

When you take a modern printed book down from the shelves, you are presented, almost without realising it, with a host of features designed to make the text easier to navigate and read. Many of these features — such as pagination, chapter divisions and title pages — were, however, absent in medieval manuscripts. In fact, the earliest medieval manuscripts contained barely any punctuation, with words instead written in *scriptura continua*, without any spacing between the words (see no. 11). To read such a work required a sense of language, to be able to discern a main clause from a subordinate clause, to know when to breathe, to understand when one word ended and another began. It is evident that this was difficult for some readers. Word spacing was inconsistent in Leiden, UBL, VLQ 94, the ninth-century *Quadratus* copy of Lucretius' *De rerum natura*, for example (see no. 19). Here, a fifteenth-century reader has added faint strokes throughout the text, separating one word from another.

To simplify reading, punctuation and word spacing were introduced by medieval scribes. Initially, punctuation was carried out using a method from Late Antiquity, whereby dots or small points were added at various heights throughout a text to indicate pauses of various lengths (for example, at the ends of sentences

Fig. 18 (top)
This colophon, opening with the word *FINIT* ('it ends'), records the date, year and time on which the manuscript was completed.
BPL 136 E, fol. 144v, detail.

Fig. 19 (bottom)
This colophon records not only that this manuscript was copied in the Abbey of Ter Doest, but also the names of three scribes active in its production, one of whom, Thomas Feye, died during its production.
BPL 45 A, fol. 218v, detail.

Fig. 20
This detail shows how a manuscript copied in the ninth century was still read in the fifteenth. The fifteenth-century user, clearly interested in the text — a rare medieval manuscript of Lucretius' *De rerum natura* — has added light pen strokes throughout to clarify the punctuation and word spacing. VLQ 94, fol. 25v, detail.

or to indicate a subordinate clause). This method, called punctuation by *distinctiones*, was not foolproof: it was often difficult to determine from the relative height of a dot how long a pause should be, and errors were easily introduced during copying. From the late eighth century onwards, a new system of punctuation, punctuation by *positurae*, was developed, whereby pauses in the texts and other emphases (like questions) were indicated with a host of new marks. These marks, which pepper medieval manuscripts, are the basis of today's system of punctuation, where texts are divided into sense units by periods, commas and semicolons. Like word spacing, punctuation was sometimes added to manuscripts retrospectively.

Punctuation was just one way in which the meaning of the text could be clarified for a reader. Another was through the use of rubrics — words often written in coloured ink (usually red), in majuscules or in a distinctive script — that were used to indicate headings or book titles. In Leiden, UBL, BUR Q 1 — a mid-eleventh-century copy of Lucan's *Bellum civile* ('On the Civil War') later owned by the Abbey of Egmond — the opening lines (fol. 1r) have been added in green and red ink and copied in 'rustic capitals', a style of script which was used extensively in Antiquity and used mainly for emphasis throughout the Middle Ages. That later readers found this script difficult to read is evident from a note copied at the bottom of the adjacent page beginning *Nota lector* ('Take note, reader'), which transcribes the first four lines of the text in an early modern hand.

Often, rubricated headings were added in the upper margin of a page, meaning that a reader could quickly scan through a book to find the section they were

Fig. 21
This mid-eleventh-century copy of Lucan's *Bellum civile*, later owned by the Abbey of Egmond, opens with lines (fol. 1r) copied in red and black rustic capitals. A later reader found them hard to understand, as the note beginning *Nota lector* on the bottom of fol. iv suggests. BUR Q 1, fols iv–1r.

32

seeking (see no. 35). Sometimes divisions within a text were marked with physical bookmarkers instead. Small tabs of parchment were sometimes glued onto the edge of a page at the start of a new section of text. Text sections or particular parts of interest of a manuscript could also be marked by cutting into the edge of the parchment and knotting the resulting strip around itself. The edges of Leiden, UBL, PER 27, for example, a twelfth-century copy of a grammatical work by the late antique writer Priscian, dangle with such parchment strips, stepped down the side of the manuscript to indicate its various divisions. Meanwhile, knots of leather were added to the fore edge of Leiden, UBL, BPL 2856, a fifteenth-century psalter and breviary, to allow rapid location of texts. These additions made the medieval book navigable by touch.

Whereas page numbers are omnipresent in modern printed books, most medieval manuscripts contain no such markings, complicating navigation for the reader. Early tables of contents simply comprised lists of chapter titles, without accompanying references to indicate where in the manuscript the start or end of each chapter could be found. Indexes, which developed in medieval manuscripts from the thirteenth century onwards, were initially keyed by text section, not by location, limiting their convenience for information retrieval. The marking of numbers on manuscript folia, known as foliation, became popular from the later medieval period onwards and meant that readers could locate and compare passages of texts more efficiently. Notably, whereas we now refer to locations in manuscripts by folio number (with each leaf or folio designated by a number and its front and back indicated by *recto* and *verso*, respectively), many medieval manuscripts foliated not the leaf but instead the double-leaf opening of the manuscript. This emphasis on the opening, not the page, as the 'unit' of the book is reflected in other choices made by the scribe, such as page design and decoration.

Another source of help for the reader as they moved through a text was annotations, added either between the lines or in the margins of the work. These annotations, or 'glosses', were often copied at the same time as the rest of the text was taken over from whatever exemplar the scribe was using, but they were sometimes added by later readers as well. Such glosses provided word-by-word commentary on a text, adding explanations, definitions and synonyms, or providing grammatical support to the reader (see nos 22 and 47). Longer annotations were added in the margins of the text, linked to the main text with marks or symbols, allowing the reader to work out which section of commentary was relevant to which part of the text (see nos 23 and 45). In Leiden, UBL, BUR Q 1 (see Fig. 21), for example, the commentary in the margin is keyed to the main text with small signs, or tie-marks, that resemble the letters of the alphabet.

Traces of the reader

Reading in the Middle Ages was by no means a universal skill. Literacy was limited to those who had access to education. In the earlier medieval period, this was predominantly the rich and those who were trained in religious contexts for participation in the liturgy. In the later medieval period, with increased urbanisation and access to a wider variety of schooling opportunities, literacy spread across different social classes, although standards could vary substantially, and many remained illiterate. It is important to note that, unlike today, reading and writing were not necessarily dependent skills. Not all scribes appear to have been able to understand the texts they were copying, while not all readers would have been able to write fluently with a quill pen.

Manuscripts allow us to reconstruct some aspects of the medieval reading experience. A reader's thumbing of pages sometimes left traces of dirt in manuscript corners; splodges of candle wax left greasy stains across parchment. By looking at such deposits of dirt, and other markings such as annotations and drawings, we

Fig. 22
The parchment edges of Leiden, UBL, BPL PER F 27, have been cut and knotted to indicate its book divisions. The fore edge of Leiden, UBL, BPL 2856, is spiked by small knots of leather, permitting rapid navigation of its 228 leaves.

can sometimes establish which parts of a text were most intensively read. This can offer significant insights — for example, whether a particular text was read linearly (from front to back) or selectively (focusing on particular sections). We may also indirectly access a reader's priorities by assessing the size of a book: large manuscripts were sometimes intended for communal or public reading, while smaller hand-sized manuscripts were often for private use.

Notes, drawings and dirt offer opportunities to reconstruct the now silenced voices of readers. A heavily annotated eleventh-century copy of the satires of Persius and Juvenal (Leiden, UBL, BPL 82; see no. 22, Fig. 2) has a small drawing of a dog's head on fol. 4r, traced on the parchment with a sharp point. While this addition may at first seem random — a sketch by a distracted reader — a close look at the accompanying text shows that it marks a passage where the author, Persius, refers to what he terms the 'canine letter', the snarling sound made by the letter r. This drawing, therefore, has multiple functions. It illustrates the text, it marks a passage of particular note for the reader (student or teacher) and it probably also served as a mnemonic prompt, reminding the reader of Persius' comparison. It is also simply amusing. In short, this small sketch allows us to recreate several possible interactions with the text that may have taken place in a medieval classroom.

Some manuscripts contain illustrations intended to support and complement the text, including both miniatures and informal sketches (see no. 13, VLO 15). For example, a copy of Horace's *Epodes* (UBL, GRO 15, c. 1100) is illustrated with a small and disturbing drawing showing how Canidia (mentioned in Epode 5 and labelled here as *Malefica*, or 'witch') murders a small boy, burying him to his neck and starving him, then preparing his corpse for a love potion (Fig. 6). Given that Horace was intensively studied in medieval schools, particularly by younger students, this scene must have shocked and perhaps gruesomely enthralled its readers.

Other manuscripts showcase how medieval readers depended on diagrams and other instructive drawings to understand a text (see nos 15 and 32). A twelfth-century copy of Priscian's standard grammar text, *Institutiones grammaticae* (Leiden, UBL, BPL 91), for example, includes a diagram that was appended by a later user. The diagram, whose form brings to mind the spokes of a bicycle wheel, represents various subtypes of nouns and probably served to summarise Priscian's discussion of the noun. A diagram like this encouraged the reader to pause and recollect and could even have been used as a study aid independent of the text.

While the examples treated thus far have predominantly looked at educational reading, many of the manuscripts in this volume were produced and used in religious contexts. Monastic orders, such as the Benedictines and the Cistercians, emphasised the importance of focused reading of religious texts, and reading was an important vehicle of prayer. In the later medieval period, religious movements such as the Modern Devotion, spearheaded in the Northern Netherlands by Geert Groote (1340–1384), encouraged lay readership of religious texts. Books of hours, which emulated the daily devotional cycles of the monastery, became increasingly popular possessions for laypeople as well as religious readers, sometimes treasured as much for their status as devotional objects as for their content (as nos 6–8 show).

Fig. 23
This diagram, whose radial spokes call to mind a bicycle wheel, presents various types of nouns and was a handy reference guide for a reader of Priscian's *Institutiones grammaticae*. BPL 91, fol. 85r.

Binding and preservation

Readers could demonstrate their interests in texts in other ways, notably through compiling and collecting texts. Today we tend to think of books as carriers of individual stand-alone texts. In the medieval period, however, copyists often came up with creative combinations, gathering texts within single bound manuscripts and encouraging a reader to study them in conjunction. For example, various history works could be gathered into a single volume (see no. 42, a twelfth-century collection prefaced by a 'contents list'). Sometimes such combinations were made at a later point, gathering texts associated by theme (for example, literary works in medieval Dutch; see no. 36), and even on the basis of more random criteria, such as size. We refer to such manuscripts as composites, distinguishing between those which were made in the medieval period (collections of various texts written by the same scribe or collections of disparate manuscript parts brought together in the medieval period) and those that were brought together only later (by collectors or by librarians).

Leiden, UBL, BPL 189, is a collection of small booklets (short texts copied in one or more quires) that are now bound together but were not produced in the same place or period. A glance shows that its various sections are irregularly sized; all parts of this manuscript were acquired together in 1666, in an auction of books previously owned by Isaac Vossius, scholar and librarian to Queen Christina of Sweden. Gathering small booklets together in such a fashion ensured their safe keeping. Its current presentation highlights that a manuscript's story does not end in the Middle Ages, but continues through the actions of the people and institutions who ensure its long-term preservation. While the second introduction to this volume will examine this phenomenon in more detail, it is worth momentarily dwelling on the role of medieval users in preserving books.

Building up a book collection — however humble — was for many religious and educational houses, and even individuals, a daunting task. Finding works, managing their copying, protecting the resultant volumes from becoming damp and damaged, and facilitating their consultation took time and effort. A library not only was a potential repository of learned works, but could also contain volumes essential for religious practice (and so for the identity of a monastery or a church), or even ones that preserved institutional memories (see nos 40 and 41). Libraries of individuals, like that of Filips van Leiden, could serve to continue the fame of their former owner after their death (see no. 43), while particular books were handed on through families as precious artefacts (see no. 3).

Library 'management' in the medieval period was, given the small scale of most collections, reasonably primitive. Most medieval book lists are 'inventories' rather than catalogues, intended primarily to itemise the holdings of a particular institution or individual. In some cases, we find evidence of more systematic attempts at organisation. Leiden, UBL, BUR Q 1, along with a number of other manuscripts originally owned by the Abbey of Egmond (see nos 20 and 21), offers a good example of such activities. In 1465, many books of the monastery were rebound. This manuscript, like others, was bound in wooden boards covered in brown leather with decorative toolings. A label was added with the text's title, *Historia Romanorum versifice*, ('A History of Rome in Verse'), presented in a *fenestra* covered with see-through horn, while small metal 'feet' were added to the base of

Fig. 24
Leiden, UBL, BPL 189, a composite manuscript, contains a number of booklets of varied size and provenance. It is likely that these short texts were bound together for protection and because they (roughly) shared the same dimensions.

the codex so it could safely stand on a shelf or desk. An additional parchment label gave the name of the author, Lucan. Finally, a note was added on fol. 1 to record the fact that this book had been rebound under Gerard of Poelgeest, then abbot (see Fig. 21; the note, at the foot of the page, is now largely illegible).

The binding of BUR Q 1, which was copied in the twelfth century, is medieval, but a later replacement. In fact, original medieval bindings are very scarce (see no. 12). While some medieval books, like this one, were bound in protective boards of wood, others were more vulnerable, bound in so-called 'limp' bindings of parchment or leather. Most medieval manuscripts have undergone a succession of rebindings over time, often at the hands of later collectors or libraries. Sometimes, such bindings have their own story to tell — for example, flyleaves may have been repurposed from other books (see no. 11) — while other aspects can mark a book as belonging to a particular collection, with stamps and notes charting its ownership through time (see no. 43).

The medieval manuscripts of Leiden University Libraries' collection, and those found in libraries worldwide, are replete with stories — beyond the obvious ones told in their texts. Their material makeup, their scripts, their decoration and evidence of their readership summon up the medieval world and its inhabitants. The contributions that follow examine a series of fifty manuscripts in depth and invite you to explore these themes in more detail.

Fig. 25
The fifteenth-century binding of Leiden, UBL, BUR Q 1, with its title *fenestra* and pastedown label (*Lucanus poeta*). Faint markings in the corners and the centre of the binding show where additional metal fittings would have originally been placed. Small metal feet and other metal additions at the corners protected the binding during storage and consultation.

Collected in Leiden

André Bouwman

The beginning

University Library

The Special Collections of Leiden University Libraries (*Universitaire Bibliotheken Leiden*, UBL) are both substantial and varied. This book is about a small fraction of those collections, namely the medieval manuscripts — handwritten books dated before around 1550. These manuscripts contain texts in Greek or Latin, or in one of the Romance, Germanic or Slavic languages. Thanks to purchases, gifts, bequests and long-term loans, Leiden University has managed to build up an impressive manuscript collection since 1587. It is one of the oldest and largest in the Benelux. In fact, there are only ten libraries worldwide that have over a hundred manuscripts from the ninth century, and Leiden is one of them.

If you were to put all the Library's manuscripts together, they would fill the shelves of maybe twenty bookcases; that may seem a modest number, but the number of users is relatively high. They include not only students and professors at Leiden University but also numerous researchers from the Netherlands and elsewhere who are constantly visiting Leiden to consult these manuscripts from medieval Europe. They do so in the University Library, at the tables in the Special Collections Reading Room or in one of the lecture rooms where the manuscripts are on display. And, increasingly often nowadays, remotely over the internet. Some eleven hundred *codices* (manuscripts in book form) have been digitised over the past twenty years and made available through the Digital Collections, the Library's image repository.

There is no other category of heritage items that brings our European civilisation closer than these written treasures do. Anyone who opens them and takes a look inside can browse through not only the thousand years of the Middle Ages but also the millennium that preceded them, the age of Antiquity. That is because it is above all the labours of medieval monks and other scribes that led to so many texts by classical authors such as Aristotle, Lucretius and Cicero being copied from fragile papyrus scrolls onto longer-lasting parchment manuscripts and later also onto paper.

That preserved these ancient texts, saving them from oblivion. These manuscripts acquired new owners over the course of time — in particular during the religious wars of the sixteenth and seventeenth centuries, when Catholic churches and monasteries in Northwest Europe were closed or destroyed by Protestant authorities during the Reformation. Age-old collections of books were scattered or lost. Many parchment manuscripts with texts that were deemed no longer useful ended up in the hands of bookbinders who boiled them into glue or cut them up to strengthen the bindings of new books. Another group — old manuscripts containing classical texts in particular — attracted considerable interest from learned collectors and academic libraries, and a lively trade in them ensued.

Leiden's university — founded in 1575 after the city had successfully withstood the rigours of a siege by Spanish troops — was funded by the States of Holland from the revenues obtained from the confiscated lands that had belonged to Egmond Abbey, which was demolished in 1573. Via various private owners, at least ten codices from the abbey in Egmond ended up in the possession of the University Library. The city of Leiden also helped the new academy that had been founded within its walls.

Fig. 1
The Academy Building and the *Faliede Bagijnkerk* with the library (and anatomical theatre), diagonally opposite each other on either side of the Rapenburg. Map of Leiden, Hagen 1670. UBL, COLLBN Port 14 N 5, detail.

Fig. 2 (left) Greek manuscript containing orations by Demosthenes, donated by Bonaventura Vulcanius in 1587 (though not his property but presumably that of Johannes Arcerius (1538–1604)). Fifteenth century, second half. Binding (from 1582 with initials of Leiden professor Petrus Tiara (1514–1586)) and flyleaf with dedication. BPG 33.

Fig. 3 (right) Painted portrait of professor Bonaventura Vulcanius (1538–1614), 1609. UBL, Icones 24.

Given that Catholic worship was no longer permitted, the city authorities proposed allowing the university to use vacated buildings, such as the churches of the Dominican sisters and of the Beguines. These were nearly opposite each other on either side of Rapenburg, Leiden's best-known canal. Extra wooden flooring added halfway up doubled the available working space in these buildings.

The former convent church of the Dominican sisterhood was put to use as the Academy Building (the *Academiegebouw*), as it remains to this day. Starting in 1587, the vaulted chamber beneath the tower was used for a number of years as a library room. When this library first opened, Leiden's professor of Greek, Bonaventura Vulcanius (1538–1614), donated a fifteenth-century manuscript with Greek orations by the Athenian lawyer and politician Demosthenes (384–322 BC). Now known as BPG 33, it was the new library's first medieval manuscript.

However, the room in the Academy Building was damp and also soon became too small as the library expanded. In 1595, the upper floor of the *Faliede Bagijnkerk*, the church of the former Beguinage on the other side of Rapenburg, became the library's new accommodation. The library remained there for almost four centuries, thanks to numerous rebuilding works and extensions, until it finally relocated in 1983 to the new building on the Witte Singel canal, where it is still housed.

Library sources

For almost four and a half centuries now, exceptional medieval manuscripts have been acquired, described and curated at Leiden's University Library and made available for research and education. From that perspective, there is nothing new in contemporary library practices, but the way everything is done has changed hugely over the course of the centuries. To get a picture of how the management — in the broadest sense of the term — of the collection of manuscripts has developed, we have to go back to two key sources: the university archives and the successive library catalogues.

The most important archive is of course the Library Archive (*Bibliotheekarchief*, BA). It contains examples of printed catalogues (with handwritten additions and corrections), handwritten journals listing the acquisitions, shelf location lists, records of loans and other administrative aspects that were important for managing the library, including correspondence with users. During the nineteenth century, the librarian acquired more and more staff, who in turn purchased, presented and

Fig. 4 (left)
First floor of the library building, Rapenburg. Floor plan for the 1915 renovation. Top right: the church; centre left: workroom and depot for western manuscripts. UBL, Library Archive, BA1 S 367.

Fig. 5 (right)
Instructions for the Librarian and the *custos*, drawn up in 1741 by the governors. Archives of the Governors, UBL, AC1 157.

loaned out more books and journals, as well as receiving more visitors during longer opening hours every weekday. Since the 1860s, the manuscripts and the printed works have been entrusted to specialist 'curators', each responsible for managing their own collection.

Final responsibility for the University Library as a whole resided with the Board of Governors, a body originally appointed by the States of Holland and then since 1815 by the national government of the Kingdom of the Netherlands. Leiden's burgomasters were members of the Board as well until 1876. As the University's administrators, the governors were responsible for the finances, for managing the buildings, appointments of professors and other staff, and their salaries. They therefore also appointed the *praefectus bibliothecae*, the Librarian. Until the nineteenth century, this was one of the professors who had a part-time role dealing with the collecting and cataloguing of books. His assistant was the *custos* (custodian or room guard), generally a Leiden bookseller whose role was to monitor things at the library and ensure that all was in order. Visitors were able to come during the regular opening hours (which, until the nineteenth century, were from noon until two o'clock on Wednesdays and Saturdays) and on occasion outside the regular opening hours. The *custos* also delivered new books and had them bound.

The governors drew up instructions for the Librarian and the *custos*, wrote the rules for visitors and made an annual budget available for acquiring new works. They were also involved in making suggestions for purchases, giving scholars from outside Leiden permission to view the manuscripts, and with loans, regular checks on the status of the books and all sorts of other tasks. Precisely for that reason, the Archives of the Governors (*Archief van Curatoren*, AC) provides a wealth of information, in particular the minuted decisions (*Resoluties*) along with the supporting documents and correspondence. One example is the *Instructie over de directie van de Publique Bibliotheecq* (Instructions regarding the management of the Public Library) of 1741, in which the governors emphasised that the Librarians and the *custos* should look after their keys carefully and not lend them to anyone: *hy zy wie hy zy, [...] zo dat de Bibliotheecq door niemandt, als door een van de Custodes zal mogen werden ontsloten ende de gesloote kassen niet mogen geopent werden, als in tegenwoordigheidt van de Bibliothecaris* (AC1 47).

The following three sections discuss the medieval manuscripts of Leiden University Library, looking at its three main management tasks: building up the collection, ensuring its accessibility, and, finally, collection care and user services. The sections about building the collection and access to it will also familiarise us further

with the second category of library sources, namely the published catalogues of the Library's possessions.

Collection building

Gifts and bequests

The University Library only had limited financial resources in its early days and was hardly able to buy any books for the fledgling academy. The Librarian and governors therefore made efforts to expand the collection through gifts. That can be seen *inter alia* from the catalogues that were printed.

The first of those was the catalogue made by acting Librarian Petrus Bertius (1565–1629), which appeared when the library was opened in the former Beguinage Church in May 1595. It was a historic moment in library history, as it was the first time a printed catalogue of the contents of a public library was produced in Europe. This *Nomenclator autorum omnium quorum libri vel manuscripti, vel typis expressi exstant in Bibliotheca Academiae Lugduno-Batavae* supplies precisely what the Latin title promises: a 'list of all handwritten and printed books present in the library of the academy at Leiden'.

In an addendum printed later that year, all the gifts and their donors since 1575 were listed too. Two years later, the Librarian Paulus Merula (1558–1607) reissued the list of gifts, this time as an independent publication, with later additions going through to 1603. There can be no doubt that this 'Catalogue of nobles, burghers and other people who have generously enriched Leiden's academy library with their gifts and bequests' was a PR instrument, even more so than the catalogue of 1595. In line with that, Merula proposed to the Curators in May 1597 that a notice should be placed in the Library once every quarter giving the names of new donors and their gifts, *om alzoo alle andere die op verscheyden tijden de Biblioteque zullen comen visiteren stilzwijgende te vermanen ende te porren tot het lofflick verstercken van de voirzeyde Biblioteque met alzulcke boucken die anders om gheldt nyet wel en zijn te becomen, als de welcke gescreven zijn met de handt* ('...thereby silently encouraging visitors to enrich the Library with books that are too expensive to be purchased, such as those written by hand', AC1 41, 1597).

Fig. 6
First catalogue of the Leiden University Library, compiled by Petrus Bertius and published in 1595.
UBL, ex. 1408 I 57, fol. A1r.

Insofar as is possible to determine from these catalogues, twenty medieval manuscripts were donated in the years 1587–1601, two in Greek and eighteen in Latin. Four of those came from Egmond Abbey. In 1595, the professor of rhetoric Henricus Bredius (†1621) donated manuscripts with texts by the late antique writers Martianus Capella (BPL 87 — more about that later) and Priscian (BPL 92). These were followed in 1597 by the 'Egmond Willeram' (see no. 28) and a composite manuscript containing William of Conches's *Philosophia mundi* (BPL 102) — donated respectively by Pieter van Meerhout, rector of the Latin school in Alkmaar, and Jan van Wittendael, a lawyer at the Court of Holland.

An alternative to a donation was a bequest — a donation in a will that comes into effect after the testator dies. That is how the library obtained the papers, manuscripts and Eastern books of Josephus Justus Scaliger (1540–1609), an eminent connoisseur of classical and Eastern Antiquity and their languages, who it was found after his death had remembered the library in his will. In 1593, this famed scholar had come to Leiden from France on the invitation of the governors. As *decus academiae*, the jewel of the academy, he was able to continue his philological studies and research into Antiquity and chronology, publishing his results through the University's printer. All while taking home a generous salary and without any obligation to give lectures. He did take several brilliant Leiden scholars under his wing, however, including Hugo Grotius (1583–1645) and Daniel Heinsius (1580–1655). After Scaliger's death, they were allowed to make a generous selection from the Western books in his private library; the remainder were auctioned off.

Heinsius — who was appointed Librarian in 1607 after the death of Merula — placed the bequest from his admired teacher in a specially made closed cupboard, the *Arca Scaligerana*. It is clearly visible on the well-known engraving of the University Library of 1610 (see p. 51), made after a drawing by Jan Cornelisz Woudanus (†1615). The library catalogue of 1612 devotes a separate section to the contents of the bookcase: *Catalogus librorum quos bibliothecae Josephus Scaliger legavit* (pp. 79–88). In this section, arranged by language and format (with printed books and manuscripts mixed together), Heinsius described the books in Hebrew, Arabic, Syrian, Ethiopian and Russian, followed by the Greek and Latin manuscripts. Two of Scaliger's manuscripts about geometry and arithmetic are addressed later in this book (see nos 33 and 35).

Fig. 7
Painted portrait of professor Josephus Justus Scaliger (1540–1609), 1604. It hung in the library above the cabinet containing Scaliger's bequest. UBL, Icones 30.

The bookcase containing Scaliger's bequest with his painted portrait above are seen as a memorial to a major scholar and language prodigy. The Eastern part in particular drew visitors from near and far in the seventeenth century. It is possible that the bequest inspired Jacobus Perizonius (1651–1715), a professor of history, Greek and rhetoric at Leiden, to include a similar stipulation in his will in favour of the library. His papers contain a copy of Scaliger's will, at any rate. On his death, Perizonius made a gift to the library of 'all of my old manuscripts with ancient authors, both Greek and Latin, and of church fathers, also printed editions collated with old manuscripts, collations recorded in notebooks, and finally some very old and rare printed editions'. On top of that, he donated 20,000 guilders to the University. Part of the income from that sum was intended for acquiring rare classical printed material and manuscripts, which explains why some of the 49 medieval *Codices Perizoniani* were acquired after his death in 1715. Perizonius stipulated that his manuscripts and books should be presented in the catalogue as 'Legatum Perizonianum' and put in a separate bookcase with his portrait above. The most spectacular manuscript is undoubtedly the tenth-century volume containing 1 Maccabees, the book of the Bible about the Jewish rebellion against Hellenic rule from Syria. In the abbeys of Saint Gall and Reichenau, the manuscript was augmented by 28 partially coloured pen drawings of

Fig. 8
The biblical book 1 Maccabees is illustrated by cavalry battles. Manuscript, tenth century, first half (c. 925?); St Gallen and Reichenau. PER F 17: 1, fols 45v–46r.

cavalry battles, that are thought to have been inspired by the raids by the Magyars in Switzerland and southern Germany in 925 (PER F 17).

The library also received numerous other medieval manuscripts as gifts or bequests. The Leiden burgomaster Jan van den Bergh (1664–1755), for instance, donated the impressive psalter of Saint Louis in 1741 (see no. 3).

A beautifully bound French *Iliad* translation (see no. 50) intended for King François I (1494–1547) was part of the bequest of books and papers from Prosper Marchand (1678–1756) that the library received in 1756. He was a Huguenot who had fled France to settle in the Dutch Republic as a bookseller and journalist. In his annual report for 1879–1880 (BA1 M 36), the Librarian Willem Nicolaas du Rieu (1829–1896) mentions with gratitude

Fig. 9
Margriet Gosker and Ferenc Postma, with one of their donations: a psalter in Latin. Fifteenth century, third quarter; South Holland. BPL 3770, fol. 1r. Photo UBL.

42

Fig. 10
Register van alsulcke boucken ende andere dinghen, in de welcke [...] voornamelick bestaet de waerdigheyd van de Bibliotheque [...]. Eerst Boucken in Latijn ghescreven mit de handt. Detail of the first page of Merula's handwritten catalogue from 1607. Three centuries later, curator Philipp Molhuysen added the current signatures in pencil in the margin (regarding BPL 48, see no. 1). UBL, Library Archive, BA1 C 3, fol. 1r.

the precious manuscript donated by the Belgian archivist Stanislas Bormans from the library of his father, containing the Life of St Servatius by Hendrik van Veldeke, one of the oldest works in Middle Dutch: *het Leven van St. Servaas door Hendrik van Veldeke in 't Limburgsch dialect, dat een der oudste Middel-Nederlandsche geschriften kan genoemd worden*. These are just a few examples.

Fortunately, gifts are still being made, such as those by Ferenc Postma and his wife Margriet Gosker at the end of 2022. They donated a book of hours in Dutch from Zwolle and a psalter in Latin from South Holland, both beautifully illuminated, to Leiden (BPL 3769 and BPL 3770). 'It was our express wish', said Postma, 'that both manuscripts should be made available for further academic research. Leiden University Libraries was the best option for that.' The donation was celebrated in May 2023 by a symposium and an exhibition about the library's collection of prayer books.

Purchases

Without the handwritten *Rariorum catalogus* of 1607 — in which Merula gave the very first summary of Leiden's special collections — we would have not known about the library's first major purchase. That is because he noted for 44 of the 71 Latin manuscripts that they had been *emt. ex. bibl. Nansii* ('bought from Nansius' library'). The classicist and lawyer Franciscus Nansius (c. 1513/20–1595) was a burgomaster of the rebel Calvinist city of Bruges. When the Duke of Parma brought the city back under the control of the King of Spain and the Catholic Church in 1584, Nansius fled to the North. He stayed for several years in Leiden, where he became friends with Justus Lipsius (1547–1606) and Vulcanius, the professors of classical languages, as well as Janus Dousa (1545–1604), one of the governors and the Librarian. The majority of the manuscripts purchased from Nansius' library (35) are medieval. They include a beautifully illuminated gospel from Saint-Amand (see no. 1). Dousa is thought to have contacted Nansius' son Franciscus Jr after the former's death. The sum he paid to this former Leiden pupil and Middelburg doctor on behalf of the University Library for the manuscripts is unknown; there is no trace whatsoever of the purchase in the academic archives.

We are better informed about the astronomical amount that the Library was to pay in 1690 for the *Bibliotheca Vossiani*, the books and manuscripts belonging to Isaac Vossius (1618–1689). The States of Holland granted the governors permission to take out a loan, *ten behouve van de voors. Universiteyt in alle stilte te doen inkoopen de nagelate bibliotheecq van wylen Isaacus Vossius, overleden in Engeland, bestaende in seer veele rare ende considerable Griecxe ende Latijnse manuscripten, wesende van verscheyde faculteyten, mitsgaders uyt een groot aental exquisite ende seer curieuse gedructe, hebbende daervoor uytgelooft in Hollands ende contanten gelde een somme van 33.000 gulden* (AC1 44). Vossius, a

Fig. 11
With this handwritten catalogue of the *Bibliotheca Vossiana*, received from the heirs, the Library minutely checked the prints and manuscripts supplied. This page describes the Latin manuscripts in quarto. Regarding the second title (183), now VLQ 55, see no. 40. BPL 127 AF, fol. 45r, detail.

classical philologist and collector of manuscripts and books, had been a librarian from 1648–1655 in the service of Queen Christina of Sweden (1626–1689). After Christina's conversion to the Catholic faith and subsequent abdication, her library was dismantled in 1654. Vossius was allowed to make a generous selection from it as compensation for the loss of his own books and manuscripts; they had disappeared from the Royal Library in Stockholm after it collapsed into chaos during several relocations. In 1656, he auctioned around 2500 items through Petrus Leffen in Leiden. Vossius also had some thousand books and manuscripts auctioned at Leffen's in 1666. According to notes about the purchase retained from the professor and Librarian Joannes Fredericus Gronovius (1611–1671), Leiden's University Library bought 38 lots at the latter auction, for 490 guilders and 12 stuivers. To put that in perspective, that sum was over twice the annual salary of a sailor. These lots included 23 medieval manuscripts, for instance two Carolingian manuscripts containing *De Excidio Hierosolymitano* and the *Lex Romana Visigothorum* (see nos 11 and 12). These manuscripts from Vossius therefore landed in the top storey of the Beguinage Church twenty-four years prior to the Bibliotheca Vossiana.

A further fifteen years passed after the death of Vossius before the biggest purchase in the library's history was finalised. The contract with Vossius' heirs was based on a handwritten catalogue that was sent from England (now BPL 127 AF). Upon arrival, the seven-hundred-plus manuscripts and nearly four thousand printed works were compared minutely against that catalogue by a committee of three professors. Various manuscripts turned out to be absent or incomplete. Moreover, it was reckoned in Leiden that their assessment of the overall value of what had been delivered did not exceed 18,000 guilders. The governors wanted either to pay less or to dissolve the contract. Vossius' heirs were challenged in the civil courts in a process that dragged on for years. In 1704, the High Court ruled in its final judgement that both parties had to stick to the contract. The heirs had to hand over the missing manuscripts and books and the library had to pay. Which both parties did. Vossius' printed books were placed among those already present, classified by subject matter and format. The *Codices Vossiani* remained together in closed bookcases, primarily subdivided by language: *Latini*, *Graeci*, *Miscellanei*, *Germano-Gallici* (except the *Chymici*, manuscripts about alchemy). Vossius' Latin manuscripts in

particular — over three hundred in number — have proved to be of great academic value in reconstructing classical texts (see for example nos 19, 30 and 47) and helped spread the name and fame of Leiden's University Library throughout Europe. It is impossible to put a figure on their current financial value — they are unique items, after all — but it must be many millions of euros.

Three other purchases with many medieval manuscripts came from the possessions of the Leiden professors Vulcanius and Lipsius and the Leiden Librarian Abraham Gronovius (1695–1775). Here too, the printed material (annotated in some cases) was placed in the library's general collection and the manuscripts and archive items were stored separately. The *codices Vulcaniani* were acquired in 1615 from Vulcanius' heirs; the *codices Lipsiani* at an auction in The Hague over a century later in 1722; the *codices Gronoviani* were bought in 1776 and 1785, at two auctions in Leiden.

As with the purchase of the Nansius manuscripts, two major auction acquisitions lead a somewhat hidden existence within the series of Latin manuscripts at the library, the *Codices Bibliothecae Publicae Latini*. In 1730, the library purchased 22 medieval manuscripts with classical Latin texts (plus a remarkable trilingual psalter, BPG 49 A) from the collection of the Hague burgomaster Samuel van Huls (1655–1734). In 1744, it obtained seven Latin bible manuscripts and four Middle Dutch manuscripts from the collection of the historian and bibliographer Isaäc Le Long (1683–1762). The quartet included both the richly illuminated codex with *Der naturen bloeme* by Jacob van Maerlant (see no. 34) and the continuation of Maerlant's *Spiegel historiael* by Lodewijk van Velthem, the only complete surviving copy of it (see no. 16).

The budget for books that the library received annually left no scope for special purchases. Nevertheless, the governors managed to winkle out considerable sums free on occasion. The Librarian Pieter Burman (1668–1741) was for instance able to spend 2000 guilders on books and manuscripts at the auction of the *Bibliotheca Hulsiana* in 1730. And in the case of the *Bibliotheca Vossiana*, the governors even took out a loan. The repayments on that must undoubtedly have delayed the professors' salary payments a few times… Nowadays too, purchasing a medieval manuscript from the library's regular budget is no simple matter. Certainly not at auctions, where cash has to be brought to the table in very short order during the bidding if you are to have any chance. Fortunately, a foundation called *Stichting Vrienden van de Universitaire Bibliotheken Leiden* has recently been set up that can provide financial support. In the spring of 2024, with backing from the Foundation, the most recently obtained medieval manuscript to date was placed in the strongroom: a Dutch prayer book that was purchased at an auction in Amsterdam, along with the double-locking metal treasure chest that the previous owner kept it in (BPL 3796, see Fig. 39).

Loans, fragments, losses and swaps

For a long time, the culture of classical Antiquity predominated at the universities and professors exclusively gave lectures in Latin. It was only after the occupation of the Dutch Republic by the French and the establishment of the Kingdom of the Netherlands in 1815 that a growing sense of national identity led to burgeoning interest in the country's own medieval past. As a result, studies of Dutch — its language and literature, and history — were able to grow into fully-fledged academic disciplines. It should therefore not surprise us that the roughly one thousand medieval manuscripts that the library had collected through to 1876 included fewer than twenty that had texts in Dutch. However, that gap was eventually dealt with — rather fortuitously. The Governors of Leiden University signed an agreement with the *Maatschappij der Nederlandse Letterkunde* (Society of Dutch Literature), whereby the latter agreed to house its books at the University Library as a long-term loan. This society (founded in 1766 and still active) promotes study of Dutch national culture and literature. It does so not only through holding lectures, issuing publications and making awards but also by maintaining and expanding its library, for which the society collects old sources, academic literature and literary works. The loan collection now comprises over 270 Middle Dutch manuscripts and fragments that are widely used in academic education and research. Key manuscripts of the collection that should not be omitted from any selection of treasures include two fourteenth-century composite manuscripts (see nos 36 and 37). These contain the only surviving copies of certain chivalric romances and fables.

Leiden's academics continued to enrich the collection of medieval manuscripts, in life and after death. In 1890, the heirs of the Leiden professor of Roman law

Fig. 12
Photographic portrait of professor of legal history Willem Matthias d'Ablaing (1851–1889).
UBL, PK-PT-319.

Willem Matthias d'Ablaing, who died young (1851–1889), gave 42 legal manuscripts on loan to the library. That loan was converted into a gift in 1907 (see no. 23).

Unexpected acquisitions — albeit from within what the library already possessed — are the fragments of what had once been deemed worthless medieval manuscripts. Such items were found when rebinding or repairing worn or damaged library books. Old parchment leaves were reused in the bindings and book blocks of later medieval manuscripts and, above all, in sixteenth-century printed works. They were employed to provide a 'limp binding' (with flexible covers), to serve as a covering for the rigid boards that protect the book block, or as flyleaves between the boards and the book block (see no. 11). Cut into strips and pieces, they were glued down the spine of the book block and against the insides of the boards, in order to strengthen the hinge action or (in the centre of the quires) to reinforce the stitching. At first, these fragments were thrown away when books were rebound, but from the nineteenth century onwards the library retained them and kept them in boxes. They are like jigsaw puzzle pieces that give a clearer picture of text transmission and the history of the manuscript book, than when the researchers only base their ideas on what has been preserved in full. The Leiden collection contains almost no liturgical manuscripts, for instance, but the fragment collection is swarming with missals, antiphonaries and graduals. Which is understandable if you remember that Catholic worship was stopped almost everywhere in the Northern Netherlands from the 1570s onwards. Of the Middle Dutch chivalric romances that appeared before 1300, only fragments remain from thirteenth-century copies, such as *Floris ende Blancefloer* by Diederik van Assenede (LTK 2040); its complete form is known solely from a fourteenth-century copy (see no. 36).

Sometimes medieval manuscripts disappeared from the library's collection. A ninth-century Virgil manuscript, purchased in 1730 at the auction of Samuel van Huls, was claimed by the French authorities in 1797 and returned to them. They were able to show that Nicolaas Heinsius (1620–1681) had at one point borrowed it from the Bibliothèque Royale but not returned it (it is now Paris, BnF, lat. 10307). The old shelfmark (BPL 6 B) was afterwards, somewhat confusingly, reused for a humanist Virgil manuscript, which had already been acquired in 1749.

Unfortunately, there have also been losses due to wartime violence. German troops, hindered in their march through neutral Belgium towards France, set the city centre of Louvain on fire in August 1914 and shot and killed more than two hundred civilians. Louvain University Library and all its collections went up in flames. In his annual report for 1914/1915, the Librarian Scato de Vries (1861–1937) reported to the governors that 'everything in Louvain's library had been utterly destroyed': *dat alles in de Leuvensche Bibliotheek volkomen vernietigd is* (BA1 M 94a). That included three medieval codices from Leiden with spiritual texts in Dutch by the Brabant mystic Jan van Ruusbroec (1293–1381) and the Dominican Dirc van Delft (c. 1365–1404), which had temporarily been in Louvain on request from Belgian scholars. There are still placeholder cards in the storeroom shelves testifying to their absence, like library gravestones, stating their reference numbers *Voss. G.G. Q 12*, *Ltk. 338*, *Ltk. 343* along with the text *Verbrand te Leuven in 1914* ('Burned in Louvain in 1914').

The acquisition and loss sides of the ledger remain balanced when manuscripts change ownership as part of an exchange agreement. In an exchange with Utrecht University Library in 1908, for instance, a *car-*

tularium containing details of gifts to the Domkapittel church in Utrecht during the years 722–1333 (formerly BPL 67 B, now transferred to the Utrechts Archief) was swapped for a composite manuscript including *inter alia* the *Ilias Latina*, a Latin summary of Homer's Greek text (now in Leiden's library as BPL 1925). Similarly, Leiden's library received a manuscript from the possessions of Filips van Leiden (c. 1325–1385), the renowned legal scholar from the county of Holland, in an exchange with the University Library of Breslau (now Wrocław in Poland) in 1942 (it is now BPL 2429 — see no. 43). In return, the library gave a manuscript in which the assets of the bishopric of Breslau are listed, which had been purchased at the Vossius auction in 1666 (formerly BPL 10). That codex was lost during the Second World War, but the textual content has been retained thanks to the edition by H. Markgraf and J.W. Schulte, *Liber fundationis episcopatus Vratislaviensis* (Breslau 1889).

Acquisitions through the ages

To get some kind of picture of the growth of the collection of medieval manuscripts over the centuries, we can compare the number of descriptions from the current online catalogue against the numbers in some of the printed catalogues. We have selected three, from different centuries: the library catalogue of 1716 by Wolfert Senguerdius (1646–1724), the catalogue of manuscripts from 1852 by Jacob Geel (1789–1862) containing the acquisitions since 1716, and the inventories of manuscripts made by the curator Henri Blok (1894–1968) in 1932 (covering the library's own possessions) and 1937 (collections on loan). None of these printed publications makes a distinction between medieval and post-medieval manuscripts: they are mixed together in the corresponding chapters (as they are on the library's shelves). We are therefore counting not only the descriptions of medieval manuscripts but also the sum total of Western manuscripts. We saw earlier that manuscripts were exchanged or lost. There are also cases of manuscripts being merged or split. For instance, a wandering quire with text from a *Sinte Franciscus leven* (Life of St Francis) — still

Fig. 13
Sinte Franciscus leven (Life of St Francis). BPL 83. Quire -ii- (here fols 1–8) described as BPL 103 in the 1716 catalogue appeared to have strayed from this codex, which began with quire -iii-, and was reinserted here in 1902. Quire -i- is still missing.

described separately in the catalogue of 1716 — BPL 103 — was appended in 1902 to codex BPL 83, from which it was missing. Conversely, a fifth-century fragment from the chronological canons of Eusebius of Caesarea (c. 260–340 AD) was taken out of VLQ 110, described separately and given the shelfmark VLQ 110 A. Finally, manuscripts were sometimes moved to other collections, where they received new shelfmarks. This all makes it difficult to obtain a clear picture of the individual manuscripts but, generally speaking, the growth of the medieval Western manuscript collection is as follows:

PERIODS	WESTERN MSS	OF WHICH MEDIEVAL
1587–1716	1232	751
1716–1852	1015	235
1852–1932/37	4017	360
1932/37–2024	3537	398
Total	9801	1744

We can see that over half the Western manuscripts that were in the library in 1716 were from the Middle Ages. That number roughly doubled over the course of three centuries, whereas the number of post-medieval Western manuscripts went up sixteen-fold over the same period. What cannot be seen from these figures is that the lion's share of the roughly 150 manuscripts that were produced before 900 AD were acquired in the library's earliest years. That may, perhaps, say something about the greater supply of medieval manuscripts in that period, or it may reveal aspects of the acquisition policy of Leiden's university in the seventeenth century, fixated on classical Antiquity and always searching for old text sources. In his catalogue of 1612, Heinsius dedicated a paean of praise in Greek to the library of the academy, including the following lines (in translation):

> 'See here, O stranger, a palace of wise souls from Italy and Greece; a wonderful place to stay for restful silence, the seat of reason, the jewel in Pallas' crown [...] Here are the dead who will live forever; here for eternity resides the silent speech of men who have passed away.'

In Heinsius' florid classical imagery, the library is a sort of heaven when visitors can come into contact with the wisdom of blessed souls. Classical authors come back to life, as it were, when their works are read. The library is moreover, as we read between the lines, the crowning glory of Leiden's Academy, as Pallas represents not only the goddess of wisdom and knowledge but also Leiden's Academy itself: ever since its foundation, it has used Minerva — Pallas Athena's counterpart in the

Fig. 14
Brass stamp (lying on the storage box of VLO 94) depicting a reading Minerva. UBL, Library Archive, BA1 E 2 – Early medieval Latin lexicon of Tironian notes (VLO 94, see no. 27). The nineteenth-century leather binding is decorated on front and back cover with an imprint of the library stamp.

Roman pantheon of gods — as its symbol, as present on the University Beadle's Staff of Office and the Great Seal of the University. It can also be seen on Leiden bookbindings, imprinted by a brass stamp that is still kept today in the library's archive (BA1 E 1).

Collection access

Catalogues

We saw above that it is possible to follow the growth in the number of medieval manuscripts of the collection based on the published catalogues (see adjacent page for an overview). At any rate, insofar as the quality of the descriptions permits — they are sometimes so brief in the oldest catalogues that several manuscripts could be being referred to. It is only since the catalogue of 1716 and the supplement of 1741 that the descriptions give us enough to work with precision. From that moment on, the descriptions are given numbers that (preceded by an indication of the sub-collection) are still in use today as shelfmarks: they are on the spines of the volumes and noted in the front of the books. Until after 1800, the collections of manuscripts were largely described as part of the library's overall possessions, mostly ordered by language into a few categories, with medieval and post-medieval manuscripts mixed together. These are preceded by more substantial categories of the collections of printed works, which were ordered by academic field: theology, law, medicine, history, philosophy, mathematics and literature.

From about 1850 onwards, the Western manuscripts (including the medieval ones) were described in greater detail for each sub-collection in separate catalogues with extensive indexes. They were therefore then separated from the collections of printed works, which had increased so greatly in number that publishing a catalogue for the whole library in book form was no longer feasible. The alternative that appeared in the nineteenth century was the card index catalogue.

Describing unique manuscripts, from the Middle Ages in particular, turns out to be much more complex than is the case for printed works. The date and location of their production is often unknown. They do not have title pages with quotable reference data and often contain too many texts for all relevant information to be recorded on identical cards in a card catalogue. However, curators — in the sense of academic collection specialists — have used card indexes since the 1860s for dates, authors and titles, owners and scribes. These cross-referenced more detailed descriptions in the printed catalogues or the handwritten shelflists. Another card index, arranged by shelfmark, made it possible to access the growing volume of academic literature about the manuscripts.

In the present digital age, card catalogues and printed variants are rapidly becoming computerised. For the printed works, it turned out to be straightforward to convert cards with standardised descriptions into bibliographical records that, once included in the online catalogue, could now be searched alongside metadata from e-books and e-journals. It is less easy for manuscripts. There are no cards containing all the essential information. On top of that, the descriptions of the manuscripts in printed catalogues are generally too copious and too unstructured for it to be feasible to include them in unmodified form in a searchable bibliographical record. The cataloguer therefore has to summarise, interpret, standardise and improvise for each manuscript in order to make a record that is suitable for entering into a database.

The overview that follows shows that a significant majority of authors used Latin until deep into the 1980s as the language for catalogue descriptions; understandable given that the majority of texts that were to be described were in Latin and Greek. So Dutch only appeared at the end of the nineteenth century in the catalogues of loan items in Dutch, drawn up by Rogge (1887), Blok (1937)

Fig. 15
Basic details of manuscript BPL 87, written by curator Gerard Lieftinck, c. 1960. Description from the card catalogue of medieval manuscripts, arranged by signature. Photo: UBL.

Survey of Leiden library catalogues with descriptions of medieval manuscripts

1595 — [P. Bertius], *Nomenclator autorum omnium quorum libri vel manuscripti, vel typis expressi exstant in Bibliotheca Academiae Lugduno-Batavae.*

1597 — [P. Merula], *Catalogus principum, civitatum, et singulariorum, qui donatione vel inter vivos vel mortis caussa, bibliothecam publicam, in Academia Lugduno-Batava institutam, liberaliter ditarunt.*

1612 — [D. Heinsius], *Catalogus librorum Bibliothecae Lugdunensis.*

1623 — [D. Heinsius], *Catalogus Bibliothecae Publicae Lugduno-Batavae.*

1640 — [D. Heinsius], *Catalogus Bibliothecae Publicae Lugduno-Batavae.*

1674 — [F. Spanhemius], *Catalogus Bibliothecae publicae Lugduno-Batavae noviter recognitus. Accessit incomparabilis thesaurus librorum orientalium, praecipue mss.*

1716 — [W. Senguerdius], *Catalogus librorum tam impressorum quam manuscriptorum Bibliothecae Publicae Universitatis Lugduno-Batavae.*

1741 — *Supplementum catalogi librorum tam impressorum quam manuscriptorum Bibliothecae Publicae Universitatis Lugduno-Batavae, ab anno 1716 usque ad annum 1741.*

1852 — J. Geel, *Catalogus librorum manuscriptorum qui inde ab anno 1741 Bibliothecae Lugduno Batavae accesserunt.*

1887 — H.C. Rogge, 'Handschriften'. In: *Catalogus der Bibliotheek van de Maatschappij der Nederlandsche Letterkunde te Leiden.* Deel 1, pp. 1-77. – Supplement (pp. 77-85) by S.G. de Vries.

1910 — [P.C. Molhuysen], *Codices Vulcaniani.*

1910 — [P.C. Molhuysen], *Codices Scaligerani (praeter Orientales).*

1912 — [P.C. Molhuysen], *Codices Bibliothecae Publicae Latini.*

1932 — [H.P. Blok], *Catalogus compendiarius continens codices omnes manuscriptos qui in Bibliotheca Academiae Lugduno-Batavae asservantur. Pars 1: Codices manuscripti Bibliothecae Academiae Lugduno Batavae = Inventaris van de handschriften, eerste afdeling.*

1937 — [H.P. Blok], *Catalogus compendiarius continens codices omnes manuscriptos qui in Bibliotheca Academiae Lugduno-Batavae asservantur. Pars 4: Codices manuscripti ex collectionibus societatum in usum eruditorum in Bibliotheca depositis = Inventaris van de handschriften, vierde afdeling.*

1946 — K.A. de Meyier, *Codices Perizoniani.*

1948 — G.I. Lieftinck, *Codicum in finibus Belgarum ante annum 1550 conscriptorum qui in bibliotheca universitatis asservantur – Pars 1. Codices 168-360 societatis cui nomen Maatschappij der Nederlandse Letterkunde.*

1955 — K.A. de Meyier, *Codices Vossiani Graeci et miscellanei.*

1965 — K.A. De Meyier, *Codices bibliothecae publicae Graeci.* | With the collaboration of E. Hulshoff Pol.

1970 — P.C. Boeren, *Catalogue des manuscrits des collections d'Ablaing et Meijers.*

1973-1984 — K.A. de Meyier, *Codices Vossiani Latini.* 4 vols.
– *Pars I: Codices in folio* (1973).
– *Pars II: Codices in quarto* (1975).
– *Pars III: Codices in octavo* (1977).
– *Pars IV: Indices* (1984). | Compiled by K.A. de Meyier and P.F.J. Obbema.

1975 — P.C. Boeren, *Codices Vossiani Chymici.*

1984 — [J.P. Gumbert], *Illustrated inventory of medieval manuscripts in the Netherlands. Experimental precursor [1]. Leiden, Bibliotheek der Rijksuniversiteit: Gronoviani, Burmaniani, Oudendorpiani, Indebetuviani, Marchandiani, Ruhnkeniani.*

1985 — [J.P. Gumbert], *Illustrated inventory of medieval manuscripts in the Netherlands. Experimental precursor 2. Leiden, Bibliotheek der Rijksuniversiteit: Lipsiani.*

1988 — C. Berkvens-Stevelinck, *Catalogue des manuscrits de la collection Prosper Marchand.* | With the collaboration of A. Nieuweboer.

2009 — J.P. Gumbert, *Illustrated inventory of medieval manuscripts in Latin script in the Netherlands.* Vol. 2. Leiden, Universiteitsbibliotheek BPL.

2023 — A. Bouwman, *Inventory of western medieval manuscripts held by Leiden University Libraries.*

and Lieftinck (1948). These were followed by a few catalogues where French was the cataloguing language: those of Boeren (1970, 1975) and Berkvens-Stevelinck (1986). Finally, two authors used English for their inventories: Gumbert (1984, 1985, 2009) and Bouwman (2023).

Arranging items on the shelf and on paper

Managing a voluminous and ever-growing collection of books and manuscripts is no easy matter. Leiden's library has in the past tried out numerous options for ordering and physically arranging its collections of

books. That was not merely about how to arrange the books in the bookcases but also about the order in the printed catalogues that kept visitors to the library and remote users informed about Leiden's holdings. The enormous growth of the collections of printed works led to ever greater divergence between their ordering in the catalogues and on the shelves. That happened to a lesser extent with the collection of manuscripts.

The oldest catalogues (1595–1640) are what are called shelf list catalogues, in which all the books are described briefly in the same order in which they were arranged in the bookcases in the upper floor of the former Beguinage Church. According to the catalogue of 1595, the few manuscripts that were present were simply in amongst the printed works. In this early period, the main factors determining location were the dimensions of the volumes and the content of the works. The largest books, in folio format (2°) were kept upside down on the shelves of what were called *plutei*, chained to a metal rod. Each of these open bookcases had a reading shelf at chest height so that visitors — when standing — could tip a book over from the storage shelf (at eye height), open it and consult it. As the print from 1610 shows (see Fig. 16), the books were kept in two rows on either side of a central aisle. There were separate bookcases for theology, law, medicine, history, philosophy, mathematics, and language and literature. The smaller books, which were not chained, were in closed bookcases at the back of the room, ordered first by subject area and then by size: first quarto (4°), then octavo (8°), duodecimo (12°) and sextodecimo (16°). These are general size indications derived from the printing process, in which the sheets of paper for a book were folded into two, four, eight, twelve or sixteen.

In principle, ordering by size is the most efficient use of space. Moreover, there is then less risk of the book blocks sagging and distorting the bindings, issues that can arise if very large and very small books are kept next to each other on the shelves, whereby they insufficiently support each other. Nevertheless, the system used during the first sixty years was not a success, in various ways. Supervision in the library hall was difficult, with visitors standing between the bookcases and more or less able to do whatever they wanted, unobserved. Quite a number of books were damaged or even stolen, despite being secured with chains. The open bookcases originally had just a single shelf, but extra acquisitions (initially appended at the ends of rows) led to extra shelves being added. Reading the books in a standing position was uncomfortable for visitors and when readers wished to consult smaller formats, the library custodian kept having to open locked cases, which presumably also had a reading shelf at chest height.

In 1653, the governors decided to change the system: the chained library now became a library hall. After his predecessor Heinsius resigned, the Librarian Anthony Thysius (c. 1603–1665) had the chains removed from the folio-sized items and had the reading desks replaced by tall, open bookcases. These were placed between the windows of the upper floor and separated off by wooden fencing from a central visitors' area in the middle, where there were tables and chairs. All the printed works in each field were given sequential numbering for each format and placed together in the bookcases, with the folio-sized material on the bottom shelves and the smaller ones above. In the 1674 catalogue, the printed works are again presented by subject

Fig. 16 (above) Engraving of the Leiden Library after a drawing by J.C. Woudanus, 1610. The folio prints are located (chained) in the two rows of lecterns, arranged by subject, the smaller formats in the closed cabinets at the back. The manuscripts are displayed in the librarian's office (front left, not visible). On the right, the cabinet containing Scaliger's bequest. UBL, Port 315-III N 22.

Fig. 17 (under) Leiden Library. Print by J.C. Woudanus, 1610. The chained books were upside down in the lectrines, with their backs facing forward (not with the fore edge out, as the engraving incorrectly suggests). UBL, Port 315-III N 22.

Fig. 18
Floor plans of the library interior on the upper floor of the church: c. 1610 (chain library), 1654 (with central visitor's area and open bookcases between the windows) and 1695 (with central double row of bookcases, space for visitors on both window sides and closed bookcases between the windows). The absis (left, without floor at half height) housed the Theatrum Anatomicum. Image after G. Grämiger, *Verortungen von Wissen* (2014), UBL, 1360 A 18, pp. 122, 161, 185.

area and format but now in a different order, namely alphabetical by author. That made the works significantly easier to find for the visitors. Each catalogue description was moreover accompanied by a number and a format indicator, so that the custodian could derive the location code from the catalogue, e.g. *Theol. Fol. 18*. In this instance the custodian simply had to fetch the eighteenth folio-size book from the shelves in the theology section and hand it over the fencing to the visitor, who could then consult it at a table.

Four decades later — when the acquisition of the *Bibliotheca Vossiana* in 1690 doubled the library's posses-

Fig. 19
Leiden Library from 1695 onwards. Print from *Les delices de Leide*, 1712. The central block of bookcases was needed to store the *Bibliotheca Vossiana*; the visitors moved to the window sides. The manuscripts are arranged in gallery bookcases above the entrance. To the left behind the gallery stairs are the cabinets containing the collections of Scaliger and Vulcanius. UBL, COLLBN Port 315-III N 11, detail.

sions at a stroke — the system had to be radically rearranged again. The governors had a long row of double bookcases placed in the middle of the room extending along the entire length, as can be seen in a print of the library's interior from the city guide *Les delices de Leide* (1712). The central block of open bookcases provided enough shelving but reduced the amount of natural light, as well as making it difficult to monitor the visitors. They could now consult their books on sides of the hall, by the windows, so the wooden fencing was moved and the cabinets by the windows were fitted with lockable doors with protective metal mesh. A second room guard was appointed to help with the surveillance.

When the 1716 catalogue was printed, it retained the division into academic fields and went even further. Within each field, the books were further subdivided into various subject areas, then sorted alphabetically by author. Theology books, for instance, were grouped into Bible editions, biblical dictionaries and commentaries, works of the church fathers, church history and so on. A general index of authors at the back of the catalogue made sure all books could be found, regardless of the academic field or subject heading under which they were listed.

It was not until the 1860s that the library abandoned the classification according to the traditional academic fields (which, after all, failed to do justice to the rapid development of the empirically oriented natural sciences) and switched to a strict placement by format. That made it possible for a printed book about a theological topic to end up on the shelf next to a mathematical work. During those years, the church of the former Beguinage was fully kitted out as a book warehouse, with service rooms for staff and reading rooms for visitors in the front building erected in the early 1820s. When visitors looked up from their textbooks, they had a view over Leiden's famous Rapenburg canal, with the Academy Building on the opposite side.

The presentation of Western manuscripts in the catalogues through to 1852 reflects where they had been placed in the bookcases. According to the Librarian Merula's handwritten *Rariorum catalogus* (1607), they were located for a while in the Librarian's office just to the left of the entrance — along with other rare and valuable works. That was because making these available for people to examine was a privilege reserved for the Librarian himself. This separated-off area cannot be seen in the Woudanus print because the entrance area is out

of view. It is interesting to see how Merula presents these early 'special collections' in his catalogue. The works are basically classified by language (Latin and Greek), then by material type (manuscripts, printed works, prints with scholars' own notes), with the Latin manuscripts further subdivided by subject area, and finally by format. Merula also noted whether the items were donated or purchased and from whom they were acquired.

All in all, it was a detailed arrangement. It was however abandoned in Daniel Heinsius' three catalogues (1612, 1623 and 1640). Heinsius clearly gave the manuscripts of his former professors Scaliger and Vulcanius the most attention, dedicating separate chapters to them. Only then did he have a subsequent chapter entitled (in translation) 'Several books, handwritten or annotated with variants from manuscripts'. Languages and formats were now mixed together, in an inconsistent order. Presumably the bookcases were similarly ordered.

The Librarian Frederik Spanheim (1632–1701), in his catalogue of 1674, gave the Greek and Latin manuscripts their own chapters. He also split Scaliger's bequest into an Eastern and a Western section, with his Greek and Latin manuscripts given separate chapters (as were those of Vulcanius). Each of those four collections of Western manuscripts (pp. 396–419) was arranged by format from large to small: first the folio-sized items and then (mixed together) the smaller formats. Each description ends with an indication of the format. It is striking, though, that each of these four chapters is continuously numbered, rather than having a single series of numbers for each format category, as the printed works in the preceding chapters do. That made it difficult to integrate new acquisitions by size.

It is thought that this may be the reason why the *Codices Graeci*, *Latini*, *Scaligerani* and *Vulcaniani* were renumbered a few decades later. At any rate, that can be seen from the corresponding chapters (pp. 324–350) in the 1716 catalogue, the work of Librarian Wolfert Senguerdius (1646–1724). Like Spanheim, Senguerdius did not bother giving these four older manuscript collections format numberings, whereas he did for the *Codices Vossiani* in the chapter that follows (pp. 358–403). The 1712 picture of the library interior shows that all these Western manuscripts (along with the Eastern ones) were by now arranged in closed gallery bookcases above the entrance (accessible via a small staircase on the left), behind which we also see the bookcases containing the manuscripts of Scaliger and Vulcanius.

The point of view in this 1712 print is incidentally the exact opposite of Woudanus', not looking towards the wall with the fireplace and the portraits of William of Orange and his son Maurits but instead towards the entrance to the library, with the fireplace to the rear.

By the early eighteenth century, it had become customary to store the manuscript collections of Leiden's scholars separately. The library was therefore arranging its manuscripts primarily by provenance. In the nineteenth century, they were transferred to a special 'manuscript room' in the front building and also displayed there in gallery bookcases closed by doors with a wire mesh. The 1932 inventory has no fewer than seventeen such 'provenance collections', fourteen of which came from Leiden professors and librarians. That cannot be a coincidence. It would seem that there had been an acquisition policy that focused on acquiring private collections from Leiden's academic circles.

Other acquisitions were placed with the *Codices Bibliothecae Publicae Latini* (BPL) and *Graeci* (BPG). The manuscripts of these two 'open' collections were arranged *de facto* by size (although the 1716 catalogue does not give the size indications). Inserting new acquisitions into this fixed numbering now became a serious issue for which various solutions were proposed. Initially, Senguerdius and his successors used 'letter signatures' as a means to insert them within the existing series, alongside manuscripts which were similar in format and/or content. That is what was done for instance with the manuscripts BPL 14 A and BPL 14 E

Fig. 20
Leiden catalogue from 1674 by Librarian Friedrich Spanheim (1632–1701). On the left the last numbers (in quarto and octavo) of the *Codices Graeci* (BPG), on the right the first numbers (in folio) of the *Codices Latini* (BPL). Spanheim numbered the manuscripts by collection, each of which was arranged by folio and (mixed together) smaller formats. UBL, ex. 1408 I 62.

Fig. 21
Photographs of the manuscript room in the late nineteenth century, pictured from two sides. Workspace and depository (with bookcases on two levels) still combined in one room. UBL, Library Archive, BA2 F 2.

Fig. 22 (left)
F.B. Waanders, Lithograph after a drawn portrait by J.F. d'Arnaud Gerkens of Librarian Jacob Geel (1789–1862). c. 1825–1849. UBL, BN 529

Fig. 23 (right)
Jacob Geel, *Catalogus librorum manuscriptorum qui inde ab anno 1741 Bibliothecae Lugduno Batavae accesserunt*. Leiden 1852, p. 1. Manuscripts, medieval and post-medieval, arranged by language and content. UBL, ex. DOUSA 91 0001.

(see nos 16 and 34, two works by or associated with Jacob van Maerlant). This 'system' remained in use until about 1850.

Jacob Geel was the first Librarian who chose to list the manuscripts in a separate catalogue (1852). He described all the acquisitions after 1716, both medieval and post-medieval. He retained the 'collection signatures' that had been assigned but, unlike his predecessors, he gave his descriptions a second 'on paper' numbering from 1–1015. This let him categorise the manuscripts independently of their placement by language and subject matter and then organise them further into three categories: I. *Codices Graeci* — manuscripts containing or about older Greek texts (nos 1–311), II. *Codices Latini* — manuscripts containing or about older Latin texts (nos 312–608), III. *Libri recentiores* — more recent manuscripts, in both Latin and the vernacular (nos 609–1015). According to this ordering, a fifteenth-century copy of Plato's *Timaeus* and an eighteenth-century copy of the same text would be placed under the same subcategory, *Philosophia* (Philosophy). The system is a bit wobbly here and there, with medieval vernacular manuscripts counted among the more 'recent' manuscripts, for instance. But in an 'on paper' arrangement, the issue of format does not play a role.

Since the middle of the nineteenth century, newly acquired manuscripts were placed at the ends of the shelves in order of acquisition, therefore acquiring ascending numbers without letters. For the 'outsize formats', placeholder cards now refer to shelves on which large folio-sized items can be stored flat, or shelves on which the smallest manuscripts are placed together. The *Maatschappij der Nederlandse Letterkunde* must similarly not have been thinking about the longer term when it catalogued its manuscripts shortly before handing its library over as a long-term loan to Leiden University Library in 1876. That is clear because they decided to organise their manuscripts in detail by content and renumber them within each series. For some time, the medieval manuscripts were therefore grouped together nicely by type, with e.g. the books of hours under references LTK 284–310. But following this loan transfer, any newly acquired books of hours was then simply placed in order of receipt and given a place number that did not match this system.

Now, in the new building on the Witte Singel canal, the manuscripts have been brought together — as far as possible — with other special collections (which was Merula's old idea). It is a long time now since the collection fitted in a *cantoor* (office); these days, it is

Fig. 24
University Library storage area, Witte Singel. Manuscript bookcases: large folios lying down (left), small formats standing together (right). Centre: rolling stacks with front row of bookcases containing Vossius manuscripts. Photos: UBL.

kept in a climate-controlled, storage area split across two floors. Here, the fixed bookcases of the past have given way to mobile bookcases (*compactuskasten* or rolling stacks), making the most efficient use of the scant space. So, in today's Leiden University Library, the time-honoured Greek adage still applies: *Panta rhei* ('Everything is in motion').

It is telling that many European libraries long continued to value the printed classical text editions in which scholars had noted variants in old manuscripts during their study tours, indeed treating them as ancient manuscripts too. The stipulation about storage added to the Leiden library instructions in November 1730 is typical: 'That all editions of books, used by a learned man and enriched with marginal annotations by the same, will

Fig. 25
Edition of Horace's *Opera omnia* (1612), in duodecimo format. Interleaved copy with variants and notes noted by Janus Broekhusius (1649–1707).
UBL, ex. 758 E 24.

Descriptions

You cannot describe details that you have not observed. That may sound blindingly obvious, but it applies to many of the humanist scholars who studied medieval manuscripts. They saw the Middle Ages as a period of decline that obscured the view of the much-admired culture of classical Antiquity. Why French monks in the ninth century might have produced a Latin manuscript of Cicero's philosophical works (see no. 18) or how it was made and used — including its later use by other owners — were questions that philologists were not yet asking. Scholars were focused on textual variants: unfamiliar words and turns of phrase that could be important in reconstructing the original works. After centuries of repeated copying, classical texts were often full of errors. Critical examination of the oldest or best sources can indeed help resolve such textual corruptions, but the lack of knowledge of medieval writing culture and book history made it difficult to determine when and where these sources (and errors) had been produced.

from now be kept in the manuscript bookcases' (AC1 31). In Leiden, the annotated printed works were removed from the manuscript collections from the 1860s onwards and moved to separate bookcases along with other printed works. According to the 1932 inventory, there were over 300 such items! It is therefore unsurprising that information about the dating and material aspects of medieval manuscripts is mostly absent from the pre-1850 catalogues or has been limited to general observations.

It was only after 1860 that more options arose for meeting the growing academic interest in the Middle Ages, thanks to the development of photography and the improved accessibility of important manuscript collections in European libraries. Old manuscripts with special letter forms and other historical features — such as the use of certain abbreviations, decorative styles, miniatures or binding techniques — were increasingly being reproduced reliably and could therefore be studied more closely.

There came a systematic search for manuscripts with colophons: texts added at the end of manuscripts in which the scribes noted the place and date of production, in some cases along with their own name and that of their patron (see nos 8 and 48). This allowed manuscripts without colophons but that did have corresponding material features to be located more accurately in medieval space and time.

At Leiden University, a fruitful interaction developed from 1900 onwards between its own collection of medieval manuscripts and codicology, the science that studies medieval handwritten books as material and historical objects. On several occasions, a professorship or chair of manuscript studies was set up and occupied by academics attached to or working closely with the University Library. The *Bibliotheca Neerlandica Manuscripta* was also placed at the Library — thanks in part to the presence of the library of the Dutch Society of Literature. Purchased with government support in 1938, this documentation system for Middle Dutch manuscripts anywhere in the world was the life's work of the Ghent philologist and codicologist Willem Lodewijk De Vreese (1869–1938). It contains hundreds of folders with descriptions (now digitised) of thousands of manuscripts. Data about their textual content and authors, their scribes and owners, characteristics

Fig. 26 (left) Painted portrait of Willem Lodewijk De Vreese (1869–1938) by Albert Neuhuys. Since 1902, this Flemish philologist and codicologist collected data for his *Bibliotheca Neerlandica Manuscripta*, a documentation apparatus for Middle Dutch manuscripts that was housed and continued at the Leiden University Library after his death. Photo: Rotterdam Municipal Library.

Fig. 27 (right) Karel de Meyier (1906–1980), in the library at the Rapenburg, c. 1965, in front of the bookcases containing the Vossius manuscripts. He holds codex VLF 49, containing Latin letters by Cicero, open (see no. 47). UBL, Library Archive, BA2 F 4.

of their handwriting, illumination, dating and so forth are accessible using extensive card indexes (now also via a database). Under these favourable conditions, the classicist Karel de Meyier (1906–1980) managed during his career at the library to describe a large proportion of classical manuscripts in a series of superb catalogues, including his life's work: the *Codices Vossiani Latini*, published in four volumes between 1973 and 1984.

We can get a good overview of over four hundred years of cataloguing by taking a brief detour through the successive descriptions of one of the University Library's earliest donations, codex BPL 87. This manuscript from the ninth or early tenth century contains an allegorical didactic text entitled *De nuptiis Philologiae et Mercurii* ('On the marriage of Philology and Mercury'). In it, the author Martianus Capella (active c. 410–420) summarises late antique knowledge of the seven liberal arts, which he describes as servants of the bride Knowledge. The Carolingian codex — which has a large number of explanatory annotations by medieval users in its margins — was no doubt welcomed as a classical treasure for the humanist university. Nevertheless, the description in the 1595 catalogue was limited to a simple mention of the author's name: *Martianus Capella MS*. You can't make it briefer than that. The description in the 1716 catalogue is a little more generous. It states the title of the work and remarks that the manuscript is incomplete, that it contains annotations and is made of 'very old parchment': *Martiani Minei Felicis Capellae libri VII (ibi enim finit) de nuptiis Philologiae, cum adscriptis hic glossis. Membran. vetustissima. 87*.

Almost two centuries later, the library's curator of manuscripts Philipp Molhuysen (1870–1944) had a lot more to say about the manuscript and the text in his 1912 catalogue — albeit still in Latin. He mentions *inter alia* the dimensions of the writing area (but not of the book block), the construction and numbering of the quires, the involvement of several scribes and that it has painted initial letters and headings. He then quotes the late antique caption at the end of Book I, the final words of the incomplete manuscript, refers to the ownership inscription and the library signature of Egmond Abbey, and describes how it came to be in the library (donated by Henricus Bredius).

Fig. 28
Martianus Capella, *De nuptiis Philologiae et Mercurii*. End of 9th or beginning of 10th century (eastern France). The text contains explanatory glosses between the lines and in the margins.
BPL 87, fols 2v–3r.

Fig. 29
Description of BPL 87 in P.C. Molhuysen, *Codices Scaligerani (praeter Orientales)*. Leiden 1912, pp. 45–46, details.

Fig. 30
Description of BPL 87 in J.P. Gumbert, *illustrated inventory of medieval manuscripts in Latin script in the Netherlands*. Vol. 2. *Leiden, Universiteitsbibliotheek BPL* (Leiden 2009), pp. 46–47, details.

In 2009, the Leiden professor of Western palaeography and manuscript studies Peter Gumbert (1936–2016) described all 586 manuscripts and 937 fragments in the BPL collection in the second volume of his *Illustrated Inventory of Medieval Manuscripts*. It was a new type of inventory, where he gathered key data from large numbers of text carriers, in concise and often abbreviated or even encoded form. For BPL 87, for instance, Gumbert's inventory gives the localisation and dating as *Fr.-E?* and *IX²*. This stands for 'France, possibly Eastern France' and 'ninth century, second half'. There is no indication of the handwriting type (Carolingian minuscule), but instead there is a reproduction of a few lines of script (4 x 7 cm). A neat approach, as it makes dating and localisation (which usually rely on analysis of the script) directly verifiable for users. Compared to Molhuysen's catalogue, Gumbert's *IIMM* inventory offers less information about the manuscripts' texts but more reliable information about the materials and improved dating. This reflects not only Gumbert's own expertise but also advances within manuscript studies as a field.

The University Library has an online catalogue nowadays, linked to an image bank containing complete digitised versions of over eleven hundred medieval manuscripts (plus all printed catalogues since 1595). Nobody could have imagined how digital text and digital images from different library systems could complement each other. In the online catalogue, the bibliographical description of BPL 87 provides not only codicological, textual and book history information, but also references to publications about the manuscript, as well as links to digital versions of the manuscript and some printed catalogues. One such link leads to an e-book published in 2023 by the curator André Bouwman, the *Inventory of Western Medieval Manuscripts held by Leiden University Libraries*. Whereas information about Leiden's medieval manuscripts previously had to be put together from various partial catalogues (in which they are described among more recent manuscripts of similar provenance), *all* medieval manuscripts are conveniently arranged here together, for the first time, with concise descriptions and comprehensive indexes. Users can use this inventory for quickly identifying other manuscripts in the Leiden collection that, like BPL 87, were made in Eastern France, or were made in the late ninth or early tenth centuries, or contain a text by Martianus Capella, and so on. If they find a manuscript interesting, the link provided in the descriptions takes them with a single mouse click to the to the corresponding bibliographic description in the online catalogue, from where with another click they can navigate to a digital version of the manuscript in the image bank.

Chalk and cheese

The descriptions in the online catalogue and *Inventory* make it possible to examine various cross-sections of the current collection of medieval manuscripts. But it can all too easily become a case of 'chalk and cheese' — comparing things that are not at all the same: the number of *manuscripts described* and the number of *manuscript descriptions* are not identical. The online catalogue and the *Inventory* contain over 1700 descriptions, but the number of manuscripts described — or to be more precise, the number of *codicological units* or production units — is considerably greater, at around 2900. There is good reason for that.

There are over 1100 bound manuscripts (*codices*) that were produced at some point as a 'project' by a single scribe, or sometimes by a group of scribes working in collaboration. The quires of each book block constitute a single production unit. Sometimes the content consists of a single text, or more often a series of texts. Manuscripts with such text collections are usually called *multi-text manuscripts*.

In addition, there are over two hundred *composite manuscripts*. These contain two or more manuscripts that originated as independent projects, with their own times and places of production. These production units were only later bound together into a single volume (see nos 36–37 and 43). Altogether, these composite manuscripts in the Leiden collection contain over 650 codicological units (i.e. an average of about three per volume) that are described as such in the *Inventory*. In total, therefore, there are some 1800 independently produced manuscripts.

The library also has *fragments* of about 1100 manuscripts, ranging in scope from a few leaves to just a couple of snippets. Fragmentary surviving manuscripts may be considered as once having been independent production units. About 400 were deemed interesting enough to be described independently in the online catalogue and the *Inventory*. The remainder were sorted by type of text or by language and placed under collection numbers, accompanied by general descriptions.

The associated collection profile characterises the medieval manuscripts (and where possible the fragments) by origin, dating, language, type of text and sub-collection.

Fig. 31 (above) Description of BPL 87 (detail) in the online catalogue (2024). Online at https://catalogue.leidenuniv.nl. Photo: UBL.

Fig. 32 (left) Description of BPL 87 (detail) in A. Bouwman, *Inventory of western medieval manuscripts held by Leiden University Libraries* (2023). Online at http://hdl.handle.net/1887.1/item:3619870.

Manuscript by origin

Number of codicological units via Bouwman's *Inventory* (2023), section 2. In case of uncertain origin (e.g. 'France, or Low Countries?') units are counted twice:

> Low Countries (721), France (624), Apennine Peninsula (428), German regions (269), British-Irish Isles (54) — Other: Greece (12), Byzantium (9), Middle East (6), Iberian Peninsula (4), Egypt (3), Russia (5), Bulgaria (1), Rhodes (1), Syria (1), Sicily (1). — Origin unknown (167).

Manuscripts by century

Number of codicological units via the *Inventory*, section 2. Some codicological units dating from classical Antiquity are included. Dates spanning two consecutive centuries are mentioned separately:

> 3rd century (1), 4th century (1), 5th century (2), 6th century (2) 7th century (1), 8th century (3) 8th/9th century (9), 9th century (111), 9th/10th century (19), 10th century (55), 10th/11th century (12), 11th century (80), 11th/12th century (20), 12th century (232), 12th/13th century (28), 13th century (215), 13th/14th century (23), 14th century (275), 14th/15th century (37), 15th century (847), 15th/16th century (53), 16th century, first half (212).

Manuscripts by language

Number of descriptions (via the online catalogue) of manuscripts/fragments with texts in the following languages:

> Latin (1125), Dutch (426), Ancient Greek (234), French (66), German (43) — Other languages: Italian (7), Czech (3), Greek (3), Church Slavonic (2), Hebrew (2), Provencal (2), Russian (2), Old English (1), English (1), Breton or Old Cornish (1), Old Irish (1), Irish (1), Yiddish (1).

Multilingualism is not specified in these numbers. The *Inventory* distinguishes:
— codicological units with with one or more multilingual texts (like glossaries and texts with a full translation);
— codicological units with various texts in different languages.

Manuscripts by text type

Number of descriptions (via the online catalogue) under various textual subject headings. Descriptions are counted repeatedly when they contain multiple subject headings:

> administration (29), artes (419), bible (161), canon law (101), classical literature/philosophy (324), historiography (258), law and regulations (76), literature (154), liturgy (120), medieval theology/philosophy (192), preaching (93), religious texts (347), Roman law (41).

Manuscripts by (sub-)collection

Number of descriptions (via the online catalogue) of manuscripts/fragments belonging to one of the following (sub-)collections:

> Bibliotheca Publica Latina (719, including 13 fragments collections). — Bibliotheca Publica Graeca (84). — Loan of Maatschappij der Nederlandse Letterkunde (277, including 4 fragments collections).
>
> Vossius (463) — Vulcanius (51). — Perizonius (49). — D'Ablaing (42). — Scaliger (34). — Gronovius (33). — Lipsius (25).— Meijers (8). — Ruhnkenius (6). — Burman (5). — In de Betouw (4). — Bibliotheca Thysiana (4). — Marchand (1). — Oudendorp (1).

Collection care and user services

Conservation

On 11 November 1616, the peat store in Leiden University's Academy Building caught fire and burned fiercely, destroying most of the building. Fortunately, the library was no longer housed in the Academy Building at that point, but on the other side of the Rapenburg canal in the former Beguinage Church. The blaze did however prompt the University's governors and burgomasters to take greater precautions to protect the library from fire. Storing peat in the direct vicinity of the building was forbidden, as were naked flames and candles inside the building: 'Furthermore we have ordered all to refrain henceforth from using fire or candles at the Library', according to the governors' *Resoluties* (Resolutions, AC1 20). For a long time, this meant that visitors could only read the books and manuscripts during daylight, in an unheated room. Elsewhere in the Resolutions too, the governors show they understood that the conditions in which the library's collection was kept could affect the state of the books. The library instructions of 1683 state that the wooden doors of the closed cabinets containing the manuscripts should be replaced by metal mesh doors so that the manuscripts were better ventilated, to help avoid mould (AC1 44). And according to Article 1 of the library instructions from 1741, the Librarian was required to make sure 'that the printed, annotated and written

Fig. 33
Manuscript (BPL 2747, no. 8) on a cushion with snake weights, to the right the storage box.

books are kept clean, dry and intact and for this reason, as soon as he sees that any defect has appeared in the roof, walls, glass or joints of the building [...], he should inform the Secretary of the Gentlemen Governors and Burgomasters immediately [...]. That after the worst of a storm or downpour has ended, the custodians should proceed to the Library and check everything carefully, so as to give notification immediately, as described above, of any defects caused'. (AC1 47)

This passive form of conservation has received the appropriate attention in the current library building on the Witte Singel canal. The storage rooms have a climate control system creating the optimum conditions for preserving the heritage collections, at constant temperature and humidity. Smoke detectors have been installed for extra fire safety; if a fire starts, they set off a gas-based extinguishing system that displaces nearly all the oxygen in the room, thereby putting out the fire. Other conservation measures have been taken too. Bound manuscripts with parchment book blocks are particularly sensitive to fluctuations in temperature and humidity. They have therefore been placed in storage boxes so that transporting them to and from the visitors' table in the Special Collections Reading Room (which has a different climate) is less harmful and does not cause impact damage. Once removed from the box and taken to the table, the manuscript is placed for reading on a cushion filled with polystyrene beads. The cushion offers maximum support for the binding and book block, which shift in shape constantly as the leaves are turned. Snake weights enclosed in velvet help to keep the book block open and therefore minimise contact between the reader's hand and the manuscript.

Despite all these measures, manuscripts are inevitably affected by the passage of time. The more intensively a manuscript is used, certainly in a university library, the greater the risk of damage or wear and tear. If that happens, physical interventions become unavoidable. This active form of conservation focuses first and foremost on the structure of the book binding. Five sixths of the medieval manuscripts kept in Leiden have lost their original bindings. It appears that many manuscripts were rebound during their stay at the library when their text block quires were restitched and inserted in a new binding. In the eighteenth century, the library binding usually consisted of a parchment spine and boards made of pasteboard or cardboard with a marbled paper covering in a distinctive red, blue and yellow pattern; see the example of the two manuscripts in the Scaliger bequest (SCA 1, SCA 36; see pp. 210, 218). Starting in 1816, several hundred medieval manuscripts in poor condition were rebound in full brown leather over cardboard (BPL 21, VLF 31; see pp. 118, 134). In some cases, such as codex VLO 94, these brown leather bindings have been

stamped with an image of Minerva reading, the 'logo' of Leiden University (see Fig. 14). Other manuscripts — for example the Life of Jesus (LTK 258) and Pliny's *Naturalis historia* (VLF 4) — were rebound somewhat later in half parchment over cardboard with a marbled paper covering in new patterns (see p. 70, 192). Records of this nineteenth-century binding work — which was outsourced to Leiden book binders such as Schamper and Emeis, later Loebèr and Labrée, who worked for their own account — were kept in binding books that are now stored in the library archives (BA1 B 1–13). However, the records do not contain any documentation of the original condition of the manuscripts. In all these cases, replacing the previous binding meant the loss of interesting historical information about the creation and use of the codex. Unfortunately, there was insufficient awareness in the past of the binding as an intrinsic part of the book.

In the period 1960 to 1990, many medieval manuscripts that had become damaged or difficult to use were repaired or rebound in the restoration workshop of Onze Lieve Vrouwe abbey in Oosterhout. The Benedictine nun who worked there, Lucie Gimbrère, used authentic materials. Moreover, where possible she reused the original binding techniques when she found traces of them. She always operated in consultation with the Leiden curator Pieter Obbema (1930–2015) who commissioned the work. Old parts were reused, and remnants were added as an appendix to the restoration report. Whenever Sister Lucie found stitching holes from an earlier binding in the quire folds, she would note them in a 'stitching scheme' (see also nos 13 and 36). The manuscripts she restored include some of the ones mentioned above (BPL 114, BUR Q 3, LTK 191, LTK 195). The archive of her restoration work on some four hundred medieval manuscripts (about half of which came from Leiden) is now part of the Leiden Special Collections (BPL 3470).

Restoration as a discipline has advanced in recent decades. Increasingly, the focus is not so much on the object's original state as on its functionality, given its use in the library. The new generation of restorers aim to preserve and stabilise the book binding in its current state — while retaining the historical information present in the object and using techniques and materials (including modern ones) that are preferably reversible — that is to say, they can be undone. In 2000 the library acquired its own workshop, where the restorer Karin Scheper puts this more cautious approach into practice with a team that varies in size and is partly employed on a per-project basis. This approach is geared more to the collections as a whole, rather than the small number of exceptional items. A key result of this new approach to the medieval manuscripts was an improvement in their storage. All parchment manuscripts got made-to-fit pH-neutral cardboard boxes. Most of the loose fragments have now been enclosed in polyester film, stitched into specially designed folders made of pH-neutral cardboard. That makes it easier and safer to consult them.

Consultation

These days, visitors who want to study Leiden's manuscript treasures with their own eyes merely need a library card to be able to enter the building on the Witte Singel canal. The manuscripts are made available in the Special Collections Reading Room on the second floor, where visitors can use them under supervision at one of the large tables. They do not need to wear gloves but they are required to have clean hands and take care in handling the objects. Restrictions are placed on the availability of certain manuscripts because of their value and fragility. The interests of the person requesting the manuscript will always need to be weighed up against the interests of the manuscript in question (or more accurately, of its future users). University lecturers can also show medieval manuscripts during classes in the library's lecture rooms, subject to strict conditions.

Fig. 34 University Library, Witte Singel; Special Collections reading room; in the background the desk with library employees.

Fig. 35
Aratea, planetarium.
Ninth century, first half.
VLQ 79, fols 93v–94r.
Shot before transport to the Getty Museum, Los Angeles, September 2024.
Photo: UBL.

Fig. 36
Loan on 14 October 1743 to Professor Frans van Oudendorp of five manuscripts containing texts by the Latin poet Claudius Claudianus: BPL 105 A, BPL 116, BPL 131, VLQ 126, VLO 39. Van Oudendorp signed, the notes are by Librarian Abraham Gronovius (1695–1775), who also recorded the return on 30 October at top left: *restitua sunt*. UBL, Library Archive, BA1 U 1.

In general, manuscripts are not lent out for use outside the University Library building. An exception is made for loans for exhibitions in professional museums. Even behind the glass of a display cabinet, ancient manuscripts with their fascinating handwriting and dazzling illuminations are at a glance able to transport viewers back in time. That is why the library gets regular loan requests from museums in the Netherlands and abroad. Of course the library will always have to discuss such matters as insurance, the duration of the loan, transport and the climate and lighting in the exhibition space in detail with the institution requesting the manuscript before the loan contract is signed and the manuscript can be allowed to travel. One object that is much in demand is the *Aratea*, one of Leiden's top treasures with its Carolingian miniatures of the constellations (see no. 31). Over the past thirty years, the manuscript has been loaned out six times, including to Aachen for its anniversary exhibition *Karl der Grosse. Macht Kunst Schätze* (2014) and recently to the Getty Museum in Los Angeles, for the exhibition *Lumen. The Art of Science and Light* (2024).

A special climate-controlled, impact-resistant crate was designed for transporting the *Aratea* to the United States to ensure the manuscript would reach the other side of the ocean undamaged. Times have changed in that respect, as can be illustrated by some examples from the library's past. Frans van Oudendorp (1696-1761), who was appointed professor of history and rhetoric at Leiden in 1740, was simply allowed to take the medieval manuscripts home with him! For example, on 14 October 1743 the Librarian Abraham Gronovius gave him five manuscripts containing texts by the Latin poet Claudius Claudianus (c. 370–c. 404), according to the loan register that Gronovius filled in and Van Oudendorp signed. He did however have to promise to return the manuscripts within three months 'without any stains, damage or lost

pages' (*absque omni macula, laesione aut inminutione*). Moreover, he promised that should he ever publish an edition of these texts, he would 'demonstrate his gratitude with an honourable mention of this favour and by offering a print copy for inclusion in the Leiden university library' (BA1 U 1).

According to Gronovius' note on the opposite page, Van Oudendorp returned the manuscripts on 30 October 1743. Lending manuscripts out to professors and lectors at Leiden was permitted by the library instructions of 1741, but researchers who were not from Leiden needed permission from the university governors. Outside the library's regular opening hours, they were allowed to browse the manuscripts or copy their content in the presence of one of the custodians, and 'whomsoever is allowed to do so, must recompense the custodian for his trouble and time spent' (AC1 47).

This practice changed dramatically at the end of the eighteenth century. From that point on, it became common practice for the library to have the medieval manuscripts delivered to the scholar's house, even if he lived abroad. In his annual report for 1880/1881, the Librarian Du Rieu still mentioned *de geroemde vrijgevigheid van onze Bibliotheek* (the 'renowned generosity of our Library'). Since 1859, no less than 1300 precious manuscripts had been lent to Dutch and foreign scholars, and safely returned (BA1 M 46).

A decade later, loans to private individuals had partially been replaced by loans to academic libraries where the scholars could consult the manuscripts, under supervision. That is evident for example from a postcard dated 5 January 1894 in which Du Rieu granted a request by a Professor Konrad Zacher to keep manuscript VGF 52 a little longer in Breslau (now Wrocław in Poland) for the correction of an article. The codex was apparently consulted in the Universitätsbibliothek of Breslau, because Du Rieu asked Zacher to show the postcard to the library director Joseph Staender: *Zeigen Sie, bitte, diese Postkarte meinem Collegen Ständer mit freundlichen Grüsse*. The practice of lending medieval manuscripts for use off the library premises declined markedly from the start of the twentieth century. The First World War put a stop to international cooperation between European libraries. At the same time, the rapid development of modern reproduction techniques brought new options for exchanging information about the manuscripts.

Photography

For more than a hundred and fifty years, the library has used photographic reproductions as an alternative to making the physical object available. In the 1884/1885 annual report, Du Rieu writes: *Aanzienlijk is het getal photographische afbeeldingen dat van de manuscripten voor buitenlandsche geleerden werd vervaardigd* (BA1 M 46). This 'considerable number of photographs' made from manuscripts for the use of scholars abroad, may well have been the work of the pioneering Leiden photographer Jan Goedeljee (1824–1905), or his son Johannes Goedeljee (1849–1921), with whom he ran a photo studio from 1879. Johannes continued to take photographs of manuscripts for the library up to his death. He made prints from the glass plate negatives, which the library then sent to scholars, particularly those based abroad.

In 1893, Du Rieu was approached by librarians in other countries with the request to use his network for an *Association internationale de reproduction des manuscrits les plus précieux* ('International association for the reproduction of the most precious manuscripts'). The idea that academic libraries should cooperate internationally in using photographic reproductions to make their most valuable medieval manuscripts available for research and education appealed to Du Rieu and he enthusiastically agreed to help out, albeit initially with little success. Too few libraries were prepared to subscribe to an expensive series of print facsimiles produced using photomechanical techniques. But the Leiden publisher

Fig. 37
Postcard from Librarian W.N. du Rieu to Prof K. Zacher from Breslau, 15 January 1894. Stored in BPL 3728.

A.W. Sijthoff did see a future in the venture and said that they would be prepared to publish the series at the company's own risk as long as Du Rieu was willing to take responsibility for the academic content. He was, and that resulted in the prestigious Leiden series *Codices Graeci et Latini photographice depicti*.

A total of 19 facsimiles were published in the main series in the period 1897–1923, plus 10 partial facsimiles in a supplementary series. Du Rieu had already died in 1896 but he was succeeded by his curator of manuscripts Scato de Vries in 1897 as both Librarian and editor-in-chief of the series. Over the next quarter of a century, De Vries used tact and patience to persuade fellow directors of heritage libraries in Bern, Dresden, Hanover, Heidelberg, Milan, Munich, Paris, St Petersburg (formerly Leningrad), Venice, Ravenna, Smyrna (İzmir), Toledo, Vatican City, Vienna and Wolfenbüttel to allow facsimiles of their most important old manuscripts to be published. For the introductions, he was able to engage such prominent scholars as Ludwig Traube, Georg Thiele and Paul Lehmann. His own library also played a significant role in the project: the main series included facsimiles of five Leiden manuscripts and the supplementary series another four manuscripts (see nos 3, 13, 18 and 19). The series made an important contribution to palaeographic and codicological research, not only on account of the facsimiled manuscripts themselves but also with respect to other manuscripts created in the same period or other copies of the same classical texts. There was general admiration for De Vries's efforts as editor-in-chief of the series, as illustrated by the fact that he was granted an honorary degree by Oxford University in 1902.

Analogue photography remained important for the library's services for the whole of the twentieth century. Leiden library even employed photographers on a permanent basis. It also invested in new equipment, such as cameras for producing, developing and duplicating microfilm along with the associated reading equipment, and cameras for colour slides in small and large format.

It was only from the end of the twentieth century onwards that digital photography brought far-reaching changes to the academic world thanks to the rise of computers, the internet, databases and smartphones. As a result, digital photography has now largely supplanted the production and use of traditional photography in academic libraries. In Leiden, major investments have been made in the digital infrastructure under the direction of the current Head Librarian, Kurt de Belder (from 2005 onwards). There is a new online catalogue that lets users search both the library's physical collections and publishers' e-books and e-journals. There is a new image database and the university has its own digital photo studio where fragile heritage objects can be recorded responsibly under the guidance of a restorer. For the medieval manuscripts, the library teamed up with a Leiden publishing company, namely Brill Publishers. This meant that more manuscripts could be digitised, although some sub-collections were (and are) temporarily only accessible within the Leiden network.

The following key step was to arrange access to digitised sources for users beyond local image databases of heritage institutions, without requiring thousands of image files to be copied or relying on the storage capacity of servers elsewhere. To enable this, a new image infrastructure has been developed with the lengthy

Fig. 38
Greek Octateuch (first eight books of the Old Testament), from the fifth century. Parts of this codex, now preserved in Leiden, Paris and St Petersburg, have been brought together in volume 1 of the facsimile series *Codices Graeci et Latini photographice depicti* (1897). Fol. 1r with verses from Genesis (31:53–32:6) from the Leiden volume in the facsimile.
Ex. DOUSA f87 0201.

Fig. 39
A Dutch prayer book, kept in a double-locking metal treasure chest by the previous owner(s). c. 1550. Purchased at auction, 2024. BPL 3796. Photo: UBL.

name of the International Image Interoperability Framework (abbreviated to IIIF, pronounced as 'triple-I F'). Providers of digital images have jointly agreed to use a standard structure for the metadata that is made available, known as a 'IIIF manifest'. Using a IIIF viewer, researchers and other users can then view images of manuscripts from various institutions at the same time on their computer, and then view, compare, digitally manipulate and annotate them.

As of 2020, the Leiden Digital collections image database has published IIIF manifests for all its digital objects. This means it is possible to add digital versions of Leiden manuscripts to such international portals as Biblissima and Europeana. In the Netherlands, the Huygens Institute is building eCodicesNL, a national portal for digital versions of medieval manuscripts that are held by Dutch institutions.

What does the future hold? The increasing availability and accessibility of digital images and metadata will undoubtedly have a significant effect on the study of medieval manuscript books, but what will that effect be? What will the dominance of the digital dimension mean eventually for the use of the physical manuscripts and their care? And how should we deal with the discrepancies that will arise over time between the digital version of a manuscript and its physical manifestation — given that the latter will inevitably suffer wear and tear, incur damage and change? The answers to these questions still lie in the future, but Leiden's written heritage will remain part of that future, and continue to be available for teaching and research.

Preface

These fifty manuscripts from the Leiden collection have been selected by the main authors to illustrate how manuscripts in medieval Europe were made, used, and preserved. The manuscripts are grouped into nine themes, according to two criteria: the manuscripts' content and the perspectives chosen by various authors. These thematic groupings bring manuscripts from different cultures, regions and periods into conversation with each other. Within each theme, manuscripts have (where possible) been arranged according to their dating, with the oldest placed first. The introductory texts to each theme were written by Irene O'Daly.

In their contributions, authors have cited texts from the manuscripts in question, chosen from the pictured pages. The transcribed text is presented in italics and the abbreviations used by the scribe have been expanded and presented between round brackets. In Latin texts, the spelling of u/v has been normalised; in vernacular texts, the spelling of i/j has also been normalised. The citations are usually followed by a translation (given in plain text or between round brackets) or a paraphrase. Citations from Greek texts are followed by a transliteration in Roman characters (in italics).

In the principal image accompanying each manuscript contribution, the manuscripts have, where feasible, been printed to true size. Instances where the dimensions of the pictured manuscript page exceed the dimensions of this book (30.5 x 24 cm) are indicated in the accompanying caption with '(image xx%)'. This is the case with nos 1, 11–13, 15, 18–20, 23, 25, 29–30, 34–35, 41–42, 45. To give the reader an impression of the relative sizes of the manuscripts, nine 'group photos' are presented per theme. As all of these photos have been taken from the same camera position (and are neither enlarged nor reduced) it is possible to compare the binding and size of all fifty manuscripts to each other.

The back matter comprises a bibliography for the two introductions and the fifty contributions. It is followed by manuscript descriptions, derived from André Bouwman's *Inventory of Western Medieval Manuscripts held by Leiden University Libraries* (2023, online at http://hdl.handle.net/1887.1/item:3619870). This inventory links to comprehensive bibliographic records in the Library's online catalogue and digitised versions of the manuscripts. All of the fifty manuscripts in *Written Treasures* have been digitised in full and are free to consult. The glossary, composed by Irene O'Daly, comprises terms relevant to the production, use and study of manuscripts and texts. The index was assembled by Yulia Knol.

This book appears simultaneously in English and Dutch editions: *Written Treasures | Schatten op schrift*. André Bouwman and the contributing authors Anne Margreet As-Vijvers, Saskia van Bergen, Tazuko van Berkel, Bart Besamusca, Jos A.A.M. Biemans, Gerard Boter, Rolf H. Bremmer Jr, Bram Caers, Claudine Chavannes-Mazel, Anna Dlabačová, Mart van Duijn, Ad van Els, Alisa van de Haar, Suzette van Haaren, Casper de Jonge, Egbert Koops, Anne Korteweg, Adrie van der Laan, Quintijn Mauer, Marco Mostert, Eef Overgaauw, Christoph Pieper, Thijs Porck, Karin Scheper, Mariken Teeuwen, Kaj van Vliet, Ed van der Vlist, Geert Warnar and Hanno Wijsman wrote their contributions in Dutch. Irene O'Daly and the other contributing authors wrote theirs in English. For the translations from Dutch to English we are thankful to Mike and Clare Wilkinson from Tessera BV. Unless otherwise indicated, the photographs were made by the Library. We thank Britanny Brighouse for enriching the book with her manuscript photography. Our thanks, too, are due to various colleagues at the Library, particularly Kasper van Ommen, Garrelt Verhoeven and Jef Schaeps. We express our warm thanks to the team at Lannoo, especially to Michiel Verplancke, for the careful manner in which they prepared and presented the text and images in this book. Finally, the principal authors thank their partners and close family for their invaluable support.

— André Bouwman, Irene O'Daly

THE WORD OF GOD

Many medieval library catalogues opened with the book regarded by medieval Christians as the most important: the Bible. From the first words of Genesis, which presents the story of God's creation of the world, to the concluding vision of a promised afterlife in Revelation, the Bible offered medieval readers an unequalled repository of dramatic stories and rules for a good and holy life, tempered by the threat of eternal punishment. The Bible was studied continuously throughout the Middle Ages, as shown by BPL 100 A (no. 2), an annotated Latin copy of the Book of Job dating from the twelfth century.

Another reason biblical books frequently headed medieval library catalogues is that they were often among the most precious possessions of a religious house or an individual. A ninth-century Gospel Book from the Abbey of Saint-Amand in France (no. 1, BPL 48) and a late-twelfth-century Psalter later owned by King Louis IX of France (no. 3, BPL 76 A) represent the potential magnificence of medieval religious book production. Rebound in the 1980s with leather-covered wooden boards to simulate its medieval appearance, the Gospel Book was intended for public display and was used in medieval monastic services. The Psalter, meanwhile, although spectacularly decorated with an illuminated cycle of images, was a book made for personal use and was later passed down through various generations of the French royal family.

The Bible's complex moral messages were further complicated by its two-part structure — the Old Testament, with its elaborate stories of prophets and kings, contrasted with the simple lives of Christ and his apostles presented in the New Testament. Texts like the Middle Dutch *Leven ons heren* (no. 5, LTK 258) sought to find connections and parallels between both parts. Understanding the historic basis of the Bible was also a preoccupation of the compiler of LTK 232 (no. 4), a 'History Bible' which combines biblical text and commentary, also written in Middle Dutch. Copied on paper, its thick bookblock — with fore edges sprinkled in red ink from a later rebinding — marks its status as a work of reference. Such vernacular reworkings of the Bible anticipate the post-medieval Reformation, when the privilege of accessing God's words in one's own language would become increasingly valued and contested. (IO'D)

The Word of God | Manuscripts, *from rear, left to right*:
LTK 232 (no. 4), LTK 258 (no. 5, *in front*), BPL 100 A (no. 2) — BPL 76 A (no. 3), BPL 48 (no. 1)

INCPT
EVGLM
SCDM
MARC

Initium
euange
lii Ihu
xpi filii
di · sicut
scriptu
est in e
saia pro
pheta ·
Ecce
mitto
angelu
meu ante facie

The other side of an illuminated page

01 | Gospel Book from Saint-Amand
Ninth century, c. 875 — BPL 48

With its attractive paintings in gold, silver, yellow, green, red and blue, this gospel book or 'evangeliary' must have made a deep impression, glittering in the candlelight in the church. The text on the back of an illuminated page is much less spectacular, but it may contain important information for anyone who wants to know how scribes and illuminators cooperated in creating this splendid codex.

For Christians, the Gospels according to Matthew, Mark, Luke and John are the most important books of the Bible because they describe the life, death and resurrection of Jesus Christ, the Son of God. They are indispensable for worship. A book of the gospels is often placed solemnly on the altar, ritually perfumed with incense and kissed after the gospel reading. People in the Middle Ages also used costly decorations to emphasise the sacred nature of the gospel books. The Leiden codex belongs to a group of sixteen gospel books, written in Carolingian minuscule (lowercase letters with regularly formed ascenders and descenders) and illuminated superbly in a decorative style that combines enlarged letters from classical scripts with woven patterns in a neat and finely balanced layout. These manuscripts have been dated to the third quarter of the ninth century and were produced in north-eastern France, perhaps at the abbey of Saint-Amand. The woven patterns were inspired by motifs developed by Irish and Anglo-Saxon book illuminators; art historians refer to this style as 'Franco-Saxon' or 'Franco-Insular'.

In the Leiden manuscript, the gospels each start with two illuminated pages. The left-hand leaf contains a neatly laid-out title consisting of abbreviated words in gold, in a capital script. The leaf on the right has one or two golden letters from the first word of the gospel, greatly enlarged; they are then filled in with detailed woven motifs and end in dogs' heads or curlicues. Both illuminated pages are framed symmetrically with a golden rectangle full of woven patterns. Its corners are accentuated with rounded, four-lobed or rectangular shapes, coloured in silver and filled with woven patterns or stylised plant motifs. The images here are of the illuminated pages of the Gospel of St Mark (fols 78v–79r).

<< Fig. 1 Opening with illuminated pages at the start of the Gospel of St Mark. On the right, Mark 1:1–2. BPL 48, fols 78v–79r (image 88%).

The capitals of the left-hand leaf can be read as follows after resolving the abbreviations: INC(I)P(I)T EV(AN)G(E)L(IU)M S(E)C(UN)D(U)M MARC(UM), which translates as 'Here begins the Gospel according to Mark'. The right-hand leaf contains the initial letter I (of *initium*) and then, in rounded uncial script, NITIUM EVANGELII (JES)U (CHRIST)I FILII D(E)I . SICUT SCRIPTU(M) EST IN ESAIA PROPHETA . ECCE MITTO ANGELU(M) MEU(M) ANTE FACIE(M). In translation: 'This is the beginning of the Gospel of Jesus Christ, the Son of God. As it is written in Isaiah the prophet: "Behold, I will send My messenger ahead of You [...]".'

The illuminated pages do not share quires with the rest of the gospel texts. In Mark, Luke and John (fols 78v–79r, 124v–135r and 192v–193r), they have been painted on a loose double leaf cut from thick parchment. That is not the case for the Gospel of Matthew, but there is a reason for that: the second quire (fols 8–15), which is also made of thick parchment, contains a consecutive series of illuminations — six openings with the concordance tables of Eusebius (265–340), stating which verses the gospels have in common. The illuminated opening to the Gospel of Matthew began therefore on the last two leaves of this quire (fols 14v–15r).

The texts in the Leiden codex have been produced modularly, with various scribes involved. The gospel text is written in a layout of 21 lines per leaf on quires consisting of four double leaves (quaternions). The switches between styles of handwriting sometimes coincide with the boundaries between quires. The Gospels of Matthew, Luke and John also end on a binion, a quire with two double leaves (fols 72r–75v, 188r–189v and 234r–237v) instead of a quaternion with four. Were the

Fig. 2
Continuation of the opening with text pages at the start of the Gospel of St Mark. On the left, Mark 1:2–9; on the right, Mark 1:10–19.
BPL 48, fols 79v–80r.

scribes perhaps copying simultaneously from an existing gospel book that was divided into separate sections, so that when they completed their modules, they halved the number of leaves in the final section in order to join up to the next module, without leaving any blank pages?

The gospel text on fol. 79v (the unruled verso side following the second illuminated opening page of Mark) has a noteworthy discrepancy. All the gospel texts are written in a layout of 21 lines per leaf, but there are only 20 lines of text here. Moreover, they are broader in form and have more space between the letters and words than is the case for the adjacent leaf (fol. 80r). That begins with *Et statim ascendens de aqua…* (Mark 1:10, in translation: 'And straightway coming up out of the water […]'). This leaf, the first of a quire, must therefore already have been written when the final verso of the double leaf with the decoration was still empty. Perhaps the missing text from Mark could not be filled in from the exemplar because this exemplar did not have this copy's layout of a two-page decorative opening with a woven-motif frame, but something less grand. The illuminator of BPL 48, therefore, must have gone his own creative way, resulting in an illuminated page that contains not only a single large initial but also no fewer than nineteen words of the Gospel. And those words were then no longer available for the reverse side, meaning that the remaining text there had to be spread out more, over only twenty lines, so that everything fitted together. The related gospel manuscript that is in the Bibliothèque Municipale in Lyon (MS 431) also has an awkward textual transition at the illuminated opening to Mark from the verso to the (already written) recto of the subsequent quire. Does this point to glitches in the communication between scribes and illuminators? Were the illuminated pages and textual pages perhaps produced at different locations?

The two text pages following the decorative opening to Mark in the Leiden codex (fols 79v–80r) were not only written at different moments (the verso later than the recto) but not even by the same scribe. This can be seen from the fact that the verso text contains a notably high number of *ra* ligatures, an older letter form that hardly occurs at all in the recto text — see for example *praeparabit* ('will prepare') in the first line of fol. 79v. This significant difference also applies across the two text pages following the decorative openings of Matthew, Luke and John. The old letter shapes must already have been present in the exemplar. Are we seeing an older scribe at work on the verso sides and a younger colleague for the recto sides who showed less of a tendency to replicate these outdated letter shapes?

— André Bouwman

Escaping the maze: Understanding the medieval Bible

02 | Book of Job (Old Testament), with gloss
Twelfth century, second half — BPL 100 A

The Bible was studied intensively during the medieval period, as this late-twelfth-century copy of the Book of Job shows. The manuscript has been glossed — annotated on a near word-by-word basis. Scholars invested much effort in interpreting the Bible, seeking the most accurate or even hidden meanings of its text. Some pages of the manuscript overflow with commentary; on others, pictures, not words, tell the story.

Fig. 1 >
Cartoon-like sketches added on a parchment leaf at the conclusion of the manuscript summarise key events of the prologue to the Book of Job. BPL 100 A, fol. 59r.

BPL 100 A contains a copy of the Old Testament Book of Job. Job is introduced to the reader in the prologue (Job 1:1-5): he is wealthy, happy and faithful. An unusual addition at the end of BPL 100 A supplies a visual summary of this opening narrative (Job 1:6-21). These sketches, added on a leaf of parchment (fol. 59r), illustrate the prologue's two pivotal moments. The caption, quoting directly from the Latin Vulgate translation of verse 6, sets the scene: [Qu]ada(m) die, cu(m) venissent filii \d(e)i\ ut assisterent cora(m) d(omi)no, adfuit int(er) eos satant [sic] ('One day, when the sons of God came to stand before the Lord, Satan was present among them'). In the first set of drawings, the figures to the left are labelled FILII D(E)I ('the sons of God'). Satan stands before them, occupying a central position, while God is seated to the right, leaning forward slightly.

As in a comic strip, each character 'speaks' their part, their (written) words emanating from their mouths. God asks Satan: *Unde venis?* ('Where have you come from?'); Satan responds: *Circuivi t(er)ra(m), (et) p(er) ambulavi eam* ('I have gone around about the earth and walked through it'). In the Old Testament text, God praises Job, but Satan contends that Job is faithful only because he is fortunate. Satan then asks God's permission to *tange cuncta quae possidet* ('touch all that he [Job] has'), then see whether Job remains faithful. In the image, these words are taken out of Satan's mouth and transposed to the start of the scroll held in God's left hand. As this transposition silently suggests, Satan can bring destruction to Job's livelihood and family, even to his body, but in doing so, acts with God's permission.

Fig. 2
Transition from a darker to a lighter shade of ink at Job 1:6-8. Note the early form of the question mark at the end of line 4: *Unde venis?* ('Where have you come from?'). BPL 100 A, fol. 2v, detail.

Job endured countless torments, losing his children, his livelihood and his health. In the second set of drawings, we are confronted with the aftermath of these trials. The unfortunate Job, labelled with his name, has been rendered physically infirm. He sits, holding a crutch, with his hands outstretched, gesturing towards Satan. Satan, wordless, points back at Job, a rod in his other hand. Job's speech, partially obscured by a parchment crease, reads: *d(omi)n(u)s dedit, d(omi)n(u)s abstulit; sic(ut) d(omi)no placuit [ita factum est]* ('the Lord gave, and the Lord took away; as it pleased the Lord [so is it done]'; Job 1:21). That is, in spite of his misfortunes, Job refused to curse God or lose his faith. Job's steadfast Christianity was praised throughout the

…dā die cū uenissent filii dī assisterent corā dño adfuit int eos satan

FILII DI **DÑS**

Vt det uen[ir]e

SATAN

circuiui trā. & p ambulaui eam

SATAN **IOB**

dñs dedit dñs abstulit sic dño placuit

Fig. 3
On account of the quantity of commentary accompanying the biblical text, additional leaves of parchment were inserted throughout. About halfway down the smaller leaf (fol. 4r), the words ALLEGOR(ICE) and MORAL(ITER) in majuscules introduce different types of biblical interpretations. BPL 100 A, fols 3v–5r.

Middle Ages, but the story also prompted much theological discussion regarding the nature of suffering, the meaning of a 'good life' and God's power to intervene in the affairs of humanity.

Whether intended to entertain or explain, the cartoon-like representation of these two key scenes, added to BPL 100 A by a contemporary reader, illustrates the level of interest the Book of Job evoked. Meanwhile, the manuscript's layout and textual content also reveal intense study. The book was designed to facilitate cross-reference between the text of Job and an associated commentary, copied simultaneously. The biblical text is written in large letters in the central column of each page. Space has been left between the lines for interlinear annotations, while the margins are also densely covered with longer remarks, written in a smaller script. On occasion, as can be observed on fols 3v–5r, the quantity of this interpretative material was such that its scribes were obliged to insert additional small pieces of parchment to accommodate it, as seen on fol. 4 in Figure 3. These annotations to the Book of Job (and to other parts of the Bible) were refined in the early twelfth century at the cathedral school of Laon and formed the so-called *Glossa ordinaria* ('Ordinary Gloss'), a standardised resource for biblical study throughout the Middle Ages that survives in thousands of manuscripts. Much of the content of the Gloss to Job, for example, was taken from the *Moralia in Job*, a lengthy sixth-century commentary on the text written by Gregory the Great (c. 540–604 AD).

The Gloss traditionally relied on a fourfold interpretative methodology. Each word or phrase of the Bible could be read on multiple levels: it had literal, allegorical, moral and spiritual meanings. In BPL 100 A, the reader could easily refer from text to marginal commentary by locating the lemma (a brief excerpt from Job) at the start of every passage of annotations. The various types of interpretation were then flagged with qualifiers such as *MORALITER* ('morally') and *ALLEGORICE* ('allegorically'), given in majuscule letters throughout. The Gloss permitted a highly dynamic reading of the Bible: on one hand, it explained the text, sometimes offering prosaic, even obvious, interpretations; on the other, it revealed its layers of meaning, complicating and extending understanding.

The twists and turns of interpretation permitted by the Gloss are echoed in another drawing found in BPL 100 A. A sketch of a labyrinth with a minotaur-like figure at its heart was added on the formerly blank recto of its opening page (fol. 1r). Labyrinths were common images throughout the Middle Ages, used to signal cosmic order and complexity. Within a Christian context, parallels were sometimes drawn between the ancient Greek story of Theseus conquering the minotaur and Jesus' Harrowing of Hell. The medieval reader would have followed the route to the centre of this maze with their finger; thus, the features of the minotaur are blurred by touch. Might this process of tracing the maze have brought to mind the words of Satan — 'I have gone around about the earth and walked through it' — recalling the pervasion of suffering in the world? Or did the artist of this labyrinth view Theseus' victory over the minotaur as a parallel to Job's ultimate reward for his faithfulness to God — the return of his possessions and a long happy life? Its meaning is ambiguous. What we can conclude is that biblical interpretation in the medieval period was a challenging, multi-layered and even imaginative process, for which sometimes words were not enough.

— Irene O'Daly

Fig. 4
At the start of the book, a later reader has drawn a sketch of a labyrinth, with a minotaur-like monster at its centre. At the top of the page, a note, *Qui differt penitentia sua usq(ue) ad finem vite sue utru(m) secur(us) exeat non su(m) secur(us)*, advises the reader not to postpone repenting of their sins until the end of their life, as that may not guarantee salvation. This theme echoes the Book of Job's focus on the merits of virtuous living.
BPL 100 A, fol. 1r.

Cist psaultiers fuut mon seigneur
saint loys qui fu roys de france
Ou quel il aprist en senfance

qui non abijt in consilio impiorū
& in uia peccatorum non stetit: & in ca
thedra pestilentie non sedit.

Sed in lege domini uoluntas eius: &
in lege eius meditabitur die ac nocte.

Et erit tanquam lignum quod planta
tum est secus decursus aquarū: quod
fructum suum dabit in tempore suo.

Et folium eius non defluet: & omnia
quecumq; faciet prosperabuntur.

Non sic impij non sic: sed tanquam
puluis quem proicit uentus a facie tre.

Ideo non resurgunt impij in iudicio:
neq; peccatores in consilio iustorum.

Qm nouit dominus uiam iustorū:
et iter impiorum peribit.

Quare fremuerunt gentes:
& populi meditati sunt inania.

Astiterunt reges terre & prin
cipes conuenerunt in unum: aduer

A sacred book — used, cherished and passed down

03 | Saint Louis Psalter
Twelfth century, c. 1190 — BPL 76 A

Bible book and relic: this Latin psalter is a sacred book in two ways. In the Middle Ages, the Book of Psalms was widely used as a book of prayer by both monks and lay people. This manuscript was used by a French king who was revered as a saint after his death. His descendants — princes and princesses — read it, cherished it and each passed it down to the next generation. What circuitous route did this venerable object take to end up in the possession of the library at Leiden?

The text of the first psalm begins with a full-page initial B on fol. 30v: *Beatus vir // qui non abiit in consilio impioru(m)...* ('Blessed is the man that walketh not in the counsel of the ungodly...'). Five medallions show music being played, for example by King David on his harp. The texts of the 150 psalms make up the lion's share of this luxurious psalter, but they are preceded (as was customary) by a liturgical calendar and a series of full-page miniatures that depict scenes from the Old and New Testaments, without further textual explanation.

An inscription was added in the fourteenth century at the bottom of this leaf (and repeated on fol. 185v): *Cist psaultiers fuit mon seigneur / saint looys qui fu roys de france / Ou quel il aprist en senfance* ('This psalter belonged to my lord Saint Louis, who was king of France, and he learned from it in his youth'). The tradition that Louis IX, king of France, had learned (and/or learned to read) from it when he was young made this manuscript a prestigious and even sacred object. His descendants cherished it as a relic; having a saint as an ancestor was pretty impressive, after all (all the more so given that most saints do not have offspring), and being able to physically touch his psalter too was quite something! The canonisation of Louis IX in 1297 was mainly in recognition of his indefatigable efforts to reconquer Jerusalem in one of the Crusades.

<< Fig. 1
Illuminated initial B and the start of the psalms. The inscription in red about Saint Louis was added later.
BPL 76 A, fols 30v–31r.

The psalter was not made for him, however. It was written in around 1190 in the north of England, probably in Lincoln or York. That can be seen from both the style of the illumination and the litany, which contains typically English saints such as St Wilfrid, a seventh-century bishop of York, on 24 April. An annotation has been added to the date 7 July (fol. 4r), *obit(us) henrici, reg(is) Angl(orum), pat(ri)s / D(omi)ni G(odefridus) Ebor(acensis) archiepi(scopi)*, showing that the manuscript must have been made for Geoffrey Plantagenet (1151–1212), Archbishop of York from 1189/91 to 1207/12. Geoffrey was an illegitimate son of King Henry II of England (1133–1189), who died on this date.

The manuscript ended up in the hands of the French royal family at some point in the early years of the thirteenth century. A second later addition to the calendar (for 6 October), *Obiit aldefo(nsus), rex castelle et toleti*, shows it was being used by Blanche of Castile (1188–1252), who was queen of France as she was the wife of Louis VIII (1187–1226). Blanche's mother was an English princess, a daughter of Henry II of England and therefore a half-sister of archbishop Geoffrey.

Blanche could indeed have taught her son Louis IX (1214–1270), better known as Saint Louis, to read using this psalter. He kept the manuscript and left it to his youngest daughter Agnes (1260–1325), who was married to Duke Robert II of Burgundy (†1306). She in turn bequeathed it to her youngest daughter, Joan of Burgundy (c. 1293–1348). Joan did not have any surviving daughters and so after her death the psalter passed on to her husband, King Philip VI of France (1293–1350). He remarried in 1350, marrying Blanche of Navarre, who retained the precious book when her husband died shortly thereafter. When she died nearly half a century later with no surviving children, she left the psalter in a codicil to her husband's youngest grandson, Philip the Bold (1342–1404). It is that

codicil, in his own hand, that has given us a great deal of information about how it was passed down. Blanche of Navarre could have left the valuable book to a woman again, as it had by then become a tradition to pass it down to the youngest daughter, but she evidently thought it was important that the manuscript should once again be in the hands of the dukes of Burgundy, as had also become a tradition.

We then encounter the psalter of *Monseigneur Saint Loys* in two fifteenth-century inventories of the library of the dukes of Burgundy, drawn up after the death of Philip the Bold's son John the Fearless (1371–1419) and of the latter's son Philip the Good (1396–1467) respectively. It is no longer listed in the subsequent inventories but is mentioned again as the *Psaultier de Saint Loys de Franche* in an early sixteenth-century list of a selection of manuscripts from the Burgundian library. The manuscripts summarised there have an educational tint: the list includes an ABC for learning, for example, a bestiary (medieval animal encyclopaedia) and a lot of illustrated material. Several of the books in this list had previously been owned by women, in particular by Margaret III, Countess of Flanders, the wife of Philip the Bold. It therefore seems likely that this list represents a group of manuscripts that were intended for the education of a young girl with the first name Margaret; this would probably have been the natural daughter of Emperor Charles V (1500–1558), who was born in 1522 and later, as Margaret of Parma (1522–1586), would be the governor of the Netherlands.

We can assume that Margaret kept the psalter for the rest of her life. Maybe she gifted it to someone. This Margaret did not have any daughters but did have a son, Alexander Farnese, Duke of Parma (1545–1592). We know at any rate that Jan van den Bergh (1664–1755), mayor of Leiden and the University's curator, donated the psalter to Leiden University Library in 1741. During the War of the Spanish Succession, he was with the States Army in the Southern Netherlands for a lengthy period as a delegate in the field on behalf of the Council of State (1706–1715) and he could have acquired the manuscript there.

We know an unusually large amount about the way this psalter was handed down from one person to the next. We can see how it was passed on from mother to daughter in the fourteenth century and then finally to a grandson, then in the fifteenth century from father to son and finally to a daughter, often to the youngest

Fig. 2
Two scenes from the life of Christ: the Last Supper, the Arrest of Christ.
BPL 76 A, fol. 23r.

scion and specifically of the Burgundian branch of the French royal house. The Saint Louis Psalter, now kept in Leiden, gives a fascinating insight into the various ways that splendid manuscripts like these were used in the late Middle Ages. They were showpieces and family heirlooms, as well as being practical educational material for teaching children to read, for learning prayers, as a catechism and for learning the words of the psalms, for which both the texts and the illustrations were important. But above all, this manuscript was a venerable and even holy object because it had been used by a saintly king, Saint Louis, the ancestor of many of the subsequent early owners.

— Hanno Wijsman

The Bible as a growing manuscript

04 | Southern Netherlands History Bible
Fifteenth century, second half — LTK 232

The collection on loan from the *Maatschappij der Nederlandse Letterkunde* (Society of Dutch Literature) includes, under shelfmark LTK 232, a 'Southern Netherlands History Bible'. That description might make you think it is a complete bible, written as a single document. However, nothing could be further from the truth. Bibles such as these often contain only parts of the biblical text and may moreover consist of several sections bound together.

Fig. 1 >
The contents of the manuscript, followed by the list of kings of Israel and Judah, on a leaf of parchment inserted at the front. LTK 232, fol. 1r.

The term 'Southern Netherlands History Bible' refers to a specific Middle Dutch translation of the Bible that was made between 1359 and 1383, commissioned by the Brussels patrician Jan Taye. This translation is also known among researchers as the 'Herne Bible' and the 'Bible of 1360', the latter because the lion's share of the translation was done in around 1360. The translator is therefore also regularly referred to as the 'Bible translator of 1360'. It is now known that the translation was probably done by a monk in Herne (near Brussels), tentatively identified as Petrus Naghel, the prior of the Carthusians at Herne.

Fig. 2
Beginning of the first Bible book Genesis:
In den beghinne sciep god / hemel ende aerde
('In the beginning God created the heaven and the earth').
LTK 232, fol. 2v, detail.

This bible translation from the southern Netherlands consists primarily of the historical and narrative books from the Old Testament; the New Testament is entirely absent. The majority of the manuscripts with this translation that have survived contain only certain books of the Bible, with the selection most probably depending on the wishes of the purchasers or owners. That applies for LTK 232 as well. In it, we have Genesis, Exodus, Leviticus, Numbers, Deuteronomy (collectively known as the Pentateuch), Joshua, Judges, Ruth, 1–4 Kings, the Prayer of Manasses, Ezekiel (part), Habakkuk (part), Ezra (part), Job (possibly an independent version), Tobit, Daniel (part; possibly an independent version), Lamentations (part), Judith and Esther. In addition, LTK 232 contains a commentary on the Pentateuch after Deuteronomy that is derived from the *Historia scholastica* — a retelling of the historical books of the Bible by Petrus Comestor (c. 1100–1179) — and the book of Jonah after Daniel, of which the original translation has not yet been identified. This selective character, with only some of the books of the Bible included, and some of those only in part and/or translated by third parties, is typical of Middle Dutch biblical manuscripts, which were often produced to order.

LTK 232 was actually copied in the Northern Netherlands somewhere in the second half of the fifteenth century, as are most of the surviving manuscripts with parts of the Southern Netherlands History Bible. The text has been written on paper quires with two parchment leaves inserted, bound together in a later binding. The first insert is right at the front,

Dit is die tafel van desen boecke na der texte die een weynich scolastica hystorie heeft. en̄ heeft dese naghescreue boeke

Inde eerste Moyses vijf boeke daerme̅ teerste va̅ hiet genesis en̄ heeft L. capit̅le. dat beghint va̅ adam en̄ eua sijn wijf en̄ sijn kinder̅ opt eerste blat daer⸝t staet.

Hier staet in va̅ noe en̄ hoe hij die arke makede en̄ beghint opt vijfste blat.

Hoe dat abraha̅ wt sine̅ lande ghinc en̄ beghint daer va̅ staet opt achte blat.

Hoe dat Jacop ghebenedijt wert va̅ ysaac sine̅ vader. opt xvi. blat.

Hoe dat joseph in egipte vcoft wart van sij̅ broder̅ op dat xxiij. blat.

Dat anderde boec hiet exodus en̄ heeft xl. capittele en̄ beghi̅t opt xxxiiij. blat.

Dat derde boec hiet leuiticus dat heeft xxvij capittele en̄ beghi̅t opt. liij. blat.

Dat vierde boec dat numerus hiet heeft xxxvi capittele en̄ beghint opt lxxi.

Dat vijfste boec dat deuteronomiu̅ hiet heeft xxxiiij capittele en̄ beghit opt xcvi.

Hier na staet dat boec iosue en̄ heeft xxiiij capittele .t beghint opt cxxi blat.

Daer na dat boec dat Judicu̅ hiet he⸝ uet xxi cap̅ en̄ beghint opt cxxxv. blat.

Daer na beghint ruths boec en̄ heeft iiij capittele opt. cl. blat.

Hier na beghint der conighe̅ vier boeke̅ die regu̅ hiete̅ daer teerste va̅ is hoe saul regnerde en̄ heeft xxx capittele en̄ beghi̅t opt clij. blat.

Dat anderde boec d' coni̅ghe heeft xxiiij capittele en̄ is hoe dat dauid regnier⸝ de en̄ het beghi̅t opt clxxi. blat.

Dat derde boec d' coni̅ghe heeft xxij cap̅. en̄ is va̅ salomo̅ en̄ va̅ sij̅ soen en̄ voert va̅ die coni̅ghe va̅ iuda en̄ isr̅l. en̄ t beghi̅t opt clxxvij blat.

Dat vierde boec heeft xxv capittele en̄ is va̅ de coni̅ghe va̅ iuda en̄ va̅ ysr̅l. en̄ beghi̅t opt cvi. blat.

Hier na beghi̅t een deel va̅ die heilige ph̅eet ezechiel en̄ een deel va̅ abbacuc en̄ heeft iij cap̅ dit beghi̅t opt cxxxi.

Hier na een deel wt Jobs boec en̄ heeft xlij capittele en̄ beghit opt cxxxiiij.

Hier na beghi̅t tobias boec en̄ heeft xiiij capitele opt ccxlviij blat.

Daer na staet een deel wt daniels boec en̄ het beghit opt cc liij. blat.

Daer na is ionas en̄ die besaeyinge ye⸝emie ph̅eet en̄ beghi̅t opt. cclx.

Daer na Judiths boec heeft xvi cap̅ en̄ beghi̅t opt CClxij blat.

Hier na beghi̅t hesters boec mit xiiij capittele opt CClxix. blat.

Dit sijn die coni̅ghe die boue̅ al ysr̅l' regnierden.
Saul
Dauid — boue̅ al ysrahel.
Salomon

Dit sij die coni̅ghe̅ die boue̅ iuda en̄ be⸝ yami̅ regnerde̅ i̅ ih̅r̅m die hiete coni̅ge
Roboam
Abia
Asa
Josaphat
Jozam Othosias Abasias
Asarias Athalia die coni̅ghi̅ne
Joas Amasias
Osias Asarias — va̅ Juda
Joathan Achas
Esechias Manasses
Amon Josias
Joathas Eliachim Joachim
Jechonias Joachim
Sedechias

Dit ware die coni̅ghe va̅ ysrahel
Jeroboam
Nabach Beasa
Hela Gambri
Amri Achab
Othosias
Jozam Jeu — va̅ ysrahel
Joas Joathas Joath
Jeroboam
Sacharias
Sellum
Manahen
Phareya
Phacee
Osee

NED. LETTERK.

Fig. 3
The transition in folio numbering from fol. 117 to fol. 119, with the extra vertical line in the 'C' on fol. 119. LTK 232, fols 117r and 119r, details.

containing a table of contents. The second insert is between fols 232 and 233, containing a portion of the Book of Ezra. The variety of hands, types of material and page numberings as well as the table of contents in LTK 232 raise the suspicion that the manuscript we have here was a growing compilation, a work in progress: a manuscript for which the maker kept copying new texts that could then be merged in later.

The manuscript consists of three main components with matching delimitation of the texts and the quires (codicological units). Those are the books of the Bible from Genesis to Deuteronomy (fols 2–117v, the original fol. 1 and fol. 118 are missing and fols 119–120v were initially blank), Joshua to Ezekiel (fols 121–232v) and Job to Esther (fols 233–275v). These texts were all written in the same hand (A), i.e. by the same single scribe. The key reason for supposing that these components were collated at a later moment is a transition in the folio numbering as it goes from 117 to 119 (as 118 is missing). The folio numbers are written more loosely at first, but in a more precise hand from fol. 119 onwards; the extra vertical line in the 'C' (standing for 100) is particularly noticeable. Moreover, they are positioned slightly differently from that point on, a little bit further to the right (see Fig. 3).

The content and the folio numbering of the above-mentioned main components match the table of contents on the first parchment insert, which is written in a different hand (C). It also contains a list of the kings of Israel and Judah, by no means unusual in a Southern Netherlands History Bible. The table of contents also lists *een deel va(n) abbacuc* ('part of the Book of Habakkuk'), which starts after Ezekiel on fol. 232v. This is an addition, written in a different hand (B) than the components mentioned above. To make everything fit, the scribe had to write in smaller and smaller letters near the end of this insert (see Fig. 4).

Not listed in the table of contents but present in the manuscript nevertheless are the commentary on the Pentateuch and the excerpt from Ezra. Both these texts were written by scribe B, who also copied Habakkuk. The commentary comes after Deuteronomy on fol. 117v and fol. 119r-v; these were originally blank leaves at the end of the first component (fol. 118 is missing and fol. 120 is still blank). Ezra is written on the second inserted folio of parchment, between fols 232 and 233.

Based on the various hands, folio numbers, material and table of contents, it is possible to come up with an idea of how LTK 232 must have grown. First, the section with the books from Genesis to Deuteronomy (fols 2–117v) was written by scribe A and foliated. The final leaves (fols 118–120) remained blank. Scribe A then wrote the books from Joshua to Ezekiel (fols 121–232v) and from Job through to Esther (fols 233–275v). These three components were placed together, with the folio numbering continuing from fol. 117 onwards in the

other two sections. After that, scribe B wrote Ezekiel at the back (on fol. 232v) and part of Habakkuk. This is presumably the point at which scribe C added the list of contents; all the texts they listed were then present.

But LTK 232 had not yet reached its final scope: at some point, its owner at the time wanted to add something more. The Book of Ezra — written on an inserted parchment leaf — is very clearly a later addition, again in the hand of scribe B. The commentary on the Pentateuch, also by scribe B, is located precisely at the transition of the folio numberings; this also could mean that this was probably only added after the collation of the three main components. Given that the text runs on from fol. 117v to fol. 119r, we can conclude that fol. 118 was deliberately removed, perhaps because of an error or mistake by the scribe. Alternatively, it could be a mistake by the rubricator, the person adding the red accents and details to improve the legibility, who then accidentally skipped 118 in the numbering.

The activities of scribe A (writing the three main components) would have taken place in a specific period and location. The same applies for scribe B (all the additional texts) and scribe C (table of contents), who seem to have kept making additions over the course of LTK 232's creation. It is however perfectly possible that all three scribes were active at around the same time and at the same location, working together on this 'growing manuscript'. The above is of course a purely hypothetical suggestion of how things went, but it gives a good impression of the complex origins of a Southern Netherlands History Bible.

— Mart van Duijn

Fig. 4
The addition of Habakkuk on fol. 132v with the second inserted leaf of parchment opposite it containing part of Ezra. LTK 232, fols 232v-232*r.

Restrained elegance for pious women

05 | *Leven ons heren*
Fifteenth century, c. 1470 — LTK 258

This 'typological' Life of Jesus written in Middle Dutch combines each of a series of events from the life of Christ with two stories from the Old Testament that were seen as presaging what happened in the Gospels. Hundreds of medieval Lives of Jesus have survived in Dutch but this is the only one to have this unusual setup. Its simple decoration — pen flourishing in pen and ink — offers clues allowing a more precise localisation and dating.

The *Leven ons heren* in this Leiden manuscript is unique among the hundreds of Middle Dutch manuscripts with a Life of Jesus that have survived. As was customary, the text was divided into chapters describing events from the life of Christ. The eighty-five chapters start with the Annunciation of the Birth of Christ and end with his Ascension, with the outpouring of the Holy Spirit at Pentecost as the final event. The text of the third chapter (fol. 20r) starts with the words from the Gospel of St Matthew:

> *Doe jhesus | geboren was | in beth |*
> *lehem judee in coninc | herodes daghen Sich |*
> *die coni(n)ghen quame(n) uut oest lant tot jheru |*
> *salem en(de) vraechden waer is hi die ghebo |*
> *ren is een coninc der joden.*

This is the story of the Three Kings (or Wise Men or Magi) who came from the east to worship the Christ Child. Many medieval texts of the Life of Jesus add explanations and further discussions taken from commentaries by church fathers and other religious writers to the extracts from the Bible. There are no such explanations in the Leiden manuscript. Instead, each Gospel story is followed by two passages from the Old Testament. In the case of the Adoration of the Magi (in which the three wise men worship the Christ Child), the two stories following it are those of the army commander Abner who visits King David (2 Sam. 3) and of the Queen of Sheba bringing gifts to King Solomon (1 Kings 10). Both events were seen in the Middle Ages as presaging the Adoration of the Magi. This way of showing the connections between the Old and New Testaments is termed 'typology' in theology; hence the *Leven ons heren* in the Leiden manuscript is also referred to as the 'Typological Life of Jesus'. Each chapter ends with a prayer.

The Leiden manuscript's layout is a one-off among Middle Dutch narrative versions of the Life of Jesus. The only similar typological Life of Jesus is currently in New York (Morgan Museum and Library, MS M.868). Its contents are more abridged, with only thirty-six chapters, to which six more chapters have been added about the death of the Virgin Mary. The chapters are similarly divided into three parts and the events that are included are broadly similar. However, there are big differences between the two manuscripts in their choice of words and spelling. Moreover, the three parts differ in length and structure. In the Leiden Life, the comparative stories from the Old Testament are extensive and clearly worded accounts, with the book of the Bible and chapter number given every time. In the New York manuscript, the two stories have often been merged to form a more general exposition in which the Old Testament events sometimes take up no more than a few lines. However, the biggest difference is that each of the forty-two chapters in the New York manuscript is illustrated with a full-page miniature. These illuminations are attributed to the Master of Peter Danielszoon, a book painter who was active in 's-Hertogenbosch in c. 1460. This luxurious design together with the rather superficial treatment of the text both suggest the manuscript would have been intended for a wealthy burgher living in or near 's-Hertogenbosch.

As regards the Leiden manuscript, both the handwriting and the decoration point to Haarlem as the place of

Fig. 1 >
Start of the text on the Three Kings from the Gospel of St Matthew, with penwork decoration around the first initial. Depiction of the Three Kings added in the margin.
LTK 258, fol. 20r.

den en ghenaecte the
richo der wandelbair
heit en der ghebreckic
licheit Dijn naem is
een licht al ons duster
nisse en is verlichten
de die donckerheit der
verouwender consci
en en brenctse tot tt
claren licht dijnre ken
nisse Hier om sellen
die ionghen en die
maechden die oude
mitten ionghen loue
den naem des here
want sijn naem alles
verhoghet is boue al
le namen die geloest
en ghebenedijt moet
wesen van allen cre
aturen die hi ghesca
pen heeft indi hemel
en inder aerden ind
eewicheit der ewicheit
Amen Vanden derte
den dach ons here hoe
die coninghen offerde
dat lant thu mathes
Doe Jhesus
ghebozen
was in beth

lehem indee in comt
herodes daghen Sich
die coninghen quame
vt oest lant tot theru
salem en vraechde
waer is hi die gebo
ren is een coninc der
ioden wi hebben sijn
sterre ghesien in oest
lant en sijn ghecome
mit gauen hem aen
te beden Doe dat die
coninc herodes hoorde
wort hi bedroeft en al
therusalem mit he
Ende vorgaderden
alle die princen der
priesteren en die scri
ben des volcs en ond
socht van hem waer
xpus gheboren waer
Di antwoorden hem
in bethlehem indee
want alsoe is gescre
uen vanden propheet
Ende du bethlehem
lant van iuda en sel
ste die minste niet we
sen in die veerstappie
van iuda want vut
di sal comen een harto

Fig. 2 Start of the text on the Healing of the Lepers from the Gospels of Luke and Matthew. The margin contains an angel bearing a banderole with the words *neminem odias* ('Thou shalt hate no one'). LTK 258, fol. 55v.

production. The text was written by a scribe who in 1469 also copied a *Bienboek* (Book of Bees), a Dutch translation of a moralistic treatise by Thomas of Cantimpré (1201–c. 1272) (now in The Hague, KB, Nationale Bibliotheek, 78 J 63). That manuscript was owned by the tertiary sisters in the convent of Saint Margaret in Haarlem. In fact, they very likely commissioned the book. The scribe's handwriting can be identified in the Leiden Life, so that manuscript must also date to around 1470 and would have come from Haarlem. Further confirmation of Haarlem as its place of origin is found in the penwork (decoration applied with a pen) at the start of the chapters and prayers.

Penwork decoration was a simple and cheap way of creating structure in a text. In most countries, this form of decoration played only a modest role alongside more prestigious painted decorations, but in the Northern Netherlands penwork developed into a decoration form in its own right with a wealth of motifs. Over time, regional variations evolved, which are a useful aid to modern researchers in determining the place and date of the creation of a manuscript. The penwork in the Leiden manuscript is in what is termed the 'multi-coloured U-bend/splinter' style, which developed in about 1470–1480 and can be placed in Haarlem (see Fig. 3). It is an ornamental style in which the geometric shapes and leaf motifs are drawn in red and purple with green highlights. While this decoration may seem restrained at first, that does not mean the book was a cheap production. The execution is just as carefully done as in a prayer book with painted illumination, as can be seen from the use of parchment as the material and the engagement of a professional scribe. Such well-crafted manuscripts with simple decorations were particularly popular with women who were members of the lower monastic orders, such as the tertiaries and canonesses regular. We can therefore be sure that the Leiden manuscript was intended for one such community.

Shortly after its completion, another visual aid was added to the text, namely five coloured drawings in the margins of the first few chapters. The depiction of the Three Kings is particularly unusual. A branch on the right extending along the text column sprouts three flower buds, from which three crowned figures emerge with their gifts. Further on, another eleven coloured drawings have been placed at random points in the margins. They are angels and little men coming out of flower buds, or from birds, dragons and other creatures. Some of these figures hold banderoles with sayings in Latin, such as the angel pictured next to the story about healing a leper (see Fig. 2) bearing the text *neminem odias* ('Thou shalt hate no one'). The inclusion of sayings in Latin in a Dutch-language manuscript is surprising, but it was also a common practice in prayer books from the town of Delft.

— Anne Korteweg

Fig. 3
Start of the text on the Healing of a Blind Man from the Gospel of St John. Duplex initial with pen flourishing in the Haarlem 'multi-coloured U-bend/splinter' style. LTK 258, fol. 66v, detail.

PERSONAL DEVOTION

In medieval monasteries, day and night were punctuated by fixed moments of prayer, the so-called 'canonical hours'. Medieval monks and nuns would wake in the middle of the night to pray; they prayed again at dawn, throughout the day at three-hour intervals, again at sunset and once more before bed. Praying the Hours — or Divine Office, as this prayer cycle (based on the Psalter) was known — sanctified a life of tasks keyed to available daylight and the seasons. Segmenting sleep turned this most basic biological need into an outlet for piety. In the later Middle Ages, the tradition of praying the Hours (albeit in a reduced form) would become popular outside the monasteries, with many laypeople seeking the intercessory benefits that regular prayer and devotional practice promised — namely, the salvation of their souls and the souls of their loved ones.

To serve this need, Books of Hours, often richly decorated, were produced in vast numbers (see nos 6, 7 and 8; BPL 224, BPL 3774 and BPL 2747, respectively). These contained various cycles of psalms and other prayers, such as the popular Hours of the Virgin Mary, to be read at fixed moments during the day. Books of hours were often personalised at the point of production, although some were produced speculatively to match the demands of the growing market. Extra prayers to saints for whom the reader-owner had particular devotion could be added, and the manuscripts were usually augmented by illustrations or lavish penwork commissioned from the best artists the owner could afford.

Collections of devotional texts were used throughout the Middle Ages to encourage and deepen a reader's personal relationship with God, with certain combinations satisfying particular devotional needs (see nos 9 and 10; BPL 2473 and LTK 237, respectively). Readers often left other traces in these devotional miscellanies and in their Books of Hours. They annotated their liturgical calendars with dates of personal significance or inadvertently darkened the margins of their favoured prayers through repeated touching. Strikingly small — with the smallest in this cluster (no. 10, LTK 237) measuring less than 140 mm × 95 mm — these manuscripts were designed for purpose, with hand-sized page dimensions that encouraged private reading. They offer us a strikingly intimate glimpse into the spiritual lives of their medieval owners — what could be more precious to a reader than a book that offered a path to eternal salvation? (IO'D)

Personal devotion | Manuscripts, *from rear, left to right*:
BPL 2747 (no. 8), BPL 2473 (no. 9, *above*), BPL 3774 (no. 7, *below*) — LTK 237 (no. 10), BPL 224 (no. 6)

Deus in ad iutorium meum intende. Domine ad adiuuandum me festina. Gloria patri. Alleluia. Ymnus.

Memento salutis auctor, quod nostri quondam corporis, ex illibata virgine, nascendo formam sumpseris. Maria mater gratie, mater misericordie, tu nos ab hoste protege, et hora mortis suscipe. Gloria tibi domine, qui natus es de virgine, cum patre et sancto spiritu, in sempiterna secula. Amen.

Antiphona. Ipse inuocabit me. Dixerunt impii apud se non recte cogitantes: circumueniamus iustum: quoniam contrarius est operibus nostris.

By and for the hands of a noble nun

06 | Book of Hours belonging to 'ic Zaers'
Fifteenth century, c. 1440 — BPL 224

We know quite a lot about 'ic Zaers', the first owner of this Book of Hours, thanks to the dozen or so notes in the calendar. She copied the text herself with great dedication, and the pen-flourishes enhancing the larger initials may be by her hand too. The manuscript contains no fewer than 21 full-page illustrations, both monochrome and coloured, painted by the best book illuminators of her day.

Lijsbeth van Zaers, a nun in the convent of Mariënpoel, transcribed a book of hours for her personal use in around 1440. It consists of almost six hundred leaves of text in Latin and Dutch in a professional book script. In the calendar at the front, she wrote down the dates of death of family members and acquaintances (someone else subsequently recorded Lijsbeth's own date of death: 5 February 14[72]). Lijsbeth came from the noble Hainault family of 'De Sars' or 'Van Zaers', who had occupied leading positions in the government of the counties of Holland, Zeeland and Hainault since the fourteenth century. From his home in Sars (near Mons in Hainault, modern Belgium), her father Willem van Zaers used to travel on business to Leiden, Schoonhoven, Oudewater (where he may have had a property) and IJsselstein Castle. There were also personal connections between the noble families of Holland and Hainault: Lijsbeth's great-grandmother Beerte was from the IJsselstein family and her mother Johanna came from the manorial domain of Liesveld near Schoonhoven.

Those family connections may have played a role in Lijsbeth's choice of convent. According to the calendar, 'ic Zaers' took her eternal monastic vows on 19 May 1425. However, Mariënpoel did not yet exist. The nuns lived in the Elfduizend Maagden convent in Oudewater, which had adopted a stricter regime (the Rule of St Augustine) in 1422. Lijsbeth would have entered the convent not long afterwards as a novice, to profess her vows after a probationary year. The convent in Oudewater had a library and we know that the nuns themselves copied books. But then came years of political unrest and war, with the nuns therefore moving to Leiden in March 1428, followed one month later by their livestock and other possessions. After several years, they found a new home in Mariënpoel in Oegstgeest, near Leiden. The Van Zaers family was the main benefactor of the new convent after the Van Swieten family, who took the lead in its foundation. In 1436, Willem van Zaers was buried there so that the nuns could pray for his soul.

< Fig. 1
Opening leaves of None in the Hours of the Virgin, in Latin, illustrated with a grisaille of the Adoration of the Magi. BPL 224, fols 82v-83r.

Fig. 2
Illuminated initial with pen-flourishes for the Mass of Christmas Eve in the Missal of Loenersloot Castle. BPL 2879, fol. 7r, detail.

The decoration of the Book of Hours reflects the dual nature of the roots of the Mariënpoel convent and its residents. That is evident first of all from the penwork initials decorated with pen flourishing. These initial letters taking up three to four rows of text are embellished with flourishes consisting of red and blue pen lines, with attractive patterns continuing into the margins. The penwork has been created according to a specific pattern, with two motifs standing out. Next to the red letter 'M' on lines 7–8 in Figure 1, we see what is termed a 'mouchette': a bent droplet shape created from a line curving twice that ends with a small tail. Underneath is a sharp-angled line that first forms a triangle and then continues in stacked lines with a small garland on top. This last motif is then repeated in the opposite direction inside the triangle. The strict sequence in which these motifs are found in this Book of Hours does not have an exact equivalent in other manuscripts. The stacked lines ending in a garland were characteristic of manuscripts from the province of South Holland and Leiden in particular until long into the fifteenth century. The mouchettes are less common. They occur in penwork from Gouda and the surrounding area, where the pointed triangular motif is also seen. When such triangles appear in manuscripts from places further to the west, they often have a very small circle or 'eye' inside. An example is seen in a missal copied in 1438 by another Mariënpoel nun, Elizabeth van Gorinchem, for the chapel of Loenersloot Castle, which belonged to the Van Swieten family (Leiden University Library, BPL 2879, fol. 7r). Underneath the triangle with its eye, we see a simpler version of the characteristic triangle motif in Lijsbeth's manuscript. The Zaers Hours, moreover, contains simpler versions of the geometric fill of the gold initial letter of the Missal. Along with the fact that the leaves with text do not have any painted decoration at all, it could mean that both the copying and the penwork took place within the walls of the Mariënpoel convent. At any rate, the pen flourishing was executed by someone with just as steady a hand as Lijsbeth had in transcribing the text.

Fig. 3
The Flagellation of Christ, by the Master of Catherine of Cleves, to illustrate a Passion devotion in Dutch. BPL 224, fols 128v-129r (terce).

94

The miniatures, however, were done elsewhere: the coloured images came from Utrecht and the monochrome ones from Delft. The latter are called grisailles because the illustrations are built up from shades of grey with just an occasional touch of gold or colour. The grisailles accompany the Latin texts of the Hours of the Virgin. They show the life of Mary and Christ's childhood in seven key events, such as the visit of the Three Wise Men who came bearing gifts for the infant Jesus. This series was probably bought as finished work, as the pictures are significantly smaller than the blocks of text on the facing pages. Grisailles from Delft were quite often delivered on loose leaves. However, it seems some of the other grisailles were made specifically for this Book of Hours as they do have the appropriate dimensions. That applies for example to the depictions of the Virgin and Child, the patroness of Mariënpoel, and of St John the Evangelist, St Jerome and St Augustine, to whom altars were dedicated in the convent chapel. The colour miniatures, which include the Flagellation of Christ, illustrate a devotion on the Passion of Christ in Dutch. This series does not seem to have been made specifically for the Zaers Hours either. The lively illustrations have been allocated appropriately to the various sections of text.

Like the penwork, the miniatures also bear witness to Mariënpoel's network, which extended across all of South Holland and into Utrecht. The Passion series is by the Master of Catherine of Cleves, who was active in Utrecht. For Oudewater and surroundings, that was the most obvious place from which to order miniatures. The grisailles are the work of a book illuminator who is known as the Master of the Delft Grisailles after the town where his workshop was situated. This was the closest centre to Leiden for miniatures. Lijsbeth's Book of Hours thus combines the world of the convent with the wider world outside. The miniatures were among the best available in 1440 and worthy of a noble nun. At the same time, copying books with religious content was seen as spiritual work. Lijsbeth may also have executed the penwork herself, using models she had become familiar with in Oudewater. The subdued tints of the grisailles did not distract too much during the communal prayers in the convent chapel, where the other nuns were also present. When alone in personal prayer, Lijsbeth would be able to lose herself in the splendid details and the dramatic events depicted in the colour illustrations.

— Anne Margreet As-Vijvers

Fig. 4
St John the Evangelist, the patron saint of the middle altar in front of the choir screen in the convent chapel of Mariënpoel, blessing the poisoned chalice; John the Baptist pointing to the Lamb of God (i.e. Christ).
BPL 224, fol. 204v.

Book production as an international business

07 | Latin Book of Hours intended for the English market
Fifteenth century, c. 1420–1440 — BPL 3774

Late medieval book production in Bruges was an international operation. The city drew craftsmen from all over Europe, such as parchment makers, scribes and miniaturists. They produced manuscripts not only for the local market but also for export to other regions and countries. This Book of Hours was made to be used in England. A variety of craftsmen worked on it, at least one of whom came from Utrecht.

Bruges was one of the most prosperous cities in Europe in the early fifteenth century, largely thanks to trade and the manufacture of luxury items. Opulent products such as sculptures, tapestries and manuscripts were made there, both for the local middle class and for export to Italy, France, England and elsewhere. Commercial book producers worked mostly in the streets around the church of St Donatian, not making complete manuscripts but instead each specialising in a single aspect of the process, such as making parchment, copying or illustrating. There were also *librariërs* (book merchants) who acted as the middlemen between the craftsmen and the clients. They took on commissions, partitioned and allocated the work and made sure that all the partial products were combined to create a single manuscript.

This working method can be seen in BPL 3774. The manuscript is a book of hours, containing prayers and subdivided according to the hours of the day. It was intended for the private devotions of lay people. A book of hours always contains a calendar with the saints' and church's feast days, the Hours of the Virgin, penitential psalms and an Office of the Dead. The textual content could however vary from one bishopric to the next, for instance because different saints were revered locally. This Book of Hours follows the liturgical texts of the bishopric of Salisbury in southern England, which was used throughout the British Isles.

The layout of the manuscript and the decoration style suggest Bruges as the most likely production site. The miniatures have been produced on separate leaves, the reverse sides of which have been left blank. That was a pragmatic approach as it meant that the miniaturist did not have to wait until the scribe had finished his task and both were able to keep on working at their own pace, as long as good agreements were made about the sizes and page layout.

The decorations around the edges of the miniatures and in the margins surrounding the texts vary in style, as can be seen in the openings of pages 46–47, shown here. The texts are decorated with linework that extends into golden leaves and simple multi-coloured floral motifs. The linework around the miniatures only contains green leaves and the floral motifs have been drawn just using red and blue. The fact that both these marginal decorations also occur independently in other manuscripts from Bruges suggests that decorating the margins was another specialist field.

The miniature shown here is of the Flagellation of Christ, illustrating one of the Hours of the Virgin. The miniatures were made by a group of illuminators known under the collective name of the Masters of Otto van Moerdrecht. This was not so much a workshop as a style that had its roots in Utrecht and that can also be found outside that city in manuscripts that were illustrated in Brabant, the IJssel region, Gelre and Flanders. The miniatures in BPL 3774 are stylistically most closely related to those produced in the city of Utrecht. Miniatures by the Flemish branch of this group of illuminators have so far been found in more than twenty books of hours. Because there is still a great deal of uncertainty about the number of workshops in the Northern and Southern Netherlands and the relationships between them, we refer to them in general as the Moerdrecht Masters.

< Fig. 1
Opening showing the Flagellation of Christ, for terce prayers in the Hours of the Virgin.
BPL 3774, pp. 46–47.

Fig. 2
Christ appearing before Pilate. A Bruges stamp in the top right corner of the loose miniature (with a cut-way Gothic b) as authentication of it being a local product. Fifteenth century, c. 1427–1436. BPL 3026, detail.

One of the reasons for assuming an Utrecht provenance is the presence of stamps on a large number of the miniatures in manuscripts from Bruges. These are related to a decree issued by the authorities in Bruges in 1427 after a conflict between the *librariërs* and the illustrators. The former were accused of preventing the latter from making a living by importing loose miniatures from Utrecht and binding them into books of hours. The Bruges city authorities therefore decided that only locally produced miniatures could be used. As a proof of provenance, such miniatures henceforth had to be certified using a registered stamp.

The miniatures in BPL 3774 do not bear any such proofing marks pursuant to this decree. Leiden University Library does however possess a loose miniature by the Moerdrecht Masters that also has a marginal decoration in the Bruges style and that does have a stamp. This is another Passion scene, this time of Christ appearing before Pilate (see Fig. 3). A vague red circle can be seen in the margin at the top right corner, with a cut-away Gothic 'b' inside it (see Fig. 2). This stamp regularly appears among the Flemish Moerdrecht Masters. There are miniatures with a Gothic 'b' and with a Gothic 'i', both in closely related styles.

Several manuscripts from Bruges are known with stamped miniatures, with the stamp comprising a red or dark brown circle with a cut-away letter or symbol inside. The symbols include a lily, a clover leaf and a lion. However, there are far more miniatures with a stamped 'b' or 'i': fifteen manuscripts are known to date, plus several loose folios. At the same time, not all miniatures produced in Bruges in that period bear stamps. The archived document describing the decree is so brief that it is difficult to form a clear picture of how the decree would have worked. Could anybody use a stamp, or did you have to be affiliated to the illustrator's guild for that? Was the stamp for a particular individual? And did the miniaturists apply it themselves, or was that a task for the city authorities? What happened to miniatures without a stamp?

As a result, we do not know for certain whether the presence of the stamps means that the Moerdrecht Masters lived and worked in Bruges on a permanent basis. It is possible that their Utrecht origins made people suspicious of them, which could explain the large number of stamps. There would undoubtedly have been good reasons for that city being named explicitly in the decree.

The Book of Hours has not withstood the rigours of time very well. Although you can never be certain with miniatures that have been added on separate folios, it does seem as if a number were removed at some point. Before page 87, where the text of the penitential psalms begins, you would have expected a miniature of the Last Judgement, but this is missing. The Office of the Dead does not contain a miniature (or at least not any more) and the cycle of Passion scenes in the Hours of the Virgin is incomplete. The miniatures must have been lost in the eighteenth century, when the manuscript was kept in the library of the earls of Devon; that is where it was given page numbering and a list of contents, but most of the missing miniatures were taken out before the numbering was done. The Book of Hours was given a new binding then too. The flyleaves that were used for this bear the watermark *L V Gerrevink*, the name of a Dutch papermaking family. That shows that international networks were commonplace in book production in the eighteenth century as well. This paper mill is known to have relied heavily on the English market.

— Saskia van Bergen

Fig. 3
Christ appearing before Pilate. Separate miniature. Fifteenth century, c. 1427–1436. BPL 3026.

KL Januarius habet xxxi Dies
Dies mari xxx
Iaris habet

Octaue sancti Stephani
Octaue sancti Iohannis
Octaue sanctorum innocentum
Vigilia
Epyphanie domini
Hylarius episcopi

Pouletz toute iceulx
Octaue Epyphanie
Donnan martiau
Sanne en ce
Marcellus papa et mar
Anthonius monachus et conf.

Up to date

08 | Book of Hours with calendar and colophon
Fifteenth century, 1498–1499 — BPL 2747

Dated and localised manuscripts are extremely important in historical research. They help give a picture of when and where a text has been handed down, or of the development and spread of certain characteristics of a script or style of illumination. Moreover, they can be used as yardsticks against which scholars can measure and compare manuscripts that have not yet been dated or localised (the vast majority, in other words) but do exhibit similarities.

The Middle Dutch Book of Hours of Aef van Bolgerien is one such yardstick. All the questions about its production — who, what, where, when and how — are answered in the colophon on the final page:

Dit getijboeck hoirt toe der eerbare | vrouwe(n) Aef va(n) bolgerien wonende | In die beverwijck. Ende heeft gescre- | ven doer een bril broeder Gherijt va(n) | Castrinchem regulier in die bever | wijck in sijn vier en(de) tsestichste jaer. | Int Jaer ons heren dusent vierhon | dert acht ende tnegentich. van o(n)ser | vrouwen nativitas of tot die ad- | vent toe. God si geloeft. Amen (fol. 203v).

'This Book of Hours belongs to the noble lady Aef van Bolgerien, who lives in Beverwijk. Brother Gherijt van Castrinchem, a canon regular in (the monastery of Sion in) Beverwijk, aged 64, has written it with the aid of a pair of spectacles. In the year of Our Lord 1498, from the Nativity of Mary to Advent. God be praised. Amen.'

There was a monastery of canons regular in the town of Beverwijk near Haarlem, Onze Lieve Vrouwe in Sion. Gerrit van Castricum was one of the canons there. In addition to the daily choral prayers of the Divine Office, his tasks also included copying books. He wrote this Book of Hours in 1498, at the age of 64, when he was also the proud owner of a pair of spectacles. He would have done so on commission, paid for by the *eerbare vrouwe* ('noble lady') Aef van Bolgerien. She lived in Beverwijk; hence the inclusion of a prayer to Saint Agatha, 'our patroness' (fol. 201r), because the parish church there was dedicated to that particular martyr. Brother Gerrit also stated that he wrote it in the period between the feast day of the Nativity of the Virgin Mary and the start of Advent. How long did it take to copy? You can answer that question using the calendar at the start of the manuscript.

Even those who are unfamiliar with an ecclesiastical calendar will find *Maria-Geboorte* (Birth of Mary) on 8 September, after a bit of browsing. That gives us the starting date for the writing. But how can we find out when Advent begins? This preparatory period before Christmas started on the fourth Sunday before 25

< Fig. 1
Calendar opening with calculation circles for working out the Golden Number and dominical letter, also showing the start of January.
BPL 2747, fols 2v–3r.

Fig. 2
Colophon written by the scribe Gherijt van Castrinchem (Gerrit van Castricum).
BPL 2747, fol. 203v, detail.

December 1498. The days of the week are not present in this calendar, and neither is 1498. Books of hours and liturgical books, with their prayers for the weekdays, Sundays and feast days of the church year, instead contain what is known as a 'perpetual' calendar. Time for a small diversion into calendrical arithmetic…

A solar year is a little longer than 365 days (which is 52 weeks plus one day). In the calendar of the Middle Ages, the annual remainder of almost six hours was dealt with by counting 24 February twice in a leap year. Because of these two irregularities, the days of the week shift every year, in such a way that a cycle of 28 years (4 x 7) is needed before all the days of the week start repeating on exactly the same days of the month. That is why the days of the week are only indicated indirectly in this calendar, in an abstract form using the letters A to G in a separate column. Books of hours often present the years of this cycle in a circle of 28 'dominical letters' for the Sundays, in a reverse alphabetic sequence. The seven leap years in this sequence have two letters, the first for the Sundays through to 24 February and the second for the Sundays thereafter. Once the dominical letter is known, for example a B, all calendar days in that year that are shown as a B will be Sundays and all the Cs will be Mondays, Ds are Tuesdays, and so forth. The calendar at the front of a book of hours thus remains usable year after year.

Gerrit van Castricum has oriented the sequence of letters in the lower circle on folio 2v by linking the years 1499 (*xcix*) and 1500 (*v.*c), which was a leap year, to letter codes F and ED. For 1498, you go back two steps to the left and get the dominical letter G. That means that in 1498, all the Gs were Sundays. The first Sunday of Advent was therefore the fourth G before 25 December, which was 2 December. So that tells us that Brother Gerrit van Castricum was busy creating this Book of Hours from 8 September to 2 December. He copied four hundred

Fig. 3
Calendar opening with March; the first full moons after 21 March are indicated in red in the outer margin for some of the nineteen solar years.
BPL 2747, fols 4v–5r.

Fig. 4
Painted decorations with date and signature of the illuminator: *Sp(ier)i(n)c 1499*.
BPL 2747, fol. 42r, detail.

leaves in twelve weeks, an average of a little more than four and a half leaves per day. Maybe three to four hours of writing per day? Perhaps rather more than that if he was not expected to pick up his pen on Sundays and feast days. A serious effort, however you want to look at it.

Fol. 2v also contains a second circle, with a series of numbers I–XIX plus the explanation *Hier vint | men dat gul | den ghetal*. The Golden Numbers I to XIX are each noted twelve or thirteen times a year in the calendar in a separate column, before the column with the dominical letters. This is because it takes nineteen solar years for the phases of the moon (new, first quarter, full and last quarter) to recur on the same days of the year. The calendar numbers state which days the new moon falls on (i.e. when it is not visible) for each of the solar year patterns I to XIX. Using this Golden Number, it was possible to determine the date of Easter, the key Christian festival when the Church remembers and celebrates Christ rising from the dead. Since the ninth century, the Roman Catholic Church has celebrated Easter on the Sunday after the first full moon after 21 March, the first day of spring. This circle gives solar year XIX for the year 1500 (*Mv.ᶜ*). For Easter in 1499 (the first year after Gerrit copied this Book of Hours), go one step anticlockwise in each of the circles, which gives the Golden Number as XVIII and the dominical letter as F. The first new moon in the spring month of solar year XVIII is on 16 March. There is a full moon thirteen days later, on 29 March. The first Sunday after that (an F-day in 1499) is then Easter, i.e. 31 March. Brother Gerrit has incidentally annotated all nineteen full moons for Easter between 21 March and 25 April in red in the outer margin — a handy addition.

It is likely that Aef van Bolgerien only received her Book of Hours after Easter 1499, after someone had added the painted illustrations in a separate working process. This illuminator has signed and dated his work on various leaves, e.g. fol. 42r where decorations have been applied to mark the time of Vespers in the Hours of the Virgin Mary. In the bottom margin, it says *Sp(ier)i(n)c* and *1499*. Spierinc illuminated at least seventeen manuscripts in northern Holland between about 1485 and 1519, almost always signing and dating his work. Can he be identified as the Sybrant Spierinc who according to archive sources was the prior of the monastery of Sion in 1511 and 1519? And is that the same person as the Brother Sybrant who was the subprior there in 1498? Sadly, that has to remain speculation.

— André Bouwman



A *manual for the higher spheres*

09 | Collection of devotional and ascetic texts
Fifteenth century, last quarter — BPL 2473

With more than six hundred leaves of devout comments, poems, miracles involving the Virgin Mary, sermons, reflections, letters and advice, this manuscript is a classic example of the range of late-medieval religious literature. It is an unusual compilation, not just because of its format — it is both unusually small and thick — but also because of the illustrations that have been added and stuck on its leaves. This raises the question of what the compiler's intentions were.

From the opening miniature onwards (fol. 2v), the religious life of women is to the foreground of this thick manuscript. Two women — a nun and a laywoman — are kneeling and offering white lilies to Jesus, flowers that symbolise their purity. The nun proffers a bunch of lilies but the woman in secular clothing only has the one flower. Their words as given in the banderoles also testify to differing ambitions. The nun opts for complete surrender: *Ic offer u heer been en(de) merch / Dat is gherey ende erf* ('I offer You, Lord, bones and marrow [i.e. everything I have], all my possessions and birthright'). The laywoman is mainly asking for assistance: *Here sterket mine(n) goede(n) opsat / ende nemet dese vrucht uut desen va(t)* ('Lord, give strength to my good intentions and accept the fruit from this chalice'). Jesus has encouraging words for both of them: *Ic nemt al te dancke eest cropel ofte manc / alle die van goeden wille sijn.* ('I accept with thanks all those who are of good will, whether they be lame or crippled'). But it is clear that the nun's ambitions are preferred. This interpretation corresponds with the text that starts on the leaf opposite (fol. 3r), which largely consists of statements by ecclesiastical authors — the names *Sinte Ancelmus, Sinte Cypriae(n)* and *Sinte Ambrosi(us)* are underlined in red — confirming the importance of purity (*reynicheit*) as a monastic vow alongside those of poverty and obedience.

The opening text and images shed light on one of the recurring themes in the manuscript: purity as a fundamental virtue in monastic life, particularly for women. The longest text in the manuscript is introduced as *een boec vander edelre ende glorioser meechdelicheit ende reynicheit* (fol. 84r). It starts by claiming that while marriage is — or rather, can be — good, it is not nearly as good as chastity. The text continues with extensive praise of monastic purity. The paper quires with this text form the original core of the manuscript (both in terms of content and in terms of material) and also hint at its origins. After the reflections on purity, the scribe (whether this was a man remains to be determined) has copied texts from a *boexken van Berberendaele*, addressed to a *lieve gemynde suster*, undoubtedly a nun who has entered a convent, probably the Augustinian convent of Sint-Barbaradal (*Berberendaele*) in Tienen, near Louvain. It is clear the scribe was familiar with the region from the enthusiastic notes about Hakendover, an *uutvercoren stat* ('chosen town') according to generations of local residents. At the end of the manuscript, the scribe wrote down a legend about the foundation of the local

< Fig. 1
Extracts about the value of purity as a monastic virtue opposite a drawing of Jesus receiving lilies of chastity from a nun and a lady.
BPL 2473, fols 2v–3r.

Fig. 2
Hier beghint een / boec vand(er) edelre en(de) / glorioser meechde- / licheit en(de) reynich(eit): 'Here begins a book on the noble and glorious virginity and purity'.
BPL 2473, fol. 84r, detail.

church that matches, down to the smallest details, the picture in the fifteenth-century altarpiece that can still be admired in the church in Hakendover.

The manuscript has much more to offer than simply an elaboration on the themes presented in the first miniature. While monastic lessons do form the main component, the collection of texts for pastoral purposes is supplemented in the course of the book by items that primarily seem to reflect personal interests, such as the rules and customs of the Holy Rosary Brotherhood in Ghent in honour of the Virgin Mary. These texts have been copied onto separate quires that seem to have been added to the manuscript by the scribe and subsequently filled and extended with a long series of miracles associated with the Virgin Mary. Decorated capital letters (cut out of a choir book) that have been stuck on suggest the scribe was also interested in book illumination. His interest in medicine and the medical profession is apparent from the leaves added at the end with a poem on the four guises of the physician (in the eyes of his patient): God when the sick person is close to death, an angel when the doctor succeeds in curing the patient, a human when the patient is well again and the devil when the physician demands his fee. The trope of the doctor's four guises would become a popular theme in prints and paintings of later centuries; this manuscript presents us with the oldest known example of a written version.

This broad range of interests does not really help in elucidating the compiler's profile, although it does give us some information. Was it one of the Augustinian monks who were installed as a rector or confessor for the nuns of Sint-Barbaradal, or one of their assistants such as Gaspar Ofhuys (1456–1523), who worked for several years as an assistant (*socius*) of the rector in Sint-Barbaradal? Ofhuys started out as

Fig. 3
Short texts and poems about death.
BPL 2473, fols 4v–5r.

Fig. 4
A call for a spiritual life according to the examples given in this manuscript. BPL 2473, fol. 4r, upper half.

a physician (*infirmarius*) at the priory of Rooklooster (near Brussels), was known for his devotion to the Virgin Mary and worked for a while in the Saint Agnes convent in Ghent. After returning to Rooklooster, he worked on a chronicle in Latin that included a summary of the legend of Hakendover.

Whoever the creator may have been of this weighty but handy tome, he (or she) was certainly deeply aware of the ephemeral nature of things — literally from the start. After the leaves with the lily miniature, bound in later at the start, the manuscript opens with short verses and sayings about death. Fol. 4v has a small drawing of a coffin: O *mensche En | hoept in die | werelt niet zere | dit huysken blijft dy En(de) niet mere.* The statement is attributed to 'the wise man', which usually means the Biblical king Solomon, who is also supposed to have penned the rhyme that follows on the gate of death that everyone has to pass through, without ever being able to return to this life:

> **Noch seit die wise ma(n)** |
> *Doer die poer | te van der doot*
> *Moet men lijden ('gaan') | Dat es noet*
> *Het es swaer daer doer | te lijden*
> *Men en coempt niet weder | in desen tijden.*

'The wise man also said:
"You have to go through the gate of death.
That is inevitable.
It is difficult to go through it,
because you do not return to this life."'

The following leaves continue along the same lines with a *vermaninghe der doot* ('warning of death') that reminds readers directly of their mortality. Just to be sure the message gets across, the compiler of this manuscript has added a drawing of a skull. Fortunately, at this point there are still more than six hundred leaves left in which to explore all aspects of religious life... So this small and thick manuscript may initially have served as a personal *rapiarium*, a collection of notes, before subsequently being repurposed for use by multiple readers in a monastic library. The binding, which was partly revised, suggests that the manuscript was subsequently treated with care as a guide to more elevated spheres or — as the scribe put it in the instructions for the reader — (fol. 4r): *Wildi gheestelijc p(ro)fijt doe(n) soe pij(n)t u nae | te volghe(n) dat ghi hier i(n) leest* ('If you wish to benefit spiritually, make efforts to emulate what you read in this book').

— Geert Warnar

[Medieval Dutch manuscript page — text largely illegible at this resolution]

A *printed manuscript?*

10 | Compendium of spiritual texts
Sixteenth century, first half — LTK 237

From the mid-fifteenth century, a new method for reproducing texts became increasingly common alongside the method of writing by hand. This was printing texts using individual letters, cast in lead. The two production methods are found in one and the same volume in this book from the first half of the sixteenth century. The codex shows how manuscripts and printing led a symbiotic existence in the early sixteenth century, as well as giving a fascinating insight into religious life at the time.

The printing press is mainly associated with the early modern period but it was in fact a medieval invention that was initially used chiefly to print religious texts. Printed books evolved from the form that readers were already familiar with: that of the manuscript. Manuscripts and printed books not only continued to exist alongside one another, they also influenced and complemented one another. A fine example of that latter process is found in LTK 237, a 'manuscript' that encompasses no fewer than four printed documents from the late fifteenth and early sixteenth centuries. This codex does not fit neatly with our modern idea of a book: it does not consist of a single medium, nor of a single edition, unlike the print books on our shelves today.

The codex in its current form presents itself primarily as a manuscript. The first seventy leaves are handwritten and contain prayers to the Virgin Mary (including ones about the seven most joyful moments in her life), Passion prayers, treatises (including a sermon on the Song of Solomon by Bernard of Clairvaux, c. 1090–1153), prayers for during Communion, prayers to the guardian angel and prayers for the souls of deceased friends and relatives. On the final leaves of this section are penned prayers to Saint Bartholomew and Saint Francis of Assisi (1182–1226). The apostle Bartholomew is addressed as a special, chosen friend (fol. 68v: *Want ic di, o hiilighe apostel, uutvercoren hebbe tot enen sonderlinghen vrent, soe bidde ic di* [...]) and Francis as 'father', and also as a special friend (*uutvercoren vrient*). This form of address makes the prayers personal and is also an indication that the book might have originated in a Franciscan setting, possibly a community of men or women in the Third Order of Saint Francis.

The next section of this composite book starts on a new leaf (fol. 70r, see Fig. 2). This is a printed text. The introduction looks a lot like the rubric commonly found in manuscripts — there is no title page:

> ¶ *Item dit devoet boexken heeft een weerdich priester genae(m)t heer Bethlem bescreven die in dat heylighe lant va(n) beloften binnen die stadt va(n) Jherusalem menighe(n) tijt gewoent heeft. En(de) hi heeft alle die heylige plaetsen nauwe ghemeten en(de) bescreven daer onse lieve heere gheleden heeft om ons arme sondaren te verlossen van die ewighe doot*

'This devout text was written by a respected priest, Heer Bethlem, who had spent a long time in the Promised Land in Jerusalem. He had also carefully measured and compiled a description of all the holy places where Our Lord suffered to redeem us miserable sinners from eternal death.'

No further information is given on this Heer Bethlem, but he may have been a member of the order of Franciscans who traditionally guided pilgrims around Jerusalem.

After a blank line, which the rubricator has filled manually with a zigzag (if you look carefully, you can also see that the capital letters have been stroked with red ink), there is information about the indulgences that can be earned by walking the *Via Dolorosa*, the Way of the Cross. It was not necessary to undertake a lengthy

< Fig. 1
Final leaf of the *Alderprofitelicste oeffeninghe vanden XV bloetstortinghen ons liefs heren Ihesu Christi* (Antwerp: Henrick Eckert van Homberch, c. 1512) with the printer's colophon and the start of *Dat spiegel der monicken*.
LTK 237, fols 92v–93r.

Fig. 2
Final leaf of the first (handwritten) section, with prayers to Francis of Assisi and the start of Heer Bethlem's *Een devote meditacie op die passie ons liefs Heeren* (Leiden: Jan Seversz, after 1514).
LTK 237, fols 69v–70r.

journey to do this: anyone who 'meditates devoutly and with compassion' (*deuotelic ende met compassie mediteren*) on the holy sites will receive the indulgence as if they had visited the holy places in person. Heer Bethlem's little book made such a virtual pilgrimage possible. And given the number of print editions — more than thirty in the first half of the sixteenth century — it was clearly incredibly popular. The copy included in LTK 237 is a Leiden imprint by Jan Seversz. Woodcuts show the places to be visited on the Way of the Cross, with an indication of the distances. For example, after falling under the weight of the cross for the first time, Jesus covered 23 ells (nearly 16 metres) to the *stede des swickbooms* (the place of the thorn bush), where two marble stones lay (see Fig. 3). On one of these stones, he was undressed by the soldiers, which caused his wounds to burst open again. The other stone was where he was shown to the people by Pontius Pilate (*Ecce homo*). The rubricator has used red lines to depict the blood flowing from Christ's wounds.

Heer Bethlem's text let the reader follow Jesus's path up to Mount Calvary. The final stations of the Cross are missing in the copy included in this codex. Instead, the book switches to another popular text, this time about the fifteen times when Christ spilled his blood (fol. 84r). This print is also incomplete. It starts with the thirteenth 'effusion of blood', whereby the text — with a prayer to Christ on the cross — neatly joins up with where the Leiden print left off. It is possible that whoever created the composite book had two incomplete copies and sought to create a new whole by combining them. The second print concludes with a series of prayers to the Virgin Mary and a brief colophon giving the identity of the printer: ¶ *Gheprent Tantwerpen. bi mi Henric eckert va(n) Homberch* (see Fig. 1).

The leaf opposite is the start of *Dat spiegel der monicken*, here under the title *dat spieghel d(er) menscheit*, on a parchment folio. The parchment has shrunk and distorted somewhat, making the leaf appear crumpled. The text is a translation of the first book of *Profectus*

religiosorum by the Franciscan David of Augsburg (late twelfth century–1272), offering practical instructions on life in a religious community. Under the heading *Vander dormiter* ('About the dormitory', fols 103v–104v), for example, readers are urged to turn their thoughts immediately to God on waking. They should sleep in both clothes and underclothes to supress desires of the flesh and to be prepared at all times for liturgical prayer.

This codex essentially contains a collection of books that initially would have been separate or have functioned in a different context. Here they have been brought together, in what seems to be a carefully considered sequence given the parallels in their content. This may have happened at some point in the first half of the sixteenth century in a religious or semi-religious setting. Such composite books in which manuscripts and print copies led a symbiotic existence — often termed 'hybrid' — were frequently taken apart at a later date, in part so that the manuscripts and print copies could be filed in the correct sections of the library. The book discussed here escaped that urge to order and classify, thereby offering us a unique insight into how manuscripts and print copies were combined in the early sixteenth century.

— Anna Dlabačová

Fig. 3
Jesus is undressed by soldiers and then shown to the people by Pontius Pilate in *Een devote meditacie op die passie ons liefs Heeren* (Leiden: Jan Seversz, after 1514). LTK 237, fols 77v–78r.

MAKERS AND MATERIALITY

When making a book by hand, the possibilities for customisation — whether of size, materials, script, decoration or binding — seem endless. However, makers of manuscripts had to manage their creative impulses within certain constraints. Their craftsmanship was limited by the materials to which they had access, while the presentation of a text was influenced, at least in part, by the anticipated needs of its reader. One important factor was the quality and character of the exemplar to which the scribe had access — the manuscript which served as model and source for the copied text. Combining content from various exemplars was a skilled art, as Leiden University's copy of the *Liber floridus* (no. 15, VLF 31), a medieval encyclopaedia, shows. Meanwhile, inexperienced or distracted scribes could inadvertently introduce errors into their copies (see no. 17, BPL 3469).

The requirements of prospective readers also influenced manuscript production. Although some books may appear scruffy to our eyes, not every reader needed their manuscript to be copied on high-quality materials. The notebooks of the eleventh-century scribe and schoolmaster Ademar of Chabannes (no. 13, VLO 15), for example, were written on small discoloured and hole-ridden sheets. A patron could save costs by commissioning a text to be copied by a professional scribe on lower-grade parchment (as was the case for no. 16, BPL 14 E). Scribes could also anticipate the abilities of their readers. One eleventh-century manuscript from southern Italy (no. 14, VLQ 1) was copied in two different scripts. Its scribes must have anticipated that its readers would not have been daunted by the variety of letter forms.

Producers and users of manuscripts managed access and affordability of materials at every turn. If a manuscript was damaged, it could be fixed. The wooden boards used to bind a ninth-century legal manuscript (no. 12, BPL 114; visible to the left of the image adjacent), for instance, were painstakingly repaired in the twelfth or thirteenth century. Even if the textual presentation of a manuscript became outdated, it could still be dismantled and its materials reused. One seventh-century manuscript, copied with minimal punctuation, was seemingly too difficult for later users to read, so its parchment was repurposed as protective flyleaves for another ninth-century manuscript (no. 11, BPL 221). Such interventions show that manuscript production was an open-ended process and are a testament to the skill and resourcefulness of medieval makers. (IO'D)

Makers and materiality | Manuscripts, *from rear, left to right*:
BPL 3469 (no. 17, *above*), VLF 31 (no. 15, *below*), BPL 21 (no. 11, *behind*), BPL 14 E (no. 16, *in front*) — BPL 114 (no. 12), VLO 15 (no. 13, *above*), VLQ 1 (no. 14, *below*)

migrauit a saeculo · uir in
omni sanctitate praecel
sus · abstinens uel acibis
uel ac[...]pis ce[...]ibear
nis · ualde elemosinari
us et cunctis humanus ·
in oratione et uigiliis sa
tis stabilis · ecclesiam
construxit · sed dum eam
ad emendationem sae
pius distruit in conposi
tam dereliquit · post
cuius obitum multi ut
fit episcopatum petiba[n]t ·
transobadus uero prbt·
qui quondam archidiac͞s·
eius fuerat maxime in hoc
intendibat · fidus quod
filium suum cum cocone
qui tunc reciserat nu
tricius commendauerat ·
condidtrat autem ep͞stes
tamentum in quo regis
exenium quid post eius
obitum acciperet indc͞
cabat · adiurans terribi
libus sacramentis ut in
ecclesia illa non ordina
ritur extraneus · non
cupidus · non conuge ali
uinculo nexus · sed his
[...]nibus expeditus qui in so
lis tantum d͞n͞i͞c͞i͞s laudibus
[...]ceba[...] uest[...]uerin[...]

transobadus autem pr
e[s]bit[er] um ipsa urbe cl
ricis praeparat · resed
tibus autem illis unus
praesbiter orum coep
antestitem memoratu
inpudicis blasphemare
sermonibus · et us q ad
erupit ut eam dele rum
fatuum nominaret · ha
co dicente · pincerna po
culum aduenit oblaturus
at ille acceptum dum ori
ximat tremiscere coepit · la
tum q demanu calicea
super alium quis ibi era
proximus caput reclin
reddidit sp͞m · ablatus q
a bepulo ad sepulchru
humo contectus est ·
post haec electe totestia
to antestitis · in praes
tia childeberthi regis ac
cerum eius · theodosiu
qui tunc arch diacona
urbis illius potiebatur
ordinatus est · ·

XLuiii audiens autem chilp̄c
omnia mala quae faci
leudastis ecclesiis to
nicis · uel omni popul

MYSTERIIS HUNC LIBRUM AMBROSIUS EPS DE GRECO IN LATINUM
INCIPIT PROLOGUS HEGESIPPI HISTORIOGRAF EXCIPIT HIE
ROSIMORUM · IN HOC CORPORE CONTINENTUR EGESIPPI HISTORIAE
LIBRI NUMERO QUINQUE

Quattuor libros regnorum quos scriptura complexa est sacra etiam biblis persecutus
capta urbe iudeorum · marique excidium ob babilonios triumphosque sublimem summamque con-
posui · Macchabeorum quoque res gestas prophetica serie paucis volumine · Et aliquo
iam usque ad incendium templi elimanibus truculentissimam pelagi · egregius historicos Iosephus egesippus iosephi
omnia religionum eluens meritis · quaereti in dignum asseri monuit sobrietati · Consona se-
cum prosaliter iudaeorum et amisso sermone exhibuit · quam deteriora supplicis manifestiorum · Ex quasi
rum deserere tamen nomen sacrilegi non deretiquit · Deplicatum flebilem aerumnam ser- IP
sus causam aerumnae non intelligere · Illi denim curae sunt · non ingenti ope sit quod fides
ac germano indulsitera iudaeorum ultra scripturae seriem sicut paulus per minima egere · et ea
quae spiritu sancto sequente sibi nec scripta impiorum facinora quaedam impietates pro soluta
sunt et David quae velde ouerentie sacrae legis vel de sacrae religionis constitutioni sunt expellente
miracula quae cum Iesus nec heredibus · vel in adversis obtinent strenui vel honore in prosperis
simul quod est indicium domesticae in gybernare · liqueat universi sit ad instituti per prius cladis
successores fuerit · Primum quod aliae curae nomine romanis in se conviae fuerint · Iudeos qui iam
regnis habebat an quibus ignorari satus sit · Sogner amorea · fidem non seruo-
turi · Prius violavere · iussae ce imparet · Postremo bella intulerit · quibus spes omnis in
moenibus et oppidorum obes · erat · cum tam in miserabile claudi obsidione · Quae sibere Miserabile claudi obsidione
propedia augere saepius quam minuere periculo solae · Aenequi uacuae fide et supple-
tum patrocinio suscepisse · ne potius ideo ut principes duces hebraeorum qui omne considere
in sibi religione clarorum uirorum famosis · inde quod ualiqua generationis eius successio cladica
utet in aero offendere · in principum serie sed mansserit · in eo cui reposita manebant
omnia · ipse erat spes generis · Hinc igitur summa excidium · EXCL PROLOGUS · INCI-
PIT LIBER PRIMUS · Bello pasthico quod inter macchabeos duces genusque medorum
tiranorum defrequentis varia e historia sunt inter scriptum · principium dedit sacrilegiocus de-
Antiochus seniorem · inlustris antiochi regis filius · ubi aegre prima quoque suo imperio
subiugatam insigibus et uris quod ab hostibus bellorum prosperus sentirent uit hebraeorum negle-
ta historica eorum prosancitum inserati · Id q postularat plerisque iudaeis · statuere
iussus quod saccum machabbaeus sacerdos per potentia nequivit · Nec solui ipse temperavit ac
collegis regulis · edicto non obseruare uni etiam immolante simulacris hostias
depopulari se fuo unam gladio transverberauit · Et cum gravem manum atque ali-
sete insolentiores ad sacra ipsam filius suis imminere · cum patrum eius parui legis

ὅς ἀλυκῶν · λυσ ενλυκῶν

The triumph of word spacing

11 | Carolingian codex with flyleaves in uncial script
Ninth century (last quarter) and seventh century (second half) — BPL 21

One of the most important developments in our writing practice is an early-medieval invention requiring no extra ink. It concerns an 'absence of meaning' that is strategically placed so as to clarify the meaning of the surrounding text. Our complex information-based society simply could not exist without the empty spaces that separate words from each other.

The improvement that word spacing made to the legibility of script is apparent in the opening pictured. On the left, we see the last verso of a double leaf that has been covered in writing. Here it is merely acting as a flyleaf, and it has been taken from a seventh-century manuscript that had been deemed redundant, a copy of the *Historia Francorum* by Gregory, bishop of Tours (c. 538–594). This history describes the conquest of Gaul by Clovis and the tumultuous times following his death in 511, when the kingdom was divided amongst his offspring. In this fragment, Gregory relates how numerous clerics were vying for the episcopal see that became vacant upon the death of Dalmatius, bishop of Rodez. In translation, but preserving its original presentation, the first lines of the column praise Dalmatius as a holy man and read as follows:

'HASLEFTTHISWORLD · A
MANEXCELLINGINALLVIR
TUES · MODERATEINHISTAS
TESANDWORLDLYPLEA
SURES · VERYGENEROUSA
NDGOODTOALL · INPRA
YERANDVIGILMOSTRES
OLUTE [...]'

<< Fig. 1
Left: Fragment of Gregory of Tours' *Historia Francorum*, in uncial script. Right: Start of *De Excidio Hierosolymitano*, written in Carolingian minuscule, and using *capitalis* for the majuscule letters. BPL 21, fols 2v–3r (image 72%).

The layout used for the flyleaf has been maintained here and this translation is difficult to read: the words are mostly juxtaposed without spaces, words that are split across lines are not marked as such and punctuation is sparse. In the academic edition by Rudolf Buchner, the Latin text is presented using a more familiar formatting: *migravit a saeculo, vir in omni sanctitate praecelsus, abstinens vel a cibis vel a concupiscentiis carnis, valde elymosinarius et cunctis humanus, in oratione et vigiliis satis stabilis.*

The northern French copyist of this work used a bookhand from Late Antiquity that is known as uncial (*uncialis*): the calligraphy of his letters uses verticals that hardly protrude above or below the ruled baseline of the text at all, and displays rounded shapes. He has written the majority of the words up against each other, a habit inherited from the Romans, for whom *scriptura continua* was the usual form of notation. Readers had to mumble along, collating the letters and syllables into words, the words and clauses into sentences, understanding and remembering all the elements as they did so. It was a difficult and slow process.

Whereas in Antiquity it had been the reader's task to separate out the uninterrupted sequence of letters into words and sentences, that task was gradually transferred to the scribe in the Middle Ages. The oldest known manuscripts with systematic word spacing were made in around 700 by Irish monks: their adoption of Christian beliefs meant that they intensively studied texts in a new (to them) foreign language, Latin. They found it to be extremely helpful when reading these texts to have small spaces between the words. Moreover, it let them read the texts more quickly, in greater numbers, and more easily in silence. This Irish invention was subsequently adopted in England (which was partly proselytised from Ireland) and later also in centres of writing on the continental mainland, after monks and missionaries brought their Insular writing traditions across from the British Isles. Many manuscripts were not fully spaced until the eleventh century; conjunctions and prepositions were often still stuck onto the next word. The Gregory fragment is in a transitional state too. The spaces with punctuation divide the text into blocks of letters; these

are easier to decode because they always begin and end with a word.

Opposite the Gregory fragment, on the right, is the beginning of *De Excidio Hierosolymitano*, a text about the Jewish Revolt (66–70 AD), that ended with the fall of Jerusalem and the destruction of its temple by the Roman legions. The historical text fills all fourteen quires of the manuscript and was copied in the final quarter of the ninth century, probably in north-eastern France. The script and layout are very different to the Saint Gregory fragment. The scribe has written in Carolingian minuscule, a regular script with letters that have ascenders and descenders and can be written quickly. This script was developed at the end of the eighth century in monasteries in northern France. All the major scriptoria of the mighty empire — which flourished culturally under Charlemagne (748–814) — were using this new script within just a few decades, not only for books but also for letters and charters. The first leaf of this text can therefore be read fluidly, not only because the scribe left spaces between most of the words but also because he consistently began each sentence with a larger letter borrowed from the majuscule scripts of Antiquity.

The calligraphy of the caption at the top is in Roman rustic capitals (*capitalis rustica*): INCIPIT PROLOGUS HEGESIPPI HISTORIOGRA\<PH\>I EXCIDII HIERO\<SO\>LIMORUM · IN HOC CORPORE CONTINENTUR EGESIPPI HISTORIAE LIBRI NUMERO QUINQUE ('Here begins the prologue of The destruction of Jerusalem by Hegesippus; this work contains Hegesippus' History in five books'). Rustic capitals and uncial had been used since the ninth century largely for emphasis, particularly for headings, initials and capital letters. Hegesippus is given in the heading as the author, but the authorship of this text is in reality a complex issue. Flavius Josephus — a Jewish priest who was himself involved in the revolt but collaborated with the Romans after he was taken prisoner — wrote this history in Greek, in seven books. A version in Latin in five books appeared in around 370. It was written from a Christian perspective. For example, the anonymous editor explains the disastrous outcome for the Jews as a punishment from God because they had not acknowledged Jesus as the Messiah and had allowed him to be crucified. In his prologue, he criticises Josephus for not having realised this. Many manuscripts ascribe the text to a certain Hegesippus, but it is unclear whether this refers to the author of the Greek work or the Latin rewrite. An interesting aspect of this Leiden manuscript is that someone has added in capital script above the title that a bishop Ambrose translated the book from the Greek: \<TR\>ANSTULIT HUNC LIBRU(M) AMBROSIUS EP(ISCOPU)S DE GRECO IN LATINU(M). Other manuscripts also ascribe the Latin version to the church father Ambrose of Milan (339–397), but that attribution is still being debated today.

A tenth-century *ex libris*, added to the last leaf, tells us that the codex was in the Abbey of Saint-Mesmin in Micy near Orleans: 'This book belongs to the Saint-Mesmin monastery of Micy. If anyone takes it from this place with the evil intent of not returning it, may he be cursed along with the traitors Judas, Annas and Caiphas.' That curse did not prevent a troop of Huguenots from plundering the monastery thoroughly in 1562. The manuscript later came into the possession of the French collector Paul Pétau (1568–1614), who placed his Greek motto in the lower margin of the first leaf: οἷς ἀτυχῶ λίαν εὐτυχῶ (*hois atychō lian eutychō*), or 'While unfortunate, I am very happy'. His son Alexandre (1610–1672) sold it in 1650 to Queen Christina of Sweden, through her librarian Isaac Vossius. It was later acquired by Vossius but he disposed of it again at an auction in Leiden in 1666, where it was purchased for the University Library.

— André Bouwman

Fig. 2 End of the fifth book of *De Excidio Hierosolymitano* with an ex libris of the monastery of Saint-Mesmin-Micy containing a book curse: HIC EST LIBER [S. MAXIMINI MICIACENSIS MO]NASTERII QUEM SI QUIS DE ISTO LOCO ALIQO INGENIO NON REDDITURUS ABSTRAXERIT CUM IUDA PRODITORE ANNA ET CAIPHA DAMNATIONEM ACCIPIAT. BPL 21, fol. 112v, detail.

Reversed, repurposed and recovered

12 | Codex with Carolingian panels in a Romanesque binding structure
c. 800 and twelfth or thirteenth century — BPL 114

Traces of use and repairs in the distant past show how manuscripts were used and valued. These material features also give us a glimpse of the repair practices at a given place and time. What materials were available and what techniques were known? What commercial choices could a bookbinder make? The traces in this codex, which includes a collection of model letters, bear exceptionally good witness to actions taken in the medieval period to prolong its useful life.

At the end of October 1987, Leiden University Library celebrated its quatercentenary with a major exhibition in the nearby National Museum of Antiquities, under the title *Goed gezien. Tien eeuwen wetenschap in handschrift en druk* ('Clearly Seen. Ten centuries of knowledge in manuscripts and in print'). In the run-up to that event, several of the manuscripts that were to be exhibited were restored by Sister Lucie Gimbrère (b. 1928). One of those manuscripts was BPL 114. The manuscript, which was copied in the Loire region around the year 800, possibly in Bourges, contains a collection of Roman law, the *Breviarium Alarici* (also known as the *Lex Romana Visigothorum*) plus a formulary of model letters and charters, the *Formulae Marculfi*. The exhibition displayed the portrait of the Emperor Theodosius II, ruler of the Eastern Empire, that is on fol. 17v. The age-old binding of the manuscript did not play a role during the exhibition. Nevertheless, it has an unusual tale to tell.

The leather cover of the wooden boards protecting BPL 114 was so badly damaged that woodworm holes could be seen in the wood. An old break, repaired with metal plates and pins, and the remains of cord, were also visible. On 7 April 1987, the manuscript was taken to the workshop at Onze Lieve Vrouwe Abbey in Oosterhout; correspondence shows that the requisite treatment had already been discussed in Leiden. Sister Lucie submitted a proposal for the restoration work to the curator at the time, Pieter Obbema, on 13 April and he approved it on 8 May. The proposal consisted of disassembling the manuscript, treating the parchment folios, re-stitching them and then replacing them in the old binding. The old leather cover would be given a supporting layer of new leather to fill in the gaps and to create the caps — the leather ends at the top and bottom of the spine — and endbands, 'as found'.

In the meantime, on 23 April Sister Lucie dismantled the manuscript, working with Janos Szirmai, a researcher into the physical aspects of medieval books. When the leather came loose, they discovered something unusual on the inside of the covering: the title of a different text, written down the length of its spine. The script, which can be dated to not before the eleventh century, shows that this leather was not the original Carolingian covering. Now that the wooden boards were exposed, they also revealed their secrets: they did turn out to be the original panels, with the laced-in cords of the Carolingian binding structure still present. To reuse them, the bookbinder had turned both boards round 180 degrees, so that the original spine

< Fig. 1
Right-hand board of the manuscript, without the covering. The Romanesque board lacing on the back and the old Carolingian board attachments at the fore-edge side are both visible, as are the metal plates mending the break in the wood. BPL 114 (image 87%).

Fig. 2
Interior of the leather cover (grain side) with old title on the spine (with *P A S T OR AL I S* still legible). BPL 114.

119

Fig. 3
Rear view of the manuscript, showing the lacing through the narrow edge of the wood, and the outside (the non-grain side of the leather) of the Romanesque board covering. BPL 114.

side with the Carolingian cord attachment ended up as the fore-edge side (but without turning them over, so that the inside and outside remained the same). The current binding structure was a Romanesque one, in which the bindings of white alum-tawed leather (onto which the quires were sewn using a technique known as linked supported sewing) were laced into the wood via the narrow side of the boards. This way of working occurs from the end of the eleventh century onwards and was used by bookbinders throughout the twelfth and thirteenth centuries. Two annotations (on fols 3 and 57r) make it probable that the manuscript was in the abbey of Saint-Remi in Reims at around the time of the Romanesque rebinding. It is therefore possible that the leather reused for the covering came from another, larger manuscript in Reims that also needed rebinding but had leather that was still good enough to be used to cover this manuscript of collected legal writings.

On 6 June 1987, Obbema went to Oosterhout to take a look at the separated leather covering with the title on its inside. A decision was then made to deviate from the treatment as originally proposed and not adhere the leather back on again, instead preserving it separately so that the old title on the inside remained accessible. That choice meant moreover that the wooden boards, with their Carolingian and Romanesque bookbinding history, remained visible. That turned out to be a choice made with foresight, showing just how cautious current conservation practices are. After all, such a radical intervention was not needed for the strength or durability of the binding nor for the accessibility of this manuscript at the University Library reading room or under exhibition conditions.

Sister Lucie worked on this manuscript for about five months, meticulously describing the composition of

the damaged work before she began the treatment. Remarkably enough, however, she did not describe the damage itself, so it is unclear exactly what was wrong with this manuscript, other than the insect-damaged leather coming loose. What she did record are the old sewing stations that were used for temporarily securing the loose quires using short lengths of sewing material known as tackets (see also no. 13) and the unusual way in which the leather covering was attached to the primary endbands, which provided extra stability at the ends of the book block spine. The leather covering had not been turned in at the head and tail of the spine but was instead cut off level with the endbands. The leather and the endbands were connected using thread that was sewn through these two elements and an additional folded strip of leather. That strip of leather was attached to the boards on both sides using small metal pins, and it had been dyed red. The red pigment was photosensitive and as a result none of the red colouring remained on the outside. Sister Lucie sketched and described all the traces that she came across in the boards and showed that the original binding had two fastenings to close it.

The reuse of the Carolingian wooden boards by the twelfth- or thirteenth-century bookbinder is striking, particularly as one of the boards was broken. The binder therefore not only had to turn the panels round and drill new holes through them in order to lace in the alumtawed leather sewing supports that were customary at the time but also had to repair the break in the wood. He used small brass plates for that, attached by pins on either side of the break: four on the outside and two on the inside. Some of those brass plates have a decorative edge; they seem therefore to have been snipped from another object and reused for this repair. The binder also decided to use the old sewing stations, from which we can work out that the parchment was undamaged there. He made it awkward for himself by doing so, however, because holes now had to be made in the wood around the places where the pins for the two closing straps of the Carolingian binding had gone in.

We know from the many surviving examples that reuse of written parchment folios was commonplace, both in the structures of bindings and for use as coverings. The reversed original boards and the inside-out leather covering taken from another manuscript around the binding of BPL 114 demonstrate that repurposing of materials also came in other forms and was more varied.

The key principles of the ethics of modern conservation treatment — reversibility and not disturbing traces or information — are embodied by BPL 114 and were already ensured in their own special way by the bookbinder from Reims. The decision-making for the restoration in 1987 went entirely along those same lines. The manuscript thereby reveals book archaeology and conservation history in all its splendour. *Clearly Seen* indeed, by Sister Lucie Gimbrère.

— Karin Scheper

Fig. 4
Details of the spine of the binding and the board, with the red-pigmented strip of leather in the insert of the endband, which had been laced onto the outside of the leather and that was fixed with a small pin beneath the covering on the board. The holes in the leather to the left and right of the hinge correspond to those pins. BPL 114.

Text and images: Two means to the same end

13 | Schoolbooks by Ademar of Chabannes
Eleventh century, c. 1010–1034 — VLO 15

This stack of 27 loose quires was the toolkit of a teacher at a medieval monastic school. What makes these 'schoolbooks' so unusual and so attractive is that their owner once used them to offer his pupils not only the customary written school texts but also visual aids, thanks to the numerous drawings.

The notes that Ademar of Chabannes (989–1034) collected throughout his life in the quires now kept together under shelfmark VLO 15 in Leiden give us a pretty clear impression of the educational programme at the monastic schools of Saint-Cybard (in Angoulême) and Saint-Martial (in Limoges). The most important authors whose works were taught in schools in the Middle Ages (the *auctores*) are represented in these quires: Avianus, Phaedrus, Prudentius, Priscian, Bede, Hyginus, Isidore of Seville. In addition, considerable attention is paid to biblical commentary, explanations of words, arithmetic and measuring time (*computus*), among many other things. In short, these schoolbooks covered much of the *artes liberales* (the liberal arts).

The manuscript is a very personal document, as can be seen in particular from its material characteristics and from the layout. Ademar has not bothered to mask the traces that show us how he put together his quires from parchment (both new and reused) and stitched the leaves of the quire together provisionally with tackets (temporary binding loops), not unlike the old school exercise books some of us may still remember. The texts themselves are partly written in the characteristic handwriting of Ademar — sometimes extremely small, the lines compressed close together, using numerous abbreviation techniques (including Tironian script, a kind of shorthand, see also no. 27). They are generally written freehand, i.e. without ruled lines, and usually on inferior or second-hand parchment. These texts are often not literal copies of the original but instead take the form of excerpts or edited versions. This type of layout and content eloquently illustrate that these notes were intended for purely personal use, as an *aide-memoire* for the teacher during verbal presentations of schoolroom texts, such as the *Etymologiae* of Isidore of Seville (fols 115r–147v).

The layout criteria for other texts indicate an educational method that invited their consultation by students and colleagues. The pupils whose Latin was more advanced were by then deemed capable of reading and understanding texts for themselves, assisted by the annotations that Ademar added between the lines. We can observe this in the carefully created copy of the *Psychomachia* by Prudentius, for instance (fols 45r–60v).

Ademar preferred yet another method of getting the message across to students, namely the use of pictures. For the youngest pupils, he drew scenes from the New Testament (fols 2r–4r); we then have to suppose that Ademar would have told the corresponding biblical stories while showing the illustrations to his pupils. Similarly, he copied a series of drawings that depict the struggle within our souls between Good and Evil, the *Psychomachia* (fols 37r–43r). On the leaves shown here (fols 39v–40r, see Fig. 1), Moderation (*Sobrietas*) is battling Luxury (*Luxuria*). These drawings, with pithy captions that acted much like speech balloons, were aimed at the younger pupils who did not yet know Latin well enough to be able to read the textual version of the *Psychomachia* mentioned above. It is striking that the text and drawings come from two different sources and were presented separately, perhaps with the express intention of rendering the knowledge from the *Psychomachia* accessible to different age categories.

A similar technique was used for conveying the moralising messages of Aesop's fables (in the Phaedrus/Romulus version) to receptive young minds. As can be seen in the image of fol. 197v (see Fig. 2), Ademar copied the series of drawings first and only then added the Latin texts to them. Given the complex layout, this way of working must have been clear only to him. This

< Fig. 1
Scenes from the battle between Good and Evil. The *Psychomachia* of Prudentius, illustrated by Ademar. VLO 15, fols 39v–40r (image 89%).

Fig. 2
The earliest known illustrated Aesop, in the Phaedrus/Romulus version, with the fable of *The Lion and the Mouse* at the top. Written and illustrated by Ademar. VLO 15, fol. 197v.

is the earliest illustrated version of Aesop's fables that we know of (see also no. 36). Because the texts and drawings do not always match — for the fable shown adjacent, for instance, the mouse is gnawing at an iron leg-hold trap, whereas the text refers to a snare made of cord — it seems conceivable that the text and the drawings came from two different sources and were juxtaposed by Ademar for teaching purposes. When he showed the drawings to his pupils, he would have recited the text that he had written down.

In Ademar's way of thinking, pupils who already had some mastery of Latin could also benefit from such drawings, for instance to make it easier for them to understand a more complex text such as *De astronomia* by Hyginus (fols 155r–188r). Whereas Ademar copied Hyginus' text from one manuscript, he used another source to illustrate that text with the mythological constellations. He put the texts and illustrations together for educational purposes. The version of Hyginus in VLO 15 is the earliest known illustrated example of *De astronomia*.

Everything in the didactic approach taken in VLO 15 points to Ademar being convinced — be it intuitively or from personal experience — that this kind of visually-oriented learning could play a significant role in transferring knowledge. He was thus anticipating what is now generally accepted as scientifically proven: knowledge that is passed on purely verbally does not stick nearly as well in the memory as when it is conveyed through visual aids too.

In essence, VLO 15 is a collection that has grown organically to become — ultimately — 27 separate quires that have an inherent dynamic all of their own. After all, the scope, content and sequence of the classroom books would have been continuously subject to change throughout Ademar's life depending on what was wanted from him in his role as educator and depending on what textual and visual material became available for him. When Ademar died in 1034, the collection lost its lifeblood. To prevent the quires from becoming lost, the collection was bound into a single volume early in the thirteenth century by Bernard Itier (1163–1225), the librarian of Saint-Martial. It was in that fixed state that VLO 15 came via Queen Christina of Sweden (1626–1689) into the possession of her teacher, the philologist and book collector Isaac Vossius (1618–1689). Because Bernard Itier's tight binding made consulting VLO 15 very awkward, it was decided in the last quarter of the nineteenth century that the quires should be removed from their binding and then split across fourteen volumes with stiff cardboard covers. That composition of fourteen small volumes was retained during the restoration of VLO 15 by Sister Lucie Gimbrère in 1992–1994 (see also nos 12 and 37). Since then, only the sixth part has been stored in an open position, to illustrate an unusual technical aspect of the book that Sister Lucie Gimbrère discovered: this quire is made up of two parchment sheets, each folded into quarters (*quadrifolia*).

— Ad van Els

Fig. 3
Teacher and pupil. Bamberg State Library, Msc. Patr. 5, fol. 1v, detail.

[Medieval Latin manuscript page; text not legibly transcribable at this resolution.]

Perfect to a fault

14 | Dioscorides, *De materia medica*
Eleventh century — VLQ 1

Leiden University Library holds the earliest known copy of *Dioscorides alphabeticus*, an alphabetised Latin version of Pedanius Dioscorides' Greek original. The manuscript was copied at Monte Cassino during the time when Constantine the African lived in the abbey and was producing a high volume of scientific texts. The Leiden manuscript shows how the flawed Latin translation was improved by a collective of scribes who probably worked closely with Constantine.

In spite of its plain appearance, VLQ 1 is a treasure among the Western manuscripts held at Leiden University Library. It contains an alphabetised version of *De materia medica*, a work on medicinal plants written in the first century AD by the Greek physician Pedanius Dioscorides (40–90 AD). His work was translated into Latin in the tenth century, and VLQ 1, the earliest surviving copy, presents the A–F section of this translation. Not only is this manuscript a particularly early witness of the transfer of scientific information from Greek and Arabic into Latin, but it was also produced in a key transmission centre of the sciences: the Benedictine Abbey of Monte Cassino. In 1077, Constantine the African († before 1086), a Tunisian immigrant, made his home in the abbey, and over the next decade, he produced many Arabic-Latin medical translations together with a team of local scribes and correctors, while also improving existing ones. VLQ 1 shows us how this collective tackled a flawed translation by applying clever correction techniques.

The Leiden *Dioscorides alphabeticus* appears to have been produced in two stages. It was started in the early eleventh century, c. 1000–1025, when scribe A copied fols 1r–13v, breaking off in the middle of a word halfway through line 37 of the second column (see Fig. 1). The manuscript appears to have remained unfinished for half a century, until its production was subsequently continued c. 1050–1075, when scribe B copied fols 13v–32r. It is unclear why the volume was shelved for so long, but it may have been because of the perceived poor quality of the translation. The transition between scribes A and B is marked with a *Chi-Rho* ('XP') symbol, a Christogram, which also functioned as a general attention sign in the medieval period. Fol. 13v shows the 'XP' symbol in the right margin and illustrates the clear difference in the ink colour used by the two scribes — it is not hard to see where one stopped and the other started. Their handwriting shows that both scribes were trained in the 'Beneventan Zone', a geographical space in southern Italy where a particular script termed *Littera beneventana* was common. Scribe A wrote his part in that script. Beneventan letter shapes have peculiar angles and can be hard to read by an untrained — or even trained — eye. Scribe B, in contrast, applied the more common Carolingian minuscule, a script that was preferred for scientific works, though he, too, employed distinct Beneventan features. The handwriting of both scribes shows evidence of the retracing campaign that unfolded in thirteenth-century Monte Cassino to counter the fading of ink. Many letters in the manuscript, especially capitals, include darker 'touch-ups', as are visible, for example, in the last ten lines of fol. 18v, column A (see Fig. 2).

Scribe B applied three medieval correction techniques that were used when a text or translation needed to be systematically upgraded. First, there is the *require* ('look this up') symbol, a small 'r' that marked passages in need of further enquiry. That is, the potential flaw was such that resolving it needed time and careful consideration. Note the presence of such tiny letters in the outer margins and between the columns of fol. 18v. A total of 192 *require* marks are encountered on VLQ 1's 32 leaves, showing just how flawed the text was considered to be. Second, scribe B skipped thirty passages in the exemplar from which he copied the

< Fig. 1
The transition from scribe A to scribe B occurs in the second column, marked with a *Chi-Rho* symbol ('XP') in the inner margin.
VLQ 1, fol. 13v.

Fig. 2
Diverse techniques were used for correcting the text, such as the use of 'r' (require) markings (present here in the outer margin) and notes indicating textual comparisons (here visible beside the end of the first column). VLQ 1, fol. 18v.

Dioscorides alphabeticus. As he deemed these passages in need of closer examination, he left a blank space into which an improved reading could later be added. Eight of these gaps (*lacunae*) are accompanied by a third correction method. In these cases, *alter liber habet* ('our other book has') was written in the margin next to an alternative reading, taken from another copy of the text in the abbey's library.

This unusual mix of observations — systematic text improvement and origins in a known translation centre, the home of Constantine the African — elevates VLQ 1 to an eyewitness of how a Greek scientific text was prepared for an audience of Latin readers. Presenting new scientific concepts, many of which still lacked Latin equivalents, provided significant challenges for translators — and headaches for the scribes who were tasked with copying them. To cope with this problem, Constantine's team of scribes and correctors used the techniques observed in VLQ 1 in other manuscripts as well, such as the *Liber pantegni* (The Hague, KB, Nationale Bibliotheek, 73 J 6) and the *Isagoge* (Paris, Bibliothèque nationale de France, NAL 1628), which contain similar examples of textual upgrading. It was crucial to get the techniques and text right, because the Monte Cassino manuscripts, including VLQ 1, would become exemplars for the distribution of these works across Europe. The upgraded *Liber pantegni* and *Isagoge*, for example, were used in medical education at universities until well beyond the medieval period. The interactive nature of the *require*

and *alter liber habet* techniques, which prompted consultation of resources in the library or even of an expert translator, were optimal for perfecting such complex translations.

A single word on fol. 18v confirms that the revision of VLQ 1 was coordinated by another person, perhaps Constantine himself. Here, scribe B deviates from his usual *alter liber habet* and adds the word *sic*, noting that 'our other book has *this*'. This remark is found at the very bottom of the left margin, where it is underscored. Even though the other copy of the text had precisely the same reading, the scribe still wrote it in the margin just below his underscored remark. There was no need to repeat the sentence, but it makes sense if we understand the work of scribe B as something he was tasked with by the person supervising the overhaul of the translation. It is as if scribe B implored his superior that he *did* check the other text and *was* doing his part in the upgrading project.

— Erik Kwakkel

Fig. 3
Connected to the main text by two dots (placed under the first word of the phrase in the final line), this note beginning *alter liber habet sic* confirms that this text was checked against another book in the abbey's library, which had the same reading. VLQ 1, fol. 18v, detail.

Gesta francor[um]

a quibu[s]dam quedam sup[er]flua quedam mi
nus continencia finguntur. pauca sub bre
uitate p[er]stringere conabor. Quatuor g[itur]
Ioseph ab ari
mathia uir di
ues et nobilis se
pulto d[omi]no a sa
cerdotu[m] p[ri]nipi
bz t[ra]ditus a iu
chudend[us] et custo
diend[us] S[ed] resurgen
te d[omi]no Ioseph
lib[er]at[us] e[st]. Cumq[ue]
p[on]tifices custo
dibz exp[ro]brando
corpus d[omi]ni ab[s]
tuliss[er] redigui[r]
rerent dicent[es]
eis ut heredes
Redditenos Io
seph et nos red
dim[us] t[ibi] xp[istu]m. S[ed]
ut ueru[m] cognos
cim[us] neq[ue] nos be
nefactorem dei
nos dei filiu[m] red
dere u[o]b[is] ualem[us].

De sepulcro
d[omi]ni quom[odo]
factum fuit.
Erat em[] lapis
magnus in ortu[]

gutt[u]lis purpureis in[]mixtis colore ca[n]
dido refulgens in cui[us] latere erat sepulcri
excisum tante magnificencie ut nouem
homines ca[m]pere ualeret et uinte alt[er]ius d[om]i[ni].
ut quisq[ue] manu culme p[er]tingere posset.
In cui[us] aq[ui]lonari p[ar]te sepulcru[m] d[omi]ni ex
cisum e[st]. Septem[?] pedes hab[ens] longitudis
et tres palmas et medium latitudin[is].

Ostium vero sepulture patulu[m] e[st] ad ori
entem ita ut capud d[omi]ni ad occidentem

illi adit[us] patent quib[us] ad eam fu[i]
it ingressus. Ab oriente. et occidente. ab
aquilone et meridie.

maria mat[er] iacobi frat[er] d[omi]ni uxor alphei. maria magd. que unxit pedes ih[s]u.

sep[ul]tura d[omi]ni.

et pedes illi[us] ad orientem respicerent.
dexta[m] quoq[ue] manu[m] ad meridie[m]. sinistra[m]
quoq[ue] ad aquilone[m]. Post ab[s]cisione[m]
u[er]o ei ip[s]iam ecclam in eode[m] loco rotunda[m]
edificant[es]. parietem ex marmore albo
stipauer[unt]. tecti[m]q[ue] laminis aureis desup[er]
et i[n]teriora crustulis aureis ornauer[unt].
In auru[m] nu[m]q[uam] inmobile [s]c[ilicet] e[st]. ut xp[istu]s
I[n] plene[] dices. In die illa i[n]du[m] resteascen
der[] signu[m] et salute[] ip[s]o[] ip[s]u[m] gentes dep
cabu[n]tur zerit sepulcru[m] eius gloriosu[m].

Jherusalem expugn.

A *unique* edition *of the* Liber floridus

15 | Lambert of Saint-Omer, *Liber floridus*
Thirteenth century, late — VLF 31

The *Liber floridus* ('Book of flowers') is a famous medieval encyclopaedia created in the early twelfth century by Lambert, a secular canon in the chapter of Our Lady at Saint-Omer. Leiden University holds a significant late thirteenth-century copy of it, which not only transmits parts that no longer survive in Lambert's autograph, but also stands out for the remarkable ambition to reconstitute and expand his work.

The *Liber floridus* transcends the arts and sciences and has a vast remit, stretching from the beginning of time into the future. It yields knowledge about Flanders and other regions of Europe, Asia and Africa, as well as then unknown parts of the earth and the substance and layout of the cosmos at large; it also shows how humankind and the world are interrelated. To achieve this, Lambert excerpted texts from a wide range of sources — to him these were the 'flowers' of various authors — and arranged them together with tables, diagrams, maps and figural imagery in ways that enabled users to forge multiple paths through the work, pursuing themes and uncovering connections. Lambert's autograph survives (now Ghent University Library, MS 92), along with a considerable number of medieval copies, each presenting a distinctive version of the work. VLF 31, created in the late thirteenth century in France, is the most ambitious of these.

The first part of the Leiden manuscript was copied in three phases from another *Liber floridus* manuscript (now lost) that included only a small selection of Lambert's texts and two of its images. These present the Holy Sepulchre in Jerusalem (fol. 84v) and a map of the city (fol. 85r), which locates the Sepulchre in the lower-left quadrant (see Fig. 1). The image of the Holy Sepulchre provides an intriguing combined view of the rock-cut tomb into which Christ's body was believed to have been laid and the church built to enshrine it. One accompanying text, placed below the image in the Leiden manuscript, reads: *Ostium vero spelu(n)ce patulu(m) e(st) ad ori | entem, ita ut capud d(omi)ni ad occidentem | (et) pedes illius ad orientem respicerent; | dextra quoq(ue) manus ad meridie(m), sinistra | quoq(ue) ad aquilone(m)* ('the entrance to the cave faced east, so that the head of the Lord would be towards the west and His feet towards the east; His right hand would be towards the south, and His left towards the north'). In the image, these directions are clearly marked. To the east (*oriens*), the entrance to the cave (*spelunca*) is presented as a dark, ghost-like opening. A red cross acts as a stand-in for the body of Christ that once lay within, though the shorter portion of the cross's vertical is here positioned by the feet (*pedes*), and the longer one by the head (*caput*), perhaps to ensure that the cross appears in an upright position for the reader of the text. The outer frame of the image is inscribed with the names of the four Marys mentioned in the Gospel accounts, ending with Mary Magdalene, *que unxit pedes ih(es)u* ('who anointed the feet of Jesus'), inviting the reader to visualise intimate care for Christ's living body while contemplating how his dead body had touched the tomb they saw before their own eyes.

As the running header across the top of the opening indicates, the two images are embedded into a larger text, the *Gesta Francorum Iherusalem expugnantium* ('The Deeds of the Franks during their Conquest of Jerusalem'), a chronicle of the First Crusade, the conquest of Jerusalem in 1099 and the early years of the Crusader Kingdom of Jerusalem. The central section of the chronicle, with its two images, is now lost from Lambert's autograph, making the Leiden version an important testimony to a core component of Lambert's original project.

<< Fig. 1
The Holy Sepulchre and a map of Jerusalem.
VLF 31, fols 84v–85r
(image 86%).

Fig. 2 (left)
Alexander the Great on his horse, Bucephalus, in the exemplar. Wolfenbüttel, Herzog August Bibliothek, Cod. Guelf. 1 Gud. Lat., second half of the twelfth century, fol. 88r, detail.

Fig. 3 (right)
Alexander the Great on his horse, Bucephalus, as copied in the Leiden manuscript. VLF 31, fol. 211r, detail.

What makes the Leiden manuscript even more significant is how its first part was subsequently expanded in two contrasting ways. For one, a large amount of knowledge was added that was entirely new to the *Liber floridus* tradition, broadening the thematic remit of the work. Among the additions was an important medical treatise, the *Tacuinum corporum*, originally composed in Arabic by Ibn Jazla (†1100), a physician in Baghdad. It was included here in the Latin translation by the Jewish physician Faraj ben Solomon of Girgenti, completed in 1280 for King Charles I of Anjou (1226–1285), brother of King Louis IX of France (1214–1270). The treatise consists of 44 tables, with commentaries on facing pages, classifying different types of illnesses and ailments, from fevers to gout, together with their cures. The cures are divided into two types: *cura regalis* ('royal treatment') and *cura levis inventionis* ('cure of easy finding').

When a more extensive and richly illuminated copy of the *Liber floridus* dating from the second half of the twelfth century (now Wolfenbüttel, Herzog August Bibliothek, Cod. Guelf. 1 Gud. Lat.) became available at an advanced stage of the production of VLF 31, the aim turned to adding as many of the items as possible from the Wolfenbüttel copy that were not already in the first part of the manuscript in progress. Identifying those items was a considerable feat, as the two manuscripts differed markedly from each other. The Wolfenbüttel manuscript was annotated to guide the Leiden copyists: triangles were added next to passages that needed to be copied, and crosses were placed next to those that could be skipped. While the ambition behind the critical comparison was to reconstitute the contents of Lambert's early twelfth-century work, the copying process also involved the further transformation of the images to suit the taste of contemporary readers. This is especially obvious when we compare the image of Alexander the Great (356–323 BC) in the Wolfenbüttel manuscript with its copy in Leiden, created by a follower of the Méliacin Master, a leading artist in Paris at the time (see Figs 2 and 3).

By the fifteenth century at the latest, this unique edition of the *Liber floridus* — designed to expand, reconstitute and transform Lambert's work — was in the possession of the charterhouse at Vauvert near Paris, which was founded by King Louis IX. It shares an illustrious ownership history with other treasures of the Leiden collection, being one of the manuscripts acquired by the French bibliophile Alexandre Pétau (†1672) that then came into the possession of Queen Christina of Sweden (1626–1689) and the renowned scholar Isaac Vossius (1618–1689).

— Hanna Vorholt

The nature of a manuscript

16 | Lodewijk van Velthem, Fifth Part of the *Spiegel historiael*
Fourteenth century, c. 1317 — BPL 14 E

If you study texts or illustrations in a medieval handwritten book but ignore the material properties and the nature of the manuscript in question, you will be missing crucial information. Is this a formal book or an informal one? Was the maker a professional scribe or a do-it-yourself writer? And why does any given manuscript have that particular appearance? The answer is often the adage: *Form follows function*.

This handwritten book from the early fourteenth century contains the sequel to Jacob van Maerlant's *Spiegel historiael*, a chronicle of the world in Middle Dutch written in rhyming verse and divided into four parts. This history is a translation and reworking of the *Speculum historiale* by Vincent of Beauvais (†1264). Jacob van Maerlant wrote the First and Third Parts and the beginning of Part Four in 1283–1288. Around 1300, Philip Utenbroeke produced the Second Part, and Lodewijk van Velthem completed the Fourth Part in about 1315. His own addition, the Fifth Part consisting of over 28,000 verses, was probably completed in 1317. Velthem had to collect his own historical sources for this largely contemporary sequel. The text on fol. 32r (see Fig. 1) tells the story of the Battle of Woeringen in Germany, near Cologne. In the battle for the Duchy of Limburg, Duke John I of Brabant faces the Archbishop of Cologne, Siegfried of Westerburg. By way of example, you can read the first ten verses of Chapter 11 of Book III of the Fifth Part. A loose translation with punctuation follows the text.

> *hoe die biscop va(n) coelne w(ar)d gevae(n) xi*
> *Nu q(ua)m va(n) coelne die biscop*
> *En(de) liep oec de(n) h(er)toge op*
> *Hi wilden doden ofte vaen*
> *M(aer) dat w(ar)d so weder staen*
> *Dat selve die biscop opte(n) dach*
> *Den h(er)toge nie en gaf slach*
> *Wa(n)t tallen stade(n) en(de) talle(n) inde(n)*
> *D(aer) hi den h(er)toge waende vinden*
> *Vant hi so grote(n) wed(er) stoet*
> *Dat hi kere(n) moest dor de(n) noet*

Fig. 1 >
Folio with a section of Book III from the Fifth Part of the *Spiegel historiael*, about the Battle of Woeringen (5 June 1288).
BPL 14 E, fol. 32r.

'**How the Bishop of Cologne was captured, chapter 11.** Now the Bishop of Cologne entered the battle and attacked the Duke. He wished to kill or imprison him. But the resistance was so strong that the Bishop could not strike the Duke at all on that day. Because wherever he thought he would find the Duke, he found instead great counter-resistance, which forced him to retreat.'

Upon examining BPL 14 E, it is evident at first glance that the quires of the manuscript consist of parchment of mediocre or poor quality. The leaves have tears that were sewn up before writing started. There are also holes, most of which have not been mended. The areas at the edges of a complete hide of parchment are usually inferior in terms of quality. When proper care is being taken when producing a book, those parts are avoided where possible but in this manuscript they are visible within the borders of the leaves. Eight of the folios had one corner that was not rectangular. To correct that, a piece of parchment was stuck on, but in five cases the extra piece has since become detached and is no longer present, with a loss of text as a result.

The book block of 94 folios now measures approximately 272 x 197 mm but it has been cropped slightly, perhaps when the manuscript received its current binding in the eighteenth century. BPL 14 E probably originally measured about 275 x 205 mm, somewhat too broad in relation to its height. The writing space is a rectangle measuring 215 x 155 mm, with three text columns of 50 lines of verse each, making 300 lines per leaf. In comparison with other manuscripts, it becomes clear that the dimensions of this layout are really too restricted for so much text and result in

3. boec — 11. 12.

pages that are excessively crowded. In manuscripts with rhyming text, some space is normally left between the first letter of each line of verse — usually presented as a capital — and the rest of the verse. In this manuscript, designing a separate column for such capitals for each of the three text columns would take up too much space and so the text in each line has been written without this feature. The space between the columns is relatively minimal and the margins are fairly narrow. Manuscripts that have been produced with care — especially luxury codices — have much broader margins.

A single scribe wrote all the text. Although he did so using a standard book script, a *littera textualis*, his writing is of a low standard because he must have worked very quickly and, as mentioned above, he had to use poor-quality parchment. Each of the eight larger sections or books in the Fifth Part starts with a painted initial in red and blue, decorated with penwork. Headings above the books and chapters are in red, as are chapter initials and paragraph marks.

When trying to assess the nature of this manuscript, relevant questions include why parchment of such poor quality was chosen and why so many verses were copied onto each leaf, so close together and in a rather sloppy bookhand. The design and production level of a manuscript — and later of printed books — are the result of choices made in advance. The answer to these questions in the case of BPL 14 E is that this book had to be produced as cheaply as possible and perhaps as quickly as possible. The low quality of its exterior and interior design would have been obvious to people in the Middle Ages too. The manuscript had no greater pretensions than to serve as the carrier for the textual content.

The text is still the most important aspect for us too, as this cheap manuscript is the only complete surviving copy of Veltham's Fifth Part. Or almost complete: aside from the lost verses on the corner pieces, a single leaf, along with its three hundred verses, is missing between folios 69 and 70.

Back to the scribe of BPL 14 E. About thirty years ago, the palaeographer Herman Mulder pointed out to me that this scribe had created another manuscript as well. His *textualis* script can be identified by (for instance) the characteristic capitals *A* and *I* he used in the two codices. Only the lower part of one leaf has survived from the other manuscript — which probably contained the Second Part of the *Spiegel historiael*. It still functions as a flyleaf in the front of the binding of an early sixteenth-century printed book, which is now kept in the library of a castle in Anholt (Germany).

We can assume that the characteristics of this fragment are representative of those of the original manuscript. It gives us sufficient clues to allow a reconstruction of the design of that codex: it had high-quality parchment, a format of approximately 320 x 230 mm, a writing space measuring 240 x 170 mm and a *mise-en-page* with three columns of 56 lines each. About 24 lines of verse in each column are visible on the fragment, which also includes a sewing fold and a narrow strip of parchment adjacent to that fold. A separate column has been created for the capitalised first letter of each verse. Neither chapter headings nor initials are present on the fragment, which coincidentally preserves a part of the *Spiegel historiael* that did not contain any major text divisions. Certainly headings and initials did occur elsewhere in the manuscript. More space has been left between the columns than in the Leiden manuscript. The writing space and the margins around the text are also much more spacious than in BPL 14 E. On examining the fragment carefully, it is evident that the scribe did produce a high quality *textualis* here. In other words, every aspect of the fragment in Anholt shows that the scribe was a skilled professional who in this particular case had been given instructions to make a carefully produced codex rather than a really cheap book.

Fig. 2
Battle of Worringen. Detail from a fifteenth-century manuscript with Jan van Boendale's *Brabantsche Yeesten*, Book IV. Brussel, KBR, IV 684, fol. 61r, detail.

That obviously raises the question of why the Leiden manuscript had to be made so cheaply. Its low-quality execution resembles that of some autograph manuscripts, but that is not the case here: Velthem did not work as a scribe, unlike the maker of both BPL 14 E and the now fragmentary manuscript of the Second Part of the *Spiegel historiael*. The manuscript of Velthem's famous *Lancelot Compilation* (The Hague, KB, Nationale Bibliotheek, KW 129 A 10) also consists of poor-quality parchment and contains leaves with corner pieces stuck on. The standard of the handwriting and initials is just as low as in BPL 14 E. This manuscript in The Hague is also a vehicle of very low-level quality for the text, but equally it is not an autograph manuscript because it was written by several scribes. One of them wrote on the final leaf that the book belonged to Lodewijk van Velthem. We can therefore assume that the author Velthem wanted to have copies of all his works. We know nothing about his financial circumstances at the time. He was appointed for life as a parish priest in Velthem and moved in high-ranking circles, yet we know he was looking for a patron in 1317. The Leiden manuscript with the Fifth Part of the *Spiegel historiael* and the Hague codex with the *Lancelot Compilation* are typologically closely related. It is almost inconceivable that the two codices were not Lodewijk van Velthem's private copies: cheap and informal text carriers intended for personal use by the author. That also makes them very special. Their remarkable nature illustrates precisely why these two poorly executed manuscripts are now highlights of their respective collections.

— Jos Biemans

Fig. 3
Old photograph of the flyleaf in a printed edition of Johannes Ludovicus Vivaldus de Monte, *Opus regale in quo continentur infrascripta opuscula*. Lyon 1518. Bottom half of the recto side with parts of the Second Part of the *Spiegel historiael*, Book v. Anholt, Fürstlich Salm-Salm'sche Bibliothek, Fragment in AD Nr. 460.

Continuation errors when copying a printed text

17 | Otto van Passau, *Boeck des guldenen throens*
Fifteenth century, after 1484 — BPL 3469

You can learn from your mistakes — if they get corrected, at any rate. The scribe of this copy of the *Boeck des guldenen throens* seems to have piled error upon error without any sign of improvement. But copying a prose text that is laid out in two columns is trickier than you might have thought.

Fig. 1 >
First chapter of Otto von Passau, *Boeck des guldenen throens: Die eerste oude hiet moyses hi wiset en(de) leert wat die me(n)sche es*
BPL 3469, fol. 2r.

Early in the 1380s, near Basel, a Franciscan monk called Otto von Passau composed a major compilation in German, *Die 24 Alten oder der goldene Thron der minnenden Seele*. He took the title and structure of the work from the biblical Book of Revelations, in which John sees a vision of 24 elders gathered around God's throne. In Passau's work, they address the reader — each in a chapter of their own. To do this, Passau has used statements by the Evangelists, church fathers, classical philosophers and medieval theologians about themes such as conscience, love, grace, faith, prayer, sin and virtue, dying and eternal life. In short, Passau has presented his Christian philosophy as a series of lectures.

Fig. 2
Lines copied down too soon after a browsing error by scribe A in his exemplar and crossed out with red ink to prevent text loss.
BPL 3469, fol. 32r.

The text was widely distributed in German-speaking countries and also in the Low Countries: eight manuscripts in Dutch and two printed editions have survived. This manuscript, in the possession of Leiden's library since 2002, bears the title *Boeck des guldenen throens* (Book of the Golden Throne). It consists of 141 leaves of paper and parchment, written by two scribes (A and B), with the latter taking over in the first column of fol. 111r. Scribe B also corrected the work of scribe A and started the table of contents at the start; that remained incomplete, however. Given the style of pen flourishing (the penwork decorations), the codex was probably made in the eastern part of the Northern Netherlands. As the exemplar, the scribes used a version of the printed edition that Jacob Bellaert had produced on his press in Haarlem in 1484. The evidence for this is a striking continuation error in the manuscript, caused by the scribe's turning of two leaves from this print exemplar instead of one.

Scribe A's attention must have wandered when copying out the tenth chapter. His exemplar ends at the bottom of the right-hand leaf with *Hi* [Augustine] *spreect / oec in sinen boec der drievoudicheit* ('He also says in his book On the Trinity', Haarlem fol. xxxi.r). For the next passage to copy, he should have turned one leaf of the printed version and carried on reading from the first column of the other side: *Ic* [Augustine] *winsche ende ic woude dat al / le joden ende heyden...* ('I would wish and want that all Jews and Gentiles...', Haarlem fol. xxxi.v). However, he flipped two leaves over and thereby skipped four columns of text. He then started copying the text that commences in the first column of the wrong verso leaf: *Minne is een stercheit der gheloven / en(de) ghelove is een cracht der min- / nen* ('Love is the spiritual force of faith and faith is the spiritual force of love', Haarlem fol. xxxii.v). It was only after completing the second column of his manuscript

138

Die eerste onde hiet moyses
lij wiset en leert wat die me-
sche es. Daer nae hoe die me-
sche nae gods beelde ghefcer-
pen es. Daer nae hoe alle creatu-
ren om des menschē wille ghe-
maect sijn. Ouer eerste onde vn-
derwiset v seluen dat ghi
voer nae bedencken
sult voer alle din-
ghen van wane ghi
ghecomē sijt. En waer ghi bint
waer ghi waert in uwer moed
lijf. wat ghi gheboeren sijt.
wat ghi noch werdē moet. Hoe
antwoert dese onde leerer en de
spreect. God heuet v ghemnect
vand asschē tot eene vistādele
mensche. en ghi ē hebt v selue
met ghemnect dan vand ghe-
nade ī die stille en vand moetdi
wed tot asschē. Daer van spre-
ect s hugo īnde derde hoec vā
der siele en spreect. Kint dā
liste en seht di selue wan ghi
ghecomē sijt en hoe ghi leuet
en wat ghi waert. Hoe voele
loens ghi verdient hebt. wā
ghi moet, of ghi sudicht of ghi
dustolny toeneet. of af neemt
met wat ghedachte ghi daechs
en nachts becomert sijt wāt
wāt begeerte uwe moet hēnyse
is. En hoe dicke ghi van de hoe
se gheest becoert wert en van
d werelt bedroest. en van v
eighē lust ghēstoert wert en
wanneer ghi v van bynē en van
bnītē bedencket. Hoe sidi v selue

onberwnē tot godlike bekenen
en van d selue ē moechdi god
nummermee bekenē. wāt ghi v
seluē niet bekenē ē wilt. noch
ghi ē cont niet bestripē die ho
uē v is. wāt ghi met ē weet
nue ghi sijt. wāt die eerste
en vnemelste spieghel gode
te siene es. dat hē die mensche
selue soect en besiet wz hi is.
Dit al sprekēt hugo de sicto
victoen en spreket wz hē by
dinerdē īnde boecke vanden sch
onbēnde lene. Dat is vele bet
en oec nutter. dat die mensche
leert hem selue kēne. dan dat
hi wetē wille d hemele loep
der amīd crachtē. d edelre
steenē wercke. der dierē na-
tuere. der menschē sedē. en
wat sy doē en luetē. En hem
elrwijs en extnjis constē. wāt
vele menschē wetē voele sulē
die hem selue niet en wetē
noch ē bekenē. En dit te we-
tē is d hoedijste conste es wāt
hi sprict cassodar opte psnl
miserere mei deus. Dat is d
groetste ordue eene dienre
gods te bekenē sī eighē cra-
nchz en sī eighē natuerlike
crachte en bidiene soe woedē
toenerlaet te hebbē. wāt dā
busse īnde menschē goddeli-
ke crachte. als die mēsche hē
selue of met īnaturelijker
anchte. Dit spreet al cassi-
odorg en gregorig ī hoerē
leerē en sprekē alsoe. Hoe
ē mensche hem selue wil besi

Fig. 3 Continuation error by scribe A with loss of text and correction by scribe B. Details from UBL, 1498 B 2, fol. xxix.v and BPL 3469, fol. 30v.

copy (ms. fol. 32r) and needing to start on the next leaf that he discovered his error. He turned back one leaf in the exemplar and started from the correct verso leaf, writing down the following in his copy: *Ick winssche en(de) ick woude dat / alle jode(n) en(de) heide(n)...* etc. ('I would wish and want that all Jews and Gentiles...', ms. fol. 32v). He crossed out the fourteen misplaced lines of prose in red ink. The Bellaert edition of 1484 is the only printed edition with a layout that would make this specific error possible, showing that the printed edition by Jacob Bellaert and manuscript BPL 3469 can be linked as exemplar and direct copy respectively. Together, they make an ideal case study for observing the behaviour of a scribe.

During the copying process, a scribe keeps going through the same cycle: reading a passage from the exemplar, remembering what was read, writing the memorised text down in the copy, recalling the last word copied and finding it in the exemplar again. Continuation errors arise when a scribe — looking for the last word that he had copied — instead skips to the identical word elsewhere in the passage. A jump like this has two possible consequences: if the scribe skips over an as-yet uncopied piece of text in the exemplar, text will be lost in the copy; alternatively, if he goes too far back in the exemplar, a repetition will appear in the copied version. These kinds of errors may be noticed and rectified during a round of proofing and corrections: missing text can be supplemented with words in the margin or at the bottom of the leaf, accompanied by a reference symbol; textual repetitions can be crossed out.

The Leiden copy contains a large number of corrections for continuation errors, the majority of them (53) in the work of scribe A. The figures show two examples of where his eye has jumped to the wrong spot, with the printed exemplar text shown on the left and the copy on the right. In the first case, the scribe has misread a statement by Augustine at two identical word clusters *ghelove sonder enighe*. The printed version has: *want god te beke(n)nen inde(n) / ghelove **sonder enighe twivelinghe** / **ende te leven na den ghelove** sonder / enighe v(er)sumenisse dat maect den me(n) / sche salich* (Haarlem, fol. xxix.v). Translation: 'For believing in God without any doubt and

Fig. 4
Continuation error and correction (crossed-out words) by scribe A to prevent text loss. Details from UBL 1498 B 2, fol. xli.r and BPL 3469, fol. 42v.

living without any shortcomings according to that belief is how man acquires heavenly salvation'. The words in bold face highlight what scribe A has skipped and scribe B later supplied in the lower margin (ms. fol. 30v). In the second case, scribe A himself noticed a jump in his text in a statement by Bonaventure (about the spiritual and sacramental communion) to another word cluster, *sacramentelic en(de) gheestelic*, with the risk of eight lines of text from his exemplar being lost (ms. fol. 42v, Haarlem fol. xli.r). He used red ink to cross out the words he had put down prematurely and resumed his copying from a point eight lines earlier in his exemplar.

How can this comedy of errors be explained? Not all scribes work with the same levels of concentration and accuracy. The layout of the exemplar can play a role too. A scribe who is trying to copy a prose text from an exemplar laid out in columns into a similar layout will come up against 'typographical' issues that are not present when copying verse. The column widths and letter sizes in a copy of a prose text are never exactly the same as those in the exemplar and it is therefore virtually impossible for scribes to maintain the same number of words per line in the columns as in the exemplar. When 'padding' the lines in the columns of the copy, he will therefore need to improvise by hyphenating words or joining previously hyphenated fragments, by expanding or inserting abbreviations, or by varying the spelling and punctuation.

Copying a prose text in columns is never 'merely' replicating the letters and abbreviation symbols. Scribes who were continually varying word forms to fill up the short lines in the columns and thereby saw the positioning of the corresponding passages in the exemplar and copy diverging ever further were more susceptible to continuation errors than their colleagues who were copying epic or lyric verse. In that type of work, every verse line ends on its own ruled line and, usually with a fixed anchoring point, the rhyming word. The scribe and corrector of this *Boeck des guldenen throens* therefore deserve our thanks, as they have provided us with some valuable insights into how copying worked.

— André Bouwman

READING, CORRECTING, ANNOTATING

An anonymous medieval reader smudged out part of an illustration, perhaps reacting to a vice they wished to avoid (see no. 20, BUR Q 3). Another took a blade and carefully erased one line of text in order to rewrite it, along with a line that was previously missing in their copy (see no. 19, VLF 30). Yet a third drew a small symbol beside a passage of text, then repeated the symbol in the margin above, alongside a note clarifying the passage (see no. 23, BPL 67). Through the evidence left by such interactions, we can reconstruct the ways in which medieval scholars studied their manuscripts.

To improve the accuracy of a text, medieval scholars would compare various copies of it. Errors which had crept in during copying — such as the repetition or omission of words and phrases — could be corrected in this way (see no. 19, VLF 30). Scholars also noted when texts diverged, adding or deleting passages and supplying alternate readings as required (see no. 18, VLF 84 and VLF 86). To obtain multiple copies of a text for such comparisons was no small feat, requiring either access to a well-stocked library or generous acquaintances prepared to loan out their precious manuscripts, sometimes across great distances.

Other scholars improved their manuscripts by adding notes. These were added for personal use, but also with an eye towards enhancing a text for future readers. One reader wrote out a list of classical gods and goddesses on the first page of a manuscript of satirical poems (no. 22, BPL 82), a nod to the texts' Roman heritage. Another reader, the ninth-century Irish scholar John Scottus Eriugena, supplied passages in Greek — a language not widely known in the medieval West — alongside a copy of a Latin grammar textbook (no. 21, BPL 67). This manuscript, still preserved in its late medieval binding, survives as a monument to the standard of grammatical knowledge in this period.

Medieval school texts were frequently 'glossed' — that is, they contained explanations, sometimes on a word-by-word level, of particular vocabulary. Such explanations facilitated a multi-layered reading and teaching of the text (see nos 21 and 22; BPL 67 and BPL 82, respectively). These glosses, along with longer commentary passages, were often copied from manuscript to manuscript. When commentary and text were copied together, sometimes in highly intricate layouts (see no. 23, ABL 14), readers could consult both simultaneously. In these ways, the medieval page could mediate the meaning of a text, even across generations of readers. (IO'D)

Reading, correcting, annotating | Manuscripts, *from rear, left to right*:
VLF 86 (no. 18), VLF 30 (no. 19), BPL 82 (no. 22), ABL 14 (no. 23) — BPL 67 (no. 21), BUR Q 3 (no. 20)

TOPICA

ut fundum. Item partem stilli ei chu mancipiorum pecudem supellectilem pecunie ceteru q̄ quae ex genere. quedam interdum uoti demenda earum ut reru q̄ nonsi n̄ ee rursuseadico quae tangi demonstrare n̄ possunt. ea ita in animo itaq; intelligi possi ut eiusdem p̱ione. Sic utela sigente. si agnatione definiar qualiu rerum lum subo quasi corp. e tamen q̄dam conformatio insignita & inpressa intelligentie quā notione uoco ea sepe in argumentando definitione explicanda sit itaq; et definitiones aliae s partitionum aliae diuisionum partitionum cū res ea; positae quasi in mbra discerpit at siquis dicat ius ciuile idem qd̄ in legib; senat consultib; reb; iudicatis peritoru auctoritate edictis magistratuum more equitate consistat;

Ergo argumentatio quae deducitur ex testimonio posita est. Testimonium aut nunc dicim omne qd̄ ab aliqua externa re sumit ad faciendam fidem psona aut nature digni testimonii pondus habet. ad fidem em faciendam auctoritas quaeritur sed auctoritatem aut natura aut tps adfert. Naturae auctoritas. in uirtute ne maxim est ponderauit multae. quae adferant auctoritatem ingeniu opes aetas fortuna, ars usus. necessitas. concursio etiam nonnum q̄ rerum fortuitarum, nā & ingeniosos & opulentos & aetatis spatio pbatos dignos quib; credat putant et recte. fortasse. sed uulq; no pmutari uix potest ad eamq; omnia dirigunt. ea uiudicant et ut existimant quae reb; ut quae dixi excellunt.i si auirtute uident excellere sed aliqui quo q̄ reb; quasi modo erunt quæ quā in iis nulla species uirtutis est. tam interdum confirmat fides. nā ut ars quaedam. ut libet. magna auctoritas et pse tacendum ratio est. aut usus plerumq; em creditur usq; expertis. facit et ipsa necessitas fidem. quae etiam corporibus

folio CVI. CVII. CVIII Vossiano fol. 34 restituta sunt.
W. G. Pluygers
18 5/10 50.

TOPICA

quoniam rebus iis quae ethicis excellunt ipsa uirtute uidetur excellere. Sed reliquis quoque rebus quasdam enumerauimus quae quia in iis nulla species inerat falsa
cauti docuimus fidei sunt artes. ipsa ad huiusmodi magna rerum uis ad persuadendum. Saepe uero uti usus plerumque credere id quod quasi facit necessitas fidei, quae uel a corporibus
tum ab animis nascatur. Nam uerberibus tormentis igni fatigati quae dicunt,
eandem ueritas ipsa dicere. Atque perturbationibus animi dolore
cupiditate iracundia metu quae necessitatem uim habent adsunt
auctoritatem et fidem mouet, etiam generis illius ex quibus uerum
non numquam inuenit, pueritia somnus imprudentia uinolentia in
sania. Nam et paruus saepe indicauerit aliquid quod pertineret
ignaros et per somnum uinum insania multa saepe patefacta sunt.
Multi etiam in re sontosi imprudenter inciderunt, ut statim
uno non per accidit quod locatus est bonus uiros sub auis culturibus pa
riete inter postes quibus paterentur, in iudicium quam plausibili res capi
talis iure damnatus est. Huic simile quiddam de lacedemonio pau
sania accepimus, sed cursio aut fortuito talis est ut si intra uenti est
cassu quum aut ageretur aliquid quod praeterendum nec eat aut diceretur.
In hoc genere et iam illae in palam aedem coniecta suspicionum
per ditionis multitudo, quod genus refutare intendum ueritas uix po
test. Huiusmodi est etiam generis fama uulgi quoddam multitudinis testi
monium quae aut uirtute fidem faciunt. Sed duae partes ex quibus alte
rum natura ualet alterum industria deorum enim uirtus natura ex
cellit hominum autem industria diuina haec fere testimonia, primum
orationis oraculi enim ex ipso appellatus sunt quod inest mus
deorum oratio, deinde rerum in quibus inerat quasi quaedam opera
diuina, primum ipse mundus eiusque omnis ordo ornatus, deinde
aeris uolatus auium atque cantus, deinde eiusdem sonitus. Et ardo
res multarumque rerum in terra portenta atque etiam per um inuen
ta per sensio. Ad dormientibus quoque multa significata ut iis quibus ex
locis sumi in tendum solent ad fidem faciendam testimonia deorum.
In homine uirtutis opinio ualet plurimum, opinio est autem non
modo eos uirtutem habere qui habeant, sed eos etiam qui habere
uideantur. Itaque quos ingenio quos doctrina quos studio praeditos

A *thousand years of textual editing*

18 | Cicero, Philosophical works (the 'Leiden Corpus')
Ninth century, mid — VLF 84, VLF 86

A cluster of eight philosophical works by the Roman orator, politician and philosopher Marcus Tullius Cicero (106–43 BC) is colloquially referred to as the 'Leiden Corpus', as three manuscripts of this cluster can be found in Leiden University's Library. The oldest of these — VLF 84 and VLF 86 — are among the most important medieval witnesses to Cicero's philosophical works, not least on account of their intriguing and interwoven history.

<< Fig. 1
A ninth-century scribe ruled through text on fol. 105v to avoid overlap with the newly supplied leaves of Cicero's *Topica* added to this manuscript. He recopied the end of this section in smaller writing at the top of fol. 106r. Three leaves were moved from here to VLF 84 in 1860, as a note in the lower margin of fol. 105r records. VLF 86, fols 105v–106r. (image 90%).

VLF 84 and VLF 86, both copied in the mid-ninth century in northern France, contain a constellation of eight philosophical works by Cicero. This collection of works — found in nearly the same order in another significant manuscript produced in Monte Cassino, Italy, in the eleventh century, also now at Leiden (BPL 118) — is known as the 'Leiden Corpus'. These three manuscripts are treasured by scholars of Cicero as important textual witnesses to his philosophical works, essential for the transmission of Ciceronian ideas to the medieval period and beyond.

Although dating from the same period and general area, VLF 84 and VLF 86 were copied from now lost manuscripts which contained subtly different versions of their texts. In the third quarter of the ninth century, they were brought together in the Abbey of Corbie in northern France. There, the two manuscripts were compared and corrected against each other and used as the basis for yet another copy of this cluster, a manuscript now at the Biblioteca Medicea Laurenziana in Florence, Italy (San Marco MS 257). The scholars involved in correcting and copying at Corbie fastidiously annotated both VLF 84 and VLF 86, as we can still trace in the shifting ink colours of these manuscripts. For example, in the depicted opening, a darker, almost black, ink was used to add missing words (e.g., *aeris* in the lower-right part of fol. 106r) and to correct individual letter forms, illustrating the precise nature of this process. The paths of the two manuscripts then diverged, before they were reunited in the collection of Isaac Vossius (1618–1689), purchased by Leiden University in 1690.

Fig. 2
This leaf, providing the start of the *Topica*, was originally inserted into VLF 86, but was moved by Pluygers to VLF 84. The scribe strategically chose a small piece of parchment to copy this short section of text in an economical way. VLF 84, fol. 76v.

In the later ninth century, in an unknown monastery in northern France, VLF 86 received yet another round of editorial attention. Both VLF 84 and VLF 86 were missing part of the text of Cicero's *Topica* ('Topics'), a guide to legal oratory. This was resolved in VLF 86 by the addition of some extra leaves supplying the missing passages, a process which required some ingenuity. For example, one short section at the opening of the *Topica* was supplied on a small leaf of parchment, written on only one side (now VLF 84, fol. 76v). Close examination shows that this leaf was ruled twice: the unused vertical ruling and the horizontal ruling ultimately used by its copyist were both etched with a sharp point into the

parchment's surface. This double ruling suggests that its scribe either made an error in calculating his desired line width, and so was obliged to turn the leaf 90° and rerule before writing, or perhaps cannily reused a piece of parchment that had originally been ruled for another purpose to supply this short text.

Another portion of missing text was copied across three leaves (now to be found in VLF 84 as fols 80r–82v). To accommodate these leaves within VLF 86, and avoid overlap in text, a ninth-century scribe struck through half a page at the point in the manuscript where the three leaves were to be inserted (see Fig. 1, fol. 105v). Then, after supplying the leaves, he added the struck-through text in its proper location at the end of the inserted leaves, continuing on to the subsequent page (VLF 86, fol. 106r). This scribe's editorial modifications, written in a small script in dark-brown ink, meant the text could be read seamlessly across the inserted leaves. The scribe's careful integration of the supplementary leaves into the manuscript showcases the complexity of text scholarship in the ninth century.

About a thousand years after their copying, VLF 84 and VLF 86 again invited textual scrutiny, this time as part of a large-scale editorial project of Cicero's works begun by Johann Caspar von Orelli (1787–1849) and continued by Karl Halm (1809–1882) and Johann Georg Baiter (1801–1877). Interested in establishing definitive readings of Cicero's texts, the editors revisited the relationships between VLF 84 and VLF 86, examining the manuscripts anew. As Halm and Baiter's second edition of Cicero's *Topica* (1845) records, after seeing the manuscripts, Halm recommended that the supplementary leaves of the *Topica* in VLF 86 — which differed in script from the rest of the codex — be moved to VLF 84.

No further rationale for Halm's perspective is offered. The editors clearly favoured VLF 84 (termed 'A' in their edition) over VLF 86 (termed 'B'); indeed, VLF 86 contains a number of misplaced sections of text and other corruptions. For Halm, it would seem, the right place for these leaves — the oldest witnesses to this section of the *Topica* — was VLF 84, his superior manuscript of the Leiden Corpus. In suggesting this emendation, Halm ignored the careful work that the ninth-century scribe had carried out in adapting the text of VLF 86 to accommodate these extra leaves of the *Topica*, perhaps on account of this scribe's vigorous, yet inexpert-looking, erasure of the text passage on fol. 105v.

Halm's advice was taken seriously. On 5 October 1860, Willem Pluygers (1812–1880), then Librarian of Leiden University, removed the supplementary leaves that completed the text of the *Topica* from VLF 86 and moved them into VLF 84. He recorded his intervention, making dated notes (in pen) to mark the places where the leaves had been removed and inserted across both manuscripts. His intervention, which went against the evidence of the manuscripts themselves, reveals a lot about library practices and attitudes during this period. Prestigious scholarly opinion (in this case, Halm's) and the canonical status of VLF 84 as the 'best' manuscript of the Leiden Corpus were weighted more heavily against the underestimated ingenuity of the ninth-century scribes who adapted and reworked VLF 86, a 'lesser' manuscript in the eyes of nineteenth-century philologists. Thus, these leaves of the *Topica*, still housed in VLF 84, function as a testimony not only to medieval processes of text editing and adaptation, but also to nineteenth-century curatorial and scholarly attitudes towards both text and manuscript.

— Irene O'Daly

Fig. 3
A note by Pluygers in the lower margin: *Desunt Topicorum ¶ 1–3. Folium quod has ¶¶ continebat Vossiano 84 restitutum est, unde olim in hunc librum fuerat translatum.* W.G. Pluygers 5/10, 1860 ('Missing *Topica* 1–3. The folio which contained [these passages] has been restored to Vossianus 84 [fol. 76], from which it was once moved into this book. W.G. Pluygers 5/10, 1860'). VLF 86, fol. 103r, detail.

et quamuis subito per colum uina uidemus

DE OLEO

Perfluere at contra tardum cunctatur oliuom
at utquia nimirum maioribus est elementis
at utmagis hamatis inter se perqueplicatis
atque ideo fit uti non tam diducta repente
inter se possint primordia singula quaeque
singula per cuiusque foramina permanare

DE MELLE

Huc accedit uti mellis lactisque liquores
iucundo sensu linguae tractentur in ore

DE ABSENTHIO

At contra taetra absinthi natura ferique
centauri foedo pertorquent ora sapore
ut facile agnoscas e leuibus atque rotundis
esse ea quae sensus lucunde tacere possint
at contra quae amara atque aspera cumque uidentur
haec magis hamatis inter se nexa teneri
propterea que solere uias rescindere nostris
sensibus introituque suo perrumpere corpus

Q̄ I V̄

DE SERRE STRIDORE

Omnia postremo bona sensibus & mala tactu
Dissimili inter se pugnant perfecta figura
Ne tu forte putes serrae stridentis acerbum
Honorem constare elementis levibus aeque
Ac musae a mele p(er) chordas organicis que
Nobilibus digitis experge facta figurant
Ne usimili penetrale putes primordia forma
Inares hominum cum tetra cadavera torrent
& cum scena cro cocilici perfusa recens est
Araque panchaeos exalat propter odores
Neue bonos rerum simili constare colores
Semine constituas oculos qui pascere possunt
& qui conpungunt aciem lacrimareque cogunt
Ac foeda specie dira turpesque videntur
Omni enim sensusque mulcae cumque videntur
A ut sine principali aliquo leuiore creata st
At contra qu(a)ecumque molesta atque aspera constat
Non aliquo sine materiae squalore repertast
Sunt & iam quaedam nec leuia iure putantur
Esse neque omnino flexis mucronibus unca q(ue)

Studying Lucretius at Charlemagne's court

19 | Lucretius, *De rerum natura*
Ninth century, first quarter — VLF 30 (*Codex oblongus*)

VLF 30, one of Leiden University Library's manuscripts of *De rerum natura* ('On the Nature of Things'), is the earliest textual witness to Lucretius' great philosophical poem. It is one of the most important extant manuscripts of a classical Latin author. It shows how a difficult pagan text was copied and studied during the Carolingian age, as it was to be again during the Renaissance and again in the nineteenth century.

Lucretius' (c. 99–55 BC) *De rerum natura* is a poetic work describing the physics of the world. Drawing on the work of the Greek philosopher Epicurus (341–270 BC), Lucretius discussed how the world was created out of atoms, invisible particles constituting all things. While Lucretius invokes the goddess Venus, there is no place for religious beliefs in his poem. Its subject matter and pagan character made *De rerum natura* a distinctive classical work which survived in very few medieval copies, of which VLF 30 is the oldest. This manuscript is sometimes referred to as the '*Oblongus*' on account of its rectangular format, and to distinguish it from another Leiden manuscript of the same work, VLQ 94 — the so-called '*Quadratus*' — which is square in format.

The manuscript consists of 192 folia, written in Carolingian minuscule in black ink. This elegant script was invented in the last quarter of the eighth century and used at the Carolingian court. The titles, written here in a red uncial script, are not original to the work of Lucretius but are a later addition to the text. At the base of fol. 39v is a quire signature with a *V* in a square, indicating that this is the fifth gathering of eight leaves of text. Fol. 40r, the start of the next gathering of eight leaves, begins with a red uncial script heading. The main scribe of this manuscript is perhaps the same scribe who copied a manuscript of the acrostic poems of Porphyrius, a prefect of Rome in 329 and 333 AD, praising the emperor Constantine (now located in the Burgerbibliothek of Berne as Cod. 212). Because those poems contain acrostics and pictures made up of coloured letters, they presented a challenge to the scribe. Clearly, the main scribe of the *Oblongus* was an expert. But even he may not have been able to cope with the very difficult Latin of Lucretius, and his text needed corrections, as fol. 40r (see Fig. 1) shows.

The last word of the third line, *acerbum* ('bitter'), and the following two lines (*De rerum natura*, Book II, 411–412) were written by the corrector Dungal (c. 780–830). Dungal was an Irish poet and astronomer who famously wrote a letter to Charlemagne (c. 748–814) — whose court attracted scholars from Ireland, England, Italy and Spain — explaining the eclipses of the sun that had occurred in 810. Dungal was intellectually curious; we know he collected manuscripts of ancient texts. Dungal's letter quoted the philosopher Macrobius (370–430 AD) to explain the movement of the planets and how eclipses could be predicted. Although Dungal did not refer to him in this letter, Lucretius also discussed eclipses in *De rerum natura*.

Dungal made frequent corrections to the text of Lucretius, using an angular, Insular-style script with distinctive letter forms, which he had learned in Ireland. Dungal's script is seen clearly on fol. 36r (see Fig. 2), where he wrote six lines over an earlier erasure of four lines, compressing his writing to fit the available space. Charlemagne's son later appointed Dungal as a teacher at the school of Pavia, and he died as a monk in the Italian monastery of Bobbio. He left 27 manuscripts to Bobbio; seven survive, with his corrections in his own hand.

<< Fig. 1
Fol. 39v and the top of fol. 40r show the interlinear titles, copied in red, which were probably added to the text of the poem in Antiquity. At the base of fol. 39v is the quire signature for the fifth gathering of eight leaves. On fol. 40r, the last word of the fourth line, *acerbum*, and the next two lines are copied by Dungal in Insular script. Note the flat-topped *g* and the wedges on the ascenders of *l* and *b* in *levibus*, typical traits of this script. VLF 30, fols 39v–40r (image 87%).

The *Oblongus* received explanatory marginal glosses at the start of the eleventh century. It was also the source of the copy of *De rerum natura* made in 1417 by Poggio Bracciolini (1380–1459), which revived humanist interest in Lucretius. It was later in Mainz; the earliest evidence is a Mainz *ex libris* on the first folio, written by Macarius von Busek, the syndic of the Cathedral chapter, and dated 1479.

Leiden University Library also holds the other complete Carolingian manuscript of Lucretius. VLQ 94, the *Quadratus*, was copied in a two-column format in the mid-ninth century in northeastern France, after pages of the exemplar from which VLQ 94 and VLF 30 were copied had been displaced. VLQ 94 belonged to the Abbey of St Bertin, and it has annotations in its margins which highlight difficult words and instances where it was unclear which syllables should be stressed. These annotations were useful for those interested in the composition of Latin poetry and who needed to know which syllables were long, which were short. Examples from *De rerum natura* were quoted in several treatises on the topic of poetic composition, including four lines which also received annotations in the *Quadratus*.

During the ninth century, Lucretius was quoted by a variety of scholars, including Dicuil (another Irish scholar; †c. 825–830), Rabanus Maurus (c. 780–856), Mico of St Riquier (†c. 853), Ermenrich of Ellwangen (c. 814–874) and Heiric of Auxerre (841–876), and in several Carolingian metric *florilegia* (collections of poetic extracts). In spite of its patchy manuscript survival, Lucretius' work was carefully read during this period.

The *Oblongus* and *Quadratus* were later owned and studied by Gerhard Vossius (1577–1649) and formed part of the collection of his son, Isaac Vossius (1618–1689), which was purchased by Leiden University in 1690. Both manuscripts were used by important classical scholars like Nicolas Heinsius (1620–1681) in the 1650s, Jacob Bernays (1824–1881) in 1846 and Karl Lachmann (1793–1851) in 1850. Bernays and Lachmann recognised that these were the earliest surviving copies of the text and that by comparing them it was possible to reconstruct the manuscript from which they were copied. Lachmann's edition of *De rerum natura* was a milestone in the history of the edition of classical texts, showing how to determine which manuscript readings were those of the author and so establishing the genealogy of Lucretius' text.

— David Ganz

Fig. 2 (left)
This is the longest passage corrected by Dungal. Beneath his Insular script, one can see the text he erased. The flat-topped *g* and the wedges on the *l* and *b* are visible here too, as is the distinctive Insular *p*. Dungal also corrected the word *ipsa* at the end of the penultimate line pictured. VLF 30, fol. 36r, detail (*De rerum natura*, Book II, 257–263).

Fig. 3 (right)
The opening folio of the *Quadratus*, with its two-column layout and the title of the poem: DE PHISICA RERU(M) ORIGINE V(E)L EFFECTU. VLQ 94, fol. 1r.

Perdita deliciis uitae cui causa uoluptas
elumbem mollire animam pellulereramoenas
haurire inlecebras & fractos soluere sensus

**LUXURIA AUDITIS TUBIS
AD BELLUM CURRIT**

At nunc peruigilem ructubat marcida cenam
Sub lucem quia forte iacens ad fercula suctos
Audierat litoos & que in de repente linquens
Pocula lapsanti per uina & balsama gressu
Ebria calcatis ad bellum floribus ibat;

LUXURIA MIRANTUR CIBI IN CURRU

Non tamen illa pedes sed curru inuecta uenusto
Saucia mirantum capiebat corda uirorum

...ioua pugnandi species nonalis harundo
...pulsa fugit nec stridola lancea torto
...icat amento frameam nec dextra minatur
...violis lascivit loete folisq rosarum
...micat & calathos inimica per agmina fundit;
...e blanditiis aer atribus halitus inlex
...pirat tenerum labefacta per ossa uenenum
...e dulcis odor domat ora & pectora & arma
...osq. toros oblitos rubore mulcet&;
DELECTIS ARMIS SECUTUR LUXURIAM

...iciunt animos ceu uicta & spicula ponunt
...ter heu dextris languentibus obstupefacta
...currum uaria gemmarum luce micantem
...tur dum bratteolis crepitantia lora
...de & auro preciosi ponderis axem
...is inhiant obtutibus & radiorum
...o albentem seriem quem summa rotarum
...ra electri pallentis corrorat & orbe
...A ACIES UERSIS SIGNIS AD DEDITIONEM TRANSIT

Erasing evil: The battle of the Virtues and the Vices

20 | Prudentius, *Psychomachia* and other works
Ninth century, second quarter — BUR Q 3

Prudentius' *Psychomachia* gave medieval readers a ringside seat to a violent battle between the Virtues and the Vices. The illustrated copy of the work at Leiden University Library, which once formed part of the library at the Abbey of Egmond in the Northern Netherlands, contains traces of what an anonymous reader thought of the text. Their reaction helps us understand why the work was popular with its predominantly monastic medieval audience.

One of the most dramatic works of the early Christian canon was written by Prudentius (348–after 405 AD), a Roman from northern Spain. Its title, *Psychomachia*, is derived from Greek and literally means 'battle of/for the soul'. It is written in the style of epic poems like Virgil's *Aeneid*, but the protagonists of this battle are neither gods nor warriors, but personifications of the Virtues (Faith, Chastity, Patience, Humility, Moderation, Good Works and Harmony) and the Vices (Paganism, Lust, Anger, Arrogance, Luxury, Greed and Heresy). In this lengthy work (over nine hundred lines), they fight over Christian values, with the Virtues ultimately defeating the Vices. The *Pscyhomachia* was exceptionally popular, surviving in around three hundred medieval copies.

Dating from the second quarter of the ninth century, this manuscript, BUR Q 3, contains various writings by Prudentius. Its text of the *Psychomachia* is distinctive, as it is one of twenty surviving illustrated copies. The reader of these copies was provided with a scene-by-scene illustration of the *Psychomachia*'s action, with graphic depictions of the gory deaths of each of the Vices. The tradition of illustrating the *Psychomachia* may stem back to the fifth century, although it is likely that BUR Q 3 was derived from a Carolingian copy of the work. The script type, a Carolingian minuscule, shows that the manuscript was produced in northern France, with Saint-Denis offered as one possible place of origin. Similarities between its penwork drawings and those of other famous medieval manuscripts, such as the Utrecht Psalter, may suggest a connection between this manuscript and the ecclesiastical centre of Reims, France.

Fols 132v–133r depict a pivotal scene of the *Psychomachia* (lines 313–339). The Vice of Luxury (*Luxuria*) is introduced at dinner, overindulging in wine and food. In the first image on fol. 132v, we see the moment she is summoned to the battle of the Virtues and the Vices by two trumpet players. As we can see in the image, Luxury is not armed with a sword (or any other conventional weapon, unlike Prudentius' other Vices), but instead bears flowers — roses and violets. In the second scene, we see her departing in her chariot, with awestruck admirers left in her wake. The third scene depicts her seducing the Virtues with the flowers' fragrance. On fol. 133r, Luxury exerts her charms. The Virtues, depicted to the left of each scene, stand powerless with their weapons in hand, struck into inaction by the sight of Luxury's glittering-gold gem-studded chariot. Their defeat seems certain, but, as Prudentius goes on to explain in the following pages, Moderation (*Sobrietas*) ultimately rallies the Virtues, defeating Luxury by trapping her under her own chariot, finally stoning her to death.

The illustrations (which were first etched on to the parchment with a sharp metal point that left grey traces to be inked) keep pace with the accompanying text. Each is accompanied by a rubricated (red-inked)

<< Fig. 1
Five illustrated scenes on the depicted opening show Luxury seducing the Virtues. The erasure of her face is particularly prominent in the central scene on fol. 132v and in both scenes on fol. 133r. The dynamism of the drawings is conveyed by the prancing of the horses out of the ruled space of fol. 133r and into the right margin.
BUR Q 3, fols 132v–133r (image 92%).

caption describing the scene (note that *Luxuria* was spelled incorrectly as *Luxoria* in these captions; the error has been corrected by another hand in brown ink). As well as adding to the drama of the written narrative, these illustrations facilitated reader engagement with the text. On fols 132v–133r, we find traces of a reader who seems to have felt particularly strongly about this portion of the epic. In four of the scenes, the face of Luxury has been erased, as though someone took their finger and forcefully rubbed it against the parchment, leaving a greyish mark.

Through erasing Luxury's face in a seeming act of rejection, this anonymous reader showed that they identified with this pivotal scene; they, too, viewed themselves as participants in the battle against the Vices, standing up to Luxury and resisting her charms. Such engagement shows that the *Psychomachia* held a personal meaning for its readers. It was widely read in medieval monastic contexts, elevating the struggles that may have been experienced by the medieval monk — such as abstinence from food and drink during periods of fasting, or the demands of the vow of chastity — into a metaphoric fight for the soul that would guarantee the reader's ultimate salvation.

Piecing together the later history of BUR Q 3 is complex. Its *Psychomachia* was used as an exemplar for two other copies of the text: Valenciennes, France, Médiathèque Simone Veil, MS 412 and Brussels, KBR, MS 9987-91. Both of these manuscripts were copied at the Abbey of Saint-Amand in France, so we know that BUR Q 3 was then in that abbey's possession. Later, it was part of the holdings of Egmond Abbey in the County of Holland. The mid-sixteenth-century inventory of Egmond's collection (now Leiden University Library, MS LTK 611), which was based in part on earlier medieval book lists, describes a similar item (fol. 146v): *it(em) prude(n)tiu(m) sichomatie* [sic] ('also Prudentius' *Psychomachia*'). This book is listed among the volumes *q(uo)s scolares illi(us) t(em)p(or)is p(ro)curaveru(n)t* ('which the students of that time [during the abbacy of Wouter (1129–1161)] obtained'). Here *procurare* is translated not according to its classical Latin meaning of 'to take care of', but in line with later Latin usage, 'to procure'. This entry may suggest that the manuscript was at the Abbey of Egmond since the twelfth century, although we cannot be certain that it necessarily refers to this copy of the *Psychomachia*.

Fig. 2
The list of books added to the Abbey of Egmond's collection during the abbacy of Wouter (1129–1161). The entry for the *sichomatie* [sic], *Psychomachia*, is underlined in pencil. The list opens with a heading describing how these books were obtained by the *scolares* ('students') of the Abbey. LTK 611, fol. 146v, detail.

The manuscript was definitely at the Abbey of Egmond no later than the late fourteenth century. Various markings, including a note in the top margin of fol. 181v indicating its total number of folia, suggest that it was inventoried at the Abbey around 1400. Following the plunder (1567) and destruction (1573) of the Abbey during the Dutch Revolt, Egmond's collection was dispersed. Profits from the Abbey's holdings were used by William of Orange (1533–1584) to finance the establishment of Leiden University in 1575. It is perhaps fitting, therefore, that this manuscript later became part of Leiden's collection.

— Irene O'Daly

animu aduorta panimu adiq̃ In u t̃co tugurnu &ca panqquissimo
hircunq nd requiri. In hir q̃ atq̃a coniugatione nascunt loco, e, u sem
mutuimus ut faciundu legundu dicundu ut trudu p̃cidendu legendu
cidum ut rudidum. Transit ta ciur cii̇ur cinietim paulur pau
paulaqm In e fortir forte pupillari sapientem In o patrur patronur
t̃co ubu olli p illi rexi rexorur In u carnir cannusse antiqui peauniffe
lubiur plibiur pessimur ppssimur. Secidu tam qp plerunq no
q̃ cum ubir siue panticipiur componunt nomina cui mutant lit̃pm
fillubam In i corriptam arma armipotenr homo homicida cornu cor
niger stella stelliger apcur apcruber focur focidicur auru aurussi caupa
sideicur lucror lucussicur cornu cornicen tuba tubicen fidor plur
le er singulare fidir; unde dimim t̃quui fidiculu fidi cen tibia tibicen
p̃tibicen tibuiia i.i. debuit mutare ut supradictur; un ponuebur In
uib una longa facta q̃ in alia copositione hi cemodi n mutantur uulnur
nificur magnur magnificur amplur amplificur fructur fructifir opur
opificer. Uel cinetim ut unu uiri umi potenr par paur parricida q̃ t a pa
coponi uel ut alii a pat̃re bre petape in i. euphoniae caupa addi; sin a
pat̃re t in i. i.qui q̃ quibdam taim uidet apunbire ee compositum 7 p par
ticida p syncopam 7 p comutatione in i m i. factum parricida lux lu
cir lucifer flor florir florifer facer facen luerpificer fructuf ut
fructifer soror sororir soromida ap apir antifer. Pauca s̃t
q̃ hanc regulam perculum ut auceps auf capienr m tii ceps m bite capri
augentur 7 similia & e q̃e duob; nominatuir coponunt ut & eucli designatur
cecinur lucur truce cenur Aliq̃ it alius ciuitatir tǎ te plimon h
bebant p in loco me ponebant u, 7 maxime umbri, t̃ures tr̃n
in a, ut cucon cucuam ne ut cucon titelu bonur b cne porcu genu
por per antiqui copere p copor in quo Colchi requimur illi H odor te pm
odonto drit O nsiq̃ ti m.i. uirgo uinginir in u t̃nbno tnsmu huc illi
p hoc illoc uir in um tunc hoc ignipotenr cuelo der cendra a balto
& plerunq q̃ap gñr nominatiuum in oc eminent o s u iacuent apnor
s̃r hoc s̃r hur et opde oe spondeur s̃r ripoc ciprur pelupoc pelagi
Multa p̃tera uetustissimi s̃r in principalib; mutabant syllabur cum

[Medieval Latin manuscript page — handwriting not reliably transcribable]

A *multicultural book*

21 | Priscian, *Institutiones grammaticae* and other texts
838 — BPL 67

In 838 AD, a manuscript was produced in a monastery in Francia that contained texts by Priscian (active c. 500 AD) about geography and Latin grammar. The unusual thing about this manuscript is that it has all the features of an Irish product. Therefore it tells the story of a multicultural society of the early Middle Ages, and has a connection to the northern Low Countries as well.

<< Fig. 1
Opening of BPL 67, with various notes by readers from different centuries in the margin.
BPL 67, fols 15v–16r.

Fig. 2
In the bottom margin of fol. 32v, John Scottus Eriugena has copied a passage from Homer's *Odyssey* in Greek, with a word-for-word translation into Latin in smaller letters above.
BPL 67, fol. 32v, detail.

Anyone who is handed this manuscript — BPL 67 — at the desk in the Leiden reading room will be surprised by its weight (more than four kilograms). It is a thick book measuring about 280 millimetres in height and 210 in width (roughly A4 format, in other words), with two hundred parchment leaves bound in thick wooden boards covered in leather. The manuscript was produced in the ninth century. It contains two works by the late classical author Priscian. This author, who hailed from Caesarea in North Africa, is mainly known for his textbook on the Latin language, *Institutiones grammaticae* ('The foundations of grammar'). That work is contained in this manuscript. It is, however, preceded by a lesser known work, *Periegesis*. This is a didactic poem about the world dating to the second or third century AD, written by the Greek author Dionysius Periegetes and translated into Latin by Priscian. The Roman province of Africa had a flourishing cultural life in late Antiquity. It was a melting pot of Greek, Roman and Middle Eastern influences, producing significant writers and thinkers such as Martianus Capella (active c. 410) and Augustine of Hippo (354–430). Priscian's textbook on grammar testifies to this cultural richness. It delves deep into the Latin language in all its complexity, following the example of Greek grammar manuals, and it is full of citations from Greek literature.

Just as Priscian's text serves as a link between the Greek and Roman cultures in Late Antiquity, this particular manuscript similarly serves as a link between the Irish and Frankish cultures in the ninth century. The book was made in Francia, possibly in Laon, but it is written using an Irish script (Insular minuscule). The shapes of the letters *e* and *g*, for example, are typically Irish, as is the decoration found in various places in the manuscript (see Fig. 3). At the end of the *Periegesis*, an Irish scholar named Dubthach (†869) added a colophon explaining that he completed copying the text on the third day before Easter and asking the reader to be mild in judging him for any errors he might have made. That is how we can deduce that the book was made in April 838.

It was not at all unusual at that time for Irish scholars to be working on the continent. From the early Middle Ages, Irish and English missionaries had crossed the sea to spread Christianity on the continent. One well-known example is Willibrord of Northumbria (c. 658–739), who converted the Frisians. In addition to these missionaries, many scholars came to the continent too. The Carolingian rulers Charlemagne (747/48–814), Louis the Pious (778–840) and Charles the Bald (823–877) pursued an active policy of gathering learned men from all over the empire at their court to forge a common identity and debate the issues of the day. By that time, Irish and Anglo-Saxon missionaries had settled in monasteries across Europe, in what is now France,

Italy, Switzerland and Germany (e.g. at Laon, Bobbio, St Gallen and Echternach). They brought books from their home countries. The contacts between the various writing cultures resulted in an interaction in which each left its traces on the other. The intermingling of cultures led to the mixing of writing practices.

Dubthach was one of those scholars. We find him in the circles of Sedulius Scottus (active c. 850), an Irish scholar at the courts of Louis the Pious and Charles the Bald. Numerous works by Dubthach have survived that bear witness to his wide reading and scholarly achievements. A third Irish scholar who moved in the same circles, namely John Scottus Eriugena (c. 810–870/880), has also left traces in BPL 67. We know he taught at the palace school of Charles the Bald and that he travelled to Reims, Soissons, Laon, Auxerre and Ferrières. We have been able to identify John's handwriting because he worked as a scholar at the behest of the emperor, who commissioned texts from him on solving and clarifying complex problems in theology, philosophy and science. In some of these texts, we can see him working on various versions of his treatises in his own hand.

We find his handwriting in BPL 67 too, as John Scottus Eriugena wrote notes in the margins of this book. The notes are comments on Greek vocabulary and terminology in Priscian's work, which reflects John's personal interests and working methods. An example can be seen in the lower margin of fol. 16r (see Fig. 1), where he has added *YPOC OROC visio vel diffinitio YLOC OLOC totius* ('*hyros/horos*, meaning sight, though the meaning is *hylos/holos*, in other words whole'). Elsewhere (for example on fol. 32v, see Fig. 2), we find longer passages where Greek quotes have been supplemented with a Latin translation in the spaces between the lines.

BPL 67 has already taken us on a journey to Roman North Africa and Irish Laon in the ninth century, but it then takes us even further: in around 1100, we can follow the manuscript's path to the northern Low Countries. That is because this manuscript has notes made later in hands that place the book in the library of the Benedictine abbey of Egmond. The book must have travelled from Laon to Ghent (a destination shared by a number of books from Laon), where it fell into the hands of a certain master Baldwin who donated it to the recently established abbey in Egmond. It would seem the library there was in need of books. It is striking to see how intensively the Egmond monks used this old manuscript written in Irish minuscule. They added keywords and brief summaries in the margins to help them find their way around this long, complex work. Their marginal texts, in their distinctive red ink, are found throughout this book. Incidentally, the chemical composition of this red ink was such that it did not stand the test of time: the ink damage to the parchment can be seen in the left outer margin of fol. 132v (see Fig. 1).

This book reveals a rich and dynamic history of scholarship in its numerous facets. The content derives from the melting pot of Roman Africa in late Antiquity while the form is the product of a Europe in which migration led to cultural cross-fertilisation and blossoming. The traces of later use in turn tell us more about the nature of education and study in the early Netherlands. This book may not have golden initials, but its modest appearance contains a treasure trove of information.

— Mariken Teeuwen

Fig. 3
Initial *Phi(losophi)* at the start of Priscian's *Institutiones*. The Insular style of decoration is evident in the animal motifs and the interlacing patterns. The Insular minuscule is clearly recognisable in the shape of the letters *e* (e.g. line 2, *-bile*) and *g* (e.g. line 9, *intelligi*). BPL 67, fol. 10r, detail.

Ut tuus iste nepos olim satur uisceris œdi
Cu morosa uago singultiet inguine uena
Patricios inmerat uolucr' m' tanta figure
Sat relicfi ast illi tronat omento popauerit
Unde anima lacro mercare atq execute sollers
Omne latus mundi nec sit prstantior alter
Cappadocas rigida pingues plauisse catasta
Rem duplica feci u triploc u mihi quarto
Iam redit in ruga decies depinge ubi sistam;
Inuentus crisippe tui finitior acerui

INCIPIT LIBER IVVENALIS

SEMPEREGOAVDITORTAN
TVMNVMQVAMNEREPONA
Vexatus totiens rauci theseide chodri
Inpune ergo mihi recitauerit ille togatas
Hic elegos inpune diem consumpserit ingens
Telephus aut summi plena iam margine libri
Scriptus et intergo necdum finitus orestes
Nota magis nulli domus e sua qua mihi lucus
Martis et eolus uicinum rupibus antrum
Vulcani qd agant uenti quas torqueat umbras
Aeacus unde alius furtiue deuehat aurum
Pelliculae quantas iaculet monte us ornos
Frontonis platani conuulsaq marmora clamant

Guided reading: An annotated classical text

22 | Persius, *Satyrae*; Juvenal, *Satyrae*
Eleventh century — BPL 82

What information did a medieval reader need at hand when navigating a classical text? This eleventh-century manuscript contains copies of collected satirical poems by the Roman authors Persius and Juvenal, enriched with a commentary full of allusions and cross-references. The manuscript reveals the variety of ways in which classical texts were augmented with additional information for interested medieval readers.

Famed for their witty satirical poetry, Persius (34–62 AD) and Juvenal (active 110–130 AD) were favoured authors for advanced medieval students. Their works frequently circulated together, perhaps inspired by late antique exemplars, where the authors were sometimes combined. The scribes of BPL 82, an eleventh-century manuscript most likely copied in Germany, may have been working from an exemplar that contained both authors, but the choice to copy both sets of poems together was, in any case, a deliberate one, targeting the perceived needs of the reader.

The point of transition between the writings of Persius and Juvenal in this manuscript occurs on fol. 14v. The first ten lines contain the last words of Persius' sixth and final satirical poem. While Persius' text ends without fanfare, the opening of Juvenal's first satire attracts attention: its two initial lines are written in large majuscule letters. Slight differences in letter forms between the two poems, along with a striking variation in ink colour, show that they were copied by two different scribes. Throughout the rest of the manuscript, subtle differences in the format of the texts suggest that the Juvenal section was added in a separate project by this second scribe.

Pairing the texts had practical and intellectual value. Containing only six satires, Persius' text is relatively short (in BPL 82, it is copied across 14 folia); if bound alone as a thin manuscript, it may have been vulnerable to physical damage. Combining the text with Juvenal's more lengthy satires gave the first work some physical protection. Furthermore, the pairing implicitly

< Fig. 1
The start of Juvenal's first satire is identifiable by the change in ink colour. The commentary passage on *togatas* ('toga wearers'), is found in the lower-left margin, introduced by a letter 'D' placed close to the edge of the page. This 'D' links commentary to text; the letter is repeated above the corresponding word in the fourth line of the first satire. BPL 82, fol. 14v.

Fig. 2
Marked with a cross, a line referring to the *canina littera*, or 'canine letter' (r), in this copy of Persius' satires is accompanied by a drypoint sketch of a dog (see discussion on p. 34). BPL 82, fol. 4r, detail.

161

Fig. 3
Persius is depicted writing on a wax tablet with a stylus. The building, with its classical features, seems to represent a portico or colonnade. The blue and green background suggests that the author is working in the open air. BPL 82, fol. 1v, detail.

encouraged readers to examine the two sets of satires in conjunction and spot the parallels in style and content shared by these late antique poets. By making such combinations of texts, scribes could exercise considerable agency in shaping the content of a manuscript and so influence the reader's experience.

The power of the scribe is implicitly acknowledged in the elaborate portrait found at the opening of Persius' first satire on fol. 1v. Here, Persius, identifiable as a classical author through his antiquated clothing, is depicted in the act of writing, as seen in figure 2. The eye is drawn to his disproportionately large hands, which hold a stylus over an open wax tablet. He is pictured working at a desk; the act of textual composition is signified by writing. This portrait reminds the reader that recording and preserving texts is the job of the scribe. It is through their actions that the text is 'voiced' to the medieval reader.

As we can see on fol. 14v, the copyist of Juvenal's satires anticipated the needs of his readers by copying alongside the text a detailed commentary derived from classical and medieval *scholia* or commentaries on Juvenal. Crowded into the margins around the central column of text and even filling the space between its lines, this commentary offers a variety of information. For example, on fol. 14v, directly to the left of the opening of the first satire, we find a short biography of the author copied in a diminutive script, beginning with the words *Iuvenalis satiricus aq(u)inates fuit, i(d est) de Aq(u)ino o(p)pido* ('Juvenal was an Aquinate satirist; that is, from the town of Aquino').

The accompanying commentary explains the text in detail, facilitating its study. For example, the fourth line of Juvenal's first satire ends with the word *togatas*, a word that can be literally translated as 'toga wearers'. The comment given above the word here explains that Juvenal used the term metaphorically to mean *comedias v(el) tragoedias* ('[Roman] comedies or tragedies'). The curious reader who wished to find out more could follow the accompanying cross-reference mark ('D') placed above the word to the lower left margin, where a passage also marked with 'D' supplies further information. This passage indicates that *togatas* is a

Fig. 4
On the opening leaf of the manuscript, a reader has noted the names of various mythological deities, starting with the nine Muses. Explanations of their attributes or powers have been added between the lines.
BPL 82, fol. 1r, detail.

word used to describe *Romanos* ('Roman citizens'), who all wore togas, meaning that they were a *togata(m) gente(m)* ('toga-wearing people'). The commentary adds that wearing the toga distinguished masters from servants, who wore a *colobium* ('undershirt') instead. Referring to a line from Virgil's *Aeneid* (in which the Roman poet criticised the elaborate clothing of Phrygian men, claiming that they should be called 'women of Phrygia', not 'men of Phrygia'), the commentary explains that the word *togatas* is feminine in gender and so evokes the effeminate extravagance of the ancient Romans.

The inclusion of such a commentary allowed the reader to explore the text on multiple levels, depending on the kind of information in which they were interested. Here the reader found not only a narrow explanation of the word *togatas* in the context of Juvenal's text (a type of drama), but also an explanation for why the word was used to connote 'Romans' in general. In addition to a short grammatical account of the gender of the word drawing a moralising parallel with another ancient Roman text, the reader received contextual information explaining the status that a toga conferred upon its wearer. As this example shows, classical texts were studied by medieval readers not only for their literary value, but also because they opened a window into the history and culture of the ancient world.

Other additions to BPL 82 show that such engagement with readers was an ongoing process. On fol. 1r, at the opening of the manuscript, a later eleventh-century hand has added a reference list of various figures associated with Greek and Roman mythology. These include the nine Muses, three Graces and three Gorgons, along with the names of the four horses who pulled the chariot of the sun god, before concluding with the names of the rivers of Hell. This list was a point of reference for Persius' and Juvenal's occasional mentions of mythological figures. More significantly, it served to orientate the expectations of the reader by situating the texts within a classical context that, for an imaginative medieval scholar, was populated not only by poets, but also by gods and goddesses.

— Irene O'Daly



[Medieval manuscript page with heavy marginal glosses surrounding a central text block. The text is in Latin, heavily abbreviated in Gothic script, and largely illegible at this resolution. Decorated initials in red and blue are visible, including an ornate "H" and "D" in the central column. Running headers read "De integru restituend." and "De iudicijs." with "Liber ij" and folio number "15". A library stamp "ACAD. LUGD. BAT. BIBL." appears at the bottom.]

Canon law in Bologna

23 | Manuscript containing the *Constitutiones Clementinae*
Fourteenth century, 1322–1334 — ABL 14

This manuscript from Bologna containing canon laws decreed by Pope Clement v was made for Hugo de Constancia, according to the inscription at the back. This young man had left Constance (on the lake of the same name) for the renowned university city in what is now Italy, to study canon law. As a student, he studied the material assiduously and added all kinds of notes.

<< Fig. 1
Constitutiones Clementinae, end of Book I and beginning of Book II. ABL 14, fols 14v–15r (image 63%).

On 21 March 1314, Pope Clement v (1264–1314) promulgated a collection of laws that he had written during the period of the Council of Vienne (1311–1312). How the first exemplar of this collection was presented to Pope Clement was recorded in the opening miniature of codex ABL 14. Because he died shortly afterwards, confusion reigned about the validity of these *Constitutiones Clementinae*. Pope John xxii therefore issued them again in 1317 through the papal bull *Quoniam Nulla* that opens this manuscript. In addition to the text of the *Clementinae*, the standard commentary — the *Glossa ordinaria* by Johannes Andreae (c. 1270–1348) — has been included too. In between the *Clementinae* and the standard commentary, the student Hugo de Constancia has also noted down other commentaries in a somewhat smaller script, such as those of Paulus de Lizariis, Guilelmus de Monte Lauduno and Bernardus Maynardi.

A custom had arisen at various universities of producing manuscripts according to the *pecia* system. Both to ensure the quality and because of financial considerations, the university made a certified sample text available from a *stationarius*, an official whose role was to make sure that the text remained authentic and complete. He also subdivided the exemplar into pieces (*peciae*), making it possible for several students to borrow parts of it at the same time and copy it (or have someone else do so). It can be seen from this manuscript that the university at Bologna utilised the *pecia* system: the scribe of ABL 14 made annotations here and there, for instance in the inner margin of fol. 4r: *finis p(rime) petie* ('The first part ends here'). It was a professional scribe rather than Hugo himself who laid out the main text and surrounding commentary in perfect symmetry for each manuscript opening, using varying letter sizes and a variable number of lines per opening for the legal texts depending on the corresponding amount of commentary. The structure of the *Constitutiones* — subdivided into five *libri* (books) and then further into *tituli* (titles) and *capita* (chapters) — was made clear using red captions, and illustrated initials and paragraph markers in red and blue.

Fig. 2
Constitutiones Clementinae, miniature of the presentation to Pope Clement v. ABL 14, fol. 1r, detail.

How was this manuscript used? To illustrate its use, a single passage of text from the heading shown (fols 14v–15r) can be taken as an example. Starting in column 15r(a) and highlighted with a blue initial 'A', we see the text of the law *Ab ecclesia*, the only text from title 11, DE RESTITUTIONE IN INTEGRUM ('On restoration to the initial state'), which ends Book I. The red heading for Title 11 was however already given in column 14v(b). A little lower down, in tiny script, the commentary on *Ab ecclesia* also begins, highlighted with a blue initial 'A'. The red heading in column 15r(b), meanwhile, marks where Title 1 of Book II, DE IUDICIIS, starts.

The first sentence of *Clem*. I.11.1 reads as follows: *Clemens quintus: Ab ecc(lesi)a adversu(s) lapsu(m) temporis, in quo se l(a)esam affirmat, in integrum restitu(ti)o peti pot(est)*. In translation: 'Clement v: The Church can ask for restoration to the initial state if the period during which it believes that it has been disadvantaged has expired.' This 'restoration to the initial state' is a legal phrase from Roman law in which the person who has suffered damages asks the judge for remediation to restore the situation that pertained before they incurred the damages. Such damages could for example have arisen through the passage of time leading to legal claims expiring or easements (the right to cross or otherwise use someone else's land) becoming void due to not being used (*non-usus*). In this older context, it is a legal phrasing mostly for protecting natural persons aged under twenty-five against legal actions that lead to them suffering damages and to protect persons who were required to spend time in distant provinces for state business. It was however not intended for use by legal persons such as a church. That was an innovation in canon law, here implemented by Clement v, for the benefit of churches that had incurred damage because they were not properly represented (*procuratio*). After a successful appeal to restoration to the initial state, the judge would grant a church reparations or compensation for the damages incurred by the deficiencies in its representation. This title is thereby a logical follow-up to Title 10, *De Procuratoribus*, of which the final chapter — in column 14v(b) and commencing with *Procuratorem* — is highlighted by a blue initial.

To find out more about this text, the reader can use the comments. In the main text, references are made to this using letters. This basically works in the same way as footnotes in modern texts. Above the word *peti* in column 15r(a) is a letter 'x' that corresponds to the 'x' of the commentary above in the inner margin. The commentary says *peti pot(est)*: *D(e) h(oc) n(on) du(bitabatur) ut abse(n)s ca(usa) rei public(a)e (vel) alia iusta ca(usa) restituitur (Digestis) Ex Quibus Ca(usis) Ma(iores) L(ege) I (prima) cu(m) si(mi)libus*. This translates as 'There could be no doubt about this, just as he who is absent for state business or because of other valid reasons will be granted restoration to the initial state. See the Digests under the title "Grounds on which people aged over twenty-five can be granted restoration to the initial state" for the first law covering comparable cases.' In these comparable cases, a natural person has suffered damages because he was absent from home on state business. Such damages could be reversed by calling for restoration to the initial state. The text can be found in the Digests of the Roman emperor Justinian (484–565), Book 4, Title 6. In addition to this manuscript with the *Clementinae*, Hugo de Constancia therefore also needed a copy of the Justinian Digests. Indeed, the applicable maxim is *Ecclesia Romana vivit lege Romana* — in other words, 'The Church of Rome lives according to Roman law.'

The student himself has also added his own 'footnotes', although he used symbols rather than the alphabet. A small cross with two dots can be seen above the word *pot(est)*, corresponding to the symbol in the additional text provided in the top left margin between the main text and the commentary. This contains a comment based on Guilelmus de Monte Lauduno: *Q(ui) dicat ei no(n) petenti iudic(is) off(ici)o no(n) s(u)bve(n)iret(ur) // cu(m) sit loco actor(is) de off(icio) iudic(is)*. In translation: 'He [Guilelmus] states that whomsoever fails to ask for restoration to the initial state cannot be assisted officially by the judge, as he [the judge] would then be taking on the role of the claimant; see the title about the office of being a judge.' This therefore means that a judge cannot of his own accord grant restoration to the initial state to a claimant unless the latter has made such a request himself. It is not unlikely that this addendum is an elaboration of a note made by Hugo during a lecture. This means he had two authoritative commentaries available in addition to the main text.

ABL 14 gives us a unique glimpse into the everyday activities of a hardworking, fourteenth-century model student. May he be a source of inspiration to the current generation of students of law in Leiden and elsewhere, and the many generations that will follow.

— Quintijn Mauer

Fig. 3
Constitutiones Clementinae, Title I.11 *Ab ecclesia*, commentary by Johannes Andreae and notes by the student Hugo de Constancia. ABL 14, fol. 15r(a), detail.

WORDS AND LANGUAGES

In essence, texts are collections of words. In the medieval period, when books were scarce and reading was a skill few possessed, words — the fundamental building blocks of a text — attracted keen attention from scholars. The primary reason for this interest is perhaps obvious: to read, particularly in a foreign tongue, one had to understand the vocabulary of the language. Special compilations were produced to introduce and teach such vocabularies. A good example is a ninth-century copy, almost square in format, of the *Hermeneumata Pseudodositheana* (no. 25, VGQ 7), a bilingual Latin-Greek textbook.

But textbooks like the *Hermeneumata* and other glossary manuscripts were more than simply points of access to vocabulary lists. Rather, they captured the infinite possibilities of language — both mundane and exotic. Medieval compilers made collections of vocabulary lists — often arranged by letter, but sometimes by theme or author — which could be browsed for various purposes. Multiple glossaries could even be copied into a single manuscript (see no. 24, BPL 67 F), creating a collection of linguistic curiosities. In such lists, definitions of common words were found alongside more exceptional ones — preserved, even treasured, on account of their rarity.

Through such manuscripts, we glimpse how words could entertain and intrigue. Unusual etymologies inspired wordplay and riddles (see no. 26, VLQ 106, in its striking modern red binding). The skills of encoding, decoding, obscuring and interpreting were hallmarks of the intellectual elite of the ninth-century Carolingian schools. An almost-forgotten shorthand system of Roman antiquity, Tironian notes, was even revived (see no. 27, VLO 94, a tiny dictionary of this shorthand). Meanwhile, unusual alphabets were also a source of fascination, as an instance where Latin phrases were copied out in Greek characters suggests (see no. 24, BPL 67 F).

This interest in words was not, of course, confined to Latin and Greek, but also extended to vernacular languages, including German (nos 25 and 28; VGQ 7 and BPL 130, respectively) and Old English (no. 26, VLQ 106). Through close examination of manuscripts and their annotations, scholars can reconstruct aspects of medieval dialects and spelling conventions and can use such evidence to localise the producers of a text or its readers. It is no wonder that glossary manuscripts and other early texts in vernacular tongues have remained a subject of fascination for scholars, inspiring research from the early modern period to the present day (see nos 26 and 28; VLQ 106 and BPL 130, respectively). (IO'D)

Words and languages | Manuscripts, *from rear, left to right*:
BPL 67 F (no. 24), VLO 94 (no. 27, *above*), BPL 130 (28, *below*) — VLQ 106 (no. 26, *above*), VGQ 7 (no. 25, *below*)

Thacia ciuitas	Trugona troia	Tumulus locus	Uestrarbus
in grecia	genia	altus t monum tu	uestri
Thapsus ciuitas	Tripudium	Tumulus clangor	Uenditarra
interiniala	pars triumphi	idē sonus cūtumulas	uenderes
ciuitas &tripoli	Tripodas	Tumidus superbus	Uestigiur Indicatur
Thesis requiemne	mensas Insacris	Turbidine	
nimphaerunt	apollinis	p̄turbationem	Uegetus fortissim̄
			Uegex ualet
Timensis clangor	Tributa donas	Tyrii cartaneñsis	Uerrunt parant
Idē sonitus cum	largir muneras	ipsi sidonii dicuntr̄	Uerbosus uerbi
tumultu	Trepidus lentus	Uadimus Imus	gratia
Torridus uelox	timidus	Uaccantia luxem	Uexatus portatur
Torax facies	Transsiuissent	paratur turpium	Uictrix femina
Torsit Inflexit	transissent	Uastatur hortatur	uidtur
Torpor stupor	Tranquillare	Uagiatur	Uicesim Inuicem
tam Animae	placare reperate	exagitatur	Uicissitudo
quā corporis	Transgredimur	Uagitatur uno	uicem reddens
Torrent arant	antecedimus	lenter flet	Uuallū signum
t siccant	Tropus sonus	Uarius falla	militare
Torrens candens	Turbo uertigo	Ubina quomodo	Uuabundus
Triacria sicilia	p̄cella	Uerisimile	mouens
	Turpidinem	uertransimile	Uirēl uiridiē
	uerti uertigine	Uergit Infundit	Uincturum
Trini terni	ruina	Uelut potius	uincturum
Tris tristis	Turbidus turba	Uestu poteratum	Ustur uidtur
Tragedia fabula	lentus p̄uidus	Uenustas	Uidiare uidiaris
tragediae	Tulere zuleti	pulchritudo	Umositas
Trux res seua	Tueamur	Uerstur dubitat	turpitudo
cū asperitate	custodiamur	par̄ sdatur	Usqueat ursus
Trucidiat	Turbat	Uertitur ueregin	possit
occidit	p̄cipitat	Uenustus pulchrius	Uidelicet sciā acre
			cer̄

62

...rentib; uoci praegonum ut die infrigidat **ABΒV**
umore pleni laudem ut que admodu pater pabi idē
iam facit diuidit uoluptas uaria quidem abur abi
...r aperit concupiscentia optandu uerbu Abactur abactor
...ecta uiridi Uosmet uos inceptor ut pote remotur
...ela coloquintae Uolumina urbes ut potui Abalio deserit
...trum p aicem Uolumen libera Uterq; duo praecipitat
...atum foetior uoluendo dicitur Utriusq; ambo Aba mater
...scera interiora Uolubilis Utriusq; ter x duo cera soror alia
...parat carnis resecata Uulnus animi Abamita soror abi
...iduuium quae Uotis nuncupat dolor Abasu infama
...or marturamisit q occurit dodi Uulgus populus domur
...ntur colligatur cacuum uotum Uulgare adsidu Abdicat repellit
...nculu alligatio Uo...tis incapitulio uni cotidianum expellit alienat
...igat crescit r...erte nuncupat **Ζema** Abdicat derogat
...ubrix corruscat Uotis incapitulio **Ζulla** detrahit
Alnus capula solito more nuncupat **Ζizanium** Abdidit occul
...xtensio manur Uolut refouit lolium ...t abscondit
Albur defensus Urtur crematur Abdit abscon
Alcur uulnus qd Urspiam ubicumq; **ΛWZΛS** dit abdicit
...perpol nascitur Usiam substan **WΘEWC** distiq;
Alba herba tia materiae Abditu abscon
palustris Ustrina ubi porci **ΛMIH** sum occultum
Uberius deinceps ostulantur Abducet subtra
Uludus humectat Usta p terra hit aufero
humectat ut comperit
...ara ampliur uidicet ...partat
Uuicae primae Uterq; urm Abeny... amila
 optimae aliqui urm umentali...
Columar menr Ut echo frigat Aberrat... ab
ΘEΛNW ...part

Searching for words

24 | Latin glossary and other texts
Eighth century, late, or early ninth century — BPL 67 F

Prior to the introduction of alphabetised dictionaries, glossaries — collections of definitions of words — were popular. These collections were often copied together, meaning that a single manuscript could contain several possible definitions of a word. This glossary collection, BPL 67 F, contains no fewer than ten separate glossaries, an appreciable collection that showcases the state of lexicographical knowledge of Latin in the early Middle Ages.

<< Fig. 1
The opening of the *Abavus* glossary is found at the start of the fourth column on fol. 62r. Note the difference in colour between the flesh (fol. 61v) and hair (fol. 62r) sides of the parchment. BPL 67 F, fols 61v–62r.

Glossaries were useful tools for those wishing to learn more about Latin; as well as providing explanations, they sometimes offered synonyms or antonyms of a word or described aspects of its grammar. BPL 67 F, copied in northeastern France in the late eighth or early ninth century, is a compilation of several glossaries, copied by multiple scribes. On fol. 62r, we find a transition from one glossary to the next. At the top of the narrow fourth column of text is the first lemma of a new glossary, written in stylised majuscule letters — *ABABU* [sic] — along with a definition: *pater p(ro)abi, id e(st) abus abi*, which defines *abavus* as 'the father of the great-grandfather; that is, the grandfather of the grandfather'. Gloss collections often take their name from their first listed word; this collection is usually referred to as the '*Abavus*

Fig. 2
At the end of the manuscript, a scribe has added the characters and names of the letters of the Greek alphabet. Writing in Latin, but using Greek characters, they identified themselves in the line that follows as Gaustmarus. BPL 67 F, fol. 158v, detail.

glossary', and BPL 67 F is one of its major, and earliest, textual witnesses.

The previous glossary (which ends in the third column of fol. 62r) concludes with two words starting with Z, ending with *zizanium*, a type of grass. The scribe of this leaf extended the majuscule letter Z across three ruled lines, adding extra ornamentation to mark the final section of the glossary and highlight this letter, which is rarely used at the start of Latin words. Following the glossary, three short lines of text added in Greek characters read: ΔωζA ϛΥ ω θεως AMIN. This is a slightly barbarised version of the Greek phrase *Doxa soi o Theos* ('Glory to you, o God'), followed by the Hebrew word 'Amen', transliterated into Greek characters. Although scribes often ended their texts with praise of God, this unusual incorporation of Greek, even if inexpertly traced, resonates with the lexicographical interests that motivated medieval glossary collectors.

While this concluding phrase in praise of God is formulaic, the scribe demonstrates further knowledge of Greek by tracing in the lower margin of fol. 62r (under its first column, see Fig. 1) the characters θεΛNω (*thelno*). It is likely that the scribe (again, inexpertly) was writing a form of θέλημα (*thelêma*), the Greek word for '[the] will', particularly as the Latin lemma directly above these characters reads *voluntas* ('will'). Scribal interest in Greek is also evident on the final folio of the manuscript, where a Greek alphabet, accompanied by the names of the letters, has been added. The scribe who recorded this alphabet (one

172

of several involved in the production of BPL 67 F) included a Latin phrase transliterated into Greek characters underneath, claiming responsibility for writing out the Greek and identifying himself as Gaustmarus. Given that knowledge of Greek was relatively rare in the early Middle Ages, these experimentations with the language show an appetite for its curious forms and exotic character.

The glossaries in BPL 67 F range from alphabetic word lists, to a thematic glossary specialising in terms from the works of the Roman poet Virgil (the *Glossae Virgilianae*), to a short list of various sounds made by animate things (*Voces variae animantium*, fol. 152r). This list of sounds opens with the words *ovis bobat, canis latrat, lupus ululat* ('the sheep bleats, the dog barks, the wolf howls'). It is derived from the *Laterculus* of Polemius Silvius, a work on the calendar written in 449 AD, and was copied often throughout the Middle Ages. Although not alphabetised, the list has its own internal structure, moving from mammals through flying insects to birds. It ends with a few unusual entries, such as *ignis crepitat* ('the fire crackles') and *cursus acquorum murmoret* ('the water course murmurs'). Although its basic content might seem more at home in a children's book, it showcases the interest the compilers of BPL 67 F had in lexicographical novelties; the use of onomatopoeic vocabulary, where the sound echoes the sense (e.g. *ululat*), is a form of wordplay. By including 'fire', 'water' and other entities usually regarded as inanimate, the list may have also prompted philosophical discussions around the nature of sound, vocalisation and the production of meaning.

Specifics about where and when BPL 67 F was produced are elusive. Its script, a regular small early Carolingian minuscule copied by multiple hands, suggests a date in the late eighth or early ninth century AD. It is likely that it was copied in northeastern France, in one of the many monastic centres engaged in manuscript production during this period. One interesting aspect of the manuscript is its use of parchment. In most manuscripts produced during the Middle Ages, sheets of parchment (bifolia) were arranged within quires so that when the book was opened the lighter-coloured flesh side of the parchment would face another flesh side while the darker-coloured hair side faced a hair side. This arrangement gave manuscript openings a visual regularity.

If we look again at fols 61v-62r (see Fig. 1), it is clear that this common arrangement has not been followed in the case of BPL 67 F. Fol. 61v is pale, using the flesh side of the parchment, while fol. 62r is darker, with visible follicles showing that this is the hair side of the parchment. In several quires of the manuscript, flesh and hair sides alternate across openings in this manner. As well as giving the manuscript an unusual visual aspect, it may suggest that it was made in a writing centre where practices of book production were not standardised, or where scribes of different backgrounds and training were working side by side. Another interesting element of parchment use visible on this opening is the use of a curved piece (i.e. a piece cut from the edge of the prepared parchment sheet) for fol. 62r. The scribe probably selected this parchment specifically for this page. Its curved edge, coinciding with the opening of the *Abavus* glossary, could serve as a handy in-built physical marker for a reader thumbing through the book and its various glossaries. Book production is a craft, but the manuscript's fundamental characteristic — to be read — was never far from the scribe's mind.

— Irene O'Daly

Fig. 3
The list of sounds made by 'animate things' is introduced by a title in majuscules, underlined in red. The list opens with the phrase *ovis bobat* ('the sheep bleats'), while the first column ends with the phrase *apis bobit* ('the bee buzzes'). BPL 67 F, fol. 152r.

καὶ αἴας τελαμῶνος	& aiax Telamonius	INCIPIT HERMENE	
ϲυνεζηλᾶται	ftatim fuerunt	UMATA ID̄ LIBRI XII	
τότε καὶ νέϲτωρ	tunc & nestor	ΠΕΡΙϹΥΝΑΝΑϹΤΡΟΦΗϹ	
διὰ τὸ γέρας	propt[er] senectutem	deconuerſatione	
πλουϲίως ἐτιμήθη	honeste honoratus e[st]	ΚΑΘΗΜΕΡΙΝΗ	cotidiana
ὅπλοις πάλιν διομήδης	armis iteru[m] diomedes	ϹΥΝΑΝΑϹΤΡΟΦΗ	conuerſatio
αἴας ὁ λέρς	oeſle	ΗΜΕΡΑ	dies
καὶ τελαμωνίοιϲ ἴϲοις	& telamonios equalis	ΕΛΕΙΟϹ	ſol
δώροις τιμηθέντες	p[ri]mus honorati sunt	ΑΝΕΤΙΔΕΝ	ortus est
ἀπεχώρηϲεν	discesserunt	ΗΛΙΟΥΑΝΑΤΟΛΗ	ſol is ortus
δίϲκω πολ ποίης	discopolr pola	ΦΩϹ	lux
τόξω τεῦκρος	ſagitate ucros	ΦΛΟϹ	lumen
καὶ ἀκοντίω	& iaculo	ΗΔΗΦΩϹΤΙ ΖΙ	iam lucet
ἀγαμέμνων	agamemnon	ΗΩϹ	aurora
καὶ ἐπῄνεθη	& laudatus est	ΠΡΟΦΛΟϹ	ante lucem
ὑπ' ἀχιλλέως	& achille	ΠΡΟΕΙ	mane
καὶ τότε ἀχιλλεὺς	& tunc achillis	ΕΓΡΟΜΑΙ	ſurgo
τὸ τοῦ ἕκτορος τῶ πῶμα	h[ec]toris corpus	ΗΓΕΡΘΗ	ſurrexit
περὶ τὸν τοῦ πατρόκλου	circu[m] patrocli	ΕΚΤΗϹΚΛΕΙΝΗϹ	delecto
τάφον	tumulum	ΚΛΕΙΝΗ	lectum
τρὶς περὶ ϲυρεν		ΕΓΡΗΤΟΡΗϹΕΝ	uigilauit
καὶ τότε ἀπόλλων		ΕΚΘΕϹ	heri
παρὰ τοῖϲ λοιποῖϲ θεοῖϲ		ΕΠΙΠΟΛΟΙ	diu
ἐρανεμεμψατο		ΕΝΔΥϹΟΝΜΟΙ	uestime[nta]
ὅτι τὸν αὐτὴν ἤρεϲκεν		ΔΟϹΕΜΟΙ	da mihi
ἤρεϲεν δὲ τοῖϲ λοιπος		ΥΠΟΔΗΜΑΤΑ	calciata
ἰν διερμορ		ΚΑΤΟΥϹΠΕΡΙΟΙϹ	&udones
το τοῦ εἰστο		ΚΛΙΝΑΖΥΛΑϹ	& brachas
ἄφελκυϲον ρὸς ϲῶμα		ΗΔΗΥΠΟΔΗΘΗΝ	iam calciatus su[m]

ενκε	adfer	χερε διδασκαλε	aue magister
ωρ προς χιρας	aquam manib;	χερε ταις συμμαθηται	au&e condisapuli
ωρ	aqua	ΜΑΘΗΣΤΑΙ	disapuli
ΝΧΗ	cancha	ΣΥΜΜΑΘΗΤΑΙ	condisapuli
ρης	manus	ΤΟΠΟΝ	locum
παραιεισιν	sordida est .o.	ΕΜΟΙ	mihi
πος	sordes	ΔΟΤΑΙ	date
ηλως	latum	ΕΜΟΝ	meum
πων	sapo	ΒΛΕΡΟΝ	scamnum
πος	unctu	ΥΠΟΠΟΘΙΟΝ	scamellum
ΛΕΙΠΟΜΕΝΟΝ	unctui	ΔΙΦΡΟΣ	sella
πυω	lauo	ΣΥΝΑΓΕΣΕ	densete
ΗΝΙΨΑΜΗΝ	lalaui	ΕΚΙ ΠΡΟΣ ΧΩΡΕΙ ΤΑΙ	illuc accedite
εμας χιρας	meas manus	ΕΜΟΣ ΤΟ ΠΟΣ ΕΣΤΙΝ	meus locus est.
ΙΤΗΝΟΨΙΝ	&faciem	ΕΤΩ	ego
ΤΜΑΣΣΩ	tergo	ΠΡΟΚΑΤΕΛΑΒΟΝ	occupaui
ΜΗΝ ΟΥ ΚΑΤΕΜΑΖΑ	adhaec tersi	ΕΚΑΘΗΣΑ	sedi
ΑΤΕΙΖΑ	tersi	ΚΑΘΗΜΑΙ	sedeo
ΟΕΡΧΟΜΑΙ	procedo	ΜΑΘΑΝΝΟ	disco
ζω	foris	ΜΑΝΘΑΝΝΙΣ	discis
ΤΟΡΚΟΡΝΟΣ	de cubiculo	ΜΕΛΕΤΩ	edisco
ΧΟΜΑΙ	uemo	ΜΕΛΕΤΑΣ	ediscis
ΗΡΧΟΜΑΙ	uado	ΗΑΗ ΚΑΤΕΧΩ	iam teneo
ΤΗΝ ΣΧΟΛΗΝ	in scolam	ΤΗΝ ΗΜΗΝ ΑΝΑΓΝΩΣΙΝ	mea lectionem
ΩΨΟΝ	prima	ΕΜΟΣ	meus
ΠΑΖΟΜΑΙ	saluto	ΕΜΗ	mea
ΝΑΙΔΑΣΚΑΛΟΝ	magistru	ΕΜΟΝ	meum
ΕΜΕ	qui me	ΕΜΟΙ	mihi
ΤΕΣ ΠΑΣΑ ΤΟ	resalutauit	ΗΜΗΤΕΡΟΣ	noster

In the classroom

25 | Glossary manuscript with the *Hermeneumata Pseudodositheana*
Ninth century, second and third quarters — VGQ 7

Who has not had that experience of memorising — or worse, learning by rote — words and phrases in a foreign language, using *Schwere Wörter*, *Mots clés*, *Basic idioms* or whatever the schoolbook may have been called? After all, you need to build up a vocabulary if you are to master a new language. Through the centuries, lists of words (glossaries) have proved to be an indispensable aid for this task.

Broadly speaking, medieval glossaries can be divided into four categories: (1) words in a different language to that of the speaker/reader; (2) words that have become obsolete or where the meaning has become obscure over time; (3) words connected with a particular field or topic and providing further information, for example about flora and fauna, buildings or legal terminology; and (4) encyclopaedic information relating to words in specific texts. The last category mainly applies to early medieval glossaries. In short, lists of words could serve different but related purposes. They were didactic tools for teaching foreign languages. That was not all, though. Glossaries also offered advanced pupils the opportunity to expand their vocabulary. In addition, they let you look up a word easily — as long as the list was alphabetic, which was not always the case. Finally, glossaries often served as channels for circulating encyclopaedic, exegetic or otherwise useful information.

Codex VGQ 7 contains the *Hermeneumata Pseudodositheana*, as well as some shorter unrelated texts. That title is quite a mouthful. The Greek word *hermeneumata* (the plural of *hermeneuma*) literally means 'explanations' but it was also the technical term for bilingual Latin and Greek education. The text is an assemblage of long lists of words and phrases divided into four sections. The first section comprises a list of words in Greek and Latin with 355 lemmas, consisting of nouns, adjectives, adverbs and verbs, more or less ordered according to the Greek alphabet. The second section is a list of words divided into 38 chapters on a variety of topics, ranging from classical mythology to the theatre. Most of the chapters have a title, for example on fol. 12v *de supellectile* ('About furniture'). Section 3 is a collection of short dialogues and stories from daily life that are intended to help the student converse in the foreign language. Take the example of the third column at the top in fol. 37v, shown here as the main illustration. Sticking just to the Latin, it starts by repeating the title: *Incipit hermene / umata . id (est) libri xii* ('Here begin the *Hermeneumata*, which are in twelve books'). Line 4 then announces the topic: *de conversatione* ('On conversation').

The fourth column starts with words for the day (*dies*) and the sun (*sol*), which has risen (*ortus est*). A boy is introduced who gets up, dresses, washes his hands and face, and goes to school. At the top right of fol. 38r, he greets the master in the singular (*ave, magister*) and his fellow pupils using the plural form (*avete, condiscipuli*). Words are repeated (*discipuli, condiscipuli*) to help the reader remember them. Then the pupil wants to sit down: *locum / mihi / date* ('Make room for me'). We see three words for where he sits: *scamnum* ('school bench'), *scamillum* ('stool') and *sella* ('seat'). The conversation continues: 'Move up!' (*densa te*). A little later, he says 'Now I understand my lesson' (*iam teneo / meam lectionem*), followed by 'my' in the masculine, feminine and neuter forms (*meus / mea / meum*). This all makes good didactic sense. The column structure is maintained throughout, even for the sentences in the dialogue.

<< Fig. 1
The title *Incipit hermeneumata* is at the top of the third column of fol. 37v. This is followed by words describing the daily routine of a schoolboy, with plenty of dialogue sentences, such as in column 4 on fol. 38r, at the top: *ave magister* ('Greetings, Master'). VGQ 7, fols 37v–38r (image 86%).

Fig. 2
Next to the word *sponda*, a contemporary German-speaking user has added the word *bettibret*, meaning the same ('bed-frame'). Note how a new chapter is introduced at the top left: *de supellectile* ('about furniture'). VGQ 7, fol. 12v, detail.

The *Hermeneumata* end with a fourth section containing various kinds of texts aimed at improving reading skills. They include some of Aesop's fables, a genealogy of the classical gods, questions Alexander the Great put to the Indian Gymnosophists, and a legal text.

The second part of the title, *Pseudodositheana*, refers to the fact that some of the *Hermeneumata* manuscripts attribute the work to *magister* (master) Dositheus, a Greek grammarian working in Rome in the fourth century AD. This attribution has not been considered certain for a long time, hence the qualification 'pseudo'. The *Hermeneumata* are often found in combination with Dositheus' *Ars grammatica*, a textbook intended for Greeks who wanted to learn Latin. However, that grammar book is not part of the Leiden manuscript.

The *Hermeneumata* in VGQ 7 comprise the oldest and most important extant source of this text, which has survived in another eight manuscripts. The text itself is thought to date from the third century AD. The manuscript is what is termed a composite, meaning that its component parts were not all produced at the same time. It comprises two codicological units that did not originally belong together but were subsequently bound in a single volume. VGQ 7 starts with a quire of two parchment leaves. This is followed by five quires that belong together, each of four leaves, also parchment. The *Hermeneumata* take up fols 3r–39r, with four columns per leaf in alternating Greek and Latin. They are followed by some medical texts in a different, slightly later hand, plus an extract from the *Etymologiae* by Isidore of Seville. The manuscript as a whole dates from the ninth century and may have been made in northwest Germany in the Rhine valley.

The Greek words in the *Hermeneumata* are all written in uncial script, with rounded capital letters, as was the custom at the time for Greek script. For the Latin text, the scribe used the Carolingian minuscule script, the bookhand that was standard throughout Europe between 800 and 1200. A knowledge of Greek could be useful when reading and studying bilingual Greek-Latin texts such as the Psalms, the four Gospels and St Paul's Epistles.

This manuscript clearly had a didactic function. Subsequent users have added the occasional explanatory word next to the columns. On two occasions, a user added a German translation of a Latin word in the *Hermeneumata*. For example, on fol. 12v in the chapter on furniture, the German word *bettibret* ('bed-frame') has been written next to its Latin translation *sponda*. Such 'interventions' in the common tongue within a Latin context usually mean that the text was being used in a monastery school, with the teacher helping his pupils out. The form of the German used in the annotation here points to southern Germany, or at any rate somewhere south of Cologne where High German was spoken. If the annotator had been born north of Cologne, he would probably have written '*beddebret*'.

— Rolf H. Bremmer Jr

Sic mea prudentes superat sapientia sophos
Nec tamen in biblis docuit me rethor Atheus
Aut ullum quam quiui quid constet sillaba noffe
Sicc ator æstiuo terit arua caumate sol hif
Ruminadens iterum plus ada flumine fontes
Salsior et nucleo cum sit quam marmora ponti
Et gelidis terrae lymphis insulsior erro
Multiplici specie cunctorum compta colorum
Ex quibus ornatur praesentis machina mundi
Lurida cum toto nunc sim fraudata colore
Ascultate mei credentes famina uerbi
Pandere quae poterit gnarus uix ore magister
Et tamen inficians non rerit fribula lector
Sciscitor inflatos fungar quo nomine sophos

EXPLICIUNT ENIGMATA FINIT. FINIT
Aurea dum Christi xpo fila uirgo ac decus amara
pallida torques aereo tu nego calamo crimgem
pinge paginas lacrimas

Dum poeta nescit ...
Nec seruant ...
...
...
...
...
...
...
...

A riddle that can be solved but cannot be read

26 | Aldhelm and Symphosius, *Ænigmata* and the Old English 'Leiden Riddle'
Ninth century, second quarter — VLQ 106

On the final leaf of a ninth-century manuscript, a monk copied the text of a riddle in Old English. The solution has been known for centuries, but the text of the riddle itself still raises numerous questions.

'I come out of the ground and am made of neither wool nor hair. Neither loom nor silkworm are responsible for me. Yet people call me 'clothing' and I am not afraid of arrows. What am I?'

This riddle is based on one of the *Ænigmata*, a hundred rhyming riddles in Latin composed by the Anglo-Saxon poet Aldhelm (†709). The answer to this specific riddle is 'chainmail'. Texts like these were a popular genre in the early Middle Ages and served as challenging puzzles for monks who wanted to practise their Latin.

The ninth-century manuscript VLQ 106 was copied in the abbey of Fleury in France. It contains about two hundred short riddles in Latin, plus one riddle in the vernacular. Remarkably, this last riddle was written not in French but in Old English, the language of the epic poem *Beowulf*, spoken in early medieval England. The Old English riddle was added to the verso of the final leaf (fol. 25v), where there was just enough room for one short extra text (even so, the scribe had to write in smaller and smaller letters, with the final words ending up in the bottom margin). The Old English text is a reformulation of Aldhelm's chainmail riddle. It starts as follows:

Mec se ueta uong uundrum freorig ob his innaðae aerist cæn...
Uaat ic mec biuorthæ uullan fliusum herum ðerh hehcraeft hygið...

'The wet ground, amazingly cold, from its innards first produced me. I know in my thoughts that I am (not) made of woollen fleece or of hair, through great skill.'

In scholarship, this Old English text is known as the 'Leiden Riddle' and it is of great literary and linguistic significance.

As it turns out, the Old English rhyming riddle in VLQ 106 is virtually unique; the only other known examples of riddles in Old English are in the famous *Exeter Book* from the late tenth century. The Leiden Riddle is at least a century older, making it one of the earliest surviving manuscript texts of an English poem. Whereas the original Latin riddle used end rhyme, this

< Fig. 1
Final leaf of the manuscript. VLQ 106, fol. 25v.

Fig. 2
Sketch of Aldhelm from a tenth-century copy of Aldhelm's works. London, British Library, MS Royal 7 D XXIV, fol. 85v, detail.

Old English version uses structural alliteration where two half lines are connected through alliteration on stressed syllables. We can see this, for example, in *ueta uong | uundrum freorig*, where the **u** at the start of a word is pronounced as a **w**, and *herum ðerh hehcræft | hygið*... The alliteration makes the Old English version almost twice as long as Aldhelm's Latin original: while Aldhelm simply calls the chainmail *vestis* ('clothing'), the Old English version in VLQ 106 notes that the chainmail *hatan mith heliðum | hyhtlic giuæde* ('is called a desirable garment among heroes').

The Leiden Riddle is perhaps even more interesting from a linguistic perspective. The text was written in Old Northumbrian, an early medieval English dialect in which relatively few texts have survived. The precise reading of this text is therefore of great importance linguistically, since dialects are sometimes distinguished by relatively small differences in vowels and consonants. That, however, is precisely the problem: the text of the Leiden Riddle is hard to read and has been the subject of discussion for almost two hundred years.

The German philologist L.C. Bethmann (1812–1867) was the first to publish the text of the Leiden Riddle, in 1845. Unfortunately, his transcription contained so many errors that it was hard to see which language the riddle was in. In 1860, another German linguist, Franz Dietrich (1810–1883), concluded that the text was in Old Northumbrian and was an adaptation of Aldhelm's chainmail riddle. Dietrich too struggled to read the text, since this had become damaged by wear and tear, caused by the original parchment covering rubbing against the final page.

The linguistic importance and the illegibility of the text were probably why the Leiden librarian W.G. Pluygers (1812–1880) decided to apply a chemical reagent to it in November 1864. The reagent briefly made the text more legible, but ultimately it led to extra stains and damage to the text. Pluygers' handwritten transcription shows that even after he had applied the reagent, he was still unsure of what he was reading: his text is still full of question marks. It is quite possible that Pluygers simply did not know how to read this early medieval script.

Following Pluygers' efforts, numerous British, German and Dutch scholars examined the text, including Henry Sweet (1845–1912), Otto B. Schlutter (active 1897–1930), J.H. Kern (1867–1933) and Albert Smith (1903–1967). What is interesting is that they all read something different. For example, Pluygers thought the word at the end of the first line was *camð* but Schlutter read *cænda*. Kern and Sweet claimed it said *cændæ* and Smith, using ultraviolet photography, was unable to decipher the fourth letter, reading *cæn.æ*. Dozens of words were disputed in this way.

Fig. 3
The barely legible Old English riddle at the bottom of the verso of the final leaf.
VLQ 106, fol. 25v, detail.

180

After the Second World War, two famous palaeographers — Malcolm Parkes (1930–2013) and Johan Gerritsen (1920–2013) — turned their attention to the Leiden Riddle. They too could not reach agreement: in various articles, they argued with one another about the shapes of the letters and whether the scribe responsible for the Old English text had also written the Latin texts in the same manuscript. This palaeographic polemic did not result in a clear winner either and there is still uncertainty today regarding the precise reading of parts of the text.

Research on the Leiden Riddle has recently been revived and there seems to be a glimmer of light at the end of the tunnel, in the form of X-rays. Researchers of Delft University of Technology and the American Lazarus project have studied the manuscript using advanced multispectral cameras, and in 2024 the Leiden Riddle was examined by German researchers using a Macro-XRF (X-ray fluorescence) scanner. The initial results seem promising: the text treated by Pluygers responds differently to the X-rays than the rest of the leaf and it may be possible to enhance this contrast to get a more legible text. Further analysis should show whether there is enough ink in the Old English riddle text to remove all doubt. If not, that could mean it may never be possible to get a precise reading of the Leiden Riddle — despite the fact its solution has long since been found, the riddle itself would then remain a riddle.

— Thijs Porck

Fig. 4
Transcription of the Old English riddle by W.G. Pluygers, November 1864. VLQ 106, at the back of the manuscript.

[Manuscript page illegible at this resolution]

Signed, sealed, delivered: A shorthand lexicon

27 | *Commentarii notarum Tironianarum*
Ninth century, late, or early tenth century — VLO 94

Measuring only 145 × 95 mm, this tiny manuscript contains an incomplete copy of the *Commentarii notarum Tironianarum* ('Commentaries on Tironian Notes'), a lexicon of shorthand symbols and their Latin equivalents. The text was a handy reference work for anyone who wished to learn this type of shorthand, newly popularised among elite intellectual circles in Carolingian monasteries from the late eighth century onwards.

The system of shorthand termed 'Tironian notes' derives its name (and fame) from Tiro (†4 BC), the scribe of Cicero (103–43 BC) who was allegedly responsible for their invention. This shorthand, consisting of 'notes' — graphic characters used to represent various words — was immediately successful and proved convenient for administrative tasks, as well as for recording texts and spoken word. For example, the Roman philosopher Seneca (4 BC–65 AD), born in the year of Tiro's death, is credited by the encyclopaedist Isidore of Seville (560–636 AD) for having composed a collection containing no less than five thousand of these shorthand notes.

Sporadically used throughout the early Middle Ages, Tironian notes were re-popularised during the Carolingian age. During a period when writing calligraphically was a time-consuming skill, this shorthand system appealed to writers and copyists: the notes could be written quickly, and their compact form saved space. However, because the notes were based on a script which was neither alphabetic nor syllabic, learning how to write and read in this shorthand was difficult. The *Commentarii notarum Tironianarum*, a lexicon of around thirteen thousand notes and their definitions, was a text that could ease this learning process. The fifteen Carolingian whole or fragmentary copies of this text that survive — including VLO 94, copied in the ecclesiastical centre of Reims, France, in the late ninth or early tenth century — demonstrate the lexicon's popularity.

Fols 54v–55r of this manuscript illustrate how the vocabularies of the shorthand developed over time. The first column of fol. 54v (see Fig. 1) starts with the words *Vir magnific(us)*, *Vir magnificentissim(us)* ('eminent man, most eminent man') and continues with a series of positive adjectival qualifiers for the word *vir* ('man'), accompanied by their superlative forms. While this could be read as simply a list of moral descriptors, many of these combinations were in fact used as honorific titles during the Roman Empire. *Vir clarissimus* ('most illustrious man') denoted a member of the Roman Senate, for example, while *vir egregius* ('distinguished man') referred to a member of the Roman Equestrian class.

Echoing the specific Roman loading of these terms, the next column proceeds to list political and legal terminology, including a variety of terms concerning the *res publica* ('public affairs', or 'republic'). The context of reference changes, however, on the adjoining page (fol. 55r). Here the first two columns are filled with Christian vocabulary, such as the heavily abbreviated *Ap(osto)l(u)s* ('apostle'), *EP(ISCOPU)S* ('bishop') in majuscule letters midway through the second column and various grades of *diaconus* ('deacon'). This juxtaposition of the Roman past with the Christian present shows how the *Commentarii* preserved both a vocabulary associated with the period during which the shorthand system was first devised and the vocabulary of new expressions invented to incorporate the offices of Christian life.

As this first set of examples illustrates, the lists of words found in the *Commentarii* were arranged in

< Fig. 1
On the left of the opening, we find a series of words which were current in ancient Roman politics, while on the right, the words of columns one and two concern Christian life.
VLO 94, fols 54v–55r.

183

Fig. 2 (left) The monogram depicting the place name *Puteoli* (Pozzuoli) is presented twice on this opening. The inks used have discoloured and stained the parchment. VLO 94, fols 64v–65r.

Fig. 3 (right) The playful monogram depicting the place name *Puteoli* (Pozzuoli), the town where Tiro, the alleged inventor of Tironian notes, died. VLO 94, fol. 65r, detail.

Fig. 4 > This page includes various words associated with writing and texts. Note how clusters of words which share thematic or etymological commonalities also share strikingly similar characters. VLO 94, fol. 70r.

thematic groups. For example, fol. 70r contains a series of words related to books and texts. It opens with the trio *liber, libellus, librarius* ('book, booklet, copyist') before referring to writing materials, including *pitaciu(m)* (a small piece of parchment), *pagina* ('page') and *paginula* ('small page'), along with *atram(en)tu(m)* (ink). Much of the rest of the page contains the names of types of texts, such as commentaries, epigrams and epics. In addition to being thematically ordered, the words are also grouped according to their etymological roots. The quartet *dialogus, p(ro)logus, epilogus, philologus* ('dialogue, prologue, epilogue, scholar'), for example, shares the common element *-logus*, derived from the Greek *logos* ('word', or 'speech'), and their shorthand equivalents are all variants on a similarly shaped character. Such combinations must have facilitated memorisation of the notes, while the association of words in thematic clusters eased the retrieval of terms.

As we have seen, in order to learn and use Tironian notes, scholars needed to understand the building blocks of a word — its root, inflection, suffix and so on. These essential differences between words permitted users to understand and employ the graphic variations between their shorthand characters. This process of reducing a word to its fundamental elements before presenting it in a graphic form is also evident in another form of wordplay popular during this period, the use of monograms. Monograms combine characters or phonetic elements of a word into a single, usually memorable, graphic structure. Charlemagne, for example, famously used a cruciform monogram of his name to authenticate coinage and royal charters.

The simultaneous popularity of Tironian notes and monograms is apparent on fols 64v–65r of this manuscript. Placed at the bottom of fol. 64v and repeated at the top of fol. 65r, a cruciform monogram presents the place name *Puteoli* (Pozzuoli), a town near Naples. Reading anti-clockwise from the top, the letters P, T/E, L and I are found at the ends of the cross-arms of the monogram, while U and O are represented by its central lozenge. Here this monogram does double duty. Its complex form emphasises the introduction of a new section of text, serving a navigational function within the manuscript. Meanwhile, its content calls to mind the origin of the shorthand system — Tiro, Cicero's scribe, lived for many years in Pozzuoli, before dying there at the age of one hundred, according to Jerome (around 347–420 AD).

Despite its diminutive size, VLO 94 offers a wealth of information about the interests and skill set of its Carolingian users. Their granular attention to the form and qualities of words played out on a larger stage in the various reforms of the period, notably the introduction of Carolingian minuscule script. That said, it seems that the use of this shorthand system remained confined to a scholarly elite; even with the help of texts like the *Commentarii*, users of the system needed to build up a vocabulary from scratch. Over time, the avid interest in Tironian notes faded, most likely on account of the time-consuming process of acquiring fluency. Only a few notes, such as the 7-shaped sign for the word *et* ('and'), remained in common circulation during the rest of the Middle Ages.

— Irene O'Daly

ɣ	Liber		Elogu
ɣ	Libellus		Elogū
ɣ	Librarius		Dialogus
	Sacrū		Plogus
	pagina		Epilogus
	paginula		Philologus
	Pgmēna		Epitapsis
	Carta		Epimeris
	Cartula		Epus
	Annūtū		Melus
	Comentū		Chirographū
	Comestariū		Singraphe
	Comentariolū		Grasiū
	Eptoma		Grasiolū
	Epigrama		Salum
	Epigramata		Sumbolū
	Eloga		Deplomū
	Elogi		

premia eterne beatitudinis. que p dexteram significant.

Adiuro uos filię hierlm p capreas Vox xl.
ceruosq, campoȝ, ut non suscitetis neq, euigila
re faciatis dilectam, quoadusq, ipsa uelit.
Verba loquor uobis, quis mater uisio pacis,
Obtestans clare uos p ceruos capreasque,
Ne mihi dilectam, dulciq, sopore solutam,
Aut sonus aut strepitus de sono suscitet ullus:
Donec ut ipsa uelit sponsam consurgere fas sit.
Obsecro uos animę quas mundę gla uitę,
Auitiis mire pmittit ad alta salire,
Videritis mentē mihimet quamcuq, uacantem,
Ne mundi studiis hanc infestare uelitis,
Donec ab hac opera placita sibi cesset in hora.
Ich besueron iuch iungfrouwon bi then reion
ande bi then hirzon. thaz ir mine winian
ne wechéd. noch wachan nodoth
unzen siu selua wolle. Ich besuervn iuch
guode sielan ir ther drephed ad supernā
hierlm bi thero reyno ande bi then dughethen
thie ir ana iuch seluon hauet. quę p munda
& serpentibus inimica animalia figurant.

How the Egmond Willeram became the Leiden Willeram

28 | West Low Franconian paraphrase of the Song of Solomon
c. 1100 — BPL 130

It must have been a real surprise for Paulus Merula, a professor of history at Leiden, when his friend Pancratius Castricomius sent him an ancient codex in March 1597. In the accompanying letter, Castricomius asked him if publishing it might be worthwhile.

Paulus Merula (1558–1607) had just been appointed librarian when he received a version of the Latin-German paraphrase of the Song of Solomon that Abbot Williram of the Bavarian monastery of Ebersberg made in around 1060. The Song of Solomon is one of the Bible's more intriguing books. It consists of a collection of wedding verses about an idealised love between a man and a woman who, in a dialogue with each other and bystanders, praise one another's beauty, and recount their desires and encounters. From early times, this paean to love was interpreted allegorically. In the Jewish tradition, the relationship between God and the people of Israel is central, whereas Christian tradition centres on that between Christ and the Church. Williram added two commentaries to the Song of Solomon that paraphrased and explained the biblical verses: one in Latin verse and the other in prose, in East Franconian.

Around 1100, a monk in Egmond Abbey (in northern Holland) made a copy. The main illustration (fol. 23r) shows clearly that Williram's paraphrasing of the Song of Solomon consisted of three components: After the dialogic indication *Vox (Christ)i* ('Voice of Christ') comes first a Bible verse (Song of Sol. 2:7) in the Vulgate version: *Adiuro vos filie hier(usa)l(e)m p(er) capreas / cervosq(ue) campor(um) ut non suscitetis neq(ue) evigila- / re faciatis dilectam quo adusq(ue) ipsa velit...* ('I adjure you, O ye daughters of Jerusalem, by the roes, and the harts of the field, that you stir not up, nor make the beloved to awake, till she please'). Then comes the Latin commentary in verse form, with each hexameter starting with a red initial on a new line: *Verba loquor vobis, quis mater visio pacis...* ('I address these words to ye who cherish the vision of peace'). Finally, there is the prose commentary in the vernacular tongue, which begins with the paraphrasing *Ich besueron iuch iungfrouwon bi then reion / ande bi then hirzon . thaz ir mine winian / ne weched noch <wachan no doth> unzen siu selva wolle.* ('I urge you, young women, by the gazelles and

< Fig. 1
Willeram, *Expositio in Cantica Canticorum*. Opening with Song of Sol. 2:7. The printer has noted the corresponding page numbers of his typesetting in the margin here, upper-left, 26. BPL 130, fol. 23v.

Fig. 2
Jacob Matham, Portrait of Paulus Merula (1558–1607). Engraving, seventeenth century. UBL, BN 964.

Fig. 3
P. Merula (ed.), *Willerami Abbatis In Canticum canticorum paraphrasis gemina*, Leiden 1598. Opening with Song of Sol. 2:7 UBL, 1370 F 30: 3, pp. 26–27.

hinds in the fields, not to disturb or awaken my beloved before she wants it herself.')

In most manuscripts, these elements are listed side by side in three columns, as is the case in an old manuscript that must have been written during Williram's lifetime and is now in the Bayerische Staatsbibliothek in Munich (Cgm 10, see Fig. 4). In the Leiden manuscript, however, they are listed one after the other.

There are numerous places where the scribe in Egmond has adapted the East Franconian text in his copy to match his own West Low Franconian dialect. When the woman praises the belly of her beloved, for example, as being made of ivory and bedecked with sapphires (*Venter eius eburneus distinctus saphiris*; Song of Sol. 5 14b), the *Vox Ecclesiae* interprets this in the commentary as meaning that her bridegroom (Christ) is both human and divine, visualised by the ivory and sapphires, respectively. In the prose commentary (fol. 65v) there is then an explanation of the human and divine dual nature of Christ:

> *Thaz himo hungredo and thursta, thaz her mutheda, thaz her gecruciget warth ande her starf, thaz draph ad humanitatem. Thaz her dodon erquekkeda, allarslachta sicheduom heileda, over mere mit drugon fuozen gieng, diuvela verdreif, thaz draph ad divinitatem*

'That he suffered hunger and thirst, that he became tired, that he was crucified and died: those were all part of being human. That he raised the dead, cured all kinds of afflictions, walked dry-footed over water and exorcised demons: those were all part of being divine'

The scribe has changed various Old Germanic word forms in this passage into Old Dutch: (1) *unte er starb* >

anda her starf; (2) *trokkenon fuozen > drugon fuozen*; (3) *ertreib > verdreif*. The Old High German name of the author (*Williram*) is modified in Old Dutch to *Willeram*. However, the words, grammar and spelling have not been converted consistently. That is not so strange, as the tradition of writing in the local tongue was still in its infancy in the Low Countries at this point. The 'Egmond Willeram' is not only one of the first books to be transcribed in the Netherlands but also the earliest source in Dutch to have survived in its entirety. Indeed, the *Oudnederlands Woordenboek* (Dictionary of Old Dutch), published online in 2009, is based largely on the lexicographical material from this manuscript.

Egmond Abbey and its library did not survive the Dutch Revolt against the rule of King Philip II of Spain (1527–1598) and the Protestant rejection of the Catholic Church. After the Iconoclastic Fury in 1566, the abbey was twice plundered and the last monks fled in November 1572. The abbey itself was destroyed by the Beggars (Dutch insurgents fighting Spanish rule in the Netherlands) in 1573. The prior Jacobus Blondeel (1536–fl. 1591) and Pieter van Meerhout (c. 1541–1603), rector of the Latin school at Alkmaar, together saved various manuscripts. Those included the Willeram, which Blondeel gave to Van Meerhout.

Back to Paulus Merula. After his friend Pancratius Castricomius (†1619), a former pupil of the rector Van Meerhout, had sent him the codex, he got down to business enthusiastically. Merula made a copy and returned the manuscript in April, but a month later he managed to convince its owner, Van Meerhout, to donate it to the library at Leiden. Still in the summer of 1597, the manuscript was removed from the binding and converted into copy for the printer. This left traces on the parchment. In the margins of fols 23v–24r, paragraph marks and page numbers (26–28) that correspond to that edition have been noted in pencil. The spelling and punctuation of the Latin have been modified; see e.g. fol. 23v, lines 2–3: *hier(usa)l(e)m* was given a capital letter, *evigila-re* a hyphen; lines 3–4 full stops after *campor(um)* and *dilectam* were changed into commas. On top of that, the Latin words in the Franconian prose paraphrasing into the common tongue have been underlined to make it clear to the printer that these texts were to be set in italics, such as <u>ad superna(m) hier(usa)l(e)m</u> (fol. 23v lines 3–4 from the bottom).

Within just a few months, Merula delivered the complete copy to the university's printer Raphelengius,

Fig. 4
Williram van Ebersberg, *Expositio in Cantica Canticorum*. Opening leaf with a three-column layout. Munich, Bayerische Staatsbibliothek, Cgm 10, fol. 10r.

consisting of the quires containing the medieval text, now with typesetting instructions, a translation of the Franconian text — thought to be by the town clerk and secretary of the university Jan van Hout (1542–1609) — and linguistic notes added by Castricomius. Merula received the printed proofs from October onwards. He must have corrected them and returned them quickly, given that the print edition was available by January 1598: *Willerami Abbatis In Canticum canticorum paraphrasis gemina [...] Edente Paullo G.F.P.N. Merula. Lugduni Batavorum: ex officina Plantiniana, apud Christophorum Raphelengium, MDIIC.*

Abbot Willeram's 'doubly paraphrased Song of Solomon' in Merula's edition contains five blocks of text per paragraph, as the illustration of the corresponding opening shows (pp. 26–27). Calculating the typesetting was a complex task as the printer had to synchronise the three textual layers of the Egmond manuscript with texts from two other handwritten manuscripts: Van Hout's retranslation and Castricomius's notes. The latter two manuscripts have been lost, but the Egmond Willeram was preserved and is now known as the Leiden Willeram thanks to Merula's efforts.

— André Bouwman

COUNTING AND CLASSIFYING

The production of manuscripts was closely linked to the natural world. Parchment, the main writing surface for medieval manuscripts (until the fourteenth century, when paper became common) was made from the skins of grazing animals; inks were made from plants and minerals; and the thick wooden boards used to bind books were carefully shaped from tree trunks. Medieval scholars were also curious about the natural world, finding ways to measure, classify and understand its earthly and heavenly aspects.

The oldest manuscript treated in this collection is a copy of the *Herbarium* of Pseudo-Apuleius (no. 29, VLQ 9), a text on plant remedies that remained influential throughout the Middle Ages. This sixth-century manuscript is filled with detailed illustrations of plants, so detailed they could even be used for identification. Meanwhile, the Leiden *Aratea* (no. 31, VLQ 79), copied in the ninth century from a late antique exemplar, shows the regard Carolingian scholarship held for ancient astronomy and astrology. The miniatures of the Leiden *Aratea*, showcasing mythological interpretations of the constellations, are saturated in rich colours. A bound facsimile of this extraordinary manuscript is pictured in the adjacent photograph.

Writing in the thirteenth century, Jacob van Maerlant was the first to compose an encyclopaedia in Middle Dutch (see no. 34, BPL 14 A; rebound in the mid-1980s with red ribbon closures), but his work derived inspiration from antique precedents, including the *Naturalis historia* ('Natural History') of Pliny the Elder, a work from the first century AD. An eighth-century copy of Pliny's work (no. 30, VLF 4), a large manuscript copied in a distinctive Insular minuscule, with a dark-blue-and-pink-marbled paper rebinding, proves that Pliny's ideas were being studied in the far reaches of northern England during that period. Both of these manuscripts illustrate the long history of the desire to collect and classify information on the natural world.

In the field of mathematics, several influential streams of learning came together in the Middle Ages. The Στοιχεῖα (*Stoicheia*, or Elements), composed by the Greek mathematician Euclid c. 300 BC (see no. 33, SCA 36), would become prized for its logical geometrical insights from the twelfth century onwards, when a full translation into Latin, via Arabic, first became available. Even more basic Greek mathematical inventions, like the abacus, were novelties in the medieval Latin West (see no. 35, SCA 1). Such newly introduced ideas existed alongside more traditional medieval mathematical practices, like finger counting (see no. 32, BPL 191 BD). Medieval study of the sciences encouraged the transmission of texts and ideas, which, enabled by the manuscripts in which they travelled, connected a variety of intellectual contexts. (IO'D)

Counting and classifying | Manuscripts, *from rear, left to right*:
SCA 1 (no. 35), VLF 4 (no. 30), SCA 36 (no. 33) — VLQ 9 (no. 29) — VLQ 79 (no. 31, *facsimile, above*), BPL 14 A (no. 34, *below*) -- BPL 191 BD (no. 32)

LX HERBA SCORDEON
SI SERPENS PERCUSSERIT

Herba scordeon trita cum oleo
laurino subacta tollit dolorem.
Herba scordeon coquitur et datur
eius potui cum uino mirauer· ipsa
tem contusa in placa inponitur it
herba scordeon allicata circa corp'
hominis tollit cottidiana uel tertia

63

est sil’s q̅ ar̅e nigre
videtur in Dioscoridem
esse Enula Campana cuius
sp̅es est Tapsus barbatus

...erua UERBASCUM ł tunicę gr̅ fal
...raeeis dicitur FLOGMON Hutych
...betae hermurabdos
...erpti natal
... diessathel
... UERBASCUM DICUNT
...scitur locis sablosis et aggerib· hanc
...bam dicitur mercurius ulixi inde
...secum uenisset ad dircem et nulla

Nature cures, miraculously or otherwise

29 | The *Herbarium* of Pseudo-Apuleius
Sixth century, second half — VLQ 9

Anyone reading up on the history of plant-based medicine in the West will pretty much immediately encounter this manuscript from the late sixth century containing the *Herbarium* of Pseudo-Apuleius, written and illustrated in Italy. Codex Vossianus Latinus Quarto 9 is the oldest preserved, well-illustrated copy of a fourth-century Latin botanical book with medicinal recipes.

In this herbarium, an unknown author — referred to by researchers as Pseudo-Apuleius (or Apuleius Platonicus or Apuleius Barbarus) — describes the beneficial health effects of 130 plants, largely basing his work on *De materia medica* by the Greek author Pedanius Dioscorides (c. 40–c. 90 AD) and the *Naturalis historia* by the Roman writer Pliny the Elder (23/24–79 AD). The concept of plagiarism did not exist then: Pliny and Dioscorides themselves copied extensively from older sources too.

Pseudo-Apuleius is more accessible than his predecessors. His work is much less extensive than that of Dioscorides, who described 383 plants, 66 venomous animals and 23 birds, and different as well to that of Pliny, who collected everything he heard and read in his encyclopaedia without distinguishing between fact and fiction. Pseudo-Apuleius must have composed his work early in the fourth century, using a fixed pattern: first a picture of the plant, then its name in Latin followed by the name in other languages, then where the plant grew and finally which parts of the plant could be used for making medicines to treat which illnesses.

If you open manuscript VLQ 9 at fols 77v–78r, it is striking how much the book has been used over the course of time, with additions and changes made by an active readership, for themselves and for others. The right-hand leaf has four different sets of numbering, for instance: number 63 added in a fifteenth-century humanist hand, then 97, 108 and finally 78 (its current foliation). Because word spacing was not yet common practice back in the sixth century, a later reader added vertical lines on fol. 77v between the words to improve the legibility (see also no. 11).

The left-hand leaf of the opening (fol. 77v) contains a picture and description of *herba scordeon*, the seventieth numbered plant in the *Herbarium*. In the modern classification of Carl Linnaeus (1707–1778), it has the Latin name *Teucrium scordium*; the plant is called water germander in English. It is now rare in Britain. The situation is very different for plant number 71 on fol. 78r, common or greater mullein, which is widespread in the wild. *Lxxi. herva verbascum* is written underneath its illustration in red ink, in an attractive, antique rounded Uncial hand. Beneath that is a list of names by which the plant was known in Pseudo-Apuleius's time: *a graecis dicitur flosmon | profetae hermu rabdos | aegyptii natal | daci diessathel | itali verbascum dicunt* ('called flosmon by the Greeks; the prophets call it hermurabdos; the Egyptians natal; the Dacians diessathel; the Italians say verbascum').

That was essential information at the time because there were no universal names for plants before Linnaeus. Even so, the list of synonyms was evidently deemed insufficient and additions were noted down over the centuries. A late medieval hand has added *est si(mi)lis yacee nigre* at the top right, below which are seventeenth-century notes: a reference to *Enula Campana* (listed in *Den Nederlandschen herbarius* of 1698, section CLXXXI) and another synonym, *Tapsus barbatus*. The modern scientific name is *Verbascum thapsus*.

Underneath this list is a practical and useful record of the places where the plant can be found:

<< Fig. 1
The *Herbarium* of Pseudo-Apuleius: *herba scordeon* and *herva verbascum*. VLQ 9, fols 77v–78r (image 88%).

Nascitur locis sablosis et aggeribus ('grows in sandy soils and in woodland verges'). The reader then comes across a curious addition: *hanc / herbam dicitur mercurius ulixin de / dissecum venisset addircem, et nulla / [fol. 78v] / mala facta eius timeret.* Meaning 'Mercury is said to have given this plant to Odysseus (*ulixin*) when he came to Circe (*dirce*) so that he would need to have no fear of evil deeds on her part'. The Greek poet Homer (eighth century BC) describes in book 10 of the *Odyssey* how Odysseus used a magical herb given to him by Hermes — Mercury's Greek counterpart — to protect himself against Circe's witchcraft. That myth explains the name given to common mullein by the so-called 'prophets' in the list of synonyms, namely *hermurabdos*, the caduceus or staff of Hermes.

If you then turn fol. 78 over to its verso side, it is followed by two unusual remedies. The first is based directly on Homer: anyone carrying a staff made of *verbascum* need not fear anything or anyone (*nullo metu terrebitur, neque occursus mali molestabunt eum*). Something miraculous also happens for sufferers of gout: if you chop the plant up finely and apply it as a compress, you will be completely free of pain within just a few hours.

Ernst Howald and Henry Sigerist classified the manuscripts in which the *Herbarium* of Pseudo-Apuleius has survived into three groups (α, β, γ) in 1927, based on the other medicinal texts they also contained. The γ-group comprises just two more or less complete manuscripts: VLQ 9, by far the oldest source, and a manuscript kept in the State Library at Kassel University (2° Ms. phys. et hist. nat. 10), which dates from the second half of the ninth century. All the manuscripts from the other two groups contain variations on the text and look different.

Comparisons with a later manuscript from the α-group that is also part of Leiden's Vossius collection show clear differences. That manuscript (VLQ 40) contains fewer texts and plants, but does still include *herba scordeon and herba verbascum*. On top of that, the original page layout as used in VLQ 9 is no longer present. Illustrations and texts are mixed together in this one, leaving it unclear exactly how it should be read. The scribe starts at the top with *Nomen herbe Greci. Flomon* — and then copies his Latin example, making lots of mistakes. Where common mullein grows is not stated and the tale about Circe is simply skipped altogether. The two remedies are included, albeit in Latin that

Fig. 2
The Herbarium of Pseudo-Apuleius: NOMEN herbe [...] latini verbascum, eleventh century. VLQ 40, fol. 28r.

has been rendered incomprehensible here and there. As far as is possible to tell, the illustration is not based on anything.

After reading the above, you might well ask yourself whether medieval writings about plant medicine, such as this, actually contain anything that is useful or even accurate. Nevertheless, there are all kinds of plants for which the positive and negative effects on the human body were known in Antiquity and the Middle Ages. Examples are *hypericum* (St John's wort), which was used for depression, and *digitalis* (foxglove), which was good for the heart (in small doses, as it is highly toxic otherwise). Negative effects were also known: a cup of an extract of the seeds of the hemlock (*conium*) was the highly effective death penalty given to Socrates in 399 BC.

Nowadays, the leaves and flowers of common mullein are widely used as folk remedies because they are thought to have anti-inflammatory properties, with a soothing and mucolytic effect in respiratory conditions such as coughing, asthma and bronchitis. Sadly, no genuine miracles have been recorded.

— Claudine A. Chavannes-Mazel

LIBRO .II. continentur situs
gentes maria oppida portus
montes flumina mensurae populi
qui sunt aut fuerunt

Mauritaniarum	Lesbi		baethone
Numidiae	hellesponus		Timorthense
Affricae	Mysia		philonide
Syrtium	Prusa		xenachona
Cyrenaicae	Galatiae iunctae gentes		asthinomo
Insularum cinca	bithinia		sthaphylo
affricam	Summa oppida & gentes		dyonysio
Auctorum affricae	Summa flumina clara		aristotele
Aegypti chope	chope Summa montium clari		aristocrito
Iudeae	thebaidis Summa insulae cxviii		ephoro
phoenices	Nili Summa quae inter ciclene		anathosthene
Syriae coeles	Anabisque oppida auciantes uationes		hypparcho
Syriae antiochie	& comthe Summa res cthistoriae & obsq		panaetio
Eufratis tium	Aegypti Arippa		Serapione antiocheno
Ciciliae cum cta pam zin	Idumeae Suetonio paulino		callimacho
Isauricae	syriaepa M. uarrone		deagathocle
Omanadum	ustines hannone carthirio		polybio
Pisidie	Samariae Cornelio nepote		Timaeo mathematico
Lycaoniae	hygno		henodoto
Pamphylie	L. uetere		mynsilo
Tauri montis	Maela		Alaxandro polyrthone
liciae	domitio corbulone		methodoro
Cariae	Liciano muciano		posidonio quipsihupur
Iuniae	Claudi caessare		in periegessis
Aeolidis gentium	Appuncio		Sotade
Troadis & iunctarum	libio filio		Pynandro
Insularum ante assia	Seboso		Aristancho Sicionio
CCXIII inns	actis triumphorum		Euloxo. Antigenae
Cypri chodi	Iuba nege		Callicrate
Coi	haecataeo		Xeno fonte lamsaccho
Nodi	hellanico		diodoro yrnacusano
Sami	damaste		hannone. himilchonae
Chii	dicae archo		Nymphodoro. callipha
			Artamidoro
			Megasthene. Isidoro
			Cleobulo
			Aristo creonte

lib V

Hinc deinde Af-
frica atq; assia dicatur.
affricam greci lybiam ap-
pellauere admare ante eam lybicum
ex egypto finitur. nec alia pars terra pau-
cIores recipit sinus. Longe aboccidē-
te litorum obliquo spatio populorum
oppidorum q nomina uel maxime sunt
ineffabilia praeterq: iam ipsorum lingus
Italicis castella ferme inhabitant princi
pio terrarum mauritaniae appellant
sq; ad c. caesarem g mami pistum
regna saeuiciae eius inclyas clinisae pro
uincias promonturium ocēni extimum
ampelusia nominatur a graecis oppi
da fuere lissa & cottae. ultra colum
nas herculis nunc & tingi quondam ab
anteo conditum post ea a cērtum quin
quaginta milia caesarē cum colonia
iacepa appellatum iraclucta iulia
ab est ab aelone oppiclo baeticae pro-
ximo traiectu xxx. abeo xii. mora ocea
n̄ colonia augusti iulia constantia zilil
regum dicioni exempta &iura inbetica
petere iussa abea xxxv. colonia ccc. ces
are facta lyxos uel fabulosissim ae
antiquis narrata. ibi regia antaei
cērtamen q; cum hercule. &hesperidū
adfuncluitur. aucton haestuaruum cnapi
fluxuoso meatu. Inquo dracones
custodie instar fuisse nunc inchus
tantum amplectitur urbsq se insulam
quamsolam euicino tractu aliquanto
excelsione nontamen aestus maius
inundant; extat meo &ara herculis;

nec praeter oleastros aliud exnarrato
illo auri fero nemore. minus profecto
mirantur portantosa graecae mēdacia
clebis etam in lyxo prodita qui cognitu
nostros nuper qualis paulo minus mon
strufica quaedam deluxdēn dracht elesse
prae ualidam hanc urbem maiorem q
magnae kartagine. preterea ex aduerso
eius sitam &p pope inm eiso tractu
abtingi quaeq alia cornelius nepos
audussime qnech elit ab lyxo xl. in medi
terraneo at et ra augusti colonia est.
babba iulia campestries appellata
& tertia banasa. xxii. paess. ualentia
cognominata. abea. xxxv. uolubile oppi-
dum trentum clan. a mari uetro que distans
at inopa al lyxo. l. amnis sububur fri
banasam coloniam cles fluchis magni fi
cus & naurzabilis abeo totidēn milibus
oppidum. sala eius dē nominis fluuio
impositum iam solitudinibus uicinum
elephantorum q; greciby infestum multo
tamen magis autolo lum gente per qua
iter est ad montem affricae uel fabu
losissimum atlantem e medi huncare
nis incolam attolli prodidere aspe
rum squalentem qua uergat ad litora
oceani cui cognomen imposuit eundem
opacum nem oposum que & scatebris
fontium riguum qua spectat affrica
fructiby omnium generum sponte ita
sub nascentiby ut num quam saties
uoluptatis elest incolarum nem inam
inter diu cērni silere omnia alio quam
soli tudinon om pore subire tactam
religion an animos pro prius accedentuim
praeter q; horrorē elati super nubila

A giant book

30 | Pliny, *Naturalis historia*
Eighth century, second quarter — VLF 4: 2

Pliny the Elder's (23/24–79 AD) compendious 37-book *Naturalis historia* ('Natural History') covers geology, geography, meteorology, astronomy, plants, animals and much more. This immense copy, the earliest from north of the Alps, was made in Northumbria, in England. A landmark in the early medieval reception of Mediterranean learning, it exemplifies the contribution of Insular scholars to the Carolingian revival of studies.

<< Fig. 1
This opening shows the prefatory material for Book 5 (taken from Book 1) on the left leaf and the start of Book 5 on the right. On fol. 29v, a fanciful fowl forms the letters *Li* of *Libro*, while on fol. 30r, the initial *H* is formed as a short-tailed beast, perhaps a hound with bird feet.
VLF 4: 2, fols 29v–30r (image 65%).

Part two (fols 3–33) of VLF 4, a composite manuscript, is one of only four extant Anglo-Saxon manuscripts of a classical text. It is also the second-most complete of the six pre-800 copies of Pliny's *Naturalis historia* and the sole example not recycled — through being overwritten, palimpsested (scraped clean) or cut into binding strips — to make way for a Christian text. Its page size — 410 × 290 mm — places it among the half-dozen largest early-medieval manuscripts, the only non-Christian work in that group. A nexus of evidence — including comparisons of script, decoration, format and textual history with contemporary manuscripts such as the enormous *Cassiodorus* manuscript located at Durham Cathedral (MS B.II.30) — makes York its likely place of origin, during the scholar Alcuin's (c. 735–804) youth. In York, knowledge of natural history was prized, even while it was scarcely studied on the continent at that time.

Fig. 2
Pliny's *Naturalis historia*, Book 4, treats populations and geographical features. Here those preparing the manuscript singled out some regions and peoples for easy reference, including *Britannia*. A large impressed *X*-marking, added with a stylus, reveals additional interest in this passage.
VLF 4: 2, fol. 28r, detail.

VLF 4: 2 consists of thirty leaves in five quires with a lacunose (incomplete) text of *Naturalis historia*, Books 2 to 5, but once transmitted an unbroken text up to at least Book 5, and probably beyond. We know this because the missing passages are the length of (or multiples of the length of) the average number of words per page and occur where an equivalent number of pages have been removed. VLF 4: 2 is a lavish, thoughtfully executed giant. An entire calfskin was required for each bifolium (double-leaf). To create a codex of such scale and quality would have been a challenge; its large format was surely chosen to accommodate Pliny's very long work. The vellum itself is exceptional — virtually flawless, with no noticeable holes. The bright white of most leaves is exactly the way the best Insular manuscripts would have originally appeared, a result of the distinctive preparation techniques then in use in the British Isles. Hair and flesh sides of the parchment are almost indistinguishable. The size and quality of the material imply a major commitment by its producers and showcase expert technique.

VLF 4: 2 is a lectern-sized book, perhaps designed to facilitate group study. It has generous interlinear spacing, wide margins and a two-column format. The page layout is perspicuous — full, yet not cramped, with infrequent abbreviations. When one considers that the exemplar would likely have been a late antique Italian manuscript in uncial script with no spaces between words and minimal punctuation, the expertise of the Northumbrian scribes is apparent. Spaces between words were inserted and the text painstakingly cor-

rected, with erasures barely visible. The script, hybrid Insular minuscule, has the distinctive elegance that comes from alternation of thin and thick strokes. The early date of VLF 4: 2 is evident from the use of more than one form for certain letters. The script, layout and other features convey discipline and clarity and suggest that facilitating consultation and navigation was a priority, a challenge for a work replete with unfamiliar terms.

Decorated letters adorn the start of each book. In addition to facilitating navigation of the text, these also evoke delight: the letters are whimsical evocations of beasts and birds, with prominent beaks and rear ends. Meanwhile, marginal indicator glosses were added for certain topics, while scratch marks are clues to actual use. For example, on fol. 28r, the scratched *X* above the word *Britannia* shows that a reader found the passage on Britain particularly interesting (see Fig. 2).

The Northumbrian scribes carried over aspects of their exemplar's layout and content, giving clues about the production of VLF 4: 2. One such clue occurs in the lower margin of fol. 29r (see Fig. 3), where the scribe faithfully reproduced the words (and boxed format) of a proofreading note by a late antique scholar at the end of Book 4:

> *Feliciter. Junius Laurentius relegi*

> 'Auspiciously, I, Junius Laurentius, have reread [and corrected the text]'

There was no Northumbrian scribe named Junius Laurentius; the original note was an addition to the imported exemplar, not part of Pliny's text.

On fol. 9r, we find another revealing clue:

> *c. pleni secundi naturae historiarum libri .ii. expliciunt. Incipit liber tertius*

> 'Two books of C. Pliny Secundus' *Naturalis historia* finish. The third book begins.'

Here a scribe copied a late antique sentence found between the end of Book 2 and the beginning of Book 3, even though its wording was incompatible with the actual contents of VLF 4: 2, which begins with Book 2, not Books 1 and 2. We can demonstrate that VLF 4: 2 never contained Book 1 by correlating its average number of words per leaf and leaves per quire with the extant quire signatures in our fragmentary text. The first surviving quire signature ('*iii/c*' on fol. 11v) occurs about halfway through Book 3. Given the average number of words per leaf and leaves per quire, there would not have been enough space in the two quires that originally preceded the surviving text to accommodate both Book 1 and the now-missing start of Book 2. In fact, early in the transmission of the *Naturalis historia*, Book 1 — which consisted of lists of the topics covered in the work — was removed and broken up, its relevant sections added to the start of each subsequent book.

Because it does not reflect the actual contents of VLF 4: 2, this second note is significant: the mention of *two* books preceding Book 3, not one, shows that an ancestor of VLF 4: 2 (perhaps, but not definitely, its exemplar) *did* actually contain Book 1 in its original location. It is tantalising, therefore, to observe that the leaf with the prefatory matter for Book 5 (fol. 29v, see Fig. 1) shows extensive erasing and reformatting (including of entire columns): the scribe appears to have been experimenting with layout as he worked, in order to incorporate the relevant prefatory material from Book 1 onto this single leaf. This may suggest that the insertion of Book 1's lists throughout the rest of the text was in fact, undertaken during the production of VLF 4: 2. Such details reveal the skill of its scribes and illustrate the importance of VLF 4: 2 in the reception of Pliny's *Naturalis historia* north of the Alps.

— Mary Garrison

Fig. 3
Two lines in the smaller, more informal minuscule script, announce the end of Book 4 and the beginning of Book 5. The words inside the box must have been a separate, and later, addition to the exemplar, because the formulaic word *feliciter* ('auspiciously') is repeated. They document late antique proofreading by an otherwise unknown Junius Laurentius. VLF 4: 2, fol. 29r, detail.

A constellation of copies and innovations

31 | Aratus / Germanicus, *Aratea*
Ninth century, between 814 and 840 — VLQ 79

The history of the Leiden *Aratea* shows how a copy and its original text are inextricably linked to one another. A copy is made of the original — for example, the Leiden *Aratea* reproduced a lost exemplar from Late Antiquity — but that copy in turn influences our understanding of the original. Copying manuscripts was a crucial activity in the Middle Ages. This practice continues even today, with digitisation serving to preserve texts and provide worldwide access to them.

The miniature on fol. 93v of VLQ 79 offers an intriguing insight into the early medieval cosmos. The heavenly bodies (the planets) circle the Earth, represented by a supine figure in a medallion. In an outer ring are the months and the constellations. The Leiden *Aratea*, with 39 full-page miniatures of constellations, contains the translation into Latin by Germanicus (c. 15/16 BC–19 AD) of the didactic poem on astronomy *Phainomena* by the Greek poet Aratus (314–245 BC). The poem describes the heavenly bodies and celestial phenomena, interspersed with mythological anecdotes about the constellations. The planetarium — a depiction of the planets — is an exceptional medieval addition that was not part of the ancient text. The planets are shown in the positions they would have been in on 18 March (or 14 April) 816 AD. This image can be used for a precise dating of the manuscript as a whole, suggesting it was probably made around 816. The miniature is a colourful depiction of the night skies at that time.

The Leiden *Aratea* is a copy of an exemplar from Late Antiquity. It is also one of the most important manuscripts from the Carolingian period; it was probably made for the court of Louis the Pious (778–840). Despite certain elements typical of Antiquity — the unconventional square shape of the leaves and the classical script — the artistic style and thickness of the parchment point to Carolingian origins. Moreover, the unique configuration of the planets places the book firmly in the Middle Ages. This is a reproduction yet at the same time an appropriation of ancient knowledge.

The practice of copying has somewhat negative associations nowadays, but it has played a crucial role in the history of cultural objects. Medieval books are a fine example of that. Manuscripts are praised now for their unique beauty, but they belong in a tradition of copying. Reproducing knowledge from the past and reliance on authoritative texts were seen as the best way of proceeding. However, it was also a way of appropriating that knowledge. The Leiden *Aratea* illustrates how ancient examples could be reused in a medieval context.

< Fig. 1
Planetarium, Leiden *Aratea*, first half of the ninth century, probably not before 816 (see Mostert and Mostert). VLQ 79, fol. 93v.

Fig. 2
Planetarium, Boulogne *Aratea*, c. 1000, Boulogne-sur-Mer, Bibliothèque des Annonciades, Ms. 188, fol. 30r.

The medieval manuscript, which was itself already a copy, thus led to a constellation of further copies.

Two medieval copies of the Leiden *Aratea* are known. One is now kept in the Bibliothèque des Annonciades in Boulogne-sur-Mer, France (Ms. 188), while the other can be found in the Burgerbibliothek in Bern, Switzerland (Cod. 88). Both copies were made in the Abbey of Saint Bertin in Saint-Omer (French Flanders), in around 1000. Whereas the depiction of the planets in the Bern *Aratea* seems to have been lost, the *Aratea* in Boulogne contains a direct copy. Four diagrams have been added in the corners providing information about the Earth, the seasons and the celestial spheres. The Leiden book and its contents were highly valued. Copying this book was a huge undertaking and yet this was done not just once but at least twice. The main purpose of these copies was to preserve and transmit the knowledge contained in the book. At the same time, information was added about monastic time recording and the new manuscripts were adapted for use in an eleventh-century monastery rather than a ninth-century court. These people were not only looking back at the past but also embedding the book in their present.

At the start of the seventeenth century, this manuscript attracted the attention of seventeen-year-old Hugo Grotius (Hugo de Groot, 1583–1645), the famous Dutch humanist and legal scholar. He published an edition of the Latin *Phainomena* entitled *Syntagma Arateorum*. Jacques de Gheyn (1565–1629) made engravings of the miniatures, including a fold-out version of the depiction. The style of engraving is unmistakably seventeenth-century, but the diagram and the figures have been taken directly from the medieval copy. The print edition of the *Aratea* made it more accessible and fostered the study of classical knowledge. Grotius, aided by technological advances, thereby made the *Aratea* part of the early modern humanist movement. In 1660, Andreas Cellarius (1596–1665) published *Harmonia Macrocosmica*, a celestial atlas with 29 richly decorated plates. It included the depiction of the planets from the *Aratea*, probably copied from a later edition of De Gheyn's engravings. Baroque elements have been added around the depiction of the planets: in the top corners, angels hold up title banners while the bottom has astronomers working with globes, books and measuring instruments — a reference to the origins of the planetarium. These two copies in print form ensured wide circulation of the *Aratea*'s contents.

Even today, making copies is an intrinsic aspect of how we deal with historic artefacts, from digitisation to museum shop gifts. The Leiden *Aratea* is a photogenic manuscript of which hundreds of photographic reproductions have found their way into numerous publications. The first black-and-white photos were taken at the end of the nineteenth century. The miniatures can be found in Georg Thiele's *Antieke Himmelsbilder*, with the planetarium provided as a separate plate. In 1987, the Lucerne-based publisher Faksimile Verlag printed a luxury facsimile edition, a perfect replica with gilt details, parchment stains and bound in sheep's leather. To make this complete photographic reproduction, the manuscript was taken out of its nineteenth-century library binding. This publication gave other heritage institutions the ability to acquire the manuscript in facsimile form and meant that the original did not have to be used so intensively. The Leiden manuscript became renowned for its beauty, a reputation that was

Fig. 3
Planetarium, *Antike Himmelsbilder*, Georg Thiele, Weidmannsche Buchhandlung, Berlijn, 1898. UBL, 12723 A 41, plate VII.

Fig. 4
Planetarium, *Atlas coelestis, seu Harmonia macrocosmica*, Andreas Cellarius, Johannes Janssonius, Amsterdam, 1660. Amsterdam, Allard Pierson, OTM: OF 69-18 (atlas), plate 8.

enhanced by the prestigious commercial facsimile edition. Thus the *Aratea* became both widely available and less accessible at the same time.

Nowadays, people are perhaps most likely to see manuscripts in digitised form. Even if they do not browse through digital collections directly, they probably come across medieval illustrations online from time to time. The Leiden *Aratea* was digitised in 2007, and again in 2014. As a result, it is now available in a hypermodern context. For ten years, the digitised *Aratea* was behind a paywall on Brill's platform; this publisher was responsible for the digitisation of much of the Vossius collection, in partnership with Leiden University. However, since the start of 2025 the digitised *Aratea* has become available to all free of charge. Now users of the Leiden University Libraries' Digital Collections can scroll through the leaves, zoom in, and compare the ninth-century illustrations against the eleventh-century copies.

The Leiden *Aratea* shows how copies made through the centuries can enhance and transform the value and meaning of the original work in various historical, institutional and technological contexts. As a significant manuscript, the Leiden *Aratea* has acquired a growing constellation of knowledge objects — from medieval copies to baroque engravings and digitised versions — that confirm and increase its importance. The manuscript's history shows that the practice of copying cultural heritage not only preserves it but also rejuvenates it, keeping ancient knowledge alive in a modern context.

— Suzette van Haaren

pollicis int medios indicis & impudici artus immittas. Cū dicis triginta ungues indicis & pollicis blando coniunges amplexu. Cū dicis quadraginta intiora pollicis latus ut dorso indicis supduces ambobus dū taxat erectis. Cū dicis quinquaginta pollice extiore artu. instar grece lrē gamme curuatū ad palmā inclinabis. Cū dicis sexaginta. pollice ut sup curuatū indice circūflexo diligent a fronte preinges. Cū dicis septuaginta indicem ut sup circūflexū. pollice immisso sup implebis. ungue dū taxat illius erecto. trans mediū indicis artū. Cū dicis octuaginta indice ut sup circūflexū. pollice in longū tenso. sup implebis. ungue uidelicet illius in mediū indicis artū infixo. Cū dicis nonaginta indici inflexi ungue. radici pollicis erecti infiges. Hactenus in leua. Trecentos in dextra. quom triginta in leua. Eode m̄ & cetos. usq̄ ad nongentos. Item mille in dextra. quom unū in leua. Duo milia in dextra quom duo in leua. Tria milia in dextra. quom tria in leua. & cetā usq̄ ad noue milia. Porro dece milia cū dicis. leua in medio pectoris suppinā appones. digitis tantū ad collū erectis. Viginti milia cū dicis eande de pectori expansam late suppones. Triginta milia cū dicis. eādē pnā s̄ erecta pollici cartilagini mediū pectoris immittes. Quadraginta milia cū dicis eandē in umbilico erectā supinabis. Quinquaginta milia cū dicis. eiusdē pne s̄ erecte pollice in umbilico pones. Sexaginta milia cū dicis. eādē pnā femur leuū comphendes. Septuaginta milia cum dicis. eandem supinam femori suppones. Octuaginta milia cum dicis eandē pnam femori suppones. Nonaginta milia cū dicis eadem lumbos apphendes. pollice ad unguinem uerso. At uero centum milia & ducenta milia usq̄ ad nongenta milia. eodem quo diximus ordine in dextera corporis parte complebis. Decies autem centena milia cum dicis ambas sibi manus insertis inuicem digitis implicabis. Est & altius modi compotus articulatim decurrens. qui quoniam specialit ad paschae rationem ptinet cum ad hanc exordine uentum fuerit oportunius EXPLICATUR.

Qd ñ sit paruipendenda cōputandi ars cū digitis cū exemplo Ieronimi

ARS cōputandi cum digitis ñ ē paruipenda cuius pene omīs sacre expositores scripture non minus quā littrarū figuris monstrant amplecti. Deniq̄ & multi alii alias. & ipse diuine scripture intpres Ieronim in euangelice tractatu sententie huī ad iuuamū discipline ñ dubitauit assumere. Centesimū mq̄ & sexagesimū & xxx fructū quiuis de una tra & de uno semīe nascūt. tam multū differt inumero. XXX referunt ad nuptias. Nā & ipsa digitoru id pollicis & indicis ciunctio & quasi molliosculo se coplectens. & federatis martiū pingit & cingit. Lx. ad uiduas eo qd in augustia & tribulatione sint posite. Vnde & supiore digito deprimunt. quinq̄ maior ē difficultas. ex pte qndā uoluptatis illecebris abstinere. tanto mai & pmiū. Porro centesimi numeri qso diligent lector attende. a sinistra trāsfert ad dexterā. & isdē qdem digitis s̄ non eade manu qb; in leua manu nupte significant & uidue. Circulū faciens exprimunt uirginitatis coronam. Hec uba Ieronim idō posui ut ex his uob commdet sollertia & scientia cōputandi q flexib; digitoru agitur.

	II	III	IIII	V	VI

	VIII	VIIII	X	XX	XXX

	L	LX	LXX	LXXX	XC

C	CC	CCC	CCCC	ↄ	ↄC

ↄCC	ↄCCC	ↄCCCC	M̄	N̄	IIĪ

IIIĪ	V̄	V̄I	V̄II	V̄III	V̄IIII

Hand signals and medieval counting

32 | Rabanus Maurus, *De computo*
Twelfth century, first half — BPL 191 BD

The practice of counting on one's fingers is nothing new, as this manuscript shows. While we might associate finger-counting with children, who are new to numerical reasoning and need a visual aid for calculations, the finger-counting illustrated in the Leiden manuscript of Rabanus Maurus' *De computo* is a sophisticated communication system that enabled one to represent numbers up to 1,000,000 using nothing more than one's hands and body.

The practice of using fingers to represent Roman numerals dates back to Antiquity; it likely developed as a means of communication in commercial settings. Prior to the introduction and widespread use of Hindu-Arabic numerals (which became popularised in Europe only from c. 1000 onwards), finger-counting simplified complex processes of calculation involving Roman numerals. This manuscript contains a copy of a computational text, *De computo*, by the medieval scholar Rabanus Maurus (780–865). In his work, Rabanus guided the reader through thorny calculations, including estimating the date of Easter. Rabanus depended heavily on a work by the English scholar Bede (†735), *De temporum ratione* ('The reckoning of time'), in which finger-counting is extensively discussed.

In addition to a textual description of how to represent various Roman numerals with the hands and body, BPL 191 BD also includes a set of tabulated visualisations which demonstrate finger-counting in action, spread across four pages (fols 4r–5v). On fol. 4r, finger gestures for numbers up to 9000 are displayed across 36 segmented spaces, divided into six rows. The table is further subdivided into two, with the first three rows showing the finger gestures of the left hand (for single digits and tens) and the lower three rows those of the right hand (for hundreds and thousands). The finger gestures for the single digits (left hand) and the thousands (right hand) are alike, but mirrored, as is the case for the gestures for the tens (left hand) and hundreds (right hand). Across the two final rows, some Roman numerals are stroked with a horizontal line, indicating that these gestures represent multiples of 1000 (in this case, the numbers 4000 to 9000).

As visualised in the table (and in contrast to contemporary finger-counting), numbers were shown not by holding the fingers up, but by holding the fingers down. The number one, for example, is demonstrated by holding down the little finger of the left hand, while the other three fingers and the thumb are held up. The hands are presented palm side up; a viewer looking at this page could simultaneously look to their own hands and copy the gestures. In medieval monasteries, silence was an important element of contemplative living, and finger-counting and other systems of sign language were encouraged forms of communication. Similar tables presenting finger-counting are found in other medieval manuscripts, perhaps showing the enduring appreciation of this counting system.

The anonymous readers of this manuscript seem to have found this section on finger-counting particularly interesting, as illustrated by the inclusion of an additional short text in the lower third of fol. 3v, in what was originally a blank space following the word *explicatur* ('as explained'). This text, a short extract from a commentary of Jerome (c. 347–420, translator of the Latin Vulgate Bible) on the biblical Parable of the Sower, is also found in Bede's *De temporum ratione*. As the Parable of the Sower recounts, some seeds 'planted on good soil' yielded a thirty-fold harvest, others a sixty-fold harvest, others a hundred-fold harvest. Jerome

<< Fig. 1
On fol. 4r, the signs for the numbers 1 to 9000 are demonstrated, while Jerome's description of finger-counting is presented on fol. 3v (introduced with a red title).
BPL 191 BD, fols 3v–4r.

related these yields to different states of good Christian living — marriage, widowhood and virginity — each represented in turn by an appropriate finger gesture, whose shape echoes each state. Marriage, for example, is represented by the number thirty. To form that figure, one joins the tips of the index and middle fingers in what Jerome described as 'a gentle embrace', like that shared by a husband and wife (a presentation that differs from the accompanying visualisation).

This text is copied by a hand contemporary with, but distinct from, that of the main scribe responsible for copying Rabanus' text; it is in a lighter shade of ink, and the letter forms are more vertical in aspect. A note squeezed into the last two lines of the page reads *Hec v(er)ba ieronimi id(e)o posui ut ex his vob(is) comm(en)det(ur) sollertia (et) scientia co(m)putandi q(ua)e flexib(us) digit(orum) agitur*, roughly translated as 'I put these words of Jerome [here] for the reason that they praise the skill and knowledge of calculation which is done by the bending of the fingers'. Jerome's text has been added to contextualise and validate the practice of finger-counting — no higher praise is needed than that offered by the translator of the Bible himself!

Turning to the manuscript's last folio (fol. 26v), we find further evidence of continued interactions by users of this manuscript. This leaf, originally left blank, contains drawings of 'magical seals'. Magical seals were popular in the medieval period and were intended to confer protection or particular blessings upon the user. These examples, circular in shape, contain a mixture of letter forms derived from the Latin and Greek alphabets, sometimes even with runic features. These markings cluster around cross-like drawings, encircled by rings sketched in red ink, which contain short prayers, various divine names or instructions regarding their purpose. One seal, for example, includes the detail that it was presented by an angel to the Irish saint Colmcille (521–597) and declares that whoever looks upon it will avoid being cut in the throat.

At the bottom of this folio, we find an unassuming sketched line. This line is a so-called 'metric relic'. As the accompanying text claims, the line is one-sixteenth the height of Christ, as measured from the Golden Cross of Constantinople, one of the relics of the Crucifixion. As it measures 11 cm, the line estimates the height of Christ to be 1 m 76 cm, the height of an average adult male. Like the seals, this metric relic was a meditational device, intended through prayerful contemplation to bring the viewer closer to immanence with God and religious mysteries. Along with the text on computation, both seals and relic present a rarified form of knowledge not accessible to everyone, and rendered even more mysterious (and perhaps precious) on that account. Through their presence, the manuscript itself becomes a vehicle for prayer and for protection, containing a power that reaches beyond its text.

— Irene O'Daly

Fig. 2
A set of 'magical seals', along with a 'metric relic', a line representing the height of Christ, has been added on the final folio of the manuscript, which was originally blank.
BPL 191 BD, fol. 26v.

An impossible object

33 | Euclid, *Elementa* XI-XV
Fourteenth century — SCA 36

The history of Greek mathematics is the history of the lettered diagram: a mathematical drawing with letters indicating the parts. Medieval manuscripts give us a unique glimpse into how this aspect of 'information technology' developed.

Proposition XI.3 from the Elements by Euclid of Alexandria (c. 300 BC), the Greek 'father of geometry', states 'Ἐὰν δύο ἐπίπεδα τέμνῃ ἄλληλα, ἡ κοινὴ αὐτῶν τομὴ εὐθεῖα ἐστιν (*ean duo epipeda temnêi allêla, hê koinê autôn tomê eutheia estin*). In translation: 'When two planes intersect, their intersection is a straight line.' The proof then follows:

For let two planes AB and BC intersect, and let the line DB be their intersection. I postulate that the line DB is a straight line.

If it were not, draw in the straight lines DEB from D to B in the plane AB and DZB from D to B in the plane BC. The two straight lines DEB and DZB would then have the same ends and yet clearly enclose an area, which is absurd. Therefore, DEB and DZB are not straight lines.

Similarly we can prove that there is no straight line joining D to B other than DB, the intersection of the planes AB and BC. Which is what we were trying to prove.

This is a typically Euclidean proposition, with the proof and supporting diagram found in SCA 36 (on fol. 3r, from line 10 onwards), one of the manuscripts that Leiden University Library received in the bequest of Josephus Justus Scaliger (1540–1609). The proof starts with a statement in generalised terms ('two planes', 'intersection', 'straight line') but then uses a specific example to complete the proof: two specifically named planes αβ (AB) and βγ (BC) and a specific straight line δβ (DB), shown in a diagram that constitutes the entire geometric universe for the duration of that proof. (In geometry texts in Greek, using the definite article τό combined with two letters is sufficient to make clear that the reference is to a plane rather than a line.)

In SCA 36, we can see how the scribe tries to help the reader visually by adding a horizontal stroke above the letters indicating the geometrical objects, so that the reader can understand at a glance that the sequence of letters δεβ (DEB) should not be read as a word but as the name of an object. The proof then utilises a typical indirect strategy: a *reductio ad absurdum*, evidence that the converse would be absurd. Instead of showing directly that there is only one possible straight line that can be constructed between points B and D, Euclid shows that the implications of the opposite scenario would be absurd. The proof ends with a formulaic ὅπερ ἔδει δεῖξαι (*hoper edei deixai*): 'that which was to be proved' — familiar from its Latin translation *quod erat demonstrandum* and its abbreviation 'QED' — followed by a colon that makes clear that the unit ends here (fol. 3r, line 13 from the bottom).

Fig. 1 >
Euclid, Elements XI.2-4. Proposition XI.3 starts on line 10 (ἂν δύο ἐπίπεδα, without the initial 'E' that the scribe has perhaps intended to add later in red ink); the closing phrase ὅπερ ἔδει δεῖξαι is on line 13 from the bottom. SCA 36, fol. 3r.

Fig. 2
Euclid, teaching students in the school of philosophy, Athens. Detail of a fresco by Raphael, 1510–1511. Vatican City, Apostolic Palace, Vatican Museums.

μέρος ἤτοι τὸ ΖΕΗ, ἡ τὸ ΗΕΚ ἐν τῷ ὑποκειμένῳ ἐστὶ πεδίῳ, τὸ δὲ λείπον ἐν ἄλλῳ, ἔσται καὶ μία τῶν ΕΖ ΑΒ καὶ τῶν μερῶν μὲν τῇ αὐτῇ ὑποκειμένης ἐπιπέδῳ, τὸ δὲ ὑπὸλοιπον. ἀλλὰ τοῦ ΕΖ τριγώνου τὸ ΖΕΗ μέρος ἦν ἐν τῷ ὑποκειμένῳ ἐστὶ πεδίῳ... τῶν ΕΖ ΑΒ κοινῶν μερῶν μὲν τῇ... ὁ περὶ τὸ ΕΝΕΧΘΗ, τὸ δὲ ΕΖ τρίγωνον, ἐν... ἐν ὧδει τὸ ΕΖ τρίγωνον, ἐν τούτοις ἑκατέρα τῶν ἑκατέρα τῶν ΖΕ ΑΒ, ἐν τούτῳ καὶ αἱ ΑΒ ΓΔ· αἱ ἄρα ΓΔ ἐν ἑνὶ δ' οὖν εἰσὶ πεδίῳ· ὅπερ ἔδει δεῖξαι:

αἱ δὲ δύο ἐπίπεδα τέμνει ἄλληλα, ἡ κοινὴ αὐτῶν τομή, γραμμή ἐστι· δύο γὰρ ἐπίπεδα τὰ ΑΒ ΒΓ τεμνέτωσαν ἄλληλα· κοινὴ δὲ αὐτῶν τομὴ ἔστω, ἡ δὲ γραμμή. λέγω ὅτι ἡ δὲ γραμμή, εὐθεῖά ἐστιν. εἰ γὰρ μή, ἐπεζεύχθω ἀπὸ τοῦ Δ ἐπὶ τὸ Β· ἐν μὲν τῷ ΑΒ ἐπιπέδῳ, ἡ ΔΕΒ ἐν δὲ τῷ ΒΓ ἐπιπέδῳ, ἡ ΔΖΒ, ἐπεὶ αἱ δύο εὐθεῖαι τῶν ΔΕΒ ΔΖΒ τὰ αὐτὰ πέρατα, καὶ περιέχουσιν δηλαδὴ χωρίον, ὅπερ ἄτοπον. οὐκ ἄρα αἱ ΔΕΒ ΔΖΒ εὐθεῖαι εἰσίν· ὁμοίως δὴ δείξομεν ὅτι οὐδὲ ἄλλη τις ἀπὸ τοῦ Δ ἐπὶ τὸ Β ἐπιζευγνυμένη εὐθεῖα ἔσται, πλὴν τῆς κοινῆς τομῆς τῶν ΑΒ ΒΓ ἐπιπέδων· ἐὰν ἄρα δύο ἐπίπεδα τέμνει ἄλληλα, ἡ κοινὴ αὐτῶν τομή, γραμμή ἐστιν· ὅπερ ἔδει δεῖξαι.

ἐὰν εὐθεῖα δι' ἄλλο δὲ ἐξ ἑνὸς σημείου ταῖς ἀλλήλαις πρὸς ὀρθάς, ἡ τῆς κοινῆς τομῆς αὐτῶν ὀρθή. δύο γὰρ ἐπιπέδων πρὸς ὀρθὰς ἔσται· καὶ γὰρ εἴ τις ἐξ δι' ἄλλοδας ταῖς ΑΒ ΓΔ τέμνουσας ἀλλήλας κατὰ τὸ Ε σημεῖον, ἀπὸ τοῦ Ε πρὸς ὀρθὰς ἐφεστὼς λέγω ὅτι ἡ ΕΖ καὶ τῷ διὰ τῶν ΑΒ ΓΔ ἐπιπέδῳ πρὸς ὀρθάς ἐστιν. ἀπειλήφθωσαν γὰρ αἱ ΑΕ ΕΓ ΕΔ ἴσαι ἀλλήλαις· καὶ διήχθω τις διὰ τοῦ Ε, ὡς ἔτυχεν, ἡ ΘΕΗ· ἐπεζεύχθωσαν αἱ ΑΔ ΒΓ· ἀπὸ δὲ αὐτοῦ σημείου τοῦ Ζ, ἐπεζεύχθωσαν

Fig. 3 (left) The text of XI.2 fills the space around the diagram of XI.1. SCA 36 fol. 2v, detail.

Fig. 4 (right) The diagram for XI.1 in the modern edition by Heiberg (1973), with an auxiliary visual construction to help the spatial interpretation of the object.

The text and diagram here actually combine to ask the reader to do something impossible: for the duration of the proof's argumentation, the reader has to imagine that the clearly curved lines in Figure 1 are in fact straight. The user has to use the diagram as a visualisation aid while at the same time not taking what the eye sees at face value — a nice example of how the text and diagram in a Euclidean proof depend on each other, and of how a diagram is something that a user has to learn how to look at.

The Elements was a canonical text even in Antiquity; it was one of the most widely copied texts from Antiquity in the Middle Ages, partly because of the position it enjoyed in education. The work continued to enjoy great popularity in the early modern period as well, not only because of the mathematical content but also because of the scientific and mathematical ideal that is embodied in the Elements. That ideal was based on two cornerstones: the unique interplay between textual and visual argumentation and what is known as the axiomatic deductive scientific approach, in which results are derived one by one from a set of definitions, principles and previously proven propositions. We know for instance that Scaliger closely followed the Euclidean method as a template in his *Cyclometrica* (1594), his attempt to square the circle (a problem since proved to be insoluble, of course).

Proposition 3, discussed above, comes from Book XI of the Elements, the book that opens SCA 36 and the solid geometry section of the work. The earlier books cover plane geometry, number theory, the theory of proportionality and irrational quantities. The five regular Platonic solids are the main focus of books XI to XIII. In addition to XI–XIII, SCA 36 also contains the two apocryphal books XIV and XV (also treatments of regular solids), which from the fifth and sixth centuries onwards became a standard part of the material handed down in many manuscripts. In Antiquity, though, they had already been explicitly attributed to other authors (indeed, in SCA 36, Book XIV is attributed to Hypsicles, one of Euclid's pupils).

Medieval manuscripts are our key source for the history of mathematical diagrams. It is difficult to uncover exactly how the diagrams we find in the manuscripts relate to the diagrams from Euclid's own time (which was, after all, often over 1,500 years earlier). We can however discern various patterns in this manuscript that tell us a little about how diagrams were used in later times. As in other Greek manuscripts, the diagrams seem to have been drawn in areas that have been deliberately left blank on the folio, usually just below the texts of the theorems to which they refer. The diagrams were probably copied later, by another scribe or in a new round of edits. That seems in the first instance to have been the case in this manuscript too. Nevertheless, the very first diagram on fol. 2v, shown in Figure 3, is an exception: the text of Proposition 2 is neatly wrapped around the diagram and was therefore copied after the text and diagram for the preceding proposition were completed.

Greek mathematical diagrams are highly schematic in nature. They are often metrically incorrect (i.e. the

proportions do not match what the text stipulates) and they have clearly been copied by eye, unassisted and more or less freehand. Although we are in the section of the Elements about solid geometry, the diagrams do not utilise any of the usual techniques for suggesting three dimensions, such as foreshortening of the perspective or auxiliary planes to emphasise the spatial projection.

The diagrams are also often 'over-specified' — in other words, they are often more symmetrical or more regular than is strictly required for the proof. A prime example is the diagram for Proposition XI.2 (on fol. 3r, in Fig. 5), which states that 'when two straight lines intersect, they are in a common plane and therefore all triangles are planar.'

In the proof, the points Z (ζ) and H (η) are chosen at random positions along the lines AB and CD; there is no need for the diagram to be symmetrical for the proposition to be valid. Even so, we see that a neatly symmetrical diagram is used in the majority of manuscripts. In these kinds of situations, modern editors expressly choose asymmetric diagrams to reinforce the generalisability of the proposition (i.e. it even works for this irregular example). It is a nice example of how aesthetic preferences and the considerations of visual rhetoric are specific to both their time and context.

— Tazuko van Berkel

Fig. 5 (left)
The diagram for XI.2. SCA 36, fol. 3r, detail.

Fig. 6 (right)
The diagram for XI.2 in the modern edition of Heiberg (1973), emphatically asymmetric.

34 | JACOB VAN MAERLANT, DER NATUREN BLOEME

Jacob van maerlãt die dit dichte
Omme te sedene teier gichte
Wille datmen dit boec noeme
In dietsche der nature bloeme
Want noch noyt in dietsche boeke
Neghene dichtere wilde roeken
Iet te dichtene van naturen
Van so menighen creaturen
Als in desen boeke staen
Niemen en hebbe dies waen.
Dat ic die materie vensede
Els dan ic die ryme pensede
Die materie vergaderde recht
Van coelne broeder alebrecht
Ute desen meesters die hier na comen
Die ic iu sal bi namen noemen.
De eerste die es aristotiles
Die te rechte deerste wel es
Want hi van alre philosophien
Van alre naturliker clerghien
Bouen allen heidene die noyt waren
Draghet hi crone in der scaren
Waer dat men dit teyken siet. Az.
Dats dat hi te segghen plicht
Plinius die coemt daer naer
Dies boeke men hout ouwaer
Solinus daerna van naturen
Schone spreect in siere scrifturen
In enen boeke die men weet.
Die van der werelt wonder heet.
Sinte Ambrosius van milane
Die van naturen doet teuerstane
In sinen boeke examiren
Dien noemtmen dicke in dit doen
Sinte basilius sekerlike.
Dien god sende van hemelrike
Enen boec van eersten nature

Staet dicke oec in dese scrifture.
Sente ysidorus oec mede
Die dicke grote nuttelycheide
Gheseyt heuet in sinen boeken
Dien moetmen dicke hier soeken
Oec meester Jacob van vetri.
Bisscop van akers so was hi.
Seder cardenael van rome
Sins eist recht dat ic hier nome
Een boec oec waer mene weet.
Wiene makede gheret
Es ghetelt onder hem somen
Experimentator hore wine nomen
Sine worde sette in hier mede
Alst noet es te menigher stede
Galienus pellidius
Platearius en philologus
Luallus phiso theofrastus
Ende die keyser claudius
En dyogenes demoticus van athene
En dyogenes apollodim ghemene
Die van den tweeden die draghen venim
Die noch heden in der werelt sim
In sinen boeken laet besien.
Dyonisius ende finicien
Caton uaro ende marthus
Eradides en orpheus
Pitagoras en menander
Homerus ende nicander
Nusianus dyagoras
Virgilius ende andreas
Coninc iuba patronus
Coninc philometor metellus
Coninc ptolomeus umbricus
Coninc antigonus alpheus
Coninc archelaus flamicus
Philemon ende nigidius.

The Creation glitters in gold

34 | Jacob van Maerlant, *Der naturen bloeme*
Fourteenth century, c. 1360 — BPL 14 A

In distant lands, there are people with dogs' heads, cyclops, savages covered in hair and with six fingers, and people with only one foot that is so large it serves as a parasol when they lie on their backs to sleep. These details and many more about the natural world are found in *Der naturen bloeme*, a late thirteenth-century encyclopaedia of the natural world of some 17,000 verses written by the Flemish sexton Jacob van Maerlant (c. 1235–c. 1290).

<< Fig. 1
Opening of *Der naturen bloeme*. Miniature with the patron praying to Saint Christopher (fol. 25v), and the prologue with the references to Maerlant's sources (fol. 26r).
BPL 14 A, fols 25v–26r (image 86%).

Fig. 2
Miniatures based on Maerlant's description of strange peoples.
BPL 14 A, fol. 29r, details.

Working in the second half of the thirteenth century, Jacob van Maerlant produced an impressive oeuvre in Middle Dutch of more than 230,000 verses in total. That makes him one of the most productive authors in any European language. However, his significance lies in the quality of what he wrote even more than in the quantity. His position as a sexton of a small church in Brielle in the south of the county of Holland was a modest clerical post and seems to have given him the opportunity to devote his life to literature. His texts were commissioned by affluent patrons in the upper ranks of the nobility and clergy. But he must have had a choice in what texts he wrote because the subject matter of his work is remarkably cohesive and clearly shows the signs of a life's mission. Maerlant wanted to translate the knowledge contained in Latin books into Dutch and make this information accessible to a lay readership. In this respect too, he was a pioneer from a European perspective.

Der naturen bloeme, which was completed shortly after 1270, is an encyclopaedia of the natural world in which Maerlant drew from the Latin reference work *De natura rerum* by the Brabant clergyman Thomas of Cantimpré (1201–c. 1272). In his prologue, Maerlant erroneously attributes his main source to Albertus Magnus (c. 1200–1280). He also mentions numerous other authorities, the most important of whom is Aristotle (fol. 26ra, capital 'D': *Die eerste die es aristotiles*). Maerlant's text can be considered a reliable record of the state of knowledge about the natural world in the late thirteenth century, even if that knowledge was mainly derived from books by earlier authors. For instance, the above-mentioned passage about the human races, which sounds strange to us, can be traced back via numerous intermediaries to Pliny the Elder (23/24–79 AD); he too is mentioned by Maerlant in his prologue (fol. 26ra, capital 'P': *Plinius die coemt daer naer*).

Maerlant abridged the Latin source text for his lay readership and simplified it as he deemed necessary. Whereas *De natura rerum* consisted of twenty 'books', or long chapters, Maerlant has only thirteen, each of which is dedicated to specific beings, plants or aspects of the natural world. Ordered alphabetically according to their Latin names, entries provide information about types or races of humans, four-footed animals, fish, birds, trees, rocks and metals, for example. That made *Der naturen bloeme* a standard reference work for looking up information, but it could equally serve as a text for a lay audience to read (or have it read aloud) as a pleasant way of sharing all kinds of facts about the Creation.

Like many medieval codices, this Leiden manuscript contains other texts in addition to *Der naturen bloeme*. The book opens with a calendar and a brief introduction to cosmology, known to scholars as *De natuurkunde van het geheelal*. These texts actually function as a lead-in to Maerlant's encyclopaedia, which is why it is generally thought that the book was deliberately compiled to centre on that text. There are nineteen known manuscripts of the encyclopaedia in the world, of which only eleven are more or less complete. Seven have illustrations, but the one in Leiden is the only manuscript to have illustrations throughout. While the other manuscripts only have illustrations for the 'human races' and various species of animals, the Leiden manuscript also has miniatures illustrating the chapters on trees and gemstones. That makes this book exceptionally significant, not just within Leiden's collections but also for our knowledge of *Der naturen bloeme* and of the manuscripts of Maerlant's work more broadly.

Jacob van Maerlant opens the prologue (fol. 26ra) confidently by citing his own name: *Jacob va(n) maerla(n)t die dit dichte / omme te se(n)dene terer gichte* ('Jacob van Maerlant, who wrote this with the intention of making it a gift'). This is followed by an explanation of what the work involved, with the author again striking a proud tone: *Wa(n)t noch noyt i(n) dietsche(n) boeke(n) / Ne ghene dichtere wilde(n) roeken / Iet te dichtene van naturen / Van so menighen creaturen / Als in desen boeke staen* ('Because never before have writers of books attempted to relate something in our language of the countless different creatures of Nature that have now found a place in this book'). In other words, the proud author introduces himself and pats himself on the back for being the first person willing to take the step of making knowledge about the natural world available in the vernacular.

Maerlant completed *Der naturen bloeme* shortly after 1270. The book was commissioned by the Zeeland nobleman Nicolaas van Kats († before 1293). This richly decorated manuscript is a copy made nearly a century later, in around 1360. It may have been made for Jan van IJsselstein (1304–1365), a canon and keeper of the treasury of the Mariakerk church in Utrecht, as his coat of arms appears four times in the margins of the opening miniature and the prologue. He was the third or fourth son of the lord holding the title of IJsselstein (a castle in Utrecht province) and therefore may always have been destined for a career in the Church. In the full-page opening miniature (fol. 25v), Saint Christopher is carrying Christ on his shoulders across a river. The background is bright red, with a subtle flower motif and gold dots. There is also a figure shown praying to the saint, which can be seen as a 'portrait' of the patron who ordered the copy.

As a secular clergyman from the ranks of the nobility, Jan van IJsselstein would fit well with what is known about the readership for the texts of Jacob van Maerlant. His patrons were high-ranking noblemen or clergymen in Holland and Zeeland. The connection with Utrecht is not unexpected either: Maerlant wrote a *Sinte franciscus leven* for the Utrecht Franciscans, and there were close connections between the nobility of Holland, Zeeland and the Prince-Bishopric of Utrecht. Later copies of Maerlant's work are found in noble, urban and church circles, depending on the nature of the texts. Little is known of what happened to the Leiden manuscript after Jan van IJsselstein's death. It is tempting to assume the manuscript became part of the impressive chapter library of the Mariakapittel church in Utrecht, but we cannot be certain of that.

— Bram Caers

Fig. 3
The Leiden manuscript of *Der naturen bloeme* is the only one that contains illuminations for trees and precious stones. BPL 14 A, fol. 115r, detail.

Travelling scholars, travelling texts

35 | Adelard of Bath, *Regulae abaci*
Fifteenth century, early — SCA 1

The *Regulae abaci* is an elaborate fifteenth-century copy of a twelfth-century introductory text on the abacus, a calculation device. The manuscript was originally bound with another set of texts concerning mathematics and other topics, now located at the J. Paul Getty Museum in California. Their history shows how medieval manuscripts can become dispersed in different collections worldwide. Detective work allows us to reunite these two manuscripts, now preserved half a world apart.

Medieval scholars often travelled for their studies. Driven by a thirst for new ideas and the promise of access to new or rare texts, they sought out teachers who were specialists in their fields. Adelard of Bath (active early 1100s) is an example of an English scholar who went abroad for his education, first to schools in France, then further afield to Salerno in southern Italy and finally to Antioch in present-day Turkey. During his travels, Adelard studied with Arabic teachers and developed a particular interest in mathematics, notably translating an Arabic version of Euclid's Elements (see no. 33) into Latin upon his return to England. This fifteenth-century French manuscript, SCA 1, contains a copy of Adelard's *Regulae abaci*, an introductory text on the use of the abacus.

Despite its introductory content, SCA 1 is a high-quality production. Measuring nearly 40 cm in height, it is copied in a refined gothic cursive script with a rightward slant on sheets of creamy, evenly coloured parchment. Any minor flaws in the parchment, such as small tears or slight discolourations, were strategically hidden in unobtrusive locations on the page (such as the inner margin, folio edge or centre of the quire gathering) to minimise their visual impact. On fol. 1r, the text block is framed by painted floral decoration touched with gold highlights, while alternating gold and blue majuscules on red and blue penwork backgrounds spell out the title of the text, REGULE ABACI.

Fig. 1 >
Copied in the early fifteenth century, this manuscript was decorated by the so-called 'Virgil Master', who was responsible for the opening miniature and the ornate border. The illuminated initial *A* represents the first word of the author's name, *Adelardus*. SCA 1, fol. 1r (image 69%).

The text opens with a decorated *A* for *Adelardus* ('Adelard' in Latin). About halfway down the first column, we find a smaller decorated initial in gold on a blue background. This marks the section where Adelard described the origins of the abacus, an invention he attributed to students of the Greek mathematician Pythagoras (c. 570–495 BC):

> *Pythagorici vero hoc opus compo | suerunt. ut ea, que magistro suo | pitagora docente audierunt. ocul(is) sub | iecta retinerent, et firmius custodirent. | Q(uo)d ip(s)i quidem mensam pithagoream ob | magistri sui reverentiam. sed post(er)i tame(n) | abacum dixerunt.*

'The Pythagoreans indeed composed this work [i.e., the abacus], so that what they had heard their teacher Pythagoras teaching they might retain, subject to the eyes and guarded more closely. They themselves [called] it the "Pythagorean table" out of reverence for their teacher, but later [scholars] called [it] the abacus.'

In his account of the abacus' origin, Adelard paid particular attention to its role as a memory device. By moving its various counters around columns representing hundreds, tens and ones, the user eased the mental strain required to carry out complex calculations.

The image on fol. 1r depicts a classroom scene, reinforcing Adelard's description of the abacus's use in

Regule Abaci

Adelardus philosophorum assecla Ozmundo suo salutem. Cum inter nonnulla ferula philosophice mense apposita nobis deorsum solitarius discumbentibus proximum connue de parte sed a tripliciter sumerent, et me de quadam sida lance pauca ori tuo instillante omnia fastidires, quippe que ab aliis sunt posita et hactenus intemptata, tibi videres puerorum antidotis ante plibasti. Pytagorici vero hoc opus composuerunt, ut ea que magistro suo propria doctrina docente audierant, oculi subiecta retinerent et firmius custodirent. Et ipsi quidem mensam pulverulentam ob magistri sui reverenciam, sed positi tamen abacum duxerunt. Decuplatione enim totum opus tepitur, quod eo nomine interpretacionis supiatur. Abacus enim vel abax decuplex interpretatur, vocatur eciam radius geometricus, quia cum ad multa pertineat maxime per hi geometrie subtilitates nos illuminantur. Dicitur eciam abacus a tribus primis litteris

grecorum vel latinorum a quibus singule sillabe huius nominis incipiunt. Materia in hoc opere est numerus secundum contrarias passiones augmenti et detrimenti consideratus. Intentio philosophorum hoc opere de hac materia tractare divisiones et multiplicationes eorum Lectorem instruere. Agunt tribus modis scilicet simpliciter, id est sine differentia quod nos aurum dicimus, et copiose, id est cum differentia quod nos ferrum vocamus. Permixtum quod nos aurum et ferrum nuncupamus. Sciendum est quod omnes numeri ab uno usque ad novem digiti, omnes vero limites, 1, v, et que supra articulos antiqui vocaverunt hec improprie est dicta et quedam alia in hoc opere invenimus sicut dominus Hubertus testis est, qui hoc opus nostrum Gallis restituit et regulis sementim compositis illustravit. Prius enim cathedi totum esse videtur, cum pluries eorum in dubio contineantur. Sed quoniam articulus in dubio finem faciat, duos limites numerorum dubitat. Duo sunt species divisionis, due in simplicibus diversoribus, tres in compositis, scilicet et audientibus et differentibus informamus preter quas nullam invenire poterimus. Prima est que fit in simplici dividendo per simplicem divisorem in una ordine et linea invenitur scilicet sortitur. Denominationes a neutro fiunt, nec a partibus, nec a toto. Singularis singularem dividet. Simplex simplicem, minime tangunt. Differentes itaque denos ad denos, centenos ad centenos se habet et deinceps. Sed denominaciones a singulari non promonebunt. Collocentur quatuor divisor et novenarius dividendus sex limites

Ex Legato Illustris Viri JOSEPHI SCALIGERI.

Fig. 2
A list scrawled at the end of the manuscript describes its original contents. The items found in the first two lines are now in J. Paul Getty Museum, MS 72, while the final line refers to the *Regulae abaci*, now SCA 1. SCA 1, fol. 18r, detail.

teaching. A teacher and two students, all bearded to indicate their maturity, are shown against a gold-chequered background. The teacher, seated on an elaborate wooden chair to demonstrate his seniority, leans forward, his gesturing fingers conveying a point. Framed on the wall is a poster, with Arabic numerals on its first line reading '1 2 3 4 5' (given in their medieval notation, with distinctive forms for the numbers four and five). References to coinage appear in the poster's lower half — to the *dragma* ('drachma') and to fractional divisions of the *libra* ('pound'), namely the *triens* ('one-third') and the *deunx* ('eleven-twelfths'). As the poster suggests, the abacus was popular in commercial contexts.

This miniature was created by an anonymous French artist known as the 'Virgil Master', since he made richly decorated manuscripts of the works of the Roman poet Virgil. The Virgil Master was active around 1380–1420 and illustrated a number of manuscripts for nobles around the court of John, Duke of Berry and Auvergne (1340–1416). From its high quality, we can deduce that SCA 1 was made for a patron in this courtly circle.

A scrawled note on the concluding flyleaf of SCA 1 describes the manuscript's original contents:

> *Libri Alcha(n)drei ph(ilosoph)i de astrologia.*
> *Item boecii de arismetica (et) de musica*
> *Ite(m) regule abaci s(e)c(un)d(u)m*
> *oppinio(ne)m pittagoricor(um)*

'The books of Alchandreus the philosopher on astrology; also of Boethius on arithmetic and on music; also the rule of the abacus according to the opinion of the Pythagoreans.'

On the basis of this note, we can determine that SCA 1 was originally joined to another manuscript, namely Los Angeles, J. Paul Getty Museum, MS 72. This manuscript, copied by the same scribe, contains not only texts relevant to the study of mathematics and music — Boethius' (c. 480–524/5 AD) *De institutione arithmetica* and *De institutione musica* — but also a text on astrology — the *Alchandreana*, a medieval compilation which depended heavily on Arabic sources. MS 72 originally formed the first part of a mathematically oriented compilation of texts, followed by the contents of SCA 1.

The two Boethian texts in MS 72 are also prefaced by teaching miniatures, similar in style to those found in SCA 1 and also illustrated by the Virgil Master. In the one introducing *De institutione arithmetica* (fol. 26r), a bearded elderly teacher leans down to instruct a schoolboy, who holds an open wax tablet inscribed with Arabic numerals. As with the miniature in SCA 1, this image invited the reader into a virtual classroom context where they, like the depicted student, could participate in the process of learning facilitated through the medium of the text.

Why the two parts were separated remains a mystery. We know that SCA 1 entered Leiden Library as part of the bequest of the scholar Joseph Scaliger (1540–1609). MS 72 was one of the many manuscripts owned by the English bibliophile Thomas Phillipps (1792–1872) and was purchased by the J. Paul Getty Museum only in 2003.

— Irene O'Daly

Fig. 3
This miniature, which opens Boethius' *De institutione arithmetica*, presents a classroom scene. A wax tablet, a support used for the teaching of mathematics, is depicted in the hand of the student. Los Angeles, J. Paul Getty Museum, MS 72, fol. 26r.

FABLES AND FICTION

The stories of King Arthur and the Knights of the Round Table have intrigued audiences for generations. Popularised by the French poet Chrétien de Troyes in the late twelfth century, Arthurian romances resonated with the chivalric traditions of the Middle Ages. The characters in these tales displayed bravery, gallantry and loyalty — virtues prized in elite medieval circles — while their heroic deeds captured the medieval imagination. Arthurian romances were transmitted and adapted in many vernaculars, a factor that only increased their popularity in the late medieval period. All three manuscripts in this section contain at least one Arthurian romance: *Roman van Ferguut* and *Roman van Walewein* (nos 36 and 37; LTK 191 and LTK 195, respectively) in Middle Dutch, and *Wigalois* (no. 38, LTK 537) in Middle High German. The *Walewein* and *Wigalois* manuscripts both contain illustrations, showcasing a knightly life of burnished armour, feasts and courtly love.

These manuscripts provide important information about the contexts in which literary fiction was produced and read. The *Wigalois* manuscript (no. 38, LTK 537), for example, was copied by a Cistercian monk in a monastery, raising interesting questions regarding the reading of secular tales in religious contexts. In a seemingly logical combination, *Walewein* shares its covers with another epic that also concerns quests and adventures (no. 37, LTK 195). Its companion text, the *Roman van Heinric en Margriete van Limborch*, takes the reader on a series of exotic journeys — east to Greece and Constantinople, and south to Aragon in Spain. However, the only surviving manuscript with *Ferguut* (no. 36, LTK 191) is a composite collection containing, among other parts, a set of moralising animal fables (*Esopet*), along with verses on the lives of the twelve apostles. Examining these sometimes incongruous combinations of texts can offer invaluable insights into how texts circulated in the Middle Ages.

As these manuscripts were copied in vernacular languages, they have been of particular interest to philologists and literary scholars alike. Their pages, especially those of texts which now survive in only a single copy, have been pored over, revealing some (though not all) of their secrets. In Leiden, study of these texts was closely allied with the mission of the *Maatschappij der Nederlandse Letterkunde* (Society of Dutch Literature). Founded in 1766, this society was responsible for the research, collection and promotion of Dutch literature. Its library — a treasure trove of manuscripts, books and other research materials — has been on permanent loan to Leiden University since 1876. Its collection has been carefully conserved. For example, when two of the manuscripts (nos 36 and 37; LTK 191 and LTK 195, respectively) required rebinding in the late 1980s and early 1990s their eighteenth-century cardboard bindings were preserved for future study. They, too, form part of these items' unique history. (IO'D)

Fables and fiction | Manuscripts, *from rear, left to right*:
LTK 537 (no. 38) — Old binding of LTK 195, LTK 191 (no. 36), LTK 195 (no. 37) — Old binding of LTK 191

For education and entertainment

36 | Composite manuscript with the fables of *Esopet*
Fourteenth century: c. 1325, second quarter and middle — LTK 191

Thanks to the generosity of a private collector, a fabulous composite manuscript has become available for study and research. Five of the six Middle Dutch texts it contains have only survived in this codex. The word 'fabulous' can be taken literally here too: one of those unique texts is the *Esopet*, a collection of fables.

Fig. 1 >
First leaf of the fourth part of the manuscript with the *Esopet*. LTK 191, fol. 85r.

Fig. 2
Last leaf of the *Ferguut* (first section) containing the opening lines of the *Dietsche doctrinael* (sixth section) in a later hand: *onder ale creaturen / heeft die meester der / naturen twee ghe / maect sijts ghewes / daer redenlec verstaen / in es dats* ('The Lord of Creation has made two (beings) — and you may be assured of this — that are capable of reason, and they are...'). LTK 191, fol. 32v, detail.

'A wolf and a lamb who were thirsty went to a river and started drinking at two different places, the wolf a little upstream of the lamb. After just a short while, the wolf said, "You're muddying all the water that I want to drink."
"Oh, sir," said the lamb, "what do you mean? The water's flowing from you to me."
"Well, well," said the wolf. "Are you trying to insult me?"
"No, sir," replied the lamb, "I wouldn't do that."
"But you are," cried the wolf. "Just like your father used to, and your whole family!"
The lamb said, "But I wasn't even born then — why should that be my fault?"
"It sounds like you're still contradicting me," said the wolf. "I'll have to punish you for that!"
And then he fell upon the lamb and tore it to pieces. Similarly, a bad person will always come up with a pretext for doing evil things to the innocent.'

This tale is part of the *Esopet*, a collection of 67 fables in Middle Dutch, based on Latin example texts (see no. 13) that in turn go back to Greek versions of works ascribed to the poet Aesop. The fable about the wolf and the lamb is written in the right-hand column of the opening leaf. The Middle Dutch version begins as follows:

Een wolf en(de) (een) lam goedertiere(n) / quame(n) drinke(n) tere rivieren / Si ghinghe(n) drinke(n) in (twee) steden / Die wolf dra(n)c bove(n) dlam benede(n) / Doe seide die wolf du bevuulst mi al / Dwater dat ic drinken sal / Ay h(ere) sprac dlam wat segdi / Dwat(er) comt van u te mi.

In each of the short moralising tales in rhyming form, the unknown author of the *Esopet* describes an encounter between characters from the animal world. The animals speak and reason like humans, but when they take action, they behave like beasts. The poet makes his intentions clear in the prologue: *Bi beesten en(de) bi vogelen leren / Wisen en(de) wel bedieden / Die nature van den lieden* ('To instruct, show and correctly explain human nature through animals and birds').

The *Esopet* is laid out in two columns of 40 lines, written on parchment in an angular and sober Gothic script that is typical of the fourteenth century. The initial letters of the verses, with red lines running through them, are in their own separate column. Each fable starts with a red initial, two or three lines in height.

If you look closely, all the fables are in fact numbered next to the initials. The numerals 1 to 3 can be seen on the first leaf (see Fig. 1). The numbering and very possibly the title ESOPET are in the hand of Zacharias Henrik

ESOPET

Ic wille u in die ere ons heren
bi beesten en bi vogelen leren
wisen en wel bedieden
Die nature van den lieden
Elke beeste heeft hare manieren
deene soe es sol canter goedertieren
sijn die man maer die quade
Bi name die goede tat es sente
die ene beeste druvet sijne
ander meer u mach te schine
Des elc man an ander sol
bedi slachte si den beesten wel
aleest scande te segghene
an teghe beeste teleggheno
en .c. beeste es noch can
in valscheden dan an .i. man
Ic sal u hier exemple make
van beeste recht of si sprake
daer merket en hoert
eer die redene dan die woert
nemet elc wort ghi vint in
redene en gaet den sin
Die goede redene bringhet voert
si qualne es ghehoert
Alwapt ander steen sijn laet
dat nemer meer but en gaet
Die groete haet broederscap ghne
Die dulle nemet al in scherne
Gelke liede horen sijne tgoet
dat es die semple en die broede
bedi en lat ic met nochtan
ic en sal segghe dat ic can
bedi en es no wijf no man
en mach lere broederscap an
Hier beghint Esopet

Jnstadnie u hues te bet
Ist mes waer .i. hane soechte
spise die hi eten mochte
Vant hi .i. dieren stoen
doe seide die hane haddi een

Spierech man aldus hier bouen
I soudi doen met sinen yonten
J soude met di malke boeste groet
Ans en hebbic ghene noet
Iquam hier soeken mine spise
te ic boer alle stene prise
wat woestu hier dme mach van en
hoen goet ghesaeh no in van di
else senule es gheseit
an te ghene die broescap hebbe leit
te no woghet no redene
It kee en roeken te bestedene
En wolf en .i. lam goedertiere
quame drinke tere riuieren.
sighinghe drinken in .i. steten
die wolf draac boue dlam benede
oe seide die wolf du belbulst mi al
twater tat ic drinken sal
Aisse sprac dlam wat segdi
wat comt van u te mi
a seide die wolf bloestu m toe
lam antwoerde hie in toe
u woest sprac hi dus rede dan under
wilen eer en dan ghes lachte algader
lam sprac in was doe niet gheboren
Wi soudiekt af hebbe twee
och seide die wolf haue di sproeke
e wane wol ic sacts in breken
die wolf sloech te sticken en scoert
dlam nochtan hads niet horet
vint .i. quaet man ocaijsoen
Als hi den goede quaet wille toe
En muus wilde tenen tiden
wer .i. riuiere liden
ghene muus bat .i. puut
dat hi haer ob holpe ganser huut
bant die muus an sine voet
en swam m die vloet
die puut het hen int water sinken
mi dat hi wilde die muus verdrincke

Fig. 3
The French binding of the set of texts when Huydecoper acquired it at an auction in 1743. Replaced in 1992. LTK 191.

Alewijn (1742–1788), one of the early owners of this manuscript. Alewijn was a member of the *Maatschappij der Nederlandse Letterkunde* (Society of Dutch Literature), an organisation that *inter alia* collected material for a Dutch dictionary, the 'Algemeen Omschrijvend Woordenboek der Nederduitsche Tael'. The dictionary's committee stated in the Society's annals, the *Handelingen der Maatschappye*, in 1784: 'That they received a large number of Low Germanic words and sayings this year from Mr Alewijn, derived from the fourteenth-century *Esopet* manuscript.' The *Esopet* had not yet been published in 1784 (that only happened in 1819, by J.A. Clignett). That is why Alewijn numbered the fables in the codex: so that he could add clear source references for the linguistic notes on his manuscript, which the dictionary index cards could then adopt. The manuscript submitted by Alewijn is thought to have been returned to him but (after various peregrinations) ended up in the possession of the Society in 1991 (LTK 2211).

The fables in the *Esopet* comprise only the fourth (fols 85–94) of the six parts of this composite volume. All six were produced in the second or third quarter of the fourteenth century. The codex begins with the Arthurian romance *Ferguut* (fols 1–32), followed by a love story set in the Orient (fols 33–58), *Floris ende Blancefloer* by Diederic van Assenede (c. 1230–1293). The third part contains *Der Ystorien bloeme* (fols 59–84), with lives of the apostles based on the *Legenda aurea*, a well-known compendium of saints' lives by Jacobus de Voragine (c. 1229–1298). The fifth and sixth part comprise two didactic poems: *Die bediedenisse van der missen* (fols 95–103) explains the liturgy of the Holy Mass and the *Dietsche doctrinale* (fols 104–146) gives lay people a *modus vivendi* for getting on well with each other and with God. So the manuscript contains a bit of everything: exciting combat, adventures in love and deeds of the apostles, plus moralising and didactic literature. In short: education and entertainment gathered in a single volume.

Upon his death, Alewijn left a generous legacy of books to the Society of Dutch Literature that included this exceptional composite volume. This manuscript was relocated to Leiden's University Library on loan in 1876, along with the Society's entire collection of books. It has remained there ever since, under the shelfmark LTK 191. Over the last two centuries, linguists, philologists, literary historians and manuscript experts have studied this parchment treasure-trove of the Dutch language intensively, but have still not yet been able to answer all the questions it poses. The identity of whoever gathered these six items together is unlikely ever to be known. We can however estimate when it was done: that seems to have been around 1400. Were the parts in a different sequence then? That is suggested by the medieval cursive hand that copied both the opening verses and final verses of the *Dietsche doctrinael*. The latter are at the end, on fol. 145r, whereas the opening verses are on fol. 32v, the final leaf of the part containing *Ferguut*. That only makes sense if what is now the sixth part had directly followed the first at some earlier stage.

The most striking observation comes from a Benedictine nun from the Onze Lieve Vrouwe Abbey in Oosterhout, Sister Lucie Gimbrère, who worked as a restorer on numerous medieval manuscripts from Leiden in her workshop. She rebound this codex in 1992 because the French binding, which had a hard layer of glue between the backing leather and the text block, was damaging the parchment of the quires. According to her restoration report, all the quires share four common series of sewing holes, but are missing other sewing holes that would only have been present when the quires of one or more other individual parts were contained in older bindings, separately or together. In their earliest stages, the six parts were therefore each kept individually as separate sets of quires. The two oldest series of sewing holes were punched. A third set are deeply cut sewing holes (then reused for the new calfskin binding). The fourth series of punched holes was applied for the French binding, which was already present when Balthazar Huydecoper (1695–1778), the first known owner, purchased the bundle in 1734 at an auction in The Hague; that binding is now preserved alongside the restoration report.

— André Bouwman

Fig. 4
The workshop of Sister Lucie Gimbrère, Onze Lieve Vrouwe Abbey, Oosterhout, July 2018. Photo: André Bouwman.

37 | ROMAN VAN LIMBORCH AND ROMAN VAN WALEWEIN

WALEWEIN

[Left column - partial marginal text:]
Inden
coninc
Arture
Es die
ven me
nichte
avontu
re Die
nemmer
mee ne
wert be
screuen


Die ic met wel ghenomen can
Ysewein ende perchevael
Lanseloot ende duuengael
Entie hoofsche walewein
Syn ghesellene was dʼne ghein
Ooc was dʼ keye die druistare
Dʼ die heren aldus saten
Si naden etene en hadden ghedweghe
Als hoghe liede pleghe
Hebben si wond groot inomen
Een scaec ten veinsteren in comen
Ende breedde hem nedʼ uptie aerde
Hi imochte gaen spelen dies beghˢte
Dus laghet dʼ uptie wile doe
Dʼne ghinc niemen of no toe
Van allen gonen hoghen heden
Nu wille v tscaecspel bedieden
Die stapplen waren root goudijn
Ente spanghen zelueryn
Elcue waest van elps bene
Wel beset met dieren stene
Men seghet ons in corten worden
Die stene die ten scake behorden
Waerdelyc ghellaerlike
Beter dan al aerturs rike
Dus saghen syt alle die daer waren
In eiten inelst up en es ghevaren
Weder dane het quam te haren
Dies addie die coninc artur tuaren
En sprac bi miere coninc crone
Dit scaecspel dochte mi so scone
In aerrt zijn heren ende siet
Hi en quam hier sond redene niet
Die up wille sitten sonder sparen
Die tscaecspel halen en echt varen
En leuerent mi in mine hant
Ic wille hem gheuen al mijn lant
En mine crone na minen liue
Willic dat zijn eghin bliue
Van alden heren die dʼ waren
En one durster een met varen
Si saten alle en zweghen stille
Die coninc seide wie so wille
Goet rudd in mijn hof bescalen
Hi sal mi dat scaecspel halen
Of wine gheneghen nemmermees

verˢ. fo. 7. b.c.

Narrative pearls in a single volume

37 | *Roman van Limborch* and *Roman van Walewein*
Fourteenth century, c. 1350 — LTK 195

At some point in the second half of the fourteenth century, someone combined two existing manuscripts into a single volume. Each of these manuscripts contained a lengthy chivalric romance: the *Roman van Limborch* and the *Roman van Walewein*. These texts are two of the high points of Middle Dutch narrative literature. The transition between the two romances is indicated by an amazing miniature, which marks this volume as a luxury product.

Would the two Flemish authors who composed a story about a knight and a floating chessboard in the mid-thirteenth century have realised they were creating a masterpiece? A work that is considered by many today to be the crowning achievement of Middle Dutch Arthurian literature? Although the prologue to the *Roman van Walewein* (fol. 121r) only mentions the name of the poet Penninc, the epilogue (fol. 181v) tells us that a second Flemish author, who calls himself Pieter Vostaert, completed the romance left unfinished by his predecessor. The text consists of over 11,000 verses in rhyming couplets. This manuscript, LTK 195, is the only surviving complete copy of the romance. According to the colophon (fol. 182r), this copy, now in Leiden, was finished in 1350.

Penninc strikes a modest tone when he introduces his tale of the knight Walewein (Gawain), the famous nephew of King Arthur. He almost apologises for writing down this story himself. If the tale had been available in French, he would definitely have preferred to translate that version (fol. 121r). But given the lack of any such prestigious source, he is forced to set his own course. All this humility hides a brilliant approach: he has used a story circulating in the oral culture as the foundation for composing a highly ingenious romance. We are able to trace what the poets did because we have other later written versions of this oral source, in particular the fairy tale *The Golden Bird*, which was collected by the Brothers Grimm.

The basic pattern for the story consists of what W.P. Gerritsen (1935–2019) called 'three dovetailed quests': a quest within a quest within a quest. The young knight Walewein leaves King Arthur's court to seize and bring back a floating chessboard. Its owner, King Wonder, is prepared to swap this valuable object for a magic sword. That sword is owned by King Amoraen, who will only hand it over in return for the beautiful princess Ysabele. When Walewein reaches the furthest point of his quest, he follows the advice of the talking fox Roges and manages to abduct Ysabele from her father's heavily guarded castle. On the way back, they find Amoraen has died. When they reach King Wonder, the enchanted fox turns back into the prince he was originally. Accompanied by Ysabele and Roges, Walewein returns to the court of King Arthur with the chessboard. Unlike the oral source, this romance has interwoven various chivalric adventures between the key events of the main story. These subsidiary episodes put Walewein's impressively heroic deeds in the spotlight, in a way that can seem somewhat hilarious to modern-day readers.

An unusual feature of LTK 195 can be seen in the image at the start of this entry: the *Roman van Walewein* is illustrated. A striking miniature was painted on a leaf that was inserted before the start of the text in or shortly after 1350 (fol. 120v). The format of the image is astounding, as full-page miniatures are incredibly rare in manuscripts of chivalric romances in vernacular European languages. What is more, the image is not the kind of standard scene that could apply to

<< Fig. 1
On the right is the start of the *Roman van Walewein*; on the left, the full-page miniature made specially for the romance. LTK 195, fols 120v–121r.

any romance: it is clearly designed specifically for the *Roman van Walewein*. The hero has just left King Arthur's court and is chasing the chessboard, which is about to disappear into the mountains on the right. The sevenfold depiction of Walewein's coat of arms may also have been inspired by a detail in the story: Ysabele dreams that a stranger will come, a young knight whose tabard is made of a lion's skin (fol. 159v). The miniature makes LTK 195 an exceptional book.

The folio that has been inserted with the miniature has another surprise in store: on the reverse side are seven lines (fol. 120r, see Fig. 2). This passage is a plea for God's mercy. It is in fact the end of the *Roman van Limborch*, which is preserved in LTK 195 in a manuscript that was created in the second quarter of the fourteenth century (fols 1–119). That date is strikingly soon after the probable date when the romance was first written, between about 1312 and 1325. The Brabant author, who calls himself Heinric, took the basic pattern for his tale — a division into twelve chapters — from Virgil's *Aeneid*. Everything about his romance is excessive: its length, at over 23,000 verses, the many storylines, the numerous characters (in particular the two children of the Duke of Limburg, Margriete and Heinric), the non-stop rush of exciting and incredible adventures, and the geographical scope that extends across Europe. The poet drew creatively from a long line of existing stories to produce a romance that must have been a hit from the start, given the many manuscripts of it that have survived.

The closing lines of the *Roman van Limborch* on fol. 120r were written not by the scribe of the manuscript but by someone else in the second half of the fourteenth century. That is an interesting fact as it shows that these two fine examples of medieval narrative were combined into a single volume back in the Middle Ages. We can only guess at the reason for putting them together. There is one obvious practical consideration: bound together, the two manuscripts make a handy book. The fact that they both had the same poetic form (rhyming couplets) may have been another reason. Their content could also have played a role in the decision: both texts are chivalric romances with a complex narrative structure. The two stories borrow extensively from other sources, playing with literary traditions, and this too may have been a reason for an aficionado of medieval literature to combine them in a single volume. Finally, both romances have a young hero as the main protagonist and this could have led to them being combined, if adolescents were the intended readership.

Whatever the reasons may have been for combining the *Roman van Limborch* and *Roman van Walewein* in one volume, LTK 195 is an important source from various perspectives. It is valuable to art historians because of the rare miniature, it is of interest to book historians because its two existing manuscripts were combined back in the Middle Ages, and it is significant for literary history because it contains two noteworthy romances from the Low Countries. We should therefore be grateful to Zacharias Henrik Alewijn (1742–1788), who donated this book to the *Maatschappij der Nederlandsche Letterkunde* (Society of Dutch Literature), along with manuscripts LTK 191 and LTK 537 discussed elsewhere (see nos. 36 and 38). It is clear that this anniversary production would not be complete without a chapter on LTK 195.

— Bart Besamusca

Fig. 2
The closing lines of the *Roman van Limborch* in a hand from the second half of the fourteenth century: …/ *Nu make god ons allen blide | En(de) geve ons allen pays en(de) verde | Nu segt amen, dat es terde | Amen.* ('May God now bring us joy, peace and harmony. Now say "Amen" for the third time'). LTK 195, fol. 120r, detail.

Wer hat mich guter uf ghe tan
Hirz ieman der mich kan
Beyde lesen vnde versten
Der sol genade an mir be gen
Ob icht wandels an mir si
Daz he mich doch lare vri
Valscher rede daz eret in
Ich werz wol daz ich nicht en bin
He luttert vnde ghe richtet
Ach so wol ghe tichtet
Nicht velsche wol ein valsch man
Wanne sich nieman vor in kan
Behuten wol wie rechte her tut
Ecken rede ist so gut
Sie en velschen sie daz werz ich wol
Waz ich valsches von in dol
Dar wan sol ich daz ich claghen
Ich wil iz harte ruighe traghen
Mach ich der besten lop be iaghen
Wer nach eren sinne
Truwe vnd eren minne
Der volghe guter lere
Daz vordert in vil sere
Vnde vlize sich dar zu
Wie her nach den ghe tu
Den die werlt des besten gibt
Vnd die man doch dar vnd siht
Nach gotes lone dienen hie

Den volge wir wan daz sint die
Den got me salde hat ge geben
Vnde dort ein ewigliches leben
Dar nach wir alle suln streben
Verich en alle wiser man
Daz ich wol mochte als ich doch kan
Hie sprechen nach des hertze mir
Leyder nu ghe swichent nur
Beyde tzunghe vnde ouch der sin
Daz ich der rede nicht meist bin
Die ich zu sprechene willen han
Wan daz ichz dar uf han ghe tan
Daz ich mine willen hie
Herne ir zteughete wiste ich wie
Daz iz die wisen duchte gut
Got gebe mir sin vnd in den mut
Daz sie mir ver nemen wol
Ich bin noch ganzer sinne hol
Des spreche ich nach kindes site
Ir tzeige ich hie icht gutes mite
Ob min geyst ghe vuchet dar
Des sol man mir danken bar
Danne eyme sinnenriche man
Der meyster ist vn spreche kan
Der hat des mere dan ich ge tan
Man sol mir des genade sagen
Daz ich her innen tagen
Mich dar uf ghe vlizzen han

The 'Holy Grail' of German Arthuriana

38 | Leiden's *Wigalois* manuscript
Fourteenth century, 1372 — LTK 537

Around 1210–1220, Wirnt von Grafenberg wrote *Wigalois*, one of the most popular chivalric romances from the area in which Middle High German was spoken. No fewer than thirteen manuscripts have survived in their entirety, two of which contain miniatures. The older of the two, the 'Leiden *Wigalois*', is notable for its unique interplay of text and image. No wonder the manuscript was recently declared the finest example of German Arthuriana.

The *Wigalois* manuscript has been in Leiden University Library since 1876, as part of the collection on loan from the *Maatschappij der Nederlandse Letterkunde* (Society of Dutch Literature). It was produced over five centuries earlier, in 1372, by a monk in the Cistercian abbey of Amelungsborn in Lower Saxony, and was commissioned by Count Albrecht II of Braunschweig-Grubenhagen according to the colophon on fol. 117v. This monk, Jan von Brunswick, copied the story by Wirnt von Grafenberg about a 'knight without fear and beyond reproach' from a Thuringian example.

The hero of this knightly epic, Wigalois (*Gwi von Galois*), becomes embroiled in a series of adventures, demonstrating unparalleled bravery. This son of Gawain eventually succeeds in the task assigned to him by Arthur's Round Table: freeing the Kingdom of Korntin from the clutches of the evil usurper Roaz. He is rewarded by being made king of Korntin himself and by being given the hand in marriage of the former king's daughter. Unlike most knights of the Round Table, Wigalois does not undergo a crisis or moral development. Instead, he has to deal with an almost continuous series of adventures that he is able to survive partly through his own powers but mainly with God's help.

This in itself would not be particularly spectacular — there are other outstanding chivalric romances in the German Arthurian literary canon — were it not for the fact that the scribe and illuminator of this manuscript created a unique form that has fascinated generations of medievalists.

The double opening of the codex strikes the reader immediately. Two consecutive images guide the reader into the manuscript by introducing its themes. The first folio evokes a paradisiacal space with the Tree of Life in the centre, also known as the Tree of Paradise. It is followed by a full-page miniature with King Arthur's Round Table in the centre. They set the tone for how this text would have been received in the late fourteenth century, positioned somewhere between Christian hagiographies and Arthurian chivalric romances. At the head of the Round Table sits Arthur and his queen Guinevere. The table is laid with expensive crockery and cutlery. The knights and ladies of the court sit around the table while elegantly clothed female servants bring the dishes from all sides. At the foot of the table are two dogs. These dogs recur in all kinds of variations in the images in the manuscript and recent research has revealed how they connect its courtly and religious storylines.

The two miniatures are followed by a rhetorically unusual prologue that lets the book address the reader directly:

> *Wer hat mich guter uf ghe tan*
> *Si iz ieman der mich kan*
> *Beide lesen vnde ver sten*
> *Der sol genade an mir be gen*
> *Ob icht wandels an mir si*
> *Daz he mich doch laze vri*
> *Valscher rede daz eret in*

<< Fig. 1
Left: Full-page miniature showing Arthur's Round Table. Right: The start of the prologue, where the book addresses the reader directly: 'What excellent person has opened me?' LTK 537, fols 1*v–1r.

'What excellent person has opened me? If it is someone who can read or understand me, may he treat me charitably if there is anything untoward about me and not speak ill of me. That will be to his honour.'

Wirnt von Grafenberg, who clearly knew his classical rhetorical styles, is explicitly emulating Ovid here (43 BC–17 AD), who used the same trick in the prologue to Book III of his *Tristia*.

The scribe wrote these verses in Gothic script (*littera textualis*). The verse initials have red lines crossing through them, while larger text blocks start with initials taking up two lines, in alternating red and blue. The romance starts with a golden initial three lines in height.

As examples of book illumination, the forty-nine miniatures are of exceptional quality. They are remarkable for their variation in the use of opaque colours and precious gold and silver. Early in the twentieth century, researchers had already seen a link between these miniatures and the northern German tapestry art which would have been their source of inspiration. The simplistic portrayal of the figures, the strikingly varied use of colour and the frequent use of floral decoration all point in that direction.

All sections of the codex bear witness to the close collaboration between the scribe and the miniaturist. The heraldic arms on the shields and helmets accurately reflect information in the text. 'All his armour was red and on his shield appeared Death in terrifying form' is how the Red Knight is described on fol. 31v. The miniaturist has therefore painted the shield with a white skull on a red background. In nine miniatures, the banderoles (speech banners) essentially repeat verses from *Wigalois*. The words with which Wigalois confirmed his eternal allegiance to the king's daughter Larie are repeated in the banderoles in the illustration on fol. 95r (see Fig. 2): *Du bist min vnd ich bin [din] daz schal ymmer stete sin* ('You are mine, I am yours and that will remain so for ever') alongside Larie's response, *her wigeloys min amis der leue enradis* ('My lord Wigalois, my beloved, we are united in love').

The manuscript changed hands numerous times before ending up in Leiden. Some of its previous owners have left traces in the manuscript in the form of marginal glosses (notes in the margin) in German and Latin and various symbols to mark texts. In particular, comments or marks have been added to passages with a theological or moralising message, often consisting of a manicule (pointing hand) or the word *Nota*. It is known for certain that the codex was owned by the Lutheran theologian Cyriacus Spangenberg (1528–1604) and in the next century by the noble Luxembourg family of De Wiltheim. The marginal notes and marks were probably made by Spangenberg, given that they are in line with his moral beliefs and correspond to the extracts from the text of the Leiden codex that he included in his *Adels-Spiegel* (1591). Evidence that substantial changes were made later to the illustrations comes from the faces that have been overpainted black in the *Waldweib Ruel* on fols 68v and 69r, and from the cut-out coat of arms in the miniature on the final leaf (fol. 118r).

That full-page miniature also shows a Cistercian monk at work in the scriptorium (see p. 13). The monk remains a mystery to this very day. Was he the miniaturist or the scribe? What is written on the wax tablet in front of him: *Tode* or *Ione*? A name? Were the writer and the illuminator separate individuals or was this unusual codex the work of one person?

— Jef Jacobs

Fig. 2
Miniature with Wigalois and the king's daughter Larie swearing eternal allegiance to one another, according to the banderoles.
Wigalois: 'You are mine, I am [yours] and that will remain so for ever';
Larie: 'My lord Wigalois, my beloved, [we are] united in love'.
LTK 537, fol. 95r, detail.

Vita et conuersa... Diui Ludgeri
... Alfridu tercui Molceñ epm.
Exemplaria litary eligo sup acq litter
ceros prediog, olim ĩ p̃a fudator.

PRESENTING THE PAST

From the eleventh century onwards, it became increasingly common for courtly administrations in Western Europe to record laws, grants of land or money and other expenditures in writing. The recipients of such grants or largesse also placed an increasing value on the possession of written documents; they could produce proof of ownership when claims were contested. Evidence of this documentary boom can be found in charters, record books and other bureaucratic sources. A ninth- or early-tenth-century cartulary (a collection of charters) from the monastery of Werden, for example, shows how its scribes carefully collected sources of particular relevance to the monastery's history (no. 40, VLQ 55; surviving in a fifteenth-century parchment binding, with a title on the front).

The list of papal succession was of particular interest to medieval chroniclers, as recorded in works like the *Liber pontificalis* ('Book of the Popes'; see no. 39, VLQ 60). This unbroken chain of power, reaching back to St Peter, demonstrated that the papacy (and the Church) had God-given legitimacy. Chroniclers could map events of local relevance against this lineage and other fixed chronologies (see no. 41, VLF 96). One fifteenth-century martyrology (no. 44, LTK 273) — a list of short biographies of saints arranged according to the dates of their feast days — has even been edited to include the names of local benefactors from the Utrecht area. By praying for these people alongside the saints, these figures of the recent (local) past were elevated into a continuous chronology of religious salvation.

Chronicles and other historical sources could present versions of the past that were favourable to a particular monastery, area or political group. The twelfth-century compendium of historical works assembled by Robert of Torigni (c. 1106–1186; no. 42, BPL 20), for example, shows a fascination with the dynastic histories of the Normans and the kings of England. Compiling historical works into a single manuscript allowed different versions of the past to be reconciled or contrasted. Filips van Leiden (1325–1382) gathered texts relevant to the history of the Counts of Holland into a manuscript also containing an account of the destruction of Troy (no. 43, BPL 2429). Rebound in the sixteenth century by the collector Thomas Rediger (1540–1576), this manuscript implicitly related local history to a broader historical context. In this way, manuscripts could safeguard, but also shape, perceptions of the past. (IO'D)

Presenting the past | Manuscripts, *from rear, left to right*:
VLQ 55 (no. 40), VLF 96 (no. 41), VLQ 60 (no. 39) — LTK 273 (no. 44, *above*), BPL 20 (no. 42, *below*) — BPL 2429 (no. 43)

LIBER

INN	APSTLTE
	SEDE
MIND	ECLESIAE
SMMI	ROMN
INPT	BEATUS
OO	PRNCEPS
EPSEPR	APSTOL
SEDIS	PETRI

SCI REMIGII:
AB IPSO INIHOANT *Anastasius* *b.*

BEATUS | ANTHIOCAENUS
 | filius Iohannis
 | prouintiae
 | Galileae uico
 | Bethsaida
 | frater
 | Andreae:
 | Primus sedit
 | cathedra
 | episcopatus
 | Inanthiochia
 | annos
 | VII
PETRUS | bic petrus In
APOT̄LS | cressus Inurbe
 | Roma
ET PRIN | Nerone cesare
 | Ibiq; sedit cathe
 | dra episcopa
TEPS | tus annos
 | XXV
APOSTO | mens II
 | dies III
LORVM | Fuit autem
 | Temporibus

A Roman history of the papacy and its readers

39 | *Liber pontificalis*
Eighth century, late — VLQ 60

The *Liber pontificalis* ('Book of the Pontiffs') is a sixth-century history of the popes composed in Rome in the form of a serial biography. Subsequently extended to the end of the ninth century, it was distributed widely within Western Europe in the early Middle Ages. VLQ 60 is particularly interesting, because it is the earliest full text of this history to have survived, and it is full of notes made by an attentive ninth-century reader.

<< Fig. 1
The title page of the *Liber pontificalis*, announcing the beginning of the book of the bishops of the holy church of Rome, and the elaborately decorated first page, beginning with the words *Beatus Petrus apostolicus et princeps apostolorum* ('Blessed Peter the apostle and prince of apostles'). The later ninth-century ownership by the monastery of Saint-Remi in Reims is recorded in the top margin. VLQ 60, fols 8v–9r.

In the fourth decade of the sixth century, anonymous officials within Rome's papal administration began to compile the history of the popes, known as the *Liber pontificalis*. The history is in the form of a serial biography, that is, a set of chronologically ordered 'Lives', from St Peter in the first century to their own day. The authors adopted a standard format for each Life, starting with the name, then the *natio* (meaning where he was born or sometimes the family's place of origin), parentage, length of reign, election, career, ordinations, death and burial, and finally the length of vacancy before the next pope. Depending on a particular author's concerns and the records available for each pope's activities, other details — such as politics, contributions to liturgical developments or church legislation, involvement in doctrinal disputes and patronage of building activity in Rome — were added to this basic framework.

The opening illustration here (fols 8v–9r) shows the title page and the dramatic beginning of the Life of St Peter († around 67 AD). His Life describes how St Peter came to Rome from Antioch, established church organisation in the city, wrote the two Epistles, confirmed the content of the four Gospels, made arrangements for his succession and was martyred along with St Paul during the reign of the Roman emperor Nero (37–68 AD). Subsequent groups of officials added more Lives from time to time, until the 112th pope, Stephen V († 891), at the end of the ninth century. In the later seventh-, eighth- and ninth-century Lives, contemporary memories contributed extra richness to the narratives. These later Lives are especially full of select historical and political detail, and some exist in a number of variant versions.

Fig. 2
In the margin beside Life 9, the Life of Pope Telesphorus (around 130 AD), the ninth-century reader has noted this pope's introduction of the singing of the *Gloria* during mass on Christmas Eve. VLQ 60, fol. 12rb, detail.

Despite its piecemeal composition, the *Liber pontificalis* presents a coherent overall narrative of the organisational and topographical transformation of Rome from a pagan imperial city to a Christian community led by its bishop. It confirms the primacy of the see of St Peter, derived from Christ's injunction to Peter recorded in Matthew 16:18 ('Thou art Peter and on this rock I will build my church'), and the role of the bishop of Rome as the arbiter of orthodoxy. The *Liber pontificalis* represents the popes as active agents in the development of the papacy as an institution at the heart of the Christian church.

Although the *Liber pontificalis* is a Roman text, one of the oddities of its transmission is that no Roman manuscripts of it are now extant from before the end of the eleventh century. Even Italian copies are rare. North of the Alps, however, the *Liber pontificalis* was disseminated widely in the Frankish realm. Among these early medieval copies, the circulation of various additions to and alternative versions of particular Lives suggests a piecemeal distribution of the original text from Rome between the sixth and ninth centuries.

Leiden University Library has no fewer than three of these early medieval copies of the *Liber pontificalis*, and each one is different. SCA 49, fols 74r–79r, for example, is an abbreviated tenth-century version from Mainz or Fulda in Germany. VLQ 41 was written in Auxerre, France, in the middle of the ninth century. It contains Lives 1–96, from St Peter to Stephen III (reigned 768–772). It has the text of what is known as the Frankish recension, meaning that it has many interpolations added by Frankish scribes highlighting the Franks' involvement in papal history, especially in the eighth-century Lives. An example, found in VLQ 41 alone, is the list of Frankish bishops who attended an important synod in Rome in 769 (fol. 103r). The third Leiden copy is VLQ 60. It is the earliest surviving full text of the *Liber pontificalis* and contains Lives 1–94, from St Peter to Stephen II (reigned 752–757). It is a different recension from that in VLQ 41, lacking the Frankish interpolations and containing an alternative version of the Life of Stephen II (Life 94) known as the 'Lombard version', because it tones down the negative portraits of the Lombard rulers of northern Italy found in the original Roman version.

From the very stylish and distinctive script and the decoration of VLQ 60, its production can be traced to northern France in the late eighth century, to the abbey of St Amand during the abbacy of Arno of Salzburg, who would later become Archbishop of Salzburg (782/785–821). Arno himself visited Italy and Rome a number of times from the 780s onwards as a royal envoy for Charlemagne (768–814), and it may have been on one of these visits that he acquired the text of the *Liber pontificalis* from which this copy was made.

The inscription at the top of the opening, LIBER S(AN)CT)I REMIGII ('The book of St Remigius'), as well as the distinctive handwriting in the notes added by an attentive reader in the later ninth century, indicate that by the second half of the ninth century, the codex had been taken to the monastery of Saint-Remi in Reims, France. These notes mark items the reader found to be of particular interest. For example, in the list of popes at the beginning of the codex (see Fig. 3), this reader commented that the lives of the great patristic writers Jerome, Ambrose and Augustine in the fourth century coincided with the reigns of Popes Felix II, Damasus, Siricius, Innocent I and Zosimus, and that Jerome died during the reign of Boniface I (418–422). On the liturgy, for example, the reader noted the credit given to Pope Telesphorus (around 130 AD) for introducing the singing of 'the angelic hymn' — that is, the Gloria — during the mass on Christmas Eve (see Fig. 2). Similarly, this Reims reader signalled historical events throughout the narrative, such as marking the visit of Pope Stephen II to Francia in Life 94 (see Fig. 4). All these notes are a precious indication of an enduring interest in papal history at Reims in the ninth and tenth centuries.

— Rosamond McKitterick

Fig. 3
In the list of popes at the beginning of the codex, the ninth-century reader has recorded the coincidence of the reigns of some of the popes with the lives of the great patristic writers Ambrose, Jerome and Augustine.
VLQ 60, fol. 6ra, detail.

Fig. 4
The visit of Pope Stephen II (752–757) to Francia, recorded in Life 94, has been noted to the right of the text by the ninth-century reader.
VLQ 60, fol. 115rb, detail.

quorum nomina infra tenentur. Notaui diem loc¨
tempus quo scripsi. ego thiatbaldus humilis p̄
rogatus scripsi & subscripsi.
Sig̅ bluduuini, qui hanc traditionem dominante
manu p̄ egit, propriaq; subtus firmauit.
Sig̅ reginberti. Sig̅ thiatbaldi.
Sig̅ thiatheri. Sig̅ frithuradi.
Sig̅ frithubaldi. Sig̅ frithubrandi.
Sig̅ reginbaldi. Sig̅ theganradi.

III. TRADITIO OODHELMI · ADUUIHT mundum

Dominus quisque in p̄senti seculo conuersatur,
cogitare deb& & p̄pendere, qualiter sibi uitam ad-
quirat & remunerationem sempiternam post
mortem. Idcirco ego oodhelmus filius quondam
ooduuerci, pro remedio animę meę, & pro ęterna
retributione, tradidi partem hereditatis meę
quę mihi iure hereditario legibus contigit. Id est,
tres houas in tribus locis, quorum nomina locor̄
Isla hec sunt: houa una Inokinni in pago Islos, altera
North Tiornt in Manher islla selihoua in pago northt tueanti,
tertia in Hasungum in eodem pago. hoc quod modo
denominaui tradidi ad reliquias sc̄i saluatoris, quę
Wichmundi in uuichmundis constitute sunt; & in manus liudger
pbri, traditumq; in ppe tuum esse uolo, & nullis um-
quam temporibus ulterius inmutari, sed ad p̄ęcuo
usus eiusdem ęclesię custodes hec omnia possideant,
cum integritate inlibata: tantum ut diebus uitę
nr̄ę, ego & coniux mea dilecta theodlinda, resistra
in benefitio eiusdem ęclesię sub usufructifero
Koh habere ualeamus: id est, ut p̄ singulos annos soli

dum minus, ad luminaria ęclesię, in natale dñi donare
debeamus; post nrm uero discessum de hac uita, in domi-
nationem supradictę edesię res ipsę melioratę pue-
niant, cum omni integritate, eiusdem eclesię legiti-
mi procuratores, ad utilitatem eius, quicquid exinde
facere uoluerint, liberam & firmissimam ab omnib;
habeant potestatem. Siquis uero, qd futurum esse
non credo, ego ipse, quod absit, aut aliquis de heredi-
bus uel prohere dibus meis contra hanc traditionē
uenire temtauerit, aut eam infrangere uoluerit,
instigatus a diabulo, Inprimis tus iram di celestis in-
currat, & a scōrum angelorum societate separetur,
& ab ingressu omnium edesiarum alienus existat,
donec se emendat a psumptione nefanda. & insup
in dominicum auri libras duas, argenti pondus ·X·
coactus exsoluat. & sic quidem quod repe tit euin-
dicare non ualeat, sed firma & inmotabilis hęc tra-
ditio in sempiternum pmaneat, stipulatione sub-
nyxa. Acta est autem publice in loco ipso quid̄r uuith-
mundi. anno ·XXX·I· regni relegiosissimi regis carli,
sub die ·V· id iunius. notaui diem tempus locum quo
hec scripta sunt. Ego thiatbaldus humilis pbr
rogatus scripsi & subscripsi.
Sig oodhelmi, qui hanc traditionis cartam fieri ro-
gauit, & propria manu sir mauit.
Sig hildigeri. Sig meginulfi.
Sig liudgeri. Sig meginungi.
Sig geruuini. Sig marcrici.
Sig chathumeri. Sig gerhardi.
IIII traditio imme - - - - - - -

Liudger's treasure-trove of charters

40 | *Liber cartarum* from Werden Abbey
Ninth century, second half, or early tenth century — VLQ 55

Liudger (742–809), who had been educated at the missionary centre in Utrecht and the cathedral school of York, spread the Christian faith in Frisia and Saxony. In 805, he was ordained as the first bishop of Münster. A great deal is known about his Frisian origins and life as missionary, not just because of the hagiography that was written after his death but also due to the dozens of charters and bequests that supported his missionary work.

<< Fig. 1
Opening with the charter of Oodhelm's donation from 799. The caption in red letters ('Transfer from Oodhelm to Wichmond') probably came from a note on the back of the original charter. VLQ 55, fols 33v–34r.

'Whereas each person who lives today must reflect and consider how he leads his life and can achieve eternal reward after his death…'. These solemn words — in translation — form the start of the charter in which Oodhelm, son of Oodwerc, transfers part of his inherited assets to the relics of Saint Salvator in Wichmond and into the hands of Liudger: a farmhouse in Oeken near Brummen, not far from Wichmond, on the opposite bank of the River IJssel, and two more farms in Twente. The transfer took place on 9 June 799 and was recorded in writing in a charter at the request of Oodhelm. Underneath (fol. 34r), we see the name of the scribe: the priest Thiatbald, one of the clergymen in Liudger's entourage.

Fig. 2
A decorated capital V in red ink with a simple drawing of a man's head inside marks the beginning of the *Vita Sancti Liudgeri* by Altfried, which takes up the first 27 folios of the manuscript. In the left-hand margin, another person has drawn the head of a clergyman with an *infula*, a hat such as those worn by abbots and bishops. VLQ 55, fol. 2v, detail.

His name is followed by the signatures, the *signum* of Oodhelm and eight other men who witnessed the transfer. Seals were not yet in use, so Oodhelm confirmed the charter by laying his hands on it.

This *carta* is one of the oldest to have survived from the eastern Netherlands. The original document has not survived but the text is contained in a *liber cartarum* or *cartularium*, a register of copies of charters that was made in the late ninth or early tenth century in Werden Abbey near Essen, on the River Ruhr. The purpose of such *cartularia* was to provide a better overview of the growing numbers of charters in the monastery archives and to have information on all the donors and benefactors whom the monks needed to commemorate. The Werden register contains sixty further copies of charters, all numbered consecutively in Roman numerals by the scribe and written in the same Carolingian minuscule. They are nearly all charters relating to donations to Liudger and his monastery, Werden Abbey. The oldest dates from 793, the latest from 848. According to the table of contents at the start (fols 30r–31r), number 61 was followed by thirteen more charters, but they are now missing. The *cartularium* probably originally consisted of five quires, of which only the first four (consisting of thirty parchment leaves in total) have survived.

In the fifteenth century, this register of charters was bound in a single volume together with another early text from Werden Abbey. This is the oldest surviving version of the *Vita Liudgeri*, the Life of Saint Liudger

written by his nephew Altfried (†849) in the 840s (fols 1r–27v). This manuscript must have been produced before May 1085, when the German Emperor Henry IV (1051–1106) solemnly announced a Truce of God during the imperial synod in Mainz. We know that because another eleventh-century hand added a copy of this *Constitutio pacis dei* on the final leaf of the fourth and final quire (fol. 28r-v). This collated volume was in the library of Werden Abbey until the start of the seventeenth century. During the tumultuous period of the Thirty Years' War, the manuscript ended up in the possession of the Leiden book collector Petrus Scriverius, and then came to Leiden via the library of Isaac Vossius.

In the charter of 799, Liudger is described as *presbiter* (priest). However, in other charters from those same years he is also referred to as *abbas* (abbot). He was given this title because Charlemagne had granted him the monastery of Lothusa, the monastery of St Peter in Leuze near Tournai. As Altfried makes clear in his *Vita*, this grant was intended to support Liudger in the mission Charlemagne had given him in 787 of proselytising the Frisian coast east of the Lauwers. Lothusa gave him his own base separate from the Utrecht mission where he had been trained and had been in charge of the churches in Dokkum and Deventer. After 792, Liudger extended his missionary activities to include Saxony, where the king granted him the previously founded church in Mimigernaford as a base. The minster (community of priests or canons) that he established that was attached to this church would form the heart of the bishopric of Münster, for which he became the first bishop from 805 until his death in 809.

Liudger's ambitions went further than that, though. He had originally had plans for a monastery on his family's land in Werinon on the River Vecht (Nederhorst den Berg), about twenty kilometres upstream from his birthplace of Zwesen near Utrecht. The charters in the *liber cartarum* show that in the 790s his attention turned to another location, however. Nearly all the donations that Liudger received during this period were granted to the relics of Saint Salvator, the Virgin Mary and other saints that he had with him at all times. He had probably taken them with him from Rome and they were stored in the portable altar that is still part of the church treasures of Werden Abbey. It is striking that the charter of Oodhelm mentions the relics of Saint Salvator, which had been given a place in Wichmond. Exactly the same formulation is also found in the charter for a donation that Oodhelm made three years earlier to Liudger and that also took place in Wichmond (fols 54v–55r). In both charters, the proceeds from the donated estates were also explicitly assigned to the clergy who were entrusted with the care of these relics, denoted in 799 as the *eiusdem eclesie custodes*, i.e. the clergy of his church. One year later, construction was indeed apparently taking place of a church dedicated to Saint Salvator in Wichmond.

However, this never became a monastery church. Further conquests by Charlemagne in 798 meant that the focal point of Liudger's Saxony mission shifted further to the east, beyond the River Weser and as far as Helmstedt and Magdeburg. Werden, located on the Ruhr, was a better location as a base for this mission and he had acquired possessions in the vicinity there since 796. Wichmond and the donations made by Oodhelm thus became part of the assets owned by Werden Abbey after Liudger's death. The same happened to all the other possessions Liudger had acquired from 793 onwards in the Veluwe and IJssel regions and in Twente and Drenthe. The original charters making these donations must have been lost quite early on in Werden, but their contents have survived intact to this very day thanks to this *liber cartarum*.

— Kaj van Vliet

Fig. 3
This reliquary shrine from the eighth century is said to have belonged to Liudger himself, according to Werden tradition. He may have used it as a portable altar. Perhaps it was the shrine in which he kept the relics of Saint Salvator and the Virgin Mary that the charters in the *liber cartarum* say he always carried with him. Probsteikirche St. Ludgerus, Essen-Werden, inv.nr. L.3.

Additions to an abbot's work by his monks

41 | Abbo of Fleury, *Excerptum de gestis Romanorum pontificum*
Eleventh century, 1027–1039 — VLF 96 (fols 1–13v)

Abbot Abbo of Fleury created an extract from the *Liber Pontificalis* (the Book of the Popes) for a political purpose, namely to curb the power of the bishop of Orleans. Various individuals added information to the manuscript after him, about later popes or giving local details on the monastery of Fleury (fols 13r–13v). This converted Abbo's extract (*Excerptum de gestis Romanorum pontificum*) into a reference work about chronology, personalised by the monks in his monastery.

Fig. 1 >
The end of Abbo's *Excerptum*, followed by blank lines and the start of the continuation. VLF 96, fol. 13r (image 88%).

Abbo of Fleury (c. 940–1004) was the abbot of the monastery of Fleury, located on the Loire about thirty kilometres upstream of Orleans. He was one of the most famous scholars active at the end of the tenth century. Abbo developed ideas about society, justice, authority and rulers, pondering ideal kingship and how monarchs ruled in practice. Those were urgent matters at the time. Abbo's monastery had previously been under the protection of the Carolingian kings; however, when Hugo Capet ascended the throne in 987, they had to fight for royal protection all over again, mainly because the ambitious bishop of Orleans claimed that his authority over Fleury was greater than that of the king.

At some point, Abbo became interested in the *Liber Pontificalis* (the Book of the Popes). It seems that this work, comprising a series of short biographies of the popes, was not available in Fleury's library and Abbo decided to rectify this by writing a summary. He stayed close to the original text, in fact, with the exception of the lists of gifts. He copied the formula from the start of each biography, giving the name of the pope, the place he had come from and the exact number of years, months and days during which he had been in charge as pope of the bishopric of Rome. Abbo continued, *inter alia* with information he could use in his dispute with the local bishop, about politics and the unity of the Church, biographical details and liturgical developments.

Two manuscripts of his extract have survived. VLF 96 is the older of the two. This manuscript was written in Fleury between 1027 and 1039. Abbo's extract takes up fols 1r–13r of the Leiden manuscript. It ends with Pope Gregory II (†731) on fol. 13r, in the second of the two columns. After six lines that have been left blank, the same scribe continues:

> 'Similarly Gregory [III]. He was the incumbent for 10 years, 8 months, 24 days.'

A second scribe takes over in line 37 of this column, in the middle of a sentence, with the last three lines on what could be said about Pope Zachary (†752) and the first line on Pope Stephen II (†752). Stephen was a former priest who was elected pope a few days after the death of his predecessor Zachary, but he in turn died of a stroke only three days later. That was why Abbo would not have had much to say about him.

It is clear that Abbo had no information about later popes in the text he used for his extract. Perhaps his copy of the *Liber Pontificalis* ended here? Or perhaps Abbo had lost interest. We don't know. However, the first and second scribes, who seem to have worked before 1035, still had something to say about some of the later popes, even if that information is often incomplete. To give an example, the second scribe had found some relevant information about Pope John VIII (†882):

> 'This Pope John came to Gaul, spending time at the town of Troyes and holding a synod of bishops there. At the synod, he gave Hincmar,

Theodosius uero pta regia in urbe ingressus qui a philippico deiecta fuerant in pristinum erga statum reuelata satisf sunt. feruore sue fidei. Tesi fluuius q appellat tiberis alueu suu egressus ultra modu intumuit. ita ut inuia leta adiuia isemis stagna aqua eide flu minis excreuisse atq a porta beati petri apli usq ad ponte molbiu aque se distenderet. Vnde romanis tribulatio maxima imminebat q serere n poterat. & idcirco ad dnm papa letanie crebro fiebant. Inde octaua die cessauer aque. XV. udelicet indictione Cumanu cia castru ipso sicut tepore a langobardis pa cis dolo puasu. Sed cum dn papa nec pcib. nec muneribus possa recipe. moenia ipsius castri noctu nosilentio ingressi. iohs dux neapolitan cum theadimo subdiacono urectore atq exercitu a langobardos pene CCC cu eoq castaldio infecer. uiuos uero ia amplius qua quingentos cu phen des. & captos neapoli duxer. Sic castru receptis p cu redeptione scissim papa sic pmiserat. dedit auri LXX libras. Tc xia nefanda sarracenoy gens cum a ispaniaru puincia p X tenuisset annos p uasa. unde amo rodanu conabat fluuiu transire. franciã occupa re ubi eudo p erat. A ui facta francoy generali moni tione sarracenos cu cu dans interemit atq decc. LXX V milia. uno se die infecta. ut eide eudoni francoy duci conuenebat epla q clari pontifici missa. Ex francis uero mille tantu & d me de bello fuer mortui. Ex quib. ppterea plures inuenerit. q anno p misso ide dux eudo in benedictione tres spongias ap dico pontifice acceperat. quas ad usu sue mse habu erat. & quib. mora qua bellu comissu est. quicuq ad sumdu modica nactus particula nec uulnera t nec mortuus e. Eodeq tpore in Campanie partib. co bustu triticum. hordeu seu legumina. quas plu uia in loco quoda e celo missa sunt. hic ponat instituit. ut q n agebatur quadragesimali tepore / in quinta feria ieiuniu atq missaru celebrita fieret. Illis interea dieb. constantinopolis ben mo e. a saracenis obsessa. sed do eis contrario maxima illuc eoy parte fame ac bello interempta. leone principe annicente confusi

recesser. Nam & eiusde ciuitatis diuersi scus & etatis postq. CCC. ferunt necessi tate pestilentie fuisse uastata. Eo quoq tepore motus certa honesta & nomine pontificis mat alb ac ita subtract e. Post cuiu obitu domu ppriã in honore sce xpi martyris agathe. a dias a fundamenco coenaculis. ut q ui monasterio erant necessaria mona choy. e nouo construx dando illi p diã urbana. ut rustica. & castru nu nu alango bardis puasu e. Ac post aliquos dies basilius dux. ioi danes cartularius. iohs subdiacon cogno columna. consiliu inier. ut pontifice inficeret. Quib. assensu p buit. marinus impialis spatarius.

ITE Gregorius sedit ann. X. m. uij. diebus. xxiij. Zacharias sedit ann. X. uiij. m. p. huiu auctoritate pipinus frem Karlomanni in monte cassino monachi facta sub regula sci benedicti. francia rege sibi constituer. abiecto Hilderico. qui postea consor cus monac effectus. Huic quippe pontifici ge neralis epla missa pipino regi ut restitueret cassimensib. corp sci benedicti. Quo do uo lente. nullu habuit effectu. cata pipinu accipiens. remigiu rotamagense epm frem Karlomanni. floriaco monasterio dirigit. quis acru pignus. ei residat. quos diuina clementia. ita oculoy lumine priuauit. ut nucios cernere n posset multis. Sed humi prostrati. ueniam petentes. clementia disen ser. & ad sua letantes reuer siunt. Stephs sed ann. V. dieb. XX. III.

& cessauit epat. dieb. xxxv. huic paschassimo Steph. reuelatio i memoria ostensa e. de consecratione altaris. apto petri i pauli qd. e. siti ante sepulcrū scoꝝ dyonisii. Rustici. i Eleutherii. v. kł. augi. Qui p obsessione atrocissimi nec nominandi h distulsi pipinū rege francoꝝ aduc. & in monasterio scoꝝ dyonisii. socioꝗ. ei. diu infirm̄ uacuit. sed scoꝝ p̄cib; sanitati redditꝰ. altare c etrnū

Qm multos p̄ cepr̄. pipinū & duos filios ei. karolū i karlomannū. ut reges francoꝝ apd sacrari a benedicꝰ. i contestat̄ e. ut nullus nisi de eoꝝ p genie p succedentiū tempoꝝ curricula in regno francoꝝ rex crearetur. Acta hec anno incarnat. dnice. dcc.liiij.

Paulus sed. ann̄. x. m̄s. i. & cessauit epat. ann̄. i. m̄s. i. hic. f̄p decesso rissui. Steph. monasteriū qd in honore scoꝝ martiꝝ dyonisii. socioꝗ. ei. in p̄priosuo edificare cepit papa Steph. Paulus successor ust. ei. nobilit cōsūmauit. i seruos dni natione grecos. ibi c stituit. & ad scos martires. i scola grecoꝝ appellari fecit.

Stephanꝰ sed. ann̄. iii. m̄s. v. ɖ. xvii. & cessauit epat. d. uiiij.

Adrianus sed. ann̄. xxiii. m̄. x. ɖ. xvii. Leo sed. ann̄. xx. m̄s. v. ɖ. xvii. hunc romani. ann̄ incarn. dni. dcc. xc. no. m̄o. uiiij. g cccc. aueꝝe. vii. kł. mai. linguāq; p ciderunt. Posit ꝗ incustodia. ad ęclam beati petri nocte c fugit. Deinde ad gloriosū rege karolū deducꝰ. i honorifice suscepi roma cū honore. e. remissus. Gloriosus aut rex karolus. in die natiuitatis dni. ante c fessione beati petri aposti residens Leo pontifex. capiti ei corona imposuit. i sic ab uniuerso romanoꝝ p̄plo adclamat. karolo augo. a d̄o coronato. magno i pacifico imp̄atori uita i uictoria. Et exinde impr̄. i aug.

appellatus est.
Stephaꝑ. sed. ann̄. vii.
Paschalis. sed. ann̄. vii. ɖ. xvi.
Eugenius. sed. ann̄. iii. m̄s. viii. ɖ. xxii.
Ualentinus. sed. ɖ. xl.
Gregorius. sed. ann̄. xvi.
Sergius. sedit. ann̄. iii.
Leo. sed. ann̄. viii. m̄s. iii. ɖ. v.
Benedictus sed. ann̄. ii. m̄s. vi. ɖ. vi.
Nicholaus. sed. ann̄. xi. m̄s. vi. ɖ. vii.
Adrianus. sed. ann̄.
Gregorius. sed. ann̄.
Johs. sed. ann̄. viii
Hic Johs papa in gallias uenit. i apud ciuitatem tretas morat e. habuitq; sinodū epoꝝ. in qua Hincmarus laudunū clauaci ep̄s. post auulsione oculoꝝ suo episcopatu. e. donat̄. Ut papa huic floriacē cenobiū subiecerit fec sub anathemate ꝓ sep de monachis ut ꝓs abbē ha
Stephꝰ. sed.
Leo. sed. ann̄ iiii
Benedictus. sed. ann̄ v
Gregorius tusculan. ex patre gregorio. sed. ann̄ vi
hic p aduersario crescentio. qui capitoliū rome cuitatis tenebat. ferentina ciuitate se c uertit. i nea diu c uersatus.

Siluester. qui i Gerbtꝰ. ex monacho factus remsiū archiep̄s. & eo relicto iteꝝ rauenatū archiep̄s fact. gregorio defūcto. ab octone im p̄atore tcio. in aplica benedicatione sublimat̄.
Johs. sed. ann̄.
Benedictus. sed. ann̄. Alexander pp. ii.
Romanus. sed. ann̄. Paschalis pp. ii.
Benedictus. sed. ann̄. Urbanꝰ pp. Honori pp.
ꝑp. ii. Innocenti natione Romā consensu omiū epoꝝ Gallia apud cernotense urbe elect ꝰ uir om lit le dign ꝰ iust tenax sedit ann̄. xv. huiꝰ tpibꝰ...
ii. Celestinꝰ bone memorie. sed ṁsibꝰ fere vi
Luciꝰ. sed

the bishop of Laon, his own bishopric after his eyes were torn out.'

This is news of more than local interest. There was no need to explain how Hincmar (c. 835/8–881), bishop of Laon, had lost his bishopric in the political wrangling of the time and then had had his eyes ripped out, as that story was common knowledge. After this report, another and later hand (possibly dated to the twelfth century) has added the following information:

> 'This pope gave this monastery of Fleury the privilege subject to excommunication [of those who did not observe the privilege] that we should always be permitted to choose our abbot from among our monks.'

This was clearly important to the monks of Fleury, because electing an abbot from among the monastery's monks was one of the key agreements resulting from Abbo's dispute with the bishop of Orleans.

The aim was to turn Abbo's extract from the *Liber Pontificalis* into a text with the nature of a chronology (apart from a few entries that were relevant for Fleury's own history), but that was not possible in most cases due to a lack of data. The continuation text ends in the second column of fol. 13v. The last pope to be mentioned is Pope Benedict IX (†1045). A Gothic hand has added another four popes' names after that, followed on the next line by a note by a less practised hand on Pope Innocent II (†1143).

A copy of the Leiden manuscript was made for the monastery of Micy sometime between 1039 and 1056. That copy is now kept in the Berne Burgerbibliothek, Cod. 120.I (fols 76r–93v). In this manuscript, the text of Abbo's extract (with the later continuation) starts on fol. 76r. The scribe did not distinguish in any way between the original text and the later additions. However, on fol. 92v, at the point where Abbo's original extract ends and the additions start, he left the same number of lines blank as in the Leiden manuscript. On the next leaf, though, he has copied the addition about Pope John VIII as if it had also been in the *Liber Pontificalis*. This copy does not contain the information about the charter this pope had given to Fleury, as that addition had only been made in the twelfth century, whereas the Berne manuscript was copied from the Leiden manuscript back in the eleventh century.

The authors who compiled the collection of papal biographies for the original *Liber Pontificalis* had a different aim to Abbo's when he produced his extract. It looks as if Abbo's intentions were political as well as to write a chronology. The idea behind the continuation of the manuscript in Fleury (with the later additions) was primarily the latter: chronological. The same applies to the copy the monks in Micy made in the eleventh century of Abbo's work with its additions. How the copy in the Berne manuscript came about, however, cannot be understood without VLF 96.

— Marco Mostert

< Fig. 2
The further continuation. Apart from one or two later additions, everything was written in one hand up to and including the (uneven) note on Pope Benedict (line 8 after the blank lines in the right-hand column). VLF 96, fol. 13v (image 88%).

Fig. 3
The continuation in VLF 96 is in the same hand as Abbo's *Excerptum*, as are the additions made to VLF 96 before the Leiden manuscript was used for the copy in Berne. Berne Burgerbibliothek, Cod. 120.I, fol. 92v.

f Taunton liber de m[...]

In hoc uo[lumine continentur]
historie [normannorum] libri octo. uidel;
ab aduentu hastingi in regnu francor usq;
ad mortē prīm henrici regis anglor et
ducis normannor. Itē uita caroli magni
imperatoris romanor & regis francor .p.
Itē uita alexandri magni regis macedonū.
Itē epl'a eiusdē de situ indie ad aristotelē ma
gistrū suū. Itē abreuiatio gestor regum
francie ab egressione eor a sicabria usq;
ad principium regni ludouici iunioris
regis francor & ducis aquitanor. Item
historiaru de regibus maioris britannie
usq; ad aduentum anglor in eandē insulam
libri. xii. In quoru septimo continetur
pphie mellini n siluestris. sed alterius
id est mellini ambrosii. Itē exceptiones ex li
bro Gilde sapientis historiographi brito
nū que coposuit de uastatione sue gentis
& de mirabilibus britannie.

dum per legatos a duce septius obiurgaretur, & ab ausu obstinati animi resipiscere nollet, consultu & auxilio Rodulfi comitis captus, in Rotomagensis urbis turre detruditur, temeritatis penitudine ibi per quinquennium luens. Nonnullos quoque suorum satellitum in seditionis proposito perseverantium, crebris certaminum tumultibus deuincens, uita priuauit, aliosque exules de suis finibus exturbauit. Willelmus tandem post quinquennium cuiusdam sui militis factione, longissimo fune per eminentiorem fenestram a turre lapsus, fuga init. Qui diebus ne aperiretur quiescens, repertusque deletescens, & noctibus iter carpens, nouissime deliberauit apud se equius illi fore cum uitæ discrimine clementiam fratris attemptare, qua cuiuspiam regis aut comitis suffragium nil sibi quandoque profuturum expetere. Sub hac quippe deliberatione animi calle conficiens, quadam die ducem repperit, se in saltu uernensi exercentem uenatum ludis. Mox eius uestigiis solotenus prouolutus ueniam commissi ab eo expetebat lugubris. Protinus cum dux miseridia fauente Radulfo comite a terra erexit, ac ut euasionis suæ ipso narrante casum agnouit, si solum errata illi indulsit, uerum etiam beniuolo animo ut fratrem karissimum deinceps dilexit. Cui non multo post Ocensem comitatum dedit, eique quandam puellam ualde speciosam uocabulo Leizelinam dedit, filiam siquidem cuiusdam nobilissimi uiri nomine Turchetilli. Ex ea tres genuit filios, Rodbertum scilicet post eius mortem comitatus illius heredem, & Willelmum Sueßionensem comitem, atque Hugonem Luxouiensem præsulem. Qui bis ita sopitis normannica rebellus siluit a facie ducis. IIII.

Ceterum hæc tempora Edelredus rex anglorum, Emmam ducis sororem in coniugio habens, quibusdam exortis dissentionum incentiuis duci nocere & dedecora ingerere sciens, maxime

nauium multitudinem in mare iussit propelli, ac militibus ex omni regno mandauit, ut constructo ab eo die ad eas conuenirent, loricis & galeis decenter armati. Cum iussis grauanter angli obtemperantes, unanimes astitissent ad naues. Rexque præ sperata multa & obtime instructa exercitus copia, astutis militiæ suæ satrapis, animi sui propositis exponens, ualida austeritate regio more præcepit: ut euntes tota normannia raptis & incendiis exterminarent. solummodo archangeli michaelis montem parcerent, ne tantæ sanctitatis & religionis locum igne concremarent. Iussit etiam ut Ricardi ducem caperent: post tergum manus uincirent: & uiuum parrita sibi subiugata conspectibus suis adducerent. His ita edictis eos ire cum festinatione imperauit. Qui subductis in altum nauibus, uelisuolo sulcantes equora uentis, ad littora sarx deuoluuntur per mensio maris limbo. Hinc prorumpentes e nauibus, continuo maritima cortisina extali uiolento trahunt. Quod ut Nigellus a speculatoribus compertis constanter tenses, cum multitudine uulgi congregauit, impetuque repentino super eos irruit, tantaque illos strage deleuit, ut nullus periculi euaderet: qui facta posteris nuntiaret. Ham unus illorum cursu nimio fatigato a longe residebat, qui uidens sociorum infortunia, timore territus corpotatisque imbecillitate oblitus, ad naues cucurrit. quampci, ceterarum gerxia nuntians custodibus. Qui pariter ex omnibus ad tres uictores se conferentes, uitra sinu marts remigio se concusierunt de uita diffidentes. Pansisque uelis in sublime cursu ocissimo regem suum repetierunt, uento aduorum spirante. Quos ut uidit, protinus ducem ab eis exigere cæpit. Aristi respondens. Nos serenissime rex duce minime uidimus, sed cum uiris comitatus genere feruocissima nobis cum incertum di-

Robert of Torigni's historical compendium

42 | Composite manuscript, including the *Gesta Normannorum ducum* by William of Jumièges
Twelfth century, second or third quarter — BPL 20

Leiden University Library houses a fascinating twelfth-century manuscript uniting several widely copied works of historiography (the writing of history) in a single codex, BPL 20. It was compiled for the use of one specific medieval individual: Robert of Torigni (c. 1106–1186), monk of the abbey of Le Bec and later abbot (1154–1186) of Mont Saint-Michel. This personal manuscript permits rare insights into Robert's working methods as a historian over his long and distinguished career.

BPL 20 is a compendium of historical narratives written between the Roman period and the first half of the twelfth century. It is a composite codex combining two previously independent books or booklets, which were copied at the Norman abbey of Le Bec and bound together in the early 1160s. Its contents are listed on the back of the manuscript's damaged opening page, which was written by an anonymous scribe in a well-trained mid-twelfth-century hand:

> *In hoc vo[lumine ... con]tinentur. Histori(a)e n[orma]nnor(um) libri octo, vide(licet) ab adventu hastingi in regnu(m) francor(um) usq(ue) ad morte(m) primi henrici regis anglor(um) et ducis normannor(um). Item vita caroli magni, imperatoris romanor(um) et regis francor(um) [...] Item hystoriaru(m) de regibus maioris britanni(a)e usq(ue) ad adventu(m) anglorum in eande(m) insulam libri xii [...]*

'In this volume are contained: eight books of the history of the Normans; that is, from Hasting's arrival in the kingdom of the Franks to the death of Henry I, king of the English and duke of the Normans. Also the life of Charlemagne, emperor of the Romans and king of the Franks [...] Also twelve books of histories about the kings of ancient Britain up to the arrival of the English on that island [...]'

In addition to medieval 'bestsellers' such as Einhard's *Vita Karoli Magni* ('Life of Charlemagne'), Geoffrey of Monmouth's *De gestis Britonum* ('On the Deeds of the Britons') and William of Jumièges' *Gesta Normannorum ducum* ('Deeds of the Norman Dukes') in the twelfth-century redaction of Robert of Torigni, BPL 20 also contains copies or short excerpts of works by Julius Valerius (Roman, c. 300 AD), Nennius (Welsh, ninth century), Orderic Vitalis (English/Anglo-Norman, twelfth century, a contemporary of Robert of Torigni) and some anonymous authors.

What makes this manuscript special is that we can identify not only where and roughly when it was made, but also the person who was responsible for its compilation and who used and annotated it over several decades. Unlike the countless makers and users of medieval manuscripts who remain anonymous, we know a fair amount about the life and career of Robert of Torigni (c. 1106–1186), the man behind BPL 20. Robert spent his formative years in the secular world before becoming a monk and prior of Le Bec in his early twenties. In 1154, Robert became abbot of Normandy's island monastery of Mont Saint-Michel, a major centre of manuscript production and illumination, where he spent the rest of his life and was buried in 1186.

Robert was not just a powerful churchman, but also a prolific reader and writer. He helped expand Le Bec's library and showed one of its treasures — a copy of

<< Fig. 1
The contents list and opening of Robert of Torigni's redaction of the *Gesta Normannorum ducum*. BPL 20, fols 1v–2r (image 86%).

Geoffrey's *De gestis Britonum* — to the visiting English historian Henry of Huntingdon (c. 1088–1156 × 1168), who would go on to write the *Historia Anglorum* ('History of the English').

The first text preserved in BPL 20 (fol. 2r), seen opposite the contents list, is one of Robert's own creations, a redaction of the *Gesta Normannorum ducum* originally written for William the Conqueror, Duke of Normandy (reigned 1035–1087) and King of England (reigned 1066–1087), which Robert expanded and continued with important events of his own day. The text's opening (comprising the *Gesta*'s early chapters) is missing due to a loss of pages that likely occurred before the book was bound and the contents list added. What remains of the text today was copied in multiple hands, which probably belonged to anonymous monks of Le Bec who worked as Robert's scribal assistants and committed his drafts to writing whilst he himself was still making changes and additions to the text.

When leaving Le Bec for Mont Saint-Michel, Robert seems to have left this manuscript behind, though he may have fetched it later as a reference work for his next writing project, a chronicle modelled on the works of Eusebius of Caesarea (c. 260–339 AD) and Sigebert of Gembloux (c. 1030–1112) (now Avranches, Bibliothèque patrimoniale, MS 159). Writing at Mont Saint-Michel, Robert used and borrowed books from Le Bec, including BPL 20. He even had an inventory drawn up for this very purpose, which spans the opening pages of his chronicle's working copy and lists BPL 20 and its contents on fols 2v–3r, alongside 164 other books, under the heading TITULI LIBRORVM BECCENSIS ALMARII ('Titles of the books of Le Bec's book chest').

BPL 20 offers unique insights into Robert's working method as a historian, thanks to the firsthand corrections and annotations he made to the texts copied by his assistant scribes. Some are grammatical in nature and reveal Robert's superior command of Latin, a literary qualification that should not be taken for granted given his secular upbringing. Others are content focused and showcase Robert's wide-ranging interests and knowledge as a scholar. This is most evident in his explanatory glosses on persons and places throughout the manuscript that add context to the historical narratives for the benefit of their readers. Robert's notes are written in darker ink than the main text and typically appear at the end of sentences and paragraphs and between lines, connecting different parts of the narrative and effectively acting as cross-references. Robert links passages, for example, by telling us that Geoffrey of Rennes was the son of Duke Conan (I) of Brittany: *sc(i)l(icet) fili(us) conani comitis brit(anniae)* (fol. 2v). He then adds that Judith, wife of Duke Richard II of Normandy, was the same Conan's daughter (and Geoffrey's sister): *s(cilicet) filia(m) conani comitis brita(n)ni(a)e* (fol. 4r). Later on, he comments that Ranulf II le Meschin's wife was called Matilda and bore him two sons, Hugh and Richard: *ex q(u)a g(enuit) duos filios hugone(m) et ricard(um)* (fol. 30v).

There are few medieval books that connect us as closely with their maker(s) as BPL 20. This is a truly remarkable and deeply personal manuscript designed to suit the changing needs of a specific individual across a long and prolific career that shows signs of continued firsthand usage over nearly half a century. It is a fascinating window into the life's work of one of the most accomplished historians of the twelfth century.

— Benjamin Pohl

Fig. 2
Robert of Torigni's glosses (in darker ink). BPL 20, fols 2v, 4r and 30v, details.

[Medieval Latin manuscript page — handwriting too cursive and abbreviated for reliable transcription]

The master's hand

43 | Composite manuscript from the private library of Filips van Leiden
Fourteenth century, middle or third quarter — BPL 2429

Many medieval books are made up of multiple components. That means that an owner decided at some point that it would be a good idea to bind various independently produced manuscripts together in a single volume. Such composite books are known as convolutes or composite volumes. To understand such a heterogeneous codex and the texts it contains, the codicologist studies the makeup of the object's layers — rather like an archaeologist or geologist might.

This manuscript, BPL 2429, consists of four separate entities, together making up 121 parchment folios, bound in a binding created in the late sixteenth century. All the components of this convolute date from the mid-fourteenth century or third quarter of that century. The first component (fols 1–30) contains the *Chronographia* of the Egmond monk Johannes de Beke. This is an influential chronicle of the bishops of Utrecht and counts of Holland, dedicated to the Utrecht bishop Jan van Arkel and Count Willem V of Holland in or shortly after 1346. This section consists of 30 folios in three quires: one with five bifolia, one with six and one with four. The verso of the last folio of the final quire was left blank.

This is followed by the second section of 11 folios (fols 31–41) containing a theological treatise by Nicholas of Lyra from 1334, *Responsio ad quendam Iudeum ex verbis ewangelii secundum Matheum contra Christum nequiter arguentem*. The text starts halfway through a quire of six bifolia, where the first five folios have been cut away and the sixth has been left blank on both sides. It is possible, indeed probable, that the first half of the quire once contained text. Whatever the case may be, the scribe who copied Lyra's *Responsio* needed extra parchment to complete his text. He therefore added two bifolia, only using the first folio (both sides); the remaining leaves were left blank (at that time).

The third section (fols 42–59) comprises a quire of nine bifolia. It contains the *Chronicon Egmundanum*, a chronicle of the monastery of Egmond from about 1270, followed by the text of the four oldest royal charters intended for the Count of Holland. Several folios were initially left blank at the end of this section too. Not long afterwards, some of this blank space was filled with two petitions to Count Willem V and a copy of a charter from 1355 from the same count for the town of Weesp.

The fourth and final component (fols 60–121) consists of the *Liber de casu Troie dictus Troianus* by Guido de Columna, which dates from 1287 and is also known as *Historia destructionis Troiae*. It is a translation of the *Roman de Troie* by Benoît de Sainte-Maure from c. 1160. Eight quires were needed to copy this: seven with four bifolia and one with three. The handwriting in this section looks neat, but that of the other components

< Fig. 1
Filips van Leiden drew a pointing hand in the margin of the *Chronicon Egmundanum* to mark a passage about the year 1166, when a large crowd of armed West Frisians crossed the Occenvorth mudflats and attacked the town of Alkmaar.
BPL 2429, fol. 48v.

< Fig. 2
Two stamps record the later fate of the manuscript which was held in the Von Rhedigersche Stadt-Bibliothek in Breslau (now Wrocław) before becoming part of Leiden's collection. The note *ex spoliis Rurmondanis* identifies the manuscript as part of the plunder seized by the troops of William of Orange in the conquering of Roermond in 1572.
BPL 2429, fol. 121v, detail.

Fig. 3 Report of events that took place in Leiden in January 1362, written by Filips' brother Gerrit Hoogstraat. BPL 2429, fol. 41r, detail.

is more irregular, suggesting they were copied for the scribe's personal use.

We know exactly who that user was. BPL 2429 is the only book that is identified as coming from the library of Filips van Leiden (1325–1382), the first known lawyer from the Netherlands. It is described very precisely in his will of 1372 (published by P.C. Molhuysen in 1900). That description shows that the book then began with another component that has since been lost, a series of lives of the church fathers that was ordered alphabetically. The numbering that was added [1]–[4] corresponds to the components discussed in the previous paragraphs.

Liber narracionum secundum ordinem alphabeti de vitis patrum antiquorum. [1] *Gesta episcoporum Traiectensium et principum Hollandie compilata per magistrum Johannem de Beec.* [2] *Quidam modicus tractatus compilatus per magistrum Nycolaum de Lyra contra argumenta cuiusdam Iudei.* [3] *Adhuc quedam gesta comitum cum quibusdam litteris prime donationis facte comitibus Hollandie, cum cyrographo de Wesep.* [4] *Gesta Troiana distincta per libros, in uno volumine.*

Filips van Leiden was closely involved with the count's chancellery in the 1350s, which easily explains why the additions to the third section are in his own hand. Filips' own hand is also seen in the *Chronographia* and the Egmond chronicle. It is possible that both texts were copied in their entirety by Filips, with the style of writing varying depending on the scribe's mood and the effort he put into the quality of his handwriting. Here and there, he drew a small hand (*maniculum* in Latin) in the margin to draw attention to a passage, as on fol. 48v.

At the end of the second component, on fol. 41r, there is a report of an uprising that took place in Leiden in January 1362. We know for certain that Filips van Leiden did not copy this report on the parchment because at that time he was either in Avignon as an envoy to the papal court or perhaps in Paris, where he taught ecclesiastical law. The scribe who wrote this report when the news was still fresh was the same person who recorded various charters in which a certain Gerrit Pietersz. plays a key role. He must have been both the author and scribe of the report. This Gerrit Pietersz. Hoogstraat (†1368/72) was Filips' eldest brother.

Gerrit Hoogstraat was appointed by Filips as the representative for his affairs in 1345. It seems he had access to Filips' books during the latter's absence. That included various books that Gerrit had copied for Filips, such as a copy of *De consolatione philosophiae* by Boethius (†524). Other relatives also copied texts for Filips van Leiden. His brother Dirk Poes wrote down the *Doctrinale* of Alexander de Villa Dei (†c. 1250) for him and Graecismus by Evrard de Béthune (†c. 1212); his cousin Dirk Gravekijn (†1349/51) copied a dictionary from around 1200. This shows how someone in medieval Leiden acquired books: by copying manuscripts himself or by engaging family members to copy them for him.

In his will, Filips expressed the wish that his library should remain available for study in his house near the Pieterskerkhof in Leiden, until a more appropriate home could be found for his books. This also included BPL 2429. Anyone who wanted to consult a book would be loaned it in return for a suitable 'caution' or guarantee statement in which the student promised to return the book unharmed.

Despite such precautions, Filips' book was not spared the effects of wear and tear, or greed. In 1572, the book ended up in Roermond, a long way from Leiden, where the Silesian book collector Thomas Rehdiger (1540–1576) acquired it as part of the spoils of war — *ex spoliis Ruremondanis*, as Rehdiger himself wrote on the final leaf. He had the manuscript, by then minus its initial text, rebound and took it home to Breslau (now Wrocław in Poland). It was not until 1942 that the book made it back from Poland to the city where it had been put together six centuries earlier by master Filips' hand.

— Ed van der Vlist

Fig. 4
Filips Pietersz. (van Leiden) appoints his brother Gerrit as the representative to handle his affairs, *alsoe langhe als hi in studie jof int scole laghe* (lines 2–3). Charter issued by Leiden aldermen, copied by Filips himself. *Erfgoed Leiden en Omstreken*, Archives of the Churches of Leiden, inv. no. 1086 (29 July 1345).

van den richter. En doe si standafftlike den afgoden mer offe-
ren en wouden worden haer lichen voerstellen en also gru-
welijken doe die stat gheslept bernulden si ten laetsten haer
marteli mitten sweerde verslaghen ¶ Op ten seluen dach
ende in der seluer stat passy der heiligher adrianus theoti-
cus en noch ander drie Die die richter inder zee verdrenc-
ken dede maer omits dienstes ens bisschops die delphyn
hier worden haere lichamen weder ten oeuer ghebrocht
¶ Te cartagen sunte ponciaus dach dese was dyake sinte
cypriaens des bischops ende ghedoechde ellende mit hem tot ten
daghe toe syns passien ende het after enen edelen voer-
syns leuen ende syne passien En daer mit veel pinlijcke-
den vordende bi die roey des leuens ¶ En noch

Die v dach in martius die maen is out

xvij	xxviij	ix	xx	i	xij	xxiij	iiij	xv	
A	b	c	d	e	f	g	h	i	
xxvi	vij	xviij	xxix	x	xxi	ij	xiij	xxiiij	
k	l	m	n	o	p	q	r	s	t

¶ In sebasten in mynre armenyen der heiligher xl ridders
dach die in des connincs licinius tiden na vanden ende
veel starkerynghe na dat oer haer aensicht mit stene ghe-
slaghen waren mit water gheseynt worden En also te laet-
sten mit crupspringhe haer marteli beruulden Die edel-
ste onder die waren quirion en candidus ¶ In der stat te nyce
na sunte gregorius bischops dach dese was sunte basilius bis-
cops van cesarien brader En was in leuen en loringhe die
alre verclaerste ¶ Inder stat baranona sunte pacianus bis-
cops dach die in theodosius des princen tiden dat er de syns
leuens verrees in gueder outheit ¶ En noch ander veel

Die x dach in martius die maen is out

xviij	xxix	x	xxi	ij	xiij	xxiiij	v	xvi	
a	b	c	d	e	f	g	h	i	
xxvij	viij	xix	xxx	xi	xxij	iij	xiiij	xxv	vi
k	l	m	n	o	p	q	r	s	t

¶ Te apamia der heiligher martelaren dach gayus ende

alexander die abt appollinaris die bisscop van serapolitaen sayst
inden voer teghen die cartiafrigas in anthonius dorus perse
vict mit martelien ghetroesit sijn ¶ In persiden der heilighen
martelaers duch vi. ghetale xlij ¶ Opte seluen duch der heili
ghen gorgonius ende firmus ¶ En noch and decl
Die xi dach in marcius die maen 10 oirt

a	b	c	d	e	f	g	h	i
xix	xxx	xi	xxii	iii	xiii	xxv	vi	xvii
xxvi	ix	xx	i	xii	xxiii	iiii	xvi	xxvii
k	l	m	n	o	p	q	r	t

¶ Te carthagen der heilighen duch herarlius zozimus alex
ander candidus piperion en noch xxx ¶ Item te carthage
sunte constantijn confessoers duch die cen ouerslaen man was
¶ Te alexandrien der heilighen dach ptholomeus bisscop ende
valerius en noch xxx ¶ In den cloester liponio sunte attalis
abdt duch dese was sunte colubai abdes discipel ¶ En noch ii

g. xiii
herardus mi
ers priester

Die xii dach in marcius die maen 10 oir

a	b	c	d	e	f	g	h	i
xx	i	xii	xxiii	iiii	xv	xxvi	vii	xviii
xxx	x	xxi	ii	xii	xxiii	v	xvi	xxvii
k	l	m	n	o	p	q	r	t

9

A. ii

¶ Te romen sunte gregorius dach dese heetmen die grote
gregorius en was een sonderlingkhe voerbarich leerre
der heiligher kerken hi was die eerste gregorius en in die
ordinaci der paeusen die lxiiijste jnt jaer ons heren vijf
hondert en lxxx regierde hi salichlijken die heilighe kerke
godes ¶ Te nycomedien sunte peter martelaers dach dese doe
hi was dyoclesiacis des princen camerlinc en hi belijt ke
nlijcke die onghemeten pinen der martelarey doe ghe
loet dannen mit midden blooticke en eerst opghinghen w..e
ser langhe mit ghiselen ghetormēt Daer na mit asijn
en sout ouersoten en ten laetsten op enen roester ghebonden
wert hi des gheluarighen peters ernaem i beyde gh. loues
ende namens ¶ Te nycomedien der heilighen egdinnus
priesters dach en noch ander sauen die elc daghes een ceus.

Liturgical or not?

44 | Middle Dutch martyrology from the St Servatius convent in Utrecht
Fifteenth century, middle — LTK 273

The liturgical language of the Middle Ages was Latin. Medieval liturgical manuscripts are therefore by definition Latin manuscripts. Strictly speaking, a martyrology in Dutch could not be used in a convent's liturgy. Nevertheless, several manuscripts have been preserved of such Middle Dutch memorial books for martyrs and other saints. How can we explain this?

<< Fig. 1
Middle Dutch martyrology, opening with the lemmas for 9–12 March. The captions, the Golden Numbers, the large initials at the start of the first lemma of the day and the paragraph symbols at the start of successive lemmas have been written in red ink. The cursive script is regular and easily legible.
LTK 273, fols 18v–19v.

In monastic liturgy, veneration of the saints is directed by the calendars of the liturgical manuscripts used, primarily in missals (with songs, prayers and readings for celebrating the Holy Mass) and breviaries (for choral prayer). In addition to calendars, martyrologies also bear witness to the veneration of saints in medieval monasteries and convents. The martyrology is a liturgical work that states which martyrs or other saints are remembered on each day. As well as giving the name of each saint, the lemmas in the martyrology also list some biographical facts. In the daily choral prayers, the lemmas for the day were read from the martyrology, generally at the end of the first prayers of the morning (prime), along with a chapter from the monastery's rule plus the names of the nuns or monks and its benefactors who had died on that day.

The vast majority of late medieval martyrologies can be traced back to the one that Usuard, a monk in Saint-Germain-des-Prés, compiled around the year 860. Over the course of the Middle Ages, his martyrology was extended with lemmas from other martyrologies and lemmas for newly canonised saints and for saints who were revered at the place where a manuscript was written (or venerated by a particular order or diocese). A martyrology is therefore always a 'work in progress'. The majority of monastic orders had their own version of Usuard's martyrology that was required to be used in the associated monasteries or convents.

In addition to over sixty Latin martyrologies from the medieval bishoprics of Utrecht and Liège, ten other Middle Dutch martyrologies from the Netherlands have been preserved, all written in the fifteenth century. Six of the ten manuscripts were used in convents in the principalities of Holland and Utrecht. One of those comes from the Cistercian convent of St Servatius in Utrecht. That can be seen from an owner's inscription on fol. 90v: *Ite(m) dit boec hoert / den bekeerden susteren toe die binnen der stat van / bi [!] uutrech bi sante servaes in marien magdalene(n) / stege woenen* ('[Also] this book belongs to the converted nuns living within the city of Utrecht in Saint Servatius, on the street called Maria-Magdalenasteeg'). It is a carefully produced manuscript on paper that can

Fig. 2
Inscription by an owner in the outer margin. This inscription (in an inexperienced hand) is all that tells us that this manuscript was used in the St Servatius convent in Utrecht (a Cistercian sisterhood) in the fifteenth century.
LTK 273, fol. 90v, detail.

be dated by its watermarks to the middle of the fifteenth century. The script is a regular Gothic cursive that must have been written by an experienced scribe. At the start of the prologues (fols 1r, 1v and 2r) and at the beginning of the martyrology (fol. 3r), high-quality initial letters with penwork embellishments have been drawn.

A few dozen obituary annotations have been added in the margins of the manuscript in a more recent script; not the names of deceased sisters of St Servatius, but probably those of the benefactors of a convent or monastery. These are men and women from Utrecht families who do not appear in the 'official' necrology of St Servatius. This striking discrepancy can only be explained by assuming that the manuscript was given at some point by the St Servatius convent to another, unknown, convent or monastery in Utrecht and that the names refer to the benefactors of that institution.

On fol. 19r of the martyrology, we find the lemmas for the saints who were remembered on 11 and 12 March. The text begins with the lemma for Pope Gregory the Great (c. 540–604): *Te Romen, sunte Gregorius dach, dese hiet men die grote Gregorius. Ende was een sonderlinghe voerbarich leerre der heiligher kerken. Hi was die eerste Gregorius ende in die ordinanci der paeusen die XLVIste. Int iaer ons Heren vijfhondert ende LXXXXV regierde hi salichliken die heilighe kerke Gods.* ('In Rome, the day of Saint Gregory, known as Gregory the Great. He was a great teacher in the Holy Church. He was the first (pope called) Gregory and the sixty-fourth in the series of popes (since Peter). In the Year of Our Lord 595'). That is followed by the lemmas for the virtually unknown martyrs Petrus and Egdunus. Saint Gregory's feast day on 12 March is usually written in red ink on liturgical calendars, emphasising the importance of the feast (from which the English term 'red-letter day' derives). The same Pope Gregory is listed, again in red, in the calendar of BPL 2747 (see no. 8).

Above the lemmas for 12 March, we can read *Die XII dach in Martius. Die maen is out* ('The 12th day of March. The moon is waning') followed by a table of dominical letters and Golden Numbers as a way of calculating how many days have elapsed since the last new moon, which needed to be stated in the *officium capituli*. However, additional data is needed for that, which is not given in this table. In the right-hand margin of fol. 19r there is an additional obituary note that is no longer complete because the page has been cropped: *Gherardus Nu / ers priester* ('Gerard Nuers priest').

Fig. 3
Penwork initial at the start of the martyrology for 1 January: *Octave der ghebuerten ons heren jhesu (christ)i*, the feast day of Saint Basil, Saint Martina, etc. LTK 273, fol. 3r, detail.

Is the St Servatius martyrology a liturgical manuscript that was read from during the choral prayers? Latin was the only language used for choral prayers and the Holy Mass until the Second Vatican Council (1962–1965). Medieval liturgical manuscripts in Dutch are therefore a great rarity. Some researchers have assumed that Middle Dutch liturgical manuscripts such as these were intended for nuns who did not know Latin well enough to be able to follow the liturgy. A translation into the local language would let people follow the choral prayers (or the mass) passively, while the other members of the monastic community (or the priest) would pray and sing using the Latin liturgy.

We know now from other sources (chronicles, inspection reports, letters) that many pious men and women who lived in monastic communities in the late Middle Ages spoke no Latin or were not fluent enough in it. They would therefore also have been unable to pray and sing the obligatory choral prayers in Latin. It would thus seem likely that the clerics who inspected such communities — often envoys appointed by the bishop — would have turned a blind eye upon finding that liturgical prayers and singing were partly or even entirely in Middle Dutch. Be that as it may, if inspectors allowed the nuns to use a martyrology in the local language, that means martyrologies must have been copied in Middle Dutch. The ten manuscripts of such works that have survived bear witness to that. The nuns of St Servatius in Utrecht (and in other convents in Utrecht and Holland) clearly made a virtue of this necessity; there can be no doubt that the St Servatius martyrology should be seen as a liturgical manuscript.

— Eef Overgaauw

OLD TEXTS, NEW READERS

Throughout the medieval period, the classical past remained a source of inspiration and authority. Through their avid reception of classical texts, medieval scholars were 'standing on the shoulders of giants', as the twelfth-century writer John of Salisbury (c. 1120–1180) would memorably record. In twelfth-century Bologna, for example, scholars revived the study of Roman law with a passion. They compiled commentaries, which were then copied into manuscripts alongside the Roman legal texts, using an innovative page design (see no. 45, BPL 6 C).

Humanist scholars of the early Italian Renaissance prided themselves on rediscovering texts which had not been studied during the medieval period, trawling monastic libraries for Carolingian or even older copies of these works. To own a manuscript of one of these newly discovered works — such as Cicero's *Epistulae ad familiares* (no. 47, VLF 49) — was to be in the vanguard of a scholarly revolution. Manuscripts copied by humanist scholars used a distinctive script and layout to signal their 'modernity', a style that attracted the interest of scholars far and wide. This is evident, for example, in a copy of the *Letters* of Pliny the Younger made by Rudolph Agricola, a pioneer of the Northern Renaissance (no. 48, VLQ 80).

Prior to the Renaissance, it was relatively unusual in medieval Western Europe to know classical Greek. Many of the works of Aristotle were translated into Latin in only the thirteenth century, and knowledge of Greek philosophy was often accessed indirectly, mediated through other sources. The fall of Constantinople in 1453 led to an influx of Greek manuscripts and Greek-speaking scholars to Western Europe, leading to the spread of texts which were commonplace in the Byzantine schoolroom (like the Greek *Tragedies* contained in no. 46, VGQ 6). Epictetus' *Enchiridion* (no. 49, VGQ 54), an important handbook of Stoic philosophy, was translated from Greek into Latin in 1479.

The spread of Greek texts throughout Europe would also be aided by a new invention, the printing press. However, the most recent item in this collection, part of a French translation of Homer's *Iliad* made c. 1540, was still copied by hand. It is a deluxe manuscript with a binding stamped all over with the letter *F*, indicating its intended reader, King François I of France. This high-quality manuscript shows that the art of copying books continued to be valued nearly a century after the invention of the printing press. (IO'D)

Old texts, new readers | Manuscripts, *from rear, left to right*:
VGQ 6 (no. 46), MAR 57 (no. 50) — VGQ 54 (no. 49), BPL 6 C (no. 45, *below*), VLQ 80 (no. 48, *above*) — VLF 49 (no. 47)

'By God, he shall not pass!'

45 | *Digestum vetus* with glosses and *additiones*
Thirteenth century, second half — BPL 6 C

In the thirteenth century, a law student had to take an exam. He appeared before the famous professor Accursius and his own teacher Jacobus. It did not go well, as the student gave a wrong answer. Jacobus tried to excuse him but Accursius burst out in anger: 'By God, he shall not pass!' This small but unique anecdote comes from a Leiden manuscript containing a copy of the *Digesta* (Digests) of the Byzantine emperor Justinian (482–565).

If you studied law in the Middle Ages, you mainly studied Roman law as laid down by Emperor Justinian in the sixth century AD. The key part of the Justinianic legal code, the Digests, had been rediscovered in the eleventh century and had dominated the curriculum in Europe's universities ever since. The foundation of Europe's oldest university, that of Bologna, was closely linked to studying this legal code. The code was one and a half times thicker than the Bible and consisted of excerpts copied from writings of Roman lawyers from the first to third centuries, served up with a sauce of imperial approval. The code was so long that it inevitably had the solution to every legal problem somewhere, as long as you knew where to look. In lectures, the professors would explain the legal jargon and the system that the code was based on. They would show how the texts were interconnected and formulated the underlying abstract rules. Students wrote their annotations ('glosses') in their own copies of the Digests, next to the stipulations their teachers had discussed with them. By the time they finished their university studies, they would have both the legal text and a commentary at hand.

Over time, the commentaries were standardised. After some competition, the Bolognese professor Accursius (c. 1182–1263) managed to conquer the market with his authoritative commentary. Accursius must have been a strict taskmaster, as is evident from a note that has survived in this manuscript, BPL 6 C, on fol. 54r. It is an anecdote to *Digesta*, Book 4, Title 8 (on arbitration cases in which fines are stipulated), section 23. The translation of the note is as follows:

> 'Regarding this section, professor Guido [de Cumis, c. 1210–1263] relates how someone was examined on this stipulation in Bologna by professor Jacobus [Balduinus, c. 1175–1235], who was his teacher, and professor Accursius. And professor Accursius asked him, "What would you say, Sir, if someone was prevented from satisfying a ruling in arbitration; would the fine be incurred?" He immediately answered that it would. But professor Jacobus, who wanted to excuse him, said he interpreted it this way because it would be that way for a contract, but differently for rulings and judgments in arbitration as below [in Dig. 22.2.9]. "No, no!" said Accursius. "That's not how it is: he has sinned against the Holy Ghost, by speaking in contravention of the case in this law on which he was examined. By God, he shall not pass!" And he was indeed told he would need to study this further. Affected by aversion, he immediately entered the Order of the Friars Minor. According to Guido.'

A sin against the Holy Ghost was unforgiveable. It would seem that Accursius thought the answer was stupid enough to publicly humiliate the student with this reproach. The law student then decided to give up his studies and enter a religious order instead. The Latin phrase *tedio affectus* is appealingly vague about whether this was due to boredom, aversion or distress.

<< Fig. 1
Opening with *Digestum vetus* (4.8.16–23), laid out in two columns and surrounded with Accursian glosses and *additiones*.
BPL 6 C, fols 53v–54r.

264

The eminent Dutch lawyer Eduard Meijers (1880–1954), known in the Netherlands as the man behind the Dutch Civil Code but renowned in other countries mainly as a legal historian, was the first person to point out this note, doing so in an article about education at the School of Orleans. This school of law was headed by Guido de Cumis after he had left Bologna. Elsewhere in the Leiden manuscript (fol. 66v), the reason for his departure is given. Guido adhered to a certain interpretation of the law. Accursius said, 'Brother, you know not what you say; it is shown immediately above the text', but Guido stuck to his guns. Following this incident, it was apparently wiser to leave Bologna.

Quite a few manuscripts have survived from the thirteenth century with the Digests and Accursius' gloss. While they are not rare, they are still valuable, as they were back then too. There are far fewer manuscripts with glosses from the period before Accursius saturated the market. Those pre-Accursian annotations shed a fascinating light at times on how legal thinking developed and how law was taught between the eleventh and thirteenth centuries. BPL 6 C is exceptional in that it contains earlier glosses in addition to the Accursian gloss, as if the person using the legal code did not agree with the Bolognese standardisation. Furthermore, this manuscript contains glosses that were produced later (*additiones*), such as the anecdotes from and about the dissident Guido de Cumis. The manuscript thus serves as a physical link between the dominant law school of Bologna and the emerging law school of Orleans.

The manuscript may have been produced in Italy or France, probably in the first half of the thirteenth century. The Digests are laid out in two columns per page, with wide margins for the commentary (added later in a different hand). The opening shown in the figure contains the paragraphs Dig. 4.8.16–23. The blue initials mark the name of the lawyer being cited, the red capitals ('Lombards') mark the quote. The explanations that follow are recognisable from the paragraph symbols, in alternating blue and red. The blue combination initial P/U (in the middle of fol. 54r, marking quotes from the work of Julius **P**aulus and **U**lpianus) starts Dig. 4.8.23 *pr: Celsus ait si arbiter intra | k(a)l(endas) septemb(res) dari iusserit...*, meaning: 'Celsus says that if an arbitrator has stated that he will present (a case) before 1 September... (and it is delivered later, then the agreed fine can be demanded).'

The manuscript was probably used intensively in Orleans; this is certainly suggested by the notes that were added. Various drawings of faces and hands indicate significant passages.

After Orleans, the manuscript moved around, ending up in England in the fourteenth century. The trail goes dead after that until the manuscript turns up again in the seventeenth century. Between 1645 and 1647, Johan de Witt (1625–1672), who would later become pensionary of the Dutch Republic, toured France and England for academic purposes. He may well have purchased the manuscript then. In any event, Cornelis van Bynkershoek (1673–1743), a member of the High Council of Holland, bought the book from the library of 'Janus Albinus' in 1696. The identity of this person has been the subject of scholarly debate but it is most likely that this was Johan de Witt. The library at Leiden obtained the book in 1743 from the library of Van Bynkershoek.

— Egbert Koops

Fig. 2
Note on the botched examination of a student in Bologna. See lines 4–6 for professor Accursius' exclamation: *n(on) n(on) dicebat accursius . no(n) (est) | ita . ipse p(ec)cavit in sp(iri)t(u)m sanc(tum) dicendo c(ontra) casum hui(us) l(egis) sup(er) <qua> examinat(us) est . per deu(m) no(n) tran | sibit...* BPL 6 C, fol. 54r, bottom margin.

Six plays for students and scholars

46 | Greek tragedies by Aeschylus and Sophocles
Fourteenth century — VGQ 6

This late medieval manuscript contains the texts of six Greek tragedies. The manuscript is not the most pristinely beautiful that can be found in Leiden's University Library, as it shows the traces of frequent use. However, that is precisely why it is such an exceptionally valuable manuscript: it is a splendid illustration of how classical Greek texts have managed to withstand the test of time.

Greek tragedies are plays that were first performed in the fifth century BC at the Dionysus theatre in Athens. They were written by the great authors Aeschylus (525–456 BC), Sophocles (496–406 BC) and Euripides (480–406 BC). Theatre companies worldwide still perform Greek tragedies — *Antigone*, *Medea* and *Oedipus* can bring in full houses even in the twenty-first century. How is it possible that these plays were not lost over the course of two and a half millennia? Codex Vossianus Graecus in Quarto 6 answers that question.

A total of 32 Greek tragedies have survived: seven by Aeschylus, seven by Sophocles and eighteen by Euripides. This body of work is the net result of a centuries-long process of selection, scrutiny and classroom use. As early as the third century BC, the three best tragedy writers and their best works had already been chosen for the Library of Alexandria. Those tragedies were studied and commented upon in depth in Alexandria, Rome and Constantinople, and pupils in classrooms from Egypt to Syria had to read these plays, interpret them and perhaps sometimes even perform them. This tradition of explanation and study turned out to be what saved the tragedies. The Greek texts that the teachers and scholars cherished had a greater chance of surviving because they were copied more often.

VGQ 6 demonstrates nicely how canonisation, scholarship and schoolroom use helped ensure that the Greek tragedies were passed on. This paper manuscript contains the texts of six plays that were particularly favoured during the Byzantine era: *Prometheus Bound*, *Seven against Thebes* and *Persians* by Aeschylus, and *Ajax*, *Electra* and *Oedipus Rex* by Sophocles. The last of these was Aristotle's favourite tragedy and it is still widely read and performed. After becoming king, Oedipus comes to the gruesome realisation that he has married his mother and killed his father. His wife and mother Jocasta then kills herself, and Oedipus leaves Thebes after taking out his own eyes.

The modern textual editions of Sophocles' *Oedipus* are based on a large number of manuscripts, the most important of which is in Florence: the codex Florentinus Laurentianus 32.9 (950 AD). A twin of that manuscript (BPG 60 A) is in Leiden (see Fig. 2). It is what is known as a palimpsest or *codex rescriptus*: a later scribe in dire need of material to write on and who did not particularly value classical poetry scraped the top layer of the parchment leaves clean and wrote Christian texts over the Greek tragedies. As a result, specialists can now only read the Sophocles layer with the help of a UV light (or, even more advanced, a multispectral camera) and a great deal of patience. VGQ 6 is less ancient than the Leiden palimpsest, but still a valuable textual witness.

Codex VGQ 6 presents six of the best tragedies by two of the three most famous tragedians. This selection meant that the manuscript played its part in the process of canonisation. The manuscript contains not only the tragedies themselves but also valuable paratexts: annotations between the lines and notes in the margins (known as *scholia*), which are partly based on very old comments added by scholars at the Library of Alexandria back in the third century BC. Just like some modern schoolbook editions, this manuscript presents the notes alongside the primary text. The pupil or reader can therefore

< Fig. 1
The opening verses of Sophocles' *Oedipus Rex*, surrounded by scholarly annotations.
VGQ 6, fol. 36v.

browse back and forth between the Greek poetry and the explanatory remarks next to it. We know that the tragedies in this manuscript were part of the Byzantine school curriculum. We can therefore assume that this manuscript was used in the classroom by teachers and students who were trying together to make sense of these Greek dramas, with their awkward metric aspects, mythological references and complex choral odes.

The text of Sophocles' *Oedipus Tyrannus* (Oedipus Rex) starts on leaf 36v. It opens with a *hypothesis*, an old plot summary, that begins by explaining the tragedy's title: Διὰ τί τύραννος ἐπιγέγραπται (*dia ti tyrannos epigegraptai*, 'Why the work bears the name "tyrannos"'). This refers to the fact that Sophocles also wrote another tragedy about Oedipus, called *Oedipus Coloneus*. To distinguish between the two works, the earlier Oedipus is therefore known as *Oedipus Tyrannus* or *Oedipus Rex* (Oedipus the King). After the hypothesis comes the dramatis personae: τὰ τοῦ δράματος πρόσωπα (*ta tou dramatos prosōpa*, 'the characters in the piece'), who are all given in relatively large letters and ligatures, in order of appearance: Oedipus (Οἰδίπους), a priest (ἱερεύς), Creon (Κρέων), a chorus of Theban elders (χορὸς ἐκ Θηβαίων γερόντων), Tiresias (Τειρεσίας), Jocasta (Ἰοκάστη), a messenger (ἄγγελος), a servant (θεράπων) and another messenger (ἐξάγγελος) who

relates the terrible events that have taken place inside the house. The Greek verses appear below that in columns. In the margin next to it, the reader can find scholarly comments, written in very small letters that are difficult to decipher. The first verse is easily readable, though:

Ὦ τέκνα Κάδμου τοῦ πάλαι νέα τροφή
Ō tekna Kadmou tou palai nea trophê

'Children, the young offspring of ancient Cadmus...'

King Oedipus is speaking in a fatherly tone to the inhabitants of Thebes (founded by Cadmus) after they have gathered in front of his palace because the city has been ravaged by plague. 'Father' Oedipus is not yet aware that he himself is the cause of the sickness devastating the city.

Although VGQ 6 is a genuinely functional item, several attractive elements can still be found in it. The titles have largely been decorated in red and there are some beautifully coloured initial letters (as on fol. 15r). Fol. 42v contains a surprise: an elegant drawing of a sailing ship, possibly added by a fifteenth-century reader and now sailing through the tumultuous seas of water

Fig. 2 Palimpsest. The overwritten text from Sophocles is visible in the margins and the later text (thirteenth/fourteenth century) is the *Viae dux* of Anastasius of Sinai (*ante* 640 – fl. 700). BPG 60, fol. 7r, lower half.

damage. This fine collection of six Greek tragedies plus scholarly annotations is one of the many classical manuscripts that the University Library possesses thanks to the philologist and collector Isaac Vossius (1618–1689). His library, acquired by Leiden University in 1690, contained editions of works by almost all the major Greek and Roman authors. VGQ 6 demonstrates that these texts were in most cases intended for intensive use. Thanks to manuscripts such as these, it was possible to retain not only the Greek tragedies themselves but also the rich tradition of textual interpretation in the form of comments: this manuscript thus links Leiden's University Library to its distant predecessor, the famed Library of Alexandria.

— Casper de Jonge

Fig. 3
Drawing of a sailing ship and traces of water damage. VGQ 6, fol. 42v.

A literary bestseller from the Renaissance

47 | Cicero, *Epistulae ad familiares*
Fifteenth century, second half — VLF 49

Cicero's *Epistulae ad familiares* ('Letters to Friends') enjoyed a wide circulation in the Renaissance. This Leiden manuscript containing Cicero's letters is a fine example of a professionally copied book from this period. In addition to the person who copied the Latin text, the book also involved a dedicated scribe for the Greek words and an illuminator. The manuscript was probably more of a status symbol than a book to be studied seriously. It ended up in Leiden in the seventeenth century.

VLF 49 was copied in Italy in the second half of the fifteenth century, a period when its text enjoyed incredible popularity among learned circles. The manuscript contains sixteen volumes of letters by the Roman rhetorician, philosopher and statesman Marcus Tullius Cicero (106–43 BC), addressed to friends and acquaintances in private life and politics — the *Epistulae ad familiares*. The letters contain a great deal of valuable information about the tumultuous political events of the time. These were the final years of the Roman Republic, before it became embroiled in civil war and was replaced by the new regime of Caesar Augustus and his successors. Cicero's letters also give first-hand insights into his own life and politics. That makes them a significant complement to the speeches and philosophical treatises that he published, in which he often presented a highly idealised version of himself.

There are two reasons why the *Epistulae ad familiares* were so astoundingly popular in the fifteenth century (there are five manuscripts in Leiden alone that were made in this period). Firstly, this was the heyday of the Italian Renaissance, when humanists were seeking to revive Classical Antiquity. Many of them saw Cicero as a role model as he was able to combine a life in service of the state with his literary activities. It is therefore hardly surprising that the humanists were so interested in all the details of his biography, and his letters were an excellent source for this. Secondly, reading Cicero's texts could let them learn an elegant form of Latin.

Cicero's letters had not always been available to readers. No manuscripts containing Cicero's correspondence were circulating in Italy in the late Middle Ages. Cicero's collected letters to his friend Atticus were rediscovered in 1345 by Petrarch (Francesco Petrarca, 1304–1374), but it was not until 1392 that the *Epistulae ad familiares* resurfaced. A copy of these letters ended up with the Florentine chancellor Coluccio Salutati (1331/1332–1406), who was himself a leading humanist scholar with a wide network of fellow humanists and patrons with cultural leanings. They all wanted their own copy of Salutati's new prize possession — if they were able to afford it.

The copy of the collection of letters that had been written for Salutati was the model for nearly all the manuscripts of the *Epistulae ad familiares* that have survived from the fifteenth century. That applies to manuscript VLF 49 as well. It must have been made for a high-ranking client with sufficient funds to purchase a book executed with such care and with such luxury decoration. The title page is a good example. It has a golden initial 'E' with colourful decorations that enclose the text block entirely, in the white vine (*bianchi girari*) style so popular with humanists, with little butterflies in the top and bottom margins. Interestingly, empty space has been left at the bottom of the page for a potential buyer's family coat of arms. This gives us an idea of the manuscript's creation process: it was probably not commissioned directly, but produced as a luxury product for what was already a flourishing book market. The

Fig. 1 >
Richly decorated first folio. Space was left for a family coat of arms in the middle of the bottom margin.
VLQ 49, fol. 1r.

Ex Bibliotheca Viri Illust. Isaaci Vossii. 79

ACAD:LVGD

EGO OMNI OFFICIO
AC POTIVS PIETATE
erga te ceteris satisfacio omnibus mihi ipi nunquam
satisfacio. Tanta enim magnitudo tuorum est erga
me meritorum: ut quoniam
tu nisi perfecta re de me
non conquiescas. Ego quia
non idem in tua causa efficio uitam mihi acerbam putē
In causa haec sunt. Hamonius regis legatus aperte pecunia nos oppugnat. Res agitur per eosdem creditores per
quos cum tu aderas agebatur. regis causa siqui sunt qui
uelint qui pauci sunt omnes rem ad pompeium deferri
uolunt. Senatus religionis calumniam non religionem
sed maliuolentia & illius regie largitionis inuidia comprobat. Pompeium & hortari & orare & iam liberius accusare & monere. ut magnam infamiam fugiat non desistimus. Sed plane nec precibus nostris nec ammonitionibus relinquit locum. Nam cum in sermone quottidiano tum in senatu palam sic egit causam tuam ut neq elo
quentia maiore quisq nec grauitate nec studio nec contentione agere potuerit cum summa tuorum in se officiorum & amoris erga se tui. Marcellinum tibi esse iratū
scis. Is hac causa regia excepta ceteris in rebus se acerrimum tui defensorem fore ostendit. quod dat accepimꝰ

Fig. 2
A folio with Greek text inserted afterwards. A later user has added some Greek, writing more rapidly and using a lighter ink than the Greek scribe in the fifteenth century. VLQ 49, fol. 181v, detail.

buyer could have his family coat of arms added for an extra charge, if so desired.

VLF 49 is a finely executed manuscript that was undoubtedly copied by a professional scribe. He used a regular humanist minuscule script (*littera antiqua*), inspired by the Carolingian script, with relatively few abbreviations. The layout is a classic one. Each page has 33 lines and the quires too are very regular, each with layers of five sheets (resulting in ten folio leaves). Each of the sixteen books of Cicero starts with an incipit in capital letters, marked by a large golden initial with multi-coloured decoration in the white vine style. Within a book, each letter starts with a red or blue initial that takes up two lines.

This all points to a manuscript written in a professional setting, with several specialists involved. The main scribe was probably only competent in the Latin alphabet, with the Greek words being added later by a second scribe. The first left room for the second in the text, with a small symbol similar to an apostrophe placed every time in the margin, indicating where the Greek words needed to be inserted. But this division of labour did not always go smoothly. There are one or two leaves where the Latin scribe forgot to leave a space and so the Greek had to be added in the margin. Fol. 181v has another kind of error: the scribe left space for Greek words in five places but forgot to add the symbol in the margin for two of them. The scribe responsible for the Greek therefore missed those insertions. The missing text was added by a later user in one instance, and the space is still blank in the other.

That addition is one of the very few traces of use in the book. The buyer, if he read it at all, left few signs of having done so. Most of the leaves have no notes at all. The Leiden manuscript was clearly not intended as a book for study — it was too expensive for that. Perhaps the first owner only wanted the manuscript because it was in fashion to have a book of Cicero's letters on your shelves. We know something of two subsequent owners. One of the flyleaves has information indicating that the manuscript was in the possession of Melchisédech Thévenot (1620–1692) in the seventeenth century. This Thévenot was not only a scholar (and an acquaintance of Christiaan Huygens), but also the librarian of King Louis XIV of France from 1684 until his death. Furthermore, the library stamp and strip of paper added later to the title page tell us that the book ended up in Leiden University Library via the library of Isaac Vossius (1618–1689). It is one of dozens of Latin and Greek manuscripts that Vossius acquired from Thévenot's private library in the late 1660s.

The manuscript is one of the many tangible witnesses to the great popularity of Cicero's letters in the fifteenth century. It is a fine example of a professionally produced manuscript from the Italian Renaissance, intended for affluent customers. The early owners also show us how a manuscript like this travelled, from Italy via France to Leiden in the Netherlands.

— Christoph Pieper

M. C. S. D. L. CHITVIO VALERIO IVRIS cōsul
Cur hęc tibi non gratificer nescio: presertim cum
his temporibus audacia pro sapientia liceat uti
Lentulo nostro egi per litteras tuo nomine gratias dilige
nter. Sed tu uelim desinas iam nr̄is litteris uti q̄ nos
aliquando reuises q̄ tibi mali esse ubi aliquo numero
sis: q̄ istic ubi solus sapere uidearis: q̄q̄ qui istinc ue
niunt partim te superbum ēē dicunt: quod nihil res
pondeas ptim contumeliosum: quod male respondeas
Sed iam cupio tecum coram iocari· quare fac ut q̄ pri
mum uenias: nec in apuliam tuam accedas: ut poss
umus saluum uenisse gaudere. Nam illo si ueneris
tanq̄ ulixes cognosces tuorum neminem VALE
M· T· C· EPISTOLARVM · LIBER · PRIMVS · FINIT
INCIPIT · SECVNDVS · AD · CVRIONEM

Quamquam me no
mine negligentię sus
pectum tibi esse doleo: tam
en non tam mihi molestum
fuit accusari abs te officii
meum; q̄ iucundum requ
iri· presertim quoniam
in quo accusabar culpa uacarem. In quo autem te desid
etate significabas meas litteras preterferis perspectum
mihi quidem: sed tamen dulcem q̄ optatum amorem
tuum. equidem neminem pretermissi: quem quidē
ad te per uenturum putarem: cui litteras non dederim·
Etenim quis est tam in scribendo impiger q̄ ego? a te uō
bis terq̄ ad summum q̄ eas per breues accepi· Quare

Fig. 3
Start of the last letter in Book 1, followed by the beginning of Book 2. At the top of the folio, the start of a new letter is marked by the use of capitals and a red initial. The decorated initial in the middle of the folio marks the start of the next book. VLQ 49, fol. 15r.

illa qua est raptus, etatem posse restitui; Vale.

C. plinius iuniori suo S.

Castigabat quidam filium suum, quod paulo sumptuosius equos et canes emeret. huic ego, iuuene digresso, heus tu nunq̃ ne fecisti? quod a patre corripi posset? fecisti dico: non interdum facis? quod filius huius, si repente pater ille, tu filius, pari grauitate reprehendat? non omnes homines aliquo errore ducuntur? non hic in illo sibi, in hoc alius indulget? hec tibi admonitus immodice seueritatis exemplo, more mutuo scripsi: ne quando tu quoq̃ filiũ tuũ durius acerbius q̃ tractares. cogita et illũ puerũ esse, et te fuisse. atq̃ ita q̃ es pater, utere: ut meminieris te hoiem esse, et hominis parem; Vale.

C. pli. genitori suo S.

Accepi litteras tuas quibus quereris tedio tibi fuisse quamuis lautissimã coenam: quia scurre, cinedi, moriones mensis inerrabant. vis tu remittere aliquid ex rugis? equidem nihil tale habeo: habeñ tamen fero. quare ego non habeo? qa nequaq̃ me ut inexpectatũ festiuũ ve delectat: si qd molle a cinedo, petulans a scurra, stultũ a morione profertur. non ratione, sed stomachũ tibi narro. atq̃ adeo q̃ multos putas esse: quos ea q̃bus capimur et ducimur partim ut inepta, partim ut molestissima offendant. quã multi quũ lector aut lyristes aut comoedus inductus est: calceos poscunt: aut nõ

VIII·

…nore cum tedio cubant; q̃ tu ista sic em̃ appel-
…prodigia perpessus es. demus igit̃ alienis oble-
…nonibus veniam: vt nostris impetremus; Vale.

· C· pli· sabiniano suo ·S·

…t bertus tuus cui succensere te dixeras, venit
…ad me aduolutus q̃ pedibus meis, tam q̃ tuis
…fleuit, multũ rogauit, multũ etiã tacuit.
…ma fecit mihi poenitentie fidem. vere credo
…endatũ, quia deliquisse se sentit. irasceris scio,
…irasceris merito, id quoq̃ scio. sed tũc quoq̃ p-
…a mansuetudinis laus: quũ ne cause iustissime
…amasti homine, et spero amabis. interim suf-
…vt exorari te sinas. licebit rursus irascissime-
…rit: quod exoratus excusatius facies. remitte
…quid adolescentie ipsius; remitte lachrymis,
…mitte indulgentie. ne torseris etiam te. tor-
…ris eñi quũ tam lenis irasceris. vereor ne vi-
…r non rogare sed cogere: si ipse precibus eius
…as iunxero. iungam tamen tanto plenius et
…usius; quanto ipsum acrius seuerius q̃ corripui
…iuste minatus nũq̃ me postea rogaturũ. hoc
…que terreri oportebat, tibi non idem. nã for-
…e iterũ rogabo, iterũ impetrabo: sit modo tale:
…rogare me, et te vt prestare deceat; Vale

· C· pli· sabiniano suo ·S·

Ene fecisti q̃ libertum aliquando tibi carum

Frisia in Ferrara

48 | Pliny's letters, copied by Rudolph Agricola
Fifteenth century, 1478 — VLQ 80

Rodolphus Agricola was one of the very first humanists in the Low Countries and an inspirational scholar. He was a hero to Erasmus. During his years studying in Ferrara, Agricola personally copied the letters of Pliny the Younger in this manuscript so typical of humanist style. This codex represents the springtime of the Renaissance in the Netherlands.

<< Fig. 1
In ep. 9.17 (*Recepi litteras tuas*; the initial *A* ought to have been an *R*), Pliny is replying to a letter from his friend Julius Genitor in which the latter complained about a luxury meal with entertainment that he was not particularly charmed by. To each his own, recommends Pliny; that will benefit us as well. VLQ 80, fols 118v–119r.

This manuscript contains a selection of letters by Pliny the Younger (61/62–before 114 AD). It ends at fol. 132v with a colophon in red ink. Here we can read *Rodolphus Agricola phrisius Ferrariae absoluit Anno / christi M cccc° lxxviii°. k(a)l(endis) / decembr(is). / Lector perpetuu(m) vale.* ('Rudolph Agricola from Frisia completed this in Ferrara in the Year of Our Lord 1478 on 1 December. Reader, farewell for ever.') This manuscript, now in Leiden, was therefore written by Rudolph Agricola himself (1443/4–1485), when he was studying in Ferrara in Italy. Knowing that is unusual in itself, as scribes generally did not identify themselves and we therefore rarely know who wrote a particular manuscript. Such identification is for example absent in BPL 16 B, another manuscript in Leiden University Library, which contains texts by the Roman historian Tacitus. However, comparison against the handwriting of this Pliny codex has shown that Agricola also wrote Leiden's Tacitus manuscript.

Rudolph Agricola was born as Roelof Huesman in Baflo, a small village that is now in the province of Groningen but was then in Frisia, the area now comprising Groningen and Friesland in the Netherlands and Ostfriesland in Germany. That is why Agricola refers to himself in the colophon as *phrisius*. He spent over a decade studying in Italy, specifically in Pavia and Ferrara, where he was not only a student but also the organist at the court of Duke Ercole d'Este. His education as a humanist began before he left Groningen, though. The land of his birth included the wealthy monastery of Aduard, where Hendrik van Rees (†1485) held sway from 1449 onwards. He encouraged the establishment of a humanist reading community in his monastery and did that so successfully that the rector of the Fraterhuis in the city of Groningen, who had witnessed Aduard's regime as a young man, remembered it half a century later as being 'more like an academy than a monastery'. Nearly all the historic buildings from Frisia's rich monastic past were destroyed when the area became Protestant in the sixteenth century. In Agricola's time, however, the numerous monasteries were flourishing, with Groningen and the surrounding area enjoying an intellectual heyday. That is also clear from the many people from Groningen who, like Agricola, studied in Ferrara in the 1470s. Agricola became the figurehead of early humanism in the Netherlands — as well as a hero to Erasmus of

Fig. 2
Lucas Cranach the Elder (1472–1553), Portrait of Rudolph Agricola, c. 1532. Munich, Alte Pinakothek.

Rotterdam (1466–1536), who a generation later managed to embed humanist thinking in the foundations of education in the Netherlands, with the universities in Leiden (1575) and Groningen (1614) as early examples. There are good reasons why the founders of the academy in Groningen saw the monastery of Aduard and Rudolph Agricola as the predecessors to their university.

The term 'humanism' refers to an educational movement that arose in the fourteenth century in Italy from the desire to form well-spoken, civilised individuals who participated actively in society. Erasmus had good cause to write *Homines non nascuntur, sed finguntur* ('Human beings are moulded, not born.') Humanists based this 'moulding', or education, on the educational ideals of Roman Antiquity. Five *studia humanitatis* ('civilising subjects') formed the core: grammar (language), rhetoric (communication), poetry (writing skills), historiography (morals in practice) and ethics (morals in theory). Like the Ancient Greeks and Romans, humanists prioritised a broad generalist education; specialisation was of secondary importance. The Dutch education system has since followed that principle for centuries. Thus traditionally, universities such as Leiden have *primarily* been institutions for general education, not vocational studies.

Two randomly selected leaves from Agricola's manuscript illustrate his humanist leanings. He writes in a humanist script developed by Italian humanists after the example of Carolingian minuscule, which was thought to be a classical Roman script. The fact that he knew classical Greek is also a typical humanist feature. Agricola has made an annotation on the left-hand page here in Greek, explaining the word *moriones* ('idiots') in Pliny's letter. He wrote ὅτι μωροί εἰσι, τοῦτο τοὔνομα εἰλήφασι. (*hoti moroi eisi, touto tounoma eilephasi*, 'They have been given that name because they are fools.') Knowledge of classical Greek was still unusual in Agricola's time, even among humanists. Agricola had gone to Ferrara in 1475/6 precisely to learn that language. His fondness for Pliny's letters also marks Agricola as a humanist, as this Pliny was rarely read in the Middle Ages. Agricola found Pliny's style of rhetoric exemplary (both literally and figuratively), like many humanists before and after him.

Of course, humanists did not make everything new; some aspects of this codex are in a medieval tradition. The paper that the text is written on had lines ruled onto it first. Agricola wrote the main text in black ink and the headings to each of Pliny's letters in red. The initials are larger and the simple calligraphy is copied alternately in red and blue ink — not drawn by Agricola himself, because he left a mark at the intended place of each initial showing the book's rubricator which letter it needed to be each time. Despite his instructions, errors crept in at times, such as here where the 'A' ought to have been an 'R' (*Recepi*). The rubricator apparently went about his work a bit too eagerly, because we often see (here too) the imprint of the initial on the next leaf, showing that the ink was not yet dry when he turned the leaf over. Strikingly enough, this has not happened for the blue initials; possibly the blue ones were always done first, giving them time to dry. Using abbreviations to save on both paper/parchment and ink is also a traditional approach. The very first word on the left-hand leaf (*illā = illam*) is an example of this and there are then dozens more on this leaf alone (e.g. line 3 *q' = quod*; line 5 *nûq = numquam*; line 9 *ducunt' = ducuntur*).

At the tops of the leaves, Agricola has consistently indicated where we are in Pliny's book of letters. Here it says *L(iber) VIII* ('Book 8'). This is actually incorrect, as these leaves contain letters from Book 9. It is understandable if we consider the fact that Agricola's version is in what is known as the γ branch of transmission of Pliny's work; all the manuscripts in that branch contain books 1 to 7 plus Book 9, which is listed here as Book 8. The *editio princeps* of Pliny's letters (Venice 1471) also belongs to that branch. Agricola owned an exemplar of that first edition and made numerous corrections and annotations in it, showing that he copied this Leiden codex from it. His incunabulum is kept in the Württemberg State Library in Stuttgart: like this Leiden codex, it is a silent witness to the ingenious spirit of the humanist Rodolphus Agricola Phrisius.

— Adrie van der Laan

Fig. 3
Colophon showing that Rudolph Agricola made the manuscript in Ferrara in 1478.
VLQ 80, fol. 132v, detail.

Ancient philosophers in Christian company

49 | Collection of Greek writings from the Near East
Fifteenth century and first half of the sixteenth century — VGQ 54

In amongst the large number of Christian texts in the codex Vossianus Graecus Quarto (VGQ) 54 are a few non-religious philosophical texts. One of those is a version of the *Enchiridion* or Handbook by the Stoic philosopher Epictetus (c. 50–c. 135 AD) and another consists of a large number of extracts from the works of Plato (c. 428–347 BC), the famous philosopher. Their presence in the codex may seem surprising, but it is no coincidence.

Fig. 1 >
First leaf of the *Paraphrasis christiana* of Epictetus' *Enchiridion*.
VGQ 54, fol. 138r.

The contents of the composite manuscript VGQ 54 include a number of scholarly texts about linguistic matters but mainly consist of texts by numerous Christian authors from Antiquity and the Byzantine era. Three texts do not fit with that Christian context: a version of the *Enchiridion* (Handbook) by Epictetus (part four), an edit by Diogenes Laërtius (active third century AD) of what are known as the *Divisiones Aristoteleae* — a text with classifications of philosophical concepts — (which is part five) and a series of excerpts from the works of Plato (part eleven). Those three texts were written by the most important scribe of the manuscript, who wrote over 200 of its total of 463 folios.

All the parts of the collected volume date from the fifteenth and early sixteenth centuries and may have been produced in the Near East. The initial letters of the chapters and excerpts are regularly written in red ink, which helps the reader navigate through the manuscript. In addition, sporadic decorations have been applied in red ink. It is not known who gathered the eleven parts into a single volume, nor what determined the sequence in which the eleven parts have been placed.

The *Enchiridion* by the Stoic philosopher Epictetus was put together by his pupil Arrianus. The teachings of the Stoics have clear areas of overlap with Christian teachings: Stoics and Christians assume that God is good, that everything in the world is determined by God and that we therefore have to accept everything as coming from God. These substantive similarities led to the *Enchiridion* being amended three times in Antiquity and in the Byzantine era to meet the needs of Christians. The variant in this manuscript is the first half of what is known as the *Paraphrasis christiana*, in which well-known figures and practices from the non-Christian world have been left out or replaced. Socrates makes way for 'the apostles and martyrs', for instance, and statements about making sacrifices have been replaced by ones about giving alms to the poor. When we lose our partner or child, Epictetus states that we should not bewail our fate with words such as 'I've lost him/her' but should instead accept it with words such as 'I've given him/her back'. The editor of the *Paraphrasis* has added a Biblical reflection here about Job 1:21, where Job says, 'The Lord giveth and the Lord taketh away.' The text breaks off in the middle of a sentence in Chapter 31. A later user of the manuscript, Patricius Junius (1584–1652), has completed the sentence and added the remark *Desunt capita 39* ('39 chapters are missing').

The main picture shows the first page of the *Paraphrasis* (fol. 138r). Right at the very top in the middle is written ιη, standing for 18; this means that this is the first folio of the eighteenth quire. To the left of the folio number 138, in a different hand, we see λεί⟨πει⟩ ιθ (*lei[pei]* 19, '[quire] 19 is missing'). This missing nineteenth quire must have contained the second half of the *Paraphrasis*. Above the decoration, the scribe has written the phrase ὑπεραγία θ⟨εοτό⟩κε, βοήθει μοι (*hyperagia th⟨eoto⟩ke, boèthei moi*, 'Holiest mother of God, help me'). It is unclear whether this plea relates to the copying work that has to be carried out, or the scribe's life in gen-

† ὑπὲρ ἀπαθείας ὅτι ἐφ᾽ ἡμῖν †

Ὑποθῆκαι, ἃς εἰς τὸ βέλτιον ἑαυτοῖς
πεπλάσθαι σπουδαίως. Τὸ νομίσαι
ἐγχειρίδιον. Κεφ. α΄. Ὅτι
τῶν ὄντων, τὰ μέν ἐστιν ἐφ᾽ ἡμῖν, τὰ δὲ
οὐκ ἐφ᾽ ἡμῖν. ἐφ᾽ ἡμῖν μὲν ἡ ὑπόληψις
ὁρμή, ὄρεξις, ἔκκλισις, καὶ ἐνὶ λόγῳ, ὅσα
ἡμέτερα ἔργα. οὐκ ἐφ᾽ ἡμῖν δὲ, τὸ σῶμα, ἡ κτῆ-
σις, δόξαι, ἀρχαὶ, καὶ ἐνὶ λόγῳ, ὅσα οὐχ ἡμέτερα
ἔργα. καὶ τὰ μὲν ἐφ᾽ ἡμῖν εἰσὶ φύσει ἐλεύ-
θερα, ἀκώλυτα, ἀπαραπόδιστα. τὰ δὲ
οὐκ ἐφ᾽ ἡμῖν, ἀσθενῆ, δοῦλα, κωλυτά, ἀλλό-
τρια. μέμνησο οὖν, ὅτι ἐὰν τὰ φύσει δοῦλα
ἐλεύθερα οἰηθῇς, καὶ τὰ ἀλλότρια ἴδια, ἐμ-
ποδισθήσῃ, πενθήσεις, ταραχθήσῃ, μέμ-
ψῃ θεοὺς καὶ ἀνθρώπους. ἐὰν δὲ τὸ σὸν μόνον
οἰηθῇς σὸν εἶναι, τὰ δὲ ἀλλότρια ἀλλότρια,
οὐδείς σε ἀναγκάσει οὐδέποτε, οὐδείς σε
κωλύσει, οὐ μέμψῃ, οὐκ ἐγκαλέσεις τινί,
ἄκων πράξεις οὐδέν, ἐχθρὸν οὐχ ἕξεις,
βλάψει γάρ σε οὐδεὶς ἀδικῶν.

Fig. 2
Portrait of Epictetus. Detail of title engraving by T. Galle, in J. Lipsius (ed.), *L. Annaei Senecae philosophi Opera*, Antwerp 1605. Leiden, UBL, 114 A 13.

Fig. 3
Portrait of Plato. Marble copy of a bust by Silanion from c. 370 BC, Musei Capitolini Rome, MC 1377.

eral, or both. The title of Epictetus' original work (Ἐγχειρίδιον) has been changed during the reworking into ὑποθῆκαι, ἃς εἰς ὑπόθεσιν ἑαυτοῖς γεγράφασι σπουδαῖοι· καὶ ὠνόμασαν Ἐγχειρίδιον (*hypothèkai, hās eis hypothesin heautois gegraphasi spoudaioi, kai ōnomasan Encheiridion*, 'Supportive advice that serious people have written down for themselves and to which they have given the name Enchiridion'). The letter α (alpha) with a squiggle above it in the right-hand margin represents the numeral 1, i.e. in this case Chapter 1. Despite the assistance of the Virgin Mary, the scribe has not managed to deliver faultless work. At the end of the last line but five, for instance, there is μόνω (*monō*) where it should be μόνα (*mona*), and τὰ ἐπὶ σοὶ μόνα (*ta epi soi mona*, 'only those things that are in your power') has become τὰ ἐπὶ σοὶ μόνῳ (*ta epi soi monō*, 'those things that are in your power alone').

Like Stoic teachings, Plato's philosophy contains elements that show similarities to Christian theology. Plato believed, as did the Stoics, that the world is controlled by a good God and that the world is thus essentially good. In the *Timaeus*, Plato describes how the material world is created by a lesser god at the behest of the supreme God. Despite the fact that Christians only recognise a single God, they were impressed by this Platonic narrative of creation. In view of this, it is not so surprising that this manuscript contains thirty folios with excerpts from Plato's work, in the same hand as that of the scribe who wrote down the *Enchiridion*.

The excerpts are taken from a large number of dialogues. A subheading gives the dialogue in question, and every new excerpt starts with a letter written in red. Figure 4 shows two passages from the *Phaedo*, in which the final day of Socrates' life and his execution are described (fol. 435r). Socrates comforts his friends with the notion that the soul is immortal. The souls of good people are rewarded in the Hereafter, whereas the souls of evil people are punished there. This fits in seamlessly with Christian beliefs about Heaven and Hell. There is a word in the margin at the middle of the page; it is a variant of a word that can be seen in the text. The text contains ἀντιλογικούς (*antilogikous*, 'about opposing views'); the reading in the margin is αἰτιολογικούς (*aitiologikous*, 'about the causes'). This shows that not all scribes were the unthinking copying automata that they are often assumed to be; this one made the effort to understand the exemplar's text and to correct it where possible.

Fig. 4
Extracts from Plato's *Phaedo*. VGQ 54, fol. 435r.

The manuscript was at one time in the possession of the peripatetic German orientalist and theologian Christiaan Rau (1613–1677), as can be seen from his signature on fol. 1r: *Christiani Ravij Berlinatis*. It came into the possession of Leiden via the library of Isaac Vossius, acquired in 1690.

— Gerard Boter

LE TIERS LIVRE DE L'ILIADE D'HOMERE TRADVICT PAR SALEL

Aprés que tost des Troyens fut sorti
hors sa Cité, renge, et departi
par esquadrons furieux au rencontre,
Soubdainement marchoient alencontre
du camp des Grecs, haussant jusques aux nues
Leur bruit et bruict, ainsi que font les Grues,
qui prevoyans la pluye et la froydure
Laissent les monts, et vont chercher pasture
prés de la mar. Dressans grosses armées
Contre les Mapns, autrement dict Pygmées.

A French *Iliad* for the king

50 | Translation of Homer's *Iliad* by Hugues Salel
Sixteenth century, c. 1540 — MAR 57

In around 1540, the French king François I instructed his chamberlain Hugues Salel to translate Homer's *Iliad*. Salel presented his work to the king in a series of manuscripts, one of which is stored in Leiden in an unusual bookbinding. The French translation by Salel was also printed, and there are quite a few differences between the manuscript and the print version.

François I (1494–1547) was a true Renaissance king with a deep interest in the classics. That is why he asked his chamberlain, Hugues Salel (1504–1553), to produce a French translation of the *Iliad*, a Greek epic poem about the Trojan War that is attributed to the poet Homer. Salel had arrived at the French Court in 1538 and probably started on his translation shortly afterwards. The first two parts of Salel's work were printed in Lyon in 1542, but he had not given permission for publication and the printer was ordered to stop the press. Three years later, the first official edition was printed in Paris, but it too was incomplete, containing only the first ten parts. Parts 11 and 12 would only be published after the translator's death, in 1554. Printing Salel's translation meant French speakers who could not read Greek or Latin would now be able to read Homer's epic for themselves, making the book a milestone in French literary history.

Salel also produced a very special manuscript version of his work for his client, King François I. Parts 1 to 10 were written out in separate small volumes made of high quality parchment, probably copied by a specialist scribe rather than Salel himself. The scribe imitated a script that was very popular among Italian humanists — a new development, in other words. Part 3, which describes how the Trojan prince Paris challenges the Greek king Menelaus to a duel, is now in the Leiden University Library. This manuscript is nice evidence of the fact that people continued to produce manuscripts for some time after the invention and spread of the printing press. Salel could easily have chosen just to present the king with a beautifully bound printed copy, but he decided instead to offer a handwritten version as well. The luxury parchment, the carefully executed letters in a modern style and the elaborate gold-coloured initial that starts this part combine to give a sense of a unique, top-quality product worthy of a king.

This handwritten version of Part 3 of the *Iliad* was probably made between 1542 (at which point only

< Fig. 1
The start of Part 3 of Salel's *Iliad* translation. Various owners made notes on the flyleaf, on the left. MAR 57, fols Iv–1r.

Fig. 2
The opening of Part 3 of the *Iliad* in the print edition of 1545. Hugues Salel, *Les dix premiers livres de l'Iliade d'Homère, prince des poètes, traduictz en vers françois par M. Hugues Salel*, Paris, Vincent Sertenas, 1545, p. 81. Bibliothèque nationale de France, département Arsenal, RESERVE FOL-BL-519.

Fig. 3 > The binding of MAR 57, which contains Part 3 of Salel's translation.

parts 1 and 2 had been printed), and the publication in print of parts 1 to 10 in 1545. A close comparison of the text in the manuscript with that of the print publication in 1545 reveals quite a few differences. The biggest difference is the fact that the manuscript is missing the final section of the text, 64 verses in total. The final leaf is full, yet it stops mid-sentence. The quire is complete, however, so it would seem that the remaining text was written on loose leaves that have been lost in the course of time.

The print version also contains woodblock illustrations that are not found in the manuscript. In addition, the printed publication offers an extra guide to the reader in the form of text printed in the margin. The manuscript only contains the translation itself. There are even differences between the Leiden manuscript and the 1545 publication in terms of the spelling and choice of words, as can be seen from a comparison of the first few verses. This passage describes how Trojan soldiers attacked the Greek camp. The sound they made is compared to that of the cranes that were said to fight the mythical Pygmy people in the winter.

> MAR 57, fol. 1r
> *Apres que lost des Troyens fut sorti*
> *hors la cite, rengé, et despartie*
> *par esquadrons furieux au renco(n)tre,*
> *Soubdainement marcherent alencontre*
> *du camp des Grecz, haulsant jusques aux nues*
> *Leur voix et bruict, ainsi que font les Grues,*
> *qui preuoyans la pluye et la froydure*
> *Laissent les monts, et vont chercher pasture*
> *Pres de la mer, dressans grosses armees*
> *Contre les Nayns, autrement dictz Pigmees*

While the manuscript spells Troyens with a 'y', the print version uses an 'i' (*Troiens*). The opposite happens with the word *sorti*. There are all kinds of possible reasons for these spelling differences. Salel himself may not have been responsible for supervising the copying of the manuscript, and the scribe may have made changes that seemed more logical to them. After all, French spelling had not yet been standardised in the sixteenth century. The spelling in the print publication may have been changed at the request of the printer, but the typesetter may also have altered the text based on their own preferences.

The manuscript binding is also unusual. Various researchers have attributed it to Etienne Roffet (active 1539–1549), who worked as the court bookbinder of François I for some time. Others ascribe it to an anonymous 'bookbinder of Salel'. Some of the manuscript parts are bound in black morocco leather, each stamped with a different variant in gold combining the letter F (for François) and the *fleur-de-lys*, the flower that symbolised the French royal family. This decoration means that it is immediately clear who the first owner of the manuscript was, even when the book is closed.

Surprisingly, the series of manuscripts have not remained together. Parts 1, 7 and 8 (which are bound together) and Part 9 are kept in the Bibliothèque Nationale de France, Part 2 is in the Musée Condé in Chantilly, along with parts 5 and 6, which are also bound together. The current whereabouts of the fourth and tenth parts is unknown. We can work out broadly how Part 3 ended up in Leiden University Library because various previous owners wrote their names in the manuscript. In 1682, a certain Estienne Marlet (about whom nothing else is known) wrote his name at the back. He must have passed the book on to a relative because a certain 'engineer and officer' with the surname Marlet wrote in it at the front in 1737. Not long afterwards, the book came into the possession of Prosper Marchand (1678–1756), a known Huguenot bookseller who set up his business in Amsterdam in 1709. Marchand bequeathed his correspondence and the books he owned, with about 2,800 print publications and 77 manuscripts, to Leiden University Library. The *Iliad* manuscript is one of the most exceptional works in this collection, and the collection as a whole is a valuable source for education and research.

— Alisa van de Haar

Literature

Windows to the past
Written treasures / Studying the manuscript
- Bischoff, B., *Latin Palaeography. Antiquity and the Middle Ages*, transl. D. Ó Cróinín & D. Ganz, Cambridge 1992.
- Brown, J., 'What is palaeography?', in: J. Bately, M. P. Brown & J. Roberts (eds), *A Palaeographer's View. Selected Writings of Julian Brown*, London 1993, pp. 47–51.
- Clemens, R. & T. Graham, *Introduction to Manuscript Studies*, Ithaca NY/London 2007.
- Fiddyment, S. *et al.*, 'So You Want to Do Biocodicology? A Field Guide to the Biological Analysis of Parchment', in: *Heritage Science*, 7 (2019), pp. 1–10.
- Gruijs, A., 'Codicology or the Archaeology of the book? A false dilemma', in: *Quaerendo*, 2 (1972), pp. 87–108.
- Kwakkel, E. & R. Thomson (eds), *The European Book in the Twelfth Century*, Cambridge 2018.
- Kwakkel, E., *Books Before Print*, Amsterdam 2018.
- Treharne, E. & O. Da Rold (eds), *The Cambridge Companion to Medieval British Manuscripts*, Cambridge 2020.
- Treharne, E., *Perceptions of Medieval Manuscripts. The Phenomenal Book*, Oxford 2021.
- Warren, M., *Holy Digital Grail. A Medieval Book on the Internet*, Stanford 2022.
- Webber, T., 'What is palaeography?', *The British Academy*, accessed through https://www.thebritishacademy.ac.uk/blog/what-is-palaeography/ on 3 February 2025.
- Whearty, B., *Digital Codicology. Medieval Books and Modern Labour*, Stanford 2022.

Materiality of the manuscript / Preparing for writing
- Bozzolo, C. & E. Ornato, *Pour une histoire du livre manuscript au Moyen Âge. Trois essais de codicologie quantitative*, Paris 1980.
- Da Rold, O., *Paper in Medieval England. From Pulp to Fictions*, Cambridge 2020.
- Gilissen, L., 'Un élément codicologique trop peu exploité. La réglure', in: *Scriptorium*, 23 (1969), pp. 150–162.
- Gumbert, J. P., 'Skins, Sheets and Quires', in: D. Pearsall (ed.), *New Directions in Later Medieval Manuscript Studies*, Woodbridge 2000, pp. 81–90.
- Holsinger, B., *On Parchment. Animals, Archives, and the Making of Culture from Herodotus to the Digital Age*, New Haven 2017.
- Ker, N. R., 'From "above top line" to "below top line". A change in scribal practice', in: *Celtica*, 5 (1960), pp. 13–16.
- Mak, B., *How the Page Matters*, Toronto 2011.
- Martin, H.-J. & J. Vezin, (eds), *Mise en page et mise en texte du livre manuscrit*, Paris 1990.
- Parkes, M. 'Layout and Presentation of the Text', in: N. Morgan & R. Thomson (eds), *The Cambridge History of the Book in Britain. Vol. 2, 1100–1400*, Cambridge 2008, pp. 55–74.
- Ryley, H., *Re-Using Manuscripts in Late Medieval England*, Woodbridge 2022.
- Thomson, R., 'Parchment and paper, ruling and ink', in: N. Morgan & R. Thomson (eds), *The Cambridge History of the Book in Britain. Vol. 2, 1100–1400*, Cambridge 2008, pp. 75–84.
- Turner, N. K., 'The Materiality of Medieval Parchment. A response to "The Animal Turn"', in: *Revista Hispánica Moderna*, 71 (2018), pp. 39–67.
- Wakelin, D., *Immaterial Texts in Late Medieval England. Making English Literary Manuscripts, 1400-1500*, Cambridge 2022.

Writing as a craft / Factors that influenced scribal performance / Writing in practice
- Coulson F. T. & R. G. Babcock (eds), *The Oxford Handbook of Latin Palaeography*, Oxford 2020.
- De Hamel, C., *Meetings with Remarkable Manuscripts*, London 2016.
- Gullick, M., 'How fast did scribes write? Evidence from Romanesque Manuscripts', in: L. Brownrigg (ed.), *Making the Medieval Book. Techniques of Production*, London 1995, pp. 39–58.
- Gumbert J. P., 'Cicerones Leidenses', in: C.A. Chavannes-Mazel & M.M. Smith (eds.), *Medieval Manuscripts of the Latin Classics. Production and Use*, Los Altos Hills/London 1996, pp. 208–244.
- Michael, M. A., 'Urban production of manuscript books and the role of the university towns', in: N. Morgan & R. Thomson (eds), *The Cambridge History of the Book in Britain. Vol. 2, 1100–1400*, Cambridge 2008, pp. 168–194.

Scripts in transition
- Brown, M. P., *A Guide to Western Historical Scripts from Antiquity to 1600*, London 1990.
- Davies, M., 'Humanism in Script and Print', in: J. Kraye (ed.), *The Cambridge Companion to Renaissance Humanism*, Cambridge 2006, pp. 47–62.
- Derolez, A., *The Palaeography of Gothic Manuscript Books from the Twelfth to the Early Sixteenth Century*, Cambridge 2003.
- Ganz, D., 'The Preconditions for Caroline Minuscule', in: *Viator*, 18 (1987), pp. 23–44.
- Ganz, D., 'Book production in the Carolingian Empire and the spread of Caroline minuscule', in: R. McKitterick (ed.), *The New Cambridge Medieval History. Vol. 2, c.700–c.900*, Cambridge 1995. pp. 786–808.
- Kwakkel, E., 'Biting, Kissing and the Treatment of Feet. The transitional script of the long twelfth century', in: E. Kwakkel, R. McKitterick & R. Thomson (eds), *Turning Over a New Leaf. Change and Development in the Medieval Manuscript*, Leiden 2012, pp. 79–126.
- Kwakkel, Erik, 'Book Script', in: E. Kwakkel & R. Thomson (eds), *The European Book in the Twelfth Century*, Cambridge 2018, pp. 25–42.
- O'Daly, I., '"Red Riding Hood" and the wolf. Marginal drawings in a collection of Cicero's works', *Leiden Medievalists Blog*, accessed through https://leidenmedievalistsblog.nl/articles/red-riding-hood-and-the-wolf-marginal-drawings-in-a-collection-of-ciceros-works on 3 February 2025.
- Parkes, M., *Their Hands Before our Eyes. A Closer Look at Scribes*, Aldershot 2008.

Decorative elements
— Alexander, J. J. G., *Medieval Illuminators and their Methods of Work*, New Haven 1992.
— Collins, K., P. Kidd & N.K. Turner, *The St Albans Psalter. Painting and Prayer in Medieval England*, Los Angeles 2013.
— Gameson, R., 'Becket in Horae. The Commemoration of the Saint in Private Prayer Books of the Later Middle Ages', in: *Journal of the British Archaeological Association*, 173 (2020), pp. 143-173.
— Korteweg, A., 'Pen Flourishing in Manuscripts and Incunabula: Similarities and Differences', in: *Quaerendo* 41 (2011), pp. 337-350.
— Panayotova, S. (ed.), *Colour. The Art and Science of Illuminated Manuscripts*, London 2016.
— Wieck, R. S., *Painted Prayers. The Book of Hours in Medieval and Renaissance Art*, New York 1997.

Scribal identities and practices
— Drimmer, S., 'Connoisseurship, Art History, and the Palaeographical Impasse in Middle English Studies', in: *Speculum*, 97 (2022), pp. 415-68.
— Horobin, S., 'Identifying Scribal Hands. Principles and Problems', in: *Speculum*, 99 (2024), pp. 688-96.
— Lieftinck, G. I. & J. P. Gumbert, *Manuscrits dates conserves dans les Pays-Bas. Catalogue paléographique des manuscrits en écriture latine, portant des indications de date*, Amsterdam 1964-1988.
— Meyier, K. A., *Codices Vossiani Latini*, Leiden 1973-84.
— Ray, A., *The pecia system and its use in the cultural milieu of Paris, c. 1250-1330*, PhD thesis, University College London, London 2015.

Navigating the text
— Kosto, A., 'Statim invenire ante. Finding Aids and Research Tools in Pre-Scholastic Legal and Administrative Manuscripts' in: *Scriptorium*, 70 (2016), pp. 285-309.
— O'Daly, I., 'The Classical Revival', in: E. Kwakkel & R. Thomson (eds), *The European Book in the Twelfth Century*, Cambridge 2018, pp. 240-58.
— Parkes, M. B., *Pause and Effect. An Introduction to the History of Punctuation in the West*, Aldershot 1992.
— Rouse R. H. & M. A. Rouse, 'Statim invenire. Schools, Preachers, and New Attitudes to the Page,' in: R. L. Benson & G. Constable (eds), *Renaissance and Renewal in the Twelfth Century*, Oxford 1982, pp. 201-225.
— Sawyer, D., 'Page Numbers, Signatures, and Catchwords', in: D. Duncan & A. Smyth (eds), *Book Parts*, Oxford 2019, pp. 139-49.

Traces of the reader
— Kwakkel, E., 'Decoding the Medieval Book. Cultural Residue in Medieval Manuscripts', in: M. Dussen & M. Johnston (eds), *The Medieval Manuscript Book. Cultural Approaches*, Cambridge 2015, pp. 60-76.
— O'Daly, I., 'Ducks and Diagrams: Insights into the Medieval Readership of Priscian's *Institutiones Grammaticae* Preserved in Leiden University Libraries, BPL 91 and BPL 186', in: *TXT Magazine*, 10 (2023), accessed through https://txtmagazine.pubpub.org/pub/odaly-ducks-and-diagrams on 3 February 2025.
— Otter, M., 'Medieval Sex Education, Or: What about Canidia?', in: *Interfaces. A Journal of Medieval European Literature*, 3 (2016), pp. 71-89.
— Rudy, K., 'Dirty Books. Quantifying Patterns of Use in Medieval Manuscripts Using a Densitometer', *Journal of Historians of Netherlandish Art*, 2 (2010), pp. 1-43.

Binding and preservation
— Gameson, R., 'The Medieval Library (to c. 1450)', in: E. Leedham-Green & T. Webber (eds), *The Cambridge History of Libraries in Britain and England, vol. 1: to 1640*, Cambridge 2006, pp. 13-50.
— Gullick, M. & N. Hadgraft, 'Bookbindings', in: N. Morgan & R. Thomson (eds), *The Cambridge History of the Book in Britain. Vol. 2, 1100-1400*, Cambridge 2008, pp. 95-109.
— Perry, R., 'The Sum of the Book: Structural Codicology and Medieval Manuscript Culture', in: O. Da Rold & E. Treharne (eds), *The Cambridge Companion to Medieval British Manuscripts*, Cambridge 2020, pp. 106-126.
— Szirmai, J. A., *The Archaeology of Medieval Book Binding*, Abingdon 2016.
— Vis, G. N. M. (ed.), *In het spoor van Egbert. Aartsbisschiop Egbert van Trier, de bibliotheek en geschiedschrijving van het klooster Egmond*, Hilversum 1997.

Collected in Leiden
General
— Berkvens-Stevelinck, C., *Magna commoditas. Geschiedenis van de Leidse universiteitsbibliotheek 1575-2000*, Leiden 2001.
— Bouwman, A. et al., *Stad van boeken. Handschrift en druk in Leiden, 1260-2000*, Leiden 2008.
— De Landtsheer, J. et al., *Lieveling van de Latijnse taal. Justus Lipsius te Leiden herdacht bij zijn vierhonderdste sterfdag*, Leiden 2006.
— Hulshoff Pol, E., 'The library', in: T.H. Lunsingh Scheurleer et al. (eds), *Leiden University in the seventeenth century: an exchange of learning*, Leiden 1975, pp. 394-466, specifically p. 446 (Merula, memorandum iv, 1597).
— Hulshoff Pol, E., 'What about the Library? Travellers' comments on the Leiden library in the 17th and 18th centuries', in: *Quaerendo. A quarterly journal from the Low Countries devoted to manuscripts and printed books*, 5 (1975), pp. 39-51.
— Hulshoff Pol, E. 'Calendarium van de Leidse UB (1)', in: *Bibliotheek-informatie. Mededelingenblad voor de wetenschappelijk bibliotheken*, 13 (Aug. 1975), pp. 9-19.
— Molhuysen, P.C., *Bronnen tot de geschiedenis der Leidsche Universiteit*. 7 vols. The Hague 1923-1924. – Online at https://resources.huygens.knaw.nl/retroboeken/leidsche_universiteit
 Vol. 2, p. 73 (fire safety, 1616). – Vol. 4, pp. 7*-9* (Appendix 884: library instructions, 1683), 25*-26* (Appendix 904: States of Holland about Bibliotheca Vossiana, 1690), pp. 137*-142* (Appendix 985: will of Perizonius, 1715). – Vol. 5, p. 94 (Van Huls auction; additions to library instructions, 1730), pp. 79*-86* (Appendix 1065: library instructions, 1741).
— Molhuysen, P.C., *Geschiedenis der Universiteits-bibliotheek te Leiden*, Leiden 1905.
— Obbema, P.F.J. 'Handschriften en oude drukken', in: P. Schneiders et al. (eds), *Bibliotheek en documentatie. Handboek ten dienste van de opleidingen*. 3rd revised and augm. edition, Deventer 1984, pp. 69-82.
— Ommen, K. van & H. Cazes, *Facebook in the sixteenth century? The humanist and networker Bonaventura Vulcanius*. Catalogue of an exhibition in Leiden University Library, Leiden 2010, no. 24
— Otterspeer, W., *Edele wijze lieve bijzondere. Een bondige geschiedenis van de Leidse universiteit*, Leiden 2016. – Online at https://hdl.handle.net/1887/41208

Archives and collections, Leiden University Libraries
— *Bibliotheca Neerlandica Manuscripta*. [Collection guide] ubl244, Leiden 2015. – Online at http://hdl.handle.net/1887.2/244
— *Collection of catalogues of the holdings of Leiden University Libraries*. [Collection guide] ubl091, Leiden 2016. – Online at http://hdl.handle.net/1887.2/091

— *Leiden University archives, Board of Governors, 1574-1815* = *Archieven van de Universiteit Leiden – Curatoren, 1574-1815*. [Collection guide] ubl002, Leiden 2005. – Online at http://hdl.handle.net/1887.2/002
 AC1 20 (Resolutions: 1616 Nov. 22, on fire safety). – AC1 31 (Resolutions: 1730 Aug. 8, on Van Huls auction; 1730 Nov. 2, addition to library instruction). – AC1 41 (Memorandum iv Merula, 1597). – AC1 44 (Library instruction 1683; States of Holland on Bibliotheca Vossiana 1690; Perizonius testament, 1715). – AC1 47 (Library instruction 1741).
— *Leiden University archives, University Library*. [Collection guide] ubl100, Leiden 2007. – Online at http://hdl.handle.net/1887.2/100
 BA1 B 1-13 (Binder books). – BA1 E 1 (Binding stamp). – BA1 M 36 (Annual report of 1879/1880, on Bormans gift). – BA1 M 46 (Annual reports of 1880/1881, on lending of 1300 manuscripts; of 1884/1885, on photographs). – BA1 M 94a (annual report of 1914/1915, on Louvain fire). – BA1 U 1 (Lending register).
— *Western medieval manuscripts collection*. [Collection guide] ubl688, Leiden 2023. – Online at http://hdl.handle.net/1887.2/688

Collection building
— Balsem, A.C. *Een biografie van de Bibliotheca Vossiana*. PhD thesis, Leiden University, Leiden 2020. – Online at https://hdl.handle.net/1887/123041
— Balsem, A.C., 'Collecting the Ultimate Scholar's Library. The Bibliotheca Vossiana', in: E. Jorink & D. van Miert (eds), *Isaac Vossius (1618-1689) between Science and Scholarship*, Leiden/Boston 2012, pp. 281–309.
— Blok, F.F., *Isaac Vossius en zijn kring. Zijn leven tot zijn afscheid van koningin Christina van Zweden 1618-1655*, Groningen 1999.
— Bouwman, A. & R. Honings, *MNL250. Jubileum van een lettergenootschap*. Exhibition at Leiden University Library, 9 June to 20 September 2016, Leiden 2016. – Online at http://hdl.handle.net/1887.1/item:1843473
— Bouwman, A.T., 'Pen op papier en perkament. De collectie Middelnederlandse handschriften', in: B. Dongelmans *et al.* (eds), *Dierbaar magazijn. De Bibliotheek van de Maatschappij der Nederlandse Letterkunde*, Amsterdam 1995, pp. 27–38, 186–188.
— [Gumbert, J.P.], *Verknipte rijkdom. Fragmenten van middeleeuwse handschriften in de Leidse Universiteitsbibliotheek*. Catalogue for an exhibition from 12 October to 9 November 1992, Leiden 1992.
— Hoftijzer, P. (ed.), *Adelaar in de wolken. De Leidse jaren van Josephus Justus Scaliger 1593–1609*. Catalogue for an exhibition in Leiden University Library, 30 June to 28 August 2005, Leiden 2005.
— Hulshoff Pol, E., 'Franciscus Nansius und seine Handschriften', in: J.P. Gumbert & M.J.M. de Haan, *Essays presented to G.I. Lieftinck*, vol. 4, Amsterdam 1976, pp. 79–102.
— Ommen, K. van, *'Tous mes livres de langues estrangeres'. Het oosterse legaat van Josephus Justus Scaliger in de Universiteitsbibliotheek Leiden*. PhD thesis, Leiden University, Leiden 2020. – Online at https://hdl.handle.net/1887/123225
— Jaski, B. *et al.* (eds), *Perkament in stukken. Teruggevonden middeleeuwse handschriftfragmenten*, Hilversum 2018.
— Lieftinck, G.I., 'Een handschrift uit de bibliotheek van Philips van Leyden', in: *Jaarboekje voor geschiedenis en oudheidkunde van Leiden en omstreken*, 38 (1946), pp. 177–191.

Collection access
— Bouwman, A., 'Op expeditie langs Europese bibliotheken. Willem De Vreese en de Middelnederlandse handschriften', in: *De Boekenwereld. Blad voor bijzondere collecties*, 37 (2021), pp. 18–25.
— *Les delices de Leide, qui contiennent une description exacte de son antiquité, de ses divers aggrandissemens, de son académie, de ses manufactures, de ses curiosités*, Leiden 1712, pp. 150/151. – Online at https://books.google.nl/books?vid=KBNL:UBL000041509&redir_esc=y
— Grämiger, G., *Verortungen von Wissen. Die Räume und Sammlungen der Universität Leiden 1575-1700*, PhD thesis, ETH Zürich, Zürich 2014.
— Gumbert, J.P., *Schrift, codex en tekst. Een rondgang door paleografie en codicologie*. Inaugural address, Leiden University, Leiden 1974.
— Gumbert, J.P., *Eenheden en fragmenten. Colophon van een codicoloog*. Farewell address, Leiden University, Leiden 2000. – Online at https://hdl.handle.net/1887/5306
— Hulshoff Pol, E., 'Afscheid – en geen afscheid – van de heer De Meyïer', in: *Open. Vaktijdschrift voor bibliothecarissen, literatuuronderzoekers, bedrijfsarchivarissen en documentalisten* 3 (1971), pp. 677–678.
— Lieftinck, G.I., *Paleografie en handschriftenkunde*. Inaugural address, Leiden University, Amsterdam 1963.
— *Manuscrits datés conservés dans les Pays-Bas. Catalogue paléographique des manuscrits en écriture latine portant des indications de date*. Vol. 1, G.I. Lieftinck, *Les manuscrits d'origine étrangère, 816-c.1550*, Amsterdam 1964; Vol. 2, J.P. Gumbert, *Les manuscrits d'origine néerlandaise (XIVe-XVIe siècles) et supplément au tome premier*, Leiden 1988.
— Teeuwen, M., *Perkamenten personen. De stratigrafie van het middeleeuwse boek*. Inaugural address, Leiden University, Leiden 2024. – Online at https://hdl.handle.net/1887/3677429
— Vries, S.G. de, *Middeleeuwsche handschriftenkunde*. Inaugural address, Leiden University, Leiden 1909.

Collection care and user services
— *A.W. Sijthoff's enterprise of the Codices Graeci et Latini photographice depicti duce Bibliothecae Universitatis Leidensis praefecto*. Leiden 1908.
— Braches, E., 'Conservering', in: P. Schneiders *et al.* (eds), *Bibliotheek en documentatie. Handboek ten dienste van de opleidingen*, 3rd rev. and augm. edn, Deventer 1984, pp. 577–586.
— Gnirrep, K. *et al.*, *Kneep en binding. Een terminologie voor de beschrijving van de constructies van oude boekbanden*. 3rd edn, The Hague 1997. – Online at https://www.mmdc.nl/static/media/2/42/kneep_en_binding_digitaal_20080410.pdf
— Hegeman, H., 'Jan Goedeljee & Zn.', in: *Geschiedenis van de Nederlandse fotografie in monografieën en thema-artikelen* 2 (1985), no. 3. – Online at https://depthoffield.universiteitleiden.nl/0203f02nl/
— Korthagen, I., 'Pioneering in the preservation and restoration of medieval manuscripts and early printed books in the Netherlands. The work of sister Lucie M. Gimbrère O.S.B.', in: *Quaerendo. A quarterly journal from the Low Countries devoted to manuscripts and printed books*, 46 (2016), pp. 251–274.
— Scheper, K. *et al.*, *Boekrestauratie in beweging. Ontwikkelingen in materialen, technieken en ethiek*. Catalogue for an exhibition of the same name in Leiden University Library, August to September 2009, Leiden 2009.

— Biblissima — https://iiif.biblissima.fr/collections
— EcodicesNL — https://ecodices.nl
— Europeana — https://www.europeana.eu/en/middle-ages

01 | The other side of an illuminated page
— Euw, A. von, *Karolingische verluchte evangelieboeken*, transl. N. van der Lof, The Hague, 1989.
— Foerster, W. & F. Mütherich, *Die karolingischen Miniaturen*, Vol. 7. K. Bierbrauer, *et al.*, *Die frankosächsische Schule*, 3 vols., Wiesbaden 2009.
— Henderson, E.T., *Franco-Saxon manuscript illumination and networks of production in ninth-century Francia*, PhD thesis, University of Leicester, [no place stated] 2021. Accessed through https://figshare.le.ac.uk in April 2024.
— Hull-Vermaas, E.P. van 't, 'De "Lebuinuscodex" en de Francosaksische school', in *Nederlands kunsthistorisch jaarboek*, 36 (1985), pp. 1–30.

02 | Escaping the maze: Understanding the medieval Bible

— Holcomb, M., 'Strokes of Genius: The Draftsman's Art in the Middle Ages', in: M. Holcomb (ed.), *Pen and Parchment: Drawing in the Middle Ages*, New Haven 2009, pp. 3–34.
— O'Daly, I., 'The Maze of Meaning: Interpreting Job Through Imagery in Leiden, UB, BPL 100 A', *Leiden Medievalists Blog*, accessed through https://www.leidenmedievalistsblog.nl/articles/the-maze-of-meaning-interpreting-job-through-imagery-in-leiden-ub-bpl-100-a on 23 September 2024.
— Reed Doob, P., *The Idea of the Labyrinth from Classical Antiquity Through the Middle Ages*, Ithaca/London 1990.
— Smith, L., *The Glossa ordinaria: The Making of a Medieval Bible Commentary*, Leiden 2009.
— Smith, L. 'Job in the Glossa ordinaria on the Bible', in: F.T. Harkins and A. Canty (eds), *A Companion to Job in the Middle Ages*, Leiden 2016, pp. 101–128.

03 | A sacred book — used, cherished and passed down

— Delisle, L., *Notice de douze livres royaux du XIIIe et du XIVe siècles*, Paris 1902, pp. 19–26, 100–101.
— Kervyn de Lettenhove, Baron, 'Le psautier de saint Louis conservé dans la bibliothèque de l'Université de Leyde', in: *Bulletins de l'Académie royale de Belgique*, 2nd series, part 20, no. 7 (1865), pp. 296–304.
— Luker, E., 'Some Observations on the Artists of the Leiden Psalter (Leiden, University Library MS B.P.L. 76A) and Their Working Practices', in: L. Cleaver et al. (eds), *Illuminating the Middle Ages. Tributes to Prof. John Lowden from his Students, Friends and Colleagues*, Leiden 2020, pp. 139–156.
— Morgan, N., *Early Gothic Manuscripts 1190-1250. A Survey of Manuscripts Illuminated in the British Isles*, 4 (2 vols.), Oxford 1982–1988, vol. I, pp. 60–62 (no. 14).
— Wijsman, H., 'Het psalter van Lodewijk de Heilige. Functie, gebruik en overlevering van een middeleeuws prachthandschrift', in: P. Hoftijzer et al. (eds), *Bronnen van kennis. Wetenschap, kunst en cultuur in de collecties van de Leidse Universiteitsbibliotheek*, Leiden 2006, pp. 32–42.

04 | The Bible as a growing manuscript

— Biemans, J.A.A.M., *Middelnederlandse bijbelhandschriften = Codices manuscripti sacrae scripturae Neerlandicae*, Leiden 1984.
— De Vreese, W.L., [Notes on LTK 232 in the Bibliotheca Neerlandica Manuscripta. Leiden University Library, under BNM 444]. Online at http://hdl.handle.net/1887.1/item:1905452.
— Kors, M., *De Bijbel voor leken. Studies over Petrus Naghel en de Historiebijbel van 1361*, Leuven 2007.

05 | Restrained elegance for pious women

— Beuken, W.H. & J.H. Marrow (eds), *Spiegel van den leven ons Heren (Mirror of the life of our Lord). Diplomatic edition of the text and facsimile of the 42 miniatures of a 15th century typological life of Christ in the Pierpont Morgan Library, New York*, Doornspijk 1979.
— Biemans, J.A.A.M., *Middelnederlandse bijbelhandschriften = Codices manuscripti sacrae scripturae Neerlandicae*, Leiden 1984, no. 168.
— Korteweg, A. (ed.), *Kriezels, aubergines en takkenbossen. Randversiering in Noordnederlandse handschriften uit de vijftiende eeuw*, Zutphen 1992, pp. 91, 102.
— Lieftinck, G.I., *Codicum in finibus Belgarum ante annum 1550 conscriptorum qui in bibliotheca universitatis asservantur. Vol. 1. Codices 168-360 societatis cui nomen Maatschappij der Nederlandsche Letterkunde*, Leiden 1948, pp. 71–72.

06 | By and for the hands of a noble nun

— Bouwman, W.P., 'Het Henegouws-Hollands riddermatig middeleeuws geslacht De Sars / Van Zaers', in: *De Nederlandsche Leeuw*, 110 (1993)/5-6, cols 193–226.
— Goudriaan, K., 'Het eerste vrouwenklooster van Oudewater', in: *Heemtijdinghen. Orgaan van de Stichts-Hollandse historische vereniging*, 35 (1999) no. 1, pp. 1–36.
— Korteweg, A.S., 'Zuid-Holland', in: A.S. Korteweg (ed.), *Kriezels, aubergines en takkenbossen. Randversiering in Noordnederlandse handschriften uit de vijftiende eeuw*, Zutphen 1992, pp. 68–83.
— Obbema, P., 'Het Leidse getijdenboek in een nieuw perspectief', in: *Idem, De middeleeuwen in handen*, Hilversum 1996, pp. 176–192.
— The Byvanck database of Dutch manuscript illumination, available online via the RKD (Netherlands Institute for Art History) at https://research.rkd.nl/en (search for 'Byvanck').

07 | Book production as an international business

— Bergen, W. van, *De meesters van Otto van Moerdrecht. Een onderzoek naar de stijl en iconografie van een groep miniaturisten, in relatie tot de productie van getijdenboeken in Brugge rond 1430*, PhD thesis, University of Amsterdam, Amsterdam 2007.
— Bergen, S. van, 'The Use of Stamps in Bruges Book Production', in: S. Hindman & J.H. Marrow (eds), *Books of Hours Reconsidered*, London/Turnhout 2013, pp. 323–337.
— Churchill, W.A., *Watermarks in paper in Holland, England, France etc. in the XVII and XVIII centuries and their interconnections*, Amsterdam 1935, p. 9.
— Farquhar, J.D., 'Identity in an anonymous age: Bruges manuscript illuminators and their signs', in: *Viator*, 11 (1980), pp. 371–384.

08 | Up to date

— Gondrie, I. et al. (eds), *Eyn corte decleringhe deser spere*, Utrecht 1983, pp. 101–106, accessed at https://www.dbnl.org/tekst/_cor001cort01_01/index.php.
— Grotefend, H., *Taschenbuch der Zeitrechnung des deutschen Mittelalters und der Neuzeit*. 11th rev. ed., T. Ulrich, Hannover 1971.
— Hoek, K. van der, 'De Noordhollandse verluchter Spierinck: Haarlem en/of Beverwijk, circa 1485-1519', in: J.M.M. Hermans (ed.), *Middeleeuwse handschriftenkunde in de Nederlanden 1988. Verslag van de Groningse Codicologendagen 28-29 april 1988*, Grave 1989, pp. 163–182.
— Scholtens, H.J.J., 'Het voormalige regulierenklooster te Beverwijk', in: *Haarlemsche bijdragen. Bouwstoffen voor de geschiedenis van het bisdom Haarlem*, 60 (1948), pp. 113–133.
— Strubbe, E I. & L. Voet, *De chronologie van de Middeleeuwen en de moderne tijden in de Nederlanden*. Photomechanical reprint of the issue of 1960, Antwerp 1991.

09 | A manual for the higher spheres

— Gerritsen, W.P., 'Een eenhoorn in "de Dikzak" (Leiden, UB, BPL 2473, fols 236r–237r)', in: *Tijdschrift voor Nederlandse Taal- en Letterkunde*, 128 (2012), pp. 126–134.
— Warnar, G., 'Het boek als bundel. Willem de Vreese en de studie van de Nederlandse letterkunde in de handschriftencultuur van de late Middeleeuwen', in: P. Hoftijzer et al. (eds), *Bronnen van Kennis. Wetenschap, kunst en cultuur in de collecties van de Leidse Universiteitsbibliotheek*, Leiden 2006, pp. 221–229.

10 | A printed manuscript?

— Dlabačová, A., 'Printed pages, perfect souls? Ideals and instructions for the devout home in the first books printed in Dutch', in: *Religions*, 11:45 (2020), pp. 1–21.

- Laan, J. van der, *Enacting Devotion: Performative Religious Reading in the Low Countries (c. 1470–1550)*, PhD thesis, University of Groningen, Groningen 2020.
- Rudy, K.M., *Image, Knife, and Gluepot Early Assemblage in Manuscript and Print*, Cambridge 2019.

11 | The triumph of word spacing
- Bay, C., *Biblical heroes and classical culture in Christian late antiquity: the historiography, exemplarity, and anti-Judaism of Pseudo-Hegesippus*, Cambridge 2023.
- Buchner, R. (ed.), *Gregorii episcopi Turonensis Historiarum libri decem = Zehn Bücher Geschichten*, Darmstadt 1970.
- Gerritsen-Geywitz, G. & W.P. Gerritsen, '"Old is beautiful". Het oudste handschrift van Gregorius' *Historiae* (Leiden, U.B., BPL 21)', in: M. de Jong *et al.* (eds), *Rondom Gregorius van Tour*, Utrecht 2001, pp. 37–54.
- Saenger, P., *Space between words. The origins of silent reading*, Stanford CA 1997.
- Ussani, V. (ed.) *Hegesippi qui dicitur historiae libri V*, Vienna 1932.

12 | Reversed, repurposed and recovered
- Breugelmans, R. (ed.), *Goed gezien. Tien eeuwen wetenschap in handschrift en druk. Tentoonstelling Rijksmuseum van Oudheden, 30 oktober 1987 – 17 januari 1988*. Leiden 1987.
- Gimbrère OSB, Sister L. [Restoration report, correspondence and description of BPL 114. 1987. UBL, BPL 3470: 1, book L (Leiden) VIII, pp. 127–136].
- Gnirrep, W.K. *et al.*, *Kneep & binding. Een terminologie voor de beschrijving van de constructies van oude boekbanden*. 2nd ed. The Hague 1997.
- Meens, R.M.J., 'Recht en schrift ten tijde van Karel de Grote. De raadsels rond het handschrift BPL 114', in: *Omslag. Bulletin van de Universiteitsbibliotheek Leiden en het Scaliger Instituut*, 1 (2005), pp. 4–5.
- Szirmai, J.A. *The Archaeology of Medieval Bookbinding*, Aldershot/Brookfield 1999.

13 | Text and images: Two means to the same end
- Cohen, M. A. *et al.*, 'Auditory recognition memory is inferior to visual recognition memory', in: *Proceedings of the National Academy of Sciences* 106, no. 14 (7 April 2009), pp. 6008–6010.
- Delisle, L., 'Notice sur les manuscrits originaux d'Adémar de Chabannes', in: *Notices et extraits des manuscrits de la Bibliothèque Nationale et autres bibliothèques*, vol. 35 (1896), pp. 241–358.
- Els, A. van, *A Man and His Manuscripts. The Notebooks of Ademar of Chabannes (989-1034)*, transl. Thea Summerfield, Turnhout 2020 (Bibliologia, 56).
- Els, A. van, *Een leeuw van een handschrift. Ademar van Chabannes en MS Leiden, Universiteitsbibliotheek Leiden, Vossianus Latinus Octavo 15*, 3 vols, PhD thesis, Utrecht University, Utrecht 2015, available online at https://dspace.library.uu.nl/handle/1874/306223.
- Gaborit-Chopin, D., 'Les dessins d'Adémar de Chabannes', in: *Bulletin archéologique du comité des travaux historiques et scientifiques*. Nouvelle série 3 (1967), pp. 163–225.

14 | Perfect to a fault
- Kwakkel, E., 'The Margin as Editorial Space: Upgrading *Dioscorides alphabeticus* in Eleventh-Century Monte Cassino', in: M. Teeuwen and I. van Renswoude (eds), *The Annotated Book in the Early Middle Ages: Practices of Reading and Writing*, Turnhout 2018, pp. 357–374.
- Kwakkel E. and F. Newton, *Medicine at Monte Cassino: Constantine the African and the Oldest Manuscript of His Pantegni*, Turnhout 2019.
- Newton, F., 'Preservation of Flyleaves, Subscriptions, Retracing of Script, and Shelf Marks: The Care of MSS. at Monte Cassino in the later Middle Ages (11th to 15th Centuries)', in: *Scriptorium: Revue internationale des études relatives aux manuscrits médiévaux*, 50 (1996), pp. 356–362.
- Newton, F., 'Beneventan (South Italian/Langobardic) Script', in: F.T. Coulson and R.G. Babcock (eds), *The Oxford Handbook of Latin Palaeography*, Oxford 2020, pp. 120–142.
- Riddle, J.M., '*Dioscorides*', in: F.E. Cranz and P.O. Kristeller (eds), *Catalogus translationum et commentariorum: Mediaeval and Renaissance Latin Translations and Commentaries: Annotated Lists and Guides*, vol. 4, Washington D.C. 1980, pp. 1–143.

15 | A unique edition of the *Liber floridus*
- Carmassi, P. (ed.), *Time and Science in the* Liber floridus *of Lambert of Saint-Omer*, Turnhout 2021.
- Derolez, A., *The Making and Meaning of the* Liber floridus: *A Study of the Original Manuscript, Ghent, University Library, MS 92*, Turnhout 2015.
- Gumbert, J.P., 'Recherches sur le stemma des copies du *Liber floridus*', in: A. Derolez (ed.), Liber floridus *Colloquium. Papers Read at the International Meeting Held in the University Library Ghent on 3–5 September 1967*, Ghent 1973, pp. 37–50.
- Korteweg, A.S., *Splendour, Gravity and Emotion: French Medieval Manuscripts in Dutch Collections*, Zwolle 2004.
- Vorholt, H., *Shaping Knowledge: The Transmission of the* Liber floridus, London 2017.

16 | The nature of a manuscript
- Besamusca, B. *et al.* (eds), *De boeken van Velthem. Auteur, oeuvre en overlevering*, Hilversum 2009, pp. 14–18 (biography).
- Biemans, J.A.A.M., *Onsen Speghele Ystoriale in Vlaemsche. Codicologisch onderzoek naar de overlevering van de* Spiegel historiael *van Jacob van Maerlant, Philip Utenbroeke en Lodewijk van Velthem, met een beschrijving van de handschriften en fragmenten* (2 vols.), Louvain 1997, pp. 19–30, 182–187, 200–205, 253–256, 376–377, 405–409, pl. 24-1, 45b-c.
- Klein, J.W., 'De handschriften: beschrijving en reconstructie', in: B. Besamusca & A. Postma (eds), Lanceloet. *De Middelnederlandse vertaling van de* Lancelot en prose *overgeleverd in de* Lancelotcompilatie. *Pars 1 (vs. 1-5530, voorafgegaan door de verzen van het Brusselse fragment)*, Hilversum 1997, pp. 51–110.

17 | Continuation errors when copying a printed text
- Bouwman, A.T., 'Prozaproductie in twee kolommen. De Middelnederlandse bronnen van Otto von Passaus *Die 24 Alten*', in: J.A.A.M. Biemans *et al.* (eds), *Manuscripten en miniaturen. Studies aangeboden aan Anne S. Korteweg bij haar afscheid van de Koninklijke Bibliotheek*. Zutphen 2007, pp. 47–58.
- Duinhoven, A.M., *Bijdragen tot reconstructie van de Karel ende Elegast*. Part I, Assen 1975.
- Jaspers, J.G., 'Otto von Passau in Nederlandse handschriften', in: *Ons geestelijk erf*, 60 (1986), pp. 302–348.
- Otto van Passau, *Boec des gulden throens*, Haarlem 1484 (ISTC i00125000, ex. UBL 1498 B 2).
- Schmidt, W., *Die vierundzwanzig Alten Ottos von Passau*, Leipzig 1938.

18 | A thousand years of textual editing
- Gumbert, J.P., 'Cicerones Leidenses', in: C.A. Chavannes-Mazel and M.M. Smith (eds), *Medieval Manuscripts of the Latin Classics: Production and Use*, Los Altos Hills/London 1996, pp. 208–244.

- Huelsenbeck, B., 'A Nexus of Manuscripts Copied at Corbie, ca. 850–880: A Typology of Script-Style and Copying Procedure', in: *Segno e testo*, 11 (2013), pp. 287–310.
- Reinhardt, T., 'A Note on the Text of Cicero's *Topica* in Cod. Voss. Lat. F86', in: *Mnemosyne*, 55 (2002), pp. 320–328.
- Reinhardt, T. (ed. and transl.), *Cicero's* Topica, Oxford 2003.
- Schmidt, P.L., *Die Überlieferung von Ciceros Schrift 'De legibus' in Mittelalter und Renaissance*, Munich 1974.

19 | Studying Lucretius at Charlemagne's court
- Butterfield, D., *The Early Textual History of Lucretius' De rerum natura*, Cambridge 2013.
- Châtelain, É.L.M., *Lucretius: Codex Vossianus oblongus phototypice editus*, Leiden 1908.
- Deufert, M., *Prolegomena zur Editio Teubneriana des Lukrez*, Berlin/Boston 2017.
- Ganz, D., 'Lucretius in the Carolingian Age: The Leiden Manuscripts and their Carolingian Readers', in: C.A. Chavannes-Mazel and M.M. Smith (eds), *Medieval Manuscripts of the Latin Classics: Production and Use*, Los Altos/London 1996, pp. 91–102.
- Lachmann, K., *Lucretii de rerum natura libri VI*, Berlin 1805.

20 | Erasing evil: The battle of the Virtues and the Vices
- Gumbert, J.P., 'De Egmondse boekenlijst', in: G.N.M. Vis (ed.), *In het spoor van Egbert: Aartsbisschop Egbert van Trier, de bibliotheek en geschiedschrijving van het klooster Egmond*, Hilversum 1997, pp. 151–179.
- Horst, K. van der *et al.* (eds), *The Utrecht Psalter in Medieval Art: Picturing the Psalms of David*, 't Goy 1996.
- Mastrangelo, M. (ed. and transl.), Prudentius' *Psychomachia*, Abingdon/New York 2022.
- Petruccione, J.F., 'The Glosses of Prudentius's *Peristephanon* in Leiden, Universiteitsbibliotheek, Burmann Quarto 3 (Bur. Q. 3) and their Relationship to a Lost Commentary', in: *The Journal of Medieval Latin*, 23 (2013), pp. 295–333.
- Woodruff, H., 'The Illustrated Manuscripts of Prudentius', in: *Art Studies*, 7 (1929), pp. 3–49.

21 | A multicultural book
- 'Dubthach', 'Sedulius Scottus', 'John Scottus Eriugena', *Dictionary of Irish Biography*, accessed at https://www.dib.ie on 25 August 2024.
- Gumbert, J. P., 'The Irish Priscian in Leiden', in: *Quaerendo* 27 (1997), pp. 280–299.
- Jeauneau, E., & P.E. Dutton, *The autograph of Eriugena*, Turnhout 1996.
- McKitterick, R., *Carolingian culture: emulation and innovation*, Cambridge 1994.
- Meeder, S., *The Irish scholarly presence at St. Gall: networks of knowledge in the early middle ages*, London/New York 2018.

22 | Guided reading: An annotated classical text
- Grazzini, S. (ed.), *Scholia in Iuuenalem recentiora, secundum recensiones Φ et X, tomus 1 (satt. 1–6)*, Pisa 2011.
- Parker, H.N., 'Manuscripts of Juvenal and Persius', in: S. Braund and J. Osgood (eds), *A Companion to Persius and Juvenal*, Oxford 2012, pp. 137–161.
- Zetzel, J.E.G., *Marginal Scholarship and Textual Deviance: The* Commentum Cornuti *and the Early Scholia on Persius*, London 2005.

23 | Canon law in Bologna
- Bertram M., 'Clementinenkommentare des 14. Jahrhunderts', in: M. Bertram, *Kanonisten und ihre Texte (1234 bis Mitte 14. Jh.)*, Leiden 2013, pp. 91–108.
- Boeren, P.C., *Catalogue des manuscrits des Collections D'Ablaing et Meijers*, Leiden 1970, pp. 52–61.
- Friedberg, E.A. & A.L. Richter (eds) (1879–1881), *Corpus Juris Canonici. Editio Lipsiensis Secunda* (2 vols), Leipzig 1879–1881.
- Menache, S., *Clement V*, Cambridge 1998, pp. 6–34, (Ch. 1: 'Clement V'), 279–305 (Ch. 7: 'The Council of Vienne and the Clementinae').
- Tarrant, J. (1984), 'The Manuscripts of the Constitutiones Clementinae', in: *Zeitschrift der Savigny-Stiftung für Rechtsgeschichte: Kanonistische Abteilung*, 70 (1984), pp. 64–133 (I. Admont to München); 71 (1985), pp. 76–146 (II. Napoli to Zwettl).

24 | Searching for words
- Bischoff, B., *Katalog der festländischen Handschriften des neunten Jahrhunderts (mit Ausnahme der wisigotischen). Teil II: Laon–Paderborn*, Wiesbaden 2004.
- Hsy, J., 'Between Species: Animal-Human Bilingualism and Medieval Texts', in: C. Batt and R. Tixier (eds), *'Booldly bot Meekly': Essays on the Theory and Practice of Translation in the Middle Ages in Honour of Roger Ellis*, Turnhout 2018, pp. 563–579.
- Lendinara, P., 'Medieval Versifications of Lists of Animal Sounds', in: S.G. Bruce (ed.), Litterarum dulces fructus: *Studies in Early Medieval Latin Culture in Honour of Michael W. Herren for his 80th Birthday*, Turnhout 2021, pp. 235–273.
- McKitterick, R., 'Glossaries and Other Innovations in Carolingian Book Production', in: E. Kwakkel, R. McKitterick and R. Thomson (eds), *Turning Over a New Leaf: Change and Development in the Medieval Book*, Leiden 2012, pp. 21–76.
- Zetzel, J.E.G., *Critics, Compilers and Commentators: An Introduction to Roman Philology, 200 BCE–800 CE*, Oxford 2018.

25 | In the classroom
- Berschin, W., 'Griechisches in der Klosterschule des alten St. Gallen', in: *Byzantinisches Zeitschrift*, 84/85.1-2 (1991/1992), pp. 329–340.
- Bremmer Jr, R.H., 'The Function of Glossaries', in: A. Seiler, C. Benati & S.M. Pons-Sanz (eds), *Medieval Glossaries from North-Western Europe. Tradition and Innovation*, Turnhout 2023, pp. 73–84.
- Ciccolella, F., '[Review of] G. Fiammini (ed.), *Magister Dositheus, Hermeneumata Pseudodositheana Leidensia*, München 2004', in: *Bryn Mawr Classical Review* online, 2005.10.34.
- Degiovanni, L., 'The *Hermeneumata Pseudo-Dositheana*', in: A. Seiler, et al. (eds), *Medieval Glossaries from North-Western Europe*, Turnhout 2023, pp. 133–148.
- Dickey, E. (ed. and transl.), *The Colloquia of the Hermeneumata Pseudodositheana. Vol. 1: Colloquia Monacensia-Einsidlensia, Leidense-Stephani, and Stephani*, Cambridge 2012.

26 | A riddle that can be solved but cannot be read
- Bremmer Jr, R.H. & C. Dekker, *Anglo-Saxon Manuscripts in Microfiche Facsimile. Vol. 13: Manuscripts in the Low Countries*, Tempe 2006.
- Dietrich. F.E., *Commentatio de Kynewulfi poetae aetate aenigmatum fragmento e codice Lugdunensi edito illustrata*, Marburg 1860.
- Gerritsen, J., 'Leiden Revisited: Further Thoughts on the Text of the Leiden Riddle', in: W.-D. Bald & H. Weinstock (eds), *Medieval Studies Conference, Aachen 1983: Language and Literature*, Frankfurt am Main 1983, pp. 51–59.

- Parkes, M.B., 'The Manuscript of the Leiden Riddle', in: *Anglo-Saxon England*, 1 (1972), pp. 207–217.
- Smith, A.H., *Three Northumbrian Poems*, London 1933.

27 | Signed, sealed, delivered: A shorthand lexicon
- Bischoff, B., *Katalog der festländischen Handschriften des neunten Jahrhunderts (mit Ausnahme der wisigotischen). Teil II: Laon–Paderborn*, Wiesbaden 2004.
- Ganz, D., 'Latin Shorthand and Latin Learning', in: S. O'Sullivan and C. Arthur (eds), *Crafting Knowledge in the Early Medieval Book: Practices of Collecting and Concealing in the Latin West*, Turnhout 2023, pp. 155-172.
- Garipzanov, I., *Graphic Signs of Authority in Late Antiquity and the Early Middle Ages, 300–900*, Oxford 2018.
- Isidore of Seville, *The Etymologies of Isidore of Seville*, ed. and transl. S. A. Barney *et al.*, Cambridge 2006.
- Walther, C., 'Tironian Notes and Legal Practice: The Use of Shorthand Writing in Early Medieval Legal Culture', in: H. Boeddeker and K. Minot McCay (eds), *New Approaches to Shorthand: Studies of a Writing Technology*, Berlin/Boston 2024, pp. 49–78.

28 | How the Egmond Willeram became the Leiden Willeram
- Bouwman, A.T., 'Willeram: From Egmond to Leiden (and beyond)', in: *Omslag. Bulletin van de Universiteitsbibliotheek en het Scaliger Instituut* 2010/3, pp. 14–15.
- Gumbert, J.P., 'The Willeram goes to print', in: *Quaerendo*, 4 (1975), pp. 205–217.
- Lähnemann, H. & M. Rupp (ed.), *Williram von Ebersberg, Expositio in Cantica canticorum und das "Commentarium in Cantica canticorum" Haimos von Auxerre*, Berlin 2004.
- Louwen, K., 'De Leidse Willeram, een Nederlandse getuige in een Duits jasje', in: *Nederlands van Nu*, 56 (2008), February, pp. 36–37; May, pp. 34–36.
- Sanders, W., *Der Leidener Willeram, Untersuchungen zu Handschrift, Text und Sprachform*, Munich 1974.

29 | Nature cures, miraculously or otherwise
- Brodersen, K. (transl.), *Apuleius, Heilkräuterbuch / Herbarius. Zweisprachige Ausgabe*, Wiesbaden 2015.
- Chavannes-Mazel, C.A. & L. IJpelaar (eds), *The Green Middle Ages. The Depiction and Use of Plants in the Western World 600–1600*, Amsterdam 2022.
- Howald, E. & H.E. Sigerist, *Antonii Musae De herba vettonica, Liber Pseudo-Apulei herbarius, Anonymi De taxone liber, Sexti Placiti Liber medicinae ex animalibus. Corpus medicorum latinorum*; Vol. IV, Leipzig 1927.
- Pradel-Baquerre, M., *Ps.-Apulée, "Herbier", introduction, traduction et commentaire*, Dissertation Archéologie et Préhistoire, Université Paul Valéry, Montpellier III, Montpellier 2013. Online at https://theses.hal.science/tel-00977562.

30 | A giant book
- Brown, J., *A Palaeographer's View: The Selected Writings of Julian Brown*, Eds J. Bately, M. Brown and J. Roberts, London 1993.
- Garrison, M., 'An Insular Copy of Pliny's *Naturalis historia* (Leiden UB VLF 4 fol 4-33)', in: E. Kwakkel (ed.), *Writing in Context: Insular Manuscript Culture 500–1200*, Leiden 2013, pp. 67–126.
- Lowe, E.A., *Codices Latini antiquiores* (12 vols), Oxford 1935–1972.
- Parkes, M.B., 'The Contribution of Insular Scribes of the Seventh and Eighth Centuries to the "Grammar of Legibility"', in: *Idem: Scribes, Scripts and Readers: Studies in the Communication, Presentation and Dissemination of Medieval Texts*, London 1991, pp. 1–18.
- Reeve, M.D., *The Transmission of Pliny's Natural History*, Rome 2021.

31 | A constellation of copies and innovations
- Dolan, M., *Astronomical knowledge transmission through illustrated Aratea manuscripts*. Cham 2017.
- Gent, R. van, 'De hemelatlas van Andreas Cellarius. Het meesterwerk van een vergeten Hollandse kosmograaf', in: *Caert-Thresoor*, 19 (2000), pp. 9–25.
- Hamel, C. de, *Meetings with remarkable manuscripts*. London 2016.
- Katzenstein, R. & E. Savage-Smith, *The Leiden Aratea: Ancient constellations in a medieval manuscript*. Los Angeles 1988.
- Mostert, R. & M. Mostert, 'Using astronomy as an aid to dating manuscripts. The example of the Leiden Aratea Planetarium', in: *Quaerendo*, 20 (1990), pp. 248–261.

32 | Hand signals and medieval counting
- Bede, *The reckoning of time*, transl. F. Wallis, Liverpool 1999.
- Denoël, C., 'Imaging time, computation and astronomy. A *computus* collection from Micy-Saint-Mesmin (Vatican, BAV MS Reg. lat. 1263) and early eleventh-century illumination in the Loire region', in: B. Kitzinger and J. O'Driscoll (eds), *After the Carolingians. Re-defining Manuscript Illumination in the 10th and 11th Centuries*, Berlin 2019, pp. 118–160.
- Falk, S., *The Light Ages: A medieval journey of discovery*, London 2020.
- Page, S., 'Medieval magical figures: Between image and text', in: S. Page and C. Rider (eds), *The Routledge History of Medieval Magic*, London 2019, pp. 432–457.
- Skemer, D., *Binding words: Textual amulets in the Middle Ages*, University Park PA 2006.

33 | An impossible object
- Heath, T.L., *The Thirteen Books of Euclid's Elements*, Cambridge 1908.
- Heiberg, J.L., & E.S. Stamatis, *Euclidis Elementa Vol. IV Libri XI-XIII cum appendicibus*, Leipzig 1973.
- Hogendijk, J.P., 'The scholar and the fencing master: the exchanges between Joseph Justus Scaliger and Ludolph van Ceulen on the circle quadrature (1594–1596)', in: *Historia Mathematica*, 37 (2010), pp. 345–375.
- Netz, R., *The Shaping of Deduction in Greek Mathematics. A Study in Cognitive History*, Cambridge 1999.
- Saito, K. & N. Sidoli, 'Diagrams and arguments in ancient Greek mathematics: lessons drawn from comparisons of the manuscript diagrams with those in modern critical editions', in: K. Chemla (ed.), *History of Mathematical Proof in Ancient Traditions*, Cambridge 2012, pp. 135–162.

34 | The Creation glitters in gold
- Biesheuvel, I. (transl.), *Jacob van Maerlant, Der Naturen Bloeme. Uit het Middelnederlands vertaald door Ingrid Biesheuvel*, Zutphen 2024.
- Oostrom, F. P. van, *Maerlants wereld*, Amsterdam 1994.
- Heniger, J., 'Jan van IJsselstein en *Der Naturen Bloeme*', in: *Historische Kring IJsselstein*, 33/34 (1985), pp. 261–280.
- Westgeest, J. P., *De natuur in beeld. Middeleeuwse mensen, dieren, planten en stenen in de geïllustreerde handschriften van Jacob van Maerlants Der naturen bloeme*, PhD thesis, Leiden University, Leiden 2006.

35 | Travelling scholars, travelling texts
- Burnett, C. (ed. and transl.), *Adelard of Bath, Conversations with his Nephew: On the Same and the Different, Questions on Natural Science, and On Birds*, Cambridge 1998.

- Coleman, J., 'Memory and the Illuminated Pedagogy of the *Propriétés des choses*', in: *Nottingham Medieval Studies*, 56 (2012), pp. 121–142.
- Juste, D., *Les* Alchandreana *primitifs: Étude sur les plus anciens traités astrologiques latins d'origine arabe (Xᵉ siècle)*, Leiden 2007.
- 'Liber Alchandrei philosophi', Los Angeles, J. Paul Getty Museum, MS 72, accessed at www.getty.edu/art/collection/object/1095S2 on 7 August 2024.

36 | For education and entertainment
- Bouwman, A., 'Alewijns aantekeningen over de *Esopet*', in: C. Berkvens-Stevelinck et al. (eds), *Miscellanea Gentiana. Een bundel opstellen aangeboden aan J.J.M. van Gent bij zijn afscheid als bibliothecaris der Rijksuniversiteit Leiden*, Leiden 1993, pp. 49–67.
- Kuiper, W., 'De filoloog als patholoog-anatoom', in: *Queeste. Tijdschrift over middeleeuwse letterkunde in de Nederlanden*, 5 (1998), pp. 172–180.
- Lieftinck, G.I., *Codicum in finibus Belgarum ante annum 1550 conscriptorum qui in bibliotheca universitatis asservantur. Vol I: Codices 168–360 societatis cui nomen Maatschappij der Nederlandsche Letterkunde*, Leiden 1948.
- Schippers, A., *Middelnederlandse fabels. Studie van het genre, beschrijving van collecties, catalogus van afzonderlijke fabels*, PhD thesis, Radboud University, Nijmegen 1995.
- Stuiveling, G. (ed.), *Esopet. Facsimile-uitgave naar het enig bewaard gebleven handschrift*, Amsterdam 1965.

37 | Narrative pearls in a single volume
- Besamusca, B. & E. Kooper (eds), *Originality and Tradition in the Middle Dutch Roman van Walewein*, Cambridge 1999.
- Biesheuvel, I. (transl.), *Roman van Heinric en Margriete van Limborch*, Translated [into Dutch] from the Middle Dutch and Ripuarian, Amsterdam 2021.
- Biesheuvel, I. (transl.), *De ridders van de Ronde Tafel. Arturverhalen uit de Lage Landen*, Amsterdam 2012.
- De Wachter, L., *Een literair-historisch onderzoek naar de effecten van ontleningen op de compositie en de zingeving van de Roman van Heinric en Margriete van Limborch*, Brussels 1998.
- Johnson, D.F. & G.H.M. Claassens (eds and transl.), *Dutch Romances I, Roman van Walewein*, Cambridge 2000.

38 | The 'Holy Grail' of German Arthuriana
- Becker, A., 'Dialogszenen in Text und Bild. Beobachtungen zur Leidener *Wigalois*-Handschrift', in: N. Miedema & F. Hundsnurscher (eds), *Formen und Funktionen von Redeszenen in der mittelhochdeutschen Großepik*, Tübingen 2007, pp. 19–41.
- Brown, J.H. *Imagining the Text. Ekphrasis and Envisioning Courtly Identity in Wirnt von Gravenberg's Wigalois*, Chapel Hill 2006.
- Domanski, K. & M. Krenn, 'Wigalois gewinnt das Land Korntin', in: *Idem, Liebesleid und Ritterspiel. Mittelalterliche Bilder erzählen große Geschichten*, Darmstadt 2012, pp. 65–76.
- Gräber, A., *Bild und Text bei Wirnts von Gravenberg Wigalois*, Freiburg im Breisgau 2001.
- Mierke, G. & C. Schanze, 'Wigalois am Rande des Paradieses. Zum Bildprogramm des Leidener *Wigalois*-Codex', in: *Beiträge zur Geschichte der deutschen Sprache und Literatur*, 143 (2021), pp. 596–631.

39 | A Roman history of the papacy and its readers
- Davis, R. (transl.), *The Lives of the Ninth-Century Popes* (Liber pontificalis)*: The Ancient Biographies of Ten Popes from AD 817–891*, Liverpool 1995.
- Davis, R. (transl.), *The Lives of the Eighth-Century Popes* (Liber pontificalis)*: The Ancient Biographies of Nine Popes from AD 715 to AD 817*, 2nd ed., Liverpool 2007.
- Davis, R. (transl.), *The Book of Pontiffs* (Liber pontificalis)*: The Ancient Biographies of the First Ninety Roman Bishops to AD 715*, 3rd ed., Liverpool 2010.
- Duchesne, L. (ed.), *Le Liber pontificalis: Texte, introduction et commentaire*, two vols, Paris 1886–1892.
- McKitterick, R., *Rome and the Invention of the Papacy: The* Liber pontificalis, Cambridge 2020.

40 | Liudger's treasure-trove of charters
- Blok, D.P. (ed.), *De oudste particuliere oorkonden van het klooster Werden*, Assen 1960.
- Declercq, G., 'Originals and cartularies: the organization of archival memory (ninth-eleventh centuries)', in: Karl Heidecker (ed.), *Charters and the use of the written word in medieval society*, Utrecht Studies in Medieval Literacy 5, Turnhout 2000, pp. 147–170.
- Diekamp, W. (ed.), *Die Vitae sancti Liudgeri*, Die Geschichtsquellen des Bisthums Münster 4, Münster 1881.
- Tiefenbach, H., 'Zu den Personennamen der frühen Werdener Urkunden', in: D. Geuenich, W. Haubrichs, J. Jarnut (eds), *Person und Name. Methodische Probleme bei der Erstellung eines Personennamenbuches des Frühmittelalters*, Ergänzungsbände zum Reallexikon der Germanischen Altertumskunde 32, Berlin/New York 2002, pp. 280–304.
- Vliet, K. van, *In kringen van kanunniken. Munsters en kapittels in het bisdom Utrecht 695-1227*, Zutphen 2002, pp. 104–107.

41 | Additions to an abbot's work by his monks
- Davis, R. (transl.), *The Lives of the Eighth-Century Popes* (Liber Pontificalis). *The Ancient Biographies of Nine Popes from AD 715 to AD 817*, Liverpool 1992.
- Davis, R. (transl.), *The Lives of the Ninth-Century Popes* (Liber Pontificalis). *The Ancient Biographies of Ten Popes from AD 817 to AD 891*, Liverpool 1995.
- Gantier, L.-M. (transl.), *Une histoire des papes, en l'an mil. L'abrégé du* Liber pontificalis *d'Abbon de Fleury (vers 950–1004)*, Louvain-la-Neuve/Louvain/Brussels, 2004.
- Mostert, M., *The Political Theology of Abbo of Fleury. A Study of the Ideas about Society and Law of the Tenth-Century Monastic Reform Movement*, Hilversum 1987.
- Van Els, A. (ed. and transl.), *Abbo van Fleury, Excerptum de gestis Romanorum pontificum*, MA/Doctoraal thesis, Utrecht University, Utrecht 2002.

42 | Robert of Torigni's historical compendium
- Cleaver, L., 'The Monastic Library at Le Bec', in: B. Pohl and L.L. Gathagan (eds), *A Companion to the Abbey of Le Bec in the Central Middle Ages (11th–13th Centuries)*, Leiden 2017, pp. 171–205.
- Lecouteux, S., 'À la recherche des livres du Bec (première partie)', in: P. Bauduin et al. (eds), *Sur les pas de Lanfranc, du Bec à Caen: Recueil d'études en hommage à Véronique Gazeau*, Caen 2018, pp. 267–277.
- Nortier, G., *Les bibliothèques médiévales des abbayes bénédictines de Normandie*, 2nd ed., Paris 1971.
- Pohl, B., '*Abbas qui et scriptor?* The Handwriting of Robert of Torigni and His Scribal Activity as Abbot of Mont-Saint-Michel (1154–1186)', in: *Traditio*, 69 (2014), pp. 45–86.
- Pohl, B., 'Robert of Torigni and Le Bec: The Man and the Myth', in: B. Pohl and L.L. Gathagan (eds), *A Companion to the Abbey of Le Bec in the Central Middle Ages (11th–13th Centuries)*, Leiden 2017, pp. 94–124.

43 | The master's hand
— Bouwman, A. & E. van der Vlist, 'Deel I. Van schrijven naar drukken. Het Leidse boek tussen begin en Beleg', in: A. Bouwman *et al.*, *Stad van boeken. Handschrift en druk in Leiden 1260–2000*, Leiden 2008, pp. 1–152.
— Feenstra, R., *Philips van Leyden en zijn bibliotheek*, Leiden 1994.
— Lieftinck, G.I., 'Een handschrift uit de bibliotheek van Philips van Leyden na vier eeuwen weer teruggekeerd in onze stad', in: *Jaarboekje voor geschiedenis en oudheidkunde van Leiden en omstreken*, 38 (1946), pp. 177-191.
— Molhuijsen, P.C., (ed.), *Philippus de Leyden. De cura reipublicae et sorte principantis*, The Hague 1900.
— Wachler, A.W.J., *Thomas Rehdiger und seine Büchersammlung in Breslau. Ein biographisch-literärischer Versuch*, Breslau 1828.

44 | Liturgical or not?
— Kunze, K., 'Usuard OSB (und deutsche Martyrologien)', in: *Die deutsche Literatur des Mittelalters. Verfasserlexikon*, 2nd ed., part 10, Berlin/New York 1999, col. 141–144.
— Overgaauw, E. A., *Martyrologes manuscrits des anciens diocèses d'Utrecht et de Liège. Étude sur le développement et la diffusion du Martyrologe d'Usuard. Vol. 1,* Hilversum 1993, pp. 422–431.

45 | 'By God, he shall not pass!'
— Bergh, G.C.J.J. van den, 'Two letters of Cornelis van Bijnkershoek (1673-1743). Concerning his acquisition of a manuscript of the Digestum vetus (now University Library Leiden BPL6C) and a new source for the study of Johan de Witt', in: *Lias*, 11 (1984), pp. 277–286.
— Bergh, G.C.J.J. van den, 'What became of the library of grand pensionary Johan de Witt (1625-1672)? With special reference to law books', in: *Tijdschrift voor Rechtsgeschiedenis*, 151 (1998), pp. 151–170.
— Feenstra, R., 'Quelques rémarques sur le texte de la glose d'Accurse sur le Digeste vieux', in: *Idem, Fata iuris romani, Études d'histoire du droit*, Leiden 1974, pp. 194–214.
— Meijers, E.M., 'L'université d'Orléans au XIIIe siècle', in: *Idem, Études d'histoire du droit*; Vol. III, ed. R. Feenstra & H.F.W.D. Fischer, Leiden 1959, pp. 3–148.
— Wouw, H. van de, 'Entre Bologne et Orléans, quelques notices et textes du Ms. Leyde BPL 6C', in: R. Feenstra & C.M. Ridderikhoff (eds), *Études néerlandaises de droit et d'histoire présentées à l'Université d'Orléans pour le 750e anniversaire des enseignements juridiques*, Orleans 1985, pp. 41–51.

46 | Six plays for students and scholars
— Dickey, E., *Ancient Greek Scholarship*, Oxford 2007.
— Meyier, K.A. de, *Codices Vossiani graeci et miscellanei*, Leiden 1955.
— Turyn, A., *The Manuscript Tradition of the Tragedies of Aeschylus*, Hildesheim 1967.
— Turyn, A., *Studies in the Manuscript Tradition of the Tragedies of Sophocles*, Rome 1977.

47 | A literary bestseller from the Renaissance
— Gumbert, J.P., 'Cicerones Leidenses', in C.A. Chavannes-Mazel & M.M. Smith (eds), *Medieval Manuscripts of the Latin Classics. Production and Use*, Los Altos Hills/London 1996, pp. 208–244.
— Pieper, C., & B. van der Velden, 'Cicero in Leidse handschriften', digital exhibition at Leiden University Library, accessed at https://webpresentations.universiteitleiden.nl/s/cicero/page/welcome on 15 August 2024.
— Rouse, R.H., 'Epistulae ad familiares', in: L.D. Reynolds (ed.), *Texts and Transmission. A Survey of the Latin Classics*, Oxford 1983, pp. 138–142.

48 | Frisia in Ferrara
— Akkerman, F. & A. van der Laan (eds and transl.), *Rudolph Agricola, Letters*, Assen/Tempe 2002.
— Akkerman, F. & A. van der Laan (eds and transl.), *Rudolf Agricola, Brieven, levens en lof van Petrarca tot Erasmus*, Amsterdam 2016.
— Römer, F., 'Agricolas Arbeit am Text des Tacitus und des jüngeren Plinius', in: F. Akkerman *et al.* (eds), *Rodolphus Agricola Phrisius 1444-1485. Proceedings of the International Conference at the University of Groningen 28-30 October 1985*, Leiden 1988, pp. 158–169.

49 | Ancient philosophers in Christian company
— Boter, G.J., *The Textual Tradition of Plato's Republic*, Leiden 1989.
— Boter, G.J., *The Encheiridion of Epictetus and its Three Christian Adaptations*, Leiden 1999.
— Jonkers, G., *The Textual Tradition of Plato's* Timaeus *and* Critias, Leiden 2017.
— Toomer, G., *Christianus Ravius: An Intellectual Biography. Vol. 1: The Wanderjahre*, Leiden 2023.
— Vancamp, B., *Untersuchungen zur handschriftlichen Überlieferung von Platons Menon*, Stuttgart 2010.

50 | A French *Iliad* for the king
— Berkvens-Stevelinck, C. & A. Nieuweboer, *Catalogue des manuscrits de la collection Prosper Marchand*, Leiden 1988, pp. 104–105.
— Kalwies, H., 'The First Verse Translation of the *Iliad* in Renaissance France', in: *Bibliothèque d'Humanisme et Renaissance*, 40 (1978), pp. 597–607.
— Laffitte, M.-P. & F. Le Bars, *Reliures royales de la Renaissance. La librairie de Fontainebleau, 1544–1570*, Paris 1999.
— Nassichuk, J., 'Le chantier épique d'Hugues Salel. La construction de la première version métrique de l'*Iliade* en français', in: *Canadian Review of Comparative Literature*, 46 (2019), pp. 217–234.
— Salel, H., *Les dix premiers livres de l'Iliade d'Homère prince des poetes*, Paris, Vincent Sertenas, 1545.

Manuscript descriptions

01 | BPL 48 — New Testament: Gospels (Latin)
— 9th century, c. 875 ; France, northern part: Saint-Amand Abbey?
— 1 volume, 251 leaves : decorated initials (inhabited) ; 298 x 219 mm — Parchment ; Carolingian script ; 21 and 27 or 31 lines on 188 x 110 mm.
— Contains: (fols 2r–5r) Prologue by Jerome. – (fols 5r–7r) Prologue and chapter list of the Gospel of Matthew. – (fols 8v–14r) Canon tables of Eusebius of Caesarea. – (fols 14v–75v) Gospel of Matthew. – (fols 76r–77r) Prologue and chapter list of the Gospel of Mark. – (fols 78v–117v) Gospel of Mark. – (fols 120r–125r) Prologue and chapter list of the Gospel of Luke. – (fols 124v–189v) Gospel of Luke. – (fols 190r–191v) Prologue and chapter list of the Gospel of John. – (fols 192v–237v) Gospel of John. – (fols 238v–251v) *Capitulare evangeliarum*.
— Bought from the library of Franciscus Nansius (†1595).

02 | BPL 100 A — Old Testament: Book of Job (Latin)
— 12th century, second half ; German regions?
— 1 volume, 59 leaves : drawings ; 251 x 162 mm — Parchment ; Pregothic script ; 24 lines on 182 x 63 mm.
— Vulgate translation of Jerome. With glosses and commentary.
— First mentioned in the Leiden catalogue of 1852 (Geel 1852).

03 | BPL 76 A — Saint Louis Psalter (Latin)
— 12th century, late ; British Isles: England (York?)
— 1 volume, 185 leaves : 24 calendar miniatures; 23 full-page miniatures; 1 full-page initial (fol. 30v), historiated, decorated and pen-flourished initials ; 243 x 177 mm — Parchment ; Gothic script: Textualis ; 20 lines on 175 x 108 mm.
— Contains: (fols 1r–6v) Calendar, illustrated with zodiac signs. – (fols 7r–29v) Miniatures of scenes from the Old and the New Testament. – (fols 30v–167r) Book of Psalms (1–150). With music notation on fol. 142v. – (fols 167r–177v) Canticles. – (fols 177v–179r) *Symbolum Athanasium (Quicumque vult)*. – (fols 179v–182v) Litany of All Saints. – (fols 182v–184r) Prayers. – (fols 184r–185v) Instructional text on praying 25 psalms on each weekday except Sunday, with accompanying collects. Added later (13th century). – Empty: fols 7v–8r, 9v–10r, 11v–12r, 13v–14r, 15v–16r, 17v–18r, 19v–20r, 21v–22r, 23v–24r, 25v–26r, 27v–28r, 29v–30r, 185v.
— Donated by Johan van den Bergh in 1741.

04 | LTK 232 — Southern Netherlands History Bible (Dutch)
— 15th century, second half ; Low Countries, northern part: Holland (north)
— 1 volume, 273 leaves : pen-flourished initials ; 262 x 200 mm — Paper and parchment ; Gothic script: Hybrida ; 2 columns, 48–53 lines on 215 x 150 mm.
— Contains: First part of the Southern Netherlands History Bible (also known as the First History Bible), translated by Petrus Naghel: Books of Genesis to Esther.
— Long-term loan from the Maatschappij der Nederlandse Letterkunde (MNL). Bought by the MNL from the books of Dirk Cornelis and his son Jan Jacob van Voorst, at an auction held by Frederik Muller, Amsterdam, 27 January 1860 (*Catalogue abrégé*, p. 19, nr. 145). Former MNL shelfmark: 11619.

05 | LTK 258 — *Leven ons heren*
— 15th century, c. 1470 ; Low Countries, northern part: Holland (north: Haarlem?)
— 1 volume, 208 leaves : pen drawings, pen-flourished initials ; 215 x 148 mm — Paper ; Gothic script: Hybrida ; 2 columns, 30–31 lines on 135/140 x 95/100 mm.
— Contains, in the Dutch translation of Johannes Scutken: (fols 1r–2v) Table of contents. – (fols 2v–9r) Prologue. – (fols 9r–190v) Typological Life of Christ. – (fols 191r–207v) Last Supper and Passion of Christ from the Gospel of John. – Empty: fol. 190 bis.
— Long-term loan from the Maatschappij der Nederlandse Letterkunde (MNL). Part of the bequest of Zacharias Hendrik Alewijn, received by the MNL in 1789. Former MNL shelfmark: 81.

06 | BPL 224 — Book of Hours and prayers (Latin, Dutch)
— 15th century, second quarter ; Low Countries, northern part: Leiden?
— 1 volume, 278 leaves : 21 miniatures, pen-flourished initials, border decoration ; 175 x 121 mm — Parchment ; Gothic script: Textualis ; 20 lines on 107 x 68 mm.
— Contains: (fols 1r–12v) Calendar (Latin), Use of Utrecht. – (fols 14r–29v) Hours of the Eternal Wisdom (Latin). – (fols 30v–37v) Short Hours of the Cross (Latin). – (fols 39r–54v) Hours of the Holy Spirit (Latin). – (fols 56r–114r) Little Office of the Blessed Virgin Mary; hymns and prayers (Latin). – (fols 116r–147v) Passion exercise; prayers (Dutch). – (fols 148r–162v) Penitential Psalms; Litany of the Saints; prayers (Latin). – (fols 164r–222v) Office of the Dead (Latin); prayers (Latin). – (fols 223r–242v) Prayers, *dicta* and the first pericope from the Gospel of John (Dutch). – (fols 243r–246v) Passion exercise (Dutch); prayers and *dicta* (Dutch, some in Latin). – Empty: fols 13r, 38r, 55r, 69r, 76r, 79r, 82r, 85r, 92r, 106r, 115r, 121r, 124v–125r, 128r, 133r, 134r, 138r, 141r, 163r, 204r, 213r.
— Part of the bequest of Louis Chastelain, received in 1785.

07 | BPL 3774 — Book of Hours and prayers (Latin)
— 15th century, c. 1420–1440 ; Low Countries, southern part: Bruges
— 1 volume, (2+) 60 (+3) leaves (pp. 1–62, 65–122): 7 miniatures, painted initials, painted border decoration, pen-flourished initials ; 193 x 135 mm — Parchment ; Gothic script: Textualis ; 33 lines on 128 x 85 mm (calendar) and 25–26 lines on 112/123 x 80 mm (rest).
— Contains, in Latin: (pp. 1–12) Calendar, Use of Sarum. – (pp. 13–27) Prayers to the Trinity and to various saints: St George (15), St John the Evangelist (19), St Anne (23), St Catherine (27). – (pp. 29–61) Hours of the Virgin Mary. Incomplete. – (pp. 63–79) Prayers to the Virgin Mary. Incomplete. Includes: Hymn based on the *Salve Regina* (65–69); Seven Joys of the Virgin Mary (75–79). – (pp. 79–80) Prayer to St John the Evangelist. – (pp. 81–85) *De septem verbis Christi in cruce* / Bede. – (pp. 87–102) Penitential Psalms and Litany of All Saints. – (pp. 103–110) Office of the Dead. Incomplete. – (pp. 113–116) Commendation of Souls. Incomplete; only Psalm 118 *Beati immaculati in via* (113–115), Psalm 138 *Domine probasti me* (115–116). – (pp. 117–119) Psalter of the Passion. Incomplete: Psalm 21 *Deus deus meus respice in me* (117–119), Psalm 30 *Ad te domine speravi* (119–120). – (pp. 121–122) Psalter of Jerome. Incomplete. – Also contains Latin prayers added in an English hand on pp. 62, 73–74, 120; also a *Veni Creator Spiritus in Textualis* on p. 62, with space reserved for initial

and versals. – Empty: pp. 16–17, 20–21, 24–24, 28, 41, 45, 52, 86. – With 18th-century table of contents on two unnumbered paper leaves after p. 122.
— Bought with financial support of the Friends of Leiden University Libraries at an auction held by Zwiggelaar, Amsterdam, 5 December 2022 (cat. 28, nr. 302).

08 | BPL 2747 — Book of Hours (Dutch)
— 15th century, 1498 ; Low Countries, northern part: Beverwijk
— 1 volume, 203 leaves : painted border decoration, historiated and decorated initials, pen-flourished initials ; 171 x 118 mm — Parchment ; Gothic script: Textualis ; 20 lines on 99 x 70 mm.
— Contains: (fols 2v–13r) Calendar with computus tables (2v, 13r). – (fols 14r–15r) Prayer to St James. – (fols 16r–51r) Hours of the Virgin. – (fols 52r–73v) Long Hours of the Cross. – (fols 74r–93v) Hours of the Holy Spirit (fols 94r–118v). – (fols 119r–140r) Hours of All Saints. – (fols 141r–157r) Penitential Psalms and Litany of the Saints. – (fols 158r–191v) Office of the Dead. – (fols 192r–203r) Prayers. – (fol. 203v) Colophon. – Empty: fols 2r (except for crossed out owner inscription), 13v, 15v, 51v, 140v, 157v.
— Bought at an auction held by J.A. Stargardt, Marburg, in 1967.

09 | BPL 2473 — Miscellany (Dutch): Devotional and ascetic texts
— 15th century, last quarter ; Low Countries, southern part: Tongeren?
— 1 volume, 336 leaves : 1 miniature, pen drawing, historiated and decorated initials, pen-flourished initials ; 140 x 103 mm — Paper and parchment ; Gothic script: Hybrida ; 23–30 lines on 110 x 80 mm.
— Miscellany (*Devotieboek*). Contains short devotional and ascetic texts: *Dicta* from or attributed to Ambrose, Augustine of Hippo, Jerome, Cyprian and others. – *Dicta, exempla*. – Passions of Christ. – Prayers on the Suffering of Christ and prayers to the Virgin Mary. – Short treatises on religious and devotional themes, etc. – Also contains a chronicle of the bishops of Trier and Tongres (fols 305r–312v).
— Exchanged for duplicate copies of printed works held by the library with antiquarian bookshop Sweris (Leiden) in 1946. From the collection of Willem De Vreese (?) according to the annual report of the librarian.

10 | LTK 237 — Composite volume, six parts (Dutch): 1, 4. Prayers and meditations (manuscript). – And other (printed) parts
— 1 volume, 189 leaves
— Long-term loan from the Maatschappij der Nederlandse Letterkunde (MNL). Bought by the MNL from Hendrik Willem Tydeman in 1864. Former MNL shelfmark: S 142.

Part 1
— 15th/16th century, c. 1500 ; Low Countries
— fols 1–69 : simple pen-flourished initials ; 138 x 95 mm — Paper ; Gothic script: Textualis ; 17–22 lines on 95/100 x 65 mm.
— Contains, in Dutch: (fols 1r–23v) *Onser liever vrouwen souter*. – (fols 24r–39v) Prayers to angels, saints and martyrs. – (fols 40r–49v) *Ceders tabernakel*. – (fols 49v–50v) *Sinte Bernaerts testament*. – (fols 51r–53v) *Uter wisheit van allen godes hilligen*. – (fols 54r–69v) Prayers.

Parts 2–3, 5–6
— Paper ; printed
— Contains printed works: (fols 70–83) *Bethlem, een devote meditacie op die passie ons liefs heeren* (Leiden: Jan Severszn, after 1514). – (fols 84–92) *Alderprofitelicste oeffeninghe vanden XV bloetstortinghen ons liefs heren Jhesu Cristi* (Antwerp: Henr. Eckert van Homberch, c. 1512). – (fols 159–166) *Vrede si mit u* (Amsterdam: Hugo Janszn van Woerden, n.d.). – (fols 167–189) *Een schoone leere ende onderwysinghe van berou ende van der bijcht* [Deventer: Richard Pafraet, between 1492 and 1500] (*Incunabula in Dutch Libaries*, nr. 1425).

Part 4
— 15th/16th century, c. 1500 ; Low Countries
— fols 93–158 : pen-flourished initials ; 138 x 95 mm — Paper and parchment ; Gothic script: Hybrida ; 18 lines on 97 x 67 mm.
— Contains: (fols 93r–133v) *Spiegel der menscheit*. – (fols 135r–140v) *Exempel van Jhesus brudegom alre oetmodigher joncfrouwen*. – (fols 140v–142r) Treatise. – (fols 142r–145v) *Van XII graden der oetmodicheit*. – (fols 145v–156v) *Capittel van den vrede*. – Empty: fols 134, 157–158.

11 | BPL 21 — De bello Judaico / Flavius Josephus
— 9th century, last quarter ; France, northeastern part
— 1 volume, 112 leaves ; 328 x 267 mm — Parchment ; Carolingian script ; 34 lines on 264 x 182 mm.
— Contains: (fols 3r–112r) *De bello Judaico* / Flavius Josephus. Translation/adaptation from the Greek by Pseudo-Hegesippus, in five books.
— Bought from books owned by Isaac Vossius at an auction held by Petrus Leffen, Leiden, 30 November 1666. First mentioned in the Leiden catalogue of 1674 (Spanhemius 1674), p. 400 (nr. 22).

Fragment (Latin)
— 7th century, second half ; France
— 2 leaves (1 bifolium) ; 315 x 262 mm — Parchment ; Uncial script (*scripta continua*) ; 2 columns, 31 lines on 245 x 216 mm.
— Maculature. Flyleaves contain text from: (fols 1r–2v) *Historia Francorum* / Gregory of Tours. – Musical notation on fol. 2r (added in 10th century).

12 | BPL 114 — Lex Romana Visigothorum / Aegidius, and other text(s)
— 8th/9th century ; France, central part: Bourges?
— 1 volume, 166 leaves : pen-flourished initials, drawing ; 252 x 155 mm — Parchment ; Carolingian script ; 26 lines on 198 x 114 mm.
— Contains: (fols 1r–8v) *Etymologiae* / Isidore of Seville. Excerpts from book X, chapters 5–6; also contains diagrams (fols 5–6), explaining relations of consanguinity. – (fols 9r–88v) *Lex Romana Visigothorum* (*Breviarium Alarici*) / Aegidius. – (fols 89r–166v) *Formulae Marculfi* etc.
— Bought from books owned by Isaac Vossius at an auction held by Petrus Leffen, Leiden, 30 November 1666. First mentioned in the Leiden catalogue of 1674 (Spanhemius 1674), p. 408, nr. 174.

13 | VLO 15 — Notebooks of Ademar of Chabannes
— 11th century, c. 1010–1033, with some 10th- and 13th-century fragments and notes ; France, southern part: Limoges
— 14 volumes, 212 leaves : pen drawings, marginal illustration ; 160/250 x 105/150 mm — Parchment ; Carolingian script ; 16–60 lines, written space varies: 110/195 x 80/125 mm.
— The present 14 booklets of this manuscript are composed of 27 quires in which Ademar of Chabannes (989–1034) copied texts and drawings. (Other hands indicated by **).
— Part of the library of Isaac Vossius, which was bought from his heirs in 1690.

Booklet I (fol. 1)
— Contains: (fol. 1r–v) **Historical notes by Bernard Itier (1163–1225).

Booklet II (fol. 2–11)
— Contains: (fols 2r–4r) Drawings (scenes from New Testament; Prudentius' *Psychomachia*). – (fol. 4v/1–7) Introductory letter to Aesop's fables / 'Romulus'. – (fol. 4v/7–45) *Versus in laude S. Benedicti = Historia Langobardorum* / Paul the Deacon. Excerpt from book 1 – (fol. 4v/45–47) *Sententiae septem sapientium*. Excerpt based on *Ludus septem sapientium* / Ausonius. – (fols 4v/47–5v/36) *Aenigmata* / Caelius Firmiatus Symphosius. – (fol. 5v/37–45) *Aenigmata*. Anonymous. – (fols 5v/45–8r/18) *Fabulae* / Avianus. – (fol. 6v margin)

Neumes. – (fol. 8r/18-23) *De laboribus Herculis* / Ausonius. – (fols 8r/23-10r/8) *De martyrio Maccabaeorum* / Pseudo-Hilary of Poitiers. – (fol. 10r/8-33) *Carmen de ponderibus et mensuris* / Remmius Flavianus. – (fols 10v/34-11v) *Periegesis* / Priscian. Incomplete.

Booklet III (fol. 12-13)

— Contains: (fol. 12r-v/24) **Praefatio in arte Donati*. – (fol. 13r) **Ars minor* / Aelius Donatus. Fragment. – (fol. 12r/3 margin) *Scholica Graecarum glossarum* (continuation of fol. 107r). – (fol. 12r margin) *Glossae miscellaneae*. – (fol. 12r-v margin) Charms, recipes. – (fols 12v margin, 13r margin, 13v) *Glossae biblicae*.

Booklet IV (fol. 14-19)

— Contains: (fols 14r-15r) **Glossary: *Haec quicumque legis*. Fragment. – (fols 15v-19v) *Glossae biblicae* (continuation).

Booklet V (fol. 20-21, 30-31)

— Contains: (fol. 20r) *De sancto Benedicto abbate* / Odo of Cluny. Fragment of sermon 3. – (fols 20v-21r) *Martyrologium* / Pseudo-Bede the Venerable. – (fol. 21v/1-28) *Conflictus veris et hiemis* / Pseudo-Alcuin of York. – (fols 21v/29 ∧ 30r/29) *Epitaphia Virgilii*. – (fol. 30r/30-32) *Versus scottorum*. – (fols 21v ∧ 30r margins) Tonalities. – (fols 21v ∧ 30r) *De artibus ac disciplinis liberalium litterarum* / Cassiodorus. Fragment. – (fol. 30r margin) Temporal adjuncts (*quando ∧ ante*). – (fol. 30v/1-12) *De est et non* / Pseudo-Priscian (Ausonius). – (fols 30v/13-31v) *In principio* (*Liber Alchandreus*).

Booklet VI (fol. 22-29)

— Contains: (fol. 22r) *Glossae biblicae* (continuation). – (fols 22v-29r/17) **Glossary: *Haec quicumque legis*. Final version including Old High German glosses. – (fols 29r/18-29v) *Glossae biblicae* (conclusion).

Booklet VII (fol. 32-36)

— Contains: (fols 32r-32v) *In principio* (*Liber Alchandreus*) conclusion. – (fol. 32v *pars inf.*) Recipes and charms. – (fols 33r-35r) **De mysterio Trinitatis et Incarnationis* / Augustine of Hippo. Fragment of sermon 245. – (fol. 36r) **Monte Libano*. Fragment of a responsory (in a later hand).

Booklet VIII (fol. 37-62)

— Contains: (fols 37r-43r) Drawings (Prudentius' *Psychomachia*). – (fol. 43v) Drawings (biblical, liturgical drama?). – (fols 43v-44r) Meander decoration (drawing). – (fol. 44r) *Carmen in Christi honorem*. Anonymous. – (fol. 44v/1-8) *Carmen XXV* / Publilius Optatianus Porphyrius. – (fol. 44v) *Index operum Prudentii*. – (fol. 44v) Diagram with the four winds (Greek-Latin). – (fols 45r-60v) *Psychomachia* / Prudentius. – (fols 61r-62r/19) *Versus de spera caeli*. – (fol. 62r/21-30) *De signis caeli* / Priscian. – (fol. 62v) *Disticha Catonis* / Pseudo-Cato. Prologue.

Booklet IX (fol. 63-82)

— Contains: (fols 63r-79v/28) *Expositio apocalypseos* / Bede the Venerable. Incomplete. – (fols 79v/29-82v/7) *Expositio in Cantica Canticorum*. Anonymous.

Booklet X (fol. 83-106)

— Contains: (fols 83r-104r/21) **Epigrammata ex sententiis S. Augustini* / Prosper of Aquitaine. – (fols 104r/22-106r) **Carmen ad uxorem* / Pseudo-Prosper of Aquitaine or Pseudo-Paulinus of Nola.

Booklet XI (fol. 107-114)

— Contains: (fol. 107r) *Etymologiae* / Isidore of Seville. Excerpt (II, 29). – (fol. 107r margin) *Scholica Graecarum glossarum* (to be continued on fol. 12r). – (fols 107v-112v/5) **Praeexercitamina* / Priscian. With Tironian notes. – (fols 112v/5-114v) **De figuris numerorum* / Priscian. Incomplete, with Tironian notes.

Booklet XII (fol. 115-154)

— Contains: (fols 115r-147v/7) *Etymologiae* / Isidore of Seville. With Tironian notes. – (fols 135v-136r margin) Neumes. – (fols 138v-144r margin) Excerpts from charters of Saint-Cybard Abbey, Angoulême. – (fol. 141v) **Ex libris of Saint-Martial Abbey, Limoges. – (fol. 147v/7-12) Colour recipes. – (fols 147v/12-148r/9) *De scholis artium in Gallia* / Gauzbertus. Genealogy of grammarians. – (fols 148r/9-153v/31) *Aenigmata* / Aldhelm. – (fols 153v/31-154v) *De metris et enigmatibus ac pedum* (*De septenario*) / Aldhelm.

Booklet XIII (fol. 155-194)

— Contains: (fols 155r-188r/17) *De astronomia* / Gaius Julius Hyginus. – (fol. 185v margin) Hymn with neumes (*Sacerdotes dei*). – (fol. 187r margin) Historical notes on Godefridus' appointment as the archbishop of Bordeaux and the third translation of St Martial (1028). – (fols 188r/20-190r/3) *De natura rerum* / Bede the Venerable. Chapters 14-17; with excerpts from (revised) *Aratus Latinus* and *Scholia Strozziana*. – (fol. 190r/6) *De astrologia Arati*. Excerpt (one line). – (fol. 190r) **List of houses belonging to Saint-Martial Abbey in Limoges / Bernard Itier. – (fol. 190v) empty. – (fols 191v-192r) Computus: texts and tables. – (fols 192v-193r) *Lunaria, Revelatio Esdrae*. – (fols 193v-194r) *Cycli decemnovenales*, 1007-1063. – (fol. 193v margin) Episcopal list of Limoges: *Marcialis – Geraldus*. – (fol. 194r margin) Neumes. – (fol. 194v) Episcopal list of Tours: *Gatianus – Arnulfus*.

Booklet XIV (fol. 195-212)

— Contains: (fols 195r-203v) *Fabulae* / Phaedrus (Romulus). Compilation; with Tironian notes. – (fols 203v-210r) *Propositiones ad acuendos iuvenes* / Alcuin of York (?). – (fol. 206r) Marriage charter. – (fol. 210v) Marriage charter. – (fol. 210v) Cufic lettering. – (fol. 211r-v) Drawings (drafts). – (fol. 212r) *Mensurae crucifixi*. – (fol. 212v) **Note on book theft (14th cent.): "Raymundus de Begonac me furatus fuit"; drawings (?).

14 | VLQ 1 — *De virtutibus herbarum* / Dioscorides

— 11th century ; Apennine Peninsula
— 1 volume, 32 leaves ; 265/280 x 180/190 mm — Parchment ; Beneventan script (fols 1r-13v) and Carolingian script (fols 14r-32v) ; 2 columns, 50-62 lines on c.205/225 x 115/155 mm.
— Contains: (fols 1r-32v) *De virtutibus herbarum* / Dioscorides. Plant texts arranged in alphabetical order. Incomplete (*Acorus – Ficus maritima*).
— Part of the library of Isaac Vossius, which was bought from his heirs in 1690.

15 | VLF 31 — *Liber floridus* / Lambert of Saint-Omer

— 13th century, after 1274 ; France, northern part
— 1 volume, 284 leaves ; c. 100 coloured drawings and maps ; 320 x 225 mm — Parchment ; Gothic script: Textualis and Cursiva ; lay out varies, mainly 2 columns, 48 lines (fols 1-120, 214-223r) and 2 columns, 43-44 lines (fols 121-213r) on 240/245 x 140/150 mm
— Part of the library of Isaac Vossius, which was bought from his heirs in 1690.

16 | BPL 14 E — *Spiegel historiael* (fifth part) / Lodewijk van Velthem

— 14th century, c. 1317 ; Low Countries, southern part: Brabant
— 1 volume, 94 leaves : pen-flourished initials ; 271 x 197 mm — Parchment ; Gothic script: Textualis ; 3 columns, 50 lines on 212 x 158 mm.
— Text is preceded by two folia with later annotations on the contents.
— Bought from the books of Isaac Le Long at an auction held by Salomon Schouten, Amsterdam, in 1744. (*Bibliotheca selectissima*, MSS p. 5, nr. 25)

17 | BPL 3469 — *Boeck des guldenen throens of der 24 ouden* / Otto von Passau
— 15th century, after 1484 ; Low Countries, northern part (east?)
— 1 volume, 152 leaves : pen-flourished initials in blue and red ; 285 x 195 mm — Paper and parchment ; Gothic script: Hybrida ; 2 columns, 40 lines on 190 x 130 mm.
— Manuscript copy of the printed edition by Jacob Bellaert, Haarlem 1484 (*Incunabula in Dutch Libraries*, nr. 1675).
— Bought at an auction held by Bubb Kuyper, Haarlem, in 2002. With financial support from Stichting Dr. Hendrik Muller's Vaderlandsch Fonds, Stichting K.F. Hein Fonds, M.A.O.C. Gravin van Bylandt Stichting and Prins Bernhard Fonds

18(a) | VLF 84 — *Opera philosophica* / Cicero
— 9th century, mid ; France, northern part
— 1 volume, 120 leaves : decorated initials ; 295 x 210 mm — Parchment ; Carolingian script ; 34–36 lines on 220 x 150/155 mm.
— Contains philosphical works by Cicero: (fols 1r–36v) *De natura deorum* / Cicero. Incomplete. – (fols 36v–66v) *De divinatione* / Cicero. – (fols. 66v–71r) *Timaeus* / Plato. – (fols 71r–75v and 77r) *De fato* / Cicero. – (fols 77r–83v) *Topica* / Cicero. Incomplete. – (fols 83v–88r) *Paradoxa stoicorum* / Cicero. – (fols 88r–104v) *Lucullus* / Cicero. – (fols 104v–120v) *De legibus* / Cicero.
— Part of the library of Isaac Vossius, which was bought from his heirs in 1690.

18(b) | VLF 86 — *Opera philosophica* / Cicero
— 9th century, mid ; France, northeastern part
— 1 volume, 192 leaves ; 287 x 205 mm — Parchment ; Carolingian script ; 29 lines on 210 x 140 mm.
— Contains philosophical works by Cicero: (fols 1r–10r, 14v–59r and 171v–176v) *De natura deorum*. – (fols 10v–14r and 59v–102r) *De divinatione*. – (fols 102r–103r and 171r–v) *De fato*. Excerpts. – (fols 103r–109r) *Topica*. Incomplete. – (fols 109r–114r and 116v–118v) *Paradoxa stoicorum*. – (fols 114v–116v and 118v–144v) *Lucullus*. – (fols 144v–162v and 170r–192v) *De legibus*. – Also contains: (fols 163v–169r) *Timaeus* / Plato. Excerpts.
— Part of the library of Isaac Vossius, which was bought from his heirs in 1690.

19 | VLF 30 — *De rerum natura* / Lucretius
— 9th century, c. 825 ; German regions, northwestern part
— 1 volume, 192 leaves ; 323 x 210 mm — Parchment ; Carolingian script ; 20 lines on 235 x 155 mm.
— Text corrected by several hands; oldest identified as that of the Irish scholar Dungal (cf. Bischoff 1977).
— Part of the library of Isaac Vossius, which was bought from his heirs in 1690.

20 | BUR Q 3 — Composite manuscript, two parts (Latin):
1. Treatise on grammar. - 2. *Carmina* / Prudentius
— 1 volume, 181 leaves
— Bought from the library of Petrus Burmannus 'Secundus' at an auction held by Samuel and Johannes Luchtmans, Leiden in 1779 (*Bibliotheca Burmanniana*, p. 15, nr. 2390).

Part 1
— 9th century, second quarter ; France
— fols 1–8 ; 239 x 150 mm — Parchment ; Carolingian script ; 20 lines on 190 x 110 mm.
— Contains: (fols 1–8) Treatise on grammar.

Part 2
— 9th century, second quarter ; France: Saint-Denis Abbey
— fols 9–181 : pen drawings ; 244 x 150 mm — Parchment ; Carolingian script ; 35 lines on 198 x 131 mm.
— Contains poems by Prudentius: (fol. 9r) *Vita Prudentii* (= *De viris illustribus*, chapter 148) / Gennadius of Massilia. – (fols 9r–9v) *Praefatio*. – (fols 10r–29r, 8rv–85r) *Cathemerinon*. – (fols 29v–83v) *Peristephanon*. – (fols 88v–105r) *Apotheosis*. – (fols 105r–119v) *Hamartigenia* (*Amartigenia*). – (fols 120r–149v) *Psychomachia*. – (fols 150r–160v, 160v–178v) *Contra Symmachum* I–II. – (fols 178v–181v) *Tituli historiarum* (= *Dittochaei*). – (fol. 181v) *Epilogus*. Incomplete (only verses 1–9).

21 | BPL 67 — Composite manuscript, two parts (Latin):
1. *Institutiones grammaticae* / Priscian, and other text(s). –
2. *Institutione de nomine et pronomine at verbo* / Priscian
— 1 volume, 218 leaves
— Bought from books owned by Isaac Vossius at an auction held by Petrus Leffen, Leiden, 30 November 1666. First mentioned in the Leiden catalogue of 1674 (Spanhemius 1674), p. 403 (nr. 62).

Part 1
— 9th century, 838 ; France, northern part: Laon?
— fols 1–207 : pen-flourished initials ; 280 x 210 mm — Parchment ; Insular script ; c.34 lines on 220x160 mm (fols 192–197, 201–207: 2 x c.45 lines on 227 x 162 mm).
— Contains: (fols 1r–7v) *Periegesis* / Dionysius of Alexandria (transl. Priscian). – (fols 8r–8v) Commentary on Book I of Priscian's *Institutiones Grammaticae*. – (fols 9r–207v) *Institutiones grammaticae* / Priscian. – Contains also 4 short late-9th-century poems written in the margins, possibly in the hand of John Scotus Eriugena. See Dutton (1992).

Part 2
— 12th/13th century, c. 1100 ; Low Countries, southern part
— fols 208–218 : decorated initial (inhabited) ; 278 x 212 mm — Parchment ; Pregothic script ; 34 lines on 219 x 157 mm.
— Contains: (fols 208r–218v) *Institutio de nomine pronomine verbo* / Priscian.

22 | BPL 82 — *Satyrae* / Persius, and other text(s)
— 10th/11th century ; German regions, western part
— 1 volume, 86 leaves : decorated initials, miniature ; 268 x 174 mm — Parchment ; Carolingian script ; 27 lines on 203 x 105 mm.
— Contains: (fol. 1r) Names of the Muses, the Hesperides etc. – (fols 1v–14v) *Satyrae* / Persius. Glossed. – (fols 14v–86r) *Satyrae* / Juvenal. With commentary by Cornutus. – (fols 86r–86v) Letter.
— Bought from the library of Franciscus Nansius (†1595).

23 | ABL 14 — *Clementinae*, and other text(s)
— 14th century, 1322–1334 ; Apennine Peninsula: Bologna
— 1 volume, 72 leaves : 1 miniature, 2 historiated initials ; c. 435 x 270 mm — Parchment ; Gothic script: Textualis (marginal notes: Cursiva Antiquior) ; textus inclusus: 2 text columns (length varies) and 2 x 84–85 gloss lines on 345 x 217 mm.
— Contains: (fols 1r–71r) *Clementinae* / Clement V (pope). With *glossa ordinaria* by Giovanni d'Andrea. – (fols 71v–72v) Copies of 11 charters and notarial documents from Constance, c. 1325–1335.
— Acquired as part of the collection of Willem Matthias d'Ablaing in 1890.

24 | BPL 67 F — Glossary (Latin), and other text(s)
— 8th/9th century ; France, northeastern part
— 1 volume, 158 leaves ; 231 x 138 mm — Parchment ; Carolingian script ; 4 columns, c. 31 lines on 178 x 100 mm.
— Contains: (fols 1r–128r) Glossaries. – (fols 129r–141v) *Synonyma* / Pseudo-Cicero. – (fols 142r–148r) *Glossae Nonii*. – (fols 148r–149r) Juridical glossary. – (fols 148v–152r) Spiritual glossary. – (fol. 152r) *Voces variae animantium*. – (fols 152v–155r) *Expositiones fidei*. – (fols 155r–158v) *Dialogi quaestionem LXV principium* / Pseudo-Augustine of Hippo. – (fol. 158v) Alphabet.
— Bought from the books of Barthold Nicolaus Krohn at an auction held in Hamburg, 1796 (*Bibliotheca Krohniana*, p. 176, nr. 2304). First mentioned in the Leiden catalogue of 1852 (Geel 1852).

25 | VGQ 7 — *Hermeneumata Pseudodositheana* (Greek and Latin), and other text(s)
— 9th century, second quarter ; German regions, northwestern part: Middle or Lower Rhine region
— 1 volume, 42 leaves ; 255 x 220 mm — Parchment : Greek script (uncial) and Carolingian script ; 4 columns, 29 lines on 195 x 175/185 mm (fols 3–39).
— Contains: (fol. 1r) Medical recipe in Latin. – (fol. 1v) Pen trials. – (fol. 2r) *Decretales* / Innocent II (pope). Excerpt (12th century); owner inscription. – (fol. 2v) Two Latin glosses; Hebrew numerals transcribed in Latin. – (fols 3r–39r) *Hermeneumata Pseudodositheana*. – (fols 39r, 39v–40v) Medical recipes and treatises. – (fol. 40r) Greek glosses, with interpretations in Latin. – (fols 40v–41r) *Carmen nautarum*. – (fols 41r–42r) *Epistula ad Antiochum regem* / Hippocrates. Latin translation. – (fols 42r–v) *Etymologiae* / Isidore of Seville. Excerpts in Greek and Latin. – Also contains two Old German glosses on fols 12v, 40r.
— Original text of fols 1–2 erased; other texts added by various hands (9th and 12th centuries).
— Part of the library of Isaac Vossius, which was bought from his heirs in 1690.

26 | VLQ 106 — *Ænigmata* / Aldhelm, and other text(s)
— 9th century, second quarter ; France, western part
— 1 volume, 24 leaves ; 225 x 150 mm — Parchment ; Carolingian script ; 24–28 lines on 180/200 x 110 mm.
— Contains: (fol. 1r–v) *Liber pontificalis*. Fragment. – (fols 2v–8v) *Aenigmata* / Symphosius. – (fols 8v–25v) *Aenigmata* / Aldhelm. – (fol. 25v) *De lorica* / Aldhelm. In Old English.
— Part of the library of Isaac Vossius, which was bought from his heirs in 1690.

27 | VLO 94 — Lexicon of Tironian notes (Latin)
— 9th/10th century ; France: Reims
— 1 volume, 113 leaves ; 145 x 95 mm — Parchment ; Carolingian script ; 2–3 columns, 15 lines on 115 x 70 mm.
— Contains: (fol. 1r–113v) *Commentarii notarum Tironianarum*.
— Part of the library of Isaac Vossius, which was bought from his heirs in 1690.

28 | BPL 130 — Composite manuscript, two parts (Latin, Dutch):
1. *Expositio in Cantica Canticorum* / Williram of Ebersberg, and other text(s). – 2. *Stromata in Cantica Canticorum* / Angelomus of Luxeuil, and other text(s)
— 1 volume, 214 leaves
— Donated by Peter Vekeman Meerhout in 1597. First mentioned in the Leiden catalogue of 1597(–1603) (*Catalogus principum*), p. B2v.

Part 1
— 11th/12th century, c. 1100 ; Low Countries, northern part: Egmond Abbey
— fols 1–100 ; 227 x 163 mm — Parchment ; Pregothic script (with additions in Gothic script: Textualis) ; 22 lines on 173 x 113 mm.
— Contains: (fols 1r–12r) *Stromata in Cantica Canticorum* (excerpts from ch. 1) / Angelomus of Luxeuil. – (fols 12r–100r) *Expositio in Cantica Canticorum* / Williram of Ebersberg. – (fol. 100v) *Duodecim signa vere dilectionis*.

Part 2
— 11th/12th century, c. 1100 ; Low Countries, northern part: Egmond Abbey
— fols 101–214 ; 227 x 163 mm — Parchment ; Pregothic script ; 20 lines on 173 x 109 mm.
— Contains: (fols 101r–209v) *Stromata in Cantica Canticorum* / Angelomus of Luxeuil. – (fols 210v–212v) Hymn. – (fols 213r–214v) *De symoniaca heresi*.

29 | VLQ 9 — *Herbarium* / Pseudo-Apuleius, and other text(s)
— 6th century, second half ; Apennine Peninsula? or France, southern part?
— 1 volume, 104 leaves : 70 miniatures ; c. 260/275 x 195/200 mm — Parchment ; Uncial script ; 21 and 27 lines on c. 180/190 x 150/155 mm.
— Contains, in Latin: (fols 1r–3v) *Praecepta*. – (fols 4r–5r) *Incantamenta magica*. – (fols 5r–6v) *Remedia ad varios morbos ex herbis*. – (fols 6v–11v) Alphabetical index of diseases dealt with in Pseudo-Apuleius's herbal. – (fols 12r–19r) *De herba vettonica* / Pseudo-Antonius Musa. – (fols 19r–81v) *Herbarium* / Pseudo-Apuleius. – (fol. 82r) *Gynaecia* / Muscio (?) Excerpts (on conception methods). – (fol. 82v) *Gynaecia* / Caelius Aurelianus. Excerpt (on conception methods). – (fols 83r–104v) Fragment from an unidentified medical work (chapters L–CLXXIII up to 100v).
— Part of the library of Isaac Vossius, which was bought from his heirs in 1690.

30 | VLF 4 — Composite manuscript, three parts (Latin):
1. *Homiliarium* / Paul the Deacon. – 2. *Naturalis historia* / Pliny the Elder. – 3. *Compendium historiae in genealogia Christi* / Peter of Poitiers
— 1 volume, 37 leaves
— Part of the library of Isaac Vossius, which was bought from his heirs in 1690.

Part 1
— 9th century, last quarter ; France, northern part
— fols 1–3 ; 410 x 295 mm — Parchment ; Carolingian script ; 2 columns, 42 lines on c. 340 x 250 mm.
— Contains: (fols 1v–3v) *Homiliarium* / Paul the Deacon. Fragment (beginning).

Part 2
— 8th century, first half ; British Isles: England; Northumbria?
— fols 4–33 ; 410 x 290 mm — Parchment ; Insular script ; 2 columns, 37 lines on 340 x 230 mm.
— Contains: (fols 4r–33v) *Naturalis Historia* / Pliny the Elder. Fragment.

Part 3
— 13th century, second half ; France: Paris?
— fols 34–37 : decorated initials ; 410 x 305 mm — Parchment ; Gothic script: Textualis ; 2 columns, 68–89 lines on c. 340 x 220 mm.
— Contains: (fols 34r–37v) *Compendium historiae in genealogia Christi* / Peter of Poitiers. Fragment.

31 | VLQ 79 — *Phaenomena* / Aratus
— 9th century, first half, c. 813–840 ; German regions, northwestern part: Aachen
— 1 volume, 99 leaves : 39 miniatures ; 225 x 200 mm — Parchment ; Capital script (rustic) and added transcription in Gothic script: Textualis ; 15 lines on c. 175 x 150 mm.
— Leiden Aratea. Contains: (fols 2r–92r) *Phaenomena* / Aratus. Latin translation from the Greek by Germanicus Caesar. With additions from the translation/adaptation by Avienus (verses 1740-1762, 1769, 1770, 1773, 1870, 1877, 1878) on fols 97r-v. - Also contains some interlinear glosses, written in Carolingian minuscule, on fols 91r-v, 94r. - Empty: 92v-93v.
— Part of the library of Isaac Vossius, which was bought from his heirs in 1690.

32 | BPL 191 BD — *De computo* / Rabanus Maurus
— 12th century, first half ; German regions: Rhineland (up to the Moselle, including Lower Rhine)
— 1 volume, 26 leaves : decorated initials, drawings ; 263 x 194 mm — Parchment ; Pregothic script ; 38 lines on 201 x 142 mm.
— Also contains an excerpt of Jerome's *Adversus Jovinianum* (concerning finger counting (*Adv. Jov.* I, 3 = *Patrologia Latina* 23, 223-224), inserted and commented upon by the scribe.
— First mentioned in the Leiden catalogue of 1852 (Geel 1852), nr. 470.

33 | SCA 36 — *Elementa* (Greek) / Euclid, and other text(s)
— 14th century ; Origin unknown
— 1 volume, 72 leaves ; 277 x 210 mm — Paper : Greek script ; 33 lines on 190 x 115 mm.
— Contains, all in Greek: (fols 1r–69r) *Elementa* / Euclid. Books 11-15. - (fols 69v–72v) *Centiloquium* / Pseudo-Ptolemy.
— Part of the bequest received from Justus Josephus Scaliger in 1609.

34 | BPL 14 A — *Der naturen bloeme* / Jacob van Maerlant, and other text(s)
— 14th century, third quarter: 1366? ; Low Countries, northern part: Utrecht
— 1 volume, 141 leaves : 24 roundel miniatures (calendar); 29 schematic drawings; 1 full-page miniature with painted border decoration, 631 miniatures, 11 historiated initials, pen-flourished initials ; 307 x 234 mm — Parchment ; Gothic script: Textualis ; 2 columns, 36–38 lines on 237 x 186 mm.
— Contains: (fols 1v–7r) Illustrated calendar. - (fols 7v–23v) *De natuurkunde van het geheelal* / pseudo-Gheraert van Lienhout. - (fols 25v–141r) *Der naturen bloeme* / Jacob van Maerlant.
— Bought from the books of Isaac Le Long at an auction held by Salomon. Schouten, Amsterdam, in 1744 (*Bibliotheca selectissima*, MSS pp. 5-6, nr. 28).

35 | SCA 1 — *Regulae abaci* / Adelard of Bath
— 14th/15th century, c. 1400 ; France: Paris
— 1 volume, 18 leaves : historiated initial ; 399 x 311 mm — Parchment ; Gothic script: Cursiva ; 2 columns, 42 lines on 245 x 177 mm.
— Part of the Scaliger bequest, received in 1609.

36 | LTK 191 — Composite manuscript, six parts (Dutch):
1. *Roman van Ferguut*. - 2. *Floris ende Blancefloer* / Diederik van Assenede. - And other part(s)
— 1 volume, 146 leaves
— Long-term loan from the Maatschappij der Nederlandse Letterkunde (MNL). Part of the bequest of Zacharias Hendrik Alewijn, received by the MNL in 1789. Former MNL shelfmark: 104.

Part 1
— 14th century, c. 1325 ; Low Countries, southern part: Dender region
— fols 1–32 : 1 historiated initial (fol. 1r), pen-flourished initials ; 248 x 165 mm — Parchment ; Gothic script: Textualis ; 2 columns, 44 lines on 217 x 142 mm.
— Contains: (fols 1r–32v) *Roman van Ferguut*.

Part 2
— 14th century, second quarter ; Low Countries, northern part (west)
— fols 33–58 ; 248 x 165 mm — Parchment ; Gothic script: Textualis ; 2 columns, 40 lines on 212 x 140 mm.
— Contains: (fols 33r–58v) *Floris ende Blancefloer* / Diederik van Assenede.

Part 3
— 14th century, c. 1350 ; Low Countries, northern part (west)
— fols 59–84 ; 248 x 165 mm — Parchment ; Gothic script: Textualis ; 2 columns, 41–42 lines on 204 x 125 mm.
— Contains: (fols 59r–84v) *Der ystorien bloeme*.

Part 4
— 14th century, c. 1350 ; Low Countries, northern part (west)
— fols 85–94 ; 248 x 165 mm — Parchment ; Gothic script: Textualis ; 2 columns, 40 lines on 205 x 130 mm.
— Contains: (fols 85r–94v) *Esopet*.

Part 5
— 14th century, c. 1350 ; Low Countries, northern part (west)
— fols 95–103 ; 248 x 165 mm — Parchment ; Gothic script: Textualis ; 2 columns, 36–39 lines on 218 x 140 mm.
— Contains: (fols 95r–103v) *Die bediedenisse van der missen*.

Part 6
— 14th century, c. 1350 ; Low Countries
— fols 104–146 : decorated initials ; 250 x 165 mm — Parchment ; Gothic script: Textualis ; 2 columns, 38–41 lines on 187 x 125 mm.
— Contains: (fols 104r–146v) *Die Dietsche doctrinale*.

37 | LTK 195 — Composite manuscript, two parts (Dutch):
1. *Roman van Heinric ende Margriete van Limborch* / Heinric van Aken. - 2. *Roman van Walewein* / Penninc and Pieter Vostaert
— 1 volume, 182 leaves
— Long-term loan from the Maatschappij der Nederlandse Letterkunde (MNL). Part of the bequest of Zacharias Hendrik Alewijn, received by the MNL in 1789. Former MNL shelfmark: 15.

Part 1
— 14th century, c. 1350 ; Low Countries, southern part: Brabant (west)
— fols 1–120 : decorated initials ; c. 250 x 165 mm — Parchment ; Gothic script: Textualis ; 2 columns, 46 lines on 209 x 125 mm.
— Contains: (fols 1r–120r) *Roman van Heinric ende Margriete van Limborch* / Heinric van Aken.

Part 2
— 14th century, 1350 ; Low Countries, southern part: Flanders (west)
— fols 120–182 : 1 full-page miniature (fol. 120v), 1 decorated initial, pen-flourished initials ; c. 250 x 165 mm — Parchment ; Gothic script: Textualis ; 2 columns, 45–48 lines on 216 x 147 mm.
— Contains: (fols 121r–182r) *Roman van Walewein* / Penninc and Pieter Vostaert.

38 | LTK 537 — *Wigalois* / Wirnt von Grafenberg
— 14th century, 1372 ; German regions: Lower Saxony; Amelungsborn Abbey
— 1 volume, 119 leaves : 49 miniatures, pen-flourished initials ; 240 x 170 mm — Parchment ; Gothic script: Textualis ; 2 columns, 27–28 lines on 182 x 136 mm.
— Long-term loan from the Maatschappij der Nederlandse Letterkunde (MNL). Part of the bequest of Zacharias Hendrik Alewijn, received by the MNL in 1789.

39 | VLQ 60 — *Liber pontificalis*
— 8th/9th century and before 845 ; France: Saint-Amand Abbey (Elno)
— 1 volume, 122 leaves : border decoration, decorated initials ; 245 x 145 mm — Parchment ; Carolingian script ; 2 columns, 28 lines on 195 x 100 mm.
— Contains: (fol. 1r) Excerpts from a commentary on the biblical book Micah / Jerome. – (fols 1v–2v) Commentaries on 1 John:4–10. – (fols 3r–121r) *Liber pontificalis*.
— Part of the library of Isaac Vossius, which was bought from his heirs in 1690.

40 | VLQ 55 — Composite manuscript, two parts (Latin): 1. *Vita Ludgeri* / Altfridus of Münster, and other text(s). – 2. *Cartularium Werthinense*
— 1 volume, 58 leaves. – Two empty paper leaves separating parts 1 and 2 (fols 29, 29a)
— Part of the library of Isaac Vossius, which was bought from his heirs in 1690.

Part 1
— 11th century, after 1085 ; German regions: Werden Abbey?
— fols 1–28 : drawing, historiated initial ; 240 x 175 mm — Parchment ; Carolingian script ; 26 lines on 175 x 125 mm.
— Contains: (fols 1r–27v) *Vita Liudgeri* / Altfridus of Münster. – (fol. 28r–v) *Constitutio pacis dei* / Henry IV (German emperor).

Part 2
— 9th/10th century, c. 900 ; German regions: Werden Abbey
— fols 30–59 ; 240 x 175 mm — Parchment ; Carolingian script ; 30 lines on 190/195 x 130/135 mm.
— Contains: (fols 30r–59v) *Cartularium Werthinense*.

41 | VLF 96 — Composite manuscript, three parts (Latin): 1. *Excerptum de gestis Romanorum pontificum* / Abbo de Fleury, and other text(s). – 2. *Chronicon* / Addo of Vienna, and other text(s). – 3. *Mythologiae* / Fabius Planciades Fulgentius, and other text(s)
— 1 volume, 78 leaves
— Part of the library of Isaac Vossius, which was bought from his heirs in 1690.

Part 1
— 11th century, shortly after 1050 ; France: Fleury Abbey
— fols 1–24 ; 290 x 225 mm — Parchment ; Carolingian script ; 2 columns, 39 lines on 235/240 x 160/165 mm.
— Contains: (fols 1r–13v) *Excerptum de gestis Romanorum pontificum* / Abbo de Fleury. Epitome. – (fol. 14r) *Expositio Vergilianae continentiae* / Fabius Planciades Fulgentius. Excerpt. – (fol. 14r) *De tropis*. Fragment. – (fol. 14v) Note on cities in Gaul. – (fols 15r–23r) *Epitoma de caesaribus* / Pseudo-Sextus Aurelius Victor. – (fol. 24r–v) List of Roman emperors.

Part 2
— 11th century, second half ; France: Fleury Abbey
— fols 25–70 : pen-flourished initials ; 290 x 225 mm — Parchment ; Carolingian script ; 2 columns, 35 lines on 215/220 x 145/150 mm.
— Contains: (fols 25r–68v) *Chronicon* / Ado of Vienna. With marginal notes on Fleury Abbey on fol. 58v. – (fols 69r–70v) *De regibus Francorum*.

Part 3
— 11th century ; France
— fols 71–78 ; 290 x 225 mm — Parchment ; Carolingian script ; 2 columns, 44 lines on 265/270 x 180/190 mm.
— Contains: (fol. 71r) *Mythologiae* / Fabius Planciades Fulgentius. Excerpt. – (fols 71r–73v) *Expositio Vergilianae continentiae* / Fabius Planciades Fulgentius. Excerpt. – (fols 73v–75r) *Expositio sermonum antiquorum* / Fabius Planciades Fulgentius. Excerpt. – (fols 75r–78v) Commentary on Cicero's *Somnium Scipionis* / Macrobius. Excerpt.

42 | BPL 20 — Composite manuscript, two parts (Latin): 1. *Gesta Normannorum ducum* / William of Jumièges, and other text(s). – 2. *Historia regum Britanniae* / Geoffrey of Monmouth, and other text(s)
— 1 volume, 107 leaves
— First mentioned in the Leiden catalogue of 1640 (Heinsius 1640).

Part 1
— 12th century, 1138–1139 ; France: Abbey of Le Bec, Normandy
— fols 2–59 : decorated initials ; 323 x 224 mm — Parchment ; Pregothic script ; 2 columns, 48 lines on 267 x 160 mm.
— Contains: (fol. 1v) Table of contents. – (fols 2r–32v) *Gesta Normannorum ducum* / William of Jumièges (F-redaction). – (fols 33r–38v) *Vita Caroli Magni* / Einhard. – (fols 38v–47r) *Vita Alexandri Magni* (Epitome of Julius Valerius). – (fols 47r–51v) *Epistula Alexandri magni ad Aristotelem*. – (fols 52r–59v) *Historia regum Francorum*. – (fol. 59v) *Genealogia comitum Flandrie*.

Part 2
— 12th century, second quarter ; France, northern part: Abbey of Le Bec, Normandy?
— fols 60–107 : drawing on fol. 60r, decorated initials ; 320 x 217 mm — Parchment ; Pregothic script ; 2 columns, 48 lines on 270 x 160 mm.
— Contains: (fols 60r–101v) *Historia regum Britanniae* / Geoffrey of Monmouth. – (fols 101v–106r) *Historia Britonum* / Nennius. – (fol. 106r–v) *Historia ecclesiastica* (Book VIII) / Orderic Vitalis. Excerpt.

43 | BPL 2429 — Composite manuscript, four parts (Latin, Dutch): 1. *Chronographia* / Johannes de Beke. – 2. *Contra Judaeos* / Nicholas of Lyra. – And other part(s)
— 1 volume, 121 leaves
— Exchanged in return for BPL 10 with the Universitätsbibliothek Breslau in 1942.

Part 1
— 14th century, third quarter ; Low Countries, northern part: Holland
— fols 1–30 : pen-flourished initials ; 289 x 217 mm — Parchment ; Gothic script: Cursiva Antiquior ; 2 columns, c. 52 lines on 238 x 162 mm.
— Contains: (fols 1r–30r) *Chronicon sive gesta pontificum Traiectensium et principum Hollandiae* / Johannes de Beke.

Part 2
— 14th century, mid ; Low Countries
— fols 31–41 ; 290 x 216 mm — Parchment ; Gothic script: Cursiva ;
c. 47 lines on 247 x 166 mm.
— Contains: (fols 32r–36v) *Contra Judaeos* / Nicholas of Lyra. –
(fol. 41r) Note on occurrences in the city of Leiden in 1362. – Empty:
fols 37r–41r.

Part 3
— 14th century, mid ; Low Countries
— fols 42–59 ; 287 x 218 mm — Parchment ; Gothic script: Textualis,
Cursiva ; layout varies.
— Contains: (fols 42r–57r) *Chronicon Egmundanum*. – (fol. 58r)
Request, in Dutch, made to Willem V, Count of Holland. –
(fols 58r–59v) Copy of a charter, in Dutch, for the city of Weesp
(20-5-1355). – Empty: fols 42v, 57v.

Part 4
— 14th century ; Low Countries
— fols 60–121 : pen-flourished initials ; 288 x 214 mm — Parchment ;
Gothic script: Cursiva Antiquior ; c. 41 lines on 227 x 161 mm.
— Contains: (fols 60r–121v) *Historia destructionis Troiae* / Guido de
Columnis.

44 | LTK 273 — *Martyrologium* (Dutch) / Usuard
— 15th century, mid (after 1421) ; Low Countries, northern part:
Utrecht?
— 1 volume, 90 leaves : pen-flourished initials ; 207 x 144 mm —
Paper ; Gothic script: Cursiva ; 35–38 lines on 155 x 100 mm.
— Contains, in Dutch: (fol. 1r) Introductory excerpt from the
Southern Netherlandish translation of Jacob of Voragine's *Legenda
Aurea* by the Bible Translator of 1360, Petrus Naghel. – (fols 1v–96v)
Translation of the *Martyrologium Usuardi*, with prologue and letter
of Usuard to King Charles the Bald.
— Long-term loan from the Maatschappij der Nederlandse
Letterkunde (MNL). Bought by the MNL from the books of Dirk
Cornelis and his son Jan Jacob van Voorst, at an auction held by
Frederik Muller, Amsterdam, 27 January 1860 (*Catalogue abrégé*,
p. 7, nr. 215). Former MNL shelfmark: 11626.

45 | BPL 6 C — *Digestum vetus* / Justinian
— 13th century, first half ; Apennine Peninsula
— 1 volume, 232 leaves ; 388 x 233 mm — Parchment ; Gothic script:
Textualis ; 2 columns, 57 lines on 195 x 110 mm.
— With Accursian gloss.
— Bought from the library of Cornelis van Bynckershoek at an auction
held by Pieter de Hondt, The Hague, 18 november 1743 (cat. p. 6,
nr. 117).

46 | VGQ 6 — *Tragoediae* (Greek): Prometheus / Aeschylus,
and other text(s)
— 14th century ; Origin unknown
— 1 volume, 42 leaves : pen drawing, pen-flourished ornaments and
initials ; c. 255 x 175 mm — Paper : Greek script ; *textus inclusus*:
mostly 1–3 text columns and 60–67 gloss lines on c. 230 x 55/155 mm.
— Contains tragedies by Aeschylus and Sophocles, with interlinear
glosses and scholia in separate columns (1–3), all in Greek: (fols
1r–8r) *Prometheus vinctus* / Aeschylus. Incomplete (first leaves
missing). – (fols 8v–15r) *Septem contra Thebas* / Aeschylus. Preceded
by introduction and list of characters. – (fols 15r–21r) *Persae* /
Aeschylus. Preceded by introduction and list of characters. – (fol.
21v) *Vita Sophoclis*. – (fols 21v–29v) *Ajax* / Sophocles. Preceded by
introduction and list of characters (fols 21v–22r). – (fols 29v–36r)
Electra / Sophocles. Preceded by introduction and list of characters
(fol. 29v). – (fols 36v–42r) *Oedipus tyrannus* / Sophocles. Preceded
by introduction and list of characters (fol. 36v). – (fol. 42v) Various
notes in later hands; drawing of a sailing ship.
— Part of the library of Isaac Vossius, which was bought from his heirs
in 1690.

47 | VLF 49 — *Epistulae ad familiares* / Cicero, and other text(s)
— 15th century, second quarter or second half ; Apennine Peninsula:
Rome?
— 1 volume, 236 leaves : decorated initials ; 300 x 205 mm —
Parchment ; Humanistic script: Textualis ; 33 lines on 205 x 110 mm.
— Contains: (fols 1r–232v) *Epistulae ad familiares* / Cicero. – (fol. 233r)
Noctes Atticae / Aulus Gellius. Fragment (III.8.8)
— Part of the library of Isaac Vossius, which was bought from his heirs
in 1690.

48 | VLQ 80 — *Epistulae* / Pliny the Younger
— 15th century, 1478 ; Apennine Peninsula: Ferrara
— 1 volume, 134 leaves ; 233 x 170 mm — Paper ; Humanistic script:
Semitextualis ; 26 lines (fols 1–89) and 27 lines (fols 90–132) on
140 x 92/95 mm.
— Contains: *Epistulae* / Pliny the Younger. Incomplete (starts at book
1.3, 3; book 8 missing). Glossed.
— Part of the library of Isaac Vossius, which was bought from his heirs
in 1690.

49 | VGQ 54 — Composite manuscript, eleven parts (Greek):
Theological miscellany
— 15th/16th century – Middle East?
— 1 volume, 463 leaves : pen-flourished and painted ornaments,
pen-flourished initials ; c. 210 x 140 mm — Paper : Greek script ;
layout varies: 20–38 lines on 150/165 x 90/105 mm.
— Part of the library of Isaac Vossius, which was bought from his heirs
in 1690.

Part 1
— Two leaves precede part 1, containing in Greek: (fol. 1r) Notes
(grammatical: excerpt from John VI Kantakouzenos, *Orationes
quatuor contra Mahometem*, 1.3) and owner inscription: '*Christiani
Ravii Berlinatis*'. – (fol. 1v) Table of contents. – (fol. 2r) *Epitaphium
in Demetrium Cydonem* / Manuel Calecas. – (fol. 2r-v) *Oraculum
de restitutione Constantinopolis* / Leo VI. – (fol. 2v) *Capita practica* /
Niketas Stethatos. – (fol. 2v) *Capita ascetica* (CPG 7869) / Isaac of
Nineveh (Isaac Syrus).
— Contains excerpts from ascetic works and other texts, in Greek:
(fols 3r–19r) *Sermones ascetici*. – (fols 19r–26r) *Asceticon* / Isaiah of
Gaza (Isaia Abbas). – (fols 26v–34v) *Doctrinae diversae* I–XVII /
Dorotheus of Gaza. – (fols 35r–49r) *Canones apostolorum*. With
explanations ascribed to Macarius Chrysocephalus. – (fols 49r–58r)
Concilii Nicaeni (I) *canones*. Preceded by a prologue (49r-v). – (fol.
58r-v) *Concilii Constantinopolitani* (II) *canones*. Incomplete (only
Can. 1–2, due to missing leaves). Preceded by a prologue, with
explanations by Theodore Balsamon and Joannes Zonaras (58r). –
(fols 59r–67r) *Dicta patrum contra blasphemiam Latinorum*. Includes:
Symbolum synodi Constantinopolitanea (III, 60v–61r), *Adnotatio
ad symbolum* (61r), *De septem synodis* (61v–62r), *Commentarius in
symbolum* (62r–66v), *De divinis nominibus* (CPG 6602) / Pseudo-
Dionysius the Areopagite. Excerpt (66v–67r). – Empty: fols 67v–68v.

Part 2
— Contains excerpts from various church fathers, in Greek: (fols 69r–70v) *In Johannem homiliae 77, 86* / John Chrysostom. – (fols 70r–71v) *In Acta Apostolorum homilia 1* / John Chrysostom. – (fols 71v–75v*) *Dialogi de Sancta Trinitate* / Maximus the Confessor. – (fol. 75v) *Capita XV* / Maximus the Confessor. – (fols 75v–76v) *Orationis Dominicae expositio* / Maximus the Confessor. – (fols 76v–78v) *Expositio fidei* / John of Damascus. – (fol. 78v) *Pseudo-Clementina 6: Epitome de gestis Petri praemetaphrastica, dicta 'altera'*. – (fols 78v–79r) *Pandectes* / Nikon of the Black Mountain (Nikon Černogorec). – (fols 79r–83r) *Theologica 5: De Spiritu Sancto (orat. 31)* / Gregory of Nazianzus. – (fol. 83r–v) *In Matth. 19, 1-12 (orat. 37)* / Gregory of Nazianzus. – (fol. 83v) *Apologetica vel De fuga (orat. 2)* / Gregory of Nazianzus. – (fol. 85r–v) *De moderatione in disputando (orat. 32)* / Gregory of Nazianzus. – (fols 85r–v, 100–101v) *Ep. 26 ad Evagrium monachum* / Gregory of Nyssa. – (fols 85v–87r) *In Heronem (orat. 25)* / Gregory of Nazianzus. – (fol. 87r) *De dogmate (orat. 20)* / Gregory of Nazianzus. – (fol. 87r–v) *In sancta Lumina (orat. 39)* / Gregory of Nazianzus. – (fols 87v–88r) *In sanctum baptisma (orat. 40)* / Gregory of Nazianzus. – (fols 88r–89v) *De vita S. Gregorii Thaumaturgi* / Gregory of Nyssa. – (fol. 88r–v) *In Basilium (orat. 43)* / Gregory of Nazianzus. – (fol. 88v) *Supremum vale (orat. 42)* / Gregory of Nazianzus. – (fols 89v–93v) *Adversus Eunomium 1–5* / Basil of Caesarea. – (fols 93v–95r, 201v–202v) *De Spiritu Sancto* / Basil of Caesarea. – (fol. 95r–v) *Enarratio in prophetam Isaiam* / Basil of Caesarea. – (fols 95v–97r) *Prologus 8 (De fide)* / Basil of Caesarea. – (fol. 97r) *Regulae brevius tractatae* / Basil of Caesarea. – (fol. 97r–v) *De Spiritu Sancto a–b (homilia)* / Basil of Caesarea. – (fol. 98r–v) *Contra Sabellianos, et Arium, et Anomoeos (homilia)* / Apollinaris of Laodicea. – (fols 99r–100v) *Expositio rectae fidei* / Theodoret of Cyrus (or Justin Martyr?). – (fols 101r–102v) *Ad Ablabium quod non sint tres dii* / Gregory of Nyssa. – (fols 102v–103r) *Ad Petrum fratrem de differentia essentiae et hypostaseos* / Gregory of Nyssa (codex: Basil of Caesarea). – (fol. 103r–v) *Testimonia adversus judaeos* / Gregory of Nyssa. – (fols 103v–104r) *Adversus Macedonianos de Spiritu sancto* / Gregory of Nyssa. – (fols 104r–106r) *Contra Eunomium* / Gregory of Nyssa. – (fol. 106r–v) *Tunc et ipse Filius* / Gregory of Nyssa. – (fols 106v–107r) *Encomium in S. Stephanum protomartyrem I* / Gregory of Nyssa. Excerpt (90, 5–15). – (fol. 107r–v) *Refutatio syllogismorum Camateri* / John XI Bekkos. – (fols 107r–109r) *Quaestiones et responsiones* / Pseudo-Caesarius. – (fol. 109r–v) *De diebus faustis et infaustis* / Pseudo-Esdras propheta. – (fol. 109v) *Anathemata (confessio fidei ad Paulinum)* / Pope Damasus I. – (fol. 109v) *De Fide Ad Petrum* / Augustine of Hippo. – (fol. 110r) *Precationes* / Pope Gregory I. – (fols 110r) *Epistulae* / Jerome. – (fols 110r–111r) *Epistula Synodica (CPG 9418)* / Pope Agatho. – (fols 111r–112r) *Epistula Synodica Ad Sergium Cpl* / Sophronius of Jerusalem. – (fols 112v–113r) *In Ps 32 (homilia)* / Basil of Caesarea. – (fols 113v–114r) *Explanatio XII Capitulorum* / Cyril I of Alexandria. – (fol. 114r–v) *Epistulae (1–92)* / Cyril I of Alexandria. – (fol. 115r–v) *Carmina dogmatica* / Gregory of Nazianzus. – (fol. 116r) *Epistulae* / Nikephoros I of Constantinople. – Empty: fols 116v–121.

Part 3
— Contains, in Greek: (fols 122r–126v) Theological treatise. – (fols 126v–137v) *Sacrum armamentarium* / Andronikos Kamateros. Incomplete (*pars 1: praefatio, exhortatio, florilegium*).

Part 4
— Contains, in Greek: (fols 138r–145v) *Enchiridion* / Epictetus. Christianized paraphrase. Incomplete (chapter 1–31).

Part 5
— Contains, in Greek: (fols 146r–153v) *Divisiones Aristoteleae* / Laertius Diogenes.

Part 6
— Contains various theological texts, in Greek: (fols 155r–167r) *Epistula archiepiscopo Aquileiae de erroribus ecclesiae Occidentalis (seu Epist. 291)* / Photios I of Constantinople. – (fols 167r–170v) *Epistula encyclica ad sedes archiepiscopales Orientis (seu Epist. 2)* / Photios I of Constantinople. Excerpt. – (fols 170r–177v) *Epistula ad Clementem papam de azymis* / John II of Kiev. – (fols 177v–201) *Liber de pane azymo* / Simeon II of Jerusalem. Actually four separate treatises, the second (fol. 191r–v) identified as: *De Azymis* / John of Damascus. – (fol. 201r–v) *De recta sententia liber* / John of Damascus. Excerpt. – (fols 201v–202v) *De spiritu sancto* / Basil of Caesarea. Excerpt. – (fols 202v–206v) *De sancta Trinitate liber* / Cyril of Alexandria. – (fol. 207r–v) Unidentified excerpt. – Empty: fols 154r–v, 208r–v.

Part 7
— Contains, in Greek: (fols 209r–213v) Book of Job. Excerpts. – (fol. 214r–v) *Prologus libri synaxariorum* / Petrus synaxarista. – (fols 215r–228v) *De utilitate mathematicae* / Theon of Smyrna. Incomplete (due to leaves lost after fol. 228).

Part 8
— Contains, in Greek: (fols 229r–254v) *De syntaxi* / John XIII of Constantinople (John Glycis).

Part 9
— Contains, in Greek: (fols 255r–273v) Lexicon: 'Τεχνολογία γραμματικῆς'. Incomplete. With inserted leaf (fol. 265r–v) *Vitae sophistarum* / Flavius Philostratus. Excerpt. – (fols 274r–315r) *Epimerismi* / Georgius Lacapenus. Incomplete (lacks beginning). – (fols 315r–316r) *Opera* / Michael Psellos (codex: Hypatos). – (fols 316r–357r) *De constructione verborum* / Michael Synkellos. – (fols 357v–359v) *De passionibus dictionum* / Tryphon of Alexandria. – (fols 359v–361r) 'Τεχνολογία γραμματικῆς'. – (fol. 361r–v) Scholia on Plato's *Euthydemus*, added in a later hand.

Part 10
— Contains, in Greek: (fols 362r–366v) *In thermas Pythicas* / Paul the Silentiary. With scholia (365r–366v). – (fols 366v–388v) Epigrams (36) from the *Anthologia Palatina* (selected from books 9–11). With interlinear glosses and marginal scholia. – (fols 389v–392v) 'Τεχνολογία γραμματικῆς'. – (fols 392v–393v) Lexicon / Maximus Planudes. Excerpts. – (fols 394r–430v) *Epigrammata* / Maximus Planudes.

Part 11
— Contains, in Greek: (fol. 431r–v) *Vitae philosophorum* / Laertius Diogenes. Excerpt (from *Vita Platonis*). – (fols 431v–460r) Excerpts from works by Plato: *De justo, Axiochus, Definitiones* etc. – (fol. 460r) *De specialibus legibus* / Philo of Alexandria (Philo Judaeus). Excerpts. – (fols 460v–461r) *Homilia de legislatore* / Severian of Gabala. Excerpts. – (fol. 461r–v) *Poemata* / Michael Psellos. Fragment.
— Two leaves follow part 11, containing in Greek: (fols 462r–463r) *Theologica* / Michael Psellos. Excerpt. – (fol. 463v) Pen trials.

50 | MAR 57 — Iliad (French) / Homer
— 16th century, c. 1540 ; France
— 1 volume, 24 leaves : one gold initial ; 170 x 125 mm — Parchment ; Gothic script: Cursiva ; 16 lines on 97 x 85 mm.
— Contains a French translation, by Hugues Salel, of Homer's *Iliad* (book 3).
— Bequeathed as part of the collection of Prosper Marchand in 1756.

Glossary

Cross-references within definitions to terms defined elsewhere within this glossary are indicated by SMALL CAPITALS.

Abbreviation | Process of representing words by a shortened form or symbol. Principal forms include abbreviation by contraction, where letters are omitted from within a word e.g. *dš = d(eu)s*), and abbreviation by suspension, where letters are omitted from the end of a word (e.g. *cō = co(ninc)*).

Alum-tawed | Process of treating an animal skin through its preservation in a solution of alum potash (aluminium and potassium sulphates) and other substances, resulting in a supple, usually yellowy-white in colour, material that is frequently used in BINDING.

Ascender | Part of the vertical component of a letter that extends above the X-HEIGHT of a SCRIPT (the height of its MINIM stroke), as seen, for example, in the letters *d, h,* and 'tall *s*' in a MINUSCULE script (cf. DESCENDER).

Banderole | Scroll-formed device for framing words in an image, usually used to evoke speech.

Baseline | The writing line, generally marked with RULING, upon which a SCRIBE writes text.

Beneventan minuscule | MINUSCULE SCRIPT common in the southern regions of Italy, in use throughout the medieval period from the eighth century onwards. Characterised by its distinctive letter forms (e.g. *a, t, r*) and idiosyncratic LIGATURES, it is a more angular script than CAROLINGIAN MINUSCULE.

Bifolium | Sheet of PARCHMENT, PAPER or other writing support folded in two across the short axis, yielding two LEAVES (four pages). The basic component of a QUIRE.

Binding | External protective structure adhered to the front, back and spine of the BOOK BLOCK, consisting of a limp cover or stiff BOARDS. Often covered in leather, PARCHMENT or decorative paper, and sometimes furnished with metal fixings or closures.

Blind ruling | Practice of RULING lines for carrying text on a LEAF with a sharp object (such as a STYLUS). Also known as DRYPOINT ruling, this technique impresses lines on both the RECTO and VERSO of the leaf.

Boards | Front and rear protective covers of a CODEX-form book, usually rectangular in form, and made of wood or, later, card.

Book block | Unitary form of the assembled FOLIA or pages of a book, excluding its cover or BINDING.

Bookhand | A SCRIPT executed with a certain degree of formality or concern for legibility that is used for copying books.

Book of hours | Popular late medieval compilation of religious texts which allowed its (often lay) reader to pray the canonical hours (set moments for prayer throughout the day), and so follow medieval monastic practices.

Border decoration | Decoration presented in the space surrounding the written text.

Canon law | The body of law used to determine ecclesiastical matters.

Carolingian minuscule | A SCRIPT popularised during the reign of Charlemagne (king of the Franks, 768-814), characterised by its legible, rounded letter forms and minimal use of LIGATURES. Also known as Caroline minuscule, this script remained in use into the twelfth century, with some of its forms revived in HUMANIST MINUSCULE in the fifteenth century.

Cartulary (*cartularium*) | A book into which charters, deeds, or other documentary material were copied for record and preservation. Often copied in medieval religious communities.

Catchword | A word added at the end of a QUIRE, in its lower MARGIN, indicating the first word of the subsequent quire and useful for ordering quire elements (cf. QUIRE SIGNATURE).

Chain lines | Widely spaced lines visible on medieval PAPER, usually oriented in parallel to the shorter end of a sheet, produced by the wire mesh of the papermaker's mould (compare LAID LINES).

Codex (pl. codices) | Book form where the constituent leaves (arranged in QUIRES) have been bound together at one edge (the spine). Often used as a generic term to refer to manuscripts in this form.

Codicology | Study of the material, structure, and other physical aspects of a book (CODEX).

Codicological unit | A number of QUIRES worked in a single operation, containing a complete text or set of texts.

Collation | 1. A physical, technical, description of the structure of a manuscript; 2. The process of comparing versions of a text and identifying variants.

Colophon | Note penned by a SCRIBE, which may include details like the place or date of production, along with personal details such as the scribe's name.

Composite | Manuscript volume containing two or more CODICOLOGICAL UNITS.

Computus | Science of time-reckoning (including the calculation of the date of Easter). Also used in a more general fashion to describe processes of calculation.

Convolute | See COMPOSITE.

Copyist | See SCRIBE.

Cursive | Handwriting characterised by connected letter forms resulting from the SCRIBE not raising their pen between each element. Often favoured in contexts where speedy, informal writing was required. Used as a BOOKHAND (*cursiva*) from the thirteenth century onwards.

Descender | The part of the vertical component of a letter that extends below the BASELINE of a script (defined as the ruled line upon which the script sits), as seen for example in the letters *p* and *q* in a MINUSCULE SCRIPT (*cf.* ASCENDER).

Display script | A SCRIPT distinctive from that used elsewhere in a manuscript, often on account of its higher grade of formality, employed to articulate text divisions and headings.

Double-leaf | See BIFOLIUM.

Drypoint | Markings made on a page with a sharp tool (e.g. a STYLUS), without use of ink.

Evangeliary | A liturgical book containing all or parts of the Gospels, the four principal books of the biblical New Testament, designed for use in religious services and often ordered according to the liturgical calendar.

Exemplar | The manuscript which serves as a model for the copied text.

Ex libris | A written note, printed stamp or pasted-down bookplate, often placed at the opening or end of a book, conveying details of ownership and useful in reconstructing the PROVENANCE of a book.

Explicit | Concluding words of a text, sometimes accompanied by the word *explicit* (colloquially, 'it is finished'). (cf. INCIPIT).

Eye skip | An unintentional error resulting from the SCRIBE's eye jumping from one line or passage in the EXEMPLAR to another, or from one instance of a particular word or letter combination to another, leading to the omission or repetition of text in the copied manuscript.

Flyleaf | LEAF at beginning or end of a manuscript intended for the protection of the BOOK BLOCK from external factors (including the abrasion of the BINDING).

Folio (fol. / fols) | LEAF of PARCHMENT or PAPER (see also RECTO, VERSO).

Foliation | Continuous numbering of the LEAVES of the manuscript, usually marked in the upper right corner of the RECTO of the FOLIO. Often supplied later.

Fore edge | Edge of the BOOK BLOCK parallel to its bound spine.

Gloss | Short annotations accompanying the text, often inserted in the MARGIN (marginal gloss) or into the INTERLINEAR SPACE between the text lines (interlinear gloss). In a narrower sense, annotations that specifically comment on the semantic or linguistic content of the text.

Grisaille | An artistic style popularised from the fourteenth century onwards whereby miniatures and other decoration is presented in varying shades of grey.

Gothic script | A family of SCRIPT types commonly in use from the thirteenth century onwards. Includes LITTERA TEXTUALIS, a Gothic BOOKHAND, along with Gothic CURSIVE hands and mixed forms, such as HYBRIDA.

Hand | An individual SCRIBE's interpretation of a given SCRIPT.

Historiated initial | A decorated INITIAL depicting narrative elements relevant to the text at hand.

Hybrida **(hybrid script)** | A MINUSCULE SCRIPT commonly in use from the fifteenth century onwards which utilised letter forms from Gothic LITTERA TEXTUALIS and CURSIVE scripts (e.g the single-compartment *a*, *f* and tall form of *s* descending below the BASELINE, and loopless ASCENDERS).

Humanist minuscule | A MINUSCULE script type popularised in humanist circles in Italy in the fifteenth century. Characterised by its revival of letter forms derived from CAROLINGIAN SCRIPT, its rounded aspect and a reduction in use of features of compression associated with GOTHIC SCRIPTS.

Illumination | Decoration of a manuscript with metallic (gold or silver) pigments. Also used in a more general sense to connote extensive colour decoration.

Incipit | Opening words of a text, sometimes accompanied by the word *incipit* ('it begins') (cf. EXPLICIT).

Interlinear space | The space between the written lines of text. Predetermined by the distance between the ruled lines and the size of SCRIPT used.

Initial | Enlarged or otherwise emphasised letter marking the beginning of a text or section or text (see also HISTORIATED INITIAL).

Insular | Adjective referring to the style or script of manuscripts produced in the islands of Ireland or Britain or inspired by the style of such manuscripts. Insular MINUSCULE is a SCRIPT type characterised by distinctive letter forms (such as a flat-topped 'g') commonly in use in the islands of Ireland and Britain in the early medieval period.

Laid lines | Narrowly spaced lines visible on medieval PAPER, usually oriented in parallel to the longer end of a sheet, produced by the wire mesh of the papermaker's mould (cf. CHAIN LINES).

Leaf | Sheet of PARCHMENT or PAPER; half of a folded BIFOLIUM.

Lemma | 1. A word to be defined; 2. A segment of text which receives commentary.

Liber | Latin term for 'book'.

Ligature | The linking of two adjacent letter forms whereby the basic form of one or both letters is modified in the process. In extreme cases a new character results, as is the case in the formation of the &, a ligature of *e* and *t* (*et*).

Littera textualis | A GOTHIC MINUSCULE BOOKHAND in popular use from the thirteenth century onwards, characterised by its angular letter forms, its vertical and horizontal compression (achieved through the use of techniques such as the 'biting' of letters, where two letters share a common stroke) and enhanced attention to the treatment of the BASELINE of the SCRIPT (as seen, for example, in the systematic addition of stylised 'feet' to MINIM strokes).

Life (*Vita*) | A biographical treatment of a significant figure such as a saint or pope. In the medieval period Lives (*Vitae*) often highlighted the moral qualities of their subjects, encouraging emulation.

Manicule | Sketch of a pointing hand, used to indicate a passage of note in a text.

Margins | Space between the boundaries of the WRITTEN SPACE and physical boundaries of a page. In principle, this space is left blank to contrast with the (written) area of the page but in reality, the margins of medieval manuscripts often contain notes and drawings.

Martyrology | A work ordered according to the liturgical calendar with brief entries giving details of the martyrs and saints to be commemorated on specific dates of the year.

Majuscule | Type of SCRIPT which is written without DESCENDERS or ASCENDERS (e.g. UNCIAL, RUSTIC CAPITALS) and so wholly (or ideally) contained in the space between the ruled BASELINE and X-HEIGHT of a script (cf. MINUSCULE).

Mise-en-page | The layout of the page and planned execution of textual and decorative elements.

Minim | Vertical element of letters such as *i*, *m*, and *n*, formed by a single pen stroke and constituting a SCRIPT's most basic constituent form.

Minuscule | Type of SCRIPT in which some letter shapes are constructed using ASCENDERS and DESCENDERS, and so extend below the BASELINE or above the X-HEIGHT of a script (cf. MAJUSCULE).

Miniature | Painted illustration in a manuscript.

Opening | The VERSO and RECTO of two adjacent LEAVES as viewed when a book is opened at any point.

Origin | Place of production of a manuscript (cf. PROVENANCE), determined either by explicit internal evidence (e.g. scribal COLOPHON) or deduced from production features (e.g. characteristics of SCRIPT).

Palimpsest | Reused PARCHMENT or other writing support produced by erasure through scraping of an existing layer of text and its overwriting with new text.

Palaeography | The study of SCRIPT.

Parchment | Writing surface made from an animal skin that has been de-haired, de-fleshed, stretched under tension and dried. Prior to use for writing, the parchment surface could be polished (e.g. with a pumice), cut to size and treated to enhance absorbency (e.g. with chalk).

Paper | Writing surface made during the medieval period from pulped and fermented rags (for example, of linen and flax), which were shaped into a sheet using a mould of wire mesh, before being dried and sized (applying a substance to control the sheet's absorbency).

Pecia (pl. *peciae*) | Sections of a manuscript EXEMPLAR (containing an authorised version of a text) which were loaned to COPYISTS for duplication. Common practice in medieval university environments.

Pen flourishing | Embellishment with decorative pen strokes.

Penwork | Decoration supplied with a pen.

Provenance | Details of ownership (personal or institutional) of a manuscript, reconstructed on the basis of internal (e.g. notes of possession) and external evidence (e.g. library catalogues) (cf. ORIGIN).

Protogothic (pre-Gothic) | Transitional SCRIPT type between CAROLINGIAN and GOTHIC SCRIPTS popularised in the 'long twelfth century'. Characterised by the incorporation of features that would ultimately be associated with Gothic script, such as the vertical and horizontal compression of characters and words (through innovations like the biting of letter forms and increased use of ABBREVIATIONS) along with a progressive angularity of appearance (in comparison to Carolingian script).

Psalter | A manuscript containing the Book of Psalms, the Old Testament collection of songs and verses, frequently recited in medieval religious houses.

Quire | A group or gathering of folded (BIFOLIA) or single LEAVES, sewn at the fold for assembly into a BOOK BLOCK. A gathering of four bifolia is termed a quaternion, consisting of eight leaves.

Quire signature | Mark (alphabetic or numeric) added in the lower MARGIN of the VERSO of the concluding FOLIO of the QUIRE to indicate the order in which the quires are to be bound (cf. CATCHWORD).

Recto (r) | The front of a FOLIO of PARCHMENT or PAPER (cf. VERSO).

Reagent | Chemical used to increase (temporarily) the visibility and legibility of a manuscript text. A popular tool in the working arsenal of the nineteenth-century scholar, reagents often stained and damaged the writing surface.

Rubric | A passage of text written in red ink. Sometimes used in a more generic sense to refer to headings (distinguished by coloured inks or DISPLAY SCRIPTS).

Rubrication | Process of adding red ink to a text (for headings and emphasis of other features).

Ruling | Preparatory stage in preparing PARCHMENT or PAPER to receive text whereby the WRITTEN SPACE is delineated by vertical and horizontal lines, and filled with horizontal lines which can be utilised as the BASELINE of SCRIPTS. Also the result of this process, usually done either in DRYPOINT, with lead (plummet) or with ink.

Running title | Title of text or indication of book-part added in the upper MARGIN of the page and repeated on every OPENING. Often split across the VERSO (left of opening) and RECTO (right of opening). Frequently RUBRICATED.

Rustic capitals | MAJUSCULE script type used in antiquity and as a DISPLAY SCRIPT throughout the medieval period. Characterised by its narrow letter forms.

Sewing holes | Holes pierced or cut into the folds of gatherings (QUIRES) permitting their linkage by sewing.

Shelfmark | See SIGNATURE.

Signature | Identificatory mark of a manuscript (usually in alpha-numeric form) kept in an institutional or personal book collection, which may comprise abbreviated information concerning size, language, acquisition details and present location in collection (shelfmark).

Scribe | The copyist of a manuscript.

Script | Group of conventional letter forms in common use in a particular period or place for writing by hand.

Scriptura continua (*scriptio continua*) | Text written without word spacing and with minimal (if any) punctuation. Standard form of presenting text in Antiquity.

Stylus | Sharp-pointed hand-held tool, used for engraving characters on a WAX TABLET and marking PARCHMENT (e.g. in RULING, tracing drawings, adding informal annotations).

Tackets | Twisted PARCHMENT strands or threads of other materials used to (provisionally) join gatherings of LEAVES into QUIRES and affix quires to BINDINGS.

Text block | See WRITTEN SPACE.

Tironian notes | Form of Roman shorthand developed in the first century BC. Revived in the Carolingian period for purposes of note-taking and for transcribing longer texts.

Uncial | Rounded MAJUSCULE BOOKHAND developed in Late Antiquity and used throughout the medieval period as a formal DISPLAY SCRIPT.

Verso (v) | The rear of a folio of PARCHMENT or PAPER (cf. RECTO).

Watermark | A pattern (such as a symbol or set of initials) impressed upon a sheet of PAPER by the wire mesh of the papermaker's mould. Such marks were often used to indicate the origin or quality of the paper, and are useful for localising and dating paper stocks (and by extension, the books in which such paper is used).

Wax tablet | Writing surface formed of a flat piece of wood covered with a layer of wax, upon which text could be inscribed (and erased), often using a STYLUS.

White-vine decoration | Form of decoration common in fifteenth-century Italian manuscripts, with uncoloured elements that resemble winding vine tendrils (*bianchi girari*). The style was likely inspired by Carolingian models.

Woodcut | Relief printing technique utilising carved wooden blocks. Used in book production for purposes of illustration and decoration.

Written space | The area of the page prepared to receive writing (text block). Usually bound by a grid of vertical and horizontal ruled lines.

X-height | The height of letter forms without any descending or ascending elements as measured from the BASELINE to the top of the letter *x*. Typically the main body of a letter form (such as the rounded bowl of *b* or *p*) will not exceed the x-height.

Index

Numbers in italics refer to illustrations
N.T. = New Testament
O.T. = Old Testament
UBL = Leiden University Libraries

Abbo of Fleury, Saint 244-247
 Excerptum de gestis Romanorum pontificum
 — in: VLF 96 (no. 41) 234, 235, 244-247, *245*, *246*
abbreviations 24, 25, 26, 27
Ablaing, Willem Matthias d' 45-46, *46*
Abner (O.T.) 86
Accursius 264-265, *265*, *266*
acrostics, *see:* wordplay
Adelard of Bath
 Regulae abaci — SCA 1 (no. 35) 61, *190*, *191*, 216-219, *217*, *218*
Adels-Spiegel (Cyriacus Spangenberg) 233
Ademar of Chabannes
 schoolbooks/notebooks — VLO 15 (no. 13) 112, 113, 122-125, *122*, *124*
Aduard, monastery of 276-277
Aef van Bolgerien 101, 103
Aeneid (Virgil) 154, 163, 229
Aenigmata (Aldhelm) — in: VLQ 106 (no. 27) 168, 169, 178-181, *180*, *181*
Aenigmata (Symphosius) — in: VLQ 106 (no. 27) 168, 169, 178-181
Aeschylus
 tragedies, *Persians*, *Prometheus Bound*, *Seven against Thebes* — in: VGQ 6 (no. 46) 260, 261, 266-269, *269*
Aesop 124, *125*, 177, 222
Africa (Roman province) 158
Agatha, Saint 101
Agnes of France 80
Agricola, Rudolph 274-277, *276*
Ajax (Sophocles) — in: VGQ 6 (no. 46) 267
Al-Majusi, Ali ibn al-Annas
 Liber pantegni 129
Albertus Magnus 214
Albrecht II, Count of Braunschweig-Grubenhagen 232
Alchandreana 218
Alcuin of York 198
Alderprofitelicste oeffeninghe vanden xv bloetstortinghen ons liefs heren Jhesu Christi
 — in: LTK 237 (no. 10) 109
Aldhelm 179
 Aenigmata — in: VLQ 106 (no. 27) 168, 169, 178-181, *180*, *181*
Alewijn, Zacharias Henrik 222-225, 229
Alexander III the Great, king of Macedon 133, *133*, 177

Alexander de Villa Dei
 Doctrinale 255
Alexander Farnese, Duke of Parma 43, 81
Alexandria, Library of 267, 269
Alexis, Saint 29
Alexis Master 28-29
Alkmaar 41, 189, 253
Altfried of Münster
 Vita Ludgeri — in: VLQ 55 (no. 40) 242-243
alum-tawed leather, *see:* leather
Ambrose of Milan, Saint 105, 117, 239, *239*
Amelungsborn, abbey of 232
Amiens 25
Anglo-Saxons 72, 159, 179, 198
Angoulême, Saint-Cybard Abbey 123
Anholt, Fürstlich Salm-Salm'sche Bibliothek 136, *137*
Annas (N.T.) 117
annotations, *see:* glosses
Anselm, Saint 105
Antike Himmelsbilder (Georg Thiele) 202, *202*
Antioch 216-236
Antiquity
 canonisation 267-268
 classical texts 23-24, 37, 48-49, 55-56, 57, 65, 144-147, 148-151, 160-163, 196-199, 200-203, 208-211, 261, 266-269, 270-273, 274-279, 278-281, 282-285
 late antique texts 23, 33, 41, 57-58, 156-159
 scriptura continua 116
 see also: majuscule scripts; rustic capitals; uncial script
Apuleius Platonicus (also: Apuleius Barbarus), *see:* Pseudo-Apuleius
Aratea (Germanicus), Latin translation of *Phainomena* (Aratus)
 Berne *Aratea* 202
 Boulogne *Aratea* 201, 202
 Leiden *Aratea* — VLQ 79 (no. 31) 13, 22-24, 23, 63, *63*, *190*, *191*, 200-203, *201*
 Syntagma Arateorum (edition by Hugo Grotius) 202
Aratus 22
 Phainomena 22
 see also: Aratea (Germanicus)
Arcerius, Johannes *38*
Aristotle 37, 214, 261, 267
Arnaud Gerkens, J.F. d' 54
Arno of Salzburg 239

Arrianus, Lucius Flavius 278
Ars Grammatica (Dositheus Magister) 177
Arthurian romances, *see:* chivalric romances
ascenders, *see:* letters
Atticus, Titus Pomponius 270
Augustine of Hippo, Saint 28, 93, 138, 140, 158, 239, *239*
 De civitate Dei — in: BPL 12 28, *28*
autographs 15, 132, 137
autopsy 16
Auxerre 159, 239
Avianus 123
Avranches, Bibliothèque patrimoniale 251
A.W. Sijthoff (publisher) 64-65

Baflo 276
Baiter, Johann Georg 147
Baldwin, master 159
banderoles (speech banners) 88, *88*, 104, 105, 233, *233*
Bartholomew, Saint (N.T.) 109
baseline 24
Bede the Venerable, Saint 123
 De temporum ratione 206
Bellaert, Jacob 139, 140
Bellum civile (Lucan) — BUR Q 1 32, *32*, 33, 35-36, *36*
Beneventan script (*littera beneventana*) 127
Benoît de Sainte-Maure
 Roman de Troie 253
Bergh, Jan van den 42, 81
Berkvens-Stevelinck, C. 50
Bernard of Clairvaux, Saint 109
Bernard Itier 125
Bernardus Maynardi 166
Bernays, Jacob 151
Berne, Burgerbibliothek 150, 202, 247, *247*
Bertius, Petrus 40
 Nomenclator autorum omnium quorum libri vel manuscripti, vel typis expressi exstant in Bibliotheca Academiae Lugduno-Batavae (Bertius) — 1408 I 57 40, *40*, 50
Bethmann, L.C. 180
Beverwijk, Onze Lieve Vrouwe in Sion monastery 101, 103
bianchi girari, see: white-vine decoration
Bible 69
 commentaries 69, 74, 76, *76*, 82, 123, 187
 interpretation 74, 76, *76*

Vulgate (Latin translation by Saint
 Jerome) 74, 187, 206
 typology (connections between O.T.
 and .N.T.) 69
 vernacular reworkings 69, 82-85
Bible, New Testament (N.T.)
 Epistles — in: BPL 136 C 21, 21
 Epistles of Saint Paul 177
 Gospel of St John 72-73, 89
 Gospel of St Mark 70-71, 72-73, 73
 Gospel of St Matthew 72-73, 86, 86, 88
 Gospel of St Luke 72-73, 88
 Gospels 21, 70-73, 177
 Parable of the Sower 206-207
 Revelations, Book of 69, 138
 see also: gospel books
Bible, Old Testament (O.T.)
 Genesis 65, 69, 82
 Job, Book of 74-77, 278
 Job (Book of), with gloss — BPL 100 A
 (no. 2) 68, 69, 74-77, 74, 75, 76, 77
 Maccabees — in: PER F 17 41-42, 42
 Psalms, Book of 80, 177
 Song of Solomon 109, 186-189
 see also: Octateuch; psalters; Southern
 Netherlands History Bible
Biblissima (portal) 66
Bienboek (Book of Bees)
 (Thomas of Cantimpré) 88
binding 35-36
 rebinding 35-36, 46, 61-62, 69, 98, 120,
 121, 191
 see also: bindings
binding books (registers of book binders) 62
binding loops, see: tackets
bindings; covers 12, 51
 blind toolings 35
 boards 35, 36, 46, 61-62, 69, 112, 113,
 118-121, 118, 119, 120, 121, 191
 closing straps
 coverings 35, 69
 fenestra; title fenestra 35-36, 36
 fastenings
 library stamps 48, 49, 61-62
 limp bindings (flexible covers) 36, 46
 repairing; restoration 61-62, 69, 112, 113,
 118-121, 118, 119, 120, 121
 see also: binding
binions, see: quires
Blanche of Castile 80
Blanche of Navarre 80-81
blind ruling, see: ruling
Blok, Henri 47, 49-50
Blondeel, Jacobus 189
Blount, Thomas 27, 27
boards, see: bindings
Bobbio, monastery of 150, 159
Boeck des gulden throens (Otto von Passau)
 — BPL 3469 (no. 17) 112, 113, 138-141, 138,
 139, 140, 141
Boeren, P.C. 50
Boethius, Ancius Manlius Severinus
 De consolation philosophiae 255
 De institutione arithmetica 218, 219

De institutione musica 218
Bologna 31, 166, 261, 262-263, 264-265, 265
Bonaventure, Saint 141
 Sinte Franciscus leven — BPL 83 47, 47, 48
book production 12-13, 25
 customised production 12-13, 22, 113
 demand for books 21, 22, 91
 export production 96-99
 personalisation of books 22, 91, 113
 professional craftspeople 21-22, 96-99
 printing press 12-13
 religious houses; churches;
 monasteries 21, 25, 28-29, 117
 towns 21-22
bookcases (UBL) 41, 44
 arrangement 51-53, 51, 52
 compactuskasten (rolling stacks) 55, 55
 gallery bookcases 52, 53
 lectrines; plutei 51, 51
bookhands, see: Beneventan script;
 Carolingian minuscule; cursive scripts;
 Gothic scripts; humanist minuscule
 script; Insular scripts; rustic capitals;
 square capitals; uncial script
bookmarkers, physical 33, 33
books of hours 29, 34, 91
 Book of Hours — BPL 2379 29, 29
 Book of Hours — BPL 3769 43
 Book of Hours — BPL 3774 (no. 7)
 22, 90, 91, 96-99, 96
 Book of Hours with calendar and
 colophon — BPL 2747 (no. 8) 61, 90, 91,
 100-103, 100, 101, 102, 103, 259
 Book of Hours belonging to 'ic Zaers'
 — BPL 224 (no. 6) 90, 91, 92-95, 92,
 93, 94, 95
 calendars 91, 93, 97, 100, 101-103, 102
 Hours of the Virgin Mary 29, 91, 92, 95,
 96, 97, 98, 103
 Office of the Dead 97, 98
 penitential psalms 97, 98
 personalisation of 22, 91
border decoration, see: decoration
Bormans, Stanislas 43
Boulogne-sur-Mer, Bibliothèque municipale
 des Annonciades 201, 202
Bourges 119
Bouwman, André
 Inventory of Western Medieval Manuscripts
 Held by Leiden University Libraries
 50, 59, 59, 60
Brabant, duchy of 97, 134
Brabantse Yeesten (Jan van Boendale) 136
Bredius, Henricus 41, 58
Breslau (Wrocław) 255
 Rhedigersche Stadt-Bibliothek 253
 University Library of Breslau 47, 64, 64
Brielle 214
Brill Publishers 65, 203
Broekhusius, Janus 55
Bruges 22, 43
 book production 96-99
 stamped miniatures 98
Brummen 242

Brussels 82
 KBR (Royal Library of Belgium) 155
Buchner, Rudolf 116
Burgundy 27, 81
 library of the dukes of 81
Burman, Pieter 45
Bynkershoek, Cornelis van 265

Caiaphas (N.T.) 117
calendars 173
 'perpetual' calendar 100, 101-103, 102
 liturgical calendar 80, 91, 93, 97, 258, 259
 see also: books of hours
call number, see: shelfmark
canonical hours 91
 see also: hours canon tables (Eusebius)
 — in: BPL 48 (no. 1) 72
Canterbury 30
capitalis quadrata, see: square capitals
capitalis rustica, see: rustic capitals
captions 74, 123, 154-155
card catalogues; card indexes,
 see: catalogues (UBL)
cardboard 61-52, 125, 221
 pH-neutral 62
Carolingian courts 150, 158-159
Carolingian minuscule 23, 25, 25, 26, 27,
 58, 72, 114-115, 117, 127, 150, 154, 173, 177,
 184, 242, 277
cartularies; cartularia; libri cartarum
 (collections of charters) 46-47, 235
 liber cartarum from Werden Abbey
 — in: VLQ 55 (no. 40) 44, 234, 235,
 240-243, 240-241, 242
Castricomius, Pancratius 187, 189
catalogues (UBL) 49-54, 57-58, 59
 card catalogues; card indexes
 49, 49, 56-57
 collection profile of medieval
 manuscripts 59, 60
 cataloguing language 49-50, 57-58
 catalogue of the Bibliotheca Vossiana
 — BPL 127 AF 44
 classification in printed catalogues 51-54
 Codices Vossiani Latini
 (Karel de Meyier) 57
 descriptions of manuscripts
 47-48, 49-50, 55-59
 handwritten 43, 43, 44, 44, 52
 manuscripts catalogues 47, 54
 image repository (Digital Collections)
 15, 37, 58, 65, 66
 indexes 49, 52
 inventories 47
 Leiden library catalogues with descrip-
 tions of medieval manuscripts 49, 50
 list of gifts (Paulus Merula) 40
 Nomenclator autorum omnium quorum libri
 vel manuscripti, vel typis expressi exstant in
 Bibliotheca Academiae Lugduno-Batavae
 (Bertius) — 1408 I 57 40, 40, 50
 online 47, 49, 58, 59, 59, 60, 65
 printed 38, 40, 47-48

Rariorum catalogus (Paulus Merula)
— BA1 C 3 43, *43*, 52
shelf list catalogues 49, 51
catchwords 19, *19*
Cellarius, Andreas
Harmonia Macrocosmica 202, *203*
chain lines 18
Chantilly, Musée Condé 284
Charlemagne, Emperor of the Carolingian Empire 25, 117, 150, 158, 184, 239, 243, 250
Charles I of Anjou, King of Sicily 133
Charles II the Bald, Emperor of the Carolingian Empire 158-159
Charles V, Holy Roman Emperor 81
charters 117, 119, 184, 235, 240-241, 242-243
see also: cartularies
Chrétien de Troyes 221
Christina, Queen of Sweden 35, 43-44, 117, 125, 133
Christopher, Saint 212-213, *215*
chronicles 27, 107, 132, 134, 235, 238-239, 248-251, 253
Chronicon Egmundanum — in: BPL 2429 (no. 43) 253, *254*
Chronographia (Johannes de Beke) — in: BPL 2429 (no. 43) 253, *254*
chronological canons (Eusebius), fragment — in: VLQ 110 A
chivalric romances; Arthurian romances 446, 221, 226-229, 230-233
Cicero, Marcus Tullius 21, 37, 183, 184
De inventione, commentary of Thierry of Chartres on — in: BPL 189 17
De officiis — GRO 36 19
De officiis — in: PER F 25 26, *26*
Epistulae ad familiares — VLF 49 22, 56, 260, 261, 270-273, *271*, *272*, *273*
Philosophical works, 'Leiden Corpus' — VLF 84, VLF 86 (no. 18) 55, 142, 143, 144-147, *144-145*, *146*, *147*
Topica — in: VLF 84, VLF 86 (no. 18) 144-147, *144-145*, *146*, *147*
Circe 195
classical Antiquity, *see*: Antiquity
Claudianus, Claudius 63, *63*-64
Clement V, pope 166, *166-167*
Clignett, J.A. 224
closing straps, *see*: bindings
Clovis I, King of the Franks 116
codex rescriptus, *see*: palimpsests
codicological units; production units 59, 60, 84
codicology 16, 56-57, 65
collation, *see*: text editing
Cologne 134, 177
Colmcille, Saint 207
colophons 16-17, 31, *31*, 56, 101, *101*, 158, 232, 276, *277*
printer's colophons *109*, 110
commentaries
on biblical texts 74, 76, *76*, 82, 123, 187
on legal and theological works 25-26, 166, *167*
see also: glosses

Commentarii notarum Tironianarum — VLO 94 (no. 27) 48, 61-62, 168, *169*, 182-185, *182*, *184*, *185*
Commentary of Thierry of Chartres on *De inventione* (Cicero) — in: BPL 189 17
comparing of text versions, *see*: text editing
composite manuscripts; convolutes 35, *35*, 59
collection of Greek writings from the Near East — VGQ 54 (no. 49) 260, 261, 278-281, *279*, *281*
compendium of spiritual texts — LTK 237 (no. 10) 90, 91, 108-111, *108*, *110*, *111*
composite manuscript — BPL 189 17, 35, *35*
composite manuscript, containing *Esopet* — LTK 191 (no. 36) 220, 221, 222-225, *222*, *223*, *224*, 229
composite manuscript, containing *Gesta Normannorum ducum* (William of Jumièges) — BPL 20 (no. 42) 234, 235, 248-251, *248-249*, *251*
composite manuscript, containing *Ilias Latina* — BPL 1925
composite manuscript, containing Maccabees — PER F 17
composite manuscript, containing *Roman van Limborch* and *Roman van Walewein* — LTK 195 (no. 37) 226-229, *226-227*, 229
composite manuscript from the private library of Filips van Leiden — BPL 2429 (no. 43) 47, 234, 235, 252-255, *252*, *253*, *254*, *255*
computus (measuring time) 123
conservation; preservation 16, 35-36
conservation; preservation (UBL) 60-62
climate 54-55, 61, 63
cushion and snake weights 61, *61*
fire safety 60, 61
storage 62
transport 13, 63
Constantijn the African 127-129
Constantine the Great, Roman Emperor 150
Constantinople 207, 261, 267
Constitutiones Clementinae — in: ABL 14 (no. 23) 142, 143, 164-167, *164-165*, *166*, *167*
continuation errors
convolutes, *see*: composite manuscripts
covers, *see*: bindings
copyists, *see*: scribes
Corbie, abbey of 146
Cornelius Heyns 31
correction 138, 150, *151*
by comparing various copies 143, 146
correction techniques 128, *128-129*, *129*
see also: errors
Cranach the Elder, Lucas 276
cursive scripts 24, 27, *27*, 31
Curtius Rufus, Quintus
Historiae Alexandri Magni — BPL 136 E 31, *31*
Cyclometrica (Josephus Justus Scaliger)
Cyprian, Saint 105

Dalmatius, bishop of Rodez 116
Dat spiegel der monicken — in: LTK 237 (no. 10) 109, 110-111
damage 51, 61, 113
dating of manuscripts 16-17, 24, 55, 56, 58, 59, 60, 101-103
David, King (O.T.) 80, 86
David of Augsburg
Profectus religiosorum 110-111
De architectura (Vitruvius) — in: VLF 88 30, *30*
De astronomia (Hyginus), illustrated by Ademar of Chabannes — in: VLO 15 (no. 13) 125
De Belder, Kurt 65
De bello Judaico (Flavius Josephus), *see*: *De excidio Hierosolymitano*
De civitate Dei (Augustine of Hippo) — in: BPL 12 28, *28*
De computo (Rabanus Maurus) — BPL 191 BD (no. 32) 14, 190, 191, 204-207, *204-205*, *207*
De consolatione philosophiae (Boethius) 255
De excidio Hierosolymitano (Pseudo-Hegesippus), adaptation of *De bello Judaico* (Flavius Josephus) — BPL 21 (no. 11) 44, 61, 112, 113, 114-117, *114-115*, *117*
De gestis Britonum (Geoffrey of Monmouth) — in: BPL 20 (no. 42) 250
De institutione arithmetica (Boethius) 218, *219*
De institutione musica (Boethius) 218
De inventione (Cicero), commentary of Thierry of Chartres on — in: BPL 189 17
De materia medica (Dioscorides) 194
alphabetised Latin version — VLQ 1 (no. 14) 112, 113, 126-129, *126*, *128*, *129*
De natura rerum (Thomas of Cantimpré) 214
De nuptiis Philologiae et Mercurii (Martianus Capella) — in: BPL 87 49, 57, *57-58*, *59*
De officiis (Cicero)
GRO 36 19
in: PER F 25
De re diplomatica (Jean Mabillon) 16
De rerum natura (Lucretius)
'Oblongus' — VLF 30 (no. 19) 142, 143, 148-151, *148-149*, *151*
'Quadratus' — VLQ 94 31, *31*, 150, 151, *151*
De temporum ratione (Bede) 206
De Vreese, Willem Lodewijk 56, *56-57*
decoration 27-30
border decorations 29, 97, *98*
illuminated pages *70-71*, *72-73*
interlace 72, *73*
penwork 86, 87, *88*, *89*, 94, 138
styles 72, 88, 94, 97, 98, 270, *272*, *273*
Delft 88
Delft University of Technology 181
Master of the Delft Grisailles 92, 95, *95*
Demosthenes
orations — BPG 33 38, *38*
Der naturen bloeme (Jacob van Maerlant) — BPL 14 A (no. 34) 54, 190, 191, 212-215, *212-213*, *214*, *215*

313

Der Ystorien bloeme — in: LTK 191
 (no. 36) 224
descenders, *see*: letters
descriptions of manuscripts 47-48, 49-50, 55-59
 bibliographic records 49
 language for descriptions 49-50, 57-58
Deventer 243
Devon, earls of 98
diagrams 34, 34, 202
 lettered 208-211, 209, 210, 211
dictionaries 169, 172, 182-185
 see also: lexicons
Dicuil 151
Die bediedenisse van der missen — in: LTK 191
 (no. 36) 224
Diederik van Assenede
 Floris ende Blancefloer — in: LTK 191
 (no. 36) 46, 224
 Floris ende Blancefloer, fragment
 — in: LTK 2040 46
Dietrich, Franz 180
Dietsch doctrinale — in: LTK 191 (no. 36) 224
Digestum vetus (Justinian) 167
 with glosses and *additiones* — BPL 6 C
 (no. 45) 260, 261, 262-265, 262-263, 265
digitisation 65-66, 203
 digital photography 17, 65-66
 image repositories 15, 37, 58, 65-66
 International Image Interoperability
 Framework (IIIF) 17, 65-66
 online catalogue 47, 49, 58, 59, 59, 60, 65
display script 22, 23, 24-25, 117
Diogenes Laërtius 278
Dionysius Periegetes
 Periegesis — in: BPL 67 (no. 21) 158
Dioscorides, Pedanius
 De materia medica 194
 De materia medica, alphabetised Latin
 version — VLQ 1 (no. 14) 112, 113, 126-129,
 126, 128, 129
Dirc van Delft 46
Dirk Gravekijn 255
Dirk Poes 255
Doctrinale (Alexander de Villa Dei) 255
Dokkum 243
Dositheus Magister
 Ars Grammatica 177
Dousa, Janus 43
drawings; sketches
 added by readers 17, 19, 34, 74-76, 75
 diagrams 34, 34, 132, 202, 208-211, 209, 210, 211
 drypoint 28, 28, 34, 161
 erased by readers 143, 152-153, 155
 maps 130-131, 132
 tables 132, 133
 visual aids 122-125, 122, 124
 see also: illuminations; illustrations;
 miniatures
drypoint, *see*: drawings
Dubthach 158-159
Dungal 148-149, 150, 151
Durham Cathedral 198

East Franconian 188
Ebersberg, monastery of 187
Echternach 159
Eco, Umberto 13
editing, *see*: text editing
educational material 81, 122-125, 122, 124, 143, 169, 174-177
*Een devote meditacie op die passie ons liefs
 Heeren* — in: LTK 237 (no. 10)
 109-110, 110, 111
Egmond, abbey of 32, 32, 37, 41, 57, 155, 155, 159, 187-189
'Egmond Willeram', *see: Leiden Willeram*
Einhard
 Vita Karoli Magni — in: BPL 20
 (no. 42) 250
Eleanor of England 80
Electra (Sophocles) — in: VGQ 6 (no. 46) 267
Elementa (Euclid) — in: SCA 36 (no. 33) 61, 190, 191, 208-211, 209, 210, 211
Elizabeth van Gorinchem 93, 94
Emeis (book binder) 62
Enchiridion (Epictetus) — in: VGQ 54 (no. 49)
 261, 278-280, 279
encyclopaedias 130-133, 191, 196-199, 213-215
England 18, 22, 25, 28-29, 80, 97, 98, 116, 158, 191
Epictetus 280
 Enchiridion — in: VGQ 54 (no. 49)
 261, 278-280, 279
Epicurus 150
Epistulae ad familiares (Cicero) — VLF 49 22, 56, 260, 261, 270-273, 271, 272, 273
Epodes (Horace) 19-20
 in: GRO 15 20, 34
Erasmus, Desiderius 276-277
Ercole I d'Este, Duke of Ferrara 276
Ermenrich of Ellwangen 151
errors; mistakes 113
 browsing errors 138, 138-139
 continuation errors 138-141, 140, 141
 erasing of 19, 143
 eye skip 140-141
 textual corruption 55
 see also: correction
Esopet — in: LTK 191 (no. 36)
 221, 222-224, 223
Etymologiae (Isidore of Seville)
 with notes by Ademar of Chabannes
 — in: VLO 15 (no. 13) 123
 extract — in: VGQ 7 (no. 25) 177
Euclid of Alexandria
 Elementa — in: SCA 36 (no. 33)
 61, 190, 191, 208-211, 209, 210, 211
Euripides 267
Europeana (portal) 66
Eusebius of Caesarea, Saint 72, 251
 canon tables (Eusebius) — in: BPL 48
 (no. 1) 72
 chronological canons, fragment
 — in: VLQ 110 A 48, 72
Evrard de Béthune
 Graecismus 255
ex libris 117, 117, 151

exemplars 15, 19, 113
 glosses copied from 34
 layout of exemplars and continuation
 errors 141
 pecia system 31, 166
exchange of manuscripts 15
Excerptum de gestis Romanorum pontificum
 (Abbo of Fleury) — in: VLF 96 (no. 41)
 234, 235, 244-247, 245, 246
Exeter Book 179
exhibitions 13, 43, 63, 119
Expositio in Cantica Canticorum
 (Williram van Ebersberg) 186, 189

fables 45
 Esopet — in: LTK 191 (no. 36)
 221, 222-224, 223
 Fables (Aesop), version of Phaedrus/
 Romulus, illustrated by Ademar of
 Chabannes — in: VLO 15 (no. 13)
 123-125, 124
facsimiles 64-65, 202-203
 *Codices Graeci et Latini photographice
 depicti* (facsimile series) 65, 65
Faraj ben Solomon of Grigenti 133
Farnese, Alexander, *see*: Alexander Farnese,
 Duke of Parma
fenestra, *see*: bindings
Ferguut — in: LTK 191 (no. 36) 220, 221, 222, 224, 225
Ferrara 276-277
Ferrières 159
Filips van Leiden 35
 composite manuscript from the private
 library of Filips van Leiden
 — BPL 2429 (no. 43) 47, 234, 235, 252-255,
 252, 253, 254, 255
finger-counting 14, 191, 204-207
fittings, metal 36
Flanders, county of 97-98, 132, 214, 228
flesh side, *see*: parchment
Fleury, abbey of 179-244-247
Florence, Bibliotheca Medicea
 Laurenziana 146
Floris ende Blancefloer
 (Diederic van Assenede)
 LTK 191 (no. 36) 46, 224
 fragment — in: LTK 2040 46
flyleaves 36, 46, 98, 113, 114-115, 116, 136, 137
foliation 33, 84-85
Formulae Marculfi (Marculfus) — in: BPL 114
 (no. 12) 112, 113, 118-121
fragments 46, 48, 59, 62, 114-115, 116-117
fore edge 33, 33, 118, 119-120
France 18, 58, 97, 116, 117, 119, 132, 146, 151, 154, 158-159, 173
Francia 158
Francis of Assisi, Saint 109, 110
 Sinte Franciscus leven (Bonaventura)
 — BPL 83 47, 48
 Sinte Franciscus leven
 (Jacob van Maerlant) 215
Franco-Insular style 72
Franco-Saxon style 72

314

François I, King of France 42, 261, 283, 284
Franconian 187-189
Friesland 242
Frisia 276
Fulda 239

Galle, Th. 280
Gaspar Ofhuys 106-107
Gaustmarus (scribe) 172, 173
Geel, Jacob 47, 50, 54, 54
Geert Groote 34
Gelre (Guelders), duchy of 97
Genesis, *see*: Bible, O.T.
Geoffrey of Monmouth
 De gestis Britonum 250-251
 De gestis Britonum — in: BPL 20
 (no. 42) 250
Geoffrey Plantagenet, Archbishop
 of York 80
Gerard van Poelgeest 36
Gerrevink (papermaking family) 98
Gerrit van Castricum 101, 101-103
Gerritsen, Johan 181
Gerritsen, W.P. 228
Germany 18, 30, 158-159, 161, 177
Germanicus Julius Caesar 23, 201
 see also: *Aratea* (Germanicus)
Gesta Normannorum ducum (William of
 Jumièges) — in: BPL 20 (no. 42) 234, 235,
 248-251, 248-249, 251
Ghent 159
 Ghent University Library 132
 Holy Rosary Brotherhood 106
 Saint Agnes convent 106-107
Gheyn, Jacobus de 202
Gimbrère, Sister Lucie 12, 62, 119-121, 125,
 225, 225
Glossa ordinaria 76
Glossa ordinaria (Johannes Andreae),
 on *Constitutiones Clementinae*
 — in: ABL 14 (no. 23) 166, 167
glossaries 169
 glossary manuscript with the
 Hermeneumata Pseudo-Dositheana
 — VGQ 7 (no. 25) 168, 169, 174-177,
 174-175, 177
 glossary produced in Amiens
 — in: VLF 26 25, 25
 Latin glossary — in BPL 67 F (no. 24)
 168, 169, 170-173, 170-171, 172, 173
glosses; annotations 21, 33, 146, 160, 161,
 162-163, 163, 164-165, 166-167, 167, 169, 177
 added by later readers 33, 34, 57, 143
 annotations in printed books 55, 55-56
 copied from exemplar 33, 143
 interlinear (between the lines) 33, 57, 123
 marginal (in the margins) 12, 20, 33, 57,
 57, 151, 156-157, 158, 159
 notes in devotional texts 91
 reference marks/symbols 32, 33, 167
 scholia 162, 267-268
glue 37
Goedeljee, Jan 64

Goedeljee, Johannes 64
gold 27, 70-71, 72, 95, 95
goose quills, *see*: quill pens
Gosker, Margriet 42, 43
gospel books
 Gospel Book from Saint-Amand — BPL 48
 (no. 1) 43, 43, 68, 69, 70-73, 70-71, 73
Gospels, *see*: Bible, N.T.
Gothic bookhands; *littera gothica*
 23-24, 25-27, 26
 littera cursiva (Gothic cursive)
 27, 216, 225, 258-259
 littera hybrida 27
 littera textualis 23, 24, 25, 136, 233
 pre-Gothic; proto-Gothic 25
Gouda 94
Graecismus (Evrard de Béthune) 205
Gregory I de Great, pope, Saint 259
 Moralia in Job 76
Gregory II, pope 244
Gregory III, pope 244
Gregory of Tours
 Historia Francorum, fragment
 — BPL 21 (no. 11) 62, 114-115, 116-117
Grimm, Jacob and Wilhelm 228
grisaille, *see*: miniatures
Groningen, city of 276, 277
Groningen, province of 276
Gronovius, Abraham 45, 63, 63-64
Gronovius, Joannes Fredericus 44
Grotius, Hugo 41, 202
Guido de Columna
 Liber de casu Troie dicte Troianus
 — in: BPL 2429 (no. 43) 235, 253-354
Guido de Cumis 264-265
Guilelmus de Monte Lauduno 166
Gumbert, Peter 50, 58, 58
Gutenberg, Johannes 27

Haarlem 138
 Convent of Saint Margaret 88
 decoration style 86-88, 89
The Hague, KB, National Library of
 the Netherlands 88, 129, 137
Hainault, county of 93
hair side, *see*: parchment
Hakendover 105-106, 107
Halm, Karl 147
hand, small/pointing, *see* manicule
hands 30, 84-85, 159, 254
Harmonia Macrocosmia
 (Andreas Cellarius) 202, 203
Hegesippus, *see*: Pseudo-Hegesippus
Heiberg, J.L. 210, 211
Heinric van Aken
 Roman van Limborch — in: LTK 195
 (no. 37) 220, 221, 226-229, 229
Heinsius, Daniel 41, 48, 50, 51, 53
Heinsius, Nicolaas 46, 151
Heiric of Auxerre 151
Hendrik van Veldeke
 Life of St Servatius (Hendrik van Veldeke)
 — in: BPL 1215 42-43

Henry II, King of England 29, 80
Henry IV, Holy Roman Emperor 243
Henry of Huntingdon 250-251
 Historia Anglorum 250-251
herbaria 191, 192-195
Herbarium (Pseudo-Apuleius)
 in: VLQ 9 (no. 29) 190, 191, 192-195,
 192-193
 in: VLQ 40 195, 195
heritage libraries, exchange for facsimile
 series 65
Hermeneumata Pseudo-Dositheana — in: VGQ 7
 (no. 25) 168, 169, 174-177, 174-175, 177
Herne 82
Herne Bible, *see*: Southern Netherlands
 History Bible
's-Hertogenbosch 86-88
Hildesheim 30
Hincmar, bishop of Laon 244-247
Historia Anglorum (Henry of Huntingdon)
Historia Francorum (Gregory of Tours),
 fragment — BPL 21 (no. 11) 62, 114-115,
 116-117
Historia Scholastica (Petrus Comestor) 82
Historiae Alexandri Magni (Curtius Rufus)
 — BPL 136 E 31, 31
historiated initials, *see*: initials
history Bibles
Holland, county of 93, 215, 253, 258
Homberch, Henrick Eckert van 109, 110
Homer
 Iliad, French translation by Hugues Salel
 — MAR 57 (no. 50) 42-43, 260, 261,
 282-285, 282, 283, 285
 Ilias Latina, Latin summary of the *Iliad*
 — in: BPL 1925 47
 Odyssey 158, 195
Hoogstraat, Gerrit Pietersz. 255, 255
Horace (Quintus Horatius Flaccus)
 Epodes 19-20
 Epodes — in: GRO 15 20, 34
 Odes 19-20
 Opera omnia, printed edition 1612
 — UBL, ex.758 E 24 55
horn 36
hours 29, 91
 see also: books of hours
Hout, Jan van 189
Howald, Ernst 195
Hugo Capet, King of France 244
Hugo de Constancia 164-169, 169
Huls, Samuel van 45, 46
humanism 27, 55, 151, 202, 261, 270-272,
 276-277, 283
humanist minuscule script
 (*littera antiqua*) 27-28, 272
Huydecoper, Balthazar 224, 225
Huygens, Christiaan 272
Huygens Institute 66
hybrida, *see*: *littera hybrida*
Hyginus 123
 De astronomia, illustrated by Ademar of
 Chabannes — in: VLO 15 (no. 13) 125

315

Ibn Jazla
 Tacuinum corporum 133
IJsselstein Castle 93
IJssel region 97, 243
Iliad (Homer)
 French translation by Hugues Salel —
 MAR 57 (no. 50) 42-43, 260, 261, 282-285,
 282, *283*, *285*
 Ilias Latina, Latin summary
 — in: BPL 1925 47
illuminations 27, 70-71, 72, 78-79
 see also: decoration
illuminators; book painters 29, 30, 72-73, 86,
 95, 97, 133, 218, 233
 signing and dating 103, *103*
Illustrated Inventory of Medieval Manuscripts
 (Peter Gumbert) 58, *58*
illustrations 27, 28-30
 see also: decoration; drawings; initials;
 miniatures
incipit 272
incunable books, *see*: printing press
indexes 33, 98
 catalogue indexes 49, 52
initials 20, 26, *26*, 27, 28, 28-29
 historiated 28, *28*
ink 20-21
 colour; pigments 20-21, 27-28
 fading 127
 recipe 12, 20-21, 191
 for ruling 20
inscriptions 58, 78-79, 80, 166, 238, 258, *258*
Institutiones grammaticae (Priscian)
 in: BPL 67 (no. 21) 142, 143, 156-159,
 156-157, *158*, *159*
 BPL 91 34, *34*
 BPL 92 41
 BPL 114 B 28, *29*
 PER F 27 33, *33*
Insular minuscule; Insular style 148-149, 150,
 151, *156-157*, *158*, *159*, 191, 199
interlinear space, *see*: lines
International Image Interoperability
 Framework (IIIF) 17, 65-66
*Inventory of Western Medieval Manuscripts
 Held by Leiden University Libraries*
 (André Bouwman) 59, 60
Ireland 25, 72, 116, 150, 158-159
Irish minuscule 159
Isagoge (Johannitius) 129
Isaiah (O.T.) 72
Isidore of Seville 123, 183
 Etymologiae, with notes by Ademar
 of Chabannes — in: VLO 15 (no. 13) 123
 Etymologiae, extract — in: VGQ 7
 (no. 25) 177
Italy 18, 25, 27-28, 31, 97, 113, 127, 158-159,
 272, 283

Jacob Egidius 31
Jacob van Maerlant 53-54
 Der naturen bloeme — BPL 14 A (no. 34)
 54, *190*, *191*, 212-215, *212-213*, *214*, 215
 Spiegel historiael 45, 134

Jacobus de Voragine
 Legenda aurea 224
Jan Taye 82
Jan van Arkel, bishop of Utrecht 253
Jan van Boendale
 Brabantse Yeesten 136
Jan van Ruusbroec 46
Jan van IJsselstein 215
Jan von Brunswick 232
Jerome, Saint 95, 184, 204-205, 206-207,
 239, *239*
Jerusalem 80, 109, 117, 130-131, 132
Jesus Christ 13, 29, 72, 76, 81, 92, 94, 95, *95*,
 96, 97, 98, 99, 103, 104, 105, 109, 110, *111*,
 117, 132, 187, 188, 207, *207*, 212-213, 215, 238
 Leven ons heren — LTK 258 (no. 5) 62, 68,
 69, 86-89, *87*, *88*, *89*
Joan of Burgundy 80
Job, Book of, *see*: Bible, O.T.
Job (O.T.) 74-77, *75*, 278
Johanna van Zaers 93
Johannes Andreae
 Glossa ordinaria, on *Constitutiones
 Clementinae* — in: ABL 14 (no. 23) 166, *167*
Johannes de Beke
 Chronographia — in: BPL 2429
 (no. 43) 253, *254*
Johannitus
 Isagoge 129
John the Baptist, Saint (N.T.) 95
John the Evangelist, Saint (N.T.) 95, *95*, 138
John I, Duke of Brabant 134
John I the Fearless, Duke of Burgundy 81
John VIII, pope 247
John XXII, pope 166
John of Berry, Duke of Berry
 and Auvergne 218
John of Salisbury 261
John Scottus Eriugena 143, 158, 159
Josephus, Flavius 117
Judas Iscariot (N.T.) 12, 117
Jude the Apostle, Saint (N.T.) 21, *21*
Junius, Patricius 278
Junius Laurentius 199, 200
Justian I, Byzantine Emperor
 Digestum vetus 167
 Digestum vetus, with glosses and
 additiones — BPL 6 C (no. 45) 260, 261,
 262-265, *262-263*, *265*
Juvenal (Decimus Junius Juvenalis)
 Satyrae — in: BPL 82 (no. 22) 34, 142, 143,
 160-163, *160*, *163*

Kassel, Landesbibliothek 195
Kern, J.H. 180
knife 20

Labrée (book binder) 62
Lachmann, Karl 151
laid lines 18
Lambert of Saint-Omer
 Liber floridus — VLF 31 (no. 15)
 61, *112*, 113, 130-133, *130-131*, *133*

Lancelot Compilation
 (Lodewijk van Velthem) 137
language
 language for descriptions 49-50, 57-58
 manuscripts/fragments 37, 54, 59, 60
 ordering/classification by language
 45, 53, 54
 see also: Latin; vernaculars
Laon 76, 158-159, 244-247
Laterculus (Polemius Silvius) 173
Latin, usage of 21, 23, 25, 26, 45, 50, 54, 57-58,
 88, 116, 172-173, 259
layout; *mise-en-page* 19-20, 26
 columns 19-20, *20*, 134-136, *135*
 margins 19, 27, 134-136, *135*
 text block; written space 19-20, 26,
 134-136, *135*
Lazarus project 181
Le Bec, abbey of 25-251
Le Long, Isaäc 45
leather 35, 61, 69, 119-121
 alum-tawed 120, 121
 limp bindings (flexible covers) 36
Leffen, Petrus 44
legal texts 25-26, 45-46, 119, 164-167, 262-265
Legenda aurea (Jacobus de Voragine) 224
Lehmann, Paul 65
Leiden
 burgomasters 39, 42, 60-61
 city authorities 37-38
 decoration style 94
 Les delices de Leide (city guide, 1712) 52, *52*
 National Museum of Antiquities 119
 see also: Leiden University;
 Leiden University Libraries
Leiden *Aratea* — VLQ 79, *see*: Aratea
'Leiden Corpus', philosophical works
 (Cicero) — VLF 84; VLF 86 (no. 18)
 55, 142, 143, 144-147, *144-145*, *146*, *147*
'Leiden Riddle' — in: VLQ 106 (no. 27)
 168, 169, 178-181, *180*, *181*
Leiden Willeram, West Low Franconian
 paraphrase of the Song of Solomon
 (also: 'Egmond Willeram') — in: BPL 130
 (no. 28) 41, 168, 169, 186-189, *186*
Leiden's *Wigalois* manuscript
 — LTK 537 (no. 38) 13, *13*, 220, 221,
 230-233, *230-231*, *233*
Leiden University
 450th anniversary 5, 13
 foundation (1575) 37, 155
 Minerva as symbol 48-49, 61-62
 professors of 38, 39, 41, 43, 44, 45-46, 53,
 58, 63-64, 187
Leiden University Libraries (UBL,
 Universitaire Bibliotheken Leiden),
 formerly Leiden University Library 37-66
 Archives of Governors
 (*Archief van Curatoren*, AC) 39
 auction acquisitions 35, 44, 45, 46, 47, 66,
 117, 224, 225
 bequests 40, 41-43
 Bibliotheca Neerlandica Manuscripta 56
 Bibliotheca Vossiana 43-44, *44*, 52, *52*

316

catalogues, *see*: catalogues (UBL)
Codices Ablaingiani (ABL) 60, 142, 143, **164-167** (**no. 23**)
Codices Bibliothecae Publicae Graeci (BPG) 38, 45, 53, 53-54, 60, 267, *268*
Codices Bibliothecae Publicae Latini (BPL) 14, 17, 21, *21*, 28, *28*, 29, *29*, 31, *31*, 33, *33*, 34, *34*, 35, *35*, 41, 42, 43, *43*, 44, 47, *47*, 53, 53-54, 57, 57-59, 60, 61, 63, 68, 69, **70-73** (**no. 1**), **74-77** (**no. 2**), **78-81** (**no. 3**), 90, 91, **92-95** (**no. 6**), **96-99** (**no. 7**), **100-103** (**no. 8**), **104-107** (**no. 9**), 112, 113, **114-117** (**no. 11**), **118-121** (**no. 12**), **134-137** (**no. 16**), **138-141** (**no. 17**), 142, 143, **156-159** (**no. 21**), **160-163** (**no. 22**), *168*, *169*, **170-173** (**no. 24**), **186-189** (**no. 28**), *190*, *191*, **204-207** (**no. 32**), **212-215** (**no. 34**), 234, 235, **248-251** (**no. 42**), **252-255** (**no. 43**), *260*, *261*, **262-265** (**no. 45**)
Codices Burmanniani (BUR) 32, *32*, 35-36, *36*, 60, *142*, *143*, **152-155** (**no. 20**)
Codices Gronoviani (GRO) 19, 20, 34, 45, 60
Codices Lipsiani (LIP) 45, 60
Codices Marchandiani (MAR) 42, 60, *260*, *261*, **282-285** (**no. 50**)
Codices Meijers (MEY) 60
Codices Oudendorpiani (OUD) 60
Codices Perizoniani (PER) 26, *26*, 33, 41-42, *42*, 60
Codices Ruhnkeniani (RUH) 60
Codices Scaligerani (SCA) 19, 27, *27*, 53, 60, 61, *190*, *191*, **208-211** (**no. 33**), **216-219** (**no. 35**)
Codices Vossiani Chymici (VCF, VCQ) 60
Codices Vossiani Germano-Gallici (VGG) 60
Codices Vossiani Graeci (VGF, VGQ, VQO) *168*, *169*, **174-177** (**no. 25**), *260*, *261*, **266-269** (**no. 46**), **278-281** (**no. 49**)
Codices Vossiani Latini (VLF, VLQ, VLO) 13, 22-24, *23*, 25, *25*, 30, 30-31, *31*, 44, 44-45, 56, 57, 60, 61-62, *63*, 112, 113, **122-125** (**no. 13**), **126-129** (**no. 14**), **130-133** (**no. 15**), *142*, *143*, **144-147** (**no. 18**), **148-151** (**no. 19**), *168*, *169*, **178-181** (**no. 26**), **182-185** (**no. 27**), *190*, *191*, **192-195** (**no. 29**), **196-199** (**no. 30**), **200-203** (**no. 31**), 234, 235, **236-239** (**no. 39**), **240-243** (**no. 40**), **244-247** (**no. 41**), *260*, *261*, **270-273** (**no. 47**), **274-277** (**no. 48**)
Codices Vulcaniani (VUL) 45, 53, 60
collection access 13, 49-59
collection building 12, 37, 40-49
collection care 13
collections and sub-collections 15, 49, 53-54, 59, 60
conservation 60-62
consultation; viewing 15-16, 37, 51-52, 62-63, 64
curators 39, 40, 47, 49, *49*, 57, 58, 62, 65, 119
custos (custodian; room guard) 39, *39*, 51, 52, 62, 64
descriptions of manuscripts 55-59
exchanges 46-47

fragments 46, 48, 59, 62
gifts 40-41, 42-43, 46, 53, 57
governors; Board of Governors 39, *39*, 40, 41, 43, 44, 45, 46, 51, 52, 60-61, 64
housing: Academy Building 37, 38
housing: Faliede Bagijnkerk 37, 38, 39, 40, 51-54, *51*, *52*, *54*, 60
housing: Witte Singel canal 38, 54-55, *55*, 61, *62*, 62
image repository (Digital Collections) 15, 37, 58, 65, 66
interior, *see*: library management (UBL)
Librarian (*praefectus bibliothecae*) 38-39, 40, 41, 42-43, 44, 45, 46, 60-61
Librarian's office *51*, 52-53
Library Archive (Bibliotheekarchief, BA) 38-39
library instructions 39, *39*, 56, 60-61, 64
library management, *see*: library management (UBL); library management (UBL), ordering/classification
library sources 38-40
loan collection *Maatschappij der Nederlandse Letterkunde* (LTK) 13, 45, 54, 60, 62, 68, 69, **82-85** (**no. 1**), **86-89** (**no. 5**), 90, 91, **108-111** (**no. 10**), 220, 221, **222-225** (**no. 36**), **226-229** (**no. 37**), **230-233** (**no. 38**), 234, 235, **256-259** (**no. 44**)
loan policy 63, 63-64
losses 46
manuscript room 53, *54*
permanent loans 45-46
photographic reproductions 64-66
purchases 43-45, 48, 53
remote users 37, 51, 64-66
special collections 37, 43, 53, 54
Special Collections Reading Room 15-16, 37, *62*, 62
storage area 45, 54-55, 61
Stichting Vrienden van de UBL 45
user services 62-66
visitors 39, 51-52, 64
letters
 ascenders 22, 24, 25, 26
 colour 23, *26*, 32, 32-33
 descenders 22, 24, 25, 26
 forms 22-27, 56, 73
 joining of letters; ligatures 24, 26, 27, 73
 majuscules 22, 117
 minuscules 24
 pen strokes 20, 24, 27, 199
 x-height 22, 24
letters/correspondence 117, 119
letters/correspondence (Cicero), *see: Epistulae ad familiares*
letters/correspondence (Pliny the Younger), selection, copied by Rudolph Agricola — VLQ 80 (**no. 48**) *260*, *261*, **274-277**, *274-275*, *277*
Leuze, monastery of St Peter (Lothusa) 243
Leven ons heren — LTK 258 (**no. 5**) 62, 68, 69, **86-89**, *87*, *88*, *89*
Lex Romana Visigothorum — in: BPL 114 (**no. 12**) 44, 112, 113, **118-121**

lexicons 48, 182-185
liber 12-13
Liber de casu Troie dicte Troianus (Guido de Columna) — in: BPL 2429 (**no. 43**) 235, 253-354
Liber floridus (Lambert of Saint-Omer) — VLF 31 (**no. 15**) 61, 112, 113, **130-133**, *130-131*, *133*
Liber pantegni (Ali ibn al-Abbas al-Majusi / Constantinus Africanus) 129
Liber pontificalis
 in: SCA 49, abbreviated version 239
 in: VLQ 41 239
 in: VLQ 60 (**no. 39**) 234, 235, **236-239**, *236-237*, *238*, *239*
 extract by Abbo of Fleury — in: VLF 96 (**no. 41**) 234, 235, **244-247**, *245*, *246*
librariërs; libraires (book merchants; stationers) 22, 30, 97, 98
libraries
 accessibility of manuscript collections in European libraries 56
 library management 36
 collection building 35
 private libraries 35, 41, 43-44, 272
 see also: heritage libraries; Leiden University Libraries (UBL); monastic libraries; university libraries
library management (UBL) 38-40, 49-59
 bookcases 41, 44, 51-53, *51*, *52*, 54, *55*, 55
 catalogues 49-54, 57-58, 59
 chain library system 51, *51*, *52*
 chains 51
 lectrines; *plutei* 51, *51*
 library hall system 51, *52*
 shelves 51-52
 theft 51
library management (UBL), ordering/classification 51-54
 by academic field 44, 51-52
 by acquisition 54
 by author (alphabetical) 51-52
 by collection 53, *53*, 54
 by language 44, 53, 54
 by material type 53
 by provenance 53
 by size 44, 51-52, 53
 by subject area 52, 53
libri cartarum, *see*: cartularies
Lieftinck, Gerard 49, 49-50
Liège, bishopric of 258
Life of St Servatius (Hendrik van Veldeke) — in: BPL 1215 42-43
ligatures, *see*: letters
Lijsbeth van Zaers 93-95
Limoges, Abbey of Saint-Martial 123, 125
Lincoln 80
lines
 interlinear space 20
 line length 19-20
 opening lines; *see also*: incipit
 verse lines 19-20, *20*, 23, 134-136, *135*
Linnaeus, Carl 194
Lipsius, Justus 43, 45, 280

litany (of saints) 80
littera antiqua, see: humanist minuscule script
littera beneventana, see: Beneventaans script
littera cursiva, see: Gothic bookhands
littera gothica, see: Gothic bookhands
littera hybrida, see: Gothic bookhands
littera textualis, see: Gothic bookhands
liturgical manuscripts 46
 in Dutch 258-259
Liudger, Saint 240-243
lives (*vitae*) 43, 48, 62, 69, 86-89, 215, 221, 224, 238-239, 243
localisation of manuscripts 17, 24, 55, 58
Lodewijk van Velthem
 Lancelot Compilation (Lodewijk van Velthem) 137
 Spiegel historiael, Fifth Part — BPL 14 E (no. 16) 45, 112, *113*, 134-137, *135*
Loebèr (book binder) 62
Loenersloot Castle 93, *94*
Loire region 119
Lombards 265
Los Angeles, J. Paul Getty Museum 13, 63, 216, 218, *218*, *219*
Louis the Pious, Emperor of the Carolingian Empire 158-159
Louis VIII, King of France 80
Louis IX, King of France (Saint Louis) 42, 69, 78-79, 80-81, 133
Louis XIV, King of France 272
Louvain, fire and destruction of University Library 46
Lucan (Marcus Annaeus Lucanus)
 Bellum civile — BUR Q 1 32, *32*, *33*, 35-36, *36*
Lucretius Carus, Titus 21, 37
 De rerum natura, 'Oblongus' — VLF 30 (no. 19) *142*, *143*, 148-151, *148-149*, *151*
 De rerum natura, 'Quadratus' — VLQ 94 31, *31*, 150, *151*, *151*
Lyon 283
 Bibliothèque Municipale 73

Maatschappij der Nederlandse Letterkunde (Society of Dutch Literature) 45, 54, 56, 60, 82 221, 224, 225, 229, 232
 see also: Leiden University Libraries (loan collection)
Mabillon, Jean 16
 De re diplomatica 16
Macarius von Busek 151
Maccabees, *see*: Bible, O.T.
Macrobius 150
magical seals 207, *i207*
Mainz 151, 239, 243
majuscule scripts, *see*: *capitalis rustica*; *capitalis quadrata*; uncial script
manicule; pointing hand; small hand (*maniculum*) 233, 253, 254-255
Marcellinus of Carthage, Saint 28, *28*
Marchand, Prosper 42, 284
Marculfus
 Formulae Marculfi — in: BPL 114 (no. 12) 112, *113*, 118-121
Margaret of Parma 81

Margaret III, Countess of Flanders 81
Marlet, Estienne 284
Martianus Capella 41, 158
 De nuptiis Philologiae et Mercurii — in: BPL 87 49, *57*, 57-58, *59*
Mary, mother of Jesus (Virgin Mary) 29, 86, 95, 101, 105, 106-107, 109, 110, 132, 243, *243*, 280
Mary Magdalene 132
martyrologies
 martyrology of Usuardus 258
 Middle Dutch martyrology from the St Servatius convent in Utrecht — in: LTK 273 (no. 44) 234, *235*, 256-259, *256-257*, *258*, *259*
Master of Catherine of Cleves 94, 95
Master of the Delft Grisailles 92, 95, *95*
Master of Peter Danielszoon 86
Masters of Otto van Moerdrecht; Moerdrecht Masters 96, 97-98, *98*, *99*
materials
 accessibility 113
 affordability 114, 136-137
 quality 22, 113, 134-137
 repairing; restoration 12, 61-62, 113, 118-121, *118*, *119*, *120*, *121*
 reuse 37, 46, 62, 113, 119-120, *121*
 see also: cardboard; horn; leather; paper; papyrus; parchment; wood
Matham, Jacob 187
mathematical texts 191, 204-207, 208-209, 216-219
Maurits of Orange 53
medical texts 126-129, 133, 191, 192-195
Meerhout, Pieter van 189
Meijers, Eduard 265
Méliacin Master, follower of the 133
memorisation 24, 184
Merula, Paulus 40-41, 43, *43*, 50, 55, 187, *187*, 188, 189
 Rariorum catalogus — BA1 C 3 43, *43*, 52-53
metric relic, *see*: relics
Meyier, Karel de 50, *56*, 57
Mico of Saint-Riquier 151
Middle Dutch 42-43, 45, 56-57, 82-85, 86-88, 93, 94, 95, 212-215
 Latin in MD manuscripts 88
Middle High German 221, 232
Mimigernaford 243
miniatures 12, 20, 27, 29-30, 34
 grisaille 27, *27*, 92, 95, *95*
 proofing marks (stamps) for 13, 98, *98*
 on separate leaves 95, 97, 98
 see also: illuminations; illuminators
minims 23
minuscule scripts 24, 27-28
 see also: Beneventan minuscule; Carolingian minuscule; humanist minuscule; Insular minuscule; *littera textualis*
Minerva 48, 48-49, 61-62
miscellanies 91
 collection of devotional and ascetic texts — BPL 2473 (no. 9) 90, 91, 104-107, *104*, *105*, *106*, *107*

mise-en-page, see: layout
missionaries 116, 158-159, 242
mistakes, *see*: errors
model letters
 Formulae Marculfi (Marculfus) — in: BPL 114 (no. 12) 119
Modern Devotion 34
Molhuysen, Philipp 43, 50, 57, *58*, *58*, 254
monasteries
 book production 21, 28-29, 117
 demand for books 21
 monastic life 29, 91, 105
 see also: individual monasteries: Aduard, Amelungsborn, etc.
monastic libraries 32, *32*, 35-36, 37, 41, 57, 93, 117, *117*, 129, 133, 151, 155, *155*, 159, 189, 238, 239, 243, 250-251
monastic orders
 Augustinian nuns 93, 105
 Augustinians 106
 Benedictine nuns 12, 62, 225
 Benedictines 12, 34, 62, 127, 159, 225
 Carthusians 82, 133
 Cistercian nuns 258, *258*
 Cistercians 13, 31, 34, 221, 232, 233,
 canonesses regular 88
 canons regular 101
 different versions of Usuard's martyrology 248
 Dominican sisters 38
 Dominicans 46
 Franciscans 109, 111, 138, 215
 tertiaries 88
monastic schools 123
monograms, *see*: wordplay
Mont Saint-Michel, monastery of 250-251
Monte Cassino, Abbey of 127-129, 146
Moralia in Job (Gregory the Great) 76
Mulder, Herman 136
Munich, Bayerische Staatsbibliothek 188
Münster, bishopric of 242, 243

Nansius, Franciscus 43, 45
Nansius, Franciscus jr. 43, 45
Naturalis historia (Pliny the Elder) 194, 214
 VLF 4 (no. 30) 62, *190*, 191, 196-199, *196-197*, *198*, *199*
navigation through texts 26, 29, 31-33
Nennius 250
Neuhuys, Albert 56
New Testament, *see*: Bible, N.T.
New York, Morgan Museum and Library 86
Nicholas of Lyra
 Responsio [...] — in: BPL 2429 (no. 43) 253, *254*
Nicolaas van Kats 215
Nomenclator autorum omnium quorum libri vel manucripti, vel typis expressi exstant in Bibliotheca Academiae Lugduno-Batavae (Bertius) — 1408 I 57 40, *40*, 50
Normans 250, 251
Northumbria 158, 198, 199
notes, *see*: glosses

Obbema, Pieter 50, 62, 119, 120
Octateuch, in facsimile series
— DOUSA f87 0201 65
Odes (Horace) 19-20
Odysseus 195
Odyssey (Homer)
Oedipus Rex (Sophocles)
in: BPG 60 A 267, *268*
in: VGQ 6 (no. 46) 266, 267, *268*
Oegstgeest, Mariënpoel convent 93-95
Old Dutch 186-189
Old English 169
Old High German 177, 188-189
Old Northumbrian 180
Old Testament, *see*: Bible, O.T.
Oodhelm 240-241, *242, 243*
Oosterhout, Onze Lieve Vrouwe Abbey
12, 62, 119-121, 225, *225*
Opus regale in quo continentur infrascripta opuscula (Johannes Ludovicus Vivaldus de Monte) 137
orations (Demosthenes) — BPG 33 38, *38*
Orderic Vitalis 250
Orelli, Johann Caspar von 147
origin 59, 60
Orléans 244-247, 265
Otto von Passau
Boeck des gulden throens — BPL 3469
(no. 17) 112, 113, 138-141, *138, 139, 140, 141*
Oudendorp, Frans van 63, *63-64*
Oudewater 93, 95
Elfduizend Maagden convent 93, 95
Ovid (Publius Ovidius Naso)
Tristia 233
Oxford 22
University of Oxford 65

page numbers 33, 98
palaeography 16, 58, 65
palimpsests; *codices rescripti* 18, 267
Pallas Athena 48-49
papacy 166-167, 238-239, 244-247
paper 18, 20, 37
parchment 17-19, *19, 20*, 27, 37, 61-62
hair side and flesh side 18, *119*, 170-171, *173*, 198
limp bindings (flexible covers) 36, 46
quality *19*, 22, 45, 113, 134-137
production 12, 17-19, 191, 198
reuse 37, 46, 113, 123
storage 62
strips as bookmarkers 33, *33*
vellum 198
papyrus 17-18, 37
Paris 22, 31, 65, 133, 255, 283
Bibliothèque nationale de France
46, 129, 283, *284*
Bibliothèque Royale 46
Parkes, Malcolm 181
patrons 56, 82, 232
Paul, Saint 177, 238
Paulus, Julius 265
Paulus de Lizariis 166

Pavia 150, 276
pecia system 31, 166
Penninc
Roman van Walewein — in: LTK 195
(no. 37) 220, 221, 226-229, *226-227*
pens, *see*: quill pens
penwork; pen flourishing, *see*: decoration
Periegesis (Dionysius Periegetes) — in: BPL 67
(no. 21) 158
Perizonius, Jacobus 41-42
Persians (Aeschylus) — in: VGQ 6
(no. 46) 267
Persius Flaccus, Aulus
Satyrae — in: BPL 82 (no. 22) 34, 142, 143, 160-163, *160, 161, 163*
Pétau, Alexandre 117, 133
Pétau, Paul 117
Peter, Saint (N.T.) 21, *21*, 235, 236-237, *238, 239*
Petrarca, Francesco 270
Petrus Comestor
Historia scholastica 82
Petrus Naghel 82
Phaedo (Plato), excerpts — in: VGQ 54
(no. 49) 280, *281*
Phaedrus, Gaius Julius 123
adaptation of *Fables* (Aesop), illustrated by Ademar of Chabannes — in: VLO 15
(no. 13) 123-125, *124*
Phainomena (Aratus),
see: *Aratea* (Germanicus)
Philip II, King of Spain 43, 189
Philip II the Bold, Duke of Burgundy 80-81
Philip III the Good, Duke of Burgundy 81
Philip Utenbroeke 134
Philip VI, King of France 80
Phillipps, Thomas 218
philology 16
Philosophia mundi (William of Conches)
— in: BPL 102 41
Philosophical works (Cicero), 'Leiden Corpus' — VLF 84, VLF 86 (no. 18)
55, 142, 143, 144-147, *144-145, 146, 147*
philosophy 146-147, 150-151, 278-281
photography 17, 56, 64-66, 202-203
digital photography 17, 65-66
microfilm 17, 65
ultraviolet photography 181
see also: facsimiles
Pieter Vostaert
Roman van Walewein — in: LTK 195
(no. 37) 220, 221, 226-229, *226-227*
pigments
Pilate, Pontius (NT) 98, 99, 110, *111*
Plato 280
excerpts from works — in: VGQ 54
(no. 49) 278, 280, *281*
Timaeus 54, 280
Pliny the Elder (Gaius Plinius Secundus)
Naturalis historia 194, 214
Naturalis historia – VLF 4 (no. 30)
62, 190, 191, 196-199, *196-197, 198, 199*

Pliny the Younger (Gaius Plinius Caecilius Secundus)
letters/correspondence, selection, copied by Rudolph Agricola — VLQ 80
(no. 48) 260, 261, 274-277, *274-275, 277*
plutei, *see*: library management (UBL)
Pluygers, W.G. 146, 147, *147*, 180-181, *18*
Poggio Bracciolini 151
Polemius Silvius
Laterculus 173
pointing hand, *see*: manicule
Porphyrius, Publius Optatianus 150
Postma, Ferenc 42, 43
Pozzuoli 184, *184*
prayer books
prayer book — BPL 3796 45, 66
psalter and breviary — BPL 2856 33, *33*
see also: books of hours
pre-Gothic; proto-Gothic 25
preservation, *see*: conservation
printing press 12-13, 26, 261
incunable books 26, 277
movable type 26, 109
printing and manuscripts combined
108-110
Priscian (Priscianus Caesariensis)
21, 123, 158-159
Institutiones grammaticae — in: BPL 67
(no. 21) 142, 143, 156-159, *156-157, 158, 159*
Institutiones grammaticae — BPL 91 34, *34*
Institutiones grammaticae — BPL 92 41
Institutiones grammaticae — BPL 114 B 28, *29*
Institutiones grammaticae — PER F 27 33, *33*
Profectus religiosorum (David of Augsburg)
110-111
Promtheus Bound (Aeschylus) — in: VGQ 6
(no. 46) 267
provenance 53, 60
Prudentius Clemens, Aurelius 123
Psychomachia — in: BUR Q 3 (no. 20)
142, 143, 152-155, *152-153, 155*
Psychomachia, illustrated by Ademar de Chabannes — in: VLO 15 (no. 13)
122, 123-125
Psalms, Book of, *see*: Bible, O.T.; psalters
psalters
psalter — BPL 3770 42, 43
psalter, trilingual — BPG 49 A 45
psalter and breviary — BPL 2856 33, *33*
Saint Louis Psalter — BPL 76 A (no. 3)
42, 68, *69*, 78-81, *78-79, 81*
Pseudo-Apuleius
Herbarium, in: VLQ 9 (no. 29) 190, 191, 192-195, *192-193*
Herbarium, in: VLQ 40 195, *195*
Pseudo-Hegesippus 117
De excidio Hierosolymitano, adaptation of *De bello Judaico* (Flavius Josephus)
— BPL 21 (no. 11) 44, 61, 112, 113, 114-117, *114-115, 117*
Psychomachia (Prudentius)
in: BUR Q 3 (no. 20) 142, 143, 152-155, *152-153, 155*

illustrated by Ademar de Chabannes — in: VLO 15 (no. 13) 122, 123-125
punctuation 23, 31-32, 31, 113, 116
see also: word spacing

quadrifolium 125
quaternions, see: quires
quill pens; goose quills 12, 20, 22
quinions, see: quires
quire signatures 19, 150, 199
see also: catchwords
quires 18-19
binions 18, 72
quaternions 18, 72
quinions 18
repairing; restoration 61, 62, 119-121
sewing holes 62, 121, 225

Rabanus Maurus 151
De computo — BPL 191 BD (no. 32) 14, 190, 191, 204-207, 204-205, 207
Raphael 208
Raphelengius, Christophorus 189
rapiarium (collection of notes) 107
Rau, Christiaan 281
reader's traces 33-34, 91, 156-159
reading
learning to read 80, 81
linearly vs. selectively 34
reading skills 34
as vehicle for prayer 34
word spacing and legibility 116
reagent 180
Rees, Hendrik van 276
Regulae abaci (Adelard of Bath) — SCA 1 (no. 35) 61, 190, 191, 216-219, 217, 218
Rehdiger, Thomas 235, 255
Reichenau, abbey of 41-42
Reims 25, 154, 159, 183
monastery of Saint-Remi 120, 121, 238, 239
relics 30, 80, 242, 243, 243
metric relic 207, 207
repairing 46, 61-62, 118-121, 118, 119, 120, 121
reproduction techniques 64-66, 201-203
see also: photography
Responsio [...] (Nicholas of Lyra) — in: BPL 2429 (no. 43) 253, 254
restoration 61-62, 118-121, 118, 119, 120, 121
reversibility 62, 121
see also: conservation; repairing
Revelations, Book of, see: Bible, N.T.
Richard II, King of England 27
riddles 169
'Leiden Riddle' — in: VLQ 106 (no. 27) 168, 169, 178-181, 179, 180, 181
Rieu, Willem Nicolaas du 42-43, 64, 64-65
Robert II, Duke of Burgundy 80
Robert of Torigny 250-251
Roermond 253, 255
Roffet, Etienne 284
Rogge, H.C. 49-50
Roman de Troie (Benoît de Sainte-Maure) 253

Roman van Limborch (Heinric van Aken) — in: LTK 195 (no. 37) 220, 221, 226-229, 229
Roman van Walewein (Penninc & Pieter Vostaert) — in: LTK 195 (no. 37) 220, 221, 226-229, 226-227
Rome
Romulus (fabulist)
adaptation of *Fables* (Aesop), illustrated by Ademar of Chabannes — in: VLQ 15 (no. 13) 123-125, 124
Rooklooster priory 106-107
Rouen 30
rubrication; rubrics 32-33, 85, 109, 110, 154-155
ruling 20, 23
blind 20, 147
plummets 20, 26
pricking holes 20
rustic capitals (*capitalis rustica*) 22-25, 23, 32, 32, 114-115, 117

Saint Gall, abbey of 41-42, 159
Saint-Amand, abbey of 43, 69, 72, 155, 239
Saint-Bertin, abbey of 151, 202
Saint-Denis Abbey 154
Saint-Germain-des-Prés, abbey of 258
Saint-Mesmin-Micy, abbey of 117, 117, 247
saints
feast days 97, 235, 258, 259
litany 80
lives (*vitae*) 43, 48, 62, 69, 86-89, 215, 221, 224, 238-239, 243
local saints 80, 97, 258
martyrologies 256-259
prayers to 29, 91, 101, 109, 110
relics 30, 80, 207, 207, 242, 243, 243
see also individual saints: Abbo, Agatha, Alexis etc.
Salel, Hugues 282, 283, 283-284
Salisbury, bishopric of 97
Salutati, Caluccio 270
Salvator, Saint 242, 243, 243
Sars (near Mons, Hainault) 93
Satan 74, 75, 76
Satyrae (Juvenal) — in: BPL 82 (no. 22) 34, 142, 143, 160-163, 160, 163
Satyrae (Persius) — in: BPL 82 (no. 22) 34, 142, 143, 160-163, 160, 161, 163
Saxony 242, 243
Scaliger, Josephus Justus 41, 41, 51, 52, 53, 61, 208, 218
Arca Scaligerana 41
Cyclometrica 210
Schamper (book binder) 62
Scheper, Karin 62
Schlutter, Otto B. 180
scholia, see: glosses
Schoonhoven 93
Scipio Africanus, Publius Cornelius 27
scribes; copyists 13, 15, 21
collaboration 30, 30-31, 72-73, 126-127, 126
female scribes 13, 21, 93
identity 30-31, 31

multiple scripts 22, 25
pecia system 31, 166
reading skills 34
scribal performance 22, 30-31, 101-102
scribal processes; writing in practice 12, 17, 21-24, 30-31
signing and dating; colophons 16-17, 31, 31, 56, 101, 101, 158, 232, 276, 277
writing as profession/craft 12, 21-22
see also: correction; errors
script; scripts 22-27
choosing scripts 22, 23, 27
legibility 22, 23, 24
purpose of text and 22, 24
regional scripts 22, 25
speed of copying 22, 24
transitional scripts 25
see also: bookhands; cursive scripts; Gothic scripts; majuscule scripts; minuscule scripts; palaeography
scriptoria 21, 117, 233
scriptura continua 31, 116
Scriverius, Petrus 243
Sedulius Scottus 159
Seneca the Younger, Lucius Annaeus 183
tragedies — BPL 45 A 31, 32
Senguerdius, Wolfert 47, 50, 53, 54
Sertenas, Vincent 283
Servatius of Tongeren, Saint 43
Servatius manuscript — BPL 1215 42-43
Seven against Thebes (Aeschylus) — in: VGQ 6 (no. 46) 267
Seversz, Jan 110, 110, 111
sewing holes, see: quires
Sheba, Queen of (O.T.) 86
shelf list catalogues, see: catalogues (UBL)
shelfmarks; signatures 15-16, 49, 52
new shelfmarks 46, 48
shorthand, see: Tironian notes
Sidrac (Middle Dutch encyclopaedia) 12
Siegfried of Westerburg, Archbishop of Cologne 134
Sigerist, Henry 195
Sigebert of Gembloux 251
signatures; see: shelfmarks
Sijthoff (publisher), see: A.W. Sijthoff
Silanion 280
Sinte Franciscus leven (Bonaventura) — BPL 83 47, 47-48
Sinte Franciscus leven (Jacob van Maerlant) 215
size
format indicators 52, 53
leaves/pages 51
ordering by book size 44, 51-52, 53
outsize formats 54, 198
small books 91
sketches, see: drawings
small hand, see: manicule
Smith, Albert 180
Socrates 195, 278, 280
Soissons 159
Solomon, King (O.T.) 86, 107
Song of Solomon, see: Bible, OT

Song of Songs, paraphrase;
 see: Leiden Willeram
Sophocles
 Oedipus Rex — in: BPG 60 A 267, *268*
 tragedies, *Ajax*, *Electra*, *Oedipus Rex*
 — in: VGQ 6 (no. 46) 260, 261, 266-269, *266*, *269*
Southern Netherlands History Bible
 (also: 'Herne Bible', 'Bible of 1360')
 — LTK 232 (no. 4) 68, 69, 82-85, *82*, *83*, *84*, *85*
spacing, *see*: word spacing; *see also*; lines; punctuation
Spanhemius, Fredericus 50
square capitals (*capitalis quadrata*) 24-25
Spangenberg, Cyriacus
 Adels-Spiegel 233
Speculum historiale (Vincent of Beauvais) 134
Spiegel historiael (Jacob van Maerlant)
 Fifth Part (Lodewijk van Velthem)
 — BPL 14 E (no. 16) 45, 112, *113*, 134-137, *135*
 First and Third Parts and beginning of Fourth Part (Jacob van Maerlant) 45, 134
 Second Part (Philip Utenbroeke) 134
Spierinc (illuminator) 103, *103*
Spierinc, Sybrant 103
St Albans, monastery of 28-29
St Petersburg 65
Staender, Joseph 64
stamps
 library stamps 36, 48, 49, 61-62
 proofing marks for miniatures 13, 98, *98*
States of Holland 37, 43
stationarius 166
stationers, *see*: librariërs
Stephen II, pope 239, *239*, 244
Stephen III, pope 239
Stephen V, pope 238
Stuttgart, Württembergische Landesbibliothek 277
stylus 28, 162, *162*
Sweet, Henry 180
Swieten family, Van 93, 94
Switzerland 42, 158-159, 202
Symphosius
 Aenigmata — in: VLQ 106 (no. 27) 168, 169, 178-181
Syntygma Arateorum, *see*: Aratea
Szirmai, Janos 119

tables 132, 133
tables of contents 33, 35, 83, *83*-85
Tacitus, Publius Cornelius 276
tackets; binding loops 18, 121, 123
Tacuinum corporum (Ibn Jazla) 133
Telesphorus, pope 238, 239
Ter Doest, abbey of 31, *31*
text block; written space, *see*: layout
text editing 143, 144-149
 comparing of text versions; collation 15
text types 59, 60
textual variants 15, 55, *55*, 151
Theodosius II, Byzantine Emperor 119
theological works 25-26

Theseus 76
Thévenot, Melchisédech 272
Thiatbald 242
Thiele, Georg 65
 Antike Himmelsbilder 202, *202*
Thierry of Chartres
 commentary on *De inventione* (Cicero)
 — in: BPL 189 17
Thomas Becket, Saint 29, *29*
Thomas Feye 31, *31*
Thomas of Cantimpré
 Bienboek (Bok of Bees) 88
 De natura rerum 214
Three Kings (N.T.) 86, 87, 88, 92, 95
Thysius, Anthony 51
Tienen, Sint-Barbaradal convent 104, 106
Timaeus (Plato) 54, 280
time measuring 100-103, 123
Tiro, Marcus Tullius 183-184
Tironian notes; shorthand 48, 123, 169, 181-184, *182*, *184*, *185*
title *fenestra*, *see*: bindings
title pages 49, 236-237, *238*, 270, *272*
Topica (Cicero) — in: VLF 84, VLF 86 (no. 18) 144-147, *144-145*, *146*, *147*
Tours 25
tragedies (Aeschylus), *Persians*, *Prometheus Bound*, *Seven against Thebes* — in: VGQ 6 (no. 46) 260, 261, 266-269, *269*
tragedies (Seneca) — BPL 45 A 31, *31*
tragedies (Sophocles), *Ajax*, *Electra*, *Oedipus Rex* — in: VGQ 6 (no. 46) 260, 261, 266-269, *266*, *269*
Traison et mort — SCA 40 19 27, *27*
transcriptions 24
Traube, Ludwig 65
Tristia (Ovid) 233
Tunisia 127
Twente 242, 243
typology, *see*: Bible

UBL, *see* Leiden University Libraries
Ulpianus, Domitius 265
uncial script (*uncialis*) 24-25, *25*, 72, 114-115, *116*, 117, 150, 177
universities
 Bologna 31, 166, 261, 262-263, 264-265, *265*
 books produced for 22
 commentaries on legal and theological works 25-26
 pecia system 31, 166
 see also: Leiden University
university libraries
 Breslau 47, 64, *64*
 Gent 132
 international cooperation 64-65
 exchanges 46-47
 Leuven 46-47
 loans of UBL-manuscripts to academic libraries 64
 Utrecht 47
 see also: Leiden University Libraries (UBL)
Usuard 258

Utrecht, city of 46-47, 215, 235
 illuminators 95, 97-98
 Mariakerk church 215
 missionary centre 242, 243
 Moerdrecht Masters 97-98
 St Servatius convent 256-259
 Utrecht University Library 46-47
Utrecht, Prince-Bishopric of 253, 258

Valenciennes 155
Valerius Polemius, Julius 250
Vauvert, charterhouse 133
vellum, *see*: parchment
Venus 150
vernaculars 26, 54, 169
 vernacular Bible reworkings 69, 82-85
 see also: East Franconian; Franconian; Middle Dutch; Middle High German; Old English; Old Germanic; Old High German; Old Northumbrian; West Low Franconian
Virgil (Publius Vergilius Maro) 46, 173, 218
 Aeneid (Virgil) 154, 163, 229
Virgil Master 218
Vincent of Beauvais
 Speculum historiale 134
Vita Karoli Magni (Einhard) — in: BPL 20 (no. 42) 250
Vita Ludgeri (Altfried of Münster)
 — in: VLQ 55 (no. 40) 242-243
vitae, *see*: lives
Vitruvius Pollio, Marcus
 De architectura — in: VLF 88 30, *30*
Vivaldus de Monte, Johannes Ludovicus
 Opus regale in quo continentur infrascripta opuscula 137
vocabularies 169, 173, 174-177
 see also: glossaries
Vossius, Gerhard 151
Vossius, Isaac 35, 43-45, 47, 55, 56, 117, 125, 133, 146, 151, 195, 243, 269, 272, 281
 Bibliotheca Vossiana 43-44, *44*, 52, *52*
Vries, Scato de 46, 65
Vulcanius, Bonaventura 38, *38*, 43, 45, 52, *53*

Waanders, F.B. 54
watermarks 18
wax tablets 28, 162, *162*
wear and tear 61
Weesp 253, 254
Werden Abbey 235, 240-243
West Low Franconian 188
white-vine decoration (*bianchi girari*) 270, 272, *273*
Wichmond 243, 244
Wigalois (Wirnt von Grafenberg),
 Leiden's *Wigalois* manuscript
 — LTK 537 (no. 38) 13, *13*, 220, *221*, 230-233, *230-231*, *233*
Wilfrid of York 80
Willem V, Count of Holland 253
Willem van Zaers 93
William of Conches 41
 Philosophia mundi — in: BPL 102 41

William of Jumièges
 Gesta Normannorum ducum — in: BPL 20 (no. 42) *234*, 235, 248-251, *248-249*, *251*
William of Orange 53, 155, 253
Willibrord, Saint 158
Williram of Ebersberg 187-189
Wiltheim, family De 233
Wirnt von Grafenberg
 Wigalois, Leiden's *Wigalois* manuscript — LTK 537 (no. 38) 13, *13*, 220, 221, 230-233, *230-231*, *233*
Witt, Johan de 265

Wittendael, Jan van 41
Wolfenbüttel, Herzog August Bibliothek 133, *133*
wood 35, 36, 69, 113, 118-121, *118*, *119*, *120*, *121*, 191
woodcuts 110, *111*
word spacing; word separation 23, 31, *31*, 114-115, 116-117, 194, 198-199
wordplay 169
 acrostics 150
 monograms 184, *184*
Woudanus, Jan Cornelisz 41, *51*, 52-53

Wouter, abbot of Egmond 155, *155*
written space, *see*: layout

x-height, *see*: letters

York 80, 198, 242

Zachary, pope 244
Zacher, Konrad 64, *64*
Zeeland, county of 93, 215

Photo credits

All photos were produced by Leiden University Libraries, except for the following images:

p. 56 — Rotterdam, Gemeentebibliotheek, Albert Neuhuys, Portrait of Willem Lodewijk de Vreese.

p. 125 — Bamberg, Staatsbibliothek, Msc. Patr. 5, fol. 1v, detail.

p. 133 — Wolfenbüttel, Herzog August Bibliothek, Cod. Guelf. 1 Gud. Lat., fol. 88r, detail.

p. 136 — Brussels, KBR, IV 684, fol. 61r, detail.

p. 137 — Anholt, Fürstlich Salm-Salm'sche Bibliothek, fragment in AD nr. 460.

p. 179 — London, British Library, MS Royal 7 D XXII, fol. 85v, detail.

p. 189 — Munich, Bayerische Staatsbibliothek, Cgm 10, fol. 10r.

p. 201 — Boulogne-sur-Mer, Bibliothèque des Annonciades, Ms. 188, fol. 30r | IRHT-CNRS.

p. 203 — Amsterdam, Allard Pierson, OTM: OF 69-18 (atlas), plate 8.

p. 208 — Vatican City, Palazzo Apostolico, I Musei Vaticani, Raphael, *The School of Athens*, detail.

p. 219 — Los Angeles, J. Paul Getty Museum, Getty Ms. 72, fol. 26r.

p. 225 — The workshop of Sister Lucie Gimbrère, Onze Lieve Vrouwe Abdij, Oosterhout | Photo André Bouwman.

p. 242 — Reliquary of Liudger | Probsteikirche St. Ludgerus, Essen-Werden, inv.nr. L.3.

p. 247 — Bern, Burgerbibliothek, Cod. 120.I, fol. 92v.

p. 255 — Leiden, Erfgoed Leiden en Omstreken, Archieven van de kerken in Leiden, inv.nr. 1086.

p. 276 — Munich, Alte Pinakothek, 9363, Lucas Cranach the Elder, Portrait of Rudolf Agricola.

p. 280 — Rome, Musei Capitolini, MC 1377, Marble bust of Plato.

p. 283 — Bibliothèque nationale de France, département Arsenal, RESERVE FOL-BL-519, p. 81 | Source: gallica.bnf.fr / Bibliothèque nationale de France.

All possible efforts have been made to trace the copyright holders of these images.
Those who believe they are still entitled to certain rights may contact the publisher.

About the authors

André Bouwman studied Dutch Language and Literature at the Vrije Universiteit in Amsterdam, before receiving a PhD (cum laude) from Leiden University for his doctoral dissertation *Reinaert en Renart* (1991). He worked for over 34 years as a Curator of Western Manuscripts at Leiden University Libraries, until his retirement in March 2025. He co-authored *Stad van boeken. Handschrift en druk in Leiden, 1260-2000* (2008); his *Inventory of Western Medieval Manuscripts Held by Leiden University Libraries* was published in 2023.

Irene O'Daly is an Assistant Professor in book studies at Leiden University. Her research interests include the history of the book (notably medieval manuscript studies), the reception of classical ideas and texts in the medieval period and the history of knowledge.

Anne Margreet As-Vijvers is Senior Curator of Medieval Manuscript Illumination at the RKD (Netherlands Institute for Art History), specialising in illuminated manuscripts from the northern and southern Netherlands. Working as *Illuminare scribendo – Research and projects in Art History*, she performed research and editing tasks for museums, universities and private collectors in the Netherlands and abroad. She has published on urban and monastic book production, on music manuscripts for the nobility, on the function of books of hours in private devotion and on the meaning of flowers and other motifs in marginal decorations.

Saskia van Bergen completed a PhD thesis in 2007 on the Flemish Masters of Otto van Moerdrecht. A year later, she started working for Leiden University Library. Since 2022, she has been the department head of Services and Collection Information for the Special Collections.

Tazuko van Berkel is Associate Professor of Greek language and literature at the Leiden University Centre for the Arts in Society. She researches the history of economic thinking in Ancient Greece.

Bart Besamusca is Emeritus Professor of Middle Dutch textual culture in an international perspective at Utrecht University. His publications cover narrative medieval literature, late-medieval manuscripts and early print editions.

Jos A.A.M. Biemans studied Middle Dutch language and literature in Utrecht and palaeography and codicology in Leiden, publishing regularly on the manuscript tradition of Middle Dutch literature. He was an editor of the Bibliotheca Neerlandica Manuscripta and deputy curator of Western manuscripts at Leiden University Library and subsequently curator of manuscripts in the Special Collections of University of Amsterdam Library. From 1986 to 2017, he taught the history of writing and of the medieval book at the University of Amsterdam, from 2004 as a professor holding an endowed chair.

Gerard Boter is Emeritus Professor of Greek language and literature at the Vrije Universiteit Amsterdam. His research focuses in particular on the textual history and interpretation of Plato, Epictetus and Philostratus.

Rolf H. Bremmer Jr is Emeritus Professor of English philology and Frisian language and literature at Leiden University. He has published extensively on both subjects. In 1994, he held the Erasmus chair in Dutch history and culture at Harvard University.

Bram Caers is Assistant Professor of Middle Dutch literature at Leiden University. He specialises in secular literature from the late Middle Ages and the sixteenth century. Together with Jan Pauwels of the Royal Library of Belgium, he edited a book in 2023 for a broad readership on Jacob van Maerlant's *Rijmbijbel*, a Middle Dutch retelling of the Bible in rhyme.

Claudine A. Chavannes-Mazel is Emeritus Professor of medieval art history at the University of Amsterdam. She obtained her doctorate in 1988 on an illustrated manuscript of the *Miroir historial* in Leiden. Her most recent publications are about the use of plants between 600 and 1600, based on medieval manuscripts.

Anna Dlabačová is Associate Professor of book history at Leiden University. Her research focuses on the role of the book in religious life in the late medieval Netherlands. She is the principal investigator leading the research project 'Pages of Prayer: The Ecosystem of Vernacular Prayer Books in the Late Medieval Low Countries, c. 1380–1550 [PRAYER]' (project number 101041517), funded by the European Research Council.

Mart van Duijn is a medievalist, book historian and archivist who works for Leiden University Libraries as Curator of Western manuscripts and archives.

Ad van Els studied socioeconomic history at Leiden, philosophy at Nijmegen and medieval studies at Utrecht. He received his doctorate in 2015 with a thesis on the notebooks of Ademar of Chabannes (VLO 15).

David Ganz has taught palaeography in Chapel Hill, North Carolina; London; and Notre Dame, and most recently at the University of Chicago as visiting professor on the history of the book. He was elected to the Comité internationale de paléographie latine in 2000 and as a corresponding member of the Monumenta Germaniae Historica in 2016. He works on Latin manuscripts from before 900 AD.

Mary Garrison teaches medieval history and palaeography at the University of York.

Alisa van de Haar is Assistant Professor of old French literature at Leiden University. She is the author of *The Golden Mean of Languages: Forging Dutch and French in the Early Modern Low Countries, 1540–1620* (Brill 2019).

Suzette van Haaren is a Postdoc at Ruhr University Bochum, where she is working on the research project *Virtuelles Mittelalter* (Virtual Middle Ages) at the collaborative research centre *Virtuelle Lebenswelten* (Virtual Worlds). Her PhD thesis was on the digitisation of medieval manuscripts at the University of Groningen and the University of St Andrews. Her research reflects on how increasing digitisation (and virtualisation) of our historical heritage is influencing our picture of the Middle Ages.

Jef Jacobs worked at Leiden University on the German Language and Culture degree programme until 2016. He published on German language and literature in the Middle Ages and early modern period.

Casper de Jonge is Professor of Greek language and literature at Leiden University. His research concentrates on ancient rhetoric and literary criticism, and on the Greek literature of the Roman world. In his lectures on Greek tragedy, he discusses the manuscripts that are kept in Leiden's University Library.

Egbert Koops is Professor of legal history at Leiden University. His research and teaching mainly deal with the reception and influence of Roman law since the Middle Ages.

Anne Korteweg studied art history in Utrecht, Amsterdam and Munich. Until her retirement in 2007, she was Curator of medieval manuscripts at the National Library of the Netherlands in The Hague. Her fields of research are book illumination in the northern Netherlands and the history of late-medieval collections.

Erik Kwakkel is Professor in the history of the book at the University of British Columbia School of Information. His research interests are related to the script and material design of medieval manuscripts. He has published several monographs and edited volumes devoted to the culture of the medieval book.

Adrie van der Laan is a classicist and Special Collections curator at the University of Groningen Library. His specialist field is early humanism in the Netherlands, from Agricola to Erasmus.

Quintijn Mauer is Assistant Professor of legal history at the Faculty of Law at Leiden University. He carries out research into Roman law, canon law and its history.

Rosamond McKitterick is Professor Emerita of medieval history at the University of Cambridge and a fellow of Sidney Sussex College. Her main publications focus on the early medieval history and manuscripts of Western Europe, especially the Frankish kingdoms and Rome. She was awarded the Dr A.H. Heineken Prize for History in 2010 and was a Scaliger fellow at Leiden University Libraries in 2010.

Marco Mostert is Emeritus Professor of medieval history at Utrecht University. His research focuses on how medieval culture became a written culture, with particular attention paid to early medieval manuscripts.

Eef Overgaauw was head of the Manuscripts Department of the Staatsbibliothek zu Berlin until his retirement in 2022. He lectures in palaeography and codicology at the Freie Universität Berlin and publishes on medieval manuscripts.

Christoph Pieper is Assistant Professor of Latin language and literature at Leiden University. His research focuses on Cicero and his reception from Antiquity to the Renaissance, the poetry of the Italian Renaissance and the history of Roman eloquence.

Benjamin Pohl is Professor of Medieval History at the University of Bristol, UK. He is an expert in medieval European history and historiography, with a special focus on manuscript studies, palaeography and codicology, book history and cultural memory.

Thijs Porck is Associate Professor of medieval English at Leiden University. He researches Old English philology, early medieval cultural history, Beowulf and medievalism. He is the author of *Old Age in Early Medieval England* (2019) and has edited various collected volumes, including *Old English Medievalism* (2022, with Rachel A. Fletcher and Oliver M. Traxel) and *Keys to the History of English* (2024, with Luisella Caon and Moragh S. Gordon).

Karin Scheper is a book restorer who also researches the material aspects of manuscripts and old printed works, largely but not exclusively in the Eastern collection of Leiden University Library. She received the De la Court prize from the Royal Netherlands Academy of Arts and Sciences for her PhD thesis *The Islamic Bookbinding Tradition. A Book Archaeological Study* (2014).

Mariken Teeuwen studied musicology and medieval studies at Utrecht and manuscript studies at Leiden, before taking up a position as Researcher at the Huygens Institute (Royal Netherlands Academy of Arts and Sciences) in Amsterdam. She studies how medieval readers and scholars used their books and made notes in the margins. She is also Professor by Special Appointment in medieval writing culture in Leiden.

Kaj van Vliet is an archivist for the national and municipal archives in Het Utrechts Archief. He obtained his doctorate for research into the development of minsters and chapters in the medieval bishopric of Utrecht. He publishes regularly on the history of the city and Prince-Bishopric of Utrecht.

Ed van der Vlist studied Western palaeography and manuscript studies with Peter Gumbert (1936-2016). He is a Curator of medieval manuscripts at the National Library of the Netherlands.

Hanna Vorholt is Senior Lecturer in the Department of History of Art at the University of York. She previously held positions and fellowships at the Fitzwilliam Museum, Cambridge University Library, the British Library and the Warburg Institute. Vorholt has published particularly on the *Liber floridus* and its transmission history, and on Jerusalem in relation to the medieval imagination.

Geert Warnar is Associate Professor at the Leiden University Centre for the Arts in Society, specialising in teaching and research in the Dutch literature of the Middle Ages. His main interest is in dialogue as a genre.

Hanno Wijsman is a member of the academic staff of the *Institut de recherche et d'histoire des textes* (IRHT-CNRS), where he researches library history and the provenance of medieval manuscripts. He publishes principally on the book culture of monarchs and nobles in the late Middle Ages in France and the Low Countries, and on book illumination in the Southern Netherlands

Lannoo

www.lannoo.com

Universiteit Leiden

www.universiteitleiden.nl

All of the fifty manuscripts in this book have been digitised in full and are free to consult in large format through https://digitalcollections.universiteitleiden.nl.

Register on the website of Lannoo to regularly receive a newsletter with information about new books and interesting exclusive offers.

Editors-in-chief: Irene O'Daly and André Bouwman
Translations: Tessera BV, Clare and Mike Wilkinson

Design: Studio Lannoo in collaboration with Keppie & Keppie

Cover image: Illuminated initial *B* from the Saint Louis Psalter, BPL 76 A, fols 30v-31r.
Frontispiece: Persius writing on a wax tablet with a stylus, as seen in BPL 82, fol. 1v.
Endpapers: BPL 76 A, fols 58v-59r (*front*) and fols 126v-127r (*back*).

All images are of items from the collections of Leiden University Libraries, unless stated otherwise.

© Lannoo Publishers nv, Tielt, 2025
and Leiden University Libraries

D/2025/45/324 — 9789401432917 — NUR 684

All rights are reserved, including those for text and data mining, AI training and similar technologies. Nothing of this publication may be reproduced, stored in an automated database and/or made public in any form or by any means, electronic, mechanical or otherwise, without the prior written permission on the publisher.

in sapientia fecisti impleta est terra
possessione tua.

Hoc mare magnum et spaciosum manibus:
illic reptilia quorum non est numerus.

Animalia pusilla cum magnis: illic
naues ptransibunt. ¶ tempore.
Draco iste quem firmasti ad illudendum ei
omnia a te expectant ut des illis escam in

Dante te illis colligent aperiente te manum
tuam: omnia implebuntur bonitate.

Auertente autem te faciem turbabuntur:
auferes spm eor et deficient et in pulue-
rem suum reuertentur.

Emitte spm tuum et creabuntur: et re-
nouabis faciem terre. ¶ suis.

Sit gla dni in sclm: letabit dns in operibus
qui respicit terram et facit eam tremere:
qui tangit montes et fumigant.

Cantabo domino in uita mea: psallam
deo meo quamdiu sum.